The World as Sculpture

THE WORLD AS
SCULPTURE

*The Changing Status of Sculpture from
the Renaissance to the Present Day*

James Hall

Chatto & Windus
LONDON

First published by Chatto & Windus 1999

1 3 5 7 9 10 8 6 4 2

© James Hall 1999

James Hall has asserted his right
under the Copyright, Designs and Patents Act 1988
to be identified as the author of this work

First published in Great Britain in 1999 by Chatto & Windus
Random House, 20 Vauxhall Bridge Road, London SW1V 2SA

Random House Australia (Pty) Limited
20 Alfred Street, Milsons Point, Sydney,
New South Wales 2061, Australia

Random House New Zealand Limited
18 Poland Road, Glenfield
Auckland·10, New Zealand

Random House South Africa (Pty) Limited
Endulini, 5A Jubilee Road, Parktown 2193, South Africa

Random House UK Limited Reg. No. 954009

A CIP catalogue record for this book is available from the British Library

Papers used by Random House UK Limited are natural,
recyclable products made from wood grown in sustainable forests.
The manufacturing processes conform to the environmental
regulations of the country of origin.

ISBN 0-7011-6882-X

Printed and bound in Great Britain
by Biddles Ltd, Guildford

To my family

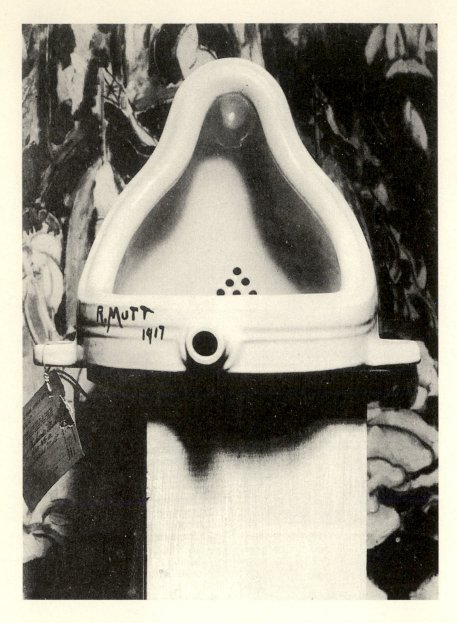

Marcel Duchamp, *Fountain*, 1917 (photograph by Alfred Stieglitzz).

Contents

Illustrations

Acknowledgements

Many people have been extremely generous with their time and knowledge. The following have read and commented on part, or all, of the text: David Batchelor, Andreas Blühm, Bruce Boucher, Françoise Carter, David Cohen, John Golding, Hugh Honour, Geraldine A. Johnson, Philip Ward-Jackson. The following answered specific questions, or made specific suggestions: Helena Bussers, Lesley Chamberlain, Penelope Curtis, Rachel Esner, Katharine Eustace, Ernst Gombrich, Andrew Graham-Dixon, Richard Hamilton, Charles Harrison, Sonia Johnson, Dominic Maréchal, Adam Waterton, Richard Wentworth, Frank Whitford and Christopher Wilk. All other intellectual debts are, I hope, fully acknowledged in the notes. The Elephant Trust, thanks to the enthusiasm of Julie Lawson, was extremely generous with its money.

I am also very grateful to the librarians of the National Art Library; the British Library; the University of London Library; the Tate Gallery; and the Warburg Institute. Renilde Montessori kindly allowed me to consult the archive of the Association Montessori Internationale in Amsterdam.

I am grateful for permission to reproduce illustrations from the sources and institutions acknowledged in the picture captions. Photographs have been kindly supplied by the galleries or museums where the works are located, with the exception of the following: Alinari 31; Bantam Books 44; Leo Castelli 27, 43; Conway Library, Courtauld Institute of Art (Philip Ward-Jackson and Geoffrey Fisher) 30, 33, 38; ADAGP, Paris and DACS, London 37; Stanley Aost 16; Library of Congress, Washington, DC 25; Regents of the University of California 34; Farrar, Straus & Giroux, Inc 44.

This book would not exist without Jonathan Burnham, who commissioned it; after his departure to New York, Jenny Uglow took the

project on. Working with her has been a privilege and a pleasure. Also at Chatto I would like to thank my designer, Neil Bradford, copy-editor Mandy Greenfield, and others in the team, Caz Hildebrand, Lily Richards, Alison Samuel, Stuart Williams, Patrick Hargadon and Hannah Corbett. My agent Caroline Dawnay invariably gave sensible advice.

I owe a special debt to Hugh Honour, who was supportive from the start. His own books, together with those written and commissioned jointly with John Fleming, first got me excited about art history.

Finally, I would like to thank Liz Brooks, whose unique way of looking at the world made me think harder than I would otherwise have done.

A NOTE ON DATES: because of the time-span, I have given dates of major artists and major works on first mention.

Introduction

Sculpture, more locked away in studios, less visible, harder to move, slower in its operations and less extensive in its compositions, not only shortens and restricts, but clouds an artistic career.

Comte de Caylus, *Reflections on Sculpture*, 1759[1]

THIS BOOK IS DEVOTED to the most disconcerting of artefacts: sculpture, object-based art, 'graven images'.

It is the product of several years spent visiting innumerable art galleries as a full-time critic. During that time I have been repeatedly struck — literally as well as metaphorically — by the way that modern artworks (paintings as well as sculptures) address the viewer. I keep seeing things that pull away, and jut out, from walls; that loom up directly from the floor, swoop down from ceilings and slice through walls; and how many times have I been surrounded, squeezed, trapped, blocked and tripped?

I have been no less impressed by the very different body language of earlier art. Whereas modern artworks have few qualms about invading the viewer's own space, Old Master sculpture and painting prefer to occupy a more distinct realm. Paintings usually consist of flat, seamless expanses of paint, neatly cordoned off by a frame; statues tend to be made with a framing wall, niche or pedestal in mind.

There has clearly been a seismic shift in ways of seeing — from what we can very provisionally term the 'pictorial' to the 'sculptural'. But when I tried to explore these issues further, I found there was no single book that answered all my questions. Why, for example, did people once feel uneasy about having to circumnavigate a work of art, when we now

1

take it for granted? Why did artists once talk up the 'gentlemanly' aspects of their trade, when now they all purport to be workmen? Prompted by a mixture of frustration and fascination, I decided to write that book myself.

Of course, any cultural history that ranges over half a millennium is bound to be a blunt instrument and this book is no exception. But I do not feel any need to apologize. It is a sort of *musée imaginaire* in which familiar material rubs shoulders with far more that is both new and strange. This material, much of it languishing in out-of-the-way places, deserves a wider audience. I should add that I have not written a history of sculpture, although many celebrated sculptures are discussed in detail; I have written a history of the ways in which people have responded to sculpture, both physically and intellectually. I begin with the Italian Renaissance as this is the first time we get sustained debate about the status of the visual arts, and of visual artists. The chapters are structured thematically because many of the same issues are addressed by viewers across the ages. My book will have served its purpose if it prompts further reflection, and if it encourages us all to get that bit closer to three-dimensional art.

WHY, FROM THE Renaissance to the nineteenth century, did sculpture occupy a more restricted and precarious position than painting in the hierarchy of the visual arts?

It is abundantly clear that although in Europe sculpture scarcely lagged behind painting in the sheer quantity produced (and indeed excavated), and in the sums spent on it, it rarely stimulated or engaged its viewers in as persistent and complete a way. This is true even if we take into account the respect accorded to antique sculpture. It was all too often treated like a rich but subordinate colony in painting's far larger conceptual empire. The reasons for this had a direct bearing on what it meant to be civilized.

In Italy in general, and Florence in particular, a handful of sculptors were very highly regarded. Ghiberti, Donatello, Michelangelo, Giambologna, Bernini and Canova are among the most successful and revered artists who ever lived. Yet they were generally treated as exceptions to prove a rule – and the rule was that there were few sculptors of note. Taste in sculpture tended to be exclusive, verging on the monotheistic (one style, one sculptor, one sculpture, one period, one place), whereas taste in painting was more catholic and polytheistic.

Monotheism in relation to sculpture seems like an unconscious concession to the biblical ban on 'graven images': if you insisted on liking sculpture, then you had to make sure you liked only one thing or one aspect at a time.

The first chapter shows how the Renaissance ideal of the 'gentleman-artist' worked to the detriment of sculptors, because sculpture required more manual labour. To outsiders, the processes of manufacture often appeared alien and mechanical. This had a direct bearing on another phenomenon – the lack of sculpted self-portraits. Since sculpture seemed a less personal and spontaneous art, the ability of the sculptor to have a 'self-image' was called into question.

Viewers also had trouble dealing with sculpture in the round. They tended to be more comfortable looking at artefacts that presented a single image, or a carefully demarcated sequence of images. The ideal viewer was stationary, and perspective posited a viewer who was absorbed in calm and rational contemplation. Metaphors for the mind – such as the *camera obscura* and the *tabula rasa* – reflected and reinforced these prejudices. As a result, a great deal of sculpture strove to be as 'pictorial' as possible, but in so doing it failed to establish itself as a distinct art. The potential to touch as well as look at sculpture also threatened the viewer's equanimity.

But how does all of this square with the pre-eminence accorded to antique sculpture? First and foremost, it fostered the belief that the artform had reached its apogee in ancient Greece. Thus sculpture was not only conceptually limited; it was also geographically and temporarily circumscribed. Modern sculpture was often compared unfavourably to the masterpieces of ancient art, and many sculptors ended up doing restorations and copies. As few ancient paintings had survived, modern painters were less beholden to the past. Critics also argued that if ancient sculpture was good, then ancient painting must have been even better. Painting was thus assumed to be a more adaptable and living art.

Before turning to the modern period, I want to say something briefly about the *paragone* debates, for it is here that the most perceptive discussions of sculpture are found. In these often acrimonious set-pieces, any number of arts or sciences might be compared (*paragone* = comparison).[2] Painting and sculpture were a popular pairing – though not nearly as popular as painting and poetry. The basic terms of the debate were set out in the years around 1500 by Leonardo da Vinci in his *Notebooks*.[3] They were elaborated upon in Italy throughout the

sixteenth century, and assimilated by the rest of Europe during the seventeenth, before taking on a new lease of life in the eighteenth and nineteenth centuries.

The following questions were central:

- Which art makes most intellectual demands on its maker?
- Which art is the most universal?
- Which art gives the truest representation of reality?
- Which art endures longest, preserving the memory of both its patron and its maker?

The pro-painting lobby argued that more brain-power was required to translate the three dimensions of the natural world into the two dimensions of a painting. More brain-power was also required to organize a picture perspectivally, to get the colours right and to use light and shade. Painting was a universal art, able to tackle any subject – histories, mythologies, portraits, landscapes and still-lifes. For this reason, God was often regarded as the first painter, 'painting' the world into existence.

In their defence, the (much smaller) pro-sculpture lobby replied that more brain-power was required to design a figure in the round, and that a statue's three-dimensionality made it a truer representation of reality. Although sculpture's subject-matter was largely confined to the human figure, this was not a disadvantage, since the human figure was the most noble subject of all. The strength of the materials from which sculpture was made meant that it stood a better chance of being preserved for posterity.

By and large, sculpture ended up the loser in these debates. A key instance of this came in the comparisons that were repeatedly made between Raphael and Michelangelo. The latter was accused of having tunnel-vision and of depicting the same stock figure again and again.[4] Even Vasari, who was otherwise in awe of Michelangelo, could not resist making this point in his *Lives of the Artists*. He wrote that when the young Raphael realized that in the depiction of nudes 'he could never attain to the perfection of Michelangelo, he reflected, like a man of supreme judgment, that painting does not consist only in representing the nude human form, but has a wider field'. Vasari then went on to describe 'an endless number' of things that painters could do.[5] Sculpture was literally and metaphorically a *niche* product.

Yet during the modern era, sculpture has established itself as an

independent, up-to-the-minute, universal art — the fine art against which all others can be measured. This in itself is part of an even larger story: the rise of object-based art. Almost every major modern artist of note has contributed in some way to what the Austrian poet Rainer Maria Rilke called, in his great essay on Rodin, 'this simple becoming-concrete'.[6] The American critic Clement Greenberg called sculpture 'the representative visual art of modernism'.[7] The increased confidence of sculptors is borne out by their extraordinary and unprecedented articulacy. Sculptors have written many of the key texts of post-war art.[8]

Why this dramatic *volte-face*? A crucial factor is the overthrow of the Renaissance ideal of the gentleman-artist. It has been supplanted by the cult of the 'worker-artist' who performs down-to-earth tasks, and who uses vernacular and even 'ready-made' materials. This matter-of-fact approach to art-making has encouraged painters to make their pictures as object-like as possible. The Cubists coined the term *tableau-objet* for their smaller oil paintings and for their collages. In 1918 the first *Dada Manifesto* proclaimed: 'The new artist protests: he no longer paints (symbolist and illusionist reproduction) but creates — directly in stone, wood, iron, tin, boulders'.[9] The corollary to this is the vast number of modern painters who have tried their hand at the more 'workman-like' art of sculpture: few painters of note in the last 150 years have failed to make at least some sculpture.

Similar considerations have also informed the modern artist's choice of subject-matter. In 1909 Picasso carved an apple out of a lump of white plaster — the first independent still-life sculpture.[10] He went on to make many more still-lifes from a wide variety of vernacular materials. The implication was that sculpture could be made from anything, and could be anything.[11]

At the same time as painters were making their paintings more three-dimensional, sculpture in the round became the rule rather than the exception. Whereas the ideal viewer of the Renaissance was static, the ideal viewer of modernity is restless and mobile. The modern city is said to subject us to a succession of shocks and surprises. Object-based art caters for this kind of experience better than painting. We now take it for granted that artworks decisively occupy floorspace and airspace.

The development of spatial awareness, and a feel for materials, has also been central to modern culture. Children undergo a sensory education in which they experience different textures, shapes and volumes. Similar techniques have been used to develop mental dexterity in adults. We are

no longer so encouraged to transcend the object-world. As a result, the *camera obscura* and the *tabula rasa* are less popular metaphors for the mind. The mind is more likely to be compared to an archaeological dig.

During the course of the twentieth century the terms sculpture and sculptural have been applied to so many entities and activities that they have been rendered virtually meaningless – so much so that since the 1970s fewer and fewer artists bother to call themselves sculptors: they are simply artists.

The term 'sculptor' is sometimes used ironically. In 1963 the British sculptor Barry Flanagan, who thought of himself as a 'three-dimensional thinker', wrote to his teacher Anthony Caro saying, 'I might claim to be a sculptor and do everything else but sculpture. This is my dilemma.'[12] The American artist Lawrence Weiner called his text-based work sculpture because 'language itself' was 'a key to what sculpture is about'.[13] Damien Hirst has claimed that his dot paintings 'are like sculptures of paintings'.[14]

The term 'sculpture' may have been expanded and tested to virtual destruction, but this does not mean that it has been at best a convenient shorthand, at worst an alibi. The major innovation in the art of this century is to insist that the artwork literally occupies the same space as the viewer. The Franco-American sculptor Louise Bourgeois recently discussed the difference between objects that are placed in the middle of a room and objects that are placed against a wall. Whereas a freestanding figure seems capable of moving 'in all directions', and thus embodies a 'shared awareness', a figure against a wall is 'removed from activity'.[15] Most of the best modern art, whether painting or sculpture, has striven to force the viewer into activity and a 'shared awareness': it jolts us into direct physical and mental engagement.

In this book I offer various explanations for the differences between the old and new ways of seeing. But it is worth noting at the outset that this perceptual revolution has gone hand in hand with the secularization of Western society. Sculpture still whips up strong emotions – but has circumspection about 'graven images' now given way to a cult of the insistently 3-D?

Part One

The Limited Art

1. The Image of the Artist

[Working in marble is] not for a gentleman.

Filarete, *Treatise on Architecture*, 1461–4[1]

Munro the sculptor, like all sculptors, lives in a nasty wood house full of clay and water-tubs, so I can't go without catching cold.

John Ruskin, 1860[2]

IN 1561 THE ITALIAN PHILOSOPHER and physician, Girolamo Cardano, published a detailed typology of professional men, which included artists. Whereas painters tended to be 'fickle, of unsettled mind, melancholic, and changeable in their manners', sculptors were usually 'more industrious and less ingenious'.[3] Nearly four centuries later some German psychologists, the Pannenborg brothers, produced a typology of artists that was remarkably similar. Painters were 'unreliable', 'discontented' and 'obsessed with the notion of liberty', while sculptors were 'constant in their habits', but less communicative and visionary.[4] In effect, sculptors are worthy but rather dull. Such qualities may have appealed to a conservative patron; but a bold patron might be better off seeking the services of a painter.

Although these characterizations are crude caricatures, there is no doubt that once people started to concern themselves with the status and character of artists, sculptors were less commonly seen as free spirits. In this opening chapter, I chart the rise of interest in visual artists, and look at the main differences between the image of the sculptor and that of the painter.

BEFORE THE Renaissance there was little interest in the character and

9

conduct of artists. In antiquity there was hardly any specialist literature on art, beyond technical manuals.[5] The same was true of the Middle Ages, when the legal status of painters, sculptors and architects was exactly the same as that of other manual workers. They were artisans who belonged to guilds, closed-shop unions that could interfere in all aspects of their members' life and work. The guilds monitored everything from contracts and the education of apprentices to attendance at church. They outlawed bad language, back-biting, the carrying of weapons, the making of obscene images – and tried to control drinking. The earliest painters' guilds were founded in Italy at the end of the thirteenth century, but they were umbrella organizations comprising related crafts such as paper makers, cabinet makers and even saddlers. Sculptors and architects were grouped with stonemasons and bricklayers. Despite these demarcations, artisans in different guilds often collaborated: sculptures were frequently painted, and on tombs and altarpieces painting was often combined with sculpture.[6]

The revolutionary art of Giotto (c. 1267–1337), and the spread of his fame throughout Italy (he worked in Padua, Assisi, Rome, Naples and Milan, as well as in his native Florence), gave the first inkling that an artist might transcend his class. Writers of novellas such as Giovanni Boccaccio and Franco Sacchetti made him out to be urbane, shrewd and witty. But the most momentous reference to Giotto and his achievements comes in the poetry of his Florentine contemporary Dante. In the *Divine Comedy*, for the first time we get a strong sense that painting is a distinct art with a distinct history, and that its practitioners have a distinct personality.

In canto XI of the *Purgatorio*, Dante meets Oderigi of Gubbio, an Umbrian miniature-painter. Oderigi's sin is pride. His punishment is conceived in sculptural terms. He is bent double by a large stone that he carries around with him, so that he looks like a corbel. Remarkably, Dante recognizes him:

> 'Art thou not Oderigi? art not thou
> Agobbio's glory, glory of that art
> Which they of Paris call the limner's skill?'
> 'Brother!' said he, 'with tints that gayer smile,
> Bolognian Franco's pencil lines the leaves.
> His all the honour now; my light obscured.
> In truth, I had not been thus courteous to him

> The whilst I lived, through eagerness of zeal
> For that pre-eminence my heart was bent on.
> Here, of such pride, the forfeiture is paid.
> Nor were I even here, if, able still
> To sin, I had not turn'd me unto God.
> O powers of man! how vain your glory, nipt
> E'en in its height of verdure, if an age
> Less bright succeed not. Cimabue thought
> To lord it over painting's field; and now
> The cry is Giotto's, and his name eclipsed.

Here Dante gives us a vivid picture of painters from different cities and generations engaged in intense competition and puffed up with pride. He considered them to be the counterparts of poets, for he compares the equally competitive and evolutionary situation in painting with that in poetry. Guido Cavalcanti had eclipsed Guido Guinicelli, and Cavalcanti will in turn be eclipsed by Dante:

> Thus hath one Guido from the other snatch'd
> The letter'd prize: and he, perhaps, is born,
> Who shall drive either from their nest.

Yet Dante does not identify in the same way with sculptors. In the previous canto he had given an extensive description of a wall of white marble:

> . . . so exactly wrought
> With quaintest sculpture, that not there alone
> Had Polycletus, but e'en nature's self
> Been shamed.[7]

The sculpted frieze illustrates famous historical examples of humility. Dante probably knew of the Greek fifth-century sculptor Polycletus from scattered references to him in Roman and medieval writers,[8] but the brevity of his reference to a sculptor, and his historical remoteness, contrast with Dante's intimate involvement with painters. Although he marvels at this wall of divine sculpture, and describes what is carved on it at length, one suspects that painting means more to him. By virtue of being a 'divine' art, it seems that sculpture has already been perfected.

11

Painting, on the other hand, is a living art in a dramatic state of flux. The changeableness that writers would ascribe to the characters of painters is here applied in a wholly positive sense to their art. Painters are palpable, organic presences, whereas sculptors are glorious yet rather abstract absences.

Despite Dante's impressive, if admonitory, puff for painters, it was only in the fifteenth century that Florentine artists started to agitate for the visual arts to be accepted as liberal arts – and began to have their claims taken seriously. The line-up of the liberal arts had been more or less constant since late antiquity. There were seven in all, divided into two groups. One group consisted of the word-based disciplines of Grammar, Logic and Rhetoric. The other consisted of the number-based disciplines of Geometry, Arithmetic, Astronomy and Music. The magnificent seven were distinguished from the supreme discipline of Philosophy, which presided maternally over them all, and from the lowly Mechanical Arts. The latter included 'manual' occupations such as carpentry, agriculture, weaving and, of course, painting, sculpture and architecture.[9]

In the mid-fifteenth century the humanist Aeneas Silvius Piccolomini, who later became Pope Pius II, could write proudly, 'After Petrarch literature emerged; after Giotto arose the art of painters; and we have seen both of them attain perfection.'[10] The fact that he saw literature and painting as disciplines that had developed in parallel is telling. In order to distinguish themselves from bricklayers and saddlers, would-be fine artists were stressing their intellectual accomplishments. They claimed they needed to know mathematics and geometry, and to read literature – as well as the book of nature. They hoped that an understanding of perspective, anatomy, ancient art and literature would be a passport to polite and even high society.

Although the vast majority of artists remained low-grade workers, the rise in social status of the very best artists during the course of the fifteenth century was real. Outside Italy, it could cause amazement. When Albrecht Dürer (1471–1528) visited Venice, he complained bitterly in a letter home of 1506, 'Here I am a gentleman, while at home I am a parasite.'[11] A little later, the cousin of the Florentine sculptor Baccio Bandinelli (1488–1559) fought a duel with the Vidame de Chartres because the Frenchman accused Florentine nobles of practising manual arts through their active interest in painting and sculpture.[12]

Yet as soon as artists tried to distinguish themselves from manual

workers, a new fissure opened up between painters and sculptors. For some painters and their apologists, sculptors were a hindrance to their own social and intellectual ambitions – and they were also rivals for commissions. The pro-painting lobby claimed that the art of sculpture was more labour-intensive, and less sophisticated and versatile, than painting: its practitioners were dirty beefcakes who lacked class. This caricature is the negative mirror-image of Dante's Polycletus. Either way, sculptors were made out to be less socialized and approachable.

The most devastating character-assassination of sculptors was undertaken by Leonardo da Vinci (1452–1519), who was himself something of a frustrated sculptor. His equestrian monument to Francesco Sforza of Milan, though greatly admired, was never cast in bronze, because the bronze that had been earmarked for it was used to make cannons to fight the French.[13] Leonardo's *Notebooks* were not published until the seventeenth century (and then only in part), but his pithy ruminations on art were widely disseminated throughout the whole of Italy.

Leonardo states that he is well qualified to compare painting and sculpture, precisely because he has done both 'to the same degree'. But Hell hath no fury like an artist scorned:

> Sculpture is not a science but a very mechanical art, because it causes its executant sweat and bodily fatigue . . . The sculptor undertakes his work with greater bodily exertion than the painter, and the painter undertakes his work with greater mental exertion. The truth of this is evident in that the sculptor when making his work uses the strength of his arm in hammering, to remove the superfluous marble or other stone which surrounds the figure embedded within the stone. This is an extremely mechanical operation, generally accompanied by great sweat which mingles with dust and becomes converted into mud. His face becomes plastered and powdered all over with marble dust which makes him look like a baker, and he becomes covered in minute chips of marble, which makes him look as if he is covered in snow. His house is in a mess and covered in chips and dust from the stone.[14]

For Leonardo, the sculptor is an abominable, and anonymous, snowman. He then moves from the ridiculous to the urbane:

> the painter's position is quite contrary to this (speaking of painters and sculptors of the highest ability), because the painter sits before his

13

work at the greatest of ease, well dressed and applying delicate colours with his light brush, and he may dress himself in whatever clothes he please. His residence is clean and adorned with delightful pictures, and he often enjoys the accompaniment of music or the company of the authors of various fine works that can be heard with great pleasure without the crashing of hammers and other confused noises.[15]

Leonardo's contrast echoes one that had been drawn between two allegorical figures by the classical orator and satirist Lucian (born AD 120). Lucian recounts a dream he had had when he was wondering whether to follow in his ancestors' footsteps by becoming a sculptor. Two women appear to him – Education and the Art of Statuary – and each tries to persuade him of her virtues. Whereas Education is beautiful, elegantly dressed and eloquent, Statuary is brusque, dishevelled and speaks with a stammer. Not surprisingly, Statuary loses the debate, and gnashes her (presumably chipped) teeth until she turns into a lump of marble.[16] Whereas Lucian makes Statuary stand for any kind of artisan, Leonardo replaces Education by Painting.

Yet Leonardo's image of the armchair-painter with his light touch and *haute couture* is wishful thinking, to say the least. Among other things, it completely ignores the fact that the pinnacle of a painter's career was still the painting of frescoes, which was hugely arduous. Leonardo himself painted the *Last Supper* in a damp refectory in Milan. Michelangelo (1475–1564) had worked on the Sistine ceiling with his face pointing upwards – a procedure which, according to Vasari, 'impaired his sight so badly' that for months afterwards he could only read and look at drawings 'with his head turned backwards'.[17] At the time, Michelangelo wrote a poem to a humanist friend, Giovanni da Pistoia, in which he complained that this 'miserable job' had given him a swollen neck 'like the cats in Lombardy'; that the 'brush spatterings' made a 'mosaic pavement of my face'; and that to balance his body 'I stick my bum out like a horse's rump'.[18] While painting the *Last Judgement*, he fell off the scaffolding.

Touching up frescoes could also cause problems. When Giovanni Lanfranco (1582–1647) was finishing the cupola of S. Andrea della Valle in Rome in 1629, he used long brushes tied to a stick, but they were so heavy that they had to be held by two men.[19] Two centuries later, a health-conscious Englishman, William Hazlitt, stressed that even easel painting was not a 'sedentary employment' for it required 'a continued

and steady exertion of muscular power'. Indeed, painting for a whole morning was like riding a horse: '[It] gives one an excellent appetite for one's dinner, as old Abraham Tucker acquired for his by riding over Banstead Downs.'[20]

Leonardo may have exaggerated the difference in the physical demands, but his vision of the gentleman-painter was to be persuasive and prophetic. It called into question the primacy of large-scale fresco cycles made for and in public settings, and precipitated the emergence of more individualized and domestically scaled forms of expression. The gentleman-painter was essentially someone who (like Leonardo) sat and drew, and painted in oil at an easel. His art was executed and scrutinized in a private setting by an invited audience of sophisticated *cognoscenti*. Solitary and tranquil contemplation was central to Leonardo's conception of the painter: he should converse only with his social and intellectual equals.[21]

So painting was beginning to be conceived of as a series of intimate and serene interactions – between the painter and his materials and subject-matter, and his humanist friends, many of whom would also have tried their hand at painting. What it also prophesied (though Leonardo had qualms about this) was the notion that all painting would become a form of self-portraiture – both literal and surrogate. It would offer a private view of the workings of the painter's mind, just as Leonardo offered a private view in words of the painter's studio. For sculptors, this was a potentially dangerous development. It was harder for them to adapt to any code of practice that put a premium on tranquillity and contem-plation, or that involved the cultivation of convivial forms of subjectivity.

THERE ARE obvious practical reasons why sculpture might not so easily be thought of as a series of intimate and serene interactions. By and large, it was a public art of commemoration. Its most conspicuous products were tombs and monuments, and these could only be made with the help of numerous collaborators – far more than were needed for comparable paintings.

Carving in marble and casting in bronze were costly and time-consuming, and this too made it harder to work speculatively or spontaneously. The combative Florentine sculptor and goldsmith Benvenuto Cellini (1500–71) claimed – with only a certain amount of exaggeration – that whereas it takes eight days to paint a picture, it takes

a year to make a sculpture.[22] Looking back from the twentieth century, the sculptor Henry Moore made a similar point, but in such a way that he questioned the viability of sculpture made with traditional methods and materials:

> I think the world has gained enormously through the Pope making Michelangelo do the Sistine Chapel paintings: Michelangelo was doing in one day, with a painting, [. . .] a sculptural idea that he might have been spending a year on, so that we have two thousand or three thousand more sculpture ideas from Michelangelo than [. . .] if he hadn't painted the Sistine Chapel.[23]

The financial and physical risks entailed in making a sculpture were far greater than those required for a painting. During the Renaissance, getting a usable piece of marble from the quarry was an artform and an endurance test in itself. To ensure getting a large, high-quality block, the sculptor often had to go to the quarry himself. It took a good day's ride, sometimes longer, to make the fifty-mile trip from Florence to Carrara, followed by a long climb to the quarry.[24] A big block might take over a month to extract, after which it had to be taken downhill and loaded on to a cart. A man was killed, and Michelangelo just missed being killed, when an iron ring snapped and a large block slid down the slope, smashing into smithereens. Anything between three months and a year was required to transport a block to Florence, with only some of the tricky journey being accomplished by boat. Accidents often occurred when blocks were being loaded and unloaded.

Once carving had begun, the sculptor might find cracks, holes, stains, iron veins and other impurities that rendered the block unusable. By the seventeenth century the emergence of specialist dealers in marble made that aspect considerably easier, but it was still a much more involved process than obtaining the materials for painting.[25] Faults were frequently found in blocks. When Bernini (1598–1680) carved a bust of *Louis XIV* while staying in Paris, there was no time to order a block from Carrara, so he was forced to use French marble which was more friable. He started work on two blocks simultaneously so that he could see which one was of better quality.[26]

The onus of finding high-quality materials led to a further accusation: that nature itself played a far bigger part in sculpture than in painting. When a painter praised Michelangelo for the quality of the bronze used

in his statue of the Pope, he replied, 'I owe the same obligation to Pope Julius, who has given [the bronze] to me, that you owe to the apothecaries who give you your colours for painting.'[27] But nothing demonstrated the importance of materials more emphatically than when statues of bronze and statuettes of gold and silver were melted down at times of economic and political crisis. This was precisely what happened to Michelangelo's bronze statue of Pope Julius. The goldsmith Antonio Pollaiuolo (c. 1432–98) is said to have decided to become a painter after many of his works were melted down during wartime.[28] You could not, of course, extract the raw materials from a painting and sell them back to an apothecary.

Because of the length of time involved from commission to completion, there was always a risk that your patron might die, change his mind or fall from grace. This partly explains why both of Michelangelo's major sculpture projects – the Julius tomb and the New Sacristy at San Lorenzo – were aborted and drastically reduced, whereas all three of his major fresco cycles were completed pretty much on time and according to plan.[29] The frustrations of being a sculptor are borne out by images showing sculptors at work. In a standard joke, they are frequently depicted holding the hammer behind their head, about to bring it down with prodigious – and wholly inappropriate – force on to a chisel resting at right-angles to the surface of the marble. The sculpture will represent a woman who seems to recoil or faint, as if fearing the worst. Michelangelo did indeed smash several sculptures in frustration, and he is shown in a woodcut of 1527 about to impale his chisel between a woman's breast and throat.[30] The implication is that marble is as infuriating as any woman, and that sculptors do not quite have the wherewithal to succeed with either.

The corollary to this is viewers' greater unfamiliarity with the techniques of sculpture. It was hardly going to be a hobby of the gentry. Sculptors' studios were not, on the whole, pleasant places to be, and although some famous people (including Socrates) were said to have practised sculpture, it was not as clean or convenient as painting or drawing.[31] Whereas Baldassare Castiglione could recommend in *The Book of the Courtier* (1528) that the ideal courtier should have 'cunning in drawyng, and the knowledge in the very rare arte of peincting', he did not think it appropriate for him to learn the less noble and skilful art of sculpture.[32] In the 1560s Sofonisba Anguissola taught painting to Isabelle de Valois, the wife of Philip II of Spain, who was himself a great lover

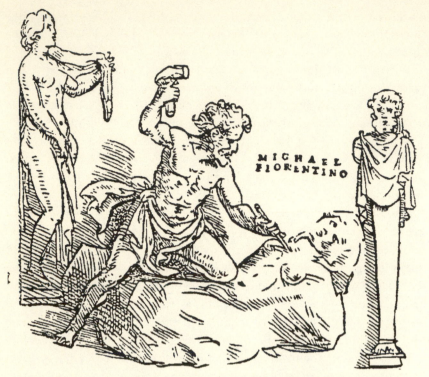

MICHAEL
FIORENTINO

1. This anonymous woodcut illustration of Michelangelo in action comes
from Sigismondo Fanti's astrological lottery-book, *Triompho di Fortuna*
(Venice, 1517). The same block is used to represent seven other sculptors,
both ancient and modern.

of painting – though she got fed up with the amount of time she had to
spend with her pupil.[33] Anton Francesco Doni, a friend of the sculptor
Baccio Bandinelli, underlined people's greater familiarity with painting
in *Il Disegno* (1549): a defender of painting claims that whereas intelligent
people can describe the art of painting, only those with long experience
of working with drills and chisels can explain what it feels like to sculpt.
He concludes with the proud declaration that he could not even make
'a watering trough for fleas with a chisel'.[34]

But sculptors' studios were not just inhospitable; they were also
downright dangerous. Before the invention of goggles, there was always
a risk of getting splinters in the eye.[35] In his racy *Autobiography*, Cellini
tells how he got a steel splinter in his right eye when he was sharpening
some chisels, and feared he would lose his sight. Luckily, however, he
was saved by a surgeon who cut a large vein in the wings of two live

pigeons, and poured the blood into his eye. 'I felt immediate relief,' he says, 'and in under two days the steel splinter came out and my sight was unimpeded and improved.'[36]

Across the centuries there are innumerable stories of statues, or bits of statues, falling on sculptors and their assistants, with terrible consequences. François Dumont died in 1726 from injuries sustained when a lead curtain that he was arranging on a tomb fell on him. Antonio Canova (1757–1822) was nearly crushed by a falling statue. The poet Ezra Pound described, in almost indecent detail, an injury sustained by Henri Gaudier-Brzeska (1891–1915) while moving a huge marble bust of Pound just before the First World War: 'One day when he was alone in the studio he attempted to shift the great block. It slipped, caught his hand under it, and he thought his sculpting days were over. He was imprisoned for several hours until he managed to attract the attention of some one working beyond the partition.'[37]

We also frequently hear of sculptors having to endure extreme heat (when they were working with bronze) and extreme cold and damp (when working with clay). Michelangelo, who was famously reclusive and hated having visitors to his studio at the best of times, suffered from the damp: 'In his latter years he wore buskins of dogskin on the legs, next to the skin, constantly for whole months together, so that afterwards, when he sought to take them off, on drawing them off the skin often came away with them. Over the stockings he wore boots of cordwain fastened on the inside, as a protection against damp.'[38] But in retrospect, Michelangelo did not suffer too badly. The French sculptor J. L. Brion was found frozen to death in his studio in the winter of 1864, his few bedclothes wrapped around the statue that he intended to submit to the Salon.[39]

The coldness of the sculptor's studio could even be used as a metaphor for the 'coldness' of the sculptor's art. In Nathaniel Hawthorne's *The Marble Faun* (1860), which is set in Rome, an American painter visits the studio of an American sculptor during winter: 'But neither was the studio anything better than a dismal den, with its marble shapes shivering around the walls, cold as the snow-images which the sculptor used to model, in his boyhood.'[40]

The sculptor's life was not all cold and dampness, however. Bronze casting was a hot and potentially lethal affair. In 1488 Andrea del Verrocchio (c. 1435–88), while casting the horse for the monument to the *condottiere* Bartolommeo Colleoni, 'caught a chill by overheating

himself', and later died.[41] Cellini, while casting the statue of *Perseus and Medusa* (1545–54), set fire to his workshop, and the stress prompted him to take to his bed with a fever, shouting, 'I'm dying!'[42] In 1885 the English sculptor Alfred Gilbert was found unconscious after struggling to keep a furnace alight for ninety-eight hours on end.[43]

All the Dantean horror stories surrounding the sculptor's studio are welded together in melodramatic fashion by Emile Zola in *The Masterpiece* (1886), his dyspeptic – yet thoroughly researched – novel about the artworld. The painter Claude Lantier makes a visit to the studio of an impoverished sculptor, Mahoudeau, who is probably modelled on the deep-frozen Brion. He is working on what he thinks will be his masterpiece, *Woman Bathing*. It is winter, and the water in one of the tubs inside the studio is frozen. The cold 'wrapped round one like a winding sheet', and the 'sinister' studio feels like a 'funeral vault'. Unsold and damaged statues stand 'shivering' in the corners like a row of 'ghastly cripples', exposing their mutilated limbs, 'all thick with dust and spattered with clay'. Mahoudeau, whose creative powers are on the wane, lights a fire and pours out his woes: 'A dog's life, being a sculptor. Masons' labourers had a better time of it.' He gingerly peels the frozen dustsheets off his full-sized clay model, which stands on a packing-case.

They discuss the statue for a while, but then, in a cruel parody of the Pygmalion myth, *Woman Bathing* starts to move. The fire has thawed the frozen clay and the statue eventually collapses – on top of its creator. Mahoudeau flings his arms wide to receive it:

> It seemed to fall upon his neck, and he folded it in his embrace, hugging it to him as its virgin nudity came to life with the first stirrings of desire. He entered it, the love-filled breasts flattened against his shoulder, its thigh pressing against his own, while the head broke off and rolled along the floor. The impact was so sharp that it sent him toppling against the opposite wall, and there he lay, stunned, still clutching the mutilated body.[44]

The sculptor is fortunate to emerge from this unusual sexual encounter with minor bruises and scratches.

The reference to crippled sculptures, and the temporary crippling of the increasingly impotent sculptor, recalls some of the myths surrounding Hephaistos (or Vulcan, as the Romans called him), the classical god of fire and thus of smithies and craftsmen. Hephaistos was lame and his

awkward movements made him a figure of fun; he was cuckolded by his wife Aphrodite.[45] In early societies, lame but strong men often became smiths because they were unable to fight, farm or hunt.[46] This basic truth, it seems, was the origin of the Hephaistos legend. But Xenophon, writing around 380 BC, provided an alternative explanation for their damaged bodies. He noted that spending the whole day by the fire ruined the worker's body and made him a poor soldier and citizen: 'The softening of the body involves a serious weakening of the mind.'[47] In Zola's novel, the sculptor and his sculptures suffer from existential lameness.

THIS IS NOT to say that people never saw the sculptor's exertions as heroic, and never visited a sculptor's studio. Vasari frequently praises artists who have conquered 'difficulties', and those difficulties included matters both physical and technical. After succeeding at the second attempt to cast an enormous equestrian monument for King Henry II of France, Daniele de Volterra (1509–66) should have been happy 'at having surmounted innumerable difficulties in so rare a casting'. Sadly, he was not. Daniele never smiled again. He was visited by a 'cruel catarrh', which killed him.[48]

Cellini is always winning against impossible odds. The 'death scene' during the casting of the resplendent *Perseus and Medusa* is the prelude to his triumphant recovery and return to the workshop to complete the job, when his assistants have given up all hope. Michelangelo was also a sustained and strategic whinger in letters to friends and patrons, bettered only perhaps by Bernini, who was the most brilliant stage-manager of 'difficulties'. When the young sculptor found that his bust of Cardinal Scipione Borghese (1632) was disfigured by a crack across the forehead, he completed a second version in a fortnight. But he unveiled the first bust, and only when the Cardinal was struggling to conceal his disappointment did he reveal the second, to general amazement – though this too had a prominent crack.

The *modus operandi* of sculptors may have been alien to most outsiders, but alchemy did give at least some patrons a framework for understanding. Several Renaissance rulers, including François II of France, Grand Duke Francesco I of Tuscany and his nephew-in-law, Rudolf II of Prague, were practising alchemists. In Giordano Bruno's comedy, *Candelaio* (1582), the alchemist's furnace is 'his paradise', and he always emerges from the laboratory with red eyes and a face like a

coal-miner's.[49] In this version of events, Hephaistos/Vulcan was regarded not as a lame duck, but as someone who had a magical power over materials.[50] Don Giovanni de' Medici witnessed the casting in one go of the horse for Giambologna's *Equestrian Monument to Grand Duke Cosimo I* on 27–8 September 1592.[51] The feat would have been regarded as a marvel.

According to his contemporaries, Cosimo I was not averse to getting his hands dirty. A treatise on alchemy claimed that Cosimo I had wished to work with his hands, 'like a master, here wielding the hammer, there painting, sometimes sculpting, sometimes labouring as a carpenter on guns; often casting at furnaces, assaying metals to see whether bronze alloys were soft or hard'.[52] Cellini records the Duke helping him clean some rust and earth away from some newly excavated antique bronze statuettes.[53] He is also supposed to have overseen the distillation of a herbal liquor so effective that tools tempered in it could work porphyry.[54]

Despite all this, there is no evidence that Cosimo ever worked at a hearth, and he would probably have regarded it as beneath his dignity to make tools.[55] Indeed, prevailing attitudes to manual operations are shown by the arrangements made by Vasari's recently founded Accademia del Disegno for Michelangelo's funeral in 1564. A cycle of paintings was commissioned, depicting various episodes from the artist's career. But whereas the symbol of Painting showed him working on the *Last Judgement*, the symbol of Sculpture showed him conversing with a female allegory.[56] The representation of painters at work was marginally more acceptable. Painters had recently started to include the tools of their trade in self-portraits, with the first example being made in 1554–5 by Alessandro Allori, an artist who worked on another of the funeral paintings.[57] Not long after the funeral, the Accademia del Disegno held a *paragone* debate, and painting was awarded the crown. Subsequently Michelangelo's nephew had the trophies of tools that had been carved for the pilasters of his uncle's tomb removed.[58]

The most successful Italian sculptors could, at carefully chosen moments, remind people of the less salubrious aspects of their trade. Bernini seems to have become so confident of his position that he is said to have received a royal visitor wearing his work clothes. His biographer Filippo Baldinucci informs us that Queen Christina of Sweden, shortly after arriving in Rome, decided to honour the Pope's sculptor by going to see him at work in his house:

Bernini received her in the heavy rough garment he was accustomed to wear when working the marble. Since it was what he wore for his art, he considered it to be the most worthy possible garment in which to receive that great lady. This beautiful subtlety was quickly perceived by the Queen's sublime genius. His action not only increased her concept of his spirit, but even led her, as a sign of her esteem for his art, to wish to touch the garment with her own hand.[59]

Yet the circumstances seem to have been exceptional. This elaborate bit of studio-theatre was specifically tailored to the Queen's highly eccentric tastes. Christina had come to Rome in 1655 at the age of twenty-eight after a shocking conversion to Catholicism – 'cross-backed . . . [with] a double Chin strew'd with some long Hairs of Beard', wearing a man's cloak and cravat.[60] Thus her appearance was at least as challenging as Bernini's, and her gesture of touching him would have acknowledged a basic similarity. Bernini's 'subtlety' was presumably that they were both humble foot-soldiers of Christ – and of his Pontiff. Shortly before dying, he bequeathed his last and favourite work to Christina, a marble bust of *Christ*.

The greater lack of knowledge of sculpture is reflected in a minor genre of European poetry, in which the poet instructs an artist by standing, as it were, at his shoulder. Around 130 'Advice-to-a-Painter' poems are recorded in English from the mid-seventeenth to the mid-nineteenth centuries, but only three 'Advice-to-a-Sculptor' poems.[61] Being given advice was not necessarily proof of esteem – the philosopher the Earl of Shaftesbury (1671–1713) regarded painters and sculptors alike as mere executants of his exalted ideas, and gave them detailed instructions[62] – but it was evidence of a *close* interest.

At the turn of the nineteenth century the English connoisseur Richard Payne Knight noted his contemporaries' unfamiliarity with sculpture, and the consequent lack of aesthetic terms derived from sculpture: 'had this art been as generally and familiarly understood, and as universally practised, as that of painting, we should have probably heard of a *sculpturesque*, as well as a *picturesque*, since the one exists in nature just as much as the other'. But since the processes of sculpture are 'more slow and laborious', and its materials 'either costly, ponderous, or cumbersome', the taste for it 'has never been sufficiently diffused among the mass of mankind to give rise to a familiar metaphor'.[63]

In the early nineteenth century there were more opportunities than

ever before to make studio visits. The rise of tourism and the emergence of middle-class patrons, and the fact that artists were not yet represented by galleries, made studio visits major social and commercial events. The huge studios of Canova and Bertel Thorvaldsen (1768–1844) in Rome were a 'must-see' for any Grand Tourist, particularly after the end of the Napoleonic Wars. But it does not seem to have made that much difference to the diffusion of knowledge about sculpture. Most visitors usually only saw the front, 'shop' end of a sculptor's studio, where finished or nearly finished works were displayed. Judging from eye-witness reports of Canova's studio, few of these visitors had any knowledge of sculpture or of sculptor's studios.[64]

Two revealing novellas featuring, respectively, sculptors and painters were written by Balzac in the 1830s. In *Sarrasine* (1830), Balzac refers in passing to the would-be sculptor Matthieu Sarrasine making sculptures from bread and logs as a child. But when Sarrasine goes as a young man to work in Rome, only the climax of the story is set in his studio, so we hear nothing about the making of his statue of the enchanting Zambinella. By contrast, all the significant action of *Le Chef d'Oeuvre Inconnu* (1831; 2nd version 1837) takes place in painters' studios in Paris, and the protagonists go into extraordinary detail about the techniques and purposes of painting. In 1832 Balzac told his editor that he intended to remove *Sarrasine* from the next edition of the *Romans et Contes Philosophiques*, because the story was neither philosophical enough nor 'of a theme easy to discover'.[65] This seems like a comment on the infathomability of sculpture itself.

By and large, sculptors had far less prestige than painters, particularly outside Italy. French kings, for example, had a 'Premier Peintre', but there was no comparable post for sculptors.[66] Other monarchs and princes frequently did without their own personal sculptor. No sculptor was ever appointed Director of the French Academy at Rome.[67] No full-time sculptor was appointed President of the Royal Academy in London until the twentieth century.[68]

ALTHOUGH SCULPTORS had greater difficulty than painters in shaking off the stigma of manual labour, considerable progress was made during the Renaissance in alleviating the physical demands of the profession. Technical developments allowed the more successful sculptors to take on a primarily managerial role. The development of 'pointing' apparatus meant that perfect copies and vast blow-ups could be made without the

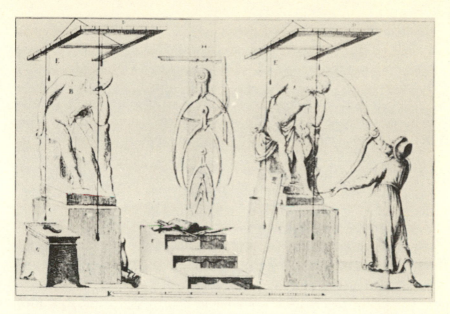

2. Pointing apparatus from Francesco Corradori's *Istruzione elementare per gli studiozi della scultura* (Florence, 1802).

sculptor breaking into a sweat – though even this, as we shall shortly see, had its drawbacks.

At the start of his brief treatise on sculpture, *De Statua* (c. 1443–52), Leon Battista Alberti asks why carpenters should have all kinds of measuring tools, when sculptors work by rule of thumb. He then describes an amazing gadget with which 'if you liked, you could hew out and make half the statue on the island of Paros, and the other half in the Lunigiana, in such a way that the joints and connecting points on all the parts will fit together to make the complete figure and correspond to the models used'.[69] By the time of *De Sculptura* (1504), by the Paduan humanist Pomponius Gauricus, Alberti's technology appears to have been substantially improved. Now, we learn, 'twenty-five artists could make a statue in different places and at different times that [when assembled] would appear to have been made in one go by a single sculptor'.[70] Even Leonardo made a contribution to the technological revolution, though his was far more modest. He describes a 'pointing' apparatus that could make replicas of small sculptures.[71]

These gadgets enabled the sculptor to delegate some of the more banal and arduous work to assistants. Standard medieval practice was to make a presentation drawing of a sculpture for a patron, and to work from that.

25

But in the fifteenth century sculptors in Florence often made preparatory models in clay or wax. The model could then be transferred to the marble using a mechanical procedure, or scaled up for eventual casting in bronze.

Michelangelo made numerous wax and clay models, but they differ from the highly finished models of the fifteenth century. Vasari explains (rather patronizingly) that the new kinds of model were a substitute for a painter's sketch: 'seeing that there are certain sculptors who have not much practice in strokes and outlines, and consequently cannot draw on paper, these work instead in clay or wax . . . Thus they effect the same thing as does he who draws well on paper or other flat surface'.[72] These models would have helped Michelangelo's assistants to block out a figure in marble, or execute statues in their entirety. For some of the figures planned for the New Sacristy at San Lorenzo, he (and/or his assistants) made full-sized models.

The model-maker gradually came to be regarded as the true artist, while the stone-carver became a technician. Giambologna (1529–1608), the leading sculptor in Florence in the late sixteenth century, took little part in the execution of his works. Numerous wax and clay models by him survive – more than by any other Renaissance sculptor. His assistants copied the models in bronze and marble 'as it were by remote control'.[73] Some of these formed the core of a large collection of sculptors' models formed by his first benefactor, Bernardo Vecchietti. They were collected for the same reasons as painters' drawings.

Giambologna's 'look, no sweat!' approach is exemplified by a contemporary portrait painting. Smartly dressed, he sits at a table in an elegant room playing with a pair of dividers. Through an open door we see a clay model displayed in an otherwise empty room. Giambologna wants us to think that his art is conjured out of thin, dust-free air (the dirty work is done by menials out at the back).[74] He was in fact illiterate and could only speak pidgin Italian. But he certainly cuts a fine figure.

These technical developments facilitated the manufacture of large numbers of statues of all sizes. To a degree, size did matter in the Renaissance, for it signified the triumph of skill and technology over matter. Vasari often mentions that a painting or sculpture was the largest made up to that time, and he only rarely criticizes works for being of excessive size.[75] Yet large statues in marble were often criticized for being static and graceless (and paintings could be made even bigger). The restrictions imposed by the marble block, and the fear of ruining

something so rare and expensive, could give rise to a white elephant. Bartolommeo Ammanati's statue of *Neptune* (1560–5) on the fountain in front of the Signoria in Florence led to his being accused of spoiling a fine marble block. The cultural fixer Vincenzo Borghini said that Ammanati had failed to give it enough *contrapposto*, though he was prepared to admit that the narrowness of the block ruled out carving a figure with its arms raised, as Ammanati had originally intended.[76] The block had in fact been vandalized in Carrara by Baccio Bandinelli, a rival for the commission.

Successful sculptors presided over huge studios, which became even bigger if architectural work was involved. When Michelangelo made the sculpture and architecture for the New Sacristy at San Lorenzo in Florence, he worked with around 300 people on an occasional or regular basis.[77] The largest workshop ever run by a sculptor was that of Bernini, who needed dozens of artists and craftsmen to carry out his designs. Since the head of a workshop employed his assistants, these organizations smacked of trade. In Bernini's case the papal chancery paid the salaries, so that the great man remained 'untouched by the odium of commercialism'.[78]

Attitudes towards manual work were quite complex. From the Middle Ages monks had done manual labour as a form of penitence. At the same time, they had also constructed labour-saving machines as a means of making more time for prayer and the contemplative life.[79] Bernini's contemporaries were amazed that such a productive man went to mass every morning, visited the Holy Sacrament daily, and each evening attended the official services of the Virgin and the seven penitentials.[80] He was only able to do this because of the efficiency of his studio. This was such that the final payment for *The Tomb of Pope Alexander VII* was made in 1672, when Bernini's model had been completed, but carving of the marble had not yet begun.[81] Execution was evidently regarded as a formality, even though it was to take another six years.

By the time of Canova, division of labour meant that the successful sculptor's studio had become so peaceful that morally uplifting entertainments could be staged. According to the German writer and painter Carl Ludwig Fernow, who published a highly critical book about Canova in 1806, the sculptor had a specialist reader among his entourage who would read out classical literature in Italian translations, while he put the finishing touches to his latest project.[82] This must be true, for in a letter

written twelve years before to a Venetian friend, Canova writes, 'The truth is that I am working the whole day like a slave, but it is also true that almost the whole day I listen to a reader, so that I have now heard all the eight volumes of your Homer edition for the third time.'[83]

The division of labour could be seen in the most exalted terms. In the nineteenth century the wife of the British sculptor John Adams-Acton described the Italian view of the three stages of sculpture as Life, Death and Resurrection: 'the clay is the artist's creation; the plaster-work is purely mechanical; then comes the marble, first measured by instruments from the plaster on to the rough block until the Creator's work reappears, and the sculptor again takes it in hand to breathe life into it and turn it into a finished work'.[84] Another analogy was to think of the sculptor as a general, 'who demands the merit of a victory which other hands have achieved, but which his own head directed'.[85]

But Fernow was more sceptical, and after Canova's death so were increasing numbers of other critics. Fernow gave the impression that Canova's involvement with the making of his statues was fairly minimal. Although he conceded that Canova spent a long time finishing off his sculptures, he hated the waxy surface effects that became Canova's trademark. The implication was that Canova had become so divorced from his material that he had little understanding of or respect for its essential nature. The French painter Jacques-Louis David (1748–1825) encouraged his students to visit Canova in Rome, but warned them not to be seduced: 'Go and see the seductive worker of marble but make sure you don't copy him, for his false and affected manner is sure to ruin a young man.'[86]

Right from the start, the sculptor's use of mechanical aids had been a Faustian pact. Alberti and Gauricus' tale about a gizmo that allows the creation of a sculpture in several different places at once is in fact adapted from a classical text where it is used disapprovingly. The writer claims that the Egyptians used just such methods, and this is why their sculptures are so much more rigid than those of the Greeks. Although some hermetic philosophers in the Renaissance thought that the 'perfect proportions' of Egyptian sculptures enabled them to be animated by divine spirits,[87] it was a risky way of establishing sculpture as a liberal art.[88]

Leonardo believed that the reproducibility of sculpture meant that it lacked uniqueness and authenticity.[89] Whereas a cast 'shares with the original the essential merits of the piece', painting 'retains its nobility,

bringing honours singularly to its author and remaining precious and unique. It never gives rise to offspring equal to itself, and such singularity gives it greater excellence than those things that are spread abroad'.[90] What he means is that not only does the process of manufacture entail the making of enlargements and models, but other versions of the same sculpture might be made from those models. Although Leonardo was conveniently ignoring the fact that he and other painters had studio assistants, working from the master's design, copying did generally seem to be more intrinsic to sculpture than to painting – so once again it would have smacked of trade. Partly for this reason, some owners tried to limit the diffusion of sculptures. The owners of antiquities were often reluctant to have them copied, and no bronze casts of Giambologna's most important monuments are known.[91]

The two Renaissance artists who are best known for having emphasized that art should *not* be made using mechanical means alone are both sculptors. Sculptors must have felt a more urgent need to clear their name. The point was made most forcibly in a popular tale about Donatello (c. 1386–1465) and his 'abacus'. It was said that Marco Barbo, the Bishop of Vicenza, had asked Donatello to show him his abacus, presuming it to be the secret of his art. The sculptor had then invited Barbo to his studio to show him how it worked. But when Barbo arrived, Donatello had nothing to show. He simply announced that he was his own abacus. If Barbo gave him a piece of paper and a stylus, he would make any kind of picture, drawn entirely from his own resources.

Michelangelo made a similar point when he said that he had 'compasses in his eyes', and this too became a talismanic saying.[92] He was particularly sensitive about the issue, and in 1547 berated his nephew Lionardo for sending him a brass measuring rod, 'as if I were a mason or a carpenter who needed to carry it around. I was ashamed to have it in the house and I gave it away'.[93] Vasari repeats the same point in his lengthy discussion of techniques and materials at the beginning of the *Lives*. The section on the nature of sculpture concludes with an emphatic rejoinder to sculptors to let the eye have the final say.[94] But no such bald rejoinder is made to painters. The mechanical use of geometry and mathematics was clearly felt to be more of a temptation for sculptors than for painters.

Although mechanical methods were generally frowned on, sculptors were still expected to use them. Henri Testelin, in a lecture to the French Academy in 1678, said that the sculptor 'must always have the compass

in his hand, whereas the painter must have the compass in his eye'.[95] Yet this was precisely what was held against the French sculptor Michel-Ange Slodtz (1705–64) when he was put forward for the prestigious Order of Saint-Michel. One of the top officials remarked that there were 'bien des mécanismes dans la sculpture',[96] before rejecting Slodtz's application. A few years later, Goethe lamented the 'proliferation of the mechanical' in the plastic arts. Only painting stood apart, though Goethe feared for the future: 'Soon there will arrive the large-scale painting factory, in which, so we will be told, any painting can be quickly and easily imitated.'[97] The concept of the 'sculpture factory' was already well established.

As scholarship became more professionalized during the eighteenth century, connoisseurs, dealers and collectors became increasingly concerned with authenticity and originality. Initially, the most far-reaching consequences were felt in relation to classical sculpture and literature. In 1795 a scandal arose when a German scholar questioned the existence of Homer. F. A. Wolf argued that the *Iliad* and *Odyssey* were a collection of ballads composed by diverse bards. According to Samuel Taylor Coleridge, Homer was 'a mere concrete name for the rhapsodies of the *Iliad*'. But most people refused to countenance the idea that Homer was a co-operative rather than a solitary genius.[98] The Homeric question had been preceded and perhaps influenced by the claims of eighteenth-century antiquarians that most of the sculptures that had survived from antiquity were Roman copies of Greek originals. The German painter Anton Raffael Mengs (1728–79) claimed that even the *Laocoön* and the *Apollo Belvedere* were not original creations. The idea that classical sculptures were copies, often debased, was generally accepted, and this slowly but surely contributed to a decline in their reputation.[99]

The use of specialists also caused concern about authenticity. In *The Marble Faun* (1860), Nathaniel Hawthorne wondered how much of the admiration that sculptors receive 'for their buttons and button-holes, their show-ties, their neckcloths' would evaporate if it became known that they were 'not his work, but that of some nameless machine in human shape'.[100] These points had been made before. The painter and writer Giambattista Passeri (*c*. 1610–1679) said that Bernini had won 'an immortal name' by using Giuliano Finelli to carve the intricate bits on works such as *Apollo and Daphne*, without giving him credit – an oversight that goaded Finelli into resigning.[101] The Director of the French Academy in Rome, La Teulière, ridiculed Jean Baptiste

Theodon's *Phaetusa* (1688–92) by pointing out that 'the two best sculptors in Rome for ornaments' had been paid to carve the bark, the ivy and the swan.[102] A Florentine legend even had it that a magician caused the statues in Via Cerretani to speak, in order to prove that they were created by a brilliant young sculptor, and not by his master.[103]

This kind of complaint was to crescendo in the late nineteenth century. A dramatic 'outing' took place during a long trial for libel held in Victorian England. *Belt v. Lawes* began in June 1882 and only ended in March 1884. The original libel had claimed that every sculpture purportedly executed by R. C. Belt between 1876 and 1881 was in fact either by Thomas Brock or Pierre François Verhyden, Belt's studio assistants.

The lawyers sought to determine whether Verhyden had hidden in Belt's studio while sitters were there, watching them unobserved so that he could work on their busts during the night. It was also claimed that whenever visitors arrived unexpectedly, Verhyden had to leave the studio through a trapdoor. Belt eventually won, partly on the grounds that there was 'no legally prescribable limit to the extent of the assistance that a studio assistant could contribute before being able to call a work his own'.[104] The critic Edmund Gosse subsequently thought that the case had been beneficial, for it had at least educated the public in the difficult processes of sculpture, and had obliged true sculptors to unite against 'the common enemy . . . the fashionable imposter and his "ghost" '.[105]

The 'fashionable imposter' may well have been a reference to Lord Ronald Gower (1845–1916), the younger son of the second Duke of Sutherland. Gower, a homosexual friend of Oscar Wilde, had decided to become a sculptor while supervising the execution of a tomb for his mother in the studio of Matthew Noble. He employed an Italian 'assistant', Luca Madrassi. His retirement from sculpture after the inauguration of his monument to Shakespeare at Stratford-on-Avon in 1888 could have been prompted by the *Belt v. Lawes* case.[106] The implication of Gower's career, and his sudden retirement, was that the upper classes might dabble in sculpture, but only if they could do so from just over arm's length.

Sculptors had their work cut out, then, to counteract the suspicion that sculpture was a less agreeable, and less personal, art. The frontispiece to *L'Artiste* (founded 1831), an art and literary periodical to which many of the leading Romantics contributed, and in which Balzac's *Le Chef d'Oeuvre Inconnu* (1831) was first published, suggests that Leonardo's distinction between the painter and the sculptor was a *fait accompli*.

31

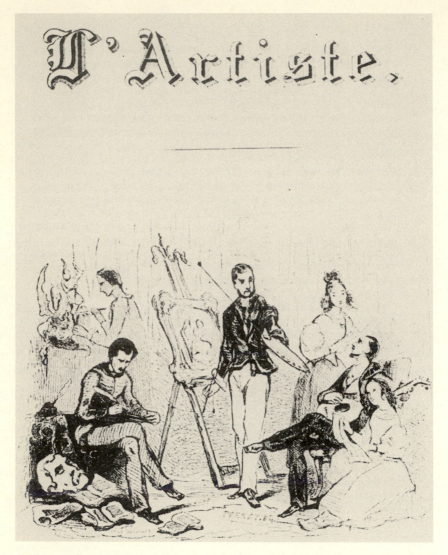

3. **Tony Johannot**, frontispiece to the leading French art periodical *L'Artiste*, first published in 1831.

 In the centre of the engraving an elegantly dressed painter stands back from his easel, flourishing his palette with a dancer's panache towards a guitar-player accompanied by a pair of coquettish singers. Opposite them, a poet perches on a chair, composing with a quill pen. All the men sport modish moustaches and/or beards. On the painter's easel is an oil-sketch of a female harp-player, and it is already surrounded by an ornate frame.

And where does the sculptor fit in to this Parisian Parnassus? In the gloomy background we perceive a wraith-like weed with his back turned towards the painter and his entourage. This anaemic troglodyte is the sculptor. Whereas we get a full-frontal of the painter, we see the sculptor in meaner profile.[107] He is a 'mere' boy, dressed in a plain smock, and he lacks facial hair (in baroque Rome, jobbing and hack sculptors were referred to as 'boys', regardless of their age).[108] He myopically prods a clay *modello* of St George and the Dragon. He pokes; George stabs. It is meant to be crude, cold and antediluvian, and it is. Here, sculpture is a trade for silent, ghostly slaves.

2. Self-Portraiture

A certain painter, I know not who, had executed a work wherein was an ox, which looked better than any other part; and Michelangelo, being asked why the painter had made the ox more lifelike than the rest, said: 'Any painter can make a good portrait of himself.'

<div align="right">Giorgio Vasari, Lives of the Artists, 1568[1]</div>

Every portrait that is painted with feeling is a portrait of the artist, not of the sitter.

<div align="right">Oscar Wilde, The Picture of Dorian Gray, 1890[2]</div>

THE SELF-PORTRAIT is one of the most important barometers of artists' increasing status and self-confidence. But the theory and practice of self-portraiture are much more fully developed in relation to painting than to sculpture. Whereas literal and surrogate self-portraiture is central to the art and aesthetic of post-medieval painting, it is almost incidental to the art and aesthetic of sculpture. Thus we are likely to be surprised if a figurative painter shows no inclination to paint self-portraits, and a great deal is made of those painted self-portraits that do exist. But there are fewer such expectations of sculptors. Indeed, they are often assumed to be anonymous, or hardly worth knowing about. It is painters who have a near-monopoly on personality – both in the sense of having a unique style and a unique psychology.

IN THE LATE fifteenth century a notion gained ground in Florence that every artwork, regardless of subject-matter, was a representation of the artist. This line of thought was encapsulated in the aphorism that 'every painter paints himself'.[3] It had two principal but related meanings. They refer, respectively, to conscious and unconscious forms of self-expression. The notion did not preclude sculptors, but it was used far more in relation to painters. Indeed, although we sometimes hear of

<div align="center">34</div>

sculptors making conscious self-portraits, we rarely hear of them making unconscious self-portraits. This suggests that self-portraiture came more naturally to painters.

A conscious self-portrait can be an artwork that shows the artist's capacity to 'get inside' his subject-matter. The classic statement of this was by Dante in his *Convivio*.[4] He said that you could only paint ('*pinge*') a figure properly if you first became that figure. It was a conscious act of empathetic understanding, which could only be performed by a 'universal man'. The resulting picture would be a mirror of the artist's capacity to comprehend. This is what Dante must have imagined himself to be doing with the huge cast of characters in the *Divine Comedy*.

Over the centuries this idea had some pretty extreme manifestations: it was often said that an artist had to be saintly to depict saints, and so on. However, when Cellini claimed that a sculptor should understand the art of war and be brave, if he is to make a successful statue of a soldier; be eloquent and literate if he is to make an orator; be musical if he is to make a musician, he got a sarcastic response from Vincenzo Borghini, who asked whether Praxiteles had had to become a 'great horse' when he sculpted a famous bronze horse in Rome.[5]

The idea was indeed taken to indecorous extremes. The painter Domenichino (1581–1641) was observed watching and mimicking a man who was boorishly scoffing in order to paint a similar figure in his fresco, and Bernini is said to have made faces in a mirror while planning his *St Lawrence* and *David*.[6] One of the more tasteful manifestations of this sort of method-acting was furnished by the German Neo-Classical painter Anton Raffael Mengs. He hummed a sonata by Arcangelo Corelli while painting, because he wanted his picture to be in Corelli's musical style.[7]

The other way in which the painter 'painted himself' was more automatic and unconscious. It was customary to think that man's soul was mirrored in his body, but the humanists had taken this idea one step further by saying that the artist's soul was mirrored in his work. Leonardo discussed the issue of unwitting self-portraiture at least seven times. The trouble was that few painters were perfect, and so these imperfections would become the content of the work: 'if the master is quick of speech and movement his figures are similar in their quickness, and if the master is devout his figures are the same with their necks bent, and if the master is a good-for-nothing his figures seem laziness itself portrayed from the life'.[8] Leonardo's notorious failure to complete work is perhaps due to his over-zealous detection of personal trademarks. But giving up was not

the only answer. Now that the painter and his idiosyncrasies had nowhere to hide, it was crucial to be a good person, or to overcome any personal limitations. Hence the paramount importance for Leonardo and his contemporaries of self-perfection and upward social mobility.[9]

The popularization of these ideas coincided in Italy with the demise of the profile portrait and its replacement by the three-quarter face and full-frontal portrait. The profile portrait had been inspired by the format of Roman coins, and was so widespread in Italy during the fourteenth and fifteenth centuries that the compiler of an inventory at Pesaro in 1500 was surprised to come across painted portraits that showed the sitters 'with two eyes'.[10] The increasing vogue for two-eyed portraits was partly due to the belief that the eyes were 'mirrors of the soul' – the *Mona Lisa* being the best-known example – but was also related to the belief that any painting is a portrait of the artist. The gentleman-painter was now fit to stand before his easel and, as it were, go head to head, eyeball to eyeball, with his subject, for every subject is a reflection of – and an advertisement for – himself. No wonder, then, that some scholars have claimed the *Mona Lisa* is an unconscious self-portrait. For in Leonardo's eyes, all painting *is* self-portraiture.

In Castiglione's *The Book of the Courtier* (1528) painting is said to be a useful and worthy activity for the ideal courtier. Castiglione touches on many aspects of painting – the usefulness of topographical drawing in wartime; the ability of painting to represent every aspect of nature; the superiority of painting to sculpture – but portraiture is the topic with which he most concerns himself. He underscores painting's primacy with a story from antiquity about Alexander the Great's special treatment of the painter Apelles, to whom he gave his favourite mistress, Campaspe.

Having got Apelles to 'paint his mistress in the nude and having understood from the marvellous beauty of the picture that the good painter was head over heels in love', Alexander 'gave her to him without any hesitation'.[11] This story was repeated *ad nauseam* during the Renaissance, but Castiglione gives it a particular emphasis. It sets the stage for a long discussion over whether someone who can paint a portrait of a beautiful woman will have a more profound understanding of her beauty. The portrait (or, indeed, any other kind of painting) is here a picture of the painter's perception of his subject; and the act of painting is a learning process about one's feelings towards the subject.

Castiglione had first-hand experience of a great painter. Raphael

(1483–1520) was a personal friend who twice painted his portrait. In the version now in the Louvre, Castiglione looks directly out at the viewer with his clear blue eyes, the epitome of elegant affability. It initially hung in Castiglione's house in Mantua, and when Castiglione visited Rome, he wrote a poem in which he imagined his wife and their son consoling themselves with the portrait 'by Raphael's hand' and believing it to be on the point of speaking.[12] But the portrait was also, in a very real sense, a self-portrait. We can indeed see 'Raphael's hand'. It is so thinly painted that individual brushstrokes and the weave of the canvas are clearly visible. The techniques and materials of painting are laid bare.

Raphael, in his turn, marvelled at a self-portrait given to him by Dürer. It was executed in gouache and watercolour on transparent linen, with the highlights left unpainted. Here, too, it was possible to imagine the artist at work, from start to finish. When Raphael sent Dürer one of his own drawings, Dürer wrote on it that Raphael had sent it 'to show him his hand'.[13] These drawings show the carefully manicured hand of artistry and courtesy.[14] And in 1521 Valentin Schaffner, a printer from Basle, devised a trademark that showed the hand of Apelles at work.[15]

These sophisticated ideas were exported all over Europe in the sixteenth century – not least by *The Courtier*, which was a pan-European best-seller: within nine years of its first publication, it had been translated into Spanish and French; German, Latin and English translations soon followed.[16] Indeed, it was Castiglione's discussion that encouraged the young English poet Sir Philip Sidney to have his portrait painted by Veronese when he visited Venice in the 1570s. The portrait performed a similar function to that performed by poets: it bestowed fame and immortality.[17]

William Shakespeare provides one of the most subtle and disturbing variations on the theme in the *Merchant of Venice* (c. 1596), when Bassanio opens the lead casket and finds a portrait of his beloved Portia inside:

> Fair Portia's counterfeit! What demi-god
> Hath come so near creation? Move these eyes?
> Or whether, riding on the balls of mine,
> Seem they in motion? Here are sever'd lips,
> Parted with sugar breath; so sweet a bar
> Should sunder such sweet friends. Here, in her hairs
> The painter plays the spider, and hath woven

A golden mesh to entrap the hearts of men
Faster than gnats in cobwebs: but her eyes! –
How could he see to do them? having made one,
Methinks it should have power to steal both his
And leave itself unfurnish'd . . .

<div align="right">(Act III, Scene II, 115–29)</div>

Here, the portrait is the occasion for speculation about the artist as much as the subject. Bassanio imagines the portrait being painted. But there is a sense of rivalry between Bassanio and the painter. We have a sneaking suspicion that the painter has somehow violated Portia: 'What demi-god has come so near creation?' Bassanio asks. He is both awe-struck and alarmed. The imagery becomes even more predatory: the spider-painter plays *in her hairs*![18] The intimacy is shocking. Finally, Bassanio wonders how the painter could possibly have painted both her eyes. Perhaps he would have preferred the lesser intimacy of a one-eyed profile portrait.

Shakespeare piles paradox upon paradox, but Bassanio's speech is more than a rhetorical exercise. It is a subtle reworking of the three-way relationship between Apelles, Alexander and Campaspe. Just as Alexander intuited from Apelles' portrait of his naked mistress that 'the good painter was head over heels in love', so the beauty of Portia's portrait makes an awe-struck Bassanio see the painter as a dangerous demi-god. This mixture of fascination with, and suspicion of, the art of painting was to precipitate the genre of 'Advice-to-a-Painter' poems mentioned in the previous chapter, which often concerned a portrait of a mistress.[19]

Shakespeare expresses a very English uneasiness about the morality of the visual arts, but his art-loving compatriot King Charles I was to have fewer qualms. He was one of the first major collectors of painters' self-portraits and had at least twelve by the time of his death. They included examples by Giorgione, Titian, Dürer, Rembrandt, Bronzino, Pordenone, Giulio Romano, and by his court artists, Rubens and Van Dyck.[20] Whereas in the early Renaissance it was generally assumed that there was only one good style to which an artist should aspire, it was now increasingly accepted that there could be a variety of distinct, but equally valid styles, rooted in the artist's personality.[21] As Castiglione put it: 'Behould in peincting Leonard Vincio, Mantegna, Raphael, Michelangelo, George of Castelfranceo: they are all most excellent dooers, yet are they in working unlike, but in any of them a man wold

not judge that there wanted ought in his kind of trade: for every one is knowen to be of most perfection after his maner.'[22] The artist's 'manner' was revealed in all genres of painting, but the self-portrait opened the clearest window on to its origin. Through all these means, painters were established as – potentially, at any rate – men of rare distinction, insight, privilege and power. They, and the noble art of painting, were becoming brilliantly conspicuous.[23]

WAS IT possible to say that 'every sculptor sculpts himself'? It certainly was, but not to the same extent. Mythologies of self and of signature styles were never as comprehensively developed in sculpture.

In *Della Pittura* (1436), the first theoretical treatise on painting since antiquity, Alberti had written that the 'inventor of painting, according to the poets, was Narcissus . . . What is painting but the act of embracing by means of art the surface of the pool?'[24] But he gives sculpture a less self-centred and contemplative origin. In *Della Statua*, the creation myth is vague, diffident and anonymous. It is prosaic rather than poetic: 'I believe that the arts of those who attempt to create images and likeness from bodies produced by nature, originated in the following way. They probably occasionally observed in a tree-trunk or clod of earth and other similar inanimate objects certain outlines in which, with slight alterations, something very similar to the real faces of Nature was represented.'[25]

Somewhat surprisingly, sculptors in the early Renaissance were if anything more alive to the possibilities of self-portraiture than painters. A series of busts in the cathedral of Prague representing benefactors of the church includes a self-portrait of the architect/mason in charge, Peter Parler the Younger (1330–99). This is 'in all probability the first real self-portrait of an artist known to us'.[26] Lorenzo Ghiberti (1378–1455), the first artist to write an autobiography, included two self-portrait busts in the bronze doors of the Baptistery in Florence. In fifteenth-century Florence, such self-assertiveness went hand in hand with a vigorous tradition of signed portrait busts, often based on death and life masks.[27]

It is hard to say why, after the sixteenth century, self-portraiture and surrogate self-portraiture become increasingly associated with painting.[28] But there are at least three main reasons. First, after Leonardo and Dürer, painters increasingly took the initiative in the development of portraiture.[29] Second, the increasing use of canvas rather than wood

supports made it possible to associate painted portraits with the most famous self-portrait in Christendom.

I am referring to the legends in which Christ is said to have impressed his features on a veil, towel or canvas. The best known is that on which Veronica (from *vera icon*, meaning true icon), taking her veil or linen cloth, wiped the sweat and blood from Christ's face as he was carrying his cross to Calvary. Miraculously his features became imprinted on the material. By the seventh century the story had been given a novel twist. Veronica was supposed to have gone to a painter for a picture of Christ. On the way to the painter, she bumped into Christ, who took the cloth and pressed it to his face.[30] Cloth was a very popular medium in Byzantine art, especially as the Christian Greeks felt uneasy about producing 'graven images'.[31] Many churches claimed to have the original cloth, or 'sudarium', and one is preserved as a relic in St Peter's, Rome. Depictions of the cloth became a particularly popular subject for painters.[32] Dürer made a large engraving of a sudarium in 1513, and Christ's self-portrait seems to have sanctioned his own – above all the one he sent to Raphael, which was painted in gouache and watercolour on transparent linen, with the white of the linen providing the highlights.[33]

The third crucial factor was Michelangelo, whose hostility to portraiture of any kind was legendary.[34] Vasari informs us that he made a pencil drawing of Tommaso de' Cavalieri, 'and neither before nor after did he take the portrait of anyone, because he abhorred executing a resemblance to the living subject, unless it were of extraordinary beauty'.[35] The basic premise – that the artist should restrict himself to noble subject-matter – was conventional enough, but the assumption that the world was bereft of sufficiently beautiful subjects, and that portraiture was thereby impossible, was characteristically extreme.

Through his rejection of portraiture, Michelangelo was also asserting that the function of art in general, and of sculpture in particular, was to deal with timeless universals rather than ephemeral particulars. When asked why a sculpture supposedly representing Lorenzo de' Medici in the Medici Chapel looked nothing like him, Michelangelo responded that it did not matter, as in a thousand years' time no one would know what he looked like anyway. Writing in 1544, Niccolo Martelli added that Michelangelo did not depict Giuliano and Lorenzo de' Medici 'as nature had portrayed and composed them, but rather gave them a size, proportion and beauty . . . which he thought would bring them greater praise'.[36]

Michelangelo may also have been well aware of the old argument, dating back to antiquity, that sculpture was ill-equipped to depict individual traits. In a twelfth-century discussion of a mosaic in the Great Palace at Constantinople, painting is preferred to sculpture because it is able to use chiaroscuro to portray 'the roughness of skin and every kind of complexion, a blush, blond hair, a face that is dark, faint, and gloomy, and again one that is sweet, comely and radiant with beauty'.[37] Vasari was to complain that you never see sculptures depicting people as though they were alive – as you could in Titian's great portrait of Pope Paul III.[38] So Michelangelo may have been avoiding a battle that he believed sculptors could no longer win. Yet in doing so, he increased the expectation that portrait sculpture in particular, and sculpture in general, should be idealized to the point of unrecognizability.[39]

In theory, this should not have mattered too much: art was supposed to 'correct' and 'transcend' nature.[40] But in practice, it made it harder for the sculptor to establish his social presence on the world stage if he was no longer expected to be an eye-witness. With sculpture's emphasis on idealization, there was a danger that patrons and public might lose sight of the sculptor's individuality too.

There was, of course, no danger of this happening with Michelangelo. Almost every sculpture that he produced had his name written all over it. The unfinished quality of so many of his later works means that even individual chisel marks are visible. The master's 'hand' is laid bare.[41] The Florentine *Pietà* group, which he mutilated and which remained unfinished, has been called 'the most subjective and most overtly emotional that has ever been produced'.[42] It was intended for his tomb, and contains Michelangelo's one undisputed sculpted self-portrait: he is the cowled figure of Nicodemus who stands behind the Virgin Mary as she supports the body of Christ, flanked by Mary Magdalene.[43] But it also happens to be one of his most pictorial sculptures. The composition is heavily influenced by *The Last Judgement*, and the group was intended for a niche.[44] Indeed, the way that Nicodemus' hood almost covers his face, and knits together visually with the other garments and winding sheets, suggests that this group is a sudarium in stone. The sudarium would never have been far from Michelangelo's thoughts, as Nicodemus was Veronica's sculptural counterpart. He was reputed to have carved Christ's portrait immediately after Calvary.[45] But when Michelangelo wanted to do a self-portrait, flat veil-like forms won the day.[46]

4. **Michelangelo**, *Pietà*, c.1547–55
(Marble, Museo dell'Opera del Duomo, Florence).

FAR MORE influential than Charles I's short-lived group of painters' self-portraits (the royal collection was sold off under the Commonwealth) was a collection formed later in the century by Cardinal Leopoldo de' Medici. From 1664 to 1675 Leopoldo established a collection of painted artists' self-portraits in the Uffizi. The tiny handful of sculptors to be included were admitted only because they had *painted* their own self-portrait.

Bernini – perhaps the greatest of all portrait sculptors, yet still one who believed that painted portraits were superior[47] – was one of the lucky few. He painted a self-portrait early on in his career, after Pope Urban VIII had ordered him to dedicate a large proportion of his time to the study of painting and architecture. Bernini's biographer Filippo Baldinucci informs us that he devoted himself to painting for two years.[48] There is a strong possibility that the Pope wanted to convert Bernini into a fresco painter, *à la* Michelangelo. However, this plan never came to fruition: 'He knew from the beginning that his strong point was sculpture. Thus, although he felt a great inclination toward painting, he did not wish to devote himself to it altogether.'[49] According to Bernini's son, the Pope wanted him to paint a vast fresco cycle but, due to a convenient illness, Bernini failed to oblige.[50]

Paradoxically, Bernini had presided over a sculptural project to provide a suitable setting in St Peter's for various saints' relics, including the sudarium, the most famous self-portrait of them all. Francesco Mochi (1580–1654) made a statue of St Veronica (1629–40), which was situated in the niche of the pillar that supports the dome of St Peter's. It is a flurry of wind-swept activity and it looks almost as though Veronica is tearing the veil, or having it torn from her grasp. It was not well-received. When it was set up, Bernini asked contemptuously where the wind was coming from.[51] Above this statue was a balcony where the veil could be exhibited on special occasions.[52] Thus a sculptural depiction of the subject occurred in a period when the incompatibility of sculpture and self-portraiture was being established. The association of painting and the sudarium had recently been confirmed by the celebrated Italian poet Gian Battista Marino, who thought painting superior to sculpture. The section on art in his *Sacred Discourses* (1614) was entitled 'Painting, or the Holy Shroud'.[53] Yet there was good reason for the primacy of sculpture in St Peter's: it had always been extremely damp and humid. The painted altarpieces were rotting in their frames and even the recently executed mosaics were falling off the walls.[54]

Bernini himself provides a rationale for sculpture appearing to be inimical to self-portraiture. Speaking in Paris in the 1660s, he noted that a painter, while working on a composition, can make continual adjustments. Thus, if asked at the end whether he has put 'all his skill into the work', he can 'assent without hesitation', for not only has he been able to 'imbue it with all the knowledge with which he began', but also 'to add what he has learned' while working on it. A sculptor cannot put all

his skill into his work, because he cannot modify the pose as he goes along and becomes more experienced. When working in marble, the pose has to be established right at the outset.[55] So the sculptor, and the sculpture, exists in a state of arrested development. It is thus a mistake to seek information about the maker from a sculpture, because it will always be a freeze-frame, limited and out of date.

Bernini's account of painting is comparable to one given earlier in the century by the French philosopher Réné Descartes, who made numerous references to painting in his writings.[56] In his unfinished dialogue, *The Search after Truth*, some friends discuss the best way of acquiring knowledge. One of them says that the imagination of children is said to be like a *tabula rasa* or blank canvas: 'The senses, the inclinations, our masters and our intelligence' are various painters who paint pictures on it, which are usually imperfect. Then intelligence comes along, but since it takes a long time to learn how to paint, it takes a while before the painting can be rectified. However, intelligence can only partially improve it, because from the beginning it has been 'badly conceived, the figures badly placed, and the proportions badly observed'.[57] This painting is obviously a group effort, in which outsiders ('our masters') as well as insiders ('intelligence') are involved, and it is not a complete success – but Descartes does demonstrate how a painting might be seen to furnish a sophisticated autobiographical account.[58] Indeed, in this period, the visible correction, the *pentimento* (derived from the word meaning to repent), became a trademark of the great master. In their late work, Rembrandt and Velázquez, like Titian before them, often changed their mind in mid-picture and took little trouble to cover their tracks: *pentimenti* demonstrated their fertility, and recorded the mind in action.[59]

The Medici self-portrait collection soon became famous and, as Florence declined politically, was an effective way of establishing the city as the cradle of the visual arts, thus making it a magnet for free-spending tourists. From 1731 to 1762 a catalogue of the entire Medici collection, which had recently been given to the people of Florence, was published in twelve large volumes lavishly illustrated with engravings. The last six were entitled '*ritratti*' (portraits) and featured 270 self-portraits, with biographies of the artists. These attested in no uncertain terms to the pre-eminent status of modern painters.[60] Until a change of policy in the twentieth century, probably brought about by the prestige and 'autograph' nature of Rodin's sculpture,[61] only one self-portrait sculpture was admitted to the collection.

This exception to the rule must have been admitted because it had a certain novelty value. It was made by a woman, an aristocratic English widow, Anne Seymour Damer (1749–1828). Damer had been encouraged to take up sculpture by the wealthy connoisseur Horace Walpole after the suicide of her husband John Damer, Lord Milton, in 1776. Walpole 'doted on her delicacy and her talent, which he grossly over-praised',[62] and at his death left her his neo-gothic dream-home, Strawberry Hill. By eighteenth-century standards Damer was an eccentric. She stomped around the fields near her home with a hooking stick, dressed in a man's coat, hat and shoes. Her special forte was animal sculptures, which Walpole regarded as the equal of Bernini, but she also gave serviceable busts of Charles James Fox and Nelson to Napoleon.[63] When Sir George Beaumont bought Michelangelo's *Taddei Tondo* (now in the Royal Academy, London), Damer had to be restrained from 'finishing it'.[64] To the Uffizi, Damer presented a white marble bust in a spirited but 'finished' Neo-Classical style.[65]

What made her contemporaries so excited about her was that in antiquity no female sculptor 'had attained to excellence sufficient to be recorded'.[66] Several of Damer's female contemporaries worked in terracotta (the tragic actress Mrs Siddons apparently executed busts of herself and her brother),[67] but Damer was unrivalled in carving marble statuary: 'Art seldom finds votaries of such high descent, nor is it usual for a sex, slim of frame and soft of hand, to enter voluntarily upon the severest of bodily drudgery to which genius has taxed itself.' Damer dressed for the occasion, wearing 'a mob cap to keep the dust of the marble from her hair, and an apron to preserve her silk gown and embroidered slippers; and with a hammer of iron in one hand, and a chisel of steel in the other, had begun to carve heads in marble'.[68]

Nonetheless, rumours circulated at the time that a 'ghost' carved her work.[69] So the only carved self-portrait in the Uffizi was clouded by a suspicion that it might not have been a self-portrait at all. Yet it was just this – the complex, collaborative nature of sculpture – that made it hard to take seriously the idea of sculpted self-portraits.

Not even Antonio Canova, the greatest Neo-Classical sculptor of all (and the Neo-Classical artist whose portrait was painted most frequently[70]), has a self-portrait sculpture in the Uffizi. He made a self-portrait bust in white marble in 1813, which was eventually placed on his tomb, and he allowed numerous plaster casts and replicas to be made.[71] But, like Bernini, Canova was an occasional painter, and he is

5. **Antonio Canova**, *Self Portrait*, 1792
(Oil on canvas, Uffizi, Florence.

represented by a self-portrait *as a painter*, painted in 1792, which was
donated to the museum by a friend shortly after the sculptor's death.[72]
Canova painted himself *as a sculptor* in 1799, but this picture remained in
his own collection. Whereas in the classicizing bust he has an averted,
ethereal gaze, in the painting his eyes drill into the viewer scorchingly.[73]
Thanks to Canova and to another Rome-based sculptor, the Dane Bertel

6. **Antonio Canova**, *Self Portrait*, 1813
(Marble, numerous casts and versions: original at Possagno, Gipsoteca
Canoviana).

Thorvaldsen (1770–1844), contemporary sculpture was at least as highly
regarded at this time as contemporary painting. But because Thorvaldsen
did not *paint* a self-portrait (he was commissioned to carve one in 1810),
he is not represented in the Uffizi collection.

In 1775 Sir Joshua Reynolds (1723–92), the most famous portraitist in Europe, donated his own self-portrait to the Uffizi. Five years later he offered his observations about sculpture in his tenth *Discourse* to the Royal Academy. This endorses the central principle on which the Medici collection was based – the fundamental anonymity of sculpture. For Reynolds, sculpture is a 'science of abstract form' confined to 'general expression',[74] a limited art, less great than painting,[75] which had 'but one style'.[76] He believes that classical figures are distinguished by their attributes more than by 'any variety of form or beauty'. The classical sculptor seems to have 'total indifference' as to which figure gets which attribute: 'Take from Apollo his Lyre, from Bacchus his Thirsus and Vineleaves, and Meleager the Boar's Head, and there will remain little or no difference in their characters.'[77]

Reynolds then turned to the Florentine mannerist Giambologna and his masterpiece, *The Rape of the Sabines* (1581–2). This *tour de force* was a three-figure composition carved from a single block of marble. It was said to have been made to prove Giambologna's dexterity, and had only been given a title upon completion. But Reynolds saw this as symptomatic of the generalized nature of sculpture: 'Thus John de Bologna . . . called his friends together, to tell him what name he should give it, and it was agreed to call it The Rape of The Sabines . . . The figures have the same general expression which is to be found in most of the antique Sculpture.'[78] Here we have a vision of sculpture as presenting a series of inexpressive masks.

Reynolds was not exactly intending to be critical – he admired Giambologna and Greek sculpture, and he believed that sculpture, by its very nature, had to be expressionless. Indeed, many eighteenth-century patrons believed that the purpose of sculpture was to be as inexpressive as possible, because generalized, blank surfaces encouraged the idea that a monument or a bust would last forever.[79] This was implicit in Horace Walpole's derisory remarks about the famous 'attitudes' of Emma Hart, wife of the British Ambassador in Naples, Sir William Hamilton, and lover of Nelson. These were performances in which she struck poses from antique statues. Walpole contemptuously dismissed Hamilton's 'pantomime witness – or wife, who acts all the antique statues in an Indian shawl. I have not seen her yet, so am no judge, but people are mad about her wonderful expression, which I do not conceive, so few antique statues having any expression at all – nor being designed to have it.'[80] This ethos was almost diametrically opposed to the one that led

Joshua Reynolds to paint arresting self-portraits. It was only in painting that self-revelation and individuation were really possible.

The assumption that sculpture had only one style meant that viewers' expectations were often more narrowly based, and at the same time more exacting, than they were for painting. For Diderot, it was axiomatic that because sculpture 'can do fewer things than painting, we're more demanding with regard to what we have a right to expect of it'.[81] Sculpture was judged with an intolerance worthy of the Old Testament (one false strike . . .), whereas painting was judged with New Testament generosity and flexibility. This double standard allowed the great critic Johann Winckelmann to admire both the restrained classicism of Raphael and the exuberant baroque of Rubens, while regarding Rubens' contemporary Bernini as an artistic anti-Christ.[82] Indeed, although Winckelmann did identify different styles in ancient sculpture, there was only one true style, and only a tiny handful of sculptures that conformed to it.[83] It was almost as though sculpture was doomed to be either untrue to its maker or to itself.

Canova's close friend Leopoldo Cicognara was to be equally draconian in his *History of Sculpture from its Revival in Italy* (1813–18), the first study of a modern school of sculpture. It was intended to be a sequel to Winckelmann's *History of Ancient Art* (1764). Cicognara argued that Italian sculpture was especially worthy of attention because whereas other nations had distinguished schools of painters, only Italy had a distinguished school of sculpture.[84] Thus modern sculpture was as geographically restricted a phenomenon as ancient sculpture. But Cicognara went further, and placed even more limitations on modern sculpture. Canova represented the crowning moment of Cicognara's history, but the only period that gained his full approval was the early fifteenth century.[85] Thus the history of modern sculpture consisted of a few oases dispersed in a cultural desert: one artist, one period, one country.

By the early nineteenth century some critics believed the Romantic cult of the sketch and of spontaneity to be inimical to the practice of sculpture, a laborious art at the best of times. For Richard Payne Knight, in his *Analytical Inquiry into the Principles of Taste* (1805), the artist had to catch 'the little transitory effects of nature' so that they 'may appear to be dropped, as it were, fortuitously from the pencil, rather than produced by labour, study, or design'. It was this that 'distinguishes a work of taste and genius from one of mere science and industry; and which often raises

the value of an inaccurate original above that of the most correct copy'. This was problematic for sculpture, as it 'is necessarily, from the process of its execution, less susceptible of this kind of excellence, than that of painting; and, as it is now generally practised, cannot admit of it in any degree whatever'.

Payne Knight believed that the situation was marginally better in antiquity: 'the brass or marble statue was not a mere servile copy, set out by the rule and compass and finished with the rasp and file, from the model of the sculptor, by the hand of ignorant mechanics: the touches of the master visited every part of it'.[86] At that very moment, however, the prestige of surviving antique sculpture was being dealt a serious blow, as connoisseurs gradually realized that the celebrated sculptures of antiquity were in fact Roman copies.[87] The touches of the master had not visited *any* part of these either.

Three years later, in Goethe's *Elective Affinities* (1808), this theme was turned into an indictment of modern society. Ottilie reflects in her journal on the inevitable divorce of the sculptor from his works. The profession of sculptor supplies the clearest evidence 'that man is least able to make his own that which most completely belongs to him. His works desert him as the bird deserts the nest in which it was hatched.' What she means is that a sculptor's work ends up in places to which he may not even be able to get access. Just like the architect, the sculptor can retain nothing that he has created. Ottilie then goes on to wonder whether this ultimately has a deleterious effect on the work: 'Must the artist not in this way gradually become alienated from his art, since his work, like a child that has been provided for and left home, can no longer have any effect upon its father?' She concludes that it must have been much better when art was public property and 'belonged to everybody and therefore also to the artist'.[88]

These kinds of complaint may have influenced Canova's plans for his own memorial. His great wealth, allied perhaps to his bachelorhood and lack of immediate dependants, allowed him to channel his money into the creation of a grandiose shrine in Possagno, his birthplace near Venice. Here he engineered a posthumous family reunion: modern sculpture came home.

Canova laid the foundation stone for the *Tempio* that was to house his tomb on 11 July 1819, dressed in red papal uniform and decorated with his numerous honorary medals. It was to be Canova's *Gesamtkunstwerk*, and was inspired by the Pantheon and the Parthenon. He designed

everything, and even painted some execrable altarpieces. The tomb contained his body, minus the heart, which was buried in a tomb in Venice; and minus his right hand, which was kept by the Venice Academy – an appropriate fate, perhaps, for a sculptor who ran a large studio. The *Tempio* was officially opened in 1830, eight years after his death. A museum to house plaster models of his works was opened in 1836. His tools and clay sketch-models were displayed in the house where he was born along with other memorabilia, such as his death mask.[89] It was the first permanent shrine to celebrate the life and work of a single artist – and it is still open to all-comers.

One of the side-effects of the Possagno complex, and in particular the presence of Canova's clay sketch-models, was that subsequent critics often used them as a stick with which to beat his finished works in marble. This was true too of painters, for at least since the time of Vasari the preparatory sketch might be preferred to the finished painting; but as Payne Knight's comments suggest, the distance between first thoughts and final realization was generally assumed to be larger in sculpture than in painting.

As Canova's shrine was being constructed, the uniformity and impersonality of sculpture – and, by inference, of sculptors – was being established in negative terms by the German philosopher Hegel in his *Lectures on Aesthetics*. He delivered these several times during the 1820s, and they were to be hugely influential. This was the very same decade in which that great temple to painting, the National Gallery in London, was founded. Hegel argued that only the arts of painting and music could express the subjective life of the soul – 'Grief, agony both spiritual and mental, torture and penance, death and resurrection, spiritual and sub-jective personality, deep feeling, fear, love, and emotion'.[90] The 'abstract external shape' of sculpture was much more limited than painting, in which we find asserted 'the particular spirit of nations, provinces, epochs, and individuals'.[91]

In his lectures Hegel went on to say that whereas sculpture was lit externally, painting had an inner light.[92] It was thus the visual artform that best expressed the modern age, which was the Christian Age of Faith. Confirmation of a sort for some of Hegel's ideas occurred a few years later when the sudarium in St Peter's developed an inner light. It started to shine of its own accord, and sales of replicas enjoyed a new boom. They bore the inscription '*Copie authentique de la Face de Notre Seigneur*'.[93]

51

What Hegel termed 'spiritual and subjective personality' was precisely what Nathaniel Hawthorne, writing in *The Marble Faun* (1860), saw in *every single one* of the Uffizi self-portraits:

> Artists are fond of painting their own portraits; and, in Florence, there is a gallery of hundreds of them, including the most illustrious; in all of which there are autobiographical characteristics, so to speak; traits, expressions, loftinesses, and amenities, which would have been invisible, had they not been painted from within. Yet their reality and truth is none the less.[94]

Later in the novel, a sculptor takes a dimmer view of his own art. He 'suspects that it was a very cold art to which he had devoted himself' and wonders whether sculpture 'really ever softens and warms the material which it handles', or whether 'carved marble is anything but lime-stone'.[95] There is no question of sculpting 'from within' here. Sculpture is scarcely more personal than a geological stratum. We are back with Alberti, seeing sculpture in a 'tree-trunk' or a 'clod of earth'.

3. Sculpture in the Round: The Tiresome Art

Low relief entails incomparably more intellectual considerations than sculpture in the round . . . because it is indebted to perspective.

Leonardo da Vinci, *Notebooks*, c. 1500[1]

What is an idea? It is an image that paints itself in my brain.

Voltaire, *Philosophical Dictionary*, 1764[2]

It has been noticed that all visual art tends towards painting.

Johann Wolfgang von Goethe, *Introduction to the 'Propyläen'*, 1798[3]

ONE OF THE main reasons why it was hard for sculpture to establish itself as an independent artform, rather than a sub-section of painting, was the insistence on seeing the world as a sequence of pictures. An ability to pictorialize was an index of rationalism. By turning the world into a picture one could believe that one was in control, observing events from a fixed and privileged vantage point.

With sculpture, there was a tendency to regard it as intellectually and morally respectable only in so far as it could be pictorialized. And yet, if a sculpture could be thought of in two-dimensional terms, the accusation could easily be made that it was the handmaiden of painting or drawing, in a state of parasitic dependency. It was a no-win situation.

IN FIFTEENTH-CENTURY Florence there was already a strong sense that all visual art had to aspire to the condition of an ideal kind of painting. This was despite the fact that many painters sculpted and many sculptors painted; that both disciplines were often combined in the same work; and that sculptures, as in the Middle Ages, were often painted.[4] But even in the fifteenth century, the most vibrant era in Florentine sculpture,

painting – both its history and its practitioners – was usually regarded as a more absorbing and sophisticated artform.

In 1401 a competition was held to make a second bronze door for the Baptistery of Florence Cathedral. It was the first artistic competition of its kind and it was open to 'skilled masters from all the lands of Italy'.[5] The new door was meant to be a counterpart to a bronze door that had been made for the Baptistery by Andrea Pisano (c. 1270–1349) in the 1330s. Seven sculptors were invited to make a trial relief of a single scene, the Sacrifice of Isaac. After much deliberation, the prize was awarded to Lorenzo Ghiberti (1378–1455), then a young unknown, against stiff opposition from Filippo Brunelleschi (1377–1446). Ghiberti was to devote most of his life to the making of this and a third bronze door for the Baptistery, which came to be known as the *Gate of Paradise*.

Years later, buoyed up by success, Ghiberti wrote the first auto-biography by a Renaissance artist, *The Commentaries* (1447–8). Yet in a potted history of Italian art since the end of the Dark Ages, he devotes far more attention to painters than to sculptors.[6] He charts the revival of painting that began with Cimabue and Giotto, and was carried on by Giotto's Florentine disciples, by the Roman painter Pietro Cavallini, by the Siennese masters Simone Martini, Duccio and, above all, by Ambrogio Lorenzetti. Unqualified superlatives abound in these biographies.

The history of Italian sculpture, by contrast, gets a derisory paragraph and includes only two names – Giovanni and Andrea Pisano. Marginally more space is devoted to a northern goldsmith, Gusmin – 'excellent in his art' – but he is not a particularly encouraging example. Ghiberti's superlatives are qualified – 'there was no other lack in him except that his statues were a little short' – and then we learn that Gusmin's finest masterpieces were melted down by the Duke of Anjou for their gold. After this catastrophe Gusmin renounced all his worldly possessions and entered a hermitage to do penance. In Ghiberti's 'history' of sculpture, it is a case of short figures with a short shelf-life being given fairly short shrift.

Why this curt and bathetic presentation? An obvious conclusion is that Ghiberti wanted to give the impression that he was the *fons et origo*, the Giotto of modern sculpture. But he probably just preferred to associate himself with painting's prestige and panache. Paradoxically, in his pioneering autobiography Ghiberti was willing his own profession into invisibility.

Alberti had already started the process of establishing painting as the thinking person's art. In *Della Pittura* (1436) painting was proclaimed 'mistress of all the arts', and, for good measure, we are informed that 'whatever beauty there is in things has been derived from painting'.[7] Though Alberti admitted that painting and sculpture were 'cognate arts, nurtured by the same genius', he always preferred the 'genius of the painter', since it 'attempts by far the most difficult art'.[8]

If these extravagant claims were to carry conviction, painting's scientific credentials had to be firmly established. Indeed, by basing painting on mathematical principles derived from a careful study of nature and antiquity, modern artists could even surpass the ancients. Rational organization of complex scenes through the use of perspective was, Alberti believed, a uniquely modern innovation: 'As we can easily judge from the works of former ages, this matter probably remained completely unknown to our ancestors because of its obscurity and difficulty. You will hardly find any "historia" of theirs properly composed either in painting or modelling or sculpture.'[9]

In his preface Alberti had already referred in glowing terms to five of his contemporaries who, he believed, were exemplary figures. One would expect most of them to be painters. Yet, by a strange paradox, there is only one bona-fide painter among them – Masaccio – and he had died seven years earlier, before Alberti even reached Florence. The others were Brunelleschi, a living architect who also sculpted, and three living sculptors: Ghiberti, Donatello and Luca della Robbia (c. 1400–82). This sleight of hand was possible because Ghiberti and della Robbia worked almost exclusively in low relief, and Donatello frequently. Ghiberti and Donatello pioneered a revolutionary form of low-relief sculpture, which was (especially in the case of Donatello) organized perspectivally. It is generally known as *rilievo schiacciato* – relief that has been squeezed flat. Thus Alberti believed that their sculpture could be regarded as painting in bronze, stucco and clay.[10] Indeed, he himself tried his hand at low-relief 'painting' when he made two bronze self-portrait medals.

But what, then, of sculpture in the round? Alberti knew of its prestige in antiquity from reading Pliny, and from the numerous freestanding statues depicted on ancient coins and cameos.[11] Not many statues had yet been excavated, but he would certainly have seen impressive ones in Rome, and plenty of bronze statuettes. More to the point, Donatello and Ghiberti had made some pretty palpable freestanding figures for the

7. **Donatello**, *The Ascension with Christ giving the Keys to St Peter*, c.1430, (detail).
(Marble, Victoria and Albert Museum, London)
One of the supreme examples of *quattrocento* low relief carving.

niches of Or San Michele, and Donatello had created craggy, bearded prophets for the Campanile of the Duomo. In 1420 a statue by Donatello had been placed on top of a freestanding column in a *piazza* in Florence. Even if these sculptures intelligently exploited foreshortening and other optical tricks, they could surely not be regarded simply as paintings. Indeed, were they not heirs to the great freestanding figures of antiquity?

No doubt they were, but Alberti did not have a blanket veneration for antiquity. In *Della Pittura* he says there is 'far more merit in a "historia"

than in a colossus'.[12] In *De Statua*, and in his much later treatise on architecture, Alberti discusses the making and placement of colossal statues, but does not seem altogether comfortable with them. After describing some of the most famous colossi of antiquity, he notes that these anecdotes 'have been included purely for amusement'.[13] The statues that he recommends are placed against the wall of a monumental arch[14] or, in the case of churches, on the altar and in niches.[15] Each statue must be 'appropriate in its size' for the location.[16]

Kenneth Clark has suggested that Alberti's implied preference for sculpture in low relief is directly related to his advocacy of perspective: 'The data of sight must be brought under control: and herein lies the superiority of painting and low relief over sculpture in the round, where the spectator is free to choose his own point of view, and so abandons some of the scientific perfection of art.'[17]

For Alberti, and for many later commentators, the territory that sculpture had to occupy in order to be regarded as a rationalized, rather than a raw, chunk of nature, was wafer-thin. But such was the force of these arguments that European sculpture would thereafter be haunted by this idealization of the plane – and, thus, of the 'pictorial'.

How enlightened and progressive was Alberti's idealization of low relief? In some respects, it was very conservative. There are remarkable parallels between *rilievo schiacciato* and the sculpture favoured by the Greek Church in Constantinople. The Greek Church had strict views about the form of religious sculpture. A sacred figure was thought to be inappropriate if you could grab hold of it by its nose.[18] *Rilievo schiacciato* passed the 'flat nose' test with flying colours.

In general, Christianity was much better disposed towards painting than sculpture. Even in the Middle Ages, the Old Testament prohibition on 'graven images' was being countered by a contention that painting was a Christian art.[19] The Western, Roman Church was nowhere near as proscriptive as the Greek Church, but it inherited a tradition in which painting and two-dimensional imagery had been extensively sanctified and mythologized. I have already discussed Veronica and the sudarium, but even more pertinent, perhaps, is the story of St Luke, who became the patron saint of painters. No one knows how or why St Luke metamorphosed into a painter, but in the sixth century AD there is mention of a painting by him of the Virgin being sent from Jerusalem to Constantinople. When the Arabs besieged the city in 717, it was carried

around the city walls.[20] Subsequently, more and more pictures were claimed to have been painted by St Luke and were thus venerated with unusual intensity. From 1613 the Cappella Paolina in the Vatican, which contained frescoes by Michelangelo, housed Luke's most famous painting of the Virgin. The establishment of Luke's *oeuvre* was taken so seriously that in 1860 Pope Pius IX set up a commission to try and determine who had painted an image of the Virgin, attributed to Luke, in the Roman church of S. Maria Maggiore.[21]

During the fourteenth and fifteenth centuries painters' guilds and confraternities were formed that used Luke's name and incorporated him into their statutes. The painter Cennino Cennini (born c. 1370) was able to refer to him as 'the first Christian painter'.[22] Some pictures actually show Luke in the home of the Virgin, making a drawing of her while she breastfeeds her gurgling child (Luke was traditionally thought to be a doctor, so he must have already developed an appropriate bedside manner); others depict him seated in his studio at an easel painting the Virgin from memory or from divine inspiration. In many Renaissance versions, the *mise-en-scène* is given an added twist by Luke being a self-portrait of the artist.

The polemical potential of this subject was fully realized in a picture by Maerten van Heemskerck (1498–1574) painted in around 1550.[23] A sumptuously dressed Luke (a self-portrait of Heemskerck) sits painting a voluptuous madonna, dressed in a negligé, and a plump Christ child, who holds a parrot. She looks out at us, smiling wryly from the corner of her mouth. The scene is set in a Roman palace, and Luke is surrounded by numerous books.

Behind them, all alone in a courtyard, is a scrawny sculptor crouching over an embryonic statue. He may even be Michelangelo.[24] He is attacking the block vigorously with hammer and chisel. The statue is a standing male nude, but it lies prone on a stone bench and it looks as though the sculptor is conducting an autopsy. His chisel rests on the figure's groin. He is surrounded by grubby-looking classical statues. The sculptor's world is clearly one of violence and dislocation; the painter's world one of calm and urbanity. We cannot help associating the slightly demonic sculptor with the men who taunted and crucified Christ.

References to famous Christian sculptors are far less frequent. During the Middle Ages the *Volto Santo*, the crucifix in Lucca that had reputedly been carved by Nicodemus, had a very high status.[25] But as far as I know,

8. **Maerten van Heemskerck,** *St Luke Painting the Virgin,* c.1550
(Oil on canvas, Musée des Beaux-Arts, Rennes).
The Dutch painter was enormously impressed by Michelangelo's work when
he visited Italy in 1532-6. But here a sculptor is upstaged by St Luke, the
patron saint of painters.

there is no artists' guild whose patron saint was Nicodemus. The mythologization of Luke's and Veronica's images was developed much further. The presence of important 'original' examples of their work in Rome, as well as in other cities, must have helped the process considerably. Unlike Luke, Nicodemus did not have an *oeuvre*, he was not an apostle, and he did not write a best-selling book. Indeed, St Luke is the prototype for the ideal artist of the Renaissance who is equally skilled in *penna* and *pennello* – with pen and brush. Thus the association of painting and intellect was given an impressive biblical precedent.

All these myths underpinned the crusade to pictorialize the world. The act of painting even ended up being sanctioned in illustrated manuals of devotion and meditation.[26] The title page of a popular devotional manual, Johannes David's *Veridicus Christianus* (1601–3), shows Christ carrying the cross on a hill surrounded by *nine* painters seated at their easels. These sons-of-St-Luke are some of the first *plein air* painters, and some of the first paparazzi. They paint scenes from the life of Christ with 'appropriate colours'. Christians are called upon to 'imitate Christ in their lives' with the unerring accuracy of 'famous and outstanding painters'. Moreover, in imitating Christ, we all become painters: 'Imagine that you see many painters all sitting at work, casting their eyes on Christ as the model, and painting him, praying in the garden, tormented.' The imagination has become a heavily oversubscribed art school.[27] There is no sign of a Nicodemus.

THE SANCTIONING of painting and low relief by Alberti, Leonardo and other distinguished Renaissance figures does not mean that there was no demand for sculpture that had to be circumnavigated, or that such sculpture had a low status. Far from it: colossal statues and equestrian monuments had enormous prestige. But there was a tendency to try and structure the viewing experience so that the statue presented either a single 'picture' or a series of clearly framed pictures. When this was not possible – when a free-standing statue spiralled round and could be viewed equally well from any direction – we often find an alibi in the subject-matter. In other words, there was a decorum governing sculpture in the round: the form and the content were determined by the location.

On the whole, the work that most invites circumnavigation tends to be of the more exuberant, 'Dionysian' kind, made for fountains and

gardens. Alberti said that he did not disapprove of 'humorous statues' for the garden – though he added the proviso, which was often unheeded, that they should not be obscene.[28] The first Renaissance sculpture that is generally credited with being planned fully in the round, rather than in relation to a series of fixed viewpoints, was Verrocchio's *Putto with a Dolphin* (early 1480s), which surmounted a fountain in the gardens of the Medici villa at Careggi.[29] The podgy little boy grasps a dolphin. It is a slippery subject for a slippery viewing experience.

Sculpture in the round was often associated with mutability. Renaissance writers and artists were fascinated by a mechanized revolving figure that was described by the Roman architect Vitruvius. Such figures were often used as an allegory of Fortune. One of the most famous representations appears in the illustrated archaeological fantasy, *Hypnerotomachia Poliphili* (1499). An obelisk is crowned by a winged nymph in a flowing gown, who balances precariously on a sphere that turns in the wind. She has a forelock of flowing tresses, but the back of her head is bald. In a relief carved by the Venetian sculptor Pietro Lombardo in the early 1490s, three putti dance around a fountain surmounted by a similar type of sculpture.[30]

The mode of address required by Michelangelo's sculpture was no less determined by subject and location. After making a few Donatello-esque Madonna-and-Child reliefs in his early years, he focused entirely on freestanding figures. Yet even a statue such as *David* is designed to be looked at frontally from below.[31] It was conceived rather like a free-standing relief. The statues of *Night* and *Day* in the New Sacristy at San Lorenzo are almost the same figure, rotated through 180 degrees. Thus Michelangelo enabled the viewer to see an entire figure without having to move too far.[32] This kind of viewing experience was reflected in the so-called 'Medusa topos', the highest form of praise for a sculpture in the Renaissance. The conceit had it that the viewer of a fine sculpture was more marble-like than the statue, because he or she was rooted to the spot in amazement.[33] In a poem written on Michelangelo's death in 1564, Laura Battifera degli Ammanati said that he 'overwhelmed whoever saw his works and left them as if petrified'.[34] Of course, the Medusa topos also implied that looking at sculpture was a terrifying experience.

Michelangelo's concept of sculpture, as expressed in his sonnets, stressed this essential frontality even more forcibly than the sculptures themselves. He believed that the way we think is akin to the process of

carving a statue. Just as one chips away at a raw block of marble until the perfect form inherent in the white stone has been revealed, so one has to extract meaning from experience. This theory is famously stated in his sonnet that begins:

> Non ha l'ottimo artista alcun concetto,
> Ch'un marmo solo in se non circoscriva
> Col suo soverchio, e solo a quello arriva
> La man, che ubbidisce all'intelletto.

[The greatest artist has no conception which a single block of marble does not potentially contain within its mass, but only a hand obedient to the mind can penetrate to this image.][35]

Here, though, there is still a sense that one holds one idea at a time in one's mind, just as one works on one marble block at a time. The block contains a single figure, too. Michelangelo continues:

> Il mal ch'io fuggo, e'l ben ch'io mi prometto,
> in te, donna leggiadra, altera e diva,
> tal si nasconde; . . .

[The evil that I flee and the good that I promise myself in you, gracious lady, noble and divine, are hidden.]

Extracting an ideal form from the unworked block is like his attempt to win over his beloved. In both cases, he is contemplating something unitary and hieratic – and the tight architecture of the sonnet reinforces the sense of a block of stone being held firmly, and frontally, in place. Here there does not even seem to be room for the thrilling *contrapposto* that animates his own sculptures.

The 'pictorialism' of sculpture was underpinned by the pre-eminence accorded to drawing. For Vasari, Michelangelo was the ideal artist precisely because he was equally skilled at painting, sculpture and architecture. All these arts had equal status because they were all arts of design – *disegno*. *Disegno* referred to the 'concept' in the mind of the artist, but it becomes synonymous with drawing.[36] Because of this theoretical framework, Vasari's *Lives* is relatively even-handed in its treatment of sculpture.[37] Nonetheless, *disegno* was a more natural partner

to painting. Vasari (who was a painter himself) later wrote that 'because painting is drawing ['*disegnare*'], it belongs to us more than to them'.[38] Since far more painters than sculptors could draw, the former seemed to possess the key to art. They frequently provided drawings for sculptors to translate into marble and bronze.

This same view was put forward with extraordinary chutzpah by the Portuguese painter Francisco d'Olanda in his *Dialogues* (1548) with Michelangelo. Michelangelo is made a mouthpiece for the assertion that drawing and painting are the one art or science from which all others spring: 'each person without being aware of it is engaged in painting this world'. Clothing, agriculture, architecture, and even sailing, military operations and funerals depend on drawing.[39] For the same reasons, d'Olanda claims that the sculptures in the New Sacristy at San Lorenzo are really paintings: 'Although some people think that [sculpture] is an independent art, it is condemned all the same to serve painting, its mistress.'[40] The Portuguese were in the vanguard of European colonialism, and here aptitude at drawing and painting is seen as crucial to the development of military and economic power. It is the ultimate secret weapon.

There is only one surviving work by Michelangelo that was made to be walked around. Not surprisingly, it is his raunchiest. *Bacchus* (1496–7) was made for the garden of his Roman patron, Cardinal Raffaelo Riario, Vice-Chancellor of the papal court. To be invited to make a sculpture for such a location was a great honour, because Roman collectors often displayed antique sculpture around the edges of their gardens, up against the walls and in niches.[41] But Riario evidently was not pleased with the *Bacchus*, because it soon entered another collection. The Cardinal probably found it too licentious, and less dignified and negotiable than his antiquities.

It certainly is a disconcerting work. The god of wine is completely naked, bar a cap made from bunches of grapes. He holds a cup and seems to stagger backwards. Standing diagonally behind him is a satyr, who steals his grapes. Bacchus' penis is now missing, but it probably was not too afflicted by brewer's droop. Scenes from mythology and pastoral poetry were subjects generally deemed appropriate for garden sculpture. Wine fitted the bill perfectly. It was associated with abundance and fertility, and fountains would sometimes be decorated with statues of satyrs with wine sacks.[42] Donatello's electrifying fountain sculpture *Judith and Holofernes* (1450s) exploited these associations too, for Holofernes

9. **Michelangelo**, *Bacchus*, 1496-7
(Marble, Museo Nazionale del Bargello, Florence).

was drunk when Judith murdered him. The viewer of *Bacchus*, by having to circumnavigate it, would be encouraged to feel a suitable state of inebriation.[43] Michelangelo's biographer Condivi explained it as an allegory of the effects of strong drink.

Biblical and Christian figures hardly feature in gardens. The only exception is Moses, who might be shown striking the rock to release the water.[44] This may be why Michelangelo's *Moses* (1513–16) has one of the most complex poses, and fantastic appearances, of any of his sculptures. The statue was designed to be placed at the corner of Pope Julius' tomb, and thus seen from several viewpoints. When the project was radically scaled down, *Moses* ended up being shoehorned into a niche.[45] But with his horned head and the matted lava-flow of his beard and robes, Moses is imbued with some of the wildness associated with gardens. In the 1550s Michelangelo did in fact propose carving a fountain statue of Moses striking the rock for the Pope.[46]

The mannerist sculptors who followed Michelangelo went further down the road towards sculpture that was fully in the round. In order to give their work intellectual respectability, however, some liked to remind their viewers that their statues were still composed of sequences of flat planes. Although Cellini sometimes argued that statues could be seen from innumerable viewpoints, on other occasions he could not bring himself to dispense entirely with the idea of a controlled sequence of planes. In his *Autobiography*, he recounts how Duke Cosimo I came to see his model for the Neptune Fountain, and 'he walked round it, stopping to inspect it from all four sides just as an expert would have done'.[47] Thus Cellini conceived of statues as prismatic columns, for in this way they still have a link with mathematics, and thereby with the supremely intellectual arts, painting and architecture. Anything less, you feel, would have meant entering a cultural desert – a land without planes.

Vincenzo Borghini, who made many disparaging remarks about sculpture in general, and about Cellini in particular (dismissing his protestations in favour of sculpture as the mere barkings of a butcher's mongrel),[48] countered his sophistry with a clever riposte: seeing a sculpture from different sides, he claimed, is just like seeing a succession of paintings.[49] He may have got this idea from his friend Vasari. In Vasari's life of Giorgione, we learn that the painter had a dispute with some sculptors at a time when Andrea del Verrocchio (1435–88) was in Venice making his bristling equestrian monument to the great *condottiere* Bartolomeo Colleoni. When the sculptors claimed that their art was

superior because it offered multiple views of one figure, Giorgione devised a painting that offered several views at a single glance, 'without any necessity for walking round'.[50]

The Venetian painter showed a back view of a naked man in a landscape. His front was reflected in a pool of water, and his sides in a strategically placed mirror and a suit of armour. Giorgione not only puts the viewer at rest; he also puts the great *condottiere* at rest, disarming him and turning him into a contemplative Narcissus. The implication is that Verrocchio's swaggering bronze sculpture declared war on the viewer: first, by being a sculpture in the round, and second, by being an *armed* sculpture in the round.[51] Painting is here the great pacifier. Appropriately enough, Vasari makes Giorgione the epitome of the gentleman-artist: 'gentle', 'benign' and of 'good breeding' throughout his whole life.[52]

The most famous monumental sculpture in the round to be produced in the Renaissance was Giambologna's tumultuous corkscrew, *Rape of the Sabines* (1581–2). It was developed, like most of his sculptures, from numerous clay and wax models rather than from drawings. It prompted the production of engravings and woodcuts that showed the statue from different viewpoints.[53] No one knows for certain where it was originally going to be located, but it has recently been suggested that it was envisaged as a garden statue for the Medici villa at Pratolino, possibly as the centrepiece of a large fountain.[54] Contemporary claims that it was purely a compositional exercise may have been licensed by a garden location (though Alberti would have probably called it *Rape of the Senses*). The subject-matter of the statue does relate to the theme of mutability. The marked differences in age of the three protagonists (old man, mature man, young girl) suggest the three ages of man.

But once it was decided to place the statue in the centre of Florence, in the Piazza della Signoria, a framing process started to take place. Its placement under the right-hand arch of the arcaded Loggia dei Lanzi 'discourages the spectator from moving freely round it', because of a low wall across the bottom of the arcade, and a change in level between the Piazza and the Loggia.[55] Moreover, the subject-matter was made more explicit by the narrative bronze relief that was installed on the pedestal.[56] The relief was, of course, placed at the front of the Loggia, and it thus established the side facing the square as the 'main view'.

Giordano Bruno's *Torch of the Thirty Statues* is a loose philosophical counterpart to some of these developments. The Italian philosopher began writing in 1587, but the book remained an unfinished fragment.[57]

10. The Loggia dei Lanzi, in an anonymous nineteenth-century photograph. Statues, far right: **Giambologna**, The Rape of the Sabines, 1581–2; far left: **Benvenuto Cellini**, Perseus and Medusa, 1545–54.

In it, the Greek sculptor Phidias 'sculpts' a series of vast mythological statues within the 'theatre' of Bruno's memory. Each statue is expressive of an aspect of his hermetic and mystical philosophy. Phidias makes these memory statues in a wide variety of ways, 'either moulding in wax, or constructing by addition of a number of small stones, or sculpting the rough and formless stone as though by subtraction': Michelangelo's 'subtractive' method of carving is here combined with the less unitary, 'additive' methods that he abhorred.[58]

It is almost certain that Bruno's statues were meant to revolve simultaneously, so that they would constantly be in the process of reformation, entering into new relationships with each other and with the 'viewer'.[59] These 'memory statues' exemplified Bruno's dynamic understanding of the human mind and of the cosmos. Yet it is the statues that move rather than the viewer. In this respect, despite their vast size, they function more like bronze statuettes, which were traditionally held in the hand and revolved. In the 1570s Francesco I, the Grand Duke of Tuscany,

67

commissioned eight large statuettes of classical deities from different sculptors, to be set in niches in the walls of his newly built study. Giambologna took three years to complete an *Apollo*, and Francesco liked it so much that he had a mechanism made so that it could be revolved in its niche.[60] The most satisfying thing of all was to be an armchair viewer.

IN THE SEVENTEENTH and eighteenth centuries, the fashion for complex large-scale sculpture in the round declined, and a more two-dimensional bias was established. Bernini's three early mythological statues – *Pluto and Persephone* (1621–2), *Apollo and Daphne* (1622–5) and *David* (1623–4) – are full of mannerist contortions, but they were designed to be placed next to walls.[61] The viewer is invited to walk round them in an arc of about 180 degrees, observing the action unfold sequentially. When they were first installed in the Villa Borghese in Rome, *Apollo and Daphne* appeared to be running towards a window that faced on to a private garden.[62]

Apart from Bernini's magnificent fountains, the later sculptures, such as *The Ecstasy of St Teresa* (1645–52), tend to be more tightly framed and less generous about viewpoints.[63] The cultural climate is indicated by an anonymous contemporary pamphlet, which criticized Bernini's equestrian statue of *Emperor Constantine the Great* (1654–70) for having no obvious viewpoint.[64] For the last decade of his life, Bernini meditated before a painting of the crucifixion that he had placed on an altar at the foot of his bed. The painting was based on an etching of his own drawing, the *Vision of the Blood of the Redeemer*.[65] Picturing, and sustained contemplation, was the order of the day.

Picture collecting was becoming a major status symbol for royalty throughout Europe,[66] and the picture gallery was a popular metaphor for the mind.[67] The English metaphysical poet Andrew Marvell wrote a wittily wistful poem about mental pictures, entitled 'The Gallery'. It was composed around 1650, just when the art collection of King Charles I was being auctioned off by the English Parliament. Charles had bought a number of antique sculptures, and had commissioned a bust from Bernini, but his collection was famous above all for its paintings. He had bought up the entire collection of the Duke of Mantua, which contained many masterpieces by Mantegna, Titian and Raphael. He had also commissioned and acquired work by Rubens and Van Dyck. Marvell still believed his own 'collection' to be even finer.

At the start of the poem, he invites his fickle mistress Clora to a private view of his soul, which he has now 'composed into one gallery'. He says he has cleared out the rich tapestries that used to fill it, so that now '. . . for all furniture, you'll find / Only your picture in my mind'.[68] Clora appears in different guises in various allegorical portraits: she lurches from being an 'inhuman murderess' and a sadistic enchantress, to resembling 'Aurora in the dawn' and 'Venus in her pearly boat'. But Marvell's favourite picture is the one 'with which I first was took'. This shows Clora as a 'tender shepherdess', adorned in the flowers she has just picked. The poet seems both exhilarated and overwhelmed by his huge image-bank. His mind is an empty stage that has, as it were, been colonized by his collection. Few other poems attest so brilliantly to the way that pictures gripped and haunted the European mind:

> These pictures and a thousand more
> Of thee my gallery do store
> In all the forms thou canst invent
> Either to please me, or torment;
> For thou alone to people me,
> Art grown a numerous colony;
> And a collection choicer far
> Than or *Whitehall*'s, or *Mantua*'s were.

The picture gallery as a metaphor for the mind continued to be popular in later centuries, though the themes addressed by the paintings were not always quite so saucy as in Marvell's gallery. Diderot said that he was in the habit of 'arranging my images [*mes figures*] in my head as if they were on a canvas'.[69] And in 1823 the recently opened Dulwich Picture Gallery – the first public picture gallery in England – inspired William Hazlitt to muse: 'A fine gallery of pictures is a sort of illustration of Berkeley's *Theory of Matter and Spirit*. It is like a palace of thought – another universe, built of air, of shadows, of colours.'[70] Needless to say, neither Diderot nor Hazlitt had much time for universes built of marble and bronze.[71]

In Marvell's poem there is a great emphasis on pastoral settings. Even in Bernini's painting of the *Vision of the Blood of the Redeemer*, the cross hovers over a choppy sea, into which Christ's blood pours. This reflects the rise of interest in landscape painting. Gardens and even landscapes were, of course, the kind of places where one might expect to find

sculptures. Yet the rise of landscape painting meant that even landscapes in which sculptures played a prominent part were subordinated to an overall pictorial conception. Usually they were decorative features placed against hedges and walls, in niches and grottoes, or lining long perspectival vistas.

The most famous sculpture-garden of the period was at Versailles. Louis XIV's *premier peintre*, Charles Le Brun (1619–90), determined the subjects and made highly finished drawings from which a team of between forty and fifty sculptors worked.[72] Many sculptors worked on making copies of antiquities and on adapting them so that they would fit the decorative scheme. The King wanted the statues to be freestanding, so care was taken to 'improve' the modelling of the backs of the antique statues, which were often thought to be too unfinished.[73]

Yet despite this attention to how statues would look 'in the round', individual pieces functioned as props in this vast perspectival stage-set. Indeed, it is probable that really important people felt it was below their dignity to walk round the back of statues in gardens. With the perspectival stage-sets that were such an important feature of Renaissance court spectacle, there was only one ideal viewpoint, and this was occupied by the King. One's importance was gauged by one's proximity to him, because in this way one came nearer to reading the spectacle through his eyes.[74] Looking round the back of a sculpture would be like being banished to the wings. Bernini's equestrian monument of *Louis XIV* (c. 1669–77), which had not met with the King's approval, was sent to the far reaches of the gardens, at the end of a long vista across a pool. In 1687, with a little re-carving, it was turned into the stoical hero Marcus Curtius.[75] But such stoicism was required by most sculptures, particularly when they ended up in a garden.

The English poet Alexander Pope (1688–1744) used classical sculptures as moralizing props in his celebrated informal garden at Twickenham, but they were a painter's props. 'All gardening is landscape-painting,' Pope claimed. He was referring primarily to the landscape paintings of Claude Lorrain or Salvator Rosa, which he thought had a variety that complemented the mind's own multiplicity.[76] There was, of course, no such thing as landscape sculpture, although grottoes and fountains often featured rocky 'landscapes', and reliefs might include a landscape background. In an early poem, 'The Temple of Fame' (1711), Pope did create a kind of landscape sculpture – and was ticked off by John Dennis, one of whose plays he had satirized.[77] The offending lines featured

Bernini-esque statues of Orpheus, Amphion and Cythaeron:

> Here Orpheus sings; trees, moving to the sound,
> Start from their roots, and form a shade around:
> Amphion there the loud creating lyre
> Strikes, and beholds a sudden Thebes aspire!
> Cythaeron's echoes answer his call,
> And half the mountain rolls into a wall:
> There might you see the lengthening spires ascend,
> The domes swell up, the widening arches bend,
> The growing towers, like exhalations rise,
> And the huge columns heave into the skies. (1.83–92)

With unimpeachable logic, John Dennis complained that 'Trees starting from their roots, a mountain rolling into a wall, and a tower rising like an exhalation are things that are not to be shown in sculpture.' After 'The Temple of Fame', Pope never again gave sculpture such a prominent role in his poetry, and his muses became landscape painters.

SCIENTIFIC DEVELOPMENTS also reinforced the primacy of painting as a metaphor for the mind. The invention of optical instruments such as telescopes and microscopes, and the perfection of devices such as the *camera obscura* and pin-hole camera around the turn of the seventeenth century, stimulated philosophers and scientists to study painting. Galileo took a keen interest in painting, and was an excellent draughtsman who drew striking illustrations of the surface of the moon. When a painter friend, Ludovico Cigoli, asked for Galileo's help in a *paragone* debate, he wrote a long reply in which, among other things, he asserted that 'the most artistic imitation is that which represents the three-dimensional in its opposite, which is the plane'.[78]

Galileo's contemporary Johannes Kepler invented the first portable *camera obscura*.[79] He also discovered that the eye consists of a lens that refracts light and imagery before projecting an image on to the surface of the retina. He left it to 'natural philosophers' to determine how the retinal image subsequently appeared before the soul, but he described this image as something that is *painted* on the retina: 'The retina is painted with the coloured rays of visible things' – and this painting was done using *pencilli*, very fine brushes.[80] Painting was setting up a research laboratory inside the human head. Descartes, Newton and Locke were

some of the many 'natural philosophers' who completed the process whereby the *camera obscura* was enlarged from merely being a model of the eye to being a model of the mind.[81]

Yet of all the metaphors for the mind, the most popular and fully articulated was that of the *tabula rasa*. This dates back as far as Aristotle, who said that the mind is nothing 'until it has thought', and that thoughts are impressed on it like characters on a writing tablet. St Thomas Aquinas, referring to Aristotle, said that the mind is 'at first like a clean tablet on which nothing is written'.[82] A major difference in its use in the seventeenth century was the unprecedented importance given to visual imagery, as opposed to signs and words. Descartes had doubts about the popular assumption that we have 'little pictures' in our head (he pointed out that signs and words 'which in no way resemble the things they signify' can also stimulate the mind), but he was as excited as his contemporaries by the idea of painting.[83]

The most important conduit for the idea of the *tabula rasa* was John Locke. In *An Essay Concerning Human Understanding* (1690), the English empirical philosopher argued that no idea can enter the mind if it does not begin as a sensory impression. So instead of being born with 'innate' characters already inscribed on our soul or mind, we are born with a 'blank tablet', which is gradually marked by sense impressions. Locke's revolutionary aim was to encourage his contemporaries to observe phenomena directly, rather than always relying on traditional authorities, such as the Church, the Crown or antiquity.

Although Locke was alive to the value of all five of the senses, and of experiences in three dimensions (he talks about dismantling clocks), almost all of his metaphors for the mind make it a place where two-dimensional representations are framed: the mind is a *camera obscura*, a white paper, a looking-glass where objects and signs are imprinted, engraved and painted: 'Let us suppose the mind to be, as we say, white paper void of all characters, without any *ideas*. How comes it to be furnished? Whence comes it by that vast store which the busy and boundless fancy of man has painted on it with an almost endless variety?'[84]

The main philosophical objection to the *tabula rasa*, and indeed to the *camera obscura*, was the implication that man is a passive mirror of the outside world, rather than a proactive shaper of the environment. One of Locke's most eminent critics was the German philosopher Gottfried Wilhelm Leibniz (1646–1716), although the book in which he took

Locke to task, *New Essays on Human Understanding*, was not published until 1765.

What is particularly striking about Leibniz's refutation of Locke's metaphors is his stress on the three-dimensionality of mental imagery. 'Where could tablets be found which were completely uniform? Will a perfectly homogeneous and even surface ever be seen?'[85] He urges us to dig into our own depths, for the mind is like a block of marble with veins in it that mark out, for example, the shape of Hercules. Hercules would be innate in the block 'even though labour would be required to expose the veins and to polish them into clarity'.[86] Things become even more interesting in Leibniz's refutation of the *camera obscura*. 'The 'screen' or 'membrane' on which the images are projected is 'not uniform but is diversified by folds representing items of innate knowledge'; what is more, because it is under tension, it has 'a kind of elasticity or active force'.[87] Here one imagines a projection on to a rucked bit of drapery from a baroque sculpture.

Even so, it is still not clear that Leibniz envisaged anything more than a 'low-relief' screen with discrete undulations; and his Hercules would probably be a glorified relief sculpture *à la* Michelangelo. It would not be until the late nineteenth century that a full-blooded three-dimensionalization of the mind would take place.[88] Eighteenth-century critiques of the *tabula rasa* tend to confirm, rather than challenge, the two-dimensional bias.

TOWARDS THE end of the eighteenth century the *tabula rasa* and its associated metaphors went out of fashion. During the Romantic period the mind was compared to more extrovert entities, such as overflowing streams and fountains, radiating candles, lamps and suns.[89] This was more a shift of emphasis than a radical break. For if one looks at the sun or a lamp, they are to all intents and purposes a *tabula rasa*: a dazzling blank. Thus light-based metaphors were not incompatible with the *tabula rasa*. Rather, they were an extreme incarnation of it. The sun was the *tabula rasa* in its most unadulterated form. A metaphor for the origin of the mind was easily transformed into an ideal to which art – and the mind – should aspire.[90]

White marble statuary seemed to be particularly well placed to profit from the change of emphasis, and so become a more popular model for the mind. Michelangelo had already called sculpture the 'lantern of painting', and he further argued that painting and sculpture related to

73

each other as do the sun and the moon (he seems to have regarded painting as the shadow of an illuminated three-dimensional object).[91] Winckelmann gave a succinct, if disconcerting, sense of how a white statue might radiate out into surrounding space:

> The colour white, since it reflects a greater number of rays, is the one to which the eye is most sensitive, and whiteness, therefore, adds to the beauty of a beautiful body; indeed, if it is naked, it seems, owing to its brilliance, to be larger than it really is; hence it is that plaster casts taken from statues seem, as long as they are new, to be larger than the originals.[92]

Neo-Classical sculptors would be far less tolerant of flaws or blemishes in the marble than their predecessors. They preferred to use the whitest marble with the finest grain. This was enlightenment in action.

Winckelmann famously hailed the 'noble simplicity and calm grandeur' of antique statues. But although he had a huge influence on the rise of Neo-Classicism, artists were less influenced by Greek statues – whether in the original or in brand-new plaster casts – than by two-dimensional art. Winckelmann himself stressed the importance of clean contours and bold outlines that can be surveyed and measured 'with a glance',[93] and statues were usually placed against walls anyway.[94] When the greatest antique sculptures were taken from Italy by Napoleon's invading forces, and installed in the Louvre from 1800 to 1815, nearly all the statues and busts were placed near the walls. It was, however, 'just possible to walk behind the *Apollo*, which was placed in a niche, with red granite Sphinxes (from the Capitol) on each side and ornamental rails in front'.[95] Some of Canova's erotic sculptures, such as the two versions of *The Three Graces* (1813–17; 1815–17), were meant to be viewed in the round, and handles were even placed on the base so that they could be revolved. But when the second version of the group was installed at Woburn Abbey, it was effectively in a niche. It was placed at the back of a small rotunda, opposite the door, which neatly framed it.

Statues were often adapted to fit in niches. A copy of Michelangelo's *Bacchus* was placed in a niche in Syon House, a country house near London whose interiors were re-designed by Robert Adam from 1762–9. But the copyist, Joseph Wilton, edited out the satyr at the back, thus enabling *Bacchus* to be less obtrusive. Even in the Uffizi, where the original marble group had been housed since the late sixteenth century, it was

placed against the wall of the long corridor, flanking a door. The statue was surmounted, very pointedly, by an ultra-iconic Bronzino portrait, which featured a far more restrained double-act, *Eleonora di Toledo with her son Don Giovanni de' Medici* (1545–6).[96] All this was in accord with an aesthetic that was given perfect expression by Leopoldo Cicognara in 1816. Having stated his preference for Michelangelo's painting, Cicognara said that not only was his sculpture marred by a 'fatal liberty', but that people generally prefer to be 'seduced by illusions' rather than 'penetrated by reality'.[97] *Bacchus* was exhibited as a freestanding sculpture in 1975 – probably for the first time since being in a Roman garden.

In general, neo-classical artists and connoisseurs were more excited by the depthless linearity of the paintings on Greek vases, and by Italian art made before the time of Raphael.[98] William Hamilton, one of the pioneering collectors of Greek vases, said that there were 'no monuments of antiquity that should excite the attention of modern artists more than the slight drawings on the most excellent of these vases'.[99] Already in the 1770s elegantly spare engravings after Masaccio, Giotto and Ghiberti's *Gates of Paradise* were being published. A close friend of William Blake, the amateur artist and poet George Cumberland was very impressed by Ghiberti's masterpiece. His drawings show exactly what the late eighteenth century was looking for in early Italian art. Lucid and fluid outline is paramount. Even an illusionistic, checkerboard ground plane is omitted because it interfered with the modern artist's stringent two-dimensional ideal. This was, after all, a time when silhouette portraits were the height of fashion.[100]

John Flaxman (1755–1826), the greatest English sculptor of the age, is perhaps its most emblematic figure. He was described at the time as 'a mixture of the Antique and the Gothic',[101] and after designing ceramic reliefs for Josiah Wedgwood, spent seven years in Italy, from 1787 to 1794. There he not only studied Greek vases, but early Italian painting and relief sculpture. He drew Donatello's panels on the pulpits in San Lorenzo, Florence, but – like Cumberland – reduced them to linear contours, and included only the main figures. A puritanical impulse underpinned these editorial purgations. He believed that the 'real ends' of all the arts are 'to elevate the mind to a contemplation of truth' – and this truth was primarily two-dimensional.[102] Even when Flaxman had worked for Wedgwood, the industrialist complained that his modelling was 'too flat'.[103] The French novelist Gustave Flaubert was thinking of 'idealists' such as Flaxman when he noted in 1846, 'They are accused of

11. John Flaxman, *Electra and the Chorus of Trojan Women Bringing Oblations*, from Aeschylus's *Choephorae*
(Engraving, 1795).

sensualism, sculptors who make real women with breasts that could give milk, and hips that could bear children. Whereas, if they did baggy drapery and figures as flat as sign-boards they would be called idealists, spiritualists.'[104]

Symptomatically, Flaxman became world-famous for outline engravings based on scenes from Homer, Hesiod, Aeschylus and Dante, rather than for his sculpture. Indeed, so successful was this side-line that he became embarrassed by their fame.[105] His engravings have cheese-wire outlines, and no shading or cross-hatching. Their limpid but rather prim simplicity caused a sensation, and they were published and re-published throughout Europe and America, influencing artists as different as Ingres and Goya. Their status as virtual *tabula rasa* upon which other, fuller images might be constructed or projected is vouched for by Jacques-Louis David. On being shown Flaxman's designs, the painter remarked, '*Cet ouvrage fera faire des tableaux*' – this work will generate paintings.[106] Flaxman thought of them as compositions upon which bas-reliefs could be based, but nothing ever came of it. His finest sculptures are rather like sculpted engravings – white marble reliefs deftly incised with flowing, powder-puff lines.

IN THE NINETEENTH century many critics continued to insist that sculpture should be as two-dimensional as possible, if it were to have the requisite clarity and hieratic power. The German writer Heinrich von Kleist furnishes one of the most interesting explanations of why sculpture in the round was considered so troubling in his essay-cum-dialogue, *On the Marionette Theatre* (1810). The marionettes are acting out the story of Apollo pursued by Daphne, watched by two friends. One of them notes that the soul of Daphne as she bends over seems to be located in the small of her back, as in a Bernini-esque naiad. This, he believes, is a serious if unavoidable mistake, a product of the Fall. For when the door to Paradise is locked, he says, 'we have to go on and make the journey round the world to see if it is perhaps open somewhere at the back'.[107] To have to journey round to the back of something is to be reminded of death. It is terribly Old Testament.

This 'mistake' would have been even more obvious to visitors to the Villa Borghese in Rome, for *Apollo and Daphne* and *David* had now been relocated to the centre of the rooms in which they stood in the middle of the eighteenth century.[108] The relocation of the statues – presumably done with the best of intentions – would have added fuel to the critical fire, incorrectly historicizing them and making them seem more mannerist.

Placement in the middle of the rooms meant that when viewers entered, they saw the sculptures front-on. But after the initial 'main view', the less satisfactory views of the back of the statues would have made them seem even more unbalanced and indecorous. For Kleist's high-minded contemporaries, having to attend to a whole body, snooping round the back, was a sisyphean pilgrimage to nowhere. The moralizing inscription on the base of *Apollo and Daphne* summed up this feeling: 'The lover who would fleeting beauty clasp/plucks bitter fruit; dry leaves are all he'll grasp'.[109] To stand motionless in front of a work of art was to forget for a while the consequences of the Fall. Stillness was grace.

Critics were also disconcerted by Canova's swooning sculpture-in-the-round, *Cupid and Psyche* (1787–93; second version 1794–6). The French connoisseur-cum-sculptor Antoine Chrysostome Quatremère de Quincy (1755–1849) did not approve of its Bernini-esque complexity and virtuosity.[110] Cicognara liked to think of Canova as an heir to the simplicity and naturalness of Ghiberti, and thought sculpture in the round almost never succeeded, because there was bound to be one view

that was better than all the rest.[111] The sculpture clearly does have a main view, whose nodal point is Psyche's exposed armpit, and this is the side from which it is always illustrated. Even so, the German critic Fernow found every viewpoint unsatisfactory: 'It is necessary to run around it, looking at it from above and then from below, always losing one's way.' Because of the necessity for this endless to-ing and fro-ing, he was relieved that it could be revolved: 'This effort is somewhat mitigated because the group pivots on its pedestal, and can be revolved at pleasure.'[112] But it was clearly only a small mercy. Canova never again made such a demanding piece.

Hegel made the most famous assertion of the alienating, unyielding and elusive nature of sculpture in the 1820s in his *Lectures on Aesthetics*. In Greek sculpture, and in sculpture generally, the figure 'is complete in itself, independent, reserved, unreceptive, a finished individual which rejects everything else'.[113] The rebarbativeness of sculpture is a function of Greek religion, for the gods, despite their human shape, have not 'experienced the deficiency of finite existence'.[114]

In Christianity, however, Hegel believed that things were very different. God became man, thus opening up a 'point of linkage'.[115] Painting is the visual artform that best expresses Christianity, for it is a two-dimensional medium in which matter is reduced and spiritualized.[116] The 'linkage' between God and man is attested to by the stationary spectator who directly faces the picture. Whereas sculpture rebuffs, painting absorbs and redeems the viewer.

One of the most vociferous nineteenth-century critics of sculpture was Baudelaire. He too was disturbed by having to circumnavigate. In his notorious demolition-job on sculpture in the Salon of 1846, 'Why Sculpture is Boring', he argued that, at its best, sculpture is a 'complementary art', which ought to be a 'humble associate' of painting and architecture, 'serving their intentions'. Yet sculpture is still a menace: 'Brutal and positive as nature herself, it has at the same time a certain vagueness and ambiguity, because it exhibits too many surfaces at once.' The sculptor cannot create a single viewpoint, for the spectator can choose a hundred viewpoints. Moreover – and this is really 'humiliating' for the artist – a change in the lighting can lead to the spectator discovering a beauty in the sculpture of which the sculptor never dreamed. Not so in a painting: 'Painting has but one point of view; it is exclusive and absolute, and therefore the painter's expression is much more forceful.'[117]

The passivity that critics had once associated with the Lockeian *tabula rasa* is here transferred to sculpture in the round. It is both crude and amorphous, with no predetermined or fixed character. Painting, by contrast, controls the viewer with a dictatorial ruthlessness. Its light shines out with unerring intensity.

4. Sight versus Touch

The notion of 'contemplation', of knowledge of universal concepts or truths as *theoria*, makes the Eye of the Mind the inescapable model for the better sort of knowledge. But it is fruitless to ask whether the Greek language, or Greek economic conditions, or the idle fancy of some nameless pre-Socratic, is responsible for viewing this sort of knowledge as *looking* at something (rather than, say, rubbing up against it, or crushing it underfoot, or having sexual intercourse with it).

Richard Rorty, *Philosophy and the Mirror of Nature*, 1980[1]

IN THE PREVIOUS chapter I argued that European critics from the Renaissance to the nineteenth century felt happier when visual inform-ation could be assimilated in two-dimensional form. The viewer, ideally, took up a central position in front of an artwork, and stayed there, rooted to the spot in solitary contemplation.

Underlying this bias was a belief, stretching back to antiquity, that the eye is the supreme sense. Leonardo wrote extensively of the power of the eye: 'The eye, which is said to be the window of the soul, is the primary means by which the *sensus communis* of the brain may most fully and magnificently contemplate the infinite works of nature.' If historians, mathematicians and poets had not seen things first through their eyes, Leonardo continues, they would 'only be able to report them feebly in [their] writings'.[2]

But the corollary to a belief in the supremacy of the eye is a distrust, and a downgrading, of the other senses. Leonardo notes, 'The eye deludes itself less than any of the other senses, because it sees by none other than the straight lines which compose a pyramid, the base of which is the object, and the lines conduct the object to the eye.' The senses of hearing and smell are deluded about location and distance, while taste and touch are dependent on direct contact with objects.[3] As a result, it is

80

impossible to 'make a science' out of these other senses.[4] Leonardo does not spell it out, but the fact that you can experience sculpture through touch made it, in the estimation of many, a lesser artform than painting.[5]

Apologists for sculpture used the fact that sculpture could be experienced through sight *and* touch to argue that it was a more universal art. One of the more articulate supporters of Michelangelo's sculpture, Benedetto Varchi, claimed that although sight was the noblest sense, touch was the surest. He cited a couple of lines from Lucretius' *De Rerum Natura*: 'For touch, through its divine omnipotence, is the sense of our whole body.'[6]

This epicurean doctrine could almost be the credo for Michelangelo's sculptures. His quasi-religious devotion to carving from a single block of marble, and his desire to make sculptures that could be rolled down a hill without undue damage, mean that the arms and hands of his figures have to come into much closer proximity with their own bodies than they would if they were carved from several pieces of stone or cast in bronze. Self-touch, and the implied activation of every nerve-end, is integral to their meaning.

Michelangelo may also have been affected by less narcissistic notions of touch. One of his favourite classical authors, Dio Chrysostom, gives a moving example of touch in his *Olympian Oration* (c. AD 79). Dio uses Phidias as a mouthpiece to mount a defence of images, such as his celebrated statue of Zeus at Olympia. Phidias argues that we need a material representation of God because it gives a sense of intimate nearness, and satisfies the human craving to touch. He cites the example of children reaching out at night to make sure that their parent is really there.[7] Michelangelo's *Taddei Tondo* is a dramatic example of this sort of scenario. The Christ child, alarmed by the fluttering wings of a bird and a crown of thorns held by John the Baptist, throws himself at his mother, grasping her with both hands.[8]

Similar arguments were used to defend the touching of religious imagery by worshippers. In the mid-fifteenth century the English religious writer Reginald Pecock devoted a long section of his *Repressor of Over Much Blaming of the Clergy* (1455) to the defence of religious imagery. Pecock argued that physical engagement with images 'ought not to be scorned or rebuked' any more than physical contact with fellow humans: 'Why, in like manner, may not the more love and good affection be engendered towards God or a saint by such touch . . .?'[9] At just this time it was fashionable for women, both lay and religious, to

12. **Michelangelo**, *Madonna and Child with the Infant St John*, ('Taddei Tondo') 1504–5
(Marble, Royal Academy of Arts, London).

have wooden dolls of the Christ child, which they would dress and treat as their own baby. German nuns called their dolls 'little husbands'. Margarethe Ebner tells how she took Jesus out of his cradle because he had been 'naughty' in the night and had kept her awake. She placed him on her lap, talked to him, then suckled him and was shocked to feel the 'human touch of his mouth'. More conjugal forms of naughtiness were provided by a life-size wooden model of the crucified Christ, which Sister Margarethe took to bed with her and placed on top of her body.[10] Not surprisingly, many religious figures, including Savonarola, condemned these practices as idolatrous.[11]

Sculptors were well versed in the tactile pleasures offered by their art, though possibly not to quite the same extent as these nuns. In the third

book of Lorenzo Ghiberti's autobiography, *The Commentaries*, the Florentine sculptor had shown himself to be intensely aware of the value of touch. He marvels at an antique statue of a hermaphrodite that had been found, rather piquantly, in a drain in Rome: 'In this statue were the greatest refinements. The eye perceived nothing if the hand had not found it by touch.'[12] Ghiberti would already have been familiar with antique bronze statuettes, which seemed to invite intimate inspection by the hand. By the late 1430s the collecting of antique statuettes was a well-established practice in Florence, and modern equivalents were being made.[13] Although Ghiberti is unlikely to have made a statuette, something of their spirit infuses the side-figures on the *Gate of Paradise*.[14]

The humanists knew full well why this artform had been venerated by the ancients: not only were the statuettes marvels of workmanship, but their small scale meant that famous former owners might have handled them.[15] This gave them the aura of religious relics – often called 'relics of touch'.[16] The value that was placed on touch is also proved by the number of painted portraits in which the subjects touch as well as gaze at antiquities; an outstanding example is Rembrandt's *Aristotle Contemplating the Bust of Homer* (1653), in which the philosopher rests his hand affectionately on top of the balding head of the poet.

Nonetheless, the fact that sculpture pandered to the sense of touch – usually regarded as the most dangerous and unreliable of the senses[17] – as well as of sight, was frequently denounced as a moral as well as scientific failing. Whenever the Five Senses were represented in art and literature, the theme of love was a kind of leitmotif, with touch as the final stage of the *gradus amoris* – the ladder of love.[18] It is telling that the antique sculpture touched by Ghiberti was a hermaphrodite, for this was a mythical creature that could enjoy the erotic sensory experiences of both sexes. Thus the act of touching occurs in a risqué erotic context. When Benedetto Varchi cited Lucretius, he tactfully omitted the following lines in which Touch is said to perform 'the generative deeds of Venus'. In Titian's great portrait of the antiquities dealer *Jacopo Strada* (1567–8), Strada clutches a Venus Pudica, his marauding fingers almost linking up with her own more modest hand. Titian loathed Strada, finding him both pretentious and ignorant, and probably meant us to be repelled by the sight of his lecherous hands.[19]

Humanists as well as ecclesiastics were determined to eliminate tactile experiences. Erasmus believed there was nothing more disgusting than the cult of relics, and insisted that physical contact has no intrinsic

meaning unless there is faith in the spiritual reality that surrounds the sacred object.[20] He believed that Christ's material incarnation on earth proved this perfectly, for if his presence had been a source of divine power and an end in itself, he would never have been tortured and crucified. Moreover, the Jews – who heard him, saw him and touched him – would logically have been the most religious nation on earth. Erasmus clinched his argument by asking rhetorically, 'Who could be more fortunate than Judas who pressed the divine mouth with his lips?'[21] Sacred icons and paintings were often kissed by worshippers but – as Sister Margarethe proves – sculptures were open to a far wider range of tactile abuses. From the ninth century wooden statues had been used as containers for saints' relics.[22] Thus any attack on 'relics of touch' could easily be construed as an attack on sculpture, the art of touch.

Vincenzo Borghini, who helped shape the constitution of Vasari's Accademia del Disegno, offers one of the most spirited critiques of touch. For him, touch is the 'most gross and material' of the senses.[23] When touch is said to be a positive attribute of sculpture, the implication is that we would all be better off blind. To Borghini, there could be nothing more absurd: calling a blind person as a witness 'was prohibited by every system of law'.[24] Anyway, he continues, touching statues is revolting. One only needs to think of the statue of Hercules described by Cicero, 'whose chin and mouth had been worn away because in Agrigento . . . it was the custom on feast days for the women to kiss it'.[25] Here, an act of adoration becomes indistinguishable from an act of desecration.

Galileo chips away at the sculptors' argument still further in his letter on the visual arts. He neatly points out that being able to touch a sculpture does not make it more realistic, for who, he argues, would ever think it was a real man:

> That sculptor who, not knowing how to deceive the eye, wants to demonstrate his excellence by deceiving the sense of touch is certainly in a sorry plight, since he is aware that not only the elevations and depressions (which constitute the relief of a statue) are subjected to the sense of touch, but also soft and hard, hot and cold, smoothness and roughness, heaviness and lightness, all indications of the statue's deceit.[26]

Thus sculpture only ever gives an impoverished account of the sense that it claims as its own.

At the turn of the seventeenth century the widespread artistic fascination with touch was pre-eminently demonstrated by the paintings of Caravaggio (1573–1610). This volatile jail-bird painted gloomy and claustrophobic nocturnes, in which the protagonists grope their way through life like seedy denizens of Plato's cave. *Doubting Thomas* (c. 1602–3) is Caravaggio's most shocking tribute to touch. It represents the moment when St Thomas, who does not believe that Christ has come back to life, puts his finger into the wound in his side and is thereby persuaded of the truth. Caravaggio's version of the story is more explicit than any other. Christ and two other apostles gaze myopically at the wound as Thomas parts the thick, labial skin and plunges his finger inside. Here touch is not just nauseating; it is an admission of ignorance and faithlessness.

Some of this feeling for the grotesqueness and truancy of touch was expressed in the vogue for paintings of blind people touching classical busts. Interest in such a subject was partly prompted by the rise of the 'science' of physiognomy, whereby you were meant to be able to tell someone's character from the geography of their facial features. There was a parallel vogue for *memento mori* paintings and plays, like *Hamlet*, in which the protagonist touches a skull. However, any scientific or religious justification for touching was undermined by a deep-rooted suspicion. Most of these touchy-feely paintings have a lurid freak-show quality – especially when it is a blind man doing the touching.[27]

A Blind Man Comparing Painting and Sculpture by Jan Miel (1599–1664), shows a blind man with one hand resting on a mythological painting and the other on the chin and nose of a classical bust. One finger is virtually up the bust's nostril. The picture is based on an experiment which a contemporary writer, Ambrogio Magenta, claimed had been performed by Leonardo.[28] The Naples-based Spanish painter Giuseppe Ribera painted an even more remarkable picture, *The Blind Sculptor*, in which an aged and seemingly destitute man runs his rough hands over a forlorn-looking antique bust. The bust lies on its side on a table in front of him, with its lower half cast in deep shadow. The sculptor's dirty cuffs are strategically placed below the bust's nostrils.

An equally disturbing image is attributed to Ribera's Neapolitan contemporary, Luca Giordano (1632–1705). It was thought to represent a sculptor, Giovanni Gonnelli, who died in around 1664. After going blind at the age of twenty-eight, Gonnelli discovered that he could still make heads of saints and portrait busts. An exhibition of his work caused

13. **Luca Giordano**, *Carneades with the Bust of Paniscus*, c.1650-54
(Oil on canvas, P & D. Colnaghi, London).

a sensation, and he received portrait commissions from exalted patrons.
More recently, however, it has been argued that Giordano's picture
represents the blind Greek philosopher Carneades.[29] Either way, the
blind sculptor/philosopher is shown prodding the bust of Paniscus, the
young god Pan.

What makes the image so disturbing is the bust's uncanny fleshiness and greasiness. It seems horribly alive. Carneades' unashamed fingers prod its lower lip and the corner of its eye. Pan was the god of lust, but even he seems alarmed at the blind man's ministrations. Touch gets us too close for comfort, and despite all the myths surrounding blind seers, it still seems the sense of last resort. A writer at the start of the seventeenth century had claimed that in his old age Michelangelo, the 'light and splendour' of sculpture, went almost completely blind and 'was accustomed to judge antique and modern statues by touching them'.[30] The obvious implication is that it was not something he chose to do in his prime.

Bernini seems to have been unhappy about viewers touching his own sculpture. His early mythological figures were made in conscious rivalry with painting,[31] and he may have set out to develop a kind of sculpture that no one in their right mind would dream of touching. Only in this way could sculpture match the aloofness of painting. His love of deep undercutting, gravity-defying poses, flapping draperies and hair makes it imperative that they are not touched. In the diary of Bernini's visit to France in 1665, written by his chaperone Paul Fréart de Chantelou, we find several uncomplimentary references to those who touch sculptures. Early on, Bernini derides the Spanish by telling of a studio visit made by their ambassador while he was working on *The Rape of Proserpine* (1621). The ambassador 'looked at it for a considerable time and handled the Proserpine'. He concluded that, although she was 'very pretty', she would be improved if her eyes were painted black.[32] The Spaniard's handling of the sculpture shows his lack of sophistication, no less than his desire for painted eyes.

When Bernini's bust of *Maria Barberini Duglioli* was handed over to the Barberini family in 1627, it was kept inside a wire cage to protect the astonishingly delicate lace collar and curling hair from prying hands. By 1649 it had been placed in a special vitrine made of walnut with three large panes of glass. This was probably done to protect it from dust, and thus avoid having to clean it, which might have caused damage. Unfortunately the glass was at least as fragile as the sculpture and one of the panes was listed as being 'half-broken'.[33]

Even more elaborate precautions were taken with Bernini's bust of *Louis XIV* (1665). After it had been unveiled in Paris to rapturous applause, a courtier said that it would be 'most difficult to prevent people from touching it, which was the way the French began looking at

sculpture'. Once again, touch was associated with uncouthness. The King then repeated the words of Cardinal Mazarin to someone inspecting his antiquities: 'Monsieur, I must point out that these pieces break when they fall.' The King was delighted that Mazarin refused to say 'Do not touch'.[34] It seems that the word itself was untouchable. To protect the royal bust, Bernini resorted to placing it on a large 'globe' pedestal.[35]

A penetrating but damning discussion of blind sculptors was undertaken at the turn of the eighteenth century by the French art theorist Roger de Piles. From the time of Vasari, drawing had been regarded as the foundation-stone of the arts, and the French Academy had raised this to a religion. But de Piles wanted colour to be regarded as the principal component of painting. Drawing was more closely associated with painting than sculpture, and so in order to discredit drawing, he mischievously associates drawing with sculpture and touch. For de Piles, drawing (like sculpture) is solely an art of contours, and these contours imitate the exterior form of objects. As such, drawing gives a banal representation of tangible reality.

To prove his point, de Piles introduces a blind sculptor from Tuscany (he leaves him derisively anonymous, but it must be Giovanni Gonnelli),[36] who proudly explains his working methods: 'I touch my model – I examine its dimensions, its protrusions and cavities, and try to keep them in my memory. Then I place my hand in the wax, and by the comparison that I make between the one and the other, running my hand over them several times, finish my work to the best of my ability.'[37] In de Piles' version of events, Gonnelli has a creativity of the most rudimentary – and distasteful – sort. We are told that he executed a portrait of the Duke of Bracciano in a cave, to prove that he really was blind. The hair was the part he found most difficult. We can imagine him running his waxy fingers intrusively over the face and hair of his subject. A more hygienic method was to use existing marble busts as models, as Gonnelli did in the case of the Grand Duke Ferdinando II of Tuscany, Charles I of England and Pope Urban VIII. We further learn that a French patron commissioned a painted portrait of the sculptor: 'The painter placed an eye at the end of each finger to make it clear that his real eyes were useless.'[38]

De Piles then drives his point home:

One can see by this blind man's story that his art, which lay wholly in drawing, gave him a chance to satisfy his mind and somehow to

console himself for the loss of a sense as precious as sight, whereas if he had been a painter, he would have lacked this consolation. The explanation of this difference is that colour and light are objects of sight alone, and that drawing, as I have said, is an object of touch as well.[39]

De Piles was also disturbed by any artwork that could be touched and held. Maintaining a distance was crucial in the appreciation of great art: 'Not all paintings are made to be seen up close or held in one's hand.' Echoing Alberti, he claims that every painting has its 'point of distance from which it should be seen'.[40] De Piles was not particularly puritanical: he did give colour priority over line, and his favourite artist was Rubens. Yet in his concern to eliminate tactile experiences by maintaining distance, and in his special disdain for sculpture, he had a great deal in common with his Reformation forebears.

IN THE EIGHTEENTH century there was an unprecedented philosophical revaluation of touch,[41] and in the second half of the century this went hand in hand with a huge upsurge of interest in sculpture. Antique sculpture was primarily discussed, whether it was in Winckelmann's *Reflections on the Imitation of Greek Works in Painting and Sculpture* (1755), Lessing's *Laocoön* (1766) or Herder's *Plastik* (1778). But later in the century contemporary sculpture was paid close attention too. The 'modern classics' of Canova and Thorvaldsen, who were both based in Rome, were avidly commissioned, collected and acclaimed.

That said, Herder's warning to contemporary sculptors – 'woe to the sculptor' who never felt 'the breast and the back of Hercules at least in his dreams'[42] – should act as a warning to us. Being able to touch both the back and front of an heroic male figure did usually occur only in dreams. It implied a levelling intimacy with greatness that had dangerous implications. After all, if you could fondle Hercules all over, he would be a vulnerable rather than an omnipotent figure and no longer placed on a pedestal. For the most part, the eighteenth century bore this in mind. The sculptures that invite touch and inspection from all sides are generally small in scale, and 'feminine' in subject matter. 'Serious' sculpture remained overwhelmingly pictorial and frontal. The icons of the age were bas–reliefs and tomb monuments, seen from the requisite distance, and statues placed on substantial pedestals, placed against walls or neatly slotted into a niche.

The viewer was not encouraged to probe too far behind the scenes.

The catalyst for this revaluation of touch was a brief passage in the second edition of Locke's *Essay Concerning Human Understanding* (1694), in which he mentions an issue that had been raised by a personal friend, William Molyneux. Molyneux's question centred on whether a man who had been blind from birth, and whose vision was suddenly restored, would be able to distinguish by means of sight alone a cube from a sphere, forms that he had previously known by touch alone. Locke said no, because otherwise he would have needed to postulate that the various senses communicated with each other using a common, pre-existing language. This would downgrade the role of empirical observation through the senses. The newly sighted man would have to learn through experience to relate the tactile sensation of both objects to their corresponding visual perception.

Subsequent commentators latched on to this short passage and used it to stress that each sense could perceive only particular qualities of objects and phenomena. The limitations of the previously sovereign sense of vision became apparent, and the value of touch more fully appreciated.[43] Diderot, with typical impudence, claimed that 'of all the senses the eye [is] the most superficial, the ear the proudest, smell the most voluptuous, taste the most superstitious and the most inconstant, touch the profoundest and the most philosophical'.[44] In his *Letter on the Blind, for the Use of Those who Can See* (1749), touch becomes a stick with which to beat conventional wisdom. When Diderot and a group of friends ask a fictional blind man if he would like to have sight, he replies: 'I would sooner have long arms: they would tell me better what was happening on the moon than your eyes or telescopes.'[45]

Diderot goes on to describe the advantages of being blind. A blind man would be able to distinguish genuine from fake medals, 'even though the latter were skilfully enough made to deceive a sharp-eyed collector', and could test the accuracy of mathematical instruments. He could easily recognize people from their busts, 'from which we see that a blind person would be able to employ statues as we do, to com-memorate historic actions and departed friends'. His feelings in touching these statues 'would be stronger than ours in seeing them. What a joy it would be to such a one, in whom the illusion is so strong, to feel with his hands the features of one he has loved!'[46]

Diderot may have considered touch to be the 'profoundest and the most philosophical' sense, yet he cannot quite follow his logic through

and celebrate sculpture wholeheartedly. Rather, he implies that sculpture is an artform that has failed to find an audience. In the passage just quoted, he suggests it cannot be fully appreciated by the sighted; yet towards the end of the letter he seems to contradict himself, saying that sight does enable sculpture to be appreciated: 'how many things are suggested to us through our senses: and what difficulty we would have, if it were not for our eyes, in attributing thought and sensation to a block of marble'.[47] It may be misguided to attribute thought and sensation to a block of marble by means of sight, but Diderot implies that without sight there would be no aesthetic experience. It is only through the auspices of sight that marble is fully animated. Elsewhere he argues that perceptions by touch are necessarily much closer, more limited and less intense than the gaze of the eye. The blind, he claims in his article on 'Beauty' for the *Encyclopédie*, are 'less affected by beauty than we, the sighted'.[48]

A similar climb-down takes place in Rousseau's *Emile* (1762), a revolutionary treatise on education that advocated a return to nature, and child-centred tuition. A key part of the child's education is to train the sense of touch. Not only will this give us a better understanding of the 'objects which surround us', but it will banish our irrational fear of darkness: 'We are blind half of our lives, with the difference that the truly blind always know how to conduct themselves, while we dare not take a step in the heart of the night.' It is dangerous to rely on artificial light sources, and so he prefers Emile to have eyes 'in the tips of his fingers than in a candle-maker's shop'.[49] But instead of then recommending that the child should model or carve, Rousseau recommends drawing from nature. The purpose of this is to make 'his eye exact and his hand flexible'.[50]

Rousseau proposes to learn drawing alongside Emile, advancing in skill at approximately the same rate. After a while they will use 'colours, brushes'.[51] Eventually they will adorn their room with their work. The drawings will be framed and 'covered with fine glass so that they no longer can be touched, and each of us, seeing them remain in the state in which we put them, will have an interest in not neglecting his own'.[52] Ultimately, in art and in life, touch has to be suppressed and transcended.[53]

AS WE APPROACH the increasingly unbuttoned era of Casanova, Byron and de Sade, *aesthetic* touch was gaining an impressive, though still dis-

reputable, momentum. It links up more unapologetically with sculpture in Johann Gottfried Herder's *Plastik* (1778).[54] Herder believed that whereas painting pertained to the visual sense, sculpture pertained to touch − a fundamental sense that allows the very young child to explore the world. 'Come into the child's playroom,' he urged his reader, 'and watch how the little empirical creature seizes, grasps, takes, weighs, touches, measures with his hands and feet, in order to acquire faithfully and securely the heavy, first and necessary concepts of bodies, figures, magnitude, space, distance.'[55] But for Herder, touch is not transcended in adulthood. Indeed, in experiencing sculpture, touch comes into its own: 'Sculpture is *Truth*, painting is *Dream* . . . A statue can embrace me; I can kneel before it and become its friend and companion, it is *present*, it is *there*. The most beautiful painting is a romance, a dream of a dream.'[56]

Herder goes on to say that 'sculpture can, properly speaking, never clothe, and painting always clothes'. This fitted in with the eighteenth-century equation of nude statuary with Greek sculpture, but the trouble was that very few Greek sculptures were of nude figures. So Herder found an ingenious solution. Even when Greek figures are clothed, they don't feel clothed, because the drapery is *wet*.[57] The wet look of Greek sculpture thematizes the idea of tactility. For when we touch the surface, we imagine the skin of the sculpted figure already touching its own wet clothes. Touch is embodied twice over. Antonio Corradini's popular veiled ladies, the first of which was made in 1717, provide a counterpart to Herder's ruminations. Critics observed that the Venetian sculptor used the veil as a means of accentuating, rather than concealing, the nudity of the figures.[58]

Herder was not alone in seeing the sensuous tactility of sculpture in terms of its wetness. Winckelmann also had distinctly wet dreams. Greek drapery was, for the most part, 'taken from thin and wet garments, which of course clasped the body, and discovered the shape'.[59] Water metaphors threaten to overwhelm Winckelmann's prose − and the sculptures about which he writes. Here are a few samples: 'As the bottom of the sea lies peaceful beneath a foaming surface, so a great soul lies sedate beneath the strife of passions in Greek figures'; 'The true feeling for beauty is like a liquid plaster cast which is poured over the head of Apollo, touching every single part and enclosing it'; 'beauty should be like the best kind of water, drawn from the spring itself'. He also cites Michelangelo's technique of immersing a wax model in water, then

14. **Antonio Corradini**, *Puritas (Bust of a Veiled Woman)*, 1717–25
(Marble, Ca'Rezzonico, Venice).

lifting it gradually out so that a clear sense is given of the model's
contour: 'The water insinuating itself, even into the most inaccessible
parts, traced their contour with the correctest sharpness and precision'.[60]
Herder misquotes this passage in *Plastik*, making it even more evocative:
'the water which slithers and flows softly along every form and curve

93

becomes, for the eye of the sculptor, the most delicate of fingers'.[61] The water touches, and is touched; penetrates, and is penetrated. Now sculpture has become an almost amniotic art. Every pore is exposed and anointed. The viewer has become a new Narcissus, staring into and then merging with a liquid landscape. Distance is annihilated.

The close association of sculpture and water seems to originate with baroque fountains. During the Renaissance, the sculpted figures on fountains tended to surmount the bowl, and to be isolated from the water jets. But Bernini, who claimed to have a special affinity with water, changed all this. He effected a revolutionary integration of sculpture and water, so that the water cascaded over the sculpted figures.[62] The baroque age was also fascinated by the idea that stone is the product of chemical reactions involving liquids. Grottoes were very popular, and here it was often possible to see allegorical sculptures surrounded by strange rock formations produced by water seeping from the roof. The standard text on mineralogy, *Museum Metallicum* (1648), by the Bolognese doctor and naturalist Ulisse Aldrovandi, included a chapter on marble. This was an especially vaporous and fluid stone because it had taken a long time to harden. It was also uniquely evocative as its markings sometimes resembled all manner of figurative imagery, such as rivers, forests, people and animals. 'Oriental' marble showed swirls of shells, algae and ocean waves 'such as no painter's hand could imitate'.[63]

Baroque fountain design culminates in the Trevi Fountain (1732–62) in Rome, designed by the architect Nicola Salvi (1697–1751). This was an allegory of water, with the figure of Oceanus at its centre. According to Salvi's written programme, Oceanus was the 'father of all things'. In this role, he was not so much 'the symbol of the powerful operative forces of water gathered together in the sea' as 'the actual working manifestation of these powers, which appear as moisture'. As moisture, water 'permeates all material things, and winding through the veins of the Earth, even into the most minute recesses, reveals itself as the everlasting source of that infinite production which we see in Nature'.[64]

Winckelmann singles out the Trevi Fountain for criticism in *The History of Ancient Art* (1764) – it exemplifies a 'degenerate tone of thought', and the 'long beard' given to the figure of Marcus Agrippa contradicts every known likeness of him[65] – yet the high priest of Neo-Classicism was as enthralled as Salvi by the invasive, tactile powers of

water. The main difference was that Winckelmann preferred smooth to rough waters.

But taking touch to such clammy extremes was potentially icono-clastic. In the imagination, marble sculpture is being taken off its pedestal and transformed into something as malleable, moist and primordial as clay. Winckelmann claims that art 'commenced with the simplest shape, and by working in clay . . . for even a child can give a certain form to a soft mass'.[66] He goes on to give clay the highest endorsement. Indeed, he is intoxicated by it:

> modelling in clay is to the sculptor what drawing on paper is to the painter. For as the first gush of the grape-juice from the press forms the finest wine, so in the soft material, and on paper, the genius of the artist is seen in its utmost purity and truth; whilst, on the contrary, it is concealed beneath the industry and the polish required in a finished painting and a completed statue.[67]

Herder's child of nature − the eighteenth-century ideal − is similarly enchanted. In *Plastik*, Herder invites us into the 'child's playroom' and stresses the importance of giving the child clay, bread or wax.[68] At the back of both writers' minds may have been the pint-sized terracotta statuettes that were becoming increasingly popular because of their seemingly greater spontaneity and intimacy.[69] In their reveries on sculpture, they were *seeing* white marble, but *feeling* primal ooze. This was also, of course, the age of the watercolour.

In Winckelmann, ideal male beauty often seems to be drowning rather than bathing. The art of sculpture suffers a fate similar to that of Pompeii. Winckelmann's assertion that the 'true feeling for beauty is like a liquid plaster cast which is poured over the head of Apollo, touching every single part and enclosing it' is paralleled in inverted form by something Chateaubriand wrote about Pompeii and Herculaneum in 1802. For the French writer, the lava 'filled up Herculaneum, as the molten lead fills up the cavities of a mould'; and in the case of the breast of a woman impressed on a piece of earth, 'Death, like a sculptor, has moulded his victim'.[70]

THE EIGHTEENTH CENTURY'S obsession with touch had a huge impact on both the form and content of contemporary sculpture.

Many of the most famous Neo-Classical sculptures are imbued with a

notional blindness. Diderot speculated that the Greeks may have intended their sculptures to be blind because, like his contemporaries, he assumed that the eyes of their statues were pupil-less (they were in fact painted). Diderot felt that this blindness made them suitably austere.[71] Many Neo-Classical busts were pupil-less,[72] and this gave them a seer-like austerity. However, when it came to sculpture other than portraiture, this blindness could imply the opposite. In some of Canova's erotic mythologies, for example, the lack of pupils seems to be an alibi for exotic sensory experiences.[73] With their trademark waxed surfaces, these weird confections represent the apogee of eighteenth-century ideas about touch, blindness and moistness.

The Three Graces (first version 1812–14; second version 1814–17), entwine their pubescent bodies more intricately and narcissistically than any previous versions. They are a disconcerting mixture of the aloofly ideal and the clammily real. The trio are a Laocoön of Love, and they are eroticized descendants of Herder's 'little empirical creature' who 'seizes, grasps, takes, weighs, touches, measures with his hands and feet'. But it is their blindness, and their corresponding lack of self-consciousness, that makes all this interaction possible. Contact of a more contrary sort occurs in Canova's first major work after his arrival in Rome, *Theseus and the Minotaur* (1782). Here, a naked Theseus sits astride the groin of the vanquished Minotaur, while resting his hand on the beast's strapping thigh. Theseus' composure suggests that he is unaware of the awkwardness of his situation. His blindness appears to have anaesthetized him to even the most outrageous of tactile experiences.

The radiant whiteness of marble, and of plaster casts, may also have prompted an association of sculpture with blindness, for as Edmund Burke pointed out in his *Philosophical Enquiry into the Origin of our Ideas of the Sublime and Beautiful* (1757/9): 'Extreme light, by overcoming the organs of sight, obliterates all objects, so as in its effect exactly to resemble darkness.'[74] In the world of Neo-Classical sculpture, bedazzled groping is the order of the day.

Although Canova's sculptures have a clearly demarcated main face, he furnished the bases of several of his sculptures with handles so that they could be rotated by the viewer: in this way, you could peruse them almost as thoroughly as any statuette. Both *The Three Graces* and his most famous work, *Cupid and Psyche*, are meant to be revolved. Touching is central to the meaning of these erotic works. As Canova's biographer Leopoldo Cicognara commented on a statue of Paris made for the

Empress Josephine, 'if statues could be made by stroking marble rather than by roughly chipping, I would say that this one had been formed by wearing down the surrounding marble by dint of kisses and caresses'.[75]

This attempted translation of marble statuary into more user-friendly forms was taken to a comic extreme by Goethe in the fifth of his *Roman Elegies*. Whilst staying in the Eternal City, Goethe spends the days studying the works of the ancients, and the nights 'studying' his mistress:

> But love keeps me occupied quite otherwise through the evenings;
> If I'm only half learned, I'm made doubly happy while learning.
> And am I not teaching myself as I look at the charming
> Curve of her bosom and let my hands glide down her hips?
> Then at last I can understand sculpture; I think and compare
> See with a feeling eye, feel with a seeing hand.[76]

Here we see why Goethe's contemporary Schiller criticized his whole way of thinking for being 'too sensuous' and proceeding 'too much by touch'.[77] Such synaesthesia is an extreme manifestation of the desire to gain knowledge through sources other than the eyes. Goethe is not just looking at something but, as the American philosopher Richard Rorty would say, 'rubbing up against it' and perhaps, eventually – when his hand has cramped up – 'having sexual intercourse with it'.[78]

Beauty and truth are no longer something public and aloof, but private and domestic. Undoubtedly, giving primacy to touch was often not much more than a convenient alibi for slightly silly sexual fantasies. What was grasped – both in dreams and in reality – tended not to be the bicep of a stern Hercules, but the breast of a compliant naiad. One doubts whether Goethe spared many thoughts for the Classics while he did primary research on his mistress in a Roman *pensione*.

With all this attention to touch, it seems surprising that the surfaces of Neo-Classical sculptures do not exhibit a wider range of textures. Not only does baroque sculpture tend to be texturally and compositionally more complex, but the seventeenth and eighteenth centuries sometimes tolerated and even appreciated veins and small imperfections in the marble. The Frenchman Jean-Antoine Houdon (1741–1828) was the leading portrait sculptor of the late eighteenth century, and some of his finest works are prominently marked. The veining 'lends a warmth that enhances the vitality of the work'.[79] By contrast, most Neo-Classical sculptors sought out pure, unflawed marble. This facilitates the creation

of a homogeneous 'skin' and a neat silhouette.[80] Hence later critics, such as Baudelaire, complained of their 'monotonous whiteness . . . exact in all their proportions of height and thickness'.[81]

Yet such perfectionism is in fact the logical outcome of an obsession with touch. Edmund Burke had insisted that smoothness is essential to our idea of beauty – and that 'any rugged, any sudden projection, any sharp angle' is inimical to it, and merely causes pain and tension, particularly to the sense of touch.[82] The removal and repression of tactile irritants in sculpture became even more urgent once its ideal *aficionados* were imagined to be the most vulnerable sections of society – children, the blind, and blind children; or adults imagining themselves to be any of these. The pursuit of painlessness in Neo-Classical sculpture explains why the Getty Museum, when it was located in Malibu, placed a copy of a statue by Canova in the atrium together with an explanatory notice: 'You may touch this statue of Aphrodite. Most people wish to touch statues.'[83] A freestanding statue by Canova was, their lawyers must have felt, least likely to result in lawsuits due to grazed skin and torn clothes.

There was a clear ethical dimension to the cult of smoothness. Herder makes this point dramatically, if not entirely plausibly. He believed that when confronted by a painting of a rotting corpse, he could turn away instantly and look at other things. However, it would take far longer to disengage from a sculpture which one touches. In encountering a grisly statue, Herder has to proceed with the slowness of a blind man, 'so that my flesh and bones are corroded, and death passes with a shudder into my nerves!'[84] He goes on to argue that fear of corrosion is the reason why Greek sculptors avoid gruesome and expressive subjects. With a marvellous turn of phrase, he writes: 'A mouth which shouts is a cave for the hand which touches, and during a smile, the cheeks are a crease'.[85] Here Herder was following conventional wisdom. The philosopher Christian Adolf Klotz, for example, claimed that whereas touching things could often cause disgust, 'strictly speaking, there are no objects of disgust to our sense of sight'.[86] There is no question here of anyone relishing being *shocked* by the touch of a sculpture as that German nun had once been.

We can see this ethos in action in a sculpture such as *The Three Graces*. Sexuality is confined to the surface. The girls can be petted and polished incessantly, but never fully penetrated or possessed. Jean-Paul Sartre has written eloquently about the frustrations inherent in the ideology of the 'smooth' body, comparing it to water:

What is smooth can be taken and felt but remains no less impene-
trable, does not give way in the least beneath the appropriate caress –
it is like water. This is the reason why erotic descriptions insist on the
smooth whiteness of a woman's body. Smooth – it is what re-forms
itself under the caress, as water re-forms itself in its passage over the
stone which has pierced it.[87]

Canova's molluscular goddesses present the viewer with a visual and
tactile field that is devoid of brusque scratches or cavities, sharp corners
or edges.[88]

It is not just flat things that have smooth surfaces – bottles and balls are
smooth – but this particular predilection threatened to end up denying
sculpture a resource which had traditionally been thought to distinguish
it from painting. It was the surface of a painting that was supposed to be
smooth. Hence, smoothness may be said to have reinforced the
'pictorial' qualities that we have already identified in Neo-Classical
sculpture. Indeed, ultimately, if an artwork has the same smooth texture
throughout, one is likely to feel that little can be gained from touching
it at all. One wouldn't be in the least surprised if, off the record, these
great men with 'seeing hands' agreed with the comment on sculptors and
sculpture in Byron's *Don Juan* (and note the way these lines seem to be
bursting out of their parenthetic niche):

> (A race of mere impostors, when all's done –
> I've seen much finer women, ripe and real,
> Than all the nonsense of their stone ideal.)[89]

IN LESS FASTIDIOUS hands, however, the impulse to touch had
momentous consequences. Knowledge could be gained not just by
caressing something, but (to quote Rorty again) by 'crushing it under-
foot'. This is precisely what happened during the French Revolution. The
sans-culottes quickly vented their anger on public monuments, whether
they were in squares, parks or churches. The term 'vandalism' was coined
in 1794, but acts of revolutionary vandalism were first discussed in June
1790, when it was decided to remove the four bronze slaves at the foot of
Martin Desjardins' statue of Louis XIV in the place des Victoires.[90] Statues
that represented rulers, clerics and any other undesirables were destroyed
or mutilated. Edmé Bouchardon's masterpiece, an equestrian statue of
Louis XV, was toppled from its pedestal and destroyed.

Paintings were treated with more respect. The finest were whisked off to the regime's most enduring showpiece, the Louvre. The worst that usually befell them was that an offensive emblem such as the fleur-de-lis might be discreetly painted out. Only days before the Louvre opened in August 1793, the revolutionary government ordered the destruction of the royal tombs in the church of St Denis. The destruction started on 6 August 1793 and continued for the next seventy-two hours. Fifty-one tombs were destroyed – according to one monk, the work of twelve centuries was wiped out in three days. Christianity was abolished in October.[91] The painter Jacques-Louis David epitomizes the revolutionaries' extraordinary double standards. He had no qualms about demanding responsible conservation of paintings at the Louvre, while at the same time proposing the erection of a colossal statue of the French people with a base made from 'feudal debris' – that is, from sculpture taken from Notre-Dame and other churches.[92]

Another painter, Alexandre Lenoir (1761–1839), was appalled by what he saw happening and, at great personal risk, had many statues and tombs – both intact and damaged – transported to a depot at the former convent of the Petits-Augustins in Paris. However, the sculptures were not entirely safe with the ambitious Lenoir. He arranged his new charges chronologically so that he could show the history of French sculpture. The better the sculpture, the brighter the illumination.[93] Lenoir 'restored' aggressively. In order to convey what he believed to be the transitional quality of fifteenth-century art, he disfigured certain exhibits, sometimes altering them beyond recognition.[94]

In 1795 the depot was officially recognized as the Museum of French Monuments, and visitors were admitted to the world's first museum with period rooms. Some visitors complained about the dark, cold and damp.[95] But the revolutionary nature of these gloomily lit sculptural assemblages was fully understood by one visitor, the journalist Sebastian Mercier. His visit to the museum in 1797 is one of the finest accounts of a personal experience of sculpture ever written. Mercier is both thrilled and horrified at the way in which he can now touch what was formerly untouchable:

It was one of the most remarkable phases of the Revolution, a time when the ferocious murderers to which it gave birth momentarily suspended their executions and turned their swords instead on statues and bronzes. They saw marble and bronze breathe with life and they

killed love, charity and genius once more for good measure . . . Lead tombs were turned into bullets, feudal parchments into cartridges, iron gates into pikes, and bronzes into cannon.

But now those 'frenzied days' had passed and whatever escaped the 'blind fury' of the people had been brought together at the Petits-Augustins:

It was the true mirror of our revolution: what contrasts, what bizarre juxtapositions, what twists of fate! What extraordinary chaos! I walked on tombs, I strode on mausoleums. Every rank and costume lay beneath my feet; I spared the face and bosom of queens. Lowered from their pedestals, the grandest personages were brought down to my level; I could touch their brows, their mouths, whisper in the ear of Richelieu and interrogate Turenne and Malebranche. There, all the centuries yielded themselves to me, and overwhelmed by a thousand ideas, stumbling over one monument after another, I wandered lost as in a valley of Josaphat in relief.[96]

This is sculpture as ravaged landscape: the vertical made horizontal, the untouchable brought within arms' length. At the end, the secular world of French politics is swept away, and we are transported back to a biblical landscape – 'a valley of Josaphat in relief'. Josaphat – or, as it is more usually known, Jehoshaphat – is the deep, rugged valley between Jerusalem and the Mount of Olives and Gethsemane. Jews traditionally looked upon this valley as the scene where the Last Judgement would take place, and thus regarded it as the ideal burial site. Citoyen Mercier is presumably wondering whether the touch of his feet and hands is the touch of good or evil; whether these sculptures are idols that deserve to be desecrated or innocent martyrs. He is overwhelmed by 'a thousand ideas', and by information primarily furnished by the risqué sense of touch.

Lenoir's experiment in direct democracy did not last long. The restitution of Church art began in 1802, and in 1816 the Museum of French Monuments was officially closed. No paintings were returned from the Louvre, however. With the development of museums in the nineteenth century, tactile enjoyment of art was to be increasingly monitored. Small sculpture was immobilized, sometimes in glass display cabinets, and viewers were constantly reminded to keep their hands to themselves: DO NOT TOUCH.

101

The most famous denunciation of the art of touch and its practitioners occurs in Baudelaire's critique of the Salon of 1846, 'Why Sculpture is Boring'. It is one of the few substantial discussions of sculpture during the Victorian period, and it oozes contempt for *le peuple* as well as for sculpture. For Baudelaire, sculpture is crude beyond belief. Sculpture was invented by Negroes in the mists of time, and it long preceded painting, which is an art involving 'profound thought' and one whose enjoyment 'demands a particular initiation'. It comes much closer to nature, so that 'even today our peasants, who are enchanted by the sight of an ingeniously-turned fragment of wood or stone, will nevertheless remain unmoved in front of the most beautiful painting. Here we have a singular mystery which one does not touch with the fingers.'[97] For him, the French peasantry are obviously as uncouth as they were thought to be in Bernini's time.

Sculpture is the primitive art *par excellence* – made by, and for, benighted black beings. That it is born in the mists of time (Baudelaire says the 'night' of time) suggests that it belongs to a culture where fingers and touch, rather than eyes and sight, are pre-eminent. Sculpture, and its practitioners, is quite literally obscene. In the very same year, 1846, the director of an institution for the blind in Berlin claimed that masturbation and nymphomania were widespread among the inmates.[98]

Many of the themes we have been looking at come together in George Eliot's novel *Romola* (1863), which is set in Renaissance Florence. Romola is the beautiful daughter of Bardo de' Bardi, a blind antiquarian who has fallen on hard times. He is a dry run for Casaubon, the fossilized scholar of *Middlemarch*. He wears 'threadbare clothes, at first from choice and at last from necessity', and sits among 'his books and his marble fragments of the past'. He has never published a thing. His gloomy study has a carpet 'worn to dimness' and it is lined with shelves: 'Here and there, on separate stands in front of the shelves, were placed a beautiful feminine torso; a headless statue, with an uplifted muscular arm wielding a bladeless sword; rounded, dimpled, infantine limbs severed from the trunk, inviting the lips to kiss the cold marble.' However, you would have to be a little perverse to want to kiss the marble as it is 'livid with long burial'.[99]

Romola reads aloud in Latin a passage about the blind prophet Tiresias, but her father is a reactionary and sterile pedant, rather than a visionary. His hands are particularly grotesque, and are contrasted with Romola's. They are 'deep-veined' and 'cramped by much copying of

manuscripts'. At one point Bardo lets his left hand, 'with its massive prophylactic rings, fall a little too heavily on the delicate blue-veined back of the girl's right, so that she bit her lip to prevent herself from starting'. Sure enough, after a while, Bardo gets up and explores a bust of Hadrian with a 'seeing hand'.[100]

Throughout the novel, the gross and gloomy world of touch, sculpture and scholarship is contrasted with the uplifting world of sight, painting and faith. Painters frequently appear in the novel and their works often have a prophetic function. Bardo's son, Dino, was to have followed in his father's footsteps, but has instead become a monk in the cloister of San Marco, which is full of frescoes by Fra Angelico. They are a radiant rebuff to sculpture — 'delicate as the rainbow on the melting cloud . . . sudden reflections cast from an ethereal world'. When Dino dies, the frescoed figures 'seemed to be mourning' with Romola, and she is simultaneously 'repelled by marble rigidity'.[101]

The novel climaxes with a supremely grotesque — and a supremely *wet* — act of touching, involving two scholars of Greek. The carnal act takes place near a pile of round stones on the banks of the Arno. The scholars are Tito and his old father Baldassare. Tito is a fugitive: having gone to work for Bardo and married Romola, he betrays them both and just about everyone else in Florence. He has to jump off the Ponte Vecchio to escape a lynch mob and floats downstream. Unfortunately, he is washed up on a river bank just where his father Baldassare — his worst and oldest enemy — happens to be. He has come to Florence to avenge himself on Tito for an earlier act of betrayal.

Baldassare strangles Tito on the river bank, *con gusto*. He 'got his large fingers within the neck of the tunic' and 'pressed his knuckles against the round throat'. He presses for hour after hour, until he himself expires with the effort. The two bodies are found by a man who has come to gather up 'the round stones that lay heaped in readiness to be carried away'.[102] But it is not possible to separate the bodies, so he puts them in his stone cart still rock-solidly locked together and takes them to Florence.

Eliot concludes this chapter portentously: 'Who shall put his finger on the work of justice, and say, "It is there"? Justice is like the Kingdom of God — it is not without us as a fact, it is within us as a great yearning.' Clearly, for this great Victorian, nothing of value can or should be fingered.[103]

5. Sculpture and Language

[A sculptor could] draw the image of Jove from the verses of Homer . . .
but this would be a representation of a single aspect – the majesty of the
God as seen in the serious expression of his face and eyes . . . But how
much better it would be to express a whole story! – just as Apelles did
when he showed Diana amidst many maidens making sacrifices, and it is
said that he improved on the passage in Homer, where the same thing is
described. What charm, what variety of clothes and shapes, what faces full
of grace and virginal bashfulness . . .

Vincenzo Borghini, *Selva di Notizie*, 1564[1]

The painter is like an orator and the sculptor is like a grammarian.

Roger de Piles, *Conversations sur la Connaissance de la Peinture*, 1677[2]

[The wife of Charcot's chief assistant] was in a certain state of exposure,
for which, however, one cannot blame a beauty. She was, by the way, as
mute as a statue.

Sigmund Freud, *Letter to his Fiancée*, 1886[3]

IF THE VISUAL ARTS were to be accepted as liberal arts, they had to
establish that they were a language – not just any language, but a
supremely persuasive and expressive one. This aspiration was most
frequently embodied in the Latin phrase *ut pictura poesis* – as in a picture,
so in a poem. The phrase had first been used by Horace in *The Art of
Poetry* in a rather throw-away manner, but during the Renaissance a vast
and sprawling aesthetic system was built upon it. As a result, painting and
poetry came to be regarded as the 'sister arts'.[4]

Scholars of art and literature generally assume that *ut pictura poesis*
applies to sculpture in the same way that it does to painting. To demon-
strate this, they usually make an occasional, token reference to a
sculpture, while primarily writing about painting.[5] The matter is further

confused by the fact that Renaissance writers usually did the same, referring to a sculpture in a discussion of painting, without clearly discriminating between the media.

But although few explicit contrasts were made between the 'literary' qualities of painting and sculpture, the differences are fundamental. *Ut pictura poesis* was far more regularly and richly explored than *ut sculptura poesis*. Whereas the relationship between words and painted images was intimate and intense, that between words and sculpted images tends to be more formal and mechanical. Indeed, if painting and poetry were called the sister arts, sculpture and poetry could almost be referred to as the stepsister arts.

IN ANTIQUITY, WORDS were quite often linked with images.[6] Plato says in *The Republic* that 'the poet is like a painter', though because he regarded both as arts of illusion, neither was admitted to his ideal state. In the *Poetics*, Aristotle says that poetry and painting were the same, since they were arts of mimesis. Simonides called painting mute poetry and poetry a speaking picture. It was also commonplace to compare visual art and rhetoric. The Hellenistic rhetorician Demetrios compared styles of oratory with styles of sculpture: 'the expressive style of the early writers has a certain polished and well-ordered quality, like those ancient images in which the art seemed to have compactness and leanness, while the style of those who came later resembles the works of Phidias in that it already has a certain grandeur and, at the same time, the quality of precision'.[7] Sculpture played a far more prominent part in these literary exercises than it did in post-classical European culture: Cicero, for example, compared the perfect orator to Phidias.

For many antique authors, vividness was the principal quality that literature and visual art shared. Descriptions and metaphors had to bring a scene or an idea before the mind's eye with immediacy and intensity. Set-piece literary descriptions of paintings and sculptures were an important rhetorical exercise.[8] Nonetheless, theoretical comparisons between images and words were usually made only in passing: they consist of 'pregnant suggestions' rather than 'fully formulated argument'.[9]

The situation was very different during the Renaissance. Whereas the ancients had only compared poetry with visual art when they were writing about poetry, the Italian humanists turned it around and spoke of poetry while writing about visual art. The fleeting remarks of the ancients were often wrenched out of context and given a totally new

meaning.[10] Horace's remarks were plundered and used to underpin some of the most influential aesthetic theories. After noting that some poems give pleasure only on the first reading, whereas others can bear close and repeated attention, Horace adds almost as an afterthought: *ut pictura poesis* – so too with painting. The Italian humanists paid no attention to the preamble and turned it into a demand for a poem to be like a painting, and vice-versa. So Homer, Ovid and Ariosto were regularly called great painters; Raphael and Titian great poets. In the eighteenth century a French antiquarian, the Comte de Caylus, even suggested ranking poets according to the number of paintings that their poems could furnish for artists.[11]

Writers were rarely called great sculptors, though in the early nineteenth century there was a fashion for calling literature 'statuesque'. This was an alternative to the term 'picturesque', which had entered the language about a hundred years earlier, and which was extremely popular. It was usually classical or classicizing texts that were described as statuesque. Coleridge, for example, called the plays of the Greek tragedians, especially Sophocles, statuesque, whereas those of a modern playwright such as Shakespeare were picturesque.[12]

EVEN IF *ut pictura poesis* was generally understood as a demand for vividness, there were many different levels and ways of seeing. The more ambitious Renaissance artists wanted to go beyond the rather prosaic level of integration of word and image that seemed to characterize the art of the Middle Ages.[13]

The most famous medieval justification for images was given by Pope Gregory the Great (590–604). It occurs in a letter written to the Bishop of Marseilles, who had destroyed the images in his church when he found his congregation paying homage to them:

> It is one thing to offer homage to a picture, and quite another to learn, by a story told in a picture, to what homage ought to be offered. For that which a written document is to those who can read, so a picture is to the unlettered who look at it. Even the unlearned see in that what course they ought to follow, even those who do not know the alphabet can read there.[14]

Nonetheless, pictures alone were rarely relied upon to discriminate between individuals, and so it was standard practice to attach verbal

inscriptions. Indeed, the Word was primary, as we can see in this remark by an eighth-century theologian: 'Divine grace is given to the materials by the naming of the person represented in the picture.'[15] Here the act of naming is akin to a christening.

The best place to begin a study of the relationship between words and images is Giotto's great masterpiece, the fresco cycle that he painted in the Arena Chapel, Padua (1305–8). The cycle is divided into three tiers. The lowest tier is filled with grisaille personifications of *Virtues* and *Vices*, with explanatory inscriptions. But Giotto marks a turning point. The big, bold, brightly coloured frescoes placed in the two tiers above have no inscriptions. To all intents and purposes, the fresco cycles *The Life of the Virgin* and *The Life of Christ* are so vivid that they can speak for themselves.

Giotto's art was immediately recognized as revolutionary, and his pictorial innovations were compared to various literary genres. His paintings were still considered histories (Bibles for the illiterate) but his knowledge of history was assumed to be distinct from, and maybe even inferior to, his 'poetical' intelligence. Giotto staged history in his own, poetical way.[16]

The poetic content of painting was given an explicit and extreme formulation by the painter Cennino Cennini (born c. 1370). In the introduction to his *Libro dell'Arte*, which is dedicated to Giotto and his followers, Cennini says that painting deserves to be 'enthroned next to theory and crowned with poetry'. This is because 'the poet with his theory . . . is free to compose and bind together, or not, as he pleases, according to his inclination. In the same way, the painter is given freedom to compose a figure, standing, seated, half-man, half-horse, as he pleases, according to his imagination'.[17]

Cennini's vision of the painter-poet is based on another selective reading of Horace. Horace made a second comparison between painting and poetry at the beginning of the *Ars Poetica*, in which he says that both the poet and the painter have the right to use their imagination – but within strict limits.[18] This cautionary coda was selectively adhered to during the Renaissance. Giotto provides a complete repertoire of postures in the Arena Chapel, and he also composes 'fantastical' scenes such as Heaven and Hell, and Jonah being swallowed by the whale. At the same time, Cennini does say that Giotto always works 'with theory' – his marvellous creations are more or less appropriate to the story, rather than being gratuitous interpolations.

Many later apologists of painting claimed that this artform was in fact superior to verbal expression. As ever, Leonardo made the basic points, and they were repeated endlessly in subsequent centuries. He argued that, unlike words, which need to be translated, painting is a universal language that can be understood by everyone. What is more, a painting presents material to us much more speedily and accurately than a verbal description. Indeed, so powerful is painting that viewers fall in love with people represented in pictures.

Painters were increasingly encouraged to become verbally self-sufficient. In his *Dialogo di Pittura* (1548), the Venetian humanist Paolo Pini recommends 'invenzione': '*Invenzione* means devising poems and histories by oneself, a virtue practised by few modern painters, and something I regard as extremely ingenious and praiseworthy.'[19] As more artists became literate and wrote poetry, autobiography and art criticism, one frequent compliment was that a painter was as skilful with the pen (*penna*) as with the brush (*pennello*).[20]

Except for Michelangelo, one rarely hears of a sculptor being praised for being as skilful with the pen as with the chisel. Baccio Bandinelli, Michelangelo's hated Florentine rival, actually *contrasted* the two instruments: it was only poverty, Bandinelli wrote, that led him to use the chisel (*il ferro*), rather than 'immortalizing myself with the pen, in a really intellectual and liberal study'.[21] Overall, there was little theoretical writing on sculpture either by sculptors or humanists, and most of it was drily technical or antiquarian.[22] The few Renaissance treatises were failures – either little read when published, or not published at all and little diffused in manuscript.[23]

A simple measure of the greater verbal fire-power of painters is the space given to the *paragone* debates in Vasari's *Lives*. The painters' objections to sculpture are more than three times as long as the sculptors' objections to painting.[24] Writing in 1759, the Comte de Caylus summed up the situation, 'Several connoisseurs have seemed surprised that hardly anything has been written about sculpture, whereas the most mediocre writer thinks himself qualified to make sovereign judgements about the merit of painters, and to speak about all aspects of painting.'[25]

OF COURSE, once the language of painting was established as an esperanto that, unlike words, had remained unaffected by the destruction of the Tower of Babel, its use as propaganda was better appreciated by royal and religious patrons. From the sixteenth century, many state-sponsored

Academies of Art were founded. In 1667 the French architect André Felibien gave a stirring address to the newly founded Royal Academy of Painting and Sculpture in Paris of which he was the Counseiller Honoraire. 'As God made man in his image,' Felibien says:

> it seems that man for his part may make an image of himself by expressing his actions and thoughts on a canvas in a manner so excellent that they remain constantly and forever exposed to the eyes of the world, so that not even the diversity of nations impedes that, by a mute language more agreeable than all the languages, they may be rendered intelligible and be understood by everyone who regards them.[26]

This is the polyglot lesson that Giotto first taught in the Arena Chapel.

A painting that needed an explanatory label or inscription might well be deemed a failure. Indeed, in Derridean terms, the verbal embellishment was a 'supplement', which pointed to a 'lack' in the original.[27] The dilemma facing artists was that, if their work was too simple or conventional, it might not be sufficiently persuasive; and if there was too much '*invenzione*', it might not be comprehensible. Either way, it would require verbal support.

The question of legibility was especially acute during the sixteenth century, when a growing emphasis in Italy on artistic freedom and subjectivity led artists to emphasize 'poetry' at the expense of 'history'. At the same time, in the aftermath of the Reformation, the Catholic Church was condemning artistic licence and was insisting, using the authority of Pope Gregory, that painting should be a Bible for the illiterate.[28] Michelangelo's *Last Judgement* (1536–41), prominently sited in the Sistine Chapel, came in for special opprobrium for its iconographic and stylistic innovations.[29]

Similarly the Venetian painter Paolo Veronese (c. 1528–88) was brought before the Inquisition in 1573 and asked to explain the presence of a jovial cast of extras – dogs, servants with bleeding noses, German soldiers, drunkards, dwarfs and buffoons – in his own painting of the *Last Supper*. Veronese did not mince his words: 'we painters take the same licence that the poets and the jesters take'.[30] And if there was any space left over, 'I fill it with figures from my imagination'.[31] The inquisitors were not convinced, and Veronese was forced to change the title to *The Feast in the House of Levi*.

At this time the Catholic Church tried to codify the nature and use of religious images. Clarity was paramount: 'One of the main praises that we give to a writer or a practitioner of any liberal art is that he knows how to explain his ideas clearly . . . We can state the same of the painter in general, all the more because his works are used mostly as a book for the illiterate, to whom we must always speak openly and clearly.' If necessary, the name of the story, the protagonists and even 'some short and significant quotations, taken from the same book of the author, and relevant to the action' should be inscribed next to the painting.[32]

An anecdote related by Cervantes in *Don Quixote* (1614) suggests that inscriptions were a device of last resort, and a proof of incompetence. At the beginning of the second part of the novel, the hero is informed that someone has written the history of the exploits recounted in the first part. However, the author of *The Ingenious Gentleman Don Quixote de la Mancha* has inserted another novel, called *The Tale of Foolish Curiosity*, right in the middle of the narrative. Don Quixote is furious:

'Now I believe that the author of my story is no sage but an ignorant chatterer,' said Don Quixote, 'and that he set himself to write it down blindly and without any method, and let it turn out anyhow, like Orbaneja, the painter of Ubeda, who, when they asked him what he was painting, used to answer "Whatever it turns out". Sometimes he would paint a cock, in such a fashion and so unlike one that he had to write in Gothic characters beside it: *This is a cock*. And so it must be with my history, which will need a commentary to be understood.'[33]

This tale is a pointed illustration of the pitfalls of artistic 'innovation'.

In the following century the issue was not so much stylistic idiosyncrasies as allegorical devices. The Abbé Jean-Baptiste Dubos, in his *Critical Reflections on Poetry and Painting* (1719), complained that although the 'gothic' use of inscriptions had died out, many contemporary paintings were incomprehensible and had need of them. He cited Rubens' *Life of Maria de' Medici* (1622–5) in the Palais Luxembourg, and the vast painting cycles by Charles Le Brun (1619–90) at Versailles. Le Brun's works were so complex and full of allegorical figures that a guidebook had been provided to explain them to visitors. To those who would accuse the Abbé of reducing painters to the condition of 'mere historians', he replied that:

the enthusiasm which constitutes painters and poets does not consist in the invention of allegorical mysteries, but in the talent of enriching their compositions with all the embellishments which the probability of the subject will admit of, as well as in giving life to their personages by the expressing of the passions. Such is the poetry of Raphael, such of Poussin, such of Sueur; and such frequently that of Le Brun and Rubens.[34]

DESPITE THEIR differences of emphasis, painters and patrons were more or less agreed that painting should and could be a self-sufficient language. A good painting should stand alone. With sculpture, however, it was far harder to get by without adding an explanatory: *This is a . . .*

Let us return to the Arena Chapel. Here there is a powerful sense that Giotto is competing not just with words, but with sculpture as well. The grisaille representations of the seven *Vices* and seven *Virtues* are painted imitations of statues in their niches. Opinions vary as to the quality of the series, and of individual figures within the series, but they have rarely been given anything like as much attention as the coloured frescoes above. Nonetheless, Giotto put them in a prominent enough position. Over each niche, the Latin name of the personification (FIDES, IRA, IUSTITIA . . .) is inscribed. Below each figure there was originally a Latin inscription, which was almost certainly an explanation of the symbol that had been selected.[35]

Many of these *trompe-l'oeil* sculptures are supremely expressive. Yet in the Arena Chapel it is sculpture (albeit painted) that requires a verbal explanation. The brightly coloured, large-scale and infinitely more complex scenes painted directly above need no textual supplements. None of the large cast of characters in the *Marriage Feast at Cana*, *Lamentation of the Dead Christ*, *Resurrection* or *Betrayal* needs a label, whereas the solitary, stony personifications that directly confront the viewer are hedged in by sub- and surtitles. Bernard Berenson would later assert that there had been 'no need to label them: as long as these vices exist, for so long has Giotto extracted and presented their visible significance'.[36] But this contrast between labelled and unlabelled images seems to be a deft way for Giotto to emphasize the magnitude of his own achievement *as a painter* – and many subsequent painters, including Van Eyck, Titian, Annibale Carracci and Watteau, would include contrapuntal, *trompe-l'oeil* sculpture in their own paintings.

Giotto implies that sculpture, for all its bulk and presence, is a less

FIDES

15. **Giotto**, *Faith*, c.1304–13
(Fresco, Arena Chapel, Padua)
Originally there was an inscription in the rectangular box below the figure.

effective *visual* language. Italian sculptors – above all the Pisano brothers
– had recently started to leave marble sculpture unpainted, both because
they were undercutting works more deeply, modelling form with
shadow, and because they assumed that classical sculpture was unpainted.

Giovanni Pisano had also developed a new kind of multi-figure relief panel.[37] Giotto would have been aware of the competition. His colourless pseudo-sculpture is far more expressive than any previous allegorical representation, but in the terms established by his own painting, these images are an inarticulate counterpoint to the visual pyrotechnics taking place on the wall above. Giotto's contemporary Dante, in the tenth Canto of the *Purgatorio*, had come across inscriptionless sculpture. He describes a marble frieze that is tantamount to 'visible speech', and he says that it is 'new to us' because its like is not to be found on earth.[38] In the Arena Chapel, Giotto implies that on earth sculptures have to have inscriptions. But paintings are exempt – they are humanity's form of visible speech.

The personification of *Faith* shows that Giotto did have other difficulties with sculpture. Faith carries a cross and uses it to crush a heathen idol, which lies broken on the ground. 'Naming' a sculpture may also, then, have been a way of neutralizing a threat, of keeping in its place something whose status and purpose were not completely clear. An interesting parallel is found in the mythical Jewish figure of the Golem.[39]

In these legends, which gained currency during the Middle Ages, a rabbi or another student of the Cabala creates a monster out of clay and gives it life by inscribing EMETH (truth) on its forehead. The legend was a popular explanation of the origin of idolatry. In some versions, the inscription is carved with a knife; in others it is written on parchment and attached to the Golem's forehead. The Golem cannot speak, and this is usually taken to mean that it lacks a human soul. But it can move, and can only be immobilized by removing or erasing the first letter, which puts it under the jurisdiction of METH (death). In most of the stories, the rabbi or occultist eventually forgets to remove the letter and the monster increases in power and runs amok. Here words not only determine the function and meaning of a sculpture, but also limit its power.

ALTHOUGH PAINTERS included inscriptions, letters and books in their work, there was nowhere near the same level of compulsion or prominence. Claude Lorrain (1600–82) is the only major painter to write the subjects of his pictures regularly on the painting, and these inscriptions are very discreet.[40] It was far harder for the more ambitious forms of sculpture to avoid being conspicuously and permanently labelled. Sculpture was the more public art, dedicated primarily to the production of tombs and monuments, and the protagonists usually

113

wanted to be properly identified. Few major public sculptures are without some form of inscription.[41] But identification was also rendered necessary by what was perceived to be sculpture's greater anonymity. This anonymity was both intrinsic and extrinsic to the artform.

I have already mentioned the persistent doubts as to the efficacy of portrait sculpture – by virtue of its being less vivid than painting. But what was perhaps even more important was the discovery and reception of antique sculpture. When Roman portrait busts were excavated, there was usually no clue as to the identity of the sitter, so the antiquarians got to work, and a name – usually famous – was soon added to the base. They were often assisted in their task by antique coins and medals, which contained profile portraits of Roman Emperors and other luminaries, surrounded by an inscription. A similar scholarly procedure was undertaken with sculptures of mythological figures. The ritual of christening was central to sculpture as it never had to be for painting.

Most Italian male portrait busts of the fifteenth century are inscribed underneath, on a classical cartellino, with the name of the sitter, artist and date. This was probably done so that their own busts escaped sinking into a similar anonymity.[42] At around the same time Pisanello (c. 1395– c. 1455) revived the Roman portrait medal, in which a bronze profile portrait is surrounded by an edifying inscription. It has been claimed that this revival in around 1438 was an answer to the complaints of humanists, such as Guarino of Verona, who believed that paintings and sculptures were inefficient transmitters of personal fame because, unlike literature, they were *sine litteris* – unlabelled.[43] This is plausible, but sculpture was to be singled out as the art that had most need of a label.

The art historian Erwin Panofsky once discussed an example of this mania for labelling in an essay on the reception of classical antiquity in Germany. He cites the beginning of a long report by the leading German humanist of the day, Conrad Peutinger, on a statue recently discovered in Augsberg. Peutinger was responsible for perhaps the earliest printed collection of classical inscriptions, published in 1505.[44] The first thing we learn is that it is 'an image of Mercury, without inscription'. He then proceeds to list the attributes – winged feet and head, cloak, pouch, caduceus adorned with serpents or snakes; the figure is flanked by a cockerel and an ox or bull. Peutinger subsequently set the sculpture into the back wall of his stables. Panofsky complains that it is 'not experienced as a thing of beauty', and notes that in other antiquarian compilations, precedence is given to monuments with an inscription and, second, to

those that illustrate a name or concept occurring in an inscription.[45] Words preceded, and attempted to pin down, sculpted images.

This order of precedence is partly borne out by two portrait engravings of eminent humanists by Dürer. Both were made in 1526. One shows Erasmus at his desk, flanked by a plaque bearing inscriptions in Latin and Greek. The Greek inscription asserts the superiority of texts: 'His writings will present a better picture.' The other engraving shows the bust of the Protestant reformer Philip Melanchthon, above a plaque bearing the inscription: 'Dürer could paint the external and vivid features of Philip, but the learned hand could not paint the mind.' It is symptomatic, however, that these humble apologias feature in two of Dürer's most self-consciously classicizing and 'carved' portraits: the classical capitals and the meticulously represented lacerations to the panel transform them into archaeological remains.[46] Erasmus and Melanchthon are living monuments, and monuments must be inscribed.

Panofsky contrasts the prosaic reaction of German antiquarians with the more emotional and aesthetic reaction of the Italians, but in Italy too the controlling hand of antiquarianism was felt. Germany and Italy were the two most important places for the study of inscriptions. Venice was the first port of call for Germans in Italy, and the surviving fifteenth-century records of antique collections usually focus not on sculpture, but on coins and inscriptions. The first major printed collection of inscriptions was published in Rome in 1521.[47] Indeed, most highly educated men from the fifteenth to the eighteenth centuries studied antique sculpture more for the information it furnished about history and literature than for its beauty.[48] Don Antonio Augustin, a pioneering archaeologist in mid-sixteenth-century Rome, doubted whether it was worth excavating nude figures because they offered 'no new information'.[49]

These attitudes affected modern sculpture. All over Italy, the style of inscriptions and the shaping of the letters on tombs and monuments were given great attention,[50] and were studied at least as carefully as the sculpture itself. Whereas in the fifteenth century the sculptural and architectural elements tended to dominate the inscription, during the sixteenth century the word became paramount. A representative sample of tomb monuments would consist 'mainly of inscribed mural tablets or plaques, often surrounded with sculptural decorations, and sometimes surmounted with a bust'.[51] Economic factors certainly played a part in their changed appearance, but the Reformation also gave priority to the word over the sculpted image.

The most extreme examples of sculptures experiencing verbal over-
load occurred in Italy. In 1501 a fragmented statue of a standing figure
with a youth in his arms was placed by Cardinal Caraffa on a base at the
corner of his palace near Piazza Navona in Rome.[52] It became known as
Pasquin, the name of a schoolmaster in whose house it had lain neglected
for many years. Each year, on a feast day, the Cardinal got a painter to
decorate the statue in a different mythological guise, and Latin verses
extolling the virtues of humanist studies were appended to it. The style
and grammar of these verses were carefully monitored. After a while,
Italian poems were added – sober at first, but then increasingly satirical.
By the middle of the sixteenth century, *Pasquin* had become a site for
libellous epigrams all year round. The statue lacked a fixed identity; it
was a mixture of 'transvestite, raconteur, and private eye'.[53]

The most celebrated defender of *Pasquin* as a work of art was Bernini.
When a foreign cardinal laughed at him for saying that it was one of the
finest antiquities, Bernini surmised that the prelate 'cannot have read
what has been written about this work, that it is by Phidias or Praxiteles
and portrays the figure of Alexander supporting [a soldier], after he had
received an arrow wound at the siege of Tyre. However the figure is so
mutilated and ruined that the beauty which remains is recognized only
by real connoisseurs.'[54] What we really have here is a case of the written
word supporting a gravely 'wounded' sculpture.

The public nature of sculpture makes this kind of treatment inevitable:
indeed, there were many other 'speaking statues' throughout Italy, and
some were thought to be prophetic. When a new statue was unveiled,
particularly in Florence, a flurry of epigrams and sonnets soon
followed.[55] Some likened epigrams to animals without head and feet
(they were 'all body'), while others compared them to scorpions, since
they had a sting in their tail.[56] The poet Pietro Aretino (1492–1556)
wrote verses of this kind. He was praised by Federico Gonzaga, Duke of
Mantua, for his 'ability to make the marbles speak most elegantly'.[57] It
was almost as though Aretino had given the raw sculptures elocution
lessons, foreshadowing Shaw's *Pygmalion*. The sculptures were ventri-
loquists' dummies as much as prophets. One of Aretino's less elegant
attempts to make the marbles speak was his likening of Laocoön's face to
the contorted features of a copulating nun.[58]

The apogee of this tradition of sculptural word-games comes with
Giambologna, and the naming of *The Rape of the Sabines*. When in 1583
it was decided to install it in the centre of Florence, Giambologna was

told by Grand Duke Cosimo I that he had to find a title: no statue could be exhibited without one.[59] It was not hard to think of a title – it was just a question of choosing from mythological rape scenes. But the necessity to name sculpture implied that it was fundamentally nameless and speechless. The sculptor was then asked to produce a relief for the base of the statue that would clarify the subject by showing more aspects of the story. The sculpture had to provide verbal and pictorial signposts in order to communicate fully.[60]

At just this time, during the Reformation in northern Europe, iconoclasts targeted sculpture more than painting, and one of their reasons was the greater difficulty of harnessing sculpture into clear and continuous narratives. This was particularly true of single, freestanding works. Thus in a homily against idolatry composed in Elizabethan England, the taciturnity of freestanding and richly ornamented artefacts was judged to be dangerous: 'Men are not so ready to worship a picture on a wall, or in a window, as an embossed and gilt image, set with pearl and stone. And a process of a story, painted with the gestures and actions of many persons, and commonly the sum of the story written withal, hath another use in it, than one dumb idol or image standing by itself.'[61] 'Dumb idols' are more resistant to being incorporated into a master narrative, and they thus encourage the viewer to plug the semantic gap with their own, potentially heretical interpretations.

SO FAR I have been arguing that the requirement to provide verbal embellishments could point to a failing in sculpture. They either bolstered the power of a relatively inexpressive and anonymous artefact; or they curbed and defused the power of a potentially rogue artefact. In the first case, verbal embellishments suggest that the language of sculpture is ineffective; in the second, that it is out of control. Thus Renaissance interest in sculpture went hand in hand with feelings of fear, guilt, contempt and pity.

Sculpture's linguistic inferiority would be asserted in a bald way by Roger de Piles in his *Conversations sur la Connaissance de la Peinture* (1677):

The painter is like an orator, and the sculptor like a grammarian. The grammarian is correct and adequate in his words, he explains himself clearly and without ambiguity in his discourse, just as the sculptor does in his works. We should understand easily what each of them presents to us. The orator needs to be instructed in those things which the

grammarian knows, and the painter in those which the sculptor knows. They are necessary for each other in order to communicate their ideas and to make themselves understood. But the orator and the painter have to go further. The painter has to persuade our eyes as much as an eloquent speaker has to move our heart.[62]

Grammar, as Erasmus pointed out in *In Praise of Folly* (1509), is the 'poorest' of the 'worthwhile arts';[63] while Savonarola replaced grammar by poetry in a list of the Liberal Arts.[64]

The legacy of all this was felt strongly in eighteenth-century England, where classical statues were popular props in landscape gardens and there was a boom in the construction of tombs. Garden statues were expected to express 'noble personification and exalted moral reflection'[65] – but not on their own. Alexander Pope wrote that his grotto at Twickenham on the River Thames required 'nothing to complete it but a good statue with an inscription'; this statue would be a personification that symbolized the 'aquatic idea of the whole place'.[66] And in Joseph Addison's celebrated essay on 'The Tombs in Westminster Abbey' (1711), although the writer pauses to criticize the appearance of a monument to Sir Cloudesley Shovel, verbal rather than visual imagery is of primary interest: 'I yesterday passed a whole afternoon in the churchyard, the cloisters, and the church, amusing myself with the tombstones and inscriptions that I met with in those several regions of the dead.'[67]

Whether to look or to read was a recurrent dilemma for visitors to the Abbey. The first published list of epitaphs had been produced, with English translations, by the antiquary William Camden in 1600. Camden reproduced the texts, but did not illustrate the monuments. When the list was reprinted in Frankfurt in 1618, the publisher Valens Arithmaeus noted that the epitaphs were lesser works of art than the monuments on which they were inscribed.[68] One can admire Arithmaeus' honesty, while wondering: (a) why he bothered publishing the epitaphs at all; (b) why he did not try to procure some illustrations.

By and large, viewers felt safer with inscriptions. The anonymous author of 'A Call to Connoisseurs' (1761) noticed that when a fictional 'elderly Gentleman' went to admire Louis François Roubiliac's *Monument to Admiral Sir Peter Warren* (1753–57) in Westminster Abbey, he went there 'to admire other beauties than those of the Inscription'. This was in contrast to an 'ignorant Gentlewoman' who was 'very noisy in deciphering the Characters'.[69] Ignoring the inscription was no mean

16. **Louis François Roubiliac**, *Monument to Admiral Sir Peter Warren*, 1753-7 (Marble, Westminster Abbey, London)

feat, as the text took up almost as much space as the bust of Sir Peter and the flanking figures of Fortitude and Britannia combined. It is significant that the 'beauties' admired by the 'elderly Gentleman', and ignored by the 'ignorant Gentlewoman', include a naked, muscle-bound male and a negligently clad female. Morally uplifting inscriptions were often an alibi – or a fig-leaf – for nudity. The most famous example is Bernini's *Apollo and Daphne*, which was supplied with an edifying Latin inscription after a French cardinal told Cardinal Borghese that he would not have had it in his house, in case Daphne's beauty excited those who saw her.[70]

In the late eighteenth century there was a reaction against the prolixity

119

and complexity of baroque inscriptions – 'concision of form, simplicity of idea, and purity of vocabulary became the rule'.[71] Yet less was more, and those few words were granted vastly increased power. In 1783 a critic at the Paris Salon suggested that in a statue of a hero, a distinction should be made between word and image: 'When a Hero who has never ceased to be important to his country is represented, why should one choose a single moment of his life? It would suffice to engrave his name on the base of his statue; just by seeing it, all that he had done for his fellow citizens would be remembered.'[72] Presumably he means that the statue should be a sober, idealising portrait, while the engraved name should trigger off colourful stories from the action-packed life. But the large, expressive power conceded to the word threatens to make the statue seem redundant. The sculptor David d'Angers (1788–1856) would later claim that the inscription of a name on a monument 'is the equivalent of a statue'.[73] If this was so, why go to the trouble and expense of having a statue at all?

IT IS SYMPTOMATIC that when Gotthold Lessing wrote *Laocoön* (1766), his polemic against Baroque allegory and the *ut pictura poesis* doctrine, he focused on a sculpture rather than on a painting. Sculpture had a less healthy relationship with words than painting. The ostensible purpose of the essay was to establish the different principles governing the 'sister arts' of poetry and painting (by which he also meant sculpture). Poetry was an art that functioned in time; painting an art that functioned in space. Contemporary critics, he felt, regarded them as interchangeable, and this meant that in poetry 'it has engendered a mania for description and in painting a mania for allegory'.[74]

The last straw for Lessing was a comment by Winckelmann about the antique statue of Laocoön. Winckelmann had compared the statue with passages describing the same subject in Greek literature, believing that the sculptor must have been inspired by literature. He claimed that Laocoön does not 'raise his voice in a terrible scream, which Virgil describes his Laocoön as doing', but suffers like the Philoctetes of Sophocles: 'The pain of body and the nobility of soul are distributed and weighed out, as it were, over the entire figure with equal intensity'.[75] Lessing agrees that the pain in Laocoön's face 'is not expressed with the same intensity that its violence would lead us to expect', but disagrees with Winckelmann's explanation that the statue was inspired by Sophocles' Philoctetes.[76] The latter, like so many other Greek tragic

heroes, cried out in anguish.[77] If, according to the ancient Greeks, 'crying aloud when in pain is compatible with nobility of soul',[78] then there must be some other reason why the sculptor depicts him differently from the poet.

That reason, Lessing claims, is the diverse nature of painting and poetry. Whereas a poet can depict all stages of an emotion or an experience, the painter has to choose a single, pregnant moment – the one that suggests what has already happened and what is about to happen.

This argument takes place during an unprecedented 'Golden Age' for writing about sculpture, but it still demonstrates the degree to which it was subjected to minute and ultimately debilitating comparisons with literature. Lessing hardly discusses any specific examples of famous paintings being treated in a similar way, either because he did not know of any or because he actually felt that painting was a more intrinsically narrative, time-based art.[79]

Ironically, Lessing ends up doing precisely what he has been warning against. In the penultimate chapter of *Laocoön* he tries to identify the so-called *Borghese Gladiator*[80] with a Greek general, because the posture of the statue agrees with a description given in a Roman biography. Lessing's argument can only be followed by those with the patience of Job and an extraordinary grasp of Latin grammar. By repositioning a comma in the relevant sentence in the Latin text, Lessing makes the correspondence between it and the statue 'absolutely perfect'. The statue must be very old, 'and with this age the form of the letters in the inscription is in perfect agreement . . .'[81] Lessing, the great grammarian, is a worthy successor of Conrad Peutinger. We touch base with the inscription.

A magnificent nadir in sculpture's relationship with words is reached with William Blake's engraving of Laocoön, *The Laocoön as Jehovah with Satan and Adam*.[82] It has recently been dated to 1826, the same year in which the first English translation (by Thomas De Quincey) of Lessing's treatise appeared.[83] In all Blake's work, there is a close interaction of word and image, but nowhere is the interaction so apocalyptic and claustrophobic. Laocoön and his sons are crushed twice-over: first, by the sea-snakes; second, by a deluge of words. Various printed texts, written at all angles, press in on the sculpture and its base. They cling to the figures like manacles and chains. The basic conceit – of an image surrounded by words – derives from classical and Renaissance medals,

121

17. **William Blake**, *The Laocoon as Jehovah with Satan and Adam*
(Engraving, c.1820).

but Blake gives the words an almost vice-like grip on the image.

Blake's texts are not complimentary. Not only are classical sculptures mere copies of lost Old Testament originals, but the classical world is a fallen civilization: 'Art Degraded, Imagination Denied'. Laocoön, he believes, is a poor pastiche of a sculpture of Jehovah. In a list of 'eternal' arts, sculpture is conspicuous by its absence: the arts are limited to Poetry, Painting, Music and Architecture.

The flattening effect of words is yet another reason why verbal supple-

122

ments have an emasculating effect on statues – and a more natural affinity with painting and with sculpture in relief.[84] The flatter the image or text, the more efficient the presentation of information, as Alexander Pope suggested in a tribute to Addison's *Dialogues Upon the Usefulness of Ancient Medals* (1721):

> The Medal, faithful to its charge of fame,
> Thro' climes and ages bears each form and name:
> In one short view, subjected to our eye,
> Gods, Emp'rors, Heroes, Sages, beauties lye. (11, 31–4)

The glance of the antiquarian or connoisseur felt thwarted by objects with deep convexities and concavities, just as his glance would have felt thwarted by a crumpled and creased piece of paper.

Two poems by Blake's contemporary Shelley – one about a sculpture, the other about a painting – succinctly underline sculpture's embarrassing enslavement by words. In the sonnet 'Ozymandias' (1817), Shelley is told by a 'traveller from an antique land' about the 'colossal wreck' of a sculpture, which he has seen lying in the desert. Although the sculptor effectively captured the 'sneer of cold command' on the 'shattered visage', the purpose of the sculpture – and the point of the poem – is encapsulated in an undamaged inscription on the pedestal: 'My name is Ozymandias, king of kings:/Look on my works, ye Mighty, and despair!' Here we must experience the sculpture at three verbal removes – first, through the inscription; second, through the tale told by the traveller; and third, through Shelley's own poetic account of the traveller's tale.[85]

In Shelley's forty-line poem, 'On the Medusa of Leonardo da Vinci in the Florentine Gallery' (1819), our experience of the painting is only at one verbal remove – as mediated through the poet's own words. The Medusa, which was then erroneously attributed to Leonardo, is understood directly by the poet:

> Its horror and its beauty are divine.
> Upon its lips and eyelids seems to lie
> Loveliness like a shadow, from which shine,
> Fiery and lurid, struggling underneath,
> The agonies of anguish and of death. (4–8)

So hypnotic is it that the viewer is transfixed, and turns to stone:

> Yet it is less the horror than the grace
> Which turns the gazer's spirit into stone,
> Whereon the lineaments of that dead face
> Are graven, till the characters be grown
> Into itself, and thought no more can trace; . . . (9–13)

The poem has been described as 'a manifesto of the conception of Beauty peculiar to the Romantics'.[86] In it, the poet expresses an almost death-driven desire for accursed and tainted beauty. It reworks the Renaissance 'Medusa topos', which had it that the viewer of a sculpture was more marble-like than the statue, because he or she was rooted to the spot in amazement. Here, however, it is a painting – by Leonardo of all people – that petrifies the viewer. The painting then carves its own lineaments on to the viewer until 'the characters' become identical. Shelley is punning, for these 'characters' are not just personalities; they are also letters and signs. Thus Shelley implies that Leonardo's magical painting writes and carves its own inscriptions. By comparison, the broken statue of Ozymandias is much less able to speak for itself. It is a dumber idol.[87]

Ozymandian statues were to be found everywhere during the French Revolution. As already noted, works by painters were not vandalized to anything like the same extent. Instead, the finest were carted off to the Louvre, and displayed in splendour in the Grande Galerie. In effect, during the French Revolution, painting tended to be treated like poetry, whereas sculpture was history. Painting was able to transcend its ostensible subject-matter and become an autonomous, 'aesthetic' entity that stands outside history. But sculpture – in the mind of its viewers – remained a cult object, the slave of its subject-matter.[88]

When Lenoir created his Museum of French Monuments, he also produced a guidebook that was sold at the entrance for twelve sous. It was far more ambitious than any previous guide, and was the forerunner of the modern museum catalogue. For the first time there were introductory essays and systematic descriptions of the contents of each room. An anonymous reviewer was highly appreciative: 'The usefulness of such catalogues is much greater than one might imagine. It is through them that the public learns to understand and appreciate its national monuments.' He added that this was particularly important because of the low reputation and status of the sculptures: 'Not all of these monuments

are masterpieces; they cannot all speak for themselves. Words are needed to supplement those lacking in expressive power; an inscription should indicate the sculptor's intention and reveal the thought he was trying to express.'[89] An explanatory inscription would have functioned like an epitaph – an epitaph to the *art* of sculpture. Here, to label is also to libel.

By the time we reach Nathaniel Hawthorne's *The Marble Faun* (1860), the need for guidebooks has become chronic. A woman painter asks a sculptor:

'Tell me what is the subject,' said she; 'for I have sometimes incurred great displeasure from members of your brotherhood, by being too obtuse to puzzle out the purport of their productions. It is so difficult, you know, to compress and define a character or story, and make it patent at a glance, within the narrow scope attainable by sculpture! Indeed, I fancy it is still the ordinary habit with sculptors, first to finish their group of statuary . . . and then to choose the subject; as John of Bologna did, with his *Rape of the Sabines*.'[90]

SCULPTURE'S AWKWARD relationship with language is also borne out by sculptures that come to life. In literature and folklore, statues that come to life (such as the Golem), rarely talk; they act. Haunted portraits are more garrulous, and are well versed in family history and in the repressed thoughts of the viewer.[91] This would suggest that sculptures are primarily physical presences, whereas paintings are mental presences.

Talking is usually problematic for animated statues, especially the one created by Pygmalion. The standard text of the story is found in Ovid's *Metamorphoses*. Pygmalion is a bachelor who is disgusted by the wicked ways of the local women, so he carves a beautiful statue of a girl from white ivory. He is so enamoured of his handiwork that he fondles and kisses the statue, dresses it in women's clothes, undresses it and takes it to bed. He then prays to Venus to give him a female companion who looks like his statue; his prayers are answered, and they get married and live happily ever after.

Interest in the Pygmalion myth was particularly pronounced in the eighteenth and nineteenth centuries. The reason for its popularity during the Enlightenment was because the story was a lascivious counterpart to John Locke's 'Molyneaux Question', in which a blind man has his sight restored. If the Lockeians were interested in what happens when a person born blind, dumb or deaf is suddenly cured, then the animation

of Pygmalion's statue could be used to make similar points about the beginning of consciousness – but in a more raunchy way. In André François Boureau-Deslandes' story *Pigmalion, ou la Statue animée* (1741), the statue's first thoughts are given special emphasis: 'Who am I and what was I an instant ago? I don't understand myself. What's my purpose? Why have I been extracted from nothingness? All that I perceive, all that I am allowed to know, is that I exist and that I feel that I exist . . .'[92] Pygmalion is, of course, on hand to give the retard a crash course in everything she needs to know.[93]

The close association of Pygmalion's statue with the Lockeian *tabula rasa* could give rise to profound musings about the origins of life and language. Indeed, the marmoreal 'nothingness' from which the figure is extracted could be regarded as a state of grace. Winckelmann associated silence and simplicity with Greek statues, and saw this state as a precondition for supernatural beauty.[94] The sculptor David d'Angers thought that silence was eminently sculptural, and that silent beings 'have a rapport with an invisible spirit'. Loquacious beings, on the other hand, lose their divine aura, as is proved by the famous chatter-box Jesus Christ![95]

But these same ideas also opened the floodgates to comic and usually misogynistic readings of the Pygmalion myth. In the eighteenth century the previously nameless statue starts to be called Galatea, a symbol of rustic coquetry.[96] She becomes closely associated with debased behaviour and language. Galatea is variously flirtatious, light-headed, lazy and a major disappointment to her creator. In *Don Juan* (1819–24) Byron uses deliberately exhausted language to describe a woman 'timidly expanding' into life: 'She looked (this simile's quite new) just cut/From marble, like Pygmalion's statue waking'.[97] The tradition of linguistic debasement gathers steam throughout the nineteenth century.

Hazlitt's *Liber Amoris, or The New Pygmalion* (1823) is a story about the writer's infatuation with a working-class girl. She looks 'as cold, as fixed and graceful as ever statue did', and her lack of garrulity is a function of her statuesqueness: 'Her words are few and simple; but you can have no idea of the . . . graces with which she accompanies them, unless you can suppose a Greek statue to smile, move, speak.' As a recent critic has noted, her 'very lack of wit and education helps to make her statue-like'.[98] The association of statuesqueness with simpletonism was already quite common. In Alexander Pope's *Dunciad*, during the reign of Dullness, mother Osborne sits 'Fast by, like Niobe (her children gone) . . . stupefy'd to stone'.[99]

Hegel was to use the myth of Niobe, whose grief at losing her children turns her to stone, as a metaphor for *all* sculpture, regardless of the subject's gender. Like the *Laocoön*, Niobe does not 'lapse into grief and despair', but keeps her 'grandeur and largeheartedness'. Yet it is 'an empty endurance of fate'.[100] She can 'only turn into stone'.[101] Elsewhere, Hegel notes an English traveller who had credited the *Medici Venus* with 'a faultless lack of intellect, a negative perfection, and a great deal of insipidity'.[102] This was in line with the findings of phrenologists, who believed that with such a small head she must have been idiotic.[103] The once evocative *tabula rasa* is becoming an empty cipher. A male equivalent is implied in a wry comment on Flaxman's monument to Dr Joseph Warton, a headmaster of Winchester. The monument represents Warton 'paternally instructing sundry angelic boys who, being composed of marble, are incapable of mutiny'.[104] Being a statue, by its very nature, requires a kind of arrested development.

Soon after Hazlitt, we find Galatea being regularly turned back into a statue because she is such a nuisance. In Barbier's two-act musical comedy *Galatée* (1852), the heroine is so fickle that her creator has her petrified; and in W. S. Gilbert's comedy *Pygmalion and Galatea* (1871) she causes so much trouble between Pygmalion and his wife that she returns to her pedestal and turns to stone. Wande van Dunajeur, the heartless dominatrix in Leopold von Sacher-Masoch's *Venus in Furs* (1870), is the most troublesome Galatea of all. She is an incarnation of a statue of Venus, but she remains cold and stony. She is articulate, but she blames woman's inability to be a proper companion to man on not having equal rights in education and work: 'For the time being there is only one alternative: to be the hammer or the anvil.'[105]

The hammer and anvil motif takes us right back to those traditional views of the noisy and lethal sculptor's studio. The disharmony of the sculptor's working conditions now parallels that of his sexual and intellectual relations. There is no alternative but to indulge in mutual iconoclasm.[106] In the end Sacher-Masoch, like so many other Pygmalions, is relieved to escape from his Galatea's clutches.

Speech is, of course, the nub of George Bernard Shaw's *Pygmalion* (1912), in which a professor teaches a Cockney flower-girl to speak like a duchess. In the preface Shaw castigated the decline of spoken and written English: 'The English have no respect for their language, and will not teach their children to speak it. They spell it so abominably that no man can teach himself what it sounds like. It is impossible for an

Englishman to open his mouth without making some other Englishman hate or despise him.' Shaw's story of the 'speaking statue' ends in tears when the flower-girl leaves the professor. But it goes without saying that when the 'statue' first speaks – and is thus closest to a statue-like state – it speaks 'abominably'. During the transformation scene, when Professor Higgins tries to grab hold of Eliza, there is a struggle during which she is on the point of screaming and tries to scratch his face. The stage directions contain 'many sado-masochistic undertones'.[107]

A vigorous variation on the theme is found in *Carnival* (1912), an early novel by the British writer Compton Mackenzie. It was a popular and critical success – second only in the best-seller list to Baroness Orczy's latest adventure of the Scarlet Pimpernel. It eventually sold more than half a million copies, and was made into three films, two stage plays and two radio plays. The hero of the novel is an unsuccessful writer, Maurice Avery, who, having fallen in love with a chorus-girl, Jenny, gives up poetry for sculpture. He decides to sculpt her and witters while he works:

'Now I must mould you, Jenny . . . By gad! I'm thrilled by the thought of it. To possess you in virgin wax, to mould your delicious shape with my own hands, to see you taking form at my compelling touch. By gad! I'm thrilled by it. What's a lyric after that? . . . There's objective art. Ha! Poor old poets with their words . . . You can't dig your nails into a word. By Jove, the Nereids in the British Museum. You remember . . .?' Jenny looked blank.[108]

Here sculpture supplants poetry, and is found wanting. Avery, in opting for a chorus-girl and for sculpture, opts for the dumbness of prose and of 'popular' music. Jenny looks blank, stays silent. Jenny's slang actually became the slang of the Edwardian smart set. For the Bonham-Carters, it was no longer a 'Cockneyism' but a 'Jennyism' to say 'Don't be soppy' or 'I must have been potty'.[109]

AT THE START of the twentieth century there was at least one example of a statue that did speak fluently. This freak was found in the art criticism of the French poet Apollinaire. From 1898 to 1911 Apollinaire made it clear that he thought the sculpture in the Salon was superior to the painting. His writing is full of statues that he imagines coming to life, but, with one conspicuous exception, they don't have that much to say

for themselves.[110] This garrulous statue appears at the Salon of 1913, and emerges from a white plaster figure made by the sculptor Jean Boucher.[111] In Apollinaire's account, Boucher tells him that his beautiful male figure has come to life, and is now discussing the other sculptures with visitors to the exhibition. He asks Apollinaire to prevent the statue from coming upstairs to the galleries of painting.

Apollinaire runs towards the stairs and is surprised to see the statue wearing a monk's cowl rather than a frock-coat. The monk is talking very loudly, and has just stopped in front of another statue. But when Apollinaire tries to interrupt, he tells him to be quiet and extols the beauty of the composition:

> The artist has expressed here the soul of the region of Brie with strong and refined art . . . Monsieur . . . Monsieur . . . This group made from stone possesses a certain spirit of Giotto-esque purity that inspires me . . . In the strolls that we will undertake one day in paradise, Niclausse will accompany us because of the soft purity that I find in his lovely little bust of a woman – which, one must say, has been influenced by Despiau.

Apollinaire is embarrassed because the monk has raised his voice and people are now staring. He tries to direct him to the exit, but he stops in front of two other sculptures by Henri Bouchard, *Fishermen* and *Claus Sluter*. Now Apollinaire is warming to the 'charming softness' with which the animated statue discusses the sculpture, but just at this moment his cicerone disappears and all that remains is his portrait in plaster.

And just who is this speaking statue? None other than Fra Angelico, the Renaissance painter-monk of San Marco, so beloved of George Eliot and the Victorians. The statue of Claus Sluter was, one presumes, also available for animation, but the great sculptor remains mute. Sluter worked for Philip the Bold of Burgundy, and eventually retired to a monastery in Dijon, so his CV was quite similar to Fra Angelico's. But, as ever, it is the painters who have a distinct personality and who are articulate – even about sculpture.[112]

It was not just in art, but in life as well, that the coarseness and stupidity of sculptors were taken for granted. Because of the low status of their work, nineteenth-century sculptors generally came from a more working-class background than painters.[113] In 1865 the Goncourt

brothers dined at the house of a painter friend, Philippe Burty. In their journal they painted a picture of domestic bliss: 'A certain atmosphere of cordiality, of wholesome childhood, of a happy family. All this made us think of various eighteenth-century circles of artists and bourgeois. At times, there glimmered a resemblance to Fragonard's house.' Then three sculptors turned up and the spell in the painter's house was broken. On seeing a salon and women, the sculptors 'recoiled, and fled gauchely' to the studio. They looked 'sinister and impoverished'.

Above all, they could not speak properly:

> They had the voices of workers out in the world, the debased, mannered accent of some young comedian who pours out his words without being sure of their spelling, or of a pimp who rolls his r's. Everything about them breathed a lack of education; they stank of pretentious gutter language corrupted by who knows what proud ideal. They uttered phrases about art like sentences in slang, things learned, dogma wheezed out.

One of them was Jean-Baptiste Carpeaux (1827–75), 'an enormously talented sculptor'; the other two were 'examples of those great nameless men; there are many of them in art'.[114] These sculptors could not even be considered grammarians.

6. Sculpture and Colour

No matter how good sculpture is, it always appears to be the material that it is. In painting, however, it seems to be the thing itself, and many are fooled into thinking that the object is real. Not only men but animals as well have been fooled by this force of colour.

<div align="right">

Filarete, *Treatise on Architecture*, 1461–4[1]

</div>

The sensation of colour is, generally speaking, the most popular form of aesthetic sense.

<div align="right">

Karl Marx, *A Contribution to the Critique of
Political Economy*, 1857–9[2]

</div>

Keats's delicate features and rich colour could not be conveyed I think in plain white marble.

<div align="right">

Oscar Wilde[3]

</div>

THE DOCTRINE OF *ut pictura poesis* is not simply a matter of establishing links between 'texts' composed of words and images. Colour is central too.

One of the most potent ways in which Giotto's frescoes demonstrate their linguistic dexterity – and their difference from sculpture – is through the use of colour. In rhetoric, the term *colores* came as early as Seneca in the first century AD to mean the embellishment and amplification of the essential structure or material of an argument. This notion was perpetuated and elaborated throughout the Middle Ages. Colour made language more persuasive but also more treacherous. In Chaucer's *Canterbury Tales*, the Franklin shows a disingenuous disdain for the 'colours' of rhetoric in a deliberately colourful passage:

> Colours ne knowe I none, withouten drede,
> But swiche colours as growen in the mede [meadow],

Or elles swiche as men dye or peynte.
Colours of rethoryk been to me queynte;
My spirit feeleth noght of swich mateere.[4]

The implication here is that nature's colours – 'swiche colours as growen in the mede' – and the colours used to make dyes and paints are acceptable, whereas the man-made colours of rhetoric are not. Giotto, with his numerous 'naturalistic' settings, was trying to use true rather than false colours in his paintings. His non-coloured colour is the plain truth.[5]

When subsequent writers on art criticize colour (and until the nineteenth century they almost invariably do), they are rarely criticizing colour *per se*. And even those who do criticize colour *per se* do so more in theory than in practice. Erasmus says that Dürer's prints accomplish with black lines what Apelles only accomplished with the help of colours, and that Dürer is therefore the better artist.[6] But this form of praise seems to have been tailored to Dürer, for Erasmus was otherwise quite happy to have relatively colourful portraits of himself painted by artists such as Holbein and Quentin Matsys. The first Director of the French Academy, Charles le Brun, said that without drawing painters would not rank any higher than colour grinders, but colourless paintings were never seriously on Le Brun's, or the Academy's, agenda.[7]

When the German poet Schiller saw the Italian paintings in the Dresden Gallery, he apparently said, 'All very well; if only the cartoons were not filled with colour . . . I cannot get rid of the idea that those colours do not tell me the truth . . . the pure outline would give me a much more faithful image.'[8] But neither painting nor sculpture were central to Schiller's thought, and in his most important book, *On the Aesthetic Education of Man* (1794–5), he makes only the most fleeting of references to the visual arts.[9] Thus wholesale condemnations of colour should be put into context, and not necessarily be taken at face value.

Usually, when writers criticize colour, they criticize false colour. So, for example, when the English poet John Dryden (1631–1700) introduces his translation of Charles-Alphonse du Fresnoy's *Observations on the Art of Painting*, the Frenchman appears to reject colour in time-honoured fashion: 'Our Author calls Colouring, Lena Sororis, in plain English, The Bawd of her Sister, the Design or Drawing: she cloathes, she dresses up, she paints her, she makes her appear more lovely than naturally she is, she procures for the Design, and makes Lovers for her. For the Design

of it self, is only so many naked Lines.' But neither does du Fresnoy reject colour (he writes about it extensively), and nor does Dryden. Indeed, on the previous page, Dryden observes: 'Expression, and all that belongs to Words, is that in a Poem, which Colouring is in a Picture. The Colours, well chosen, in their proper places, together with the Lights and Shadows which belong to them, lighten the Design, and make it pleasing to the Eye.'[10] The key words here are that the colours should be 'well chosen' and 'in their proper places'. In other words, they should respect the laws of propriety and decorum.[11]

Yet this instinctive suspicion of colour did sometimes work to the advantage of sculpture. In Renaissance Italy it was assumed that antique sculpture had been unpainted, and its stark purity and the clarity of its contours were seen as a sign of its moral seriousness and virtue. A great deal of sculpture in the Middle Ages and early Renaissance had been painted,[12] but from around 1500 it became accepted that serious sculpture had to be made from white marble. The example of Michelangelo, who insisted on using white marble, was irresistible. Colour was, at best, relegated to peripheral parts of compositions, and to the decorative arts. Such views were reinforced by Neo-Platonism, which encouraged artists to concern themselves with the creation of ideal forms that somehow transcended the material world. The leading Florentine Neo-Platonist Marsilio Ficino called the sun the *statua Dei*, and what he had in mind was the radiant whiteness of cleaned-up antique sculpture.[13]

But the cult of white was espoused by Protestant reformers as well as Catholic humanists. Alberti had urged that churches be painted white,[14] and this became the norm in northern Europe during the Reformation. After thirteen days of systematic iconoclasm in Zurich, the Swiss reformer Huldreich Zwingli proudly announced, 'In Zurich we have churches which are positively luminous; the walls are beautiful white!'[15] In this cultural climate it made sense for sculpture, which was particularly vulnerable to attack, to clean up its act. White marble helped make idols and idolatry more acceptable: paganism was purged.

The moral significance of white marble sculpture is deftly signalled in a pair of engravings from a book by the Italian humanist, Bartolommeo Delbene. Delbene was an Italian attached to the court of the French King Henri III, and was a member of the so-called Palace Academy — primarily a forum for moral and intellectual debate. Its most famous member was the poet Ronsard. Delbene's book was written around

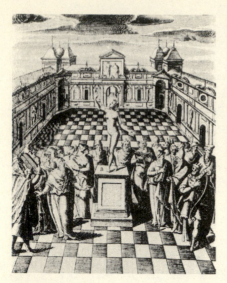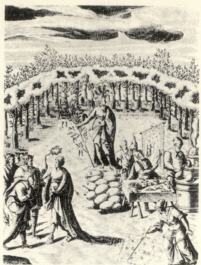

18. **Thomas de Leu** (?), *Palace of Truth* and *Grove of Falsehood*
(Engraving from Bartolomeo Delbene's *City of Truth* (Paris, 1609)

1585, but not published until 1609. It was a Latin poem in the form of
a dream, in which Aristotle conducts the author, his patroness
Marguerite of Savoy, and two of her ladies-in-waiting round the City of
Truth. After passing through the palaces of the moral virtues and the
temples of the intellectual virtues, the dreamers are left by Aristotle in the
presence of sublime mysteries.[16]

The relevant illustrations face each other on the same page. One
shows the Palace of Truth; the other the Grove of Falsehood. In the
centre of the courtyard of the classical Palace of Truth stands a white
statue on a pedestal. It is a standing female nude with one arm pointing
effetely upwards to the heavens. The statue is surrounded by a densely
packed group of the Great and the Good. They are male luminaries who
have been inspired by the breath of the supreme *numen*. They include
the Old Testament heavyweights, Moses and David. In the Grove of
Falsehood we find a very different scene. It is dominated by a bewigged
and masked woman swathed in heavy robes. She stands in a clearing on
a pile of windbags, which signify false rhetoric, surrounded by
practitioners of the lying arts. Closest to her is a painter working on an
allegorical picture at an easel.[17]

A moral discourse by one of Delbene's fellow academicians, Amadis
Jamyn, gives us a good idea of what it all means:

Men are generally ready to give credence to Truth when she is beautified with the colour and sweetness of words; yet the simple and naked Truth is found shining amongst the virtuous without any artifice, for she is ornament enough in herself; and when she is painted with external adornments she becomes corrupted. Falsehood, on the contrary, cannot please save by the exterior appearance of a borrowed embellishment, which soon disappears if it is not renewed with fresh paint.[18]

Sculpture may have lacked colour in a literal sense, but this did not necessarily mean that it could not become coloured in the eye of the beholder. Indeed, the biggest cliché of sculpture criticism was that, thanks to the skill of the sculptor, a statue seemed to be made of warm flesh and blood, rather than of cold marble. A visitor to Rome in the early thirteenth century was amazed by a classical figure of Venus 'made from Parian marble with such wonderful and intricate skill, that she seems more like a living creature than a statue; indeed she seems to blush in her nakedness, a reddish tinge colouring her face, and it appears to those who take a close look that blood flows in her snowy complexion'.[19] Six hundred years later, in an ode 'On the Death of Canova' written by Lady G. S. Stanley, not much has changed:

> . . . youthful Hebe's graceful modest form,
> And Love and Beauty's captivating Queen,
> Here bloom like Nature's tints and colours warm,
> For fancy paints the blush alone unseen . . .[20]

Bernini used various stratagems to 'paint' his sculptures. Chantelou recorded his comments on the subject while he was working on the marble bust of Louis XIV. First the sculptor emphasized the difficulty of making a convincing likeness in a monochrome material:

he told me a remarkable thing, which he has since repeated on many occasions – that if a man bleached his hair, his beard, his eyebrows, and, if it were possible, the pupils of his eyes and his lips, and showed himself in this state to those who were accustomed to see him every day, they would have difficulty in recognizing him. To prove it he added that the pallor which fainting brings makes a man almost unrecognizable, so that people explain, 'He no longer seems to be the same man'.[21]

135

The man with whitened features recalls Leonardo's caricature of the dust-covered sculptor.

But Bernini took up the challenge to infuse marble with colour. He re-engineered the sitter's face: 'in order to represent the dark which some people have around their eyes, one must hollow out the marble, in this way obtaining the effect of colour and supplementing, so to speak, the art of sculpture, which cannot give colour to things. So naturalism is not the same as imitation'.

With the rise of Neo-Classicism, colourlessness in art had more advocates than ever. There was less need for Bernini-style ingenuity, as pallid complexions and colour schemes were the height of fashion. The pale, consumptive girl dressed in white, who might suddenly exclaim, 'Beneath this white wool, my white arms, oh, how white!'[22] and the 'chiselled' features of an Aryan aristocrat, were the north and south poles of the Neo-Classical ideal.[23] Winckelmann believed that white was *the* colour: 'The colour white, since it reflects a greater number of rays, is the one to which the eye is most sensitive, and whiteness, therefore, adds to the beauty of a beautiful body.'[24] 'Sensitivity' was vital in the Age of Sensibility, and white surroundings were necessary both for its cultivation and stimulation. The English aesthete Walter Pater, in an essay on Winckelmann and Greek art, expresses the fragile Utopianism underpinning Neo-Classicism:

> This colourless, unclassified purity of life, with its blending and interpenetration of intellectual, spiritual, and physical elements, still folded together, pregnant with the possibilities of a whole world closed within it, is the highest expression of the indifference which lies beyond all that is relative or partial. Everywhere there is the effect of an awakening, of a child's sleep just disturbed.[25]

Colourlessness is here an essential component of a return to the purity of childhood. But in the course of Pater's reverie, the icebox of Greek culture is transformed into an incubator.

White marble sculpture also became tinted and heated in the viewer's imagination, owing to the principle that extremes eventually meet. In *Beyond Good and Evil* (1886) Friedrich Nietzsche satirized the propensity of human beings to misinterpret sensations at opposite ends of the spectrum: 'So cold, so icy that one burns one's fingers on him! Every hand is startled when touching him. – And for that reason some think he

glows.'[26] Nietzsche was presumably thinking of one of those statuesque and marmoreal Victorian stuffed-shirts. That this breed of man might be thought to glow – and thus exude warmth and colour – was a delusion he could do without.

So COLOURLESSNESS certainly had its advocates. That said, some viewers of sculpture either did not appreciate having to use their imagination and sensitivity to 'paint' a sculpture, or found that sculpture did not stimulate their imagination sufficiently. In 1561 Francesco Sansovino, the son of the great sculptor Jacopo, lamented that sculptures were not as abundant as paintings, 'because [sculpture] gives less delight . . . in that it lacks the charm of colour . . .'[27] Not surprisingly, this deficiency is often alluded to in discussions of painters' use of antique sculpture.

From very early in the Renaissance there seems to have been a tacit understanding that it was extremely hard for the 'fancy' to 'paint' marble. Painters were often warned against copying too exclusively from antique sculptures because the stone was intrinsically hard and cold. This criticism was made of Andrea Mantegna (1431–1506) by his teacher Squarcione, and repeated approvingly by Vasari. Squarcione criticized some of Mantegna's frescoes 'because in making them he had imitated the ancient works in marble, from which it is not possible to learn painting perfectly, for the reason that stone is ever from its very essence hard, and never has that tender softness that is found in flesh and in things of nature, which are pliant and move in various ways'. This annoyed Mantegna, Vasari says, but was of 'great service' to him, because he recognized that Squarcione was 'in great measure speaking the truth'. Vasari endorses the criticism when he concludes that Mantegna's manner is 'somewhat hard and sometimes suggesting stone rather than living flesh'.[28]

The great flesh-painter Rubens (1577–1640) made a similar point in his essay *On the Imitation of Statues*. The best antique statues cannot be studied too much, Rubens writes, yet this knowledge 'must be judiciously applied' so that the painting 'may not in the least smell of stone'. Indeed, 'instead of imitating flesh', inexperienced painters 'only represent marble tinged with various colours'.[29] A passionate supporter of Rubens, Roger de Piles, was in turn to criticize Poussin because his figures displayed the 'hardness of marble' rather than the 'delicacy of flesh, full of blood and life'.[30]

Squarcione, Vasari, Rubens and de Piles are criticizing not so much the lack of colouring in paintings inspired by sculptures, as the crudeness of the colouring. But behind this distinction lies the assumption that stone is fundamentally colourless and inimical to colour. Only occasionally does it suggest full-blooded, living flesh. Much later Goethe would note that if a painter worked from nature, there is 'no fear of becoming a feeble colourist, as there is in working from marble'.[31]

Transcending the 'smell of stone' was an imperative for Renaissance writers as well as painters. The French poet Joachim du Bellay, who lived in Rome from 1553 to 1557, gives us a strong sense of how the colours of poetry and painting come to the rescue of sculpture. They bring sculpture to life and modernize it, making it palatable and powerful. In the prefatory sonnet to his famous poem *Les Antiquités de Rome* (1558), du Bellay tells the King of France that although he is unable to bring antique works of art to Paris and Fontainbleau, he will present them to him in 'this little painted picture . . . of poetic colours' (*'ce petit tableau peint . . . de couleurs poétiques'*). As a result, du Bellay will have dragged the 'dusty relics' (*'poudreuses reliques'*) from their tomb, and the grandeur of the Romans will be rebuilt in France – 'painted' in the King's own language.[32] The modern, colourful language of painting is here imperiously contrasted with the venerable but wan language of sculpture.

The equation of colour, and hence painting, with expressive language is one of the reasons why sculpture is often thought to exist prior to language, or even beyond language. 'Sermons in stone' tend not to go on for very long. This in turn accounts for the rarity and brevity of sermons *about* stone.

The first major English art critic, the portrait painter Jonathan Richardson the Elder (1665–1745), is literally lost for words because of sculpture's lack of colour. In his *Two Discourses on the Art of Criticism, as it Relates to Painting* (1719),[33] Richardson compares a 'Michelangelo' bas-relief of Count Ugolino eating his sons in prison with Dante's description of the same event. It is beyond words: 'it would be ridiculous to undertake to describe this admirable bas-relief . . .'[34] On the face of it, this is the highest praise, but it is really Richardson's alibi for completely ignoring it.[35] He goes on to say that although the bas-relief represents the peak of the sculptor's art, and is superior to Dante's description, a painting of the same subject by Michelangelo would have been preferable. The addition of colours would have been able to 'express the

quality of the persons the more to excite our pity, as well as to enrich the picture by their variety'. That sculpture shows everyone in the nude, whereas in painting people can be clothed, also contributes to variety.[36] Here sculpture's monotonous monochromaticism seems to defy verbal analysis and elaboration.

During the nineteenth century, sculpture's colourlessness came increasingly to be associated with frigidity, sterility and a kind of moral rigidity. Not only did sculpture represent unchanging ideals, but its style, subject-matter and medium (white marble) were also perceived to be unchanging. The point about colour was that it suggested and stimulated vitality. In Lord Lytton's pot-boiler, *The Last Days of Pompeii* (1834), the character Lepidus makes a standard Romantic point: 'Those old poets all fell into the mistake of copying sculpture instead of painting. Simplicity and repose – that was their notion; but we moderns have fire, and passion . . . we imitate the colours of painting, its life, and its action.'[37]

More and more sculptors experimented with colour. Canova was evidently frustrated by the limitations of white marble, for he took the revolutionary step of tinting some of his works, and using combinations of marble and bronze.[38] Indeed, the Hebe mentioned by Lady Stanley in the poem quoted earlier did not only blush because it was 'painted' by 'fancy'. It had in fact been tinted by Canova. His patron, the Duke of Bedford, heard about these experiments but, like many of his contemporaries, preferred to see the 'genuine lustre of the pure Carrara marble'. Yet he was not too disappointed by Hebe and her companion Terpsichore, when he saw them at the Royal Academy summer exhibition in London in 1817. This was because no artificial colouring had been applied, apart from 'a slight tint of vermilion on the cheeks and lips of *Hebe,* which however, as you justly observe, may easily be taken off with a wet sponge'.[39] Hebe was duly sponged and thus returned to a state of absolute whiteness, or what Canova termed the '*color di morto*' – the colour of death.[40] Thus, although sculpture was often criticized for being colourless, it was still expected to be so.

A nadir of sculpture's moral and intellectual crusade occurs in Henry James' formulaic, yet representative novel *Roderick Hudson* (1875). Hudson is a young American sculptor who has been taken to Rome by his protector, Rowland Mallett, to 'imitate the antique'.[41] A stuffy potential patron, Mr Leavenworth, arrives on the scene: 'What do you say to a representation, in pure white marble, of the idea of Intellectual Refinement?' Later on Leavenworth decrees that Intoxication is an

unsuitable subject for sculpture: 'Spotless marble seems to me false to itself when it represents anything less than Conscious Temperance.' This brings Hudson's looming creative crisis to a head, for he already feels trapped by the rules and limits of his art. He laments the fact that there are so few subjects a sculptor can treat, and sighs, 'If I had only been a painter.'

Yet Hudson fails to escape from his stylistic straitjacket. He will not be able to make a statue of a Jew because of their 'pendulous noses', or of Judas because he cares only for 'perfect beauty'. In desperation, he dreams of making ideal sculptures: 'They shall simply be divine forms. They shall be Beauty; they shall be Wisdom; they shall be Power; they shall be Genius; they shall be Daring.' One of his interlocutors, the suggestively named Miss Blanchard, notes drily that it is all 'rather abstract, you know', but Hudson is not put off his stride, and toys with other subjects – 'Then there are all the Forces, and Elements, and Mysteries of Nature . . . I mean to do the Morning; I mean to do the Night! I mean to do the Ocean and the Mountains; the Moon and the West Wind. I mean to make a magnificent statue of America!' Finally Gloriani, a sculptor 'of the ornamental and fantastic sort', drives the final nail into Hudson's white marble coffin: 'America – the Mountains – the Moon! . . . You will find it rather hard, I'm afraid, to compress such subjects into classic forms.' Pure white marble simply cannot cope with the *colores* of nature.

THE ISSUE of transcending the 'smell of stone' is also central to Renaissance interpretations of the myths of Prometheus and Pygmalion. These classical figures are the most important mythological sculptors.

The idea that Prometheus was the creator of man and of all other living creatures, moulding them out of clay and water, was developed by the Romans.[42] It subsequently influenced the iconography of the biblical creation story, but Prometheus was also castigated as the maker of the first idols. During the Middle Ages and the early Renaissance he was often thought of as a magus and astrologer, as well as a sculptor. Gradually, however, in humanist circles, Prometheus' theft of fire takes on greater importance. For the Florentine Neo-Platonists, he was a philosopher who stole the fire of superior wisdom from God and infuses man with it. The mannerist painter Pellegrino Tibaldi went so far as to show Prometheus animating his statue in a fresco painted over a fireplace in the Palazzo Fava in Bologna.

Sculptors could represent an unspecified moment of animation – as in the inflamed writhings of Michelangelo's *Slaves* – but it was almost impossible for them to represent Prometheus bringing his statue to life with divine fire. Fire was one of those things – like light, air and smoke – that sculptors, in contrast to painters, were supposed to be unable to represent. One of the very few freestanding sculptures in which fire appears – Bernini's *Saint Lawrence* – was a carefully contrived demonstration piece, in which the saint is slowly cooked over a necessarily bulky wood-and-coal fire.[43] Of course bronze-casting had numerous Promethean associations, but Michelangelo's insistence that white marble was the supreme medium served to diminish the usefulness of that metaphor.

There was another, even more important reason why the theme was hardly ever tackled by sculptors: fire infused the sculpture not just with life but with colour. In one of the best-known Renaissance representations of the Prometheus myth, the two panels by Piero di Cosimo painted in around 1515–20,[44] we pass from an almost monochrome gloom to a hazy warmth. In the first painting there are two clay statues. One is finished and standing on a pedestal, while the other is having its arm brutally yanked into position by the sculptor. The picture is in poor condition, but the unpleasant appearance of both statues is unmistakable: the former is a treacly green and the latter bitumen black. The second picture is very different. Without much ado, Prometheus presses a flaming torch to the chest of his statue on the pedestal. The statue, and the whole picture, is infused with a mellow and eminently 'painterly' glow. Indeed, in some other Renaissance representations of Prometheus, the torch is a delicate wand held like a paintbrush.[45]

The distinction between these two evolutionary stages was made even more clearly in relation to God and the creation of Adam. In the sixteenth century those involved in the *paragone* debates argued over whether God was a painter or a sculptor.

In almost all early belief systems, God is any of two things: a builder of the world and/or the modeller of man.[46] The builder-God is both an architect and a smith. But the most common image is of the God who models man out of clay or earth. In the Bible, God moulds Adam from earth (literally 'dust'). The most vociferous campaigner for his being a sculptor was, naturally enough, Cellini. In an essay written to protest about the pre-eminent position initially given to the allegory of painting on Michelangelo's catafalque, Cellini claimed that God made man in

'completely round relief', and it was only afterwards that his creation was painted and then became a 'coloured sculpture'.[47]

The idea of God as a painter dates back to the early Greek writers Empedocles and Pindar, but it is only with Christianity, and particularly with the Renaissance, that it really starts to proliferate.[48] There was ultimately much more fire-power on the painters' side, not least because the world was multi-coloured and consisted of far more than human figures. In Castiglione's *The Book of the Courtier*, we learn that the 'machine of the world' is a 'great painting', composed by the 'hand of Nature and of God'.[49] The heretical corollary to this is that the painter is a second God. Alberti wrote, 'The virtues of painting, therefore, are that its masters see their works admired and feel themselves to be another God.'[50]

The painters' case was spelt out categorically and alchemically by Felix da Costa, a Portuguese painter who accompanied Catherine of Braganza to England in 1662 for her marriage to Charles II. The painter, Costa wrote in his treatise *The Antiquity of the Art of Painting*, imitates the divine creator:

> since when he paints the human figure he creates a body and then instils life into it . . . He provides it with flesh by making blood out of vermilion; with choler, by adding a pale colour; with phlegm, by adding white; and with melancholy, by blackening the shadows. When these four colours have been blended, the figures become lifelike, and earthly matter has been inspired to life by art.[51]

This process of inspiration is clearly akin to the 'magus' Prometheus' application of fire.

In the late eighteenth and early nineteenth centuries, the Prometheus myth was re-enacted in sculpture galleries. It became fashionable to view antique sculpture at night by torch, candle or lamplight. The viewer thus became a second Prometheus, endowing white marble with flickering life.[52] In Shelley's *Prometheus Unbound*, written in Rome in 1819, 'emulous youths' walk through a temple created by Prometheus and filled with 'Praxitelean shapes'. Through the 'divine gloom', they carry:

> The lamp which was thine emblem; even as those
> Who bear the untransmitted torch of hope
> Into the grave, across the night of life.[53]

Some viewers thought that the theatrical contrivance required to bring marble fully alive showed that there was something lacking in it. Goethe contrasted nature with the materials of sculpture, and saw a deficiency in the latter: 'Why is nature always beautiful, and beautiful everywhere? And meaningful everywhere? And eloquent! And with marble and plaster, why do they need such a special light? Isn't it because nature is in continual movement, continually created afresh, and marble . . . is always dead matter? It can only be saved from its lifelessness by the magic wand of lighting.'[54] Once again, colour was not the central issue, but it was hard to think of nature and light without also thinking of colour. Goethe did, after all, write a major treatise on colour.

A keen sense of the transfiguration of 'cold white marble' by coloured light is felt in a poem by the English writer Matthew Arnold, 'The Church of Brou' (1852–3). The poem is based on an episode from Renaissance history. The Duke of Savoy was killed in a hunting accident and his young bride Marguerite went into mourning. She then had a church built on a lonely mountainside, 'from men aloof'. Inside there was a tomb for them both in 'marble pale', but the saints in the 'rich painted' stained-glass windows smiled down on them:

> So sleep, for ever sleep, O marble Pair!
> Or, if ye wake, let it be then, when fair
> On the carved western front a flood of light
> Streams from the setting sun, and colours bright
> Prophets, transfigured Saints, and martyrs brave,
> In the vast western window of the nave;
> And on the pavement round the Tomb there glints
> A chequer-work of glowing sapphire-tints,
> And amethyst, and ruby – they unclose
> Your eyelids on the stone where ye repose,
> And from your broider'd pillows lift your heads,
> And rise upon your cold white marble beds;
> And, looking down on the warm rosy tints,
> Which chequer, at your feet, the illumined flints,
> Say: *What is this? we are in bliss – forgiven –*
> *Behold the pavement of the courts of Heaven!*[55]

This Marguerite is a predecessor of the Marguerite of Savoy who was escorted around the City of Truth by Aristotle in Bartolommeo

Delbene's poem. Arnold seems to find the 'aloofness' of the church a little self-indulgent, and the aridity of the Duchess of Savoy's expression of her emotion is symbolized by the 'cold' white marble. By way of contrast, entry into a state of bliss means entry into a painted world of 'rosy tints' and 'colours bright'. Visually, this is a complete turn-around from Delbene's poem. Delbene's Garden of Falsehood, with its painter's colours, has become Matthew Arnold's idea of Heaven.[56]

THE PYGMALION myth enacts a cruder critique of colourlessness than does the Prometheus myth. There are almost as few sculpted representations of Pygmalion as there are of Prometheus, but attitudes towards this sculptor developed in a rather different way.[57] In the Middle Ages, Pygmalion was frowned on by the Church and regarded as a lecherous magician. In John Gower's *Confessio Amantis* (1393), the statue goes to bed with Pygmalion and proves to be a lusty lover who bears him a 'knave child', whereupon Gower rather churlishly condemns idolatry.[58] This disapproval is paid lip-service to in Shakespeare's *The Winter's Tale* when, just before asking Hermione to come down from the pedestal, Paulina says that people will think she is assisted by 'wicked powers'. A painting of Pygmalion by the Florentine mannerist Jacopo da Pontormo (1494–1552) implies both magic and idolatry. As Pygmalion kneels before the statue, a bull burns in a fire in the background. The colouristic pyrotechnics underscore, however, that the real magic is that of a painter rather than a sculptor.[59]

From the eighteenth century, only one freestanding sculpture of Pygmalion seems to have survived. It was made by Etienne-Maurice Falconet (1716–91) in 1763.[60] The sculptor kneels awestruck before his gently unfurling statue, still clasping his hands together as though in prayer. The statue was widely admired. Diderot praised it, though he felt there should have been impassioned physical contact between the two. He invited the viewer to do what Pygmalion fails to do: 'Press your finger there and the matter which has lost its hardness will give way to your pressure.'[61] The sculpture was thought to be throwing down a gauntlet to painters. According to Diderot, the painter Joseph-Marie Vien said that Falconet had 'this once' demonstrated sculpture's 'superiority to painting'.[62] The operative words are 'this once'.

During the nineteenth century the discovery that antique sculpture was in fact coloured, and the awakening of interest in medieval art, encouraged sculptors to experiment with colour. The most celebrated

example is by Canova's British pupil John Gibson (1790–1866). The hair, lips and eyes of Gibson's *Tinted Venus* (1851–6) were painted, and the flesh tinged. He thought of himself as a modern Pygmalion: 'yes — yes, indeed, she seems an ethereal being with her blue eyes fixed upon me!'[63] When the statue was exhibited at the London International Exhibition of 1862, a pair of polemical Latin inscriptions were placed on the brightly coloured niche devised by Owen Jones:

Formas Rerum Obscuras Illustrat Confusus Distinguit Omnes Ornat Colorum Diversitas Sauvis

Nec Vita Nec Sanitas Nec Pulchritudo Nec Sine Colore Iuventus

[The gentle variety of colours clarifies the doubtful form of things, distinguishes the confused and decorates everything.

Without colour there is neither life nor health, neither beauty nor youth.][64]

Introducing colour to sculpture was a risky business. First and foremost, it implied that previous sculpture was wanting. The British sculptor Richard Westmacott (1775–1856), writing in the *Archaeological Journal* of 1855, asked, 'Do we feel that the Theseus and Ilyssus, the Venus of Melos, the Apollo of the Belveder, and others, show a deficiency that colour could supply?'[65] Moreover, it made this critique using a weapon that was assumed to belong to painters, and to decorative artists. Thus the introduction of colour could appear to signal the vulgarization of sculpture and its capitulation to other artforms. The traditional hostility to colour was expressed by Francesco Milizia in his *Dictionary of Fine Arts* (1787). Milizia wrote that coloured statues 'are not for artists, but for artisans, and for the most common crowd'.[66] Nonetheless, in the late nineteenth century increasing numbers of painters were also tempted to try their hand at sculpture, both coloured and non-coloured, so it was by no means one-way traffic. Indeed, the emergence of the 'painter-sculptor' was one of the most important developments of the late nineteenth century, and would ultimately revolutionize painting as much as sculpture.

The difficult balancing act performed by artists who coloured their sculpture was exemplified by the French painter Jean-Léon Gérôme

19. **Jean-Léon Gérôme**, *Painting breathes Life into Sculpture*, 1893
(Oil on canvas, The Art Gallery of Toronto)

(1824–1904).[67] Late in life he tried his hand at sculpture and was obsessed by the Pygmalion theme, making both a painting (1890) and a sculpture (1892) that showed Pygmalion kissing his semi-animated statue. In the painting, the circulation of blood starts in the head and moves down the body.

But a painting of 1893, set in ancient Greece, tries to suggest that it was the painter, rather than the sculptor, who brought art to life. Gérôme gave the painting a Latin title, to suggest that what it showed was archaeologically correct: *Sculpturae vitam insufflat picturae* – painting breathes life into sculpture. A languid beauty, clad in a white robe, sits cross-legged in a comfortable studio serenely painting the surface of a dancing figurine. She might almost be applying make-up. Ostensibly the picture asks us to marvel at the intoxicating and transforming power of paint. But Gérôme is not quite sure. Leonardo's vision of the painter's studio has been banalized and feminized. Here colouring seems to be, as Dryden put it, 'The Bawd of her Sister, the Design or Drawing'. Paint, the preserve of this coy female artisan, is the ultimate procuress.

7. The Classical Ideal and Sculpture's Lack of Modernity

In one respect fortune was favourable to the labours of Andrea [Pisano], because there had been brought to Pisa . . . many antiquities and sarcophagi [. . .], and these brought him such great assistance and gave him such great light as could not be obtained by Giotto, for the reason that the ancient paintings had not been preserved as much as the sculptures.

> Giorgio Vasari, *Lives of the Artists*, 1568[1]

. . . I strongly suspect that if, in the modern age, sculpture leaves a lot to be desired, whereas painting has been brought to the peak of perfection, this phenomenon is explained by the fact that whereas the Farnese Hercules together with other famous sculptures of classical antiquity have come down to us, the Ialysus of Protogenes and the Venus of Apelles have not.

> Giambattista Vico, *On the Study Methods of our Time*, 1708[2]

WHAT I HAVE SAID so far would appear to be contradicted by almost any portrait of a Renaissance art collector. Take, for example, the magnificent portrait of Andrea Odoni, which was painted by Lorenzo Lotto in Venice in 1527. The wealthy merchant and connoisseur is shown seated at a table surrounded by choice pieces from his collection. He is enveloped in a bloated black-velvet jacket, and this gives him the appearance of a dark planet attended by bright satellites.

Venice was just becoming aware of having a great school of painters – Titian, the supreme colourist, was then in his prime. Even in the previous century Jacopo Bellini (c. 1400–70, father of the even more

147

20. **Lorenzo Lotto**, *Portrait of Andrea Odoni*, 1527
(Oil on canvas, Royal Collection, London)

famous Gentile and Giovanni) had been praised in exalted terms. Having defeated the painter and medallist Pisanello in a portrait competition in 1441, Bellini was eulogized in several sonnets. He was 'the man from the noble salty shores' and – even better – 'the excelling painter,/New Phidias for our unseeing world'.[3] He was also said to be the heir to 'divine Apelles and noble Polycleitus'.[4]

According to Vasari, Andrea Odoni's Venetian palazzo was a home-from-home for connoisseurs, and it even had frescoes painted on the outside walls in about 1531 by Girolamo da Treviso. Inside, there were paintings by Giorgione, Titian and many others. Yet in Lotto's portrait, Odoni proffers a marble statuette to the viewer, and is hemmed in on all sides by larger sculptures: in this major work celebrating connoisseurship and patronage, there is not a single painting in sight.[5]

There is nothing untoward about this, for all of Odoni's sculptures are

148

classical antiquities. Throughout and well beyond the Renaissance it was perfectly possible to venerate antique sculpture while feeling that painting was a more versatile and modern medium. A double standard operated, which was to be clearly formulated in theoretical treatises during the Enlightenment.[6] There was a tacit understanding that sculpture was something that belonged to, and had been perfected in, the pagan past. As ever more antiquities were excavated, the sheer weight of evidence made such an assumption compelling. Thus sculpture could be regarded as a great medium, but one that was nevertheless circumscribed stylistically, thematically and historically.

Few paintings survived from antiquity and most were in minor and decorative genres. None could be convincingly attributed to any of the great masters like Apelles and Zeuxis. Although some critics claimed that ancient painting must have been superior to ancient sculpture, the past weighed less heavily and directly on modern painters.[7] Painting appeared to belong more completely to the here and now. It could be, in the best sense, a Christian art – universal, colourful, expressive. This is why an assertion that Jacopo Bellini, a painter, was the new Phidias and Polycleitus *as well as* the new Apelles is perfectly natural and requires no explanation. Modern painters supersede ancient sculptors as well as painters. The honour is not reciprocated: modern sculptors are never called the 'new' Apelles.[8]

Lotto engages with these paradoxes in his portrait. The classical sculptures are almost all fragmented; some are precariously and casually placed. The bust of Hadrian peeps out comically and ignominiously at an angle from beneath a green table-cloth; a broken torso of Venus seems to lean against the side of his head. But the most telling feature of these sculptures is their lack of arms. Their arms have almost all either been broken off or (in the case of a Hercules and Antaeus) are hidden from view. Most striking of all is the statuette that is thrust towards us, which nestles in the baseball-mitt hollow of Odoni's hand. This piece represents the earth goddess, Artemis of Ephesus, from whose torso sprout innumerable breasts.

However emotive these ambassadors of the past may be, in a literal sense, they lack reach. By way of contrast, the protagonists of the present are positively predatory. In Venetian and Venice-influenced portraiture, we often find the motif of a hand resting paternally on an antique bust, but the bust – as in a lost portrait of Erasmus by Holbein – is almost always in a subordinate position.[9]

Odoni's expansive body language is remarkable. He makes dramatic arm and hand gestures that spread across the width of the picture. The hand that is not proffering the statuette caresses the fur trim of his jacket and points to a crucifix. With these gestures, and with the different types of tactile experience to which they draw attention, Lotto underscores the capaciousness and seductiveness of *his* canvas, *his* painting, *his* world. The picture was painted in the same year in which Rome was sacked. It is through Odoni, the collector and patron, and through Lotto, the painter, that antiquity is truly restored. Sculpture's empire is in ruins; now Painting is the broadest and brightest church.[10]

By way of a final irony, Odoni did in fact collect modern sculpture. In this, he was very unusual among his Venetian contemporaries, and most scholars do not even mention this aspect of his collecting. Marcantonio Michiel, the connoisseur who recorded the contents of major collections in Venice and Padua, visited Odoni in 1532 and found three modern works mingled with the antiquities in his ground-floor courtyard, and other modern sculptures indoors.[11] But in Lotto's painted portrait – as in almost all Renaissance portraits – sculpture means antique sculpture.

IN THE PREFACE to the third and final part of the *Lives of the Artists*, Vasari gives one of the most startling examples of how an awareness of classical antiquity could be seen to transfigure contemporary sculpture. After assessing the work of Quattrocento artists – they were better than their predecessors, but excessive study had led to a dry style – Vasari moves on to the golden age of Leonardo, Raphael and Michelangelo. Now art reaches the pinnacle of achievement:

> their successors were enabled to attain to it through seeing excavated out of the earth certain antiquities cited by Pliny as amongst the most famous, such as the Laocoön, the Hercules, the great torso of the Belvedere, and likewise the Venus, the Cleopatra, the Apollo, and an endless number of others, which, both with their sweetness and their severity, with their fleshy roundness copied from the greatest beauties of nature, and with certain attitudes which involve no distortion of the whole figure but only a movement of certain parts, and are revealed with a most prefect grace, brought about the disappearance of a certain dryness, hardness, and sharpness of manner . . .[12]

It is a very rudimentary model of stylistic development and, to be fair, not one to which Vasari sticks very closely in the subsequent *Lives*. Here, his heroes seem to spend more time studying nature and anatomy[13] than antiquity. Elsewhere in the *Lives* we are indeed made to doubt whether the influence of antique sculpture is necessarily beneficial – or even necessary – to the progress of art.

In the life of Donatello, Vasari suggests that a lack of antique models can add to, rather than detract from, the artist's achievements. Donatello, he writes, 'deserves all the more praise inasmuch as in his time no antiquities had been discovered and unearthed, apart from the columns, sarcophagi and triumphal arches'.[14] This partly contradicts what he says in the passage I have already quoted, for the implication here is that art became easier once Laocoön *et al.* were discovered. Post-Laocoön, the artist could, as it were, stand on the shoulders of giants: most of the hard work had already been done.

Alberti had also been concerned with how the presence of models might affect our estimation of art. In the preface to *Della Pittura*, he observes that he and his illustrious contemporaries in Florence are having to create their cultural revolution *ex nihilo*. But this is not necessarily such a bad thing: 'I admit that for the ancients, who had many precedents to learn from and to imitate, it was less difficult to master those noble arts which for us today prove arduous; but it follows that our fame should be all the greater if without preceptors and without any model to imitate we discover arts and science hitherto unheard of and unseen.'[15]

An important paradox is being expressed here. On the one hand, any modern cultural revival centres on the imitation of ancient models. On the other, moderns receive more credit for discoveries and innovations for which there are no ancient models. These demands are conflicting. The first implies that what is needed is a faithful restoration of antiquity; the second desires a transcendence of antiquity. Such contradictory aspirations represent some of the first stirrings in what came to be known in the seventeenth century as the Quarrel of the Ancients and Moderns.[16]

Once there was an onus on innovation and on going beyond the ancients, painting was potentially in a better position than the other visual arts. As so few paintings had survived from antiquity, painters lacked such obvious role-models. For sure, there were verbal records of famous paintings in antique literature: Alberti discusses the *Calumny* of Apelles, although the picture was only known from a celebrated

151

description by Lucian. But a painter, guided only by descriptions and by antique sculptures, appeared to have more room for manoeuvre in his 'imitations' than a sculptor, who was surrounded by source material in the same medium. This may have been another reason why Alberti was prepared to regard painting as the supreme art. With so few antique survivals, it was easier to play God when defining as well as practising it.[17]

The Paduan humanist and amateur sculptor Pomponius Gauricus may have been thinking along these lines when he wrote his treatise *De Sculptura* (1504). He makes an impassioned appeal to sculptors to take their inspiration from antique literature, rather than from antique sculpture: 'It pains me to admit it here, but, in a conversation with some sculptors, their indolence made them so bold as to say that a knowledge of literature might be useful to a sculptor, but it wasn't in the least bit necessary. It suffices, they said, to conform to the rules of art and, as far as possible, to nature.' Gauricus is suitably contemptuous:

> Undoubtedly, but where does one find this art? Is it by spending one's days in a perpetual state of astonishment in churches, galleries and shops? Is it by visiting private homes, by having cabinets full of statues and cases full of casts? Is it by admiring them and looking at them again and again with a gaping mouth? Is it by imitating what seems beautiful and incorporating it into your work? Is this what you call art? Is that the imitation of nature?

Gauricus' answer is a resounding 'no!' Contemporary sculptors should realize that the greats of the past and the best of modern masters – such as Donatello – did things differently. Phidias, for example, took his inspiration for his famous statue of Zeus from a passage in Homer where the great poet 'truly pictures with simple words all the power and majesty of Jupiter'.

Gauricus then offers his own breathtakingly simple recipe for great sculpture:

> Given that nothing can be represented that hasn't first of all been grasped by a concept and an idea, where better could I go, if I had to make a colossus, than to Virgil's Polyphemus – 'horrible, hideous, enormous monster . . .' – or to Homer – 'For he was fashioned a wondrous monster, and was not like a man that lives by bread, but like

a wooded peak of lofty mountains which stands out to view alone, apart from the rest.'[18]

What strikes us immediately is the lack of detail in the descriptions. These literary titbits are simplicity itself. Thus, for Gauricus, recourse to literature seems to mean recourse to the artist's imagination.[19] Later, Gauricus asks rhetorically whether a description of a horse by Statius is not more 'intense' than a sculpture of a horse by Donatello; even so, he still suggests a recipe for a truly creative form of *ut sculptura poesis*, in which the image fleshes out the word. The 'intensity' of certain poetic descriptions opens up huge possibilities for an artist — or at least it offers more potential than the study of classical antiquities.

SOME WRITERS were to claim that the lack of extant antique paintings diminished the dignity of modern painting[20] — just as the lack of Roman ancestry could diminish the dignity of a town or family. Others asserted that the durability of ancient sculpture *vis-à-vis* ancient painting proved sculpture's superiority as a medium. The Venetian sculptor Tullio Lombardo (c. 1455–1532), for example, wrote to his patron in 1526 to congratulate him on his choice of sculpture as the medium for his altarpiece: 'The altarpiece will be an everlasting memorial . . . painting is a transitory thing, hardly to be compared with sculpture . . . whereas the sculpture of the ancients has survived to this day, nothing whatever remains of their painting.'[21] But in general the veneration of antiquity would pose more problems for modern sculptors than for modern painters. For sure, connoisseurs might claim that Apelles and Zeuxis were far superior to any modern painters, but non-existent pictures could hardly take up the modern painter's wall-space. Modern sculptors, however, were on the front line, competing for *Lebensraum*.

The Italian art-lover Sabba di Castiglione gives a good example of the tricky predicament of the modern sculptor in his moral guidebook, *Ricordi* (1546). In the section dealing with the Decoration of the House, Sabba remarks: 'Others decorate their houses with antiques, such as heads, torsos, busts, ancient marble or bronze statues. But since good ancient works, being scarce, can not be obtained without the greatest difficulty, they decorate it with the works of Donatello . . . Or they decorate it with the works of Michelangelo.'[22] Sabba gives fulsome praise to both the Florentines — they are at least as good as any ancient Greek sculptor — but they are nonetheless second choice.

Moreover, antiquities were not as scarce as Sabba makes out: if you could not afford an original, you could get a modern copy or a plaster cast. Casts of busts and other relatively small-scale work had been collected since the fifteenth century.[23] It was still hard, however, to get casts of very large or famous works. The sculptor Leoni Leone began collecting casts of famous antiquities before 1550, which he displayed in the court of his house in Milan, but he needed a special papal licence to have them made.[24]

Some of the most fiercely fought contests between the ancients and the moderns took place in France. An early episode involves Cellini, and is recounted in his *Autobiography*. Cellini had gone to France to work for the French King François I at his palaces in Fontainebleau and Paris. The French King has just praised Cellini's latest creation – a statue of Jupiter – when his tetchy mistress, the duchesse d'Etampes, ticks him off: 'Have you lost your eyes? Don't you see how many beautiful [antique] bronze figures there are placed further back? The true genius of sculpture resides in them, not in this modern rubbish.'[25] The antique sculptures were casts that had been recently taken of the most famous works in Italy (Leoni was to use the same moulds for some of his casts).[26] According to Cellini, the idea of making the casts came from the painter Francesco Primaticcio – who hoped thereby to discredit him at court. After the duchesse's outburst, Cellini claims that the King sprang to his defence, asserting that his work 'not only rivals, it surpasses the antiques'. But seeds of doubt have been sown.

From this time until the nineteenth century, any serious collection had two main strands: antique sculptures and modern paintings from, and after, the time of Raphael. The only modern sculptor to be regularly and knowingly represented in collections was the Florentine mannerist Giambologna. Copies of his bronze statuettes were to be found on smart tables, desks and mantelpieces all over Europe. But these were relatively small exceptions to prove the rule.[27] There was, of course, a huge trade in garden statuary, but most of this was anonymous and a great deal comprised copies or adaptations of antiquities.

When the Dutch portrait painter Daniel Mytens painted a matching pair of portraits of the Earl and Countess of Arundel in around 1618, the Earl – one of the first major English collectors – is flanked by his large collection of antique sculptures, while the Countess is flanked by sixteenth-century painted portraits. Thomas Peacham wrote in his pastiche of Castiglione, *The Compleat Gentleman* (1622), that Arundel

21. **Johan Zoffany**, *The Tribuna of the Uffizi*, 1772-8/9
(Oil on canvas, Royal Collection, London)
The room was not normally so crowded: Zoffany included several works that
were not normally displayed, like the antique group of 'Cupid and Psyche' on
the far left.

gave his countrymen 'the first sight of Greeke and Romane statues', and
for the next twenty years 'continued to transplant old Greece into
England'.[28]

A basically similar scenario – though infinitely grander – is shown in
Johann Zoffany's celebrated picture, *The Tribuna of the Uffizi* (1772–8).
The picture was painted for King George III, and shows some eminent
English Grand Tourists inspecting works by Titian and Raphael, and
classical sculptures such as the Venus de Medici. Except for an '*all'antica*'
bronze statuette on a mantelpiece (*Arion*, by Bertoldo di Giovanni),
which was probably assumed to be antique, the work of Italian sculptors
is nowhere to be seen. Indeed, in the whole of the Uffizi, only a tiny
handful of modern sculptures were exhibited. The best known, because
they were reproduced in the *Museum Florentinum*, were Michelangelo's
Bacchus and Sansovino's *Bacchus*, which were placed up against the wall

155

in the long corridor together with many antique sculptures.[29]

The same scale of values is confirmed by Italian export controls for items of cultural heritage. A ban on the export of antiquities was first instituted by Pope Sixtus IV in 1471. This prohibited such exports from Rome and its territories, and was followed by many other papal bans. Sixtus IV was also the founder of the first museum for antiquities, on the Capitoline Hill.[30] The earliest export ban relating to post-classical art was published in Florence on 24 October 1602 by the Accademia del Disegno. This made it illegal to export the work of seventeen sixteenth-century painters, plus the fifteenth-century painter Fra Filippo Lippi. Pietro Perugino, the teacher of Raphael, was added to the list on 6 November. Michelangelo was the only sculptor to be included, which means that there was not a single full-time sculptor on the list.[31] It is an astonishing statistic when one considers that Florence – the home of Ghiberti, Donatello, Michelangelo, Cellini and Giambologna – was more sympathetic to modern sculpture than anywhere else. On 28 October Siena, which was administered by Florence, followed suit in a more sweeping manner. The city banned the export of 'any picture by dead and famous painters'.

Both the papal and the Florentine initiatives were to be repeated by other Italian cities in later centuries. Thus a strict temporal hierarchy of the arts – whereby sculpture signified antiquity, and painting signified modernity – was enshrined in law.

ALTHOUGH I HAVE said that Zoffany's picture of the Tribuna in the Uffizi features no work by an Italian sculptor, this is not strictly true. After all, an important part of the sculptor's job was the restoration and the copying of antiquities.

The first systematic restoration of antique statues was carried out in the 1520s and 1530s by the sculptor and architect Lorenzo Lotti (1490–1541) when he was organizing a sculpture courtyard for Cardinal Andrea della Valle in Rome. After the 1540s very few of the best antiquities were left in a fragmented state. Vasari concluded his praise of Lotti's complete restorations with the following assertion: 'In truth, antiquities restored in this way have more grace than those mutilated trunks, members without heads, or figures which are in any other way maimed and defective.'[32]

An indication of what restoration could mean in the Renaissance can be gathered from this passage written by the Florentine humanist Angelo

Poliziano, who died in 1494, and who was an acquaintance of the young Michelangelo. It comes from *De divinatione*, the first section of a book about Latin poets, where he talks about restoring ancient texts:

> The second book of Cicero's *De deorum natura* is just as mangled in all ancient and modern manuscripts as was Hippolytus once, pulled apart by frightened horses. The legends tell how Aesculapius later gathered the torn members, pieced them together and restored them to life, for which act he is said to have been struck by lightning as a result of the gods' jealousy. But what jealousy will deter me, what lightning bolt, from daring to restore [*restituere*] the very father of the Roman language and philosophy, whose head and hands have been lopped off again by I know not what Antony? We did this before for his correspondence, and this restoration [*redintegratio*], so to speak, of ours has now been accepted, so far as I know, in that version, clearly printed at last, which we determined on the basis of the early manuscripts.[33]

The restoration of a headless and handless statue could be a similarly Aesculapian task. Indeed, restoration was sometimes not just a great test of patience but also of imagination. The smaller the surviving fragment, the greater the ingenuity required. Most of the antique sculptures that we see in our museums are what Marcel Duchamp might have called 'assisted ready-mades' - they have a 'ready-made' antique core that has been subjected to modern interventions of varying interpretative force.

Many of the Earl of Arundel's antiquities started life as anonymous busts and were 're-worked' by Italian sculptors into portraits of Roman worthies. Louis XIV personally supervised the restoration of statues for the Gallery at Versailles, and each had to be six and a half feet high.[34] Of the antiquities shown in Zoffany's picture of the Uffizi, the *Dancing Faun* was furnished with new arms and head in the sixteenth century, and the additions were considered to be of such high quality that they were attributed (as so often happened in such cases) to Michelangelo.[35]

As a rule, however, serious sculptors had little interest in restoration.[36] Cellini was willing to get involved only if there was maximum room for manoeuvre. Here is how he proposed a restoration of a classical torso to Cosimo de' Medici in 1548:

> My Lord, it's a statue in Greek marble, and it's a splendid piece of

157

work: I don't remember ever having seen such a beautiful antique statue of a little boy, so beautifully fashioned. Let me make an offer to your Most Illustrious Excellency to restore it – the head and the arms and the feet. I'll add an eagle so that we can christen it Ganymede. And although it's not for me to patch up statues – the sort of work done by botchers, who still make a bad job of it – the excellence of this great master cries out to me to help him.[37]

Here Cellini is plastic surgeon, priest and image consultant rolled into one.

A striking example of the radical nature of some restorations is the so-called *Rondanini Faun*. This antique statue of a dancing faun has been part of the British Museum's Department of Greek and Roman Antiquities since the early nineteenth century. Recently, however, it has been made the centrepiece of the Italian Baroque gallery at the Victoria and Albert Museum. This is because the statue was heavily 'restored' by the Rome-based sculptor François Duquesnoy (1594–1643). It was furnished with a new head, arms and legs, and the surface of the original torso heavily reworked. Although Duquesnoy was deemed by his contemporaries to be an 'absolutely perfect' restorer, the elasticity of the faun's pose is now regarded as typical of its time.[38]

In many ways the modern sculptor's involvement in restoration, and in ancillary activities such as making casts and reduced copies of antique originals, put him in a compromising situation. It meant – at least in theory – that the sculptor had to exercise greater humility, and accept greater anonymity, than the painter. At best, he would be famous by proxy: he was an invisible power behind the throne, or a dwarf squatting anonymously on a giant's shoulders. Would it not have been preferable to have found in the Tribuna a sculpture that was 100 per cent Michelangelo?

The sculptor's dilemma was epitomized very early on by the Florentine sculptor and architect Antonio Averlino (c. 1400–1469), who adopted the surname Filarete ('Friend of Virtue'). In 1465 Filarete made the first signed and dated small bronze statuette, and dedicated it to Piero de' Medici. One might see it as a proud and pioneering expression of Renaissance individualism, but it is more complicated than that. The statuette is a small version of the antique equestrian statue of Marcus Aurelius in Rome (though Filarete identifies the Emperor as Commodus). Bronze statuettes had been a popular artform in antiquity,

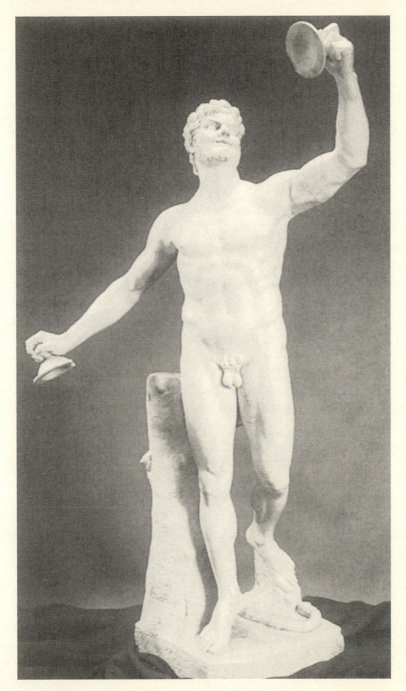

22. **Francois Duquesnoy,** *Rondanini Faun,* c.1625–30
(Marble, Victoria and Albert Museum, on loan from the British Museum).

and they were revived during the Renaissance – but their main use was for the reproduction of antique masterpieces. There are innumerable instances of a Renaissance copy or pastiche being taken for a genuine antique, and vice-versa.[39] Filarete's is one of only a tiny handful to have been signed.[40] He has not made an exact reduction, for the proportions are slightly changed, the harness is polychrome, and the front of the horse is supported by a helmet. Indeed, part of the attraction of making small versions of large-scale statues was that the original could be 'improved' in translation.[41] They could also be examined more thoroughly, and in better lighting conditions, than the original.[42] But the antique derivation of Filarete's statuette is instantly recognizable.

Twenty years earlier Filarete had completed the monumental bronze doors of St Peter's in Rome after more than a decade's work. These included even clearer quotes from antiquity – direct casts of ancient coins and medallions. A modern scholar has written that one must have 'a twentieth-century feeling for revivalistic and *objet trouvé* art in order to appreciate Filarete's approach'.[43] Yet a growing sense of the modern sculptor's lack of dignity and power may explain why Filarete, in his *Treatise on Architecture* (c. 1461–4), argued vociferously for the superiority of painting over sculpture. Not only is sculpture a profession not fit for a gentleman, but 'No matter how good sculpture is, it always appears to be the material it is.'[44] Filarete may have been the first to appreciate how hard it would be for modern sculpture to transcend its origins – social, material and even historical.

The restoration and reproduction of antiquities had become a major industry during Filarete's working life. Venice was the centre during the Renaissance for the trade in fake and genuine antiques imported from Greece and the eastern Mediterranean.[45] But the most celebrated forum for restoration was the Medici sculpture garden. Both Donatello and Verrocchio restored antiquities there for Cosimo de' Medici. Donatello's pupil, Bertoldo di Giovanni (whose *all'antica Arion* was the only modern interloper into Zoffany's *Tribuna*) was subsequently put in charge of antiquities by Lorenzo de' Medici.

Vasari mythologizes the garden. He says that artists were allowed to come to the sculpture garden to study, and that Lorenzo was particularly keen to encourage young sculptors: he regretted that there were far fewer good Florentine sculptors than painters. At the time of writing, Vasari was keen to present the garden as a prototype of his own Accademia del Disegno, but it seems more likely that artists were

primarily employed as restorers – and as makers of pastiche antiques.[46] Michelangelo was the most famous alumnus, and at least one of his works was palmed off as a genuine antique. Lorenzo de' Medici was so struck by the beauty of a statue of a *Sleeping Cupid* that he advised Michelangelo to age it artificially and send it to Rome. There he could sell it as an antique and achieve a far better price.

The sequel to the story is extraordinary. The *Sleeping Cupid* was sold as an antique to Cardinal Raffaele Riario in Rome for a high price. Word then reached Riario that he had bought a work by a Florentine sculptor, whereupon he sent an agent, Lorenzo Galli, to Florence. Having located Michelangelo, Galli prevailed upon him to return to Rome, where he was lodged in the agent's house. Despite being mightily impressed by the *Sleeping Cupid*, Riario returned it to the dealer because it was modern and had thus been sold to him at an inflated price. It was then put back on the market. Isabella d'Este's agent in Rome tried to interest her in it, but she cared only for antiquities – for which she had an 'insatiable desire'.[47] Six years later, however, in 1502, it entered her collection in Mantua. It arrived on a mule, together with an antique Venus, after being looted from the city of Urbino.

Three years later it was furnished with an antique twin, secured by Isabella after lengthy negotiations. The pair were displayed side by side in a niche in her 'Grotta', together with coral branches, shells, fossils, amber and other antiquities. The Cupids were juxtaposed for the edification and amusement of *cognoscenti*. However, it seems that the modern sculpture was usually deemed second best. Isabella wrote in a letter that Michelangelo's *Cupid* 'for a modern work, has no equals'. Subsequent visitors followed suit, and awarded the crown to the antique. We now remember Isabella as a great patron of contemporary painting (she commissioned a series of mythological paintings from Costa, Correggio, Mantegna and Perugino), but not, apart from a revealing exception, of contemporary sculpture.[48] The most distinguished sculptor whom she patronized was Piero Jacopo Alari Bonacolsi, nicknamed 'Antico' because of his exceptional ability to make bronze imitations, and stylish gilt, bronze and silver reductions, of famous antique sculptures.[49]

To a degree, the Renaissance enjoyed creating and consuming fakes.[50] When Alberti was only about twenty, he wrote a light comedy that he successfully passed off as the work of a fictional classical playwright – and it does not seem to have harmed his prospects.[51] Vasari praises Tommaso

Porta in the *Lives* for being the supreme fakist of antique sculpture, and mounted one of Porta's 'antique' masks on the chimney of his house in Arezzo.[52] However, a different kind of fake, passed off by Pomponius Gauricus, the future author of *De Sculptura*, brought disapproval. While studying in Padua, he published 'newly discovered' fragments of Cornelius Gallus. But when it was found out that they were in fact verses of Maximianus Etruscus that had already been published, he was strongly censured by several humanists.[53] A faker obviously received more credit if he had created his own fake, rather than passing off someone else's creation as their own. For the ambitious artist, making a fake was clearly a good way of getting noticed and demonstrating his skill. But it was still a lower order of artistry. Vasari praises Tommaso Porta only in the most perfunctory manner: he grants him a single paragraph. The most important thing was to do what the erstwhile faker Alberti had urged – surpass the ancients.[54]

Michelangelo did, of course, manage to convince vast numbers of his contemporaries that he had outstripped the ancients, and his approval was certain to guarantee fame for an antique statue.[55] But the fact that so many of his sculptural projects ended in incompletion or failure (there is no Sistine or Pauline Chapel of sculpture), and that he virtually gave up sculpture in his later years, makes one wonder if he stopped believing in the viability and validity of modern sculpture. Might he not have felt – on seeing an endless flow of damaged masterpieces pulled from the earth, restored to rude health, and praised and purchased at the expense of modern sculpture – that there was less need for new sculptures than for new paintings?

Paradoxically, his chronic inability to complete so many of his sculptures turned them into antiquities of sorts. After making a handful of highly finished works in his early years, Michelangelo later made sculptures which appear increasingly distressed. They are not just unfinished, but fragmented too. It has been said that with his final works – the two broken and mutilated *Pietàs* – 'antiquity now seems a long way off'.[56] But it is the intact antiquity of the museums that is a long way off; not the smashed and corroded antiquity of the building sites. Michelangelo's sculptures cry out for Aesculapian attention.

Restoration completes as well as starts Michelangelo's career as a sculptor. In 1561 the partly smashed and incomplete *Pietà* which was meant to adorn his tomb was bought by Francesco Bandini and heavily restored by Tiberio Calcagni. For the last three years of his life

Michelangelo could experience one of his own works being treated like a genuine antique from the Medici sculpture garden. This bizarre state of affairs may have been prophesied by Michelangelo early on in his career. It is said that he broke off the arm from his statue of *Bacchus*, then buried the mutilated statue on a building site and waited for it to be dug up by the builders. On discovery, it was acclaimed as an antique, whereupon Michelangelo came forward with the broken arm to prove his authorship.[57] The Dutch artist Maerten van Heemskerck drew the *Bacchus* with a broken arm in 1535, displayed amidst Jacopo Galli's antiquities.[58] This story may be an invention, but it is still revealing. For a modern sculptor, emulating antiquity might even entail sabotaging his own work.

In the next century the job of restoration became increasingly prevalent – and increasingly frowned upon. Fame by proxy lost what little lustre it had had. Many impecunious sculptors (like Duquesnoy) restored part-time to make money, but full-time salaried restorers also came on the scene for the first time. The sculptor and restorer Orfeo Boselli (c. 1600–1667), who worked for Bernini, is on the defensive in his unpublished treatise *Observation on Antique Sculpture* (1650s). While lamenting the fact that the best sculptors no longer do restoration, he asserts that it is 'not a mediocre art, as many people may think, but rather a venture so varied and sublime that it equals the greatest forms of art'.[59] But Boselli was fighting a losing battle. Alessandro Algardi (1595–1654) was one of the best-known restorer-sculptors, but his contemporaries claimed that original work by him in marble was 'cold' and 'confused' because he had spent too much time restoring.[60]

It already seemed to some that the tail of restoration was wagging the dog of original composition. In 1627 an Italian professor of rhetoric, Agostino Mascardi, made an analogy with sculpture when criticizing the way that academics laboured over old texts without offering any new insights. He laments the fact that in Rome he has only ever seen a whole piece of marble in Bernini's studio. The other studios are full of antique fragments: 'these miserable menders of old stone, abandoned by their imagination and betrayed by art, poor in design, and beggars of invention, wear out their lives making a nose through a Tropean operation; in mending an elbow, in attaching a finger, and in retouching decrepit figures with new marble, they succeed only in making (as the ancients used to say) a patchwork'.[61] The Tropean operation is a reference to a family from Tropea who apparently performed successful

rhinoplasty (plastic surgery on the nose) in the sixteenth century. The operation was controversial, however, and some people believed that the nose was in fact displaced to a hole deep in the arm.[62] So Mascardi implies that the restorers end up producing freaks.[63]

But despite the general scorn for restorers, it also became axiomatic that sculptors had to follow the antique more religiously than painters. For all the variety of antique sculpture, sculptors were painted into a much tighter critical corner. Charles Alphonse du Fresnoy, writing in his *Observations on the Art of Painting* (1668), noted that 'Painters are not oblig'd to follow the Antique as exactly as the Sculptors: for them the Picture would savour too strongly of the Statue, and would seem to be without Motion.'[64] His advice seems to have been followed, for in 1765 Diderot could write, 'It seems to me that sculptors follow the antique style more than painters. Might it be because the Ancients have left us some beautiful statues, whereas their paintings are only known to us from the descriptions and testaments of litterateurs?'[65] Later in the same century some critics thought that sculptors' closer proximity than painters to classical models was a point in their favour, but this dependence meant that their reputations were built on a fragile and rather defensive premise.[66]

Winckelmann epitomizes the uncertainty. In *The History of Ancient Art* (1764) he praises some contemporary Roman sculptors who, 'in conformations, forms, and conceptions, far surpass all their predecessors in modern times'. This is because they have engaged 'in a more attentive study of the works of antiquity', through being forced to make copies.[67] But Winckelmann fails to identify a single one of these 'pioneers' (he merely notes their 'modesty'), and the only contemporary sculptor to be named in his *History* is Bartolomeo Cavaceppi, a fabulously rich restorer and dealer who never tried his hand at original work after his student years.[68]

Later on Winckelmann changes tack, and lays the blame for any 'deformities' in antique sculpture at the door of restorers,[69] attacking copying: 'It cramps the spirit to copy . . . the imitator has always proved inferior to him whom he has imitated.'[70] This proviso did nothing to save the reputation of non-copyists like Bernini. Neo-Classical critics berated him for betraying the cause. A follower of Winckelmann, Francesco Milizia, was amazed that Bernini could have strayed from the antique path in Rome, of all places: 'From his infancy and throughout the course of his very long life, Bernini was surrounded by the master-

pieces of antiquity existing in Rome. He saw them every day, at every hour. Yet he renounced them so completely, it is as if he had never seen them.'[71]

Some art historians have tried to argue that after the High Renaissance, painters suffered from what literary critic Harold Bloom has termed the 'anxiety of influence'.[72] In other words, the veneration in which painters like Raphael were held made it hard for them to have confidence in their own efforts, or in their own originality. They were left to paint feeble footnotes to the High Renaissance. But until the late nineteenth century, any 'anxiety of influence' felt by painters was mere hypochondria compared to the long-standing second-class citizenship endured by sculptors.

IN THE EIGHTEENTH century restoration became even more dominant. By the middle of the century the demand for antiquities – particularly from British *milordi* – was so great that many of the best Roman sculptors worked exclusively as restorers and copyists.[73] The English were the worst offenders, but the French and Germans were not that far behind. La Teulière, Director of the French Academy in Rome at the end of the seventeenth century, set the tone: 'I would prefer good copies after the antique than mediocre originals.'[74] Indeed, in 1707 he suggested that the Academy should be closed down, since sufficient quantities of casts of antique sculpture had already been sent back to France.[75] The only modern sculpture that generated widespread enthusiasm was portrait busts – albeit, *all'antica*. For a sculptor, originality was not a very lucrative proposition.[76]

Later in the century the prevalence of restoration and copying was being increasingly blamed for the decline of sculpture in Italy. The French connoisseur Quatremère de Quincy recalled how, on his first visit to Rome in 1776, he had asked to be taken to sculpture studios. He had been shown nothing but restored antiquities. When he was at last shown some original work by the famous restorer Cavaceppi, it was an insipid pastiche of Bernini, presumably a piece of juvenilia.[77] The anecdote is partly meant to prepare the way for the miraculous arrival on the Roman scene of de Quincy's hero, Antonio Canova. But others felt even more strongly that sculptors in Rome were overwhelmed by the past.

In Herder's treatise on sculpture, *Plastik* (1778), the German bewailed the artistic impotence of sculptors in Rome – home to the largest

collection of surviving antiquities: 'It is a tragic and irreparable loss, but perhaps a good thing, that the barbarians destroyed so many of them. Their number can lead us astray and overwhelm us . . .'[78] In this, he was following in the footsteps of the Italian philosopher Giambattista Vico, who had suggested earlier in the century that, in the interests of originality, all the best artistic models – and especially antique sculpture – ought to be destroyed.[79]

Canova tried to assert his independence from tradition by refusing to restore antiquities when he arrived in Rome. Indeed, he contributed to the rising tide of hostility to restoration, and to the growing appreciation of fragments, by declining a request to restore the Elgin Marbles. He sought a *carnosita* (fleshiness) in the surface qualities of sculpture that linked him with painters such as Rubens and Titian, as much as with antique statuary. Thanks to this, his most assiduous critic, Carl Ludwig Fernow, accused him of having betrayed the canons of classical sculpture, and compared him to the dread Bernini. Fernow preferred Canova's more chaste Danish contemporary Thorvaldsen (who, incidentally, heavily restored the Aegina Marbles, now in Munich).

In a letter of 26 November 1806 to Quatremère de Quincy, Canova defended his approach: 'To become a truly great artist you must do more than just borrow here and there from antique pieces and throw them together without any sort of evaluation. Better study Greek examples day and night, be steeped in their style, impress it in your mind; and then develop your own style, but always looking to beautiful nature, seeking in it those same principles.'[80] Canova's principled stand paid off handsomely. From early on in his career he could command prices that compared favourably with those for newly discovered antiquities. Historical events would, however, have told Canova to be wary of considering himself the practitioner of a living art.

In 1796 Napoleon's armies invaded Italy. North and central Italy were defeated within a few months. Separate peace treaties were made with the heads of the various states, but they all included an unprecedented feature: from each state Napoleon demanded a certain number of paintings and/or antique sculptures. Whereas the Duke of Parma had to hand over twenty paintings, the Pope had to relinquish eighty-three sculptures, seventeen paintings and five hundred manuscripts. The loot was carted back to Paris and installed in the Louvre – or rather the Musée Napoléon, as it was renamed in 1803. The Old Master paintings were

displayed in the Grand Galerie and the antique sculpture on the ground floor.[81]

Not a single post-classical sculpture was taken from Italy. Indeed, the only post-classical sculpture of note to be requisitioned in all Napoleon's campaigns was Michelangelo's *Bruges Madonna*, which was taken during the Belgian campaign of 1794. The niches in the Grande Galerie contained a handful of modern and ancient sculptures, but the fact that we know so little about them – what they were, and for how long they were displayed – suggests that they were mere background muzak.[82] The main event was the masterpieces of European painting, which had been carefully selected and hung.

We do know that Michelangelo's *Slaves* were on display from 1794. They had been rescued by Alexandre Lenoir from the mob that was ransacking a house and garden belonging to the descendants of Cardinal Richelieu. They had been there since the seventeenth century. Like most statues in French collections, they had been placed outdoors, flanking a balcony that faced on to the garden.[83] The *Slaves* performed a similar function in the Grande Galerie: they had a 'decorative role, framing but not crossing the entrance'.[84]

It is symptomatic that Michelangelo's paintings were almost always regarded far more highly than his sculptures. Joshua Reynolds, the great eighteenth-century idolizer of Michelangelo, could still only single out one of Michelangelo's sculptures in his *Discourses* – the *Moses*.[85] John Flaxman disapproved even more strongly. In his Royal Academy *Lectures on Sculpture*, he focused entirely on Michelangelo's frescoes, because his sculptures lacked the 'chaste simplicity of Grecian art'.[86]

In stark contrast, a wide variety of European painting entered the Musée Napoléon. The most highly rated artists were the sixteenth- and seventeenth-century painters Raphael, Correggio, Veronese, Titian, Rubens, Domenichino, Reni, Guercino and the Carracci. But paintings by Van Eyck, Holbein, Dürer, Leonardo, Van Dyck and Rembrandt were also displayed. And in 1814 a pioneering exhibition was held of looted paintings by Italian 'primitives'. It featured works by Cimabue, Giotto and Fra Angelico. Taste had been stretched further than ever before – though not as far as Ghiberti or Donatello.[87] That said, even when the antique sculptures from Italy were on show, the picture galleries drew the biggest crowds. An English visitor, Henry Redhead Yorke, remarked, 'The herd of men flock to the gallery of paintings to indulge their eyes with the brilliant luxury of beauty but in the hall of

statuary very few admirers greet the trophies of French conquest.'[88]

Although there was scarcely any post-classical sculpture in the Musée Napoléon, this did not prevent Napoleon's family from being Canova's devoted patrons. One of Canova's biographers even claimed that he was offered the Directorship of the museum. Eventually, after the fall of Napoleon, Canova was to preside over its dismantling. He arrived in Paris on 28 August 1815 as the Pope's emissary, charged with bringing back the looted antiquities and paintings. One can only wonder what he was thinking as he made his way through this palace of art created by his great patron – a patron who was reputed to have said, 'If I weren't a conqueror, I would wish to be a sculptor.'[89] Seeing little but antique sculpture and modern painting must have been a bit like attending his own profession's (as well as Napoleon's) funeral.

Examples of Canova's work, and that of a few other post-classical sculptors, were eventually shoehorned into the Louvre, but in less than ideal circumstances. The Musée de la Renaissance, which was created inside the Louvre in 1824, was a showcase for modern sculpture. It was small, closed to the public – and controlled by the department of classical antiquities. It only became accessible to the public in 1835, and even then only with the greatest difficulty. Its scope went far beyond what we now understand by the Renaissance. The exhibits ranged from Michelangelo's *Slaves* and Germain Pilon's *Three Graces* (1561–3) to Edme Bouchardon's *Cupid* (c. 1740) and two works by Canova. It would have been a Babel of disparate styles, eras and nationalities, a giant step backwards from Lenoir's Museum of French Monuments, and perhaps even from the niches in the Grande Galerie.[90]

HEGEL'S CREATION in his lectures of the 1820s of a temporal hierarchy of the arts – whereby sculpture reached its apogee with the Greeks, and painting was a Christian art extending into the present – was a literary counterpart to the Musée Napoléon. Much subsequent thought about the arts was also shaped by it. When Delacroix wrote the following in 1857, he was writing a cliché: 'One can say of painting as of music, that it is essentially a modern art . . . Paganism gave sculpture a satisfactory career . . . Christianity, on the contrary, summons the life within: the aspirations of the soul, the renunciation of the senses, are difficult to express in marble and stone: it is, on the contrary, the role of painting to give expression to almost everything.'[91]

The late nineteenth-century cult of Leonardo, many of whose

surviving paintings were in the Louvre, was also symptomatic of this post-sculptural consciousness. In 1869 Walter Pater contrived a *paragone* in his famous essay on the artist: 'Set [the Mona Lisa] for a moment beside one of those white Greek goddesses or beautiful women of antiquity, and how they would be troubled by this beauty, into which the soul with all its maladies has passed! All the thoughts and experience of the world have etched and moulded there . . .' He goes on to say, as we all know by heart, that she is 'older than the rocks among which she sits' and a 'diver in deep seas'. It is a contrast between pre-Christian innocence and post-Christian experience – and the latter is the more compelling. Painting plumbs the depths.

As the Greek ideal was itself challenged, people started to look with curiosity, if not complete conviction, at other forms of sculpture. Some of this post-dated the classical age, but it was still hard to establish sculpture's relevance. In Marcel Proust's preface to his 1904 French translation of Ruskin's *The Bible of Amiens*, the medieval Vierge Dorée on Amiens Cathedral is contrasted with the *Mona Lisa*.

> Coming no doubt from the quarries near Amiens, having made only the one trip in her youth to come to the porch of Saint Honoré, not having moved since, having been weather-beaten little by little by the damp wind of the Venice of the North which bent the spire above her, gazing for so many centuries on the inhabitants of this city of whom she is the oldest and most sedentary, she is truly an Amienoise. She is not a work of art.

By contrast, the Mona Lisa is 'the Mona Lisa of [da] Vinci . . . what does her birthplace matter to us, what does it even matter to us that she is naturalized French? – She is rather like a wonderful woman "without a country". Nowhere where thoughtful looks meet hers could she ever be a "displaced person".'[92]

Proust is moved by the Vierge – she is a 'beautiful friend we must leave at the melancholy provincial square from which no one has ever succeeded in taking her away' – but there is an awful feeling of futility about Amiens' 'oldest and most sedentary' citizen. Leonardo's painting is a cosmopolitan citizen of the world, always alive to 'thoughtful looks'. The Vierge is a lovely cul-de-sac, a lame duck.

To many commentators, retrospection seemed to be intrinsic to the creation and reception of sculpture. In Hawthorne's *The Marble Faun*

(1860), Miriam tries to get her sculptor friend to admit that 'you sculptors are, of necessity, the greatest plagiarists in the world'.[93] The Futurist painter Umberto Boccioni (1882–1916) was to paint a similar picture of the situation in his *Technical Manifesto of Futurist Sculpture* (1912), but in much more brutal terms. He lamented that:

> sculpture of every country is dominated by the moronic mimicry of old, inherited formulas . . . Latin countries are bowed down under the opprobrious burden of the Greeks and Michelangelo . . . In the Teutonic countries we find nothing but a kind of gothicky, Hellenophilic fatuity . . . In Slav countries, on the other hand, we have a discordant clash between an Archaic Greek style and Nordic and Oriental prodigies.[94]

Two years later, in another manifesto, he would even add tribal carvings to his hit-list of sculptures that were moronically mimicked. While he acknowledged that African wood carvings 'have helped to free us from classicism', they still represented yet another 'obsession with the past, a cultural phenomenon related to the influence of the classical world'.[95]

Boccioni could not understand how 'thousands of sculptors can go on, generation after generation, constructing puppet figures without bothering to ask themselves why the sculpture halls arouse boredom or horror, or are left absolutely deserted; or why monuments are unveiled in squares all over the world to the accompaniment of general mirth or incomprehension'.[96] What made matters even worse was that the situation was not so bad in painting, 'since painting is continually undergoing renewal'. Though this process of 'modernization' is very slow, it still provides 'the best and clearest condemnation of all the plagiaristic and sterile work being turned out by all the sculptors of our own days'.[97]

Boccioni's solution was to create sculpture that was dynamic rather than static. He was not only rejecting Winckelmann's ideal of 'calm grandeur', but also the culture that created Proust's 'sedentary' Vierge and that appreciated tribal art. He was repelled by 'hieratic immobility' and 'antique solemnity'. Instead, he sought inspiration from a 'barbaric element in modern life'. This element could not be manifested in static, idol-like figures, but only in those whose 'lines and outlines . . . exist as forces bursting forth from the dynamic actions of the bodies'.[98] Boccioni, with his whirling vision of exploding forms, was trying to stop sculptors from merely looking over their shoulders with tunnel-vision. He was

searching for a sculpture that did not live passively by proxy and that was unashamedly of its time.

With hindsight, though, Boccioni would seem to protest too much. For what makes this historical moment so special is that Boccioni and his painter contemporaries were keen to have a hands-on role in the reformation of sculpture. They were not satisfied with merely sniping at it from the wings.

Part Two
The Art of Modernity

8. Worker-Artists i: Courbet to Picasso

– no inspiration, but only work . . .

<div align="right">Auguste Rodin, 1907[1]</div>

I am battling with sculpture: I work work work and I don't know what results . . .

<div align="right">Umberto Boccioni, 1912[2]</div>

DURING THE COURSE of the nineteenth century, while painters had established themselves as the pre-eminent 'gentleman'-artists, the over-whelming majority of sculptors still tended to be regarded as tradesmen who went about their business in a workshop or factory, rather than in a studio. But even as the cult of the painter became ever more extreme, the first seeds of a counter-revolution were being sown. Artists started to challenge the assumption that they were superior, special beings. Instead of associating themselves (however fractiously) with the denizens of élite society, they cultivated the image of men of the people. The myth of the worker-artist was born. This primitivizing cult was to change the course of art.

Since sculptors already, by and large, had the status of workmen, the practice of sculpture gained a certain cachet. Thus we find, in the last 150 years, enormous numbers of painters trying their hand at sculpture.[3] By no means all of them would have thought of themselves as worker-artists, but many painters were drawn to sculpture by the myth of the workman-like. The painter-sculptors range from academic artists, like Leighton, Landseer, Meissonier, Watts, Gérôme and Sargent, to the more avant-garde figures of Courbet, Degas, Gauguin, Renoir, Eakins, Picasso, Matisse, Modigliani, Boccioni, Ernst and Miro. In the post-war

period Pollock, Newman, de Kooning, Kelly, Dubuffet, Fautrier, Johns, Warhol, Stella, Morley, Kirkeby, Kiefer, Baselitz and Schnabel have all made sculpture. Equally, there are many painters who have made object-based art, such as Duchamp and Dalí. A German critic, writing in 1922, said that for many painters sculpture was a 'secret love'.[4]

Even in Karl Marx's *German Ideology* (1845) we see pressure being put on painters to avoid narrow specialization: 'In a communist society there are no painters but at most people who engage in painting among other activities.'[5] Marx wanted to normalize the painter, force him to do less rarefied activities. In the twentieth century these 'other activities' have included things like film-making and performances. Still more have marked their rejection of 'élitist' values by painting mural- and billboard-scale pictures.

But the migration into three dimensions, with its connotations of the 'workman-like', has been by far the most striking and radical phenomenon (even if it is not quite what Marx had in mind). Directly related to this is a marked emphasis on the painting's status as an object: thick and complex impastos, collage, shaped and unframed canvases have become ubiquitous. Some painter-sculptors were just momentarily slumming it, or flexing their creative muscles, but for a significant majority object-based art has answered a genuine need. It allows the painter to imagine that their art partakes of, and projects into, the 'real' world. It no longer hangs aloofly on a wall.

At the same time it has become a cliché for artists to downplay and even dismiss notions of artistic 'inspiration' and 'genius', and to exalt the more matter-of-fact and even collaborative aspects of their profession. The birth of the worker-artist is thus the corollary to the so-called 'death of the author'. All these developments underpin the ascendency of sculpture and object-based art.

GUSTAVE COURBET (1819–77) is the first important example of a worker-artist. Symptomatically he is a painter who used thick impastos, and a painter who made sculpture.

Early on in his career Courbet painted a number of self-portraits in which he appears to be searching for, and toying with, his identity. He portrayed himself with a black dog, a pipe and a cello, in a range of moods – dandyish, melancholy and aggressively louche.[6] These self-portraits were fairly standard images of the Romantic painter. The identification with a cellist, for example, was a cliché in an age that often

23. **Gustave Courbet**, *The Sculptor*, 1845
(Oil on canvas, Private Collection, New York).

regarded music as the supreme artform. But in 1845 the 25-year-old artist painted a self-portrait in which he presents himself as a foppish sculptor in a rocky and wooded landscape.[7] Thematically – and, to a lesser extent, aesthetically – it is one of the most prophetic pictures of the nineteenth century.

The young Courbet wears a debonair medieval costume and has been

177

carving directly into the rock with a mallet and chisel. Now he is resting. He leans his head back, displaying an almost post-coital mixture of enervation and ecstasy. We can dimly discern what he has been carving in the rock. It is a woman's head propped against an amphora. Real water pours from the mouth of the amphora, because the rock contains a natural spring, into a stream that wells up in the bottom corner of the picture. One critic has drawn attention to the confrontational nature of the picture and the feeling that its contents are 'spilling over' into the world of the viewer.[8]

The conceit of a sculpture being carved from the 'living rock' or, indeed, from the earth, was not especially new. Numerous sculptors, including Michelangelo, had toyed with the idea of carving mountains, while in many Renaissance grottoes the sculptures looked as though they had been carved directly out of the rock. But these proto-Land Art notions had recently been put into practice in a major way. The *Lion of Lucerne* (1819–21), by Canova's great rival Bertel Thorvaldsen, was cut out of a cliff face. It was a memorial to the Swiss Guards killed in the French Revolution, and consisted of a wounded lion stretched out in a cavernous niche. Its composition was highly original: 'The whole rock-face, indeed the whole "elemental" setting with fresh spring water below, trees on either side and small plants sprouting from fissures in the cliff, is . . . part of the work of art, forming, in fact, a new type of total "art work".'[9] Courbet's combination of stone, water, woman and vegetation is a more modest variation on this theme, whereby the world is shaped by the sculptor.

Courbet's self-portrait is a landmark. Until this moment it was sculptors who tended to dream of being painters; now we have a painter dreaming of being a sculptor.[10] Even more importantly, the worker-artist Courbet would turn his dream of being a sculptor into reality. He included a plaster portrait medallion of the wife of the socialist poet Max Buchon in his second one-man show at the 1867 Exposition Universelle.[11] He also showed a bronze statue, *Le Pêcheur de Chavots* (The Boy Catching Bullheads), modelled on another of his statues that had been erected on a fountain in his home town of Ornans. It was redolent of Donatello's *David* and featured a naked adolescent peasant boy prodding fish with a harpoon. Courbet made other reliefs, and several busts, including a female bust in white marble of *Helvetia*, in homage to 'Swiss hospitality' after he had lived there during his period of exile from France.[12] This was erected in 1875 in front of the church in La Tour de

Peilz on Lake Geneva.

But why should Courbet have pursued this interest? He seems an unlikely sculptor. After the fall of the Paris Commune in 1871, Courbet, who had been President of the Arts Commission, was blamed for the destruction of the Vendôme Column, and the new government ordered him to pay for its rebuilding. In a cartoon of the time, Courbet is shown receiving the 'humble petition of the bronze men of Paris, who ask not to be melted'.[13] He and other realists were also routinely accused of (metaphorically) mutilating statues of 'virgin goddesses' with the 'hammer of a stonebreaker'. This was a reference to Courbet's *The Stonebreakers* (1850): its 'message' was assumed to be that a rebellious mob of stonebreakers might one day 'break' the state.[14]

The medieval costume worn by the youthful sculptor in Courbet's painting gives a clue as to why Courbet might have taken a positive and personal interest in sculpture. The nineteenth century was intoxicated by the Middle Ages, and used them as a stick with which to beat the modern world. Whereas its citizens believed modern society to be fragmented, individualistic and materialistic, they saw medieval society as organic, co-operative and spiritual. The gothic cathedral was the great unifying and, above all, *natural* symbol. It became standard practice to compare gothic architecture with petrified forests. Goethe thought the tower of Strasburg Cathedral was 'a lofty, wide-spreading tree of God, declaring with a thousand branches, a million twigs, and with leaves as numerous as the sands of the sea, the glory of the Lord, its Master'.[15]

But the Middle Ages furnished examples of sexual as well as spiritual desire. It was the age of chivalry. In the garden of Lenoir's Museum of French Monuments, an extraordinary canopied sepulchre was set up to the medieval lovers Abelard and Héloïse.[16] Their tomb was the favourite of both Lenoir and the public. He claimed that those who stood near the monument might easily believe they heard '*soupirs de tendresse et d'amour . . . Héloïse! Abelard! Abelard! Héloïse!*'[17] Courbet's self-portrait brings together the mythology that had grown up around medieval cathedrals and graveyards. Not only is it set in a 'labyrinthine' forest, with sheer cliffs in the background, but the sculptor is emitting '*soupirs de tendresse et d'amour*' as he carves his homage to womanhood.

The medievalists assumed that the medieval artist was superior to his modern counterparts. Instead of having to pander to the fickle and fashion-led market-place, and being obsessed with novelty and prestige, medieval artists were assumed to be immune to such petty and

corrupting concerns. They worked with and for their communities, willingly and contentedly. The liberal philosopher Edgar Quinet, writing in 1839, argued that the gothic represented the unification of mankind in all its diversity. It was the creation of master-masons in towns where feudalism had been superseded by the establishment of municipal councils.[18] The moment that marked the end of the Middle Ages varied according to the writer, and often embraced the Renaissance up to and including Michelangelo.

In such visions of the Middle Ages, the central figure is often the mason-cum-sculptor. John Ruskin gives one of the most stirring accounts of the medieval sculptor in *The Stones of Venice* (1851–3). After describing the degrading 'slavery' in which the modern worker lives, Ruskin urges his reader to 'go forth again to gaze upon the old cathedral front, where you have smiled so often at the fantastic ignorance of the old sculptors'. Here they should 'examine once more those ugly goblins, and formless monsters, and stern statues, anatomiless and rigid'. But they are not to mock them – 'for they are signs of the life and liberty of every workman who struck the stone; a freedom of thought, and rank in scale of being, such as no laws, no characters, no charities can secure'.[19] Elsewhere Ruskin celebrates the 'uncouth animation' of northern gothic sculptures, 'full of wolfish bite' and 'changeful as the clouds that shade them'.[20] The variety and even the imperfection of gothic sculpture is evidence of the sculptors' freedom, and of their ability to express 'their weaknesses together with their strength'.[21] The 'Gothic heart' is characterized by an 'unselfishness of sacrifice, which would rather cast fruitless labour before the altar than stand idle in the market'.[22]

This vision was located firmly in the past, and early Neo-medieval artistic groups, such as the German Nazarenes, were overwhelmingly composed of painters. But William Morris, Ruskin's greatest disciple, did give sculpture a leading role in a feminized and post-industrial future. In his utopian novel set in the twenty-first century, *News From Nowhere* (1890), the only artists we meet are the diligent Mistress Philippa and her beautiful, black-haired – and presumably illegitimate – daughter. Mistress Philippa is the 'head carver', and her daughter is her assistant. Together they are carving a wreath of flowers surrounded by figures on to the façade of a wooden house by the Thames. It will be the 'prettiest house' possible.[23]

The carving in Courbet's self-portrait has been described as 'inchoate',[24] but this is Courbet's way of expressing his own 'life and

liberty'. Indeed this painting, in which Courbet depicts himself as a medieval artisan, offers the first unequivocal evidence of Courbet's desire to be a 'worker-artist'. The notion of the worker-artist gained ground in the 1830s and 1840s, when there was increasing interest in popular folk art and rustic poetry. Several poets – some of whom were socialists – adapted and aped vernacular language.[25] In the 1840s the popular *chansonnier* Pierre Dupont celebrated the life of weavers and peasants, and that of the proletariat, in *Le Chant des Ouvriers*. Baudelaire's outburst against sculpture at the Salon of 1846 takes place against this backdrop: it is because sculpture is closer to nature that 'our peasants are enchanted by the sight of an ingeniously-turned fragment of wood or stone'.[26]

Courbet was first described as a worker-artist in a scathing piece of criticism of 1851: 'To me, M. Courbet must have spent a long time painting signs, especially those of stove-setters and coal-merchants. Probably he aimed no higher than this when he travelled the fairs – so the rumour goes, and they tell us that it is true – showing his incredible canvases in a booth with a great sign: GREAT PICTURES OF COURBET, WORKER-PAINTER.'[27] In this version of events, Courbet's desire to be a worker-artist has led him to renounce easel-painting and associate himself with sign-painting. Although a shop sign would probably have been painted on wood, there is little suggestion here that being a worker-artist necessarily entailed an interest in object-based art. But Courbet certainly did show an interest.

That the cult of the worker prompted Courbet to try his hand at sculpture is attested to by a letter written in 1862 to Léon Isabey. Having mentioned the sculptor Louis-Joseph Leboeuf, who had exhibited a full-length statuette of Courbet at the 1861 Salon, he adds wryly but affectionately, 'Sculptors are sedentary and theirs is, in a way, the life of a workman. They need someone to make the soup.'[28] His own efforts in sculpture at this time would have been prompted by just such considerations. In December 1861 Courbet opened an art-school in Paris, but instead of dictating to his students, he proposed to run it as a 'group atelier, recalling the fruitful collaborations of the Renaissance ateliers'.[29] For Courbet, the Middle Ages and the Renaissance amounted to the same thing: an era of freedom and equality. The first piece that Courbet did at what he referred to as his 'students' atelier' was the Donatello-esque *Boy Catching Bullheads*.[30] One of his first efforts was a plaster portrait of the wife of Max Buchon. In 1865 he referred to her as the 'mother of Realism'.[31]

A further stimulus to Courbet's efforts to become a painter-sculptor would have been the cult of Michelangelo, which had been gathering momentum throughout the nineteenth century and would reach frenzied proportions in 1875, with the celebrations of the fourth centenary of his birth. Whereas the attention of previous generations had been largely directed towards Michelangelo's paintings, he was now increasingly recognized as a sculptor. The organizers of the centenary celebrations in Florence were keen to stress that his genius had been most evident in marble,[32] and commissioned a painting of Michelangelo carving *Moses*. Although this emphasis would have been influenced by the paucity of painted work by Michelangelo in the city,[33] such a view was by no means unique. In 1849–50 Delacroix had painted *Michelangelo in his Studio*, which shows a brooding rugged Michelangelo dwarfed by the *Medici Madonna* and the leg of *Moses*. The great man's tools lie on the ground. The figure of Michelangelo was assumed to be a self-portrait of Delacroix by an early critic, and this interpretation stuck.[34] One of the first casts ever taken of Michelangelo's *David* was presented by the Grand-Duke Ferdinand III of Tuscany to Queen Victoria in 1856, and it was soon to become one of the most famous artworks in the world.[35] *L'Art*, a sumptuous new French art journal, which began publication in the anniversary year of 1875, put *Moses* on its masthead. Subsequent painter-sculptors, such as Picasso and Matisse, had casts of the Louvre *Dying Slave* in their studios.[36]

THE CULT OF the worker-artist also stimulated Courbet's revolutionary painting methods. He added sand to his oil-paint, and created rich impastos through the use of a bristle brush, palette knife, spatula and even his own fingers.[37] This aspect of his work was mocked in a caricature of his painting *The Wave*, where the surf is a solid block of pigment served up on a cake-knife by a rugged-looking hand, with the caption: 'Allow me to offer you a slice of this light [*légère*] painting.'[38] A caricature from 1863 depicts Courbet's *Le Retour de la Conférence* as a bas-relief.[39] Another from 1852 shows Courbet standing in front of a canvas while his model, an infuriated farmer, bombards him with implements.[40] A spade is impaled in the canvas, and this collage-cum-assemblage gives a good sense of the intrusive materiality that contemporaries discerned in his art. John Berger has called Courbet the 'heroic St Thomas of painting – in so far as he believed in nothing which he could not touch and judge with his hand'.[40]

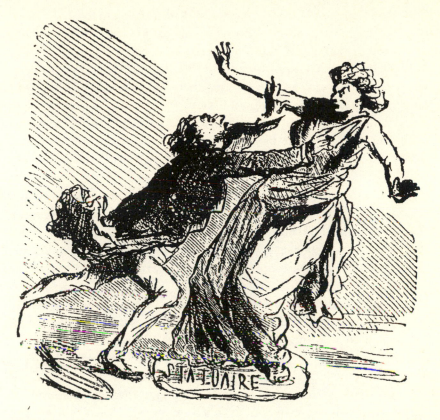

M. Courbet se jetant cette année dans les bras de la
sculpture qui recule épouvantée.

24. Cham, 'M. Courbet throwing himself this year into the arms of Sculpture
who recoils in terror'
(Engraving, in *Le Charivari*, 7 May 1865).

Links between thick impastos and a workman-like approach to art had
already been made by critics earlier in the century when writing about
the landscape paintings of John Constable (1776–1837). Constable
pioneered the thickly impastoed oil sketch, begun – if not always
finished – on the spot. It was variously said of his pictures that it looked
as though 'a plasterer had been at work where the picture hung'; that the
picture had been 'scattered over, whilst the colouring is fresh, with a
huge quantity of chopped hay'; and that his method was akin to 'keeping
up the scaffolding, after the house is built'.[42] These similes took their cue

from Constable's own subject-matter, with its references to rural labour. But Courbet's textural innovations, and his less idealised subject-matter, were thought to be even more outrageous.

Thick and varied impasto was to become a calling card of later worker-painters, such as Vincent van Gogh (1853–90). The Dutch artist agreed with a famous saying about Millet's *Sower* – that the sower appears to be painted with the very earth that he is sowing. He was to say something similar about his own major peasant picture, *Potato Eaters* (1885): 'I have tried to emphasize that those people, eating their potatoes in the lamplight, have dug the earth with those very hands they put in the dish, and so it speaks of *manual labour*, and how they have honestly earned their food.'[43] The heavy, clotted impasto was meant to speak directly of manual labour – a world of rough rather than smooth skins. Paradoxically, of course, a technique meant to emphasize down-to-earthness and solidarity came to signify the extreme subjectivity of the artist.[44]

Some Old Masters had emphasized facture. But they were relatively few and far between. Indeed, in earlier centuries artists who insisted on painting in an unorthodox way were usually advised to begin with a painstaking and fine technique and to adopt a rough manner only late in life – as did Titian and Rembrandt. Technical experimentation of this kind was not seen as something for the young, or the less than brilliant artist.[45] But this rule-of-thumb starts to break down during the nineteenth century. Never before had the physical construction of the surface of the painting been exposed in such a blatant and varied way by so many artists – and at such early stages in their careers. Technical innovation was starting to be normalized.

Many of the issues I have been discussing come together in the American painter-sculptor Thomas Eakins (1844–1916). When Eakins arrived in Paris in 1866 to study in the studio of the French painter-sculptor Gérôme, he wrote to his father, 'It is an incalculable advantage to have all around you better workmen than yourself.'[46] Later, he is pleased to be producing 'solid, heavy work'. The American artist most admired by Eakins was the self-taught sculptor William Rush (1756–1836), who worked in wood and terracotta, and who specialized in allegorical figureheads and scrolls for ships. Eakins painted several pictures of him at work.[47] The first of these was *William Rush Carving His Allegorical Figure of the Schuykill River* (1877). Eakins made statuettes in wax of the main figures and of the sculptures in Rush's studio. This was

a procedure he regularly used when planning a painting. He also made independent sculptures, carving several reliefs and modelling the horses for two public monuments. After 1900 he modelled portrait figures in his studio and collaborated with his sculptor friend Samuel Murray on other portrait subjects.[48]

In the first version of the William Rush pictures, the sculptor is in period costume, and Eakins has put his own signature on a fragment of wood lying in the studio. In the version of 1908 Rush wears workman's clothes. The model's minder concentrates on her knitting and Rush has a similar absorption in his own work. The studio is a simple workshop and the wall is covered in saws and tools. This time Eakins signed one of Rush's architectural scrolls. As Rush was little known to Eakins' contemporaries, he wrote an explanatory statement on a piece of cardboard to be exhibited alongside the picture. Its first paragraph could hardly be more matter-of-fact:

> William Rush was a celebrated Sculptor and Ship Carver of Philadelphia. His works were finished in wood, and consisted of figure heads and scrolls for vessels, ornamental statues and tobacco signs called Pompeys. When after the Revolution, American ships began to go to London, crowds visited the wharves there to see the works of this Sculptor.[49]

In Eakins' final picture of Rush, *William Rush and His Model* (1908), Rush is a stocky figure seen from behind wearing overalls. It is thought to be a self-portrait of the painter.[50]

SCULPTORS WERE slower than painters to make a virtue of their being worker-artists. There was less incentive for full-time sculptors to take on this mantle when so many people already assumed they were workers. It was stating the obvious, not the exotic. They were also slower to represent workers: 'Nearly thirty years elapsed before any French sculptor produced a worker as believable as Courbet had created in his *Stonebreakers*, and yet another decade passed before such a worker appeared in the context of a permanently installed monument.'[51] Those that were produced were idealized genre figures in the nude. Courbet's *Boy Catching Bullheads* is a case in point. It is as smooth as a bar of soap. It was perhaps more than enough for Courbet to lead the life of a soup-slurping workman while making the sculpture. He could not take the

process one step further and sculpt an image of a worker that was as workman-like as the carving included in his early self-portrait.

From the 1880s, however, sculpted images of workers became much more widespread in European art. Two Italian sculptors were important pioneers. Achille d'Orsi's *Proximus Tuus* (1880) depicted an exhausted yet contemplative farm worker sitting on muddy soil with his hoe. Vincenzo Vela's *Victims of Labour: Monument in Honour of the Workers who Died during the Building of the St Gotthard Tunnel* (1882) imbued the workers who carry a stretcher with a scrawny and dogged muscularity. Most important of all, however, were the worker images of the Belgian sculptor Constantin Meunier. His sculpture *The Hammerman* (1886) caused a sensation at the Paris Salon. He also made sculptures of miners, foundrymen, glassworkers, fishermen and rural labourers, and an ambitious *Monument to Labour* occupied the years leading up to his death in 1905. A contemporary Belgian critic wrote that the worker was no longer 'the vague, far-off person who gets talked about when catastrophes occur; he has made his way into the town, he has set up camp in the art rooms, he has taken up residence in the museums, he has come from distant horizons to make his real, living, tragic presence felt, and he is someone with whom a number of age-old scores will soon have to be settled'.[52] Sculpture, with its potential for decisive occupation of space, was vital for making that presence felt.

According to the leading French sculptor Jules Dalou (1838–1902), work was 'the cult called forth to replace past mythologies'.[53] Dalou made much of the fact that he too was a worker – 'we are artisans before we are artists'[54] – and included his own self-portrait together with that of other workers in a monument to *J.-C.-Adolphe Alphand* (1899), the Director of Public Works for the City of Paris. He wears a worker's smock and holds a mallet and chisel.[55] Dalou was very moved by an incident that occurred while he was studying workers in the countryside during the summer of 1894. A peasant had enquired about Dalou's profession and, on receiving the answer, replied: 'An artist, what is an artist?'[56]

For Dalou, the division of labour that was necessary for the production of monumental sculpture had the advantage of bringing him into direct contact with the proletariat. At the unveiling ceremony for his monument *Triumph of the Republic* in 1889, which included a robust figure of a blacksmith dressed in apron and boots, Dalou believed that there were no workers present in the vast crowd of around 100,000

people who filed past the monument. He was disappointed: 'Where was the army of labour hiding during this old-fashioned gala? Where were my *praticiens*, my *adjusteurs*, my casters, and my plaster workers? or the millions of arms which create? or those who labour the soil? I saw guns and sabres, but not a work tool.'[57] Of course this idea of close comradeship between sculptor and *praticien* was a bit of a myth. Assistants rarely appeared in photographs of nineteenth-century sculptors,[58] and when Jean-François Raffaelli painted a portrait of the bronze-caster Gonon working in a foundry with his assistants on Dalou's memorial to Mirabeau and Dreux-Breze, Dalou was nowhere to be seen.[59] Even in the monument to *J.-C.-Adolphe Alphand*, Dalou and other associates of Alphand occupy a middle ground between the really big cheeses on the top row and the labourers in the frieze. But it is nonetheless true that the work-cult could be turned to sculptors' advantage: it gave them a bit of street-cred.

The most successful and influential nineteenth-century incarnation of the worker-artist was undoubtedly Auguste Rodin (1840–1917). With the possible exception of Picasso, no modern artist has been so celebrated and honoured.[60] He was also the first sculptor working outside Italy to have a major international reputation.[61] Central to the Rodin myth was the idea that he combined the down-to-earth practical skills of a *praticien* with the lofty inspiration of a genius. He became a symbol of the artist in a modern democracy – even though many of his views were feudal rather than democratic.

In conversations with the critic Paul Gsell, published in 1911, Rodin laments that people 'seem to consider work as a ghastly necessity, as a damnable drudgery', when they ought to regard it as 'their reason for being and their happiness'. Now it is only 'true artists' who 'practise their trade with pleasure'. He dreams of a time when everyone is an artist: 'It would be desirable that there be artists in all professions: artist–carpenters, happy to skilfully adjust tenons and mortises; artist–masons, mixing plaster with love; artist–carters, proud of treating their horses well and not running over pedestrians. Wouldn't this create an admirable society?'[62]

His model for an admirable society is 'the France of old', in which 'art was everywhere' and 'even the peasants used only objects that were beautiful to behold'.[63] Though Michelangelo was his artistic hero, he idealized the Middle Ages, and when he was planning a one-hundred foot *Tower of Labour*, he thought of it as a modern equivalent of the

cathedrals: 'The Middle Ages had their cathedrals . . . Today the people believe above all else in work; almost everyone puts his faith in it. Thus it is to work, to work-the-king, that I wish to raise a monument which would be at once architectural and sculptural.'[64] The tower would have looked like a non-leaning version of the Leaning Tower of Pisa. Had it been built, visitors would have started off in a crypt dedicated to underground workers – miners and divers – which was lit by electric light. At ground level there would have been reliefs of masons, blacksmiths, carpenters and potters. The highest tiers were reserved for what Rodin regarded as the noblest calling of all – that of artist, poet and philosopher. The final proposal was for a tower 420 feet high, half the height of the Eiffel Tower.

When Rodin was interviewed about the monument in 1898, he was keen that the interviewer should refer to his *praticiens* Jean Baffier and Jules Desbois as 'collaborators since the first moment'.[65] Modesty and humility have, of course, always been the prerogative of the unassailable. But after Rodin's death, Desbois told an interviewer, 'If he was great, it was because he knew his weakness, because he felt humble when he looked at nature and into the face of beauty. He expected others would come up with ideas, lessons from which he could learn.'[66] In this version of events, Rodin was as pious and humble as a medieval artisan. How this squared with the artists getting the penthouse suite in the *Tower of Labour* is anyone's guess. But you could just as easily argue that in such a tall tower, which did not have a lift, the workers on the ground floor occupied the *piano nobile*, while the artists had been consigned to the attic.

Although the *Tower of Labour* (1893–9) never got beyond a plaster maquette, *The Gates of Hell*, commissioned in 1880, and *The Thinker* embodied many similar ideals. Not only were *The Gates of Hell* based on Dante's *Inferno*, a medieval source, but they were intended to adorn a new museum of decorative arts, which would itself be a celebration of the creations of often anonymous French craftsmen (it was meant to rival the Victoria and Albert Museum in London, but was never built).[67] It was during and after the inauguration of *The Thinker*, placed in front of the Pantheon in 1906, that the worker theme reached its apogee. When the statue had first been made, in around 1880, for *The Gates of Hell*, it was meant to represent poets in general, and Dante in particular. But when exhibited as an independent statue, its meaning gradually evolved.

At the inauguration ceremony before the Pantheon, the Under-

Secretary of State for Fine Arts, Henri Dujardin-Beaumetz, declared that Rodin was a 'son of the people', who had toiled for many years as a *praticien* without recognition. He was referring to the many years that Rodin had spent working as an ornamental sculptor in order to subsidize his own work. Dujardin believed that *The Thinker* was an image of an anonymous toiler, muscular and vigorous 'like a clearer of his native soil', but one whose strength would only be used 'in the service of law'. He was a 'thinker to the common soul' who does not forget that 'it was he, bent to the earth, who first seeded and harvested'. The speech then rose in a stirring, if preposterous, crescendo: 'It is he a hundred years ago who made of vengeful iron the tool of liberty. He is the hard-working worker who successively made supple and disciplined materials furnished by nature and utilized them for social progress. It is he in the end who by work built the modern world and wants it worthy of his long efforts.'[68] Dante, the great Florentine sage, has been recast. He emerges into the spotlight, eyes blinking, as a French *ouvrier-poète*.

An anonymous writer in 1904 had claimed that either *The Thinker* was Rodin's *praticien* or that Rodin himself was a worker and that the sculpture 'is a worker dreaming of his meagre salary, or of the difficulties of life'. The writer goes on to say that 'the knotted body and face of the dreamer was discovered in the studio and raised to the level of a symbol – a symbol of 'egalitarian society and the entire Republic'.[69] The sculptor's studio as well as its products have become a magisterial, yet industrious symbol of the age: the sculptor forges the nation.

Rainer Maria Rilke's celebrated essay on Rodin, which was published in German in 1903, is the most eloquent variation on this theme. For the Austrian poet, the sculptor who is planning his *Tower of Labour* is a monk-like worker: 'Rodin does not think of representing labour by any great figure or gesture; it is not visible from afar. Its place is in factories, in work-rooms, within the brain; in hidden places. He knows, for it is so with his own work; and he works incessantly. His life passes like a single working-day.' Rodin's studios are, he continues, 'bare, poor cells, filled with dust and greyness'. But their poverty is 'like the great, grey poverty of God, in which the trees in March awaken. There is something of early spring about it; a quiet promise and a deep solemnity.'[70] Mention of trees brings us full circle, right back to gothic cathedrals.

The doctrine of the worker-artist is obviously full of ironies and contradictions. There is a conflict between the artist's desire to create forms of expression that are at once personal and communal. In

Courbet's early self-portrait, the sculptor creates alone, directly carving the rock. This autograph artisanal approach seems to guarantee the authenticity and intensity of the sculpture. Yet the isolation of the artist can also make the work seem remote and solipsistic. When Courbet came to make his own sculpture, he 'collaborated' with *praticiens*. But the problem with relying on assistants is that the sculptures might end up looking derivative and mechanical – and, for the most part, Courbet's are far more generic than his paintings.

With consummate irony, the collapse of Rodin's reputation soon after his death in 1917 was due to 'revelations' in the press that some of his sculptures were the work of his *praticiens*, and that his studio had been run along the lines of a factory where extensive use was made of pointing machines.[71] Before 1880 four assistants worked in his studio. After 1900, when his solo-show at the Paris *Exposition* had given him superstar status, he had fifty. His preferred material became marble, and most of the work was delegated. His style in this medium became increasingly curvaceous and idealized. It was obviously an inexact science knowing quite how far an artist could go in his efforts to identify with workers.[72]

BY THE SECOND decade of the twentieth century, the cult of the 'worker-artist' was so deeply entrenched that artists felt able to take the notion to unimagined extremes. In the years before the First World War, Picasso (1881–1973) and Braque (1882–1963) were the most striking and subversive examples. For both, their status as worker-artists involved a repudiation of easel-painting, and a migration to collage and constructed sculpture.

During the development of Cubism, Picasso and Braque made much of being worker-artists.[73] They regularly wore blue mechanic's outfits. Their dealer Daniel Kahnweiler recalled them arriving at the gallery one day 'cap in hand acting like labourers'. They immediately announced, 'Boss, we're here for our pay.'[74] But it was more than just a matter of costume and demeanour. They worked together as 'collaborators' until their paintings became almost indistinguishable, and they even gave up signing their work on the front of the canvas. Sometimes they got Boischaud, Kahnweiler's assistant, to sign for them on the back. The only form of writing that appeared on the front of the canvas was stencilled letters or newsprint. Picasso later explained to Françoise Gilot: 'we felt the temptation, the hope of an anonymous art, not in its expression, but in its point of departure'.[75] In 1952, while recalling the

achievements of Cubism, Picasso told Kahnweiler, 'But one cannot do it alone, one must be with others . . . It requires teamwork.'[76] This may have been the reason why Apollinaire claimed in *The Cubist Painters* (1912) that Courbet was 'the father of the new painters'.[77]

It was not too long before their art started to take a three-dimensional turn. Braque was probably experimenting with paper sculpture in the summer of 1911, for in September of that year he wrote to Kahnweiler saying how much he missed 'the collaboration of Boischaud in making my painted papers'.[78] The following year he added sand and metal filings to his paint and simulated the appearance of wood grain and marbling with a house-decorator's comb. Braque knew about these techniques because he came from a family of house decorators. In September 1912 he glued woodgrain wallpaper to the canvas, thus making the first *papier collé*.[79]

At the time that Braque was making the paper sculptures, he had signed a letter to Kahnweiler 'Wilburg Braque'. This nickname (after the American aviator Wilbur Wright) seems to have originated in 1908, when a review of Braque's first Cubist paintings was placed above a news item about Wright's victory in an aviation contest. Picasso and Braque often went to see planes take off and land, and are reputed to have tried to make a model aeroplane.[80] The frequent use of the name in 1912, however, is probably because Braque's sculptures had a fragility and angularity that reminded Picasso of Wright's biplanes.[81]

Wright's personality – and the fact that he collaborated with his brother Orville – would also have been an attraction. Whereas in Europe flying tended to be a glamorous and often aristocratic sport, the Wright brothers thought of themselves as 'inventors' who were primarily interested in advancing the 'science of aeronautics'. In Europe they were often criticized for being nothing more than talented 'mechanics' and 'acrobats' who, after years of practice, had learned to control the movements of their flying machine.[82] Wilbur Wright was portrayed by the leading aeronautical journalist in France as a simple man who had astonished the employees at the Bollee car factory (where the Flyer had been assembled) by his dedication and craftsmanship. He worked the same hours as other factory employees, finishing his work when the factory whistle sounded, cooking his own meals, making his own spare parts and sleeping in spartan accommodation next to his plane.[83] A postcard shows Wright sewing a new patch of canvas on to the wing of his plane with a home-made needle.[84]

Picasso used dressmaker's pins to experiment with the placement of

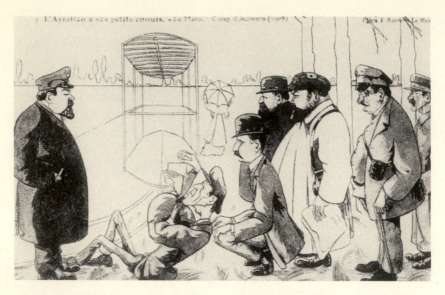

25. Wilbur Wright repairing the Flyer. The caption to this postcard, c. 1910, says 'Aviation has its little irritations'.

cut paper, and on at least thirteen occasions he left the pins in position in the completed work.[85] This technique has been put down to Picasso's repeated exposure to women who practised dressmaking,[86] but Wright's own bouts of sewing and patching may also have been influential. No wonder the art critic André Salmon, writing about Picasso and Braque in his book *La Jeune Sculpture Française* (1919), warned his readers not to underestimate their interest in 'the beauty of artisanal work'.[87]

According to the art historian William Rubin, the fact that Cubism 'unfolded essentially through a dialogue between two artists extending over six years makes it a phenomenon unprecedented, to my knowledge, in the history of art'.[88] Rubin further believes that the collaboration reached its height in 1912, the year when constructed sculpture, collage and *papier collé* were the 'central innovations'.[89] You have to turn to the Neo-medieval arts-and-crafts movements to find another collaboration remotely like it. The Impressionist painter Renoir, who had taken up sculpture in 1907 (making extensive use of an assistant, the young sculptor Richard Guino), wrote a preface in 1911 to Cennino Cennini's *Libro dell'arte*, in which he extolled medieval practice: 'We must insist that it is the totality of the work left by numerous forgotten or unknown

artists which makes a country's greatness, and not the original work of a man of genius.'[90] So in this respect the idea of collaborative art would have been very much in the air.[91]

But of course Braque and Picasso challenged received ideas about craftsmanship as much as they exploited them. The most obvious way in which they did this was through the use of ephemeral and non-art materials – sand, newspaper, wallpaper, sheet-metal, rope, glass, enamel paint, etc. These may be humble materials, but they are certainly not the stuff of which cathedrals were made. They are humble in an unsolemn, jerry-built sort of way. Braque's mixed-media work tends, however, to be more homogeneous and 'crafted' than Picasso's.[92] He only ever incorporated paper, and only used it in conjunction with drawn images. His use of paper is also more literal-minded. His first *papier collé*, *Fruit Dish and Glass* (September 1912), includes *faux bois* wallpaper, but it is used to signify wood. The placement and cutting of the paper are relatively neat and 'classical'. Overall, experimentation in new media was less important for Braque than for Picasso.

Picasso was more interested in creating violent and disruptive contrasts in medium and style. *Still-Life with Chair-Caning* (c. May 1912), which may well be Picasso's first mixed-media work, is visually and texturally unstable. It has an oval format, and it is 'framed' by a continuous piece of hemp rope. The painted part is a richly impastoed still-life, Cubist in style, grey in tonality. Butting into this is a piece of oilcloth printed to imitate chair caning and glued to the canvas. Picasso then partially painted over it. There was much discussion at the time about the creation of a *tableau-objet* – a painting that was an object – and this workman-like artefact is a pioneering example.[93]

Some of Picasso's most makeshift and disruptive works were made in 1914. *Still-Life* is a relief made from painted wood and a cheap upholstery fringe. The still-life components appear to be a glass with a slice of lemon floating in it; a piece of cheese surmounted by a slice of tomato; and a knife. These rest on a ledge adorned with a gold fringe, from which dangle silk baubles. The whole *mise-en-scène* suggests lunch in a work-man's café. The presence of the knife – with its blade pointing out over the edge of the ledge – is important. The implication is that Picasso creates in the same way that the workman eats: crudely but heartily. The wood has been sawn, cut, split, painted and assembled in a very rough-and-ready way.

In addition to using unconventional materials, there was another way

26. **Pablo Picasso**, *Still-Life*, 1914
(Mixed–media construction, Tate Gallery, London).

in which Picasso creatively corrupted conventional ideas about crafts-
manship. His wood constructions are an extreme manifestation of the
vogue for direct carving manifested in the 'inchoate' carving in
Courbet's self-portrait and in the writings of Ruskin and Morris. The
vogue for direct carving – and, indeed, for direct modelling - had
received a big boost following a Gauguin retrospective in 1906 that had
included twenty-seven of his wood carvings and stoneware ceramics.[94]
Before this moment, very few people were aware that Gauguin
(1848–1903) was a sculptor as well as a painter.

Wood carving put Gauguin in touch with reality in an almost mystical
way. In his Tahitian journal *Noa Noa* he marvels at the 'majestic
sculptural form' of the younger Tahitians, and goes into the mountains
with an androgenous youth to get some rosewood for his carving (the
Tahitian for rosewood is *noa, noa*). Gauguin 'plunged eagerly and
passionately into the wilderness' and 'struck out with joy' at the finest
rosewood tree with an axe, until his hands bled. Back in his studio he is
just as ecstatic: 'I have never made a single cut with the knife into this
branch of rosewood, that I did not each time more powerfully breathe
in the perfume of victory and rejuvenation: *noa, noa!*'[95] Gauguin was also
inspired by the Maori tradition of decorating houses with carved
woodwork. He made a series of carved panels, and saw it as a riposte to

European civilization in general, and to painting in particular: 'Farewell painting! My home shall be of carved wood.'[96]

Although Picasso had made a handful of sculptures before 1906, the year of Gauguin's retrospective was to be the first time in which he gave it serious consideration.[97] In the summer of 1906 Picasso carved three wooden figures at Gosol, probably whittling them with a knife.[98] One female figure was carved from a gnarled, anthropomorphic length of boxwood. Gauguin's influence is also discernible in *Fernande Combing her Hair* (1906), which was originally executed as a ceramic in the studio of Paco Durrio, but is now known only in a bronze cast.[99] Durrio was a sculptor, jeweller and ceramicist who owned a superb collection of Gauguin's work in all media, a gift from the artist. Picasso made several ceramics in Durrio's studio, though all but one have disappeared. He made only a handful of bona-fide carvings in subsequent years, probably because he found carving too laborious,[100] yet when he came to make his wooden and metal constructions he made a virtue of being a worker working on the hoof. Ruskin believed that, whatever form society takes, 'rough work will remain to be done by rough men'.[101] But he would have never imagined anything quite this rough in the realm of the visual arts.

9. Worker-Artists ii: Duchamp to Now

Using already existing materials . . . brings a real place and time into the aesthetic reality . . . It is an anti-heroic art. Even if the artist is viewed as a hero . . . the tasks and the acts are ordinary.

Julian Schnabel, 1986[1]

IN THEORY, IF NOT always in practice, collaboration was central to the cult of the worker-artist. But the question then had to be asked: how much of the artwork has to have the artist's imprimatur on it, and how much can be delegated to others – and borrowed from others? When the Cubists imported newspaper, wallpaper and sand into their pictures, and appropriated each other's innovations, they implied that you can do as little and as much as you like. But then a further question needed to be asked: if, as a result of an extensive division of labour, you appeared to do very little, did that make you more or less of a worker?

The most shattering answers to these questions were provided by Marcel Duchamp (1887–1968). Soon after the invention of collage, he gave up painting and, in 1913, developed his first ready-mades. Duchamp was another worker-artist, but for many critics, 'work' is precisely what he failed to do. His ready-mades, while seeming to exalt certain mass-produced objects, reduce the role of the artist to one of selection and presentation. The American Land Artist Robert Smithson (1938–73) believed that Duchamp's ready-mades were not only 'a complete denial of the work process', but manifested an aristocratic contempt for it.[2]

Duchamp in fact showed an acute understanding of modern work processes.[3] A year after he made his *Bicycle Wheel* (1913), a book was

published by the great American sociologist Thorstein Veblen in which the startling suggestion was made that modern methods of production were similar to pastoral methods. In *The Instinct of Workmanship, and the State of the Industrial Arts* (1914), Veblen writes:

> In a general way the relation in which the skilled workman in the large industries stands to the machine process is analogous to that in which the primitive herdsman, shepherd or dairymaid stand to domesticated animals under their care, rather than to the relation of the craftsman to his tools. It is a work of attendance, furtherance and skilled interference rather than a forceful and dexterous use of an implement.[4]

For Veblen's disciple Lewis Mumford, the modern worker was a 'machine-herd, attending to the welfare of a flock of machines which do the actual work'.[5] Already in the nineteenth century Engels had noted that mechanization deprived man of pride in his muscular prowess,[6] while the historian Michelet lamented that the machine was making manly strength an anachronism.[8]

Duchamp's *Bicycle Wheel*, in which the forks of a bicycle wheel were inverted and fixed into the seat of a wooden stool, demands just this kind of 'attendance' on behalf of the viewer. The viewer is expected to spin the wheel occasionally and watch it while it spins. As for *Fountain*, the ceramic urinal that shocked New York in 1917, this mass-produced object was turned into an artwork after 'skilled interference' by the artist – in other words, he chose it from the millions of other objects, inverted it, signed it R. MUTT, called it fountain, displayed it in a gallery. The title ironically brings it back into a pastoral world where everything can be found, chanced upon or shepherded.[8] Duchamp's art is in fact full of images of pastoral idylls,[9] presumably because it is in Arcady where everything is not only 'ready made', but immediately available.[10]

The idea of the ready-made was already inherent in theories of sculpture. Courbet's sculptor found his fountain-sculpture largely 'ready-made' in a rock spurting water, in accordance with traditional ideas about the origins of sculpture. Duchamp strongly alluded to traditional sculpture, for *Fountain*, with its homogeneous white surface and undulating, anthropomorphic shape, has a distinctly sculptural feel. It might even be seen as a pastiche of a Rodin, for his studio was then churning out white marble versions of his work (mostly for American collectors) as if there were no tomorrow.

But it can hardly be said that Duchamp wholeheartedly endorses the modern version of 'pastoral', whereby the artist is merely a machine-herd. *Fountain* is quite clearly a polluted fountain, an image of paradise lost. Herder had said in *Plastik* that it was pointless erecting statues in public places as they would only be abused: he thought they would be pissed on. Duchamp erects a statuesque object in a public place, whose only function *is* to be pissed on. It is a monument for a world that does not care. The same kind of pessimism was embodied in the snow-shovel entitled *In Advance of a Broken Arm*.

In fact, Duchamp more often seemed to identify with pre-industrial craftsmen than with machine-herds. They are marginally less alienated. When expressing his admiration for the painter Georges Seurat, he compared him to a carpenter: 'The only man of the past whom I really respected was Seurat, who made his big paintings like a carpenter, like an artisan. He didn't let his hand interfere with his mind.'[11] As with so many of the examples I have already given, there is nostalgia here for pre-industrial forms of manufacture, and scant interest in making parallels with factory production. His approval of Seurat's 'carpentry' is hardly an affirmation of modernity. Why not Seurat's welding, riveting, typesetting or engineering? The same compliment might have been paid by Jean-Jacques Rousseau. In *Emile*, Rousseau had said that work was an 'indispensable duty for social man' and that 'every idle citizen is a rascal'.[12] When he looked for a trade for Emile, he concluded that the artisan comes closest to the state of nature, and that carpentry is the best artisanal occupation.[13] Duchamp compared Seurat with a carpenter because he hated the modern fixation with the artist-as-genius, with his own unique touch and style,[14] but in the age of mass-production carpenters still suggested something relatively hand-made and object-based.

Duchamp's machine images never looked as modern as those of his contemporaries Picabia and Leger. His first machine image – a painting of a *Coffee Mill* (1911) that was made for his brother's kitchen – is a traditional wooden mill turned by a hand crank. It has been called 'almost medieval'.[15] The products and iconographies of modern service industries hardly figure in Duchamp's work. Unlike the Cubists, he made little use of newspapers, and he rarely made direct use of photography; unlike the Pop artists, he hardly concerned himself with global brands or celebrities. His raw materials tended to be unbranded, and to come from hardware stores.

27. **Marcel Duchamp**, *Large Glass*, 1915–23
(Mixed–media panel, Philadelphia Museum of Art).

Duchamp's greatest work is the *The Bride Stripped Bare by the Bachelors Even* (1915–23), which is usually known as the *Large Glass*. It is his most painstaking and artisanal work, and the one that most decisively occupies floor- and air-space. Not only did Duchamp labour over it obsessively for eight years, but labour is one of its central themes. The *Large Glass* is a freestanding panel, about nine feet tall and six feet wide. Various kinds of imagery made from a variety of media are sandwiched between panes of clear glass encased in a steel and wood frame. It is impossible to classify. It is an object that has to be looked through, and walked round. Looking at it is a communal experience, because you can see other viewers through the glass. It borrows aspects of stained glass, painting, sculpture and joinery. The frame cuts across the middle of the panel, dividing it into an upper and lower tier.

Duchamp's published notes explain who the protagonists are. In the upper tier we find 'the bride', a cubist-style insect. She is referred to in the notes as an 'agricultural machine' and an instrument for ploughing.[16] The lower section is much busier. It is full of mechanisms and implements — a water-mill, scissors, sieves, capillaries and a chocolate grinder. These are (in theory) operated by a group of nine uniformed 'bachelors', in the form of thimble-like moulds. Taken together, the two sections of the *Large Glass* are a mock-heroic tale about thwarted passion. The various machines are supposed to transmit the bride's sexual requirements down to the bachelors, and their 'love gasoline' then passes through the machinery in the lower section up to the bride. But the machinery fails, the love gasoline never makes it, the bride is never stripped bare — and the bachelors are forced to 'grind their own chocolate'.

It has often been pointed out that the format of the work resembles that of traditional representations of the Assumption of the Virgin, and Duchamp makes the point that it is 'a sort of apotheosis of Virginity' in his working notes.[17] What does not seem to have been noticed is how closely it picks up on a more recent trend in religious iconography whereby artisanal work is put in a religious setting. The Pre-Raphaelite Brotherhood frequently set male artisans or workers into religious contexts. Ford Madox Brown's *Work*, Millais' *Christ in the House of his Parents*, Rossetti's *The Girlhood of Mary Virgin*, Leys' *Capestro, the Carpenter of Antwerp, Preaching in his Work-Yard*, and Holman Hunt's *Finding of Christ in the Temple* are the best-known examples.[18] Thomas Carlyle had set the agenda in his polemical social tract *Past and Present* (1843): 'In a

thousand senses, from one end of it to the other, true Work is worship.'[19] So terrified were the Victorians of 'idleness' that even Heaven became a place of work. A heaven of workers replaced the heaven of lovers that had been the ideal of the Romantics.[20] Christ's presence in the carpenter's shop in Nazareth was used to justify the notion that all the saints work in heaven and have vocations as many and varied as their personalities and skills.[21] Through their work, spiritual improvement occurs. So busy did heaven become that by 1901 a Baptist pastor in New York could reliably report that 'practically it is a workshop'.[22]

The *Large Glass* is a playful but sceptical response to these kinds of beliefs. The heaven of lovers comes into conflict with the heaven of work. Work here seems to confine men to single-sex communities, and thus perhaps to a life of masturbation. Just as the Pre-Raphaelites prided themselves on taking years to complete pictures (Ford Madox Brown spent thirteen years on *Work*), so Duchamp spent eight years and more on the *Large Glass* and then twenty years on his final work, *Etant Donnés*. Although the Pre-Raphaelites' fixation with work did not result in any of them becoming serious 'painter-sculptors', they did lead the way in integrating pictures with their frames, and in painting directly on to furniture, thus emphasizing the artwork's status as an object.[23] This is probably why, a year after his retrospective at the Tate Gallery, Duchamp would say, 'Look at the Pre-Raphaelites; they lit a small flame, which is still burning despite everything.'[24]

In the end, it was an accident that brought the *Large Glass* to completion. The glass on both sections was cracked in transit, but Duchamp felt that the cracks 'brought the work back into the real world', so he painstakingly reassembled the shards of glass and encased them within two further panes.[25] No doubt an important part of its being brought back into the real world was that it gave Duchamp lots more work to do. At the same time, because he did not replace the broken glass, every subsequent viewer would at some level assume that it was still broken, and that work needed to be done on it. The viewer might be inclined to replace the glass themselves in their imagination, just as they mentally repaired antique fragments, wondering what they would look like whole. But it was the ideology of work itself that initially brought art back into the real world, and set it squarely in the viewer's own space. It is not so much the Bride who is stripped bare: the work of art is stripped bare and given maximum exposure by being deposited in the centre of a room.

The cult of the worker-artist is in part a psychological defence mechanism against the isolation of the modern artist. It is an attempt to normalize the avant-garde. The more incomprehensible and distasteful modern art became to the art establishment and to the general public, the more artists protested their averageness and their integration into the 'real' world. Leo Steinberg has written that to be workman-like 'is an absolute good. Efficiency is self-justifying; it exonerates any activity whatsoever . . . those activities which, like bloodshed and art, sometimes seem dubious on moral grounds – they more than any need the higher ideal of efficiency to shelter under.'[26]

During the years that Duchamp was working on *Etant Donnés* (1946–66), he combined efficiency with lassitude. He would leave his apartment every morning between ten and eleven, take the bus to his studio and return punctually at five. His wife Teeny was amazed that he would 'always appear at the time he'd said he would'. Nonetheless, although his studio was filled with metal, wood, plaster dust and electrical cables, she was keen to stress that he did not work like a normal worker: 'He worked on it all the time, but never like a workman. He would work for fifteen or twenty minutes and then he'd smoke a cigar or study chess problems or do something else.'[27] Clearly she had never come across a workman who takes endless 'tea-breaks'.

Creating a community – literal or imaginary – is also central to the ideology of the worker-artist.[28] The avant-garde has been defined by the formation of groups and movements, sometimes with their own manifestos. Duchamp stressed that the creative act is not performed by the artist alone. It is a collaborative act between the artist and the spectator. The spectator's act of interpretation 'completed' the work. Art only becomes art by virtue of being experienced. Duchamp's definition of the spectator varied. Sometimes he imagined the spectator to be a devoted *aficionado*; at other times he defined the spectator as 'the whole of posterity and all those who look at works of art who, by their vote, decide that a thing should survive'.[29] Related to this is his description of the ready-made as 'a sort of rendez-vous'.[30] The selection and discovery of the object is not a punitive or aggressive act on the part of the patriarchal artist. It is a formalized engagement between two consenting parties.

This dream – or nightmare – of teamworking also underlies the startling shifts in style, subject and media that are so fundamental a feature of modern art. William Rubin has argued that Picasso compensated for

Braque's departure for the war in 1914 by creating a 'dialectical "other" within the style alternatives of his own work'.[31] In other words, he became two artists – a Cubist and a Neo-Classicist. Picasso himself said that when he began a work, he felt that it was a collaborative work: 'When I begin a picture, there is somebody who works with me. Toward the end, I get the impression that I have been working alone – without a collaborator.'[32] The work of art is a dialogue between the artist and his *alter ego*, and then between the artist and the spectator.

This quote was elicited from Picasso in 1935 at his château of Boisgeloup. He had bought the château in 1930 and converted the stables into sculpture studios. In 1933 Brassaï had taken photographs of the studios to illustrate the essay by André Breton, *Picasso In His Element*, which celebrated his Cubist constructions and his most recent sculpture.[33] When Picasso talked about collaboration, he was probably prompted by his recent ventures in sculpture. From 1928 to 1932 Julio Gonzalez had given him technical assistance with welded wrought-iron sculpture, and Picasso had also worked with the bronze caster Valsuani. He later said of his excitement in 1928, 'I felt just as happy again as in the year 1912.'[34]

Collaboration not only takes place with people, real or imagined. It also takes place with materials. In 1948 Picasso again looked back to 1912: 'We sought to express reality with materials we did not know how to handle . . . we surrendered ourselves to [the work] completely, body and soul.'[35] One can extrapolate from this and see why sculpture, even in traditional materials, has been so enticing to modern painters. It is an activity where, because they are not properly trained, painters are not in complete control. To a certain extent they do have to *surrender* them-selves to the materials. The materials, by default, are co-workers, with an equal say in the final appearance of the object.

Authenticity born of unfamiliarity and lack of dexterity is a recurring feature of modern art.[36] It has often prompted artists to seek out new media, and as there are not that many different kinds of paint, this often means a move into three-dimensional media. The supporter of Degas, Louis-Émile Edmond Duranty – in the same decade in which Degas made his first revolutionary mixed-media sculpture, the *Little Dancer* (1878–81), from wax, hair and muslin – stressed the importance of technical innovation in art. Duranty believed that great moments in art always followed in the wake of the invention of new media. But, once the new medium had been fully assimilated, it was no longer possible to

produce great art. Contemporary artists, he wrote, feel themselves shackled by traditional tools: 'They would like to have other colours, they would like instruments other than the broad and fine brush. They are experimenting with the knife and would try out the spoon if it seemed promising.'[37] Juan Gris said that the Cubists' thickening of paint, and the use of collage, was prompted by a distaste for the slickness of oil paint.[38] Familiarity breeds mediocrity.

There was much talk between the First and Second World Wars of sculptors who used direct carving techniques 'collaborating' with stone or wood – instead of, as had previously been the case, 'collaborating' with *praticiens*. But collaboration was still central to their aesthetic. In *The Meaning of Modern Sculpture* (1932), the British critic R. H. Wilenski stated that modern sculptors regard direct carving 'as a kind of collaboration between the sculptor and the substance'.[39] This is because they think of sculpture 'as the conversion of a mass without formal meaning into a mass that [has] been given such meaning by the sculptor; this contains the idea of collaboration; Michelangelo's notion of the statue imprisoned within the stone and released by the sculptor contains it also'.[40] The use of the word 'conversion' in close proximity to the word 'mass' has confusing religious connotations: one thinks of baptism, and of communion. The implication is that through art substances are redeemed, but only because they choose of their own free will to be redeemed.

A triple collaboration took place between the Surrealist painter Max Ernst, the sculptor Alberto Giacometti and Mother Nature, in Switzerland in 1935:

> Alberto Giacometti and I are afflicted with sculpture-fever. We work on granite blocks, large and small, from the moraine of the Forno Glacier. Wonderfully polished by time, frost and weather, they are in themselves fantastically beautiful. No human hand can achieve such results. Why not, therefore, leave the spadework to the elements and confine ourselves to scratching on them runes of our own mystery.[41]

Here nature had a role akin to that of the traditional *praticien* – it did most of the basic work, and the sculptor just applied the finishing touches. The Surrealist-influenced Franco-American sculptor Louise Bourgeois (born 1911) started to use marble instead of wood in 1967. In a recent interview with the sculptor Alain Kirili, she explained that wood is 'too

soft a material' and 'offers no resistance'. When Kirili said that the resistance of the material is the 'extraordinary advantage' of sculpture over painting, Bourgeois simply replied, 'Painting doesn't exist for me.'[42]

I QUOTED EARLIER William Rubin's observation that Cubism unfolded as an unprecedented, six-year dialogue between two artists that reached its height in 1912, the year when constructed sculpture, collage and *papier collé* were the 'central innovations'. A comparable kind of extended dialogue between two painters was to be repeated almost half a century later, and it too resulted in a dissatisfaction with painting, and a migration to object-based art. This was the 'collaboration' between Robert Rauschenberg (born 1925) and Jasper Johns (born 1930), which took place in New York from the mid-1950s to the early 1960s.

Both artists had studios in the same building, and they were lovers for over six years, until 1961.[43] During this period Rauschenberg developed his mixed-media 'combines', while Johns developed complex impastos, sometimes incorporated objects into his paintings, and from 1958 to 1961 made most of his sculptures (ale cans, torches, light-bulbs, paint-brushes, etc.). The critic Max Kozloff, writing in his 1967 monograph on Johns, declared:

> Their association, in some respects, has been as professionally complex and intertwined as was the one between Picasso and Braque during the early phase of Cubism. The social ingredients were formed by their mutual reverence for Duchamp, their early economic struggles, their common friendship with John Cage and Merce Cunningham and their representation in the same gallery [Leo Castelli] from 1958 on.[44]

Kozloff had in mind things like Rauschenberg's introduction of concrete motifs, such as a chair and a hanging brush, that were subsequently picked up by Johns. They also occasionally contributed to each other's work. As Johns explained, 'You get a lot by doing. It's very important for a young artist to see how things are done. The kind of exchange we had was stronger than talking.'[45] Unlike the Cubists, however, their works looked very different, and could never be confused.

Rauschenberg saw his art as an exploration of the real world. 'I don't want a picture to look like something it isn't,' he said. 'I want it to look like something it is. And I think a picture is more like the real world

when it's made out of the real world.'[46] But this was a collaboration with, rather than a colonization of, the real world: 'I've always felt as though, whatever I've used and whatever I've done, the method was always closer to a *collaboration* with materials than to any kind of conscious manipulation and control.'[47] Rauschenberg's working method was another kind of rendezvous – and Johns was one of those 'materials' with which he worked.

Allied to this collaborative impulse is a desire to dismantle and reassemble the real world, so that all its component parts can be fully comprehended. Nothing must remain hidden or repressed. In 1959 Rauschenberg made a statement for *Sixteen Americans*, the catalogue to an exhibition at the Museum of Modern Art (MOMA), New York. 'There is no poor subject,' he said. 'A pair of socks is no less suitable to make a painting with than wood, nails, turpentine, oil and fabric.'[48] Here we get an acute sense of Rauschenberg as *praticien*. The standard way of referring to the ingredients of a painting is to say 'oil and canvas' – the stuff that stands in the foreground. But Rauschenberg mentally strips it right down to the stretcher, to the wood and nails. You can almost feel him taking it off the wall, turning it round, examining the nails (and you can almost smell his socks).

Both Rauschenberg and Johns included items in their mixed-media works that could be manipulated by the viewer. The lids of the wooden boxes containing plaster casts in Johns' *Target with Plaster Casts* (1955) could be opened or closed. In *Field Painting* (1963–4) three-dimensional wooden letters spelling out the primary colours RED, YELLOW and BLUE were hinged in a vertical line down the centre of the canvas. Magnets were fixed to the letters, and objects used to make the painting (such as a palette knife, brushes and tins) were attached to the magnets. The 'R' of RED is made of neon tubing that lights up when the switch embedded in the surface of the painting is turned on. This is a painting as literal *work* of art. It is a representation of the artist's studio in all its workman-like glory.

Rauschenberg moved away from New York in 1961, and the following year he stopped using concrete objects and started to silk-screen images on to canvas instead. Johns' interest in sculpture waned after 1961. His use of collage elements increased for a few years after the split, but then gradually declined from the mid-1960s. Most critics agree that Rauschenberg and Johns did their best work together.

Voice 2 (1968–71) is an important staging-post in Johns' career. It is a

28. **Jasper Johns**, *Painted Bronze*, 1960
(Painted bronze, collection of the artist, on loan to Philadelphia Museum of Art)
This freestanding sculpture which represents a bundle of dirty paint brushes
protruding from a tin can is an archetypal self-portrait of the worker-artist.

three–part canvas with some collage elements, such as a piece of string
stretched diagonally across one of the panels. Johns initially seems to have
wanted it to be a riposte to Baudelaire's belief that painting was superior
to sculpture because it could control the position of the viewer.

At the time, he wrote in his sketchbook, 'Have made a silk-screen of
Baudelaire's description of sculpture as an inferior art. Use this in VOICE
(2) or somewhere else. Perhaps fragment it so that its legibility is
interfered with.'[49] Each panel was intended to be exhibited any way
round and in any order: 'upside down, sideways, backwards'.[50] In the
end, though, Johns failed to achieve this, and the passage from Baudelaire
did not appear. Johns recently explained that it was 'too difficult for me,
too complicated', and so he 'settled for the more simple order'.[51]

In retrospect, this set the pattern for the rest of his career. Johns came
down increasingly on the side of two–dimensional 'order'. Few of his
subsequent works have had the material and conceptual richness of his

previous mixed-media works.[52] It was at this point that he finally said goodbye to the Baudelaireian peasant in him, who was enchanted by the sight and the touch of objects, and who wanted his own work to be manipulated by the viewer.

DURING THE 1950s and 1960s performing artists as well as visual artists were fascinated with the notion of the workman-like. Johns and Rauschenberg made sets and costumes for the dances created by Merce Cunningham and John Cage. Their dances were a reaction against the emotionalism of so much modern dance, as exemplified by the work of Martha Graham and by some kinds of Abstract Expressionist painting. Cage encouraged Cunningham to incorporate ordinary 'found movements' in his dances, and to cultivate an emotional coolness. These ideas were developed in the 1960s by groups such as the Judson Dance Theater of New York. A chart drawn up by Yvonne Rainer, one of its founding members, explained the principles on which their dances were based:

> energy equality and 'found' movement
> equality of parts
> repetition and discrete events
> neutral performance
> task or tasklike activity
> singular action, event, or tone
> human scale

Objects were central to these performances, and Rainer drew up a parallel list of specifications for these too:

> factory fabrication
> unitary forms, modules
> uninterrupted surface
> nonreferential forms
> literalness
> simplicity
> human scale[53]

One of the artists to be most closely involved with the new dance was Robert Morris (born 1931), who subsequently became one of the leading Minimalist sculptors. His earliest works were heavily influenced

by Johns and Duchamp, but explored the 'work ethic' in a much more direct way. *Box with the Sound of its own Making* (1961) was a nine-inch cube made from walnut wood. Concealed inside was a tape recorder that broadcast a three-hour tape recording of the sounds made when Morris constructed the box. This was effectively a self-portrait of the artist in his studio. At the same time, however, the fact that the tape was buried inside the coffin-like box suggests that, in the end, the art transcended the labour that had produced it. The artist-as–*praticien* was simultaneously acknowledged and repressed.

Morris devised performance pieces, several of which explored the idea of work. *Site*, which he performed with Carolee Schneemann at the Surplus Theater, New York in 1964, turned the stage into a kind of construction site. A white box played a tape of construction workers drilling with jackhammers. Morris stood on stage for several minutes before walking towards a large geometrical structure made from white-washed plywood boards. Dressed in work clothes, gloves and boots, he proceeded to dismantle the box. Inside lay Schneemann, naked and in the reclining pose of Manet's *Olympia* – in its day, a rather shocking image of a working woman. Having revealed her, Morris moved away and manipulated one of the plywood planks in a variety of ways – kneeling next to it, balancing it on his back, etc.[54]

The idea of transparency is central to Morris' work. In *Box with the Sound of its own Making* we eavesdrop on every moment of the creative process. What is normally hidden behind the scenes is shown in exhaustive, yet elusive detail. In *Site*, when Morris manipulates the plank into different positions, it is like a *Kama Sutra* of construction. In later works, other people get hands-on experience of Morris' props. A 1971 exhibition at the Tate Gallery had to be closed after five days because of fears about safety: viewers were expected to climb up and down ramps, dragging weights; to seesaw on slabs of plywood; walk across beams and wires. Several injuries were sustained, including some nasty splinters in mini-skirted bottoms and thighs.[55]

In such pieces, 'work' is demanded equally of the artist and the viewer, so that there is no dividing line between creation and consumption. Such an aesthetic obviously favours an object-based art. It is much harder to 'work' with, or on, a conventional painting hung on a wall. Or at least if the painting is worked with, its status as something that is viewed from a distance by a stationary viewer will be destroyed. A performance by American Neo-Dadaist Jim Dine, called *The Smiling Workman* (1960),

featured Dine, a blank canvas and a table with three jars of paint and two brushes. After drinking a jar of paint and pouring the other jars over his head, Dine dived through the canvas. Yoko Ono's self-explanatory 'instruction' pieces of 1960–2, such as *Painting to be Stepped On* and *Painting to Hammer a Nail In*, are interacted with in an equally iconoclastic way. The implication of Dine's and Ono's pieces is that your average 'workman in the street' is baffled by painting and feels a compulsion to manhandle it, thus turning it into an accessible object in space.[56]

Few post-war artists have gone to more elaborate lengths to establish their worker credentials and the 'workability' of their art than the Minimalist sculptor Carl Andre (born 1935). Andre liked to wear overalls, and made much of the fact that from 1960 to 1964 he worked on the Pennsylvania Railway as a freight brakeman and conductor. The experience of 'continually shifting cars around and making new strings of [raw] material'[57] was crucial for the development of his sculpture, which consisted of horizontal arrangements of discrete bricks, blocks and slabs – what he called particles. But it was not just his experience of the railway that made him interested in geometric arrangements of 'particles'. His bricklayer grandfather was also crucial, because 'the whole theory of masonry is in being able to make large structures by using small units. I've only done one work in my life where I could not manipulate the particles of the piece myself'.[58]

Direct physical involvement, both by the artist and the viewer, was crucial. The viewer is expected to walk across and stand on the sculptures, and thus to become 'sensitive to the properties of the material'. Different materials make different sounds and have different textures. The owners of the pieces can easily install and dismantle the pieces themselves.[59] This level of involvement means that everyone becomes what Andre calls an artworker: 'the term artworker . . . includes everybody who has a contribution to make in the art world . . . I make artworks by doing art work but I think the work itself is never truly completed until somebody comes along and does artwork himself with that artwork.'[61]

This ethos has also affected the way in which art is taught, and the places in which art is made and exhibited. The aura of the workman-like has affected art-schools, artists' studios, and museums and galleries.

It has become *de rigueur* (in theory, at any rate) for teaching to be conducted on a workshop basis, with plenty of give and take between

the teacher and pupil. Indeed, in artists' CVs, we often read that they 'studied with' a famous artist, rather than being 'taught by' them. A celebrated example is the 'teaching' given by the sculptor Anthony Caro (born 1924) at St Martin's School of Art in London during the 1950s and 1960s. It has been said that Caro 'established a "workshop" situation that involved group collaboration on sculptural projects as well as much critical give-and-take, all in an informal atmosphere'.[61]

Caro himself has described it as follows:

It was a very exciting time. We would be going to one another's studios, or into the sculpture school; there'd be work to look at, work that would call your own work into question. When we went to each other's studios and saw what the other person had done, it would make you say, 'My God, he opened up a whole area', or 'He's pressing a new area, say, for example the use of colour, which I hadn't thought about, and that, maybe, raises some doubts about the direction or quality of what I'm doing'. All of us were questioning the assumptions by which sculpture had said 'I'm Sculpture'.[62]

At least one student, however, was not so enamoured: 'twelve adult men with pipes would walk for hours around sculpture and mumble!'[63] Still, Courbet might have been happy.

The ideal studio for the modern artist – whether painter or sculptor – has also changed. It is no longer Leonardo's elegantly furnished domestic space. It is closer to Leonardo's image of the sculptor's studio. This is partly because even the painter is likely to be working with unconventional materials and methods, and to be emphasizing the object-based nature of his or her picture; partly because so many studios are situated in lofts in converted warehouses and factories. In the post-war period artists in the United States, and elsewhere, started to move into disused industrial buildings, and into buildings where manual work had previously taken place. A major attraction was that they were relatively cheap and light, and spacious enough to accommodate large works. But the romantic associations of industrial and artisanal work were important too. This is the era of the undomesticated studio space.

Both the painter Jackson Pollock (1912–56) and the sculptor David Smith (1906–65) were drawn to the mythology of the worker-artist. Smith made his welded steel sculptures in a former ironworks, and presented himself as a rough-and-ready Hephaistos figure, rather like the

heroic workers who appear in the sculpture of Constantin Meunier, and in Social Realism. In 1959, the suitably named Smith gave a vivid description of the changed *modus operandi* of modern artists

> When I lived and studied in Ohio [in the 1920s], I had a very vague sense of what art was . . . Genuine oil painting was some highly cultivated act . . . and when I got to New York and Paris I found that painting was made with anything at hand, building board, raw canvas, self-primed canvas, with or without brushes, on the easel, on the floor, on the wall, no rules, no secret equipment, no anything, except the conviction of the artist . . . Sculpture was even further away . . . I now know that sculpture is made from rough externals by rough characters . . . The mystic modelling clay is only Ohio mud, the tools are at hand in garages and factories. Casting can be achieved in almost every town.[64]

Jackson Pollock was also interested in the idea of the worker-artist, and this in turn went hand-in-hand with a desire to be a sculptor. He was always fascinated by sculpture, and had serious intentions of making some. Writing to his father in 1932, he reveals himself as a classic 'worker-artist'. He is studying at the Art Students League of New York, and reckons it will take him a 'good seventy years more' to make a good artist: 'And when I say artist I don't mean it in the narrow sense of the word – but the man who is building things – creating moulding the earth – whether it be plains of the west – or the iron ore of Penn. Its all abig [sic] game of construction.' He goes on to register a preference for sculpture: 'Sculpturing I think tho is my medium. I'll never be satisfied until I'm able to mould a mountain of stone, with the aid of a jack hammer, to fit my will.'[65] His desire to mould a mountain was influenced by Gutzon Borglum's contemporaneous work on Mount Rushmore.[66]

Pollock took a course in stone-carving the following year – 'it's great fun but damned hard work'.[67] When he was hospitalized in 1938, he made some more sculpture as part of an occupational therapy programme, but then gave it up until he moved to Long Island. A major reason for the move was that it would enable him to make sculpture. He had a back yard full of scrap iron and rocks that he collected.[68] Around 1949 he made some small wire and plaster 'models' for a scale-model museum for his paintings, and did some clay modelling. His last sculpture

was a papier mâché construction, about sixty inches long, of rejected rice-paper drawings. It had a chicken-wire frame and was mounted on a wooden door laid horizontally, and was shown at an exhibition of *Sculpture by Painters* in 1951. After the show, Pollock left the sculpture outside and it soon disintegrated.[69] From photographs, it resembles a craggy, but slightly biomorphic mountain. In the end he had realized his ambition to 'mould a mountain' – though this was a mountain of paper rather than of stone.

Pollock did not in fact make many sculptures, but the memory of sculpture is present in his painting methods and materials, and in his choice of studio. He worked in a barn, laying his vast, unstretched canvases directly on the floor. He explained, 'I need the resistance of a hard surface. On the floor I am more at ease. I feel nearer, more a part of the painting, since this way I can walk around it, work from the four sides and literally be *in* the painting.'[70] The corollary to this was that he rejected traditional tools and media: 'I continue to get further away from the usual painter's tools such as easel, palette, brushes, etc.' Instead he preferred 'sticks, trowels, knives and dripping fluid paint or a heavy impasto with sand, broken glass and other foreign matter added'.[71] The foreign matter included nails, keys, buttons, coins, matches, tacks, cigarette butts, steel gauze, string and pebbles.

Pollock allowed himself to be photographed and filmed at work. He was shown from all angles – from above, from the side and even (when he painted on a sheet of glass) from below. This is what we might call painting 'in the round'. The most influential images were the black-and-white photographs and film made by Hans Namuth in 1950. Here, in his barn, he is a living incarnation of the worker-artist. Pollock always compared his method with that of Indian sand painters, but what the arduous yet lyrical iconography of his art-making suggests is images such as Millet's *Sower* or Dalou's clay models of workers, hovering over the ground.[72] His posture also harks back to the traditional iconography of the sculptor carving a stone sculpture in his studio. Whereas the painter addressed the easel in a vertical position, sculptors such as Michelangelo were sometimes depicted crouching over a lump of stone laid on or near the ground. They too needed the resistance of a hard surface.

The photographs and films of Pollock at work probably had a greater influence on subsequent art than his exhibited paintings. Allan Kaprow, the pioneer of 'Happenings' and 'Environments', saw his legacy in vernacular terms. Post-Pollock, 'we must become preoccupied with and

even dazzled by the space and objects of our everyday life, either our bodies, clothes, rooms, or, if need be, the vastness of Forty-Second Street. Not satisfied with the suggestion through paint of our other senses, we shall utilize the specific substances of sight, sound, movements, peoples, odours, touch.'[73] In the 1950s and 1960s, Happenings (loosely structured performances featuring all manner of specially made and scavenged props) were held in a wide range of non-art venues. Claes Oldenburg's performance/exhibition *The Store* (1961) took place on the premises of a former shop. The exhibits were made and sold on-site. The barn, the factory, the warehouse, the store: these are the meccas of the modern artist.

Even the more traditional kind of painter who has persevered with easel-painting has had to adapt. Jasper Johns' British contemporary Frank Auerbach (born 1931) is a good example. His expressionistic figurative paintings, particularly those from the 1950s, have astonishingly thick impastos. They were once described as the 'thickest pictures that anyone is ever likely to see'.[74] Auerbach's north London studio was purpose-built in around 1900. Yet it now looks like the venue for a particularly messy Happening.

The critic Robert Hughes described a visit in the 1980s: 'The studio is actually a generous-sized room, but it seems constricted at first, all peeling surfaces, blistered paint, spilling plaster, mounds and craters of paint, piles of newspapers and books crammed into rickety shelves, a mirror so frosted with dust that movements reflected inside it are barely decipherable. It is a midden-heap.' And it gets worse:

> Because Auerbach paints thick and scrapes off all the time, the floor is encrusted with a deposit of dried paint so deep it slopes upwards several inches, from the wall to the easel. One walks, gingerly, on the remains of innumerable pictures. Where he sets his drawing easel this lava is black from accumulated charcoal dust. 'I changed the lino three times,' Auerbach says. 'The last time quite recently, less than ten years ago. If I didn't, the paint would be up to here.' He gestures at thigh-height. And then, a few days later: 'Leonardo said painting is better than sculpture because painters kept clean. How wrong he was!'[75]

Everything has turned full circle, and the painter aspires to the uncouth conditions of the sculptor. One of Auerbach's favourite subjects in the 1950s was chaotic building sites; but the most elaborate building site of

all is the one he has created in his own studio. It epitomizes the triumph – and the pathos – of the workman-like.

A workshop environment by no means always inspired object-based art, but it has certainly stimulated artists to think in such terms. When Andy Warhol (1926–87) moved into his so-called Factory on East 47th Street in November 1963 (it was a single 100 × 40 foot room on the fifth floor of a former hat factory), his thoughts immediately turned to sculpture. The first new project he devised was to make around 400 sculptures of grocery boxes for Campbell's tomato juice, Kellogg's cornflakes, Del Monte peach halves, Brillo pads, etc. out of plywood. The logos were silkscreened on to the boxes, which were nailed shut. Warhol worked on these sculptures for three months with his *praticien* Gerard Malanga. One observer said it looked like 'a production line in a surrealist sweat-shop'. Malanga subsequently said that this was the hardest he ever worked with Warhol.[76]

By the end of the 1960s commercial galleries such as Leo Castelli in New York started to hold exhibitions in former industrial buildings, and they did not seek to disguise the building's appearance. In 1969 Holly and Howard Solomon opened a ground-floor loft space in SoHo, New York, and they left it up to the artists they selected to decide what they would do in and to the space. They called it by the most neutral of names: 98 Greene Street. The 112 Greene Street Workshop opened nearby and had an even more *laissez-faire* policy. Artists often started to make work and perform in the gallery without warning.[77]

The warehouse-gallery was an architectural 'found object' that underwrote the rawness and authenticity of the art it contained. Robert Harbison has written, 'Because they are so uncommunicative for long stretches, one attributes absolute integrity to industrial structures . . . The aesthete is seldom more credulous than when presented with brute facts of labour.'[78] Even some brand-new museum buildings have aspired to the condition of the industrial artefact. Richard Rogers' and Renzo Piano's Pompidou Centre, which opened in 1977 with a Duchamp retrospective, was routinely compared to an oil refinery.

Over the last twenty years museums in converted factories, railway stations, market halls, hospitals, prisons and power stations have been opening at an ever-increasing, even alarming rate.[79] A *mise-en-scène* that epitomizes the spirit of the age can be found in a room at the Saatchi Gallery in London. The gallery opened in 1985 in a former paint factory in a north London suburb. Its official name is its street name: 98A

215

29. **Richard Wilson**, 20:50, 1987
(Mixed media installation, Saatchi Collection, London).

Boundary Road. The interior was adapted by the architect Max Gordon. He furnished it with impeccable white walls, but otherwise stressed its industrial credentials. Underfoot there are unforgiving expanses of grey-painted concrete and, overhead, the original glazed factory roof with busy zigzags of steel girders. The gallery shows the private collection of the advertising magnate Charles Saatchi in a series of changing displays.

One room, and one work, has been singled out. This is a large rectangular space that contains *20:50* (1987), a startling installation by the British artist Richard Wilson (born 1953). It is the only work in the Saatchi Collection to be permanently on display. *20:50* was initially commissioned as a site-specific work for Matt's Gallery, an artist-run space in a dilapidated former industrial building in east London. It was bought by Saatchi and its proportions adapted to those of a much larger room in his own gallery.

20:50 is a steel tank filled with 2,500 gallons of used engine oil. It spans virtually the whole room, and gives off a strong smell. The viewer can 'enter' the pool of oil along a steel walkway let into the tank, which

narrows and rises towards the end. When the viewer walks along the walkway, he or she is surrounded by oil up to waist height. The roof, with its girders, is reflected in the oil's perfect mirror surface. Wilson's works are initially suggested by the form of the interior space. He calls his work sculpture, but it is sculpture 'that's located in the fabric of the building'.[80]

20:50 is a conceptual hall of mirrors. It is a three-dimensional 'oil' painting made from used engine oil and installed in a former paint factory. It offers a semi-moving picture of the remains of an industrial product, and of an industrial workplace. Appropriately enough *20:50* came about because of the artist's inability to leave the workplace, both literally and psychologically. Wilson explained the creative process to an interviewer:

> I had gone away on holiday thinking about the exhibition. I never really take holidays, and I'd spent four weeks by a swimming pool [in the Algarve]. I was up to my eyes in water thinking *what can I do!*
>
> INTERVIEWER: *I know, boredom of holidays.*
>
> Exactly, and there was this horizontal plane of liquid which slowly began to present itself, like a useful topic.[81]

Like so many modern artists, Wilson would have no truck with ideas about gentlemen-artists. Modern art means achieving a sublime ordinariness.

10. Beyond Relief

The piece of sculpture was a thing standing apart as the picture was apart, the easel-picture, but, unlike the latter, it did not need even a wall. Nor even a roof.

Rainer Maria Rilke, *The Rodin-Book*, 1903[1]

Statues should be put back where they really belong. Go to the Louvre, for example, drag one of those Egyptian colossi out of its somnolence, and then set it up in the heart of a crowded neighbourhood.

Pablo Picasso, as reported by Jaime Sabartes, 1948[2]

IN PART ONE I discussed the way in which painting tended to be given priority by writers on art ranging from Alberti to Baudelaire. The ideal artform presented information on a flat plane, and clearly indicated to the viewer the optimum viewing position. As a result, most sculpture tended to be 'pictorial' and ever mindful of its relationship to walls and architecture. What I want to do in this chapter is show how the pictorial paradigm broke down in relation to public monuments, and even in relation to architecture. I will explain how and why seeing without what has been called 'the boring security of a frontal viewpoint'[3] has become the modern ideal.

In the nineteenth century sculpture was increasingly installed in the centre of public spaces. This not only encouraged viewers to look at it from all angles, but prompted sculptors to make work that was fully 'in the round'. Because sculpture now posited a mobile viewer and variable viewing conditions, it had the potential to mirror modern experience more fully than painting, which is more likely to be viewed from a single viewpoint. In so many accounts, modernity is associated with restlessness, nomadism, instability; and modern life is envisaged as a series of shocks and surprises.

What happened with public sculpture is paralleled in architecture. In

218

the twentieth century many of the leading architects have striven to create architecture 'in the round'. Whereas most pre-modern architecture was thought of as 'pictorial' – that is, comprehensible from a single viewpoint or from a ground plan – the best modern architecture is often referred to as 'sculptural'.

For these and for many other reasons, sculpture and the 'sculptural' have become key cultural reference points.

DURING THE 1920s and 1930s it became axiomatic in advanced art circles to say that all 'true' sculpture was sculpture in the round. The catalyst for this revolution was thought to be African art. Roger Fry, in his influential essay on *Negro Sculpture* (1920), claimed that only African artists 'really conceive form in three dimensions'.[4] Fry and many of his contemporaries believed that tribal art had discredited Renaissance 'pictorialism' once and for all. Tribal art was seen to be the catalyst that caused modern sculptors to assert their independence from painting and architecture; it taught them how to create sculpture that was truly 'in the round'.

Writing in the 1940s, the connoisseur of Italian Renaissance painting Bernard Berenson contemptuously dismissed the current craze. If nothing else, Berenson's remarks show just how entrenched was the assumption that the discovery of tribal art had revolutionized modern art:

When negro sculpture first came to Paris, some five and thirty years ago, the dealer who launched it hoped to win us over by saying that no Greek masterpiece could hold its head up against it, and that it was in the round. This cry, that Negro sculpture was in the round, you heard for a season at all the Paris dealers, and collectors, and in all Paris social gatherings, and the next season everywhere in New York, and finally after a decent interval you read in luscious language in London dailies, weeklies, and monthlies, and heard at all London luncheon parties and tea-tables: 'The great thing about Negro sculpture is that it is in the round.' It occurred to nobody to ask the pioneer dealers and their disciples, the London critics and dilettanti: 'What of it? What if they are in the round?' And 'what has their roundness to do with their being great works of art? Are not gasometers in the round, and the enormous pipes that disfigure subalpine valleys?' 'Ah, but they are cylindrical', and no epithet could be more decisive, more majestically final.[5]

Other art critics (particularly those who were familiar with the work of Constantin Brancusi) were even prepared to sanction the use of cylindrical forms of art. One of the London critics to whom Berenson alludes must have been R. H. Wilenski. Writing about tribal art in the 1930s, Wilenski had argued that 'form of this kind revolving around an axis is, of course, the fundamental characteristic of pottery'. The 'cylindricality' of the trees from which the sculptors carved their work was also crucial.[6] One of the artists Wilenski discusses is Henry Moore, and Moore was to stress repeatedly the importance of his study of non-European art in the British Museum for the development of sculpture 'fully in the round'.

Despite all this, there is strong evidence to suggest that the 'discovery' of tribal art was not the initial, or even the principal catalyst for the creation of sculpture in the round. The main stimulus was much closer to home. The numerous public monuments that were erected during the so-called *statuemania* of the late nineteenth and early twentieth centuries long pre-dated the 'discovery' of tribal art, and it is hardly coincidental that *statuemania* reached a climax in the years 1900–14 – at exactly the same time when avant-garde artists began actively to seek out tribal art.

Without the vogue for public statues, the history of modern art would have been very different, but because its products have been routinely dismissed as both stylistically and ideologically regressive, their avant-garde qualities have tended to be overlooked. In important respects, *statuemania* and 'tribalmania' are two sides of the same coin.[7]

One of the most stimulating treatises on art in the late nineteenth century was *The Problem of Form in Painting and Sculpture* (1893) by the German sculptor Adolf von Hildebrand (1847–1921). It has been described as 'the most read and most influential' art book in the two decades before the First World War.[8] Hildebrand loathed the products of *statuemania* precisely because he recognized their revolutionary – and primitive – aspects. Not surprisingly, we find a re-statement of the relief ideal in its most extreme form. For Hildebrand, an artwork had to have unity, and unity was always a consequence of 'pictorial clearness'.[9] In order to achieve the requisite clarity, Hildebrand suggests that the relief sculptor should design his composition as if it were sandwiched between two sheets of glass, with several points of the highest relief touching the front sheet: 'Each form tends to make of itself a flat picture within the visible two-dimensions of this layer, and to be understood as such a flat picture.'[10] If this procedure were not followed, the figures would seem

30. **Auguste Rodin**, *Monument to Claude Lorrain*, 1884–92
(Marble, Parc de la Pepinière, Nancy).

to be 'arbitrarily stuck on before the visual projection'.[11] It sounds like a
perfect formula for museum art – an art that would present no problem
for the glaziers and cabinet makers. The use of glass for paintings was a
new trend at the time. It made the surface of pictures appear more
even.[12]

221

As for statues 'in the round', Hildebrand believed that these must occupy a clear-cut space – 'a rectangle of greater or lesser depth'.[13] The purpose of sculpture, he asserts, 'is not to put the spectator in a haphazard and troubled state regarding the three-dimensional or cubic aspect of things'.[14] When this is not the case, the 'unitary pictorial effect is lost' and a 'tendency is then felt to clarify what we cannot perceive from our present point of view, by a change of position'.

It is generally assumed that Hildebrand's target in this essay was his contemporary Rodin. Rosalind Krauss, in the most influential recent book on modern sculpture, quotes Hildebrand and then says that the relief is 'paradigmatic for all of nineteenth-century sculpture . . . except Rodin'.[15] Rodin certainly did contravene Hildebrand's strictures more conclusively than any other monumental sculptor in the nineteenth century. The convulsive, pulsating forms in Rodin's reliefs do not project evenly, and are irregularly dispersed. The allegorical reliefs on the base of his *Monument to Claude Lorrain* (1884–92) are especially disruptive. They represent Apollo driving the chariot of the Sun, but Rodin's allegorical sun is more akin to the erupting suns of van Gogh than the diaphanous suns of Claude. The figures explode from the base. Rodin's intention was to 'personify, in the most tangible manner possible, the genius of the painter of light . . . I have a living Claude Lorrain, instead of a sheet of paper more or less covered with black strokes'.[16] There is nothing thin and 'papery' about this relief.

Rodin clearly was in Hildebrand's mind, but the French sculptor is never mentioned in the text.[17] This is because Hildebrand's target in the 1890s was a phenomenon that was much more widespread than Rodin, and that long pre-dated him. Rodin was the tip of a huge artistic iceberg. Hildebrand makes this quite clear towards the end of his essay when he asserts, 'to-day the relief form of art scarcely exists. Sculpture to the modern man signifies some figure in the round, destined to stand in the centre of a public square.'[18] He then loses his temper: 'Can such work rank higher than convict labour?'[19] It is primitive to the point of degeneracy.

The nineteenth century, according to Hildebrand, had seen a disastrous separation of sculpture from architecture. The first example he gives is Canova's funeral monument to *Maria Christina of Austria* in the Augustinerkirche, Vienna (1798–1805). It is perhaps Canova's greatest and most prophetic work. It consists of a pyramid-shaped mausoleum placed against a wall. In the centre is a dark, rectangular opening. From

the left, a procession of marble figures walks up a short flight of steps towards the opening. On the right, a lion lies at the top of the steps with an allegorical figure of Genius perched below him, his left leg dangling over the bottom edge of the steps.

Hildebrand abhorred the way the figures 'appear to be set up in front without any regard to any spatial impression'. As a result they belong 'more to the public than they do to the tomb; it seems as though they had just climbed up into their positions . . . What is here constructed is not a picture seen, but a drama acted out: – the figures are real men and women turned to stone.'[20] According to Hildebrand, this kind of realism had had a huge and catastrophic influence: 'One has but to recall the numerous state monuments at the bases of which crouch figures in stone or bronze, perchance to inscribe a name, or deposit a laurel wreath.' Such innovations blurred the boundary between the statue and the street. A disastrous levelling process had taken place: 'There is no definite line drawn between the monument and the public; – as well bring a few stone spectators on the scene!'[21] Hildebrand has an almost Malthusian horror of crowding, together with a revulsion at public spectacle.

The tendency that Hildebrand describes had in fact been given a theoretical underpinning by a close friend of Canova, Quatremère de Quincy, in some essays about the Elgin Marbles published in 1818, shortly after the sculptures had been put on public display in the British Museum. The essays were cast in the form of a series of letters addressed to Canova in Rome. Quatremère explains that whenever sculpture is integrated into architecture, it loses its grandeur and specificity, for the viewer is compelled to take in the whole building. The Elgin Marbles, however – having been removed from their position high up on the Parthenon and redisplayed at eye-level in the British Museum – could be experienced far more intensely: 'Here, on the contrary, you are on the building-site or in the studio itself, and the objects are to hand in their actual dimensions; you can move around each one, counting up the fragments, assessing relationships and measurements.' The down-to-earth, workman-like presentation allows the imagination to take flight. A very similar aesthetic was even being manifested in domestic interiors. In earlier centuries, furniture had been placed against walls when not in use, and the backs of upholstered chairs were often left uncovered (just as the backs of sculptures were often left unfinished). But at the start of the nineteenth century it became the fashion in England to distribute furniture informally around fireplaces and in the

middle of rooms. An unimpressed French visitor in 1810–11 said the apartments of fashionable houses 'look like an upholsterer's or cabinet-maker's shop'.[22]

Although Hildebrand singles out a wall monument by Canova that was situated inside a church, it was the siting of monuments outdoors that represented the greatest innovation – and the greatest threat. They were by no means exclusive to the nineteenth century, but until then freestanding public monuments had been relatively rare. They had been erected to the monarch and, occasionally, to military heroes.[23] By and large, they had been neatly – and safely – sited in relation to surrounding state palaces and buildings, and surrounding streets. Now, however, the emphasis shifted to all manner of 'great men' – scientists, artists, writers, politicians, businessmen, inventors, philanthropists – who could inspire virtuous and patriotic thoughts and deeds in citizens and in colonial subjects. In theory, these monuments improved the appearance of new roads and crossroads, and 'settled upset environments'[24] in the rapidly expanding cities. But for observers like Hildebrand, their informality, and the fact that they were often precariously stranded in chaotic and ever-changing environments made them conspicuous symbols of modern decadence. Sculpture now seemed to be ubiquitous and out of control. Hildebrand's diagnosis was so compelling that until recently it was treated as virtual art historical 'fact' that sculpture in the round is quintessentially modern, and that earlier sculpture is demurely pictorial.[25]

Hildebrand drew a parallel between the new monuments and 'such artistic crudities as wax figures and panoramas'.[26] The most recent panoramas were mixed-media installations consisting of 'mere painting of flat surfaces and real objects distributed over the foreground'. They were so brutal they could even make the viewer feel ill. It was impossible for the eye to accommodate artificial perspective and real objects: 'This contradiction brings forth unpleasant feelings, a sort of dizziness, instead of satisfaction which attends a unitary spatial impression.'[27] Like so much of modern culture, they induced physiological and psychological chaos.

Hildebrand might have been thinking of any number of nineteenth-century monuments, in any number of styles. Many of the worst offenders were described as Neo-baroque – misleadingly, because baroque sculptors had rarely been quite so cavalier about framing and composition. The monuments of Hildebrand's rival Reinhold Begas were particularly effusive, with their exuberant flotsam and jetsam of

pedestal figures.[28] Begas was chosen by Kaiser Wilhelm II to make a fountain monument in Berlin, although Hildebrand had won an open competition to design it. Another monument that would have horrified Hildebrand is the Albert Memorial (1863–72) in London. It is one of the most outlandish of nineteenth-century monuments, and although the architectural canopy is neo-gothic, it defies categorization. It was initially intended to be a memorial building, but it was then decided that the design for the architectural portion of the memorial should be 'regarded chiefly as a means of ensuring the most effective arrangement of the sculpture which is to complete it'.[29] George Gilbert Scott won the architectural competition and eleven sculptors, including John Foley and William Theed, provided the sculpture. Its plump pedestal sculptures splay out from all four corners of the central gothic-style canopy – so much so that it has been dubbed a 'polychrome banana split'.[30]

The impact that *statuemania* had on European cities was extraordinary. The post-1848 statistics for Paris speak for themselves: thirteen '*statues aux grands hommes*' were erected in 1848–70; 153 in 1870–1914; and sixty-four in 1915–40. The most prolific decade was 1900–10, when fifty-one statues were erected.[31] This does not include the thousands of monuments erected in cemeteries such as Père Lachaise. The term *statuemania* had been coined at least as far back as 1851,[32] and became current in the 1880s. By 1901 there were press campaigns against the erection of new statues in Paris because it was thought there was no more space for them.[33] The Conseil Municipal passed the first legislation to curb such monuments in 1904. In 1923 *Les Nouvelles Littéraires* conducted a survey '*Faut-il tuer des statues?*'[34] and the Germans subsequently obliged by melting down seventy-five bronze statues during the Occupation.

The phenomenon is brilliantly explored by Jean-Paul Sartre in his first novel *Nausea* (1938). The leading protagonist is a researcher called Roquentin, who has developed an obsessional loathing of sculpture. The novel opens with Roquentin's realization that he has been wasting his time by going on a trip to Indo-China. The moment of truth comes while he is 'staring at a little Khmer statuette on a card-table next to a telephone'.[35] The statuette strikes him as 'stupid and unattractive and I felt I was terribly bored'.[36] Roquentin returns to France, and while studying in a small French provincial town comes across the statue of a school inspector and occasional painter and author, Gustave Impetraz, who died in 1902. He assumes the statue is a reassuring presence for the

local people: 'a man of bronze has made himself their guardian'.[37] But Roquentin is fascinated and appalled in equal measure: 'This square may have been a cheerful place about 1800, with its pink bricks and its houses. Now there is something dry and evil about it, a delicate touch of horror. This is due to that fellow up there on his pedestal. When they cast that scholar in bronze, they turned him into a sorcerer.'

Roquentin examines him more closely:

> I look Impetraz full in the face. He has no eyes, scarcely any nose, a beard eaten away by that strange leprosy which sometimes descends, like an epidemic, on all the statues in a particular district. He bows; his waistcoat has a big bright-green stain over his heart. He looks sickly and evil. He isn't alive, true, but he isn't inanimate either. A vague power emanates from him, like a wind pushing me away. Impetraz would like to drive me out of the cour des Hypothèques. I shan't go before I have finished this pipe.[38]

Here, the modern statue has taken on all the power that is usually attributed to tribal fetishes. The latter are just blandly boring and tame (the Khmer statuette sits on a card-table near the telephone). Roquentin is making an exceptional effort not to be outmanoeuvred by this formidable product of *statuemania*.

The low quality of many of these monuments, some of which were mass-produced, should not detract from the fact that the *mise-en-scènes* of which they are a part represent a revolution in seeing. *Statuemania* was not the last gasp of outmoded academic values, as art historians tend to claim; it was a vital and often shocking manifestation of modernity. Although press accounts of the unveiling of new statues tend to be far more concerned with subject-matter than with aesthetic issues, some French writers were intuitively aware of the raw, exotic power of these new forms of street furniture from very early on.

Gustave Flaubert had many close encounters with statues, some relatively conventional, some much less so. In 1845 he paid homage to Canova's *Cupid and Psyche*: 'I kissed under the armpit that swooning woman who stretches out to Love her two long marble arms.'[39] This mode of address was, as we have seen, pretty much in line with Neo-Classical norms. Psyche's armpit is the only erogenous zone that is easily accessible, and it is in the front, at dead centre of the composition, so it reinforces a frontal viewpoint. Thus Flaubert's lips

have been carefully chaperoned by the sculptor towards this fairly safe nodal point.

Flaubert's amazingly violent and lustful historical novel *Salammbô* (1862) offers a less orthodox and controlled engagement with sculpture. Although the novel is set in Carthage, it climaxes with a *mise-en-scène* involving sculpture that has some typically modern characteristics. A barbarian horde of unpaid mercenaries has rebelled and, in a final effort to defeat them, the Carthaginians knock down part of a wall in the temple of Moloch. The temple slaves, having mounted the colossal temple statue of Baal on rollers, push it backwards through the gap in the wall. It is then transported to the middle of the main square. A vast crowd accompanies it on its journey, bringing statues of other gods, and fetishes that include 'little loaves, in the shape of a woman's sex'.[40] When the colossus reaches the centre of the main square, the priests set up trellises around the god to keep the crowd back, while they themselves stand round its feet and between its legs. We are told with bathetic precision that the Carthaginian general Hamilcar stands by the toe of its right foot. The colossus stands on a circular plinth, which in turn suggests that it can be viewed fully 'in the round'.

Now everything gets horribly touchy-feely. A high priest touches the statue's legs with outstretched arms, and then a fire is started between its legs. As the temperature rises, the temple slaves open up seven compartments in the god's body. The seventh compartment, the largest, 'gaped wide'.[41] Food and animals are thrown inside. More slaves stand behind the god holding chains that pass over its shoulders and are connected to its arms. When they pull on the chains, they can make the arms flail jerkily against its torso, like a puppet. Human sacrifices are placed on its hands, and when the chains are pulled, they are propelled inside the idol's red-hot body with 'dizzy' arm movements. This contraption, with its gaping compartments, lies midway between Canova's funeral monument (in which a dark opening 'swallows up' a procession of figures) and Salvador Dalí's *Venus de Milo with Drawers*.

Eventually, evening falls: 'The pyre, now without flames, made a pyramid of embers up to his knees; completely red, like a giant covered with blood, he seemed, with his head flung back, to be staggering under the weight of his intoxication.' Those who had been imbibing narcotic drinks 'crawled on all fours round the colossus roaring like tigers'.[42] Naturally enough, the barbarian hordes are subsequently routed, and Carthage is saved.

The placement of the statue in the central square is a symptom of that characteristic nineteenth-century condition: *horror vacui*. Even the walls of the main square are 'crammed' with people, and seem to crumble 'under the screams of horror and mystic pleasure'.[43] Everywhere, and everything, is crowded and confused. Sightlines are overloaded into instability. *Salammbô*, like so many of Flaubert's novels, almost suffocates under the weight of its minutely detailed descriptions of jewellery and other exotica. Flaubert was an obsessive 'worker-artist' who put endless amounts of research into his novels.[44] While researching another novel, *Bouvard et Pécuchet*, he informed a friend of his predicament: 'I am, sir, *inside a labyrinth*.'[45] The striving for realism gives Flaubert's novels a numbing intensity. There is a relentless incantation of information.

Flaubert's insistence on seeing things from every angle, on having constantly to shift one's position, helps to explain his gloating fascination with sculpture: our attention is even called to the toe of the sculpture's right foot. Later in the century mobile viewing would become one of the fundamental principles of phenomenology. As Edmund Husserl would write in 1907, 'All spatiality is constituted through movement, the movement of the object itself and the movement of the "I".'[46] It is true that most statues (unlike Flaubert's Baal) did not move, but they did change, in the sense that they were exposed to different light sources and weathers, and were viewed against endlessly changing backgrounds.

After 1872, for the first time in the history of the Paris Salon, critics began to voice the opinion that French sculpture was superior to French painting.[47] Some of the reasons for this state of affairs are not very impressive – sculpture is often preferred because it respects tradition more than contemporary painting, and because it selflessly furnishes patriotic images at a time of national crisis (the aftermath of the Franco-Prussian War).[48] But sculpture is also preferred because of its greater proximity to nature: 'Sculpture is truly a model of man, and, like him, she lives and palpitates.'[49] That primitive sense of sculpture being alive was bound up with its placement in the streets and parks.

Even Baudelaire seems to have been affected by the nineteenth-century's obsession with public sculpture – though in a rather more sober way than his friend Flaubert. Thirteen years after writing about why sculpture is so boring, Baudelaire revised his wholly negative opinion about this artform. He devoted a long section of his *Salon of 1859* to sculpture, and the section opens with a powerful description of live confrontations with it. Not all of this is necessarily nineteenth-

century sculpture, but the way Baudelaire responds to sculpture is very much of its time. Each description is given its own paragraph and starts abruptly. He begins with a statue of silence 'at the heart of an ancient library, in the propitious gloom which fosters and inspires lengthy thoughts', before jump-cutting to a park where a 'passing dreamer' sees a statue of Melancholy in a wood gazing at her face in the waters of a pool. Suddenly the pace quickens:

> As you are hurrying towards the confessional, in the midst of that little chapel which is shaken by the clatter of the omnibus, you are halted by a gaunt and magnificent phantom who is cautiously raising the cover of his enormous tomb in order to implore you, a creature of passage, to think of eternity!

We are then confronted by a 'prodigious figure of Mourning' at the corner of a 'flowery pathway', before being dragged back to a 'boudoir of greenery' where Venus and Hebe are displaying 'the charms of their well-rounded limbs'. Finally, we are dropped off in the middle of a big city:

> You are passing through a great city which has grown old in civilization – one of those cities which harbour the most important archives of universal life – and your eyes are drawn upwards, *sursum*, *ad sidera*; for in the public squares, at the corners of the crossways, stand motionless figures, larger than those which pass at their feet, repeating to you the solemn legends of Glory, War, Science and Martyrdom, in a dumb language. Some are pointing to the sky, whither they ceaselessly aspired; others indicate the earth from which they sprang . . . Be you the most heedless of men, the most unhappy or the vilest, a beggar or a banker, the stone phantom takes possession of you for a few minutes and commands you, in the name of the past, to think of things which are not of the earth.
> Such is the divine role of sculpture.[50]

Baudelaire goes on to summarize some of his earlier views on sculpture, but he is much less wholehearted than he was in 1846. His criticisms are more modulated. Sculpture is a 'strange art, whose roots disappear into the darkness of time', but even in 'primitive ages' it was 'producing works which cause the civilized mind to marvel!'[51] Now it seems that

sculpture's association with darkness, and with inadequate and/or unstable lighting, gives it a unique power. When Baudelaire comes across the first statues in his essay, they loom up like ghosts. The ancient library is bathed in a 'propitious gloom'; eternal Melancholy is 'sheltered beneath heavy shades'. At this time, Baudelaire was increasingly giving primacy to the imagination, and the essence of imagination was mystery.[52]

Baudelaire reiterates that the bas-relief is 'a step taken in the direction of a more civilized art'[53] – that is, painting, an art that can be looked at from only one viewpoint. But what is so striking about his appreciation of public sculpture is the *frisson* created by the viewer casually stumbling into its presence. There is no formal way of seeing it; or at least Baudelaire suggests that the ideal way of seeing it is by half-seeing it. It ambushes the viewer; and vice-versa. The abrupt beginnings to Baudelaire's paragraphs, and the jump-cuts between location, grab the reader by the lapels – 'At the heart of an ancient library'; 'In the fold of a wood'; 'As you are hurrying towards the confessional'; 'You are passing through a great city'. The statues force you to crane your neck every which way.

In 'Le Masque', a poem inspired by a sculpture that Baudelaire describes in the 1859 Salon, the jolt administered to the poet's system is quite explicit.[54] The statue was by Baudelaire's friend, Ernest Christophe, and was initially called *La Douleur*, and then *La Comédie Humaine*. It is a voluptuous figure. Baudelaire implores us to approach and 'take a turn around her beauty'. But suddenly:

O blasphemy of art! fatal surprise!

He is horrified (and thrilled) to discover that this woman 'with a divine body' is a double-headed monster. But there is still another shock in store:

– But no! it's just a mask . . .

It is only a mask, under which can be discerned a beautiful, weeping face. This sequence of shocks completely contravenes his previous idealization of bas-relief. Indeed, we imagine him prowling round the statue, peering behind the mask, and making out the weeping face that is probably cast in shadow. The statue was later sited in the Tuileries Gardens.

This ability to shock and to provide a series of surprises is the essence of sculpture's modernity.[55] Baudelaire makes the point explicitly, when he says that in the midst of 'that little chapel which is shaken by the clatter of the omnibus, you are halted by a gaunt and magnificent phantom'. Just as the chapel is shaken by the omnibus, so the penitent is shaken by the sculpture. The tomb offers us a *deus ex machina* for the machine age. This is a subtle, but crucial development from the views expressed by Baudelaire in 1846. Then sculpture was always a complementary art that harmonized with its background. Now it is starting to leap out from its background and become part of the montage – and labyrinth – of modern life.[56]

Some of the close encounters with sculpture that Baudelaire details are paralleled in Manet's *Déjeuner sur l'Herbe* (1863). This painting is routinely regarded as the first work of 'modern' art. Its early viewers were shocked and baffled by the abrupt juxtaposition of two clothed men with two naked women in a wood. Manet's painting has always been regarded as a modernized version of Giorgione's *Fête Champêtre* in the Louvre, in which two clothed men fraternize with two naked women in a landscape.[57] But direct experience of garden sculpture may have been a more important catalyst. The woman in the background of Manet's picture, who stands bent over in a pool, is a counterpart to Baudelaire's figure of Melancholy gazing 'at her august face in the waters of a pool as motionless as she is'. In general, we might say that we have tumbled 'into a boudoir of greenery', where Venus and Hebe are displaying the 'charms of their well-rounded limbs'. The clothed man who snuggles up to the woman in the central foreground of Manet's picture is in fact a sculptor, the young Dutchman Ferdinand Leenhoff. Leenhoff was the brother of Manet's future wife, Suzanne. He specialized in mythological and religious sculptures as well as portrait busts.[58]

Of course Manet has de-idealized the pastoral idyll, and early viewers thought the women's faces were coarse, rather than august or charming. The painting could thus be a private joke between him and Leenhoff. Manet may be supplanting the sculptor's idea of pastoral beauty with his own, 'realist' version; at the same time, he may be implying that Leenhoff is Pygmalion with a down-market Galatea. Either way, the abrupt erotic 'surprises' staged in Manet's painting – clothed men confronting unclothed women in a 'real' landscape – probably owed as much, if not more, to modern ideas about the impact of public sculpture as they did to Renaissance painting.

31. **Giorgio De Chirico**, *The Enigma of a Day*, 1914
(Oil on canvas, Museum of Modern Art, New York.)

AMONGST THE finest testaments to the emotive power of *statuemania* are
the metaphysical paintings of Giorgio de Chirico (1888–1978).
Metaphysical iconography first emerges during de Chirico's stay in
Munich between 1908 and 1909,[59] and it is tempting to wonder whether
de Chirico read Hildebrand's treatise, since Munich was one of the
sculptor's principal residences. A complex passage in which Hildebrand

232

explains this 'superstitious regard for the centre of a square' might have
been of particular interest to de Chirico:

> It is due to the uncultured mind which fancies an open square to be a
> sort of organic unity . . . Accordingly the open space is conceived as
> something which exists for its own sake, instead of being regarded as
> a thing *seen*, of which the artistic right of existence depends entirely
> on its *being seen*, and of which artistic properties [i.e. statues] can be
> treated only from this point of view.[60]

De Chirico's squares are not entities that can be 'seen' in any direct or
integral way. They are labyrinths with multiple vanishing points, ob-
structed by numerous objects and shadows. The architecture seemingly
has no logical relation to the sculptures that are displayed in their midst.
The bronze statue of a frockcoated figure in *The Enigma of a Day* (1914)
is cut in half by shadow and is sandwiched between two arcades. We
only see this statesman-like figure from the side. He gestures grandly
towards a blank, shadowy arcade with a massively bloated hand. In *The
Uncertainty of the Poet* (1913) a classical torso sits directly on the ground
and rubs up against a bunch of bananas. These objects seemingly exist for
their own sake in what de Chirico termed 'plastic solitude'.[61] Where
modern monuments and panoramas induced 'a sort of dizziness' in
Hildebrand, de Chirico warms to their hallucinatory intensity. They are
clumsy misfits, which casually spill their shadows. They stand on
ceremony, but there is no obvious ceremony.

De Chirico's hero was Nietzsche – specifically Nietzsche's Zarathustra.
De Chirico wrote that he was 'surprised' by Zarathustra, and this word
'surprised' contained 'all the enigma of revelation that comes suddenly'.[62]
Encounters with statues were central to these sudden revelations. De
Chirico was born in Greece, and he revered classical sculpture. He
believed that 'the idea of representing a god with a human face which the
Greeks conceived in art was an external pretext for discovering sources of
new sensations'.[63] But his experience of modern public sculpture was far
more important. Indeed, it is modernity incarnate.

De Chirico describes a 'primal scene' that took place one autumn
afternoon while he was sitting on a bench in Piazza di Santa Croce in
Florence. It was not the first time he had been there, but he was just
recovering from a long illness that rendered him more susceptible than
usual:

The whole of nature, including the buildings and the fountains, seemed to be convalescing. In the middle of the square stood a statue representing Dante in a long robe, holding his book against his body, raising his pensive head, crowned by laurels, towards the sun. The statue is made from white marble; but time has given it a grey tinge, very pleasant to the sight. The autumn sun, tepid and loveless, lit up the statue like the façade of the church. I then had the strange impression that I saw everything for the first time.[64]

This statue was not just any statue. It was one of the most famous modern statues in Florence. This is how it is described by Karl Baedeker in his guide to Italy of 1906:

In the spacious Piazza di Santa Croce rises *Dante's Monument* by Enrico Pazzi, inaugurated with great solemnity on the 600th anniversary of the birth of the great poet, 14th May, 1865. It consists of a white marble statue 19 ft in height, on a pedestal 23 ft high, the corners of which are adorned with four shield-bearing lions with the names of his four most important works after the Divina Commedia: the Convito, Vita Nuova, De Vulgari Eloquio, De Monarchia. Round the pedestal below are the arms of the principal cities of Italy.[65]

Local legend had it that if you sat at the edge of the piazza and recited a special poem invoking Dante, the man himself would appear from around the back of the pedestal and would sit on it 'like an ordinary person' and read a book.[66] This conjunction of sublimity and ordinariness, and of surprise, is integral to this type of monument. The revelation in Piazza di Santa Croce was to inspire one of de Chirico's first 'metaphysical' paintings, *Enigma of an Autumn Afternoon* (1910).

And just why should de Chirico's epiphany have occurred in front of this statue, rather than before a Renaissance masterpiece? Of course, the obvious answer is that if he was ill, he was not in a fit state to pick his spot. But de Chirico's highly contrived primal scene was surely far more than mere happenstance. De Chirico, no less than Hildebrand, seems to have regarded the siting of statues in the middle of public spaces as a modern phenomenon. There was a freestanding Renaissance monument in the Piazza della Signoria, Giambologna's *Equestrian Statue of Grand-Duke Cosimo I*, but the most famous statues – Donatello's *Judith and Holofernes*, Giambologna's *Rape of the Sabines* and Cellini's *Perseus and*

32. Piazzale Michelangelo (1875), Florence, from a nineteenth century photograph.

Medusa – were sited in a covered arcade, the Loggia dei Lanzi. Until 1873, when it was taken indoors to the Accademia, Michelangelo's *David* had been placed against the front wall of the Palazzo della Signoria. Pazzi's Dante Monument probably seemed more daringly exposed and isolated, and thus more suited to de Chirico's needs.

De Chirico would have had to cross the Arno and go up the hill by the Viale Michelangelo to Piazzale Michelangelo, if he wanted to find Renaissance sculptures displayed in a more congenial way. The Piazzale had been inaugurated in 1875, Michelangelo's anniversary year. In a Salammbô-esque gesture, bronze casts of Michelangelo's *David* and the *Times of the Day* from the New Sacristy in San Lorenzo had been set up in the centre of the square. Not only was *David* now displayed 'in the round', but the *Times of the Day* projected longways from the corners of the monument, like flying buttresses.[67] On seeing the *Times of the Day* exposed in this way, one is reminded of the marble reclining figure in de Chirico's *Melancholy* (1912). The sculpture is isolated in the centre of a square and observed obliquely from the rear by two figures.

235

De Chirico's enthusiasm for Nietzsche and for Zarathustra was also intimately related to *statuemania*. Nietzsche had been staying in Turin when he wrote *Thus Spake Zarathustra*, and it was at about this time that he had started to go mad. De Chirico visited Turin on his way to Paris in 1911. Nietzsche's room looked out on to an arcaded square, which contained an equestrian monument by one of the most famous and successful nineteenth-century Italian sculptors – Carlo Marochetti (1805–67).[68] Marochetti was born in Turin, and he went on to become the favourite sculptor of Queen Victoria and Prince Albert: his best-known British work is the equestrian monument of *Richard the Lion Heart* outside the Houses of Parliament in London.

The fabric of Turin had been more radically transformed by *statuemania* than any other Italian, and perhaps even any European, city. Turin was laid out on a grid, and had several large arcaded squares, but it was only in the nineteenth century that these began to be filled with statues. According to *Turin and Its Neighbourhoods*, a detailed guide published by the 'Pro Torino' Association in 1911, Marochetti's equestrian *Statue of Duke Emmanuel Philibert* (1838) was the 'first monument erected in the squares of Turin'. The granite base, orna-mented with bronze friezes, measures fourteen feet high; and the statue rises a further fourteen and a half feet. It received a 'star' from Baedeker (the same as Michelangelo's *David*), and the Pro Torino Association was understandably enthusiastic: 'The attitude of the duke, arresting the onward course of his fiery charger, with its nostrils dilated and its mane floating in the wind; the general artistic motion of the group; the just proportion of the parts; the aesthetic correctness of the whole monument from whatever side it is seen, concur in making it a masterpiece of modern art.'[69] Since the inauguration of this masterpiece 'in the round', Turin had been glutted with monuments to all manner of 'great men'. Baedeker lists at least thirty outdoor monuments, excluding all those in the cemetery.

Marochetti-ish equestrian monuments were to feature in de Chirico's *Still-Life: Turin in Spring* (1914), *The Pink Tower* (1913) and numerous other paintings. The figure of a Philosopher, which frequently appears in de Chirico's work, derives from a statue of a local intellectual Giovanni Battista Bottero, which stands on a low plinth in a park. The Mole Antonelliana (1863–90), a freestanding tapering tower, 275 feet high, appears in *The Nostalgia of the Infinite* (1913–14).[70]

Partly inspired by de Chirico, the Surrealists were equally fascinated

by the products of *statuemania*. *The Enigma of a Day* was owned by the leader of the Surrealists, André Breton (1895–1966), and almost became the ur-image of the movement. Early on in his novel *Nadja* (1928), Breton pays homage to the Italian artist: 'Chirico acknowledged at the time that he could paint only when *surprised* (surprised first of all) by certain arrangements of objects, and that the entire enigma of revelation consisted for him in this word: surprise.'[71]

Breton's text is illustrated with photographs. The first shows the Hôtel des Grands Hommes, where Breton lived in 1918, with a statue of a '*grand homme*' planted side-on in the street outside. The third illustration shows an elaborate Parisian monument with pedestal figures. The statue of the '*grand homme*' is introduced into the narrative when Breton protests that the reader should not expect his narrative to be logical:

> I must insist, lastly, that such accidents of thought not be reduced to their *unjust* proportion as *faits-divers*, random episodes, so that when I say, for instance, that the statue of Étienne Dolet on its plinth in the Place Maubert in Paris has always fascinated me and induced unbearable discomfort, it will not immediately be supposed that I am merely ready for psychoanalysis, a method I respect and whose present aims I consider nothing less than the expulsion of man from himself, and of which I expect other exploits than those of a bouncer. I am convinced, moreover, that as a discipline psychoanalysis is not qualified to deal with such phenomena, since despite its great merits we already do this method too much honour by conceding that it exhausts the problem of dreams or that it does not simply occasion further inhibitions by its very interpretation of inhibitions.[72]

Etienne Dolet (1509–46) was a publisher and writer. He killed a man, apparently in self-defence, but after receiving a royal pardon, in 1537, he held a banquet attended by his friend Rabelais. In 1546, having been suspected of materialism and atheism, he was burned at the stake for heresy in Place Maubert. The bronze statue by Ernest-Charles Demosthène Guilbert (1848–1913) was erected in 1889, and the pedestal is adorned with a high relief showing the City of Paris Protecting Freedom of Thought, and some allegorical statues.[73] So Dolet was an obvious hero for the Surrealists (and a threat to the Nazis, who destroyed the statue during the Occupation).

But the subject-matter alone does not explain the mixture of

'fascination' and 'unbearable discomfort' felt by Breton. This was due to the utter intractability of public statuary. *Statuemania* is effortlessly incorporated into a scurrilous dream narrative, but psychoanalysis can do nothing to explain the presence of this statue in Breton's text.[74] Psychoanalysis may operate with the force of a bouncer, but it cannot dislodge or disarm the statue of Etienne Dolet. Breton's association of statuary and psychoanalysis is probably due to the prevalence in psycho-analysis of archaeological metaphors. Freud often compared the task of the psychoanalyst to that of an archaeologist on a dig.[75] Breton is suggesting that a psychoanalyst/archaeologist would not be able to rationalize or assimilate this kind of modern statue. It just stands there, irrepressible. Only much later does Breton illustrate two tribal sculptures – a mask from New Britain, which makes Nadja exclaim, 'Goodness, Chimene!', and an Easter Island statuette that seems to say to Nadja, 'I love you, I love you.'[76] Their insertion into the novel seems tokenistic and glib by comparison.

The most dazzling and extended sequence of Surrealist *statuemania* occurs in the second part of Louis Aragon's novel *Le Paysan de Paris* (1926). The movement's love–hate relationship with statues is here given full rein. The novel is divided into two parts, and the second part is entitled *A Feeling for Nature at the Buttes-Chaumont*. It centres on a nocturnal visit by Aragon to the park of the Buttes-Chaumont in Paris in the company of Breton and Marcel Noll. The park had been created by J.-C.-Adolphe Alphand on rocky heights 230 feet above the city of Paris, and had opened in 1866–7. At the centre of the park was a famous 'bridge of suicides'.

Before describing the visit, Aragon briefly discusses the 'strange statuary' that is sprouting up over the entire country – the statuary of petrol pumps:

These modern idols share a parentage that makes them doubly redoubtable. Painted brightly with English or invented names, possessing just one long, supple arm, a luminous faceless head, a single foot and a numbered wheel in the belly, the petrol pumps sometimes take on the appearance of the divinities of Egypt or of those cannibal tribes which worship war and war alone. O Texaco motor oil, Esso, Shell, great inscriptions of human potentiality, soon we shall cross ourselves before your fountains, and the youngest among us will perish from having contemplated their nymphs in naphtha.[77]

There is no sense, however, that these new kinds of anonymous statuary will supplant the more regular products of *statuemania*: they will be complementary monuments in a world wholly given over to fetishism and idolatry.

Aragon is thrilled at the prospect of going to Buttes-Chaumont: 'At last we were going to destroy boredom, a miraculous hunt opened up before us, a field of experiment where it was unthinkable that we should not receive countless surprises and who knows? a great revelation that might transform life and destiny.'[78] The park is the town's 'collective unconscious'[79] and sculpture – both literally and metaphorically – is ubiquitous. The park is described as a three-part relief,[80] and the people on the approaches to the park loom up out of the surrounding waste ground and allotments 'with all the conventional majesty and the frozen gestures of statues'.[81] Aragon then describes Breton's walking stick decorated with obscene carvings, which are possibly by Gauguin.[82] The artform that once bored Baudelaire has become the key component of a troglodyte world where boredom is unknown.

There follows a delirious diatribe over *statuemania* by Aragon. The poet is both scathing of the statues' ugliness and awe-inspired by their power. He sees a Malthusian explosion of statues, which will soon make it impossible to move through streets and fields: 'Humanity will perish from statuemania, that's what. The god of the Jews, who feared competition, knew what he was doing when he prohibited graven images. Great private symbols exercising their concrete power over the world, the statues will eat your hair up, passers-by.'[83] They are more powerful than ancient monuments: 'in their flannelette dressing-gowns, their comfortable jackets, their smiling amiability, these simulacra of modern times derive from the very inoffensiveness of this garb a magical power unknown to Ephesus or Angkor'. So powerful are they that secret religions have been established in honour of the 'new idols'.[84] The Surrealist poet Paul Eluard deposits the tributes of 'an amorous cult' before Antonin Mercié's *Paris During the War* – a statue of a woman brandishing a sword.[85] Aragon comments that although she was 'generally considered hideous', Eluard liked to insist that it was really 'an extraordinary and powerful image of the "woman of the people" (an opinion which the author endorses)'.[86] We cannot tell exactly how serious they are. But they are paying considerable attention. And that, for the Surrealists, is being serious.

After Aragon's outburst, we are honoured with a long and garrulous

speech by an unnamed male statue. The idea that a statue might be articulate — and racily entertaining — is a compliment indeed. This self-styled 'vagrant idol' and vagabond metaphysician addresses the founder of population studies: 'O Malthus, great-hearted bishop, it is my sister statues who will finally give substance to your chimeras: women no sooner see us than they abort, and with our polished members we help to set in motion the sluggish imagination of the timid girls who excite themselves in the strange shadow cast by our forms, in love henceforth with our superhuman bodies and nothing else.'[87] This must be a reference to sculptures like Jules Dalou's pole-axed effigy of the dead *Victor Noir* (1891) in Père Lachaise cemetery, which regularly had its generously modelled groin area rubbed by women in the hope that it would promote fertility.[88] Needless to say, Aragon's speaking statue would be dismissed by Hildebrand — its 'strange cast shadow' and its 'polished member' would be accused of being 'arbitrarily stuck on before the visual projection'. But there is no doubting this statue's potency. The swaggeringly intrusive products of *statuemania* are impregnating the city.

In 1930 the dissident Surrealist poet, Robert Desnos, demanded that statues should have 'no dedication, no name, no pedestal'[89] — but the vagaries of vision that were the inevitable consequence of *statuemania* were bringing about a highly poetic anonymity anyway. Aragon's loquacious statue mentions the fact that plinths are 'engraved with famous names', but one of the effects of all-weather and nocturnal viewing in the round is the demotion, disruption and even obliteration of the inscription. We are inclined to forget the dreadful atmospheric pollution in cities. Aragon's statue, which is not named, mentions being covered in dew and the mist 'racing to our heads'.[90]

Reading takes place after seeing and, when the Surrealists do try, it is fiendishly hard work: 'Turning their attention away from this volcano of appearances . . . they decipher one by one, with the aid of a whole succession of the lighted matches that are their firebrands, the inscriptions on the four-angled column which adorns this philosophic traffic circle.'[91] What they turn towards is in fact an 'obelisk-indicator', but for the Surrealists the act of decipherment is as hard as discovering hieroglyphs in an Egyptian tomb.

A fine example of the Surrealist displacement of a statue's inscription — and, indeed, of its context — is Brassaï's photograph, *The Statue of Marshal Ney in the Fog* (1935). The statue is one of the most famous works of François Rude, and was erected in the Place de l'Observatoire

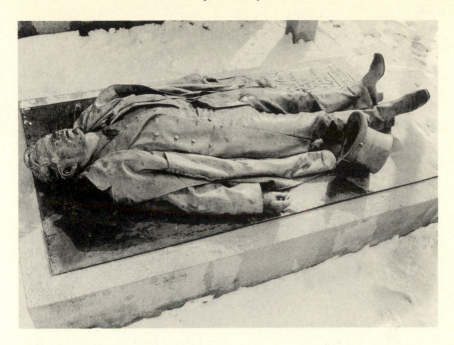

33. **Jules Dalou**, *Victor Noir*, 1891
(Bronze, Père Lachaise cemetery, Paris).

in 1853. Apollinaire said there was no statue 'more alive, more modern, or more daring'.[92] Here the statue and pedestal are reduced to a spectral silhouette, and the only 'inscription' is a neon sign that glows through the fog. It says HOTEL. Brassaï photographed the statue from a low vantage point, directly behind and to the right of the figure. Due to this careful choreography, the most loyal of Napoleon's generals seems to be gesturing towards the hotel with his upraised sword. He is not just a 'vagrant idol', perhaps dreaming of a bed for the night, but an unlabelled idol – *sine letteris*. *Statuemania* enables the Surrealists to express the unhinged and untitled nature of the modern city.

The Surrealists' complex relationship with *statuemania* reaches something of a climax with *La Mort et les Statues* (1946), a record of the removal of various monuments during the Nazi Occupation prior to their being melted down for their bronze. Ostensibly the bronze was to be used by German industry, but we now know that a great deal was sent to the leading Nazi sculptor, Arno Breker. The book features a text by Jean Cocteau and photographs by Pierre Jahan.[93] There's a strange symmetry to this, as in 1942 Cocteau wrote a text in which he claimed

that Breker was the heir to Michelangelo, and after the war Breker modelled Cocteau's portrait.[94]

Cocteau begins by saying that the essence of poetry is displacement: 'The job of the poet (a job which can't be learned) consists of placing those objects of the visible world which have become invisible due to the glue of habit, in an unusual position which strikes the soul and gives them a tragic force.'[95] This, Cocteau claims, is what Pierre Jahan has done by secretly photographing the depot 'where Germany crushed, broke and melted down our statues'. Thanks to Jahan's camera angles, 'even the most mediocre statue is endowed with a grandeur and a drama of solitude'.[96] The twenty-two photographs are indeed dramatic: bronze legs point skywards; and famous heads get tangled up with mud and scrap metal.

We see a pedestal that has been tipped backwards with a solitary boot attached to it. A *trompe-l'oeil* scrolled inscription has been inverted. It says SUFFRAGE UNIVERSEL, then something illegible, then RÉPUBLIQUE. Just beyond it is a railway line, flanked by a statue of two men taming a bull. Cocteau provides a caption: 'Is it a pedestal or a coffin? A Roman soldier guards the rails beside which a white boot witnesses some great atomic catastrophes.'[97] Further on, a half-crushed nymph with a steel cable round her neck carries on smiling: 'When the police arrive only the traces of a rape remain. What was this ANDROGENOUS creature intending to do in this garret? Who had the inclination to destroy her, to crush her breasts, thighs, and to disembowel her soul?'[98] Later, a standing figure is thrust against the alligators from the pedestal of Dalou's *Triumph of the Republic* in the Place de la Nation;[99] and a politician seated in an armchair is hoisted into the air by a crane.[100]

Looking at all this from a Hildebrandian perspective, the Nazis only brought to its logical conclusion the iconoclasm that was inherent in *statuemania* itself. For *statuemania* contributed to the desacralization of sculpture by placing statues in the public realm; it destabilized statues by putting them in the centre of squares; and it dethroned statues by bringing them down to street-level. What the Nazis did was another act of 'displacement', and this is why Cocteau, despite his regrets, cannot help finding it poetic. The writer Anatole France once accused Rodin – because of the fragmentation and instability of his figures – of 'collaborating too much with catastrophe'.[101] But that is equally true of the phenomenon of *statuemania* as well.

In fact, the most innovative feature of *statuemania* – the placement of

statues designed to be seen in the round in the centre of spaces – was rejected by the Nazis. In 1934 a law was passed in Germany that required the use of sculpture on all public buildings. But the sculpture patronized by the state hardly ever disrupted the lines of the architecture. Reliefs were placed in predetermined locations, usually high up, and statuary was positioned in front of smooth walls. Most statues had a frontal orientation, with a clean silhouette, and were designed to be seen head-on from below. Nazi cultural policy was heavily influenced by Hildebrand's writings, and from him they would have learned that sculpture in the round was 'convict labour' and insufficiently aloof.[102] Thus, although the Nazis put Otto Freundlich's primitivizing stone head, *The New Man*, on the front cover of the catalogue to the 1937 *Degenerate Art* show, they would have known that it was *statuemania*, more than tribal art, that precipitated the downfall of European art.

The Nazi aesthetic was clearly expressed by the outdoor statues at the 1937 International Exhibition in Paris. The entrance to the German pavilion – a towering, 215-foot-high cubic mass designed by Albert Speer – was flanked by 23-foot-high sculptural groups by Josef Thorak of *The Family* and *Comradeship*. The figures all had their backs to the building. The roof of the pavilion was surmounted by a crest-like eagle. Here sculpture took its cue from the sheer, immutable architecture, and was subordinate to it.

In the Soviet pavilion, which directly faced the German, that situation was reversed. The sculpture dominated the architecture and was set free from it. The architecture, designed by Boris Iofan, functioned like a pedestal for Vera Mukhina's *Industrial Worker and Collective Farm Girl*, which was half its height (82 feet). The figures were startlingly dynamic, and seemed to surge upwards and forwards, leaving a flurry of garments in their wake. The exterior of the Spanish pavilion, which was a show-case for the Republican government, featured freestanding sculptures – by Picasso and Alberto Sanchez Perez – that were in no way dictated by the building.

IT IS USUALLY assumed that *statuemania* fizzled out after the end of the Second World War. In certain respects this is true: there has been a marked decline in the production of monuments to 'great men' in the post-war period (though there has been a recent revival in Italy[103]), and relatively few of the major sculptors have regarded the production of public monuments as an important part of their job. Moreover, as so

many sculptors started to use unconventional materials, their works were often unsuitable for permanent outdoor exhibition.

At the same time, however, there has been an increase in figurative monuments celebrating 'ordinary' people and things, and an increase in abstract monuments. These have tended to have low pedestals, or no pedestals at all, and are sited so that they can be viewed 'in the round'. Henry Moore (1898–1986) is the obvious, but not the only, example. In the fifteen years after the end of the Second World War Britain experienced 'a renewal of interest in the possibilities of sculpture as an outdoor public art such as had not been seen since Victorian times'.[104] For sure, there were difficulties and scepticism, with some saying there was no place for public sculpture in the modern world,[105] but the problems were hardly more pressing than those that had beset earlier makers of statuary. Public sculpture practically ended up being promoted as *the* art of the post-war era.[106] After Moore won the International Sculpture Prize at the Venice Biennale in 1948, he received numerous official commissions from around the world.[107]

Herbert Read, the official voice of British Art, expounded the new/old ethos: 'The sculptor must come out into the open, into the church and the market place, the town hall and the public park; his work must rise majestically above the *agora*, the assembled people. But one must also point out that the people should be worthy of the sculpture.'[108] This is *statuemania* in Welfare State clothing: coming out 'into the open' would have rung all the right political bells. Here and now, in the free world, there was no need for secrecy. Moore actually said that he preferred to work outdoors, because being shut in a studio was like 'being in a prison'.[109] He also wanted the spectators of his art to be able to move freely round his sculptures, because in this way sculpture could have 'a continual, changing, never-ending surprise interest'.[110]

There have been some important public sculpture commissions in the United States, as well. Alexander Calder, Isamo Noguchi, Claes Oldenburg and Richard Serra have all produced considerable bodies of public sculpture, in the US, Europe and elsewhere. European sculptors, apart from the ubiquitous Moore, have also received important commissions. In 1967 Picasso made a 65-foot-high woman's head for the plaza in front of a civic centre in Chicago. It utilized 'all the resources of the local steel industry'.[111] Brancusi was commissioned to erect a 1,312-foot-high steel column by a lake in Chicago, but his death in 1957 intervened.[112]

Sculpture parks are another symptomatic post-war development. Private patrons have always sited sculpture in gardens and parks, but the first major initiatives by public institutions took place after the war. From 1948 until the mid-1960s the London County Council's Parks Committee held exhibitions in Battersea and Holland Parks. This initiative influenced similar developments in Europe and America.[113] The ethos of sculpture parks was in tune with the sculpture of Moore, Hans Arp and Barbara Hepworth, with its obvious landscape associations. Moore himself firmly believed that sculpture is 'an art of the open air', and said that he would prefer his sculptures to be sited in 'almost any landscape, than in, or on, the most beautiful building'.[114] Openness is once again the operative word.

Since the 1960s there have been increasing numbers of sculptures and installations temporarily exhibited in public. They are often referred to as 'site-specific interventions' into a particular space – meaning that they are made with a particular location in mind, and that they change our perception of that location. No big biennale, arts festival or even art fair is complete without some 'intervention' into a public space or building. Organizations exist that deal solely with this kind of temporary public artwork. But I will leave discussion of this phenomenon to a later chapter, for I want to focus here on sculpture that is permanently on public view.

Paradoxically the largest and most conspicuous legacy of *statuemania* is not strictly sculpture at all. It is architecture, but with a 'sculptural' form. Much of the most prestigious modern architecture is routinely referred to as sculptural; and it is often seen to be inherently superior to the more 'pictorial' architecture that was produced in previous centuries. That architects should strive to make their buildings sculptural attests to the way that sculpture has become a crucial reference point in modern culture. It has also meant that 'sculptural' experiences have become more prevalent than ever before, and on a larger scale.

The most influential vehicle for the idea of sculptural architecture has been Siegfried Giedion's *Space, Time and Architecture*. After publication in 1941, five revised editions were produced. It was one of the most influential texts on the modern movement. In the first three editions, modern painting is seen as the key catalyst for modern architecture. But in the fourth edition of 1962 there is a dramatic change. In a section entitled 'The Present State of Architecture', Giedion writes that many architects 'are disturbed by the sculptural tendencies evinced in much of

245

today's architecture . . . Architecture is approaching sculpture and sculpture approaches architecture.'[115] This was happening because modern architecture was concerned not just with modelling interior space, but with the interaction of freestanding volumes in space. The most representative sculptor is Giacometti: 'For twenty years Alberto Giacometti experimented with the interplay of primitive forms: from his *Pour un Place* of 1930 and the *Palace at 4 a.m.* of 1932 until he designed a small bronze group, *Passers-by on a Square*, in 1948. The bodies of these passers-by are dematerialized to the utmost, yet they are so formed and placed that they fill the space between and beyond them.'

Le Corbusier is Giacometti's counterpart. In his project for the *City Centre of Saint-Dié* (1945), the different buildings are designed and placed in such a way that 'each emanates and fills its own spatial atmosphere and simultaneously each bears an intimate relationship with the whole'. Today's architects, Giedion believes, are constantly faced with having to situate volumes of different height and form in mutual relationship. But few can accomplish this, 'perhaps because the shaping of interior space has for so long been regarded as architecture's supreme task. Even the marvelous urban courts and squares of the late baroque, with their surrounding walls, were a form of interior space, roofed by the open sky.'[116] In 1947 Le Corbusier had asserted the affinity between sculpture and architecture in a catalogue essay on the sculptor Antoine Pevsner: 'Architecture and sculpture: the masterly, correct and magnificent play of forms in light.'[117]

Giedion was reacting against a notion of architecture whereby you could comprehend the entire structure at a single glance. This was generally seen to be a typical characteristic of Renaissance architecture. The German architectural historian Paul Frankl had made this point in his *Principles of Architectural Style* (1914). In early Renaissance architecture there is no temptation to walk round the building 'because we realize at once that it can offer us no surprises'.[118] There is uniformity of illumination and image. Individual images 'are frontal', and new images that appear as we walk 'can complete or elucidate the architectural image but not essentially alter it'.[119] With mannerist and baroque architecture, however, Franks believed that the situation changes. There is uneven illumination, uneven spatial division, and wavy façades that demand oblique viewing: 'This extreme lack of clarity gives to the whole composition a quality of restless allure . . . The view of any separate elevation does not satisfy us, since the others cannot be deduced from it.'

A 'great flood of movement' urges the viewer round and through the building.[120] Frankl's book is exactly contemporary with de Chirico's metaphysical painting.

Frankl has been criticized for suggesting that architects would try to make buildings that functioned like labyrinths,[121] but there is no doubt that the labyrinth is a form that has intrigued modern artists and architects. Expressionist architecture was frequently seen to have a disorientating and therefore sculptural quality. In 1923 a critic claimed that the 'sculpturesque' was so strong a feature of Hans Poelzig's buildings that they give the impression of having been cast 'in one molten throw, or hewn with boldest strokes with a modelling tool out of some plastic material'. The interior of his phantasmagoric *Grosses Schauspielhaus* in Berlin was a 'severe and grandiose up-piling of bulk upon bulk, like the *massif* of a mountain'.[122]

The Russian Constructivists also wanted to break away from pictorial models. In Nikolai Tarabukin's essay 'From the Easel to the Machine' (1923) the trajectory of modern art moves from painting on canvas, to wall reliefs made from real materials (Picasso and Braque), to reliefs cantilevered across corners (Tatlin), and then to centrally located objects that are a fusion of painting, sculpture and architecture.[123] There is a gradual increase in scale and ambition. Tatlin's spiralling *Monument to the Third International* (1920), a glass-and-steel tower with a revolving core, which was intended to be twice the height of the Empire State Building, is the key example of the final fusion, even though it was never built. The Constructivists would not have called it 'sculptural architecture', but their ideal structures were aggressively freestanding. The prominence given to sculpture on the Soviet pavilion at the 1938 Paris Exhibition would have been influenced by this aesthetic. Indeed, the architectural base of the pavilion was Constructivist in style.

An important by-product of this new, sculptural sensibility was the increasing use of models by architects. Giedion draws attention to this repeatedly. He cites the way in which the Expressionist architect Hans Scharoun planned the Philharmonie in Berlin (1956–63): 'He worked with sculptural models – not two-dimensional drawings – in an atelier next to the building, just as Gaudi had done.'[124] Jorn Utzon 'solved' the problem of the shell-like roofs of the Sydney Opera House 'when he turned from the two-dimensionality of the drawing board to three-dimensional representation'.[125] While studying in Paris Utzon had met Le Corbusier and the painter Fernand Léger, but the crucial contact was

with the sculptor Henri Laurens: 'From him Utzon learned how one builds forms in the air, and how to express suspension and ascension.'[126]

The corollary to this use of models is that site-maps and plans are rendered redundant. Urban planning had begun to move 'from two-dimensional to three-dimensional planning'.[127] With the fourteen buildings of New York's *Rockefeller Center* (1929–39), 'Nothing new or significant can be observed in looking over a map of the site. The ground plan reveals nothing . . . They cannot be grasped from any single position or embraced in any single view.'[128] This was then in accordance with phenomenology. It was a fundamental tenet of phenomenology that ground-plans revealed very little of any kind of building: buildings could only be understood as a unified entity by bodily movements through them.[129] Computer modelling is no less predicated on this. It now means that every building and consumer durable is designed 'in the round'.

Not only buildings, but even roads could come under the aegis of sculpture. According to Giedion, flyovers and bridges feature 'mounting drives, and the modern sculpture of numberless single or triple clover-leaves'. The meaning and beauty of these and other landscaped roads 'cannot be grasped from a single point of observation'. They can be revealed 'only by movement, by going along in a steady flow as the rules of the traffic prescribe. The space-time feeling of our period can seldom be felt so keenly as when driving, the wheel under one's hand, up and down hills, beneath overpasses, up ramps, and over giant bridges.'[130] Sculpture is landscape, and vice-versa. These kinds of ideas underlay an often quoted description by the Minimalist sculptor Tony Smith of a car journey on a dark night along the unfinished New Jersey Turnpike. The sculptor found it a revealing experience: 'The road and much of the landscape . . . did something for me that art had never done . . . It seemed that there had been a reality there which had not had any expression in art . . . Most painting looks pretty pictorial after that. There is no way you can frame it, you just have to experience it.'[131].

Sculptural architecture was treated in an introductory survey *What is Sculpture?* (1969) written by Robert Goldwater for the Museum of Modern Art, New York. The final chapter, 'Architecture as Sculpture', explained the reasons for convergence:

Since a large portion of recent sculpture has been nonfigurative it has had to confront more directly than in the past the harmonious recon-ciliation of abstract forms and spaces which have been the architect's

248

traditional concern. The architect, in return, through the modern materials of glass, steel, concrete and plastic can have a command of space and a freedom of form akin to that assumed by the sculptor.[132]

Goldwater begins by discussing two architectural projects by sculptors – Rodin's *Tower of Labour* and Tatlin's *Monument for the Third International* – then moves on to the Expressionist architecture of Gaudi and Mendelsohn. He concludes with Le Corbusier's Chapel at Ronchamp (1950–54) – 'The forms . . . belong to the same family as the biomorphic shapes of Arp and Moore'[133] – and Eero Saarinen's bird-like TWA Terminal at Kennedy Airport.

Of course in aesthetics, as in life, there are no free lunches. The danger of thinking that a building is 'sculptural' is that it may well be thought of as self-sufficient. Any other adornment might be regarded as redundant. Thus Giedion, while he extols the sculptural qualities of the Rockefeller Center, fails to mention the numerous specially commissioned Art Deco-style figurative sculptures at ground level, which were such a notable feature of the scheme. The sculptural architecture drowns out the architectural sculpture. New York was to become the quintessential city-as-sculpture. A city-zoning ordinance had been passed in 1916 in an attempt to prevent the streets from becoming sunless canyons. Architects and developers were urged to step their buildings back as they went up, so that more sunlight could enter the streets below. This encouraged 'a more sculptural approach to mass and, by leading the street-level eye up the diminishing façades, gave importance to the top of the building, its crown or finial, on which architects lavished much fantasy and ingenuity'. [134] Brancusi told an American interviewer on his first visit to New York in 1926 that true architecture is sculpture,[135] and that New York was 'my studio on a large scale'.[136] But could not the sculptor now be reduced to the status of a maker of unbuildable architectural models?

The dilemma posed by sculptural architecture was acidly expressed by the British architect James Stirling. When he collaborated with the sculptor Michael Pine on a structure derived from a photographic study of soap bubbles for the exhibition *This is Tomorrow* (1956), he wrote: 'Why clutter up your building with "pieces" of sculpture when the architect can make his medium so exciting that the need for sculpture will be done away with and its very presence nullified?'[137] Stirling may have been irritated by the large quantity of sculpture and object-based art in the exhibition, and by the high international reputation of so many

British sculptors, but the assumption was quite commonly held. It was another architect, the American James Wines, who coined the term 'turd in the plaza' for Henry Moore-style sculptures that seemed to have been dumped in a site without any serious consideration being given to its suitability.

On the whole, though, architects who were hostile to sculpture tended to be hostile to modern art in whatever medium. When Frank Lloyd Wright's Guggenheim Museum opened in 1955, the architect's disdain for modern art was legendary, and the building seemed to express that hostility. It was hard to install any work – painting or sculpture – in Wright's spiralling *tour de force*. Allan Kaprow made a logical proposal: 'I am attracted to the idea of clearing out the museums and letting the better designed ones like the Guggenheim exist as sculptures, as works, as such, almost closed to people.'[138] This sounds like a manifesto for the wrapped buildings of the sculptor Christo.[139] 'Pure' architecture may have been better off without contents of any kind. But at least, in its appearance, it came down on the side of sculpture. Imitation is, after all, the sincerest form of flattery.

These issues were not new. In the 1890s the German aesthetician August Schmarsow was one of many to discuss the consequences of failing to experience a building's interior space: 'To contemplate the enclosed building as an entity outside ourselves, within a generalized space, already implies a considerable step toward the allied art of sculpture.'[140] André Salmon, writing in *La Jeune Sculpture Française* (1919), said that the pyramids are not only tombs, but also 'famous pieces of sculpture and of a plastic perfection that has not often been rivalled'.[141] The same point would be reiterated in the 1960s by the critic Lucy Lippard in an essay on Minimalism: 'The pyramids started out as architecture, but once the tombs were closed, they became sculpture.'[142]

Sculptural architecture was attacked by Robert Venturi in *Learning from Las Vegas* (1972). In such buildings, he argued, 'architectural systems of space, structure, and programme are submerged and distorted by an overall symbolic form. This kind of building-becoming-sculpture we call the *duck* in honour of the duck-shaped drive-in, "The Long Island Duckling".'[143] Saarinen's bird-shaped TWA Terminal (1959–62) and Frank Gehry's gilded banana-split, the Bilbao Guggenheim Museum (1994–7), are good examples of architectural 'ducks'. A cartoon by Robert Sowers from the mid-1970s lampoons 'ducks'.[144] It shows a colossal Henry Moore reclining nude balanced precariously on *pilotis*

34. **Robert Sowers**, *Building in the form of a Henry Moore sculpture*, c. 1977 (drawing).

with an irregular smattering of small windows set into its body. Venturi believed that this kind of bravura architecture, as well as soul–less glass and concrete monoliths, would be much more honest if they had a huge billboard on top stating I AM A MONUMENT.[145] Thus, by a clever sleight of hand, modernist architecture is shown to have its ideological origins in *statuemania*.

Venturi much preferred the 'decorated shed' type of architecture, where ornament is applied *after* the building has been designed. But even here statuary is ubiquitous. He describes driving through suburbia, glancing at the 'eclectic ornament' on and around each house: 'The lawn sculpture partway between the house and the curving curb acts as a visual booster within the space, linking the symbolic architecture to the moving vehicle. So sculptural jockeys, carriage lamps, wagon wheels, fancy house numbers, fragments of split-rail fences, and mailboxes on erect chains all have a spatial as well as a symbolic role.' Their forms 'identify vast space'.[146] Elsewhere in the book we find full-page spreads revealing the replicas of classical and Renaissance statuary at Caesars Palace,[147] and inventories of the 'sculpture' in hotels and petrol stations. The hotel 'sculpture' ranges from fake camels to abstract architecture and advertising towers;[148] the petrol station 'sculpture' consists (*à la* Aragon) of petrol pumps.[149]

What we see here is a shift from monolithic structures to loose, mixed-media assemblages sprawling across the American landscape. But there is still a strong sense of the city, and the road, as analogies for – and extensions of – sculpture. Their counterparts would be the commodity sculpture of Jeff Koons and Hans Steinbach from the 1980s, in which all manner of consumer kitsch was transformed into sculpture. Koons cast various found objects in bronze and stainless steel, or had them modelled in porcelain and carved in wood; Steinbach juxtaposed a huge range of pristine found objects on a variety of wedge-shaped shelves.

Where Koons and Steinbach allow each found object to preserve its own identity, the Scottish sculptor David Mach sweeps found objects up into organic wholes. *Adding Fuel to the Fire* (1987) was a huge installation made from many tons of unsold newspapers and magazines shaped into a mountainous tidal wave that cut across the gallery space. Woven into this sinewy mound of paper, and seemingly swept along by it, were all sorts of vernacular items: a car with its doors open, a mirror, a television set, a statue, a piano, a video and various items of furniture. It was an apocalyptic incarnation of that modern sculptural 'space-time feeling'.

THE LEGACY OF *statuemania* has been enormous: it has put sculptural experiences at the heart of everyday life. This is because *statuemania* was predicated on something peculiarly modern: the movement of the spectator. We are always striving, as Kleist put it, 'to go on and make the journey round the world to see if it is perhaps open somewhere at the back'. A major recent manifestation of some of these notions would be Rachel Whiteread's sepulchral *House* (1993). It was a concrete cast of the interior of a freestanding three-storey house, in which all the windows and doors were blocked up.

11. The Education of the Senses i:
Child's Play

As for myself, my art goes way back, further than the horses on the Parthenon – all the way to the dear old wooden horsy of my childhood.

Paul Gauguin, *Diverses Choses*, 1896–8[1]

New York is the most innocent town in the world. It looks as if it were made of children's building blocks.

Joseph Beuys, 1973[2]

For Mummy and Daddy Chapman

Jake and Dinos Chapman, Dedication to *Chapmanworld*, 1997[3]

IN CHAPTER 4, 'Sight versus Touch', I noted Herder's assertion that in every playroom children should have access to clay and wax, so that they can develop their sense of touch. This understanding of the importance of the 'education of the senses' was a revolutionary development. In the eighteenth century sensory education had initially been tried out on deaf-mutes, but radical educationalists believed that the senses of normal children should be trained as well. This became increasingly widespread in the second half of the nineteenth century.

The first thing that 'normal' children tended to be taught was reading and writing – and this only at a relatively advanced age. With industrialization and the need to instruct large numbers of pupils, sensory education was all but ignored. The Lancasterian system, developed in England in the early nineteenth century and exported all over the world, required children to sit immobile in regimented rows and chant in unison the teacher's words. In the description of the Italian educational reformer Maria Montessori, these pupils were 'like butterflies mounted on pins . . . fastened each to his place, the desk, spreading the useless

253

wings of barren and meaningless knowledge which they have acquired'.[4]

Towards the end of the nineteenth century the idea gained ground that a wholesale education of the senses was necessary before children could begin to read and write. Moreover, whereas previously a child's education had not begun until well after infancy, the early years were now thought to be crucial to the child's future development. These beliefs were manifested in the international kindergarten movement, and in the schools founded by Maria Montessori. Manual work and physical exercise were central to the new systems, and children were encouraged to 'learn by doing'. Constructional toys were made specially for the courses, and were intended to break down the barrier between work and play. The doctrine was summed up as 'things are the best teachers'.[5] In adult life, vision was still supposed to take over from touch, but the emphasis on tactile education was now such that people began to wonder if touch ought not to have a greater role in later life.

Thanks to the romantic notion that 'the child is father to the man', and the related idea that the artist is an honorary child, we find that modern artists have been keen to emulate the consciousness of the child. The most frequently discussed example of this is the interest shown by modern artists in children's drawings.[6] But in the development of modern art in general, and of abstraction in particular, children's drawings are not the most important catalyst. The perceived need of the child to explore the world three-dimensionally has had far greater repercussions. Artists have shown a comparable desire, and modern art is full of concrete 'things' whose purpose seems in part to be the sensory education of the viewer.

Since the 1960s it has become a cliché of criticism to compare works of contemporary art to toys, but the analogy can be taken back much further and used much more carefully. Throughout the century, *homo faber* has merged with *homo ludens*, and the artist's studio has been a combination of workshop and playroom.

ONE OF THE most important pioneers of sensory education for children was the Swiss reformer Johann Pestalozzi (1746–1827). Inspired by Rousseau, Pestalozzi believed that all thinking starts with direct experience of concrete objects. The curriculum in his influential school at Yverdon included handicrafts, gardening and the formation of collections. For the teaching of geography, Pestalozzi took his pupils on some of the first educational field-trips. A former pupil recalled:

We were taken to a narrow valley, not far from Yverdon . . . After taking a general view, we were made to examine the details until we had obtained an exact and complete idea of it. We were then told to take some clay which lay in beds on one side of the valley . . . and on our return we took our places at the long table and reproduced in relief the valley we had just studied . . . Only when our relief was finished were we shown the map, which by this means we did not see till we were in a position to understand it.'[7]

This concrete, site-specific approach meant that the place has to be felt, as well as seen.

The German educationalist Friedrich Froebel visited Pestalozzi's school and, although impressed, found the curriculum and teaching too inflexible. Froebel established the first *Kindergarten* in 1837 in Thuringia, and devised a series of educational toys – or 'gifts' – that were intended to encourage learning through play. For Froebel, play was 'the highest expression of human development in childhood, for it alone is the free expression of what is in the child's soul'.[8] The child always had to be active. When not outdoors exercising, 'constructive work with paper and cardboard, modelling, etc.' was 'indispensable'.[9] Froebel was one of the first educationalists to emphasize the importance of group activities, and by insisting that every child had the potential – even the need – to be expressive, he also undermined the ideas about artistic genius. In theory, artists would no longer be the chosen few.[10]

The 'gifts' consisted of balls, both soft and hard, cubes of various sizes, cylinders, bricks, tablets and sticks. The games played with these objects were meant to 'awaken the capacity to compare, infer, judge, think' and 'foster the feelings'.[11] While the globe could be regarded as 'the physical expression of pure movement', the cube expressed 'pure rest'.[12] Unlike conventional toys, which were relatively realistic representations, these 'gifts' stimulate the child's imagination. The bricks can stand for an endless variety of objects. With a few adjustments, a large 'brick' table becomes a table and two benches. Six bricks can be 'an avenue of trees . . . Or they are a cow and its calf, a horse and its foal, and so on.'[13] A wall built of bricks can be 'laid down flat as a floor'.[14] This versatility gives the child a keen sense of a 'necessary internal connexion in the object' and confirms that it is 'union which creates life'.[15] Subsequent tasks include the folding and cutting of paper, the arrangement of sticks, modelling in clay, drawing and painting. The emphasis on free

expression was too much for the Prussian government, however, and the kindergartens were closed down. But this forced Froebel's disciples to take his message abroad: the first kindergartens in England and the United States opened in the 1850s.

The American painter-sculptor Thomas Eakins depicts a Froebelian childhood in a painting of 1876, *Baby at Play*.[16] His two-and-a-half-year-old niece is shown playing in the back yard of Eakins' home. The child lies on a brick patio and plays with wooden blocks, which she has taken from a rudimentary cart drawn by a toy horse. A ball, a rickety 'tower' made from cubic and rectangular building blocks, and some loose blocks lie before the child. The tower is made from six blocks and is shaped like a capital A with a flat top. The cubic blocks have a seemingly random selection of capital letters imprinted on them. Behind the girl, and just in front of a plant pot, lies a discarded doll, face-down. The doll represents the *ancien régime* of the toy world. Sadly, this sensory education was of little practical use to Eakins' niece. She spent some time in a mental asylum, and in 1897 blew her brains out with a shotgun. Her family, for reasons that remain mysterious, held Eakins at least partly responsible.[17] On the other side of the Atlantic, another user of Froebel's gifts would also come to a sticky end. Vincent van Gogh used to roll balls of coloured wool in order to explore colour theory[18] – a 'materialization' of colour that may have influenced his own tangled impastos.

Maria Montessori (1870–1952) elaborated and refined the kindergarten system and its variants. Her method and her charm took the world by storm in the early years of the twentieth century. As the first woman to qualify as a doctor from an Italian University (1896), she was a vanguard New Woman – though a journalist at her graduation party was relieved to discover that a woman did not have to lose her feminine charms if she studied and pursued a serious occupation.[19] Montessori developed a set of toys, and insisted that they be used in a more structured way than in the kindergartens. She believed that her methods respected the laws of nature: 'I set to work like a peasant woman who having set aside a good store of seed-corn has found a fertile field in which she may freely sow it. I was wrong. I had hardly turned over the clods of my field when I found gold instead of wheat; the clod had concealed a precious treasure.'[20] The 'treasure' she had found was the realization that children preferred order to chaos, work to play. But this 'work' was universal. Children, for example, were absorbed in the 'work of growth'.[21] The formative years for the education of the senses were from three to seven.

35. A child doing tactile exercises while blindfolded; photograph from *Dr Montessori's own Handbook* (1914).

Montessori developed the concept of a 'Children's House', a lilliputian classroom that contained movable furniture and fittings adapted to the scale and needs of children. The workroom contained a low cupboard and a chest of drawers. The cupboard housed didactic material, while each child had his own drawer in the chest of drawers where he could put his belongings. Instead of simply sitting at tables, the children were encouraged to spread rugs on the floor and work on them. The walls would be covered with low-level blackboards and pictures, and brackets of different shapes and sizes on which 'statuettes, artistic vases or framed vases' should be placed.[22]

The didactic material was much more extensive and elaborate than Froebel's had been. There were all kinds of geometric solids, and frames to which different types of material had been attached. The material was joined together by different kinds of fastening (buttons, hooks, ribbons, cords, etc.). There were moulds for making clay tiles, vases and bricks. Three sets of wooden cylinders with decreasing diameters and heights had to be put in the right order into the appropriate holes in a solid piece of wood. Ten wooden cubes of decreasing size had to be built into a

tower, then knocked down and built up again. Ten wooden 'prisms' had to be arranged into a broad and then a long 'stair'. These activities were undertaken by both boys and girls.

For the education of the tactile sense, the child had to pass his or her (scrupulously clean) fingers over wooden boards to which rough and smooth strips of paper had been glued. Some of these boards had two contrasting surfaces, while another had several variations in texture. After these preliminary exercises, the child would feel different types of cloth, ranging from 'coarse cloth' to 'fine silk'.[23] The experienced child 'finds the greatest pleasure in feeling the stuffs, and, almost instinctively, in order to enhance his appreciation of the tactile sensation he closes his eyes. Then, to spare himself the exertion, he blindfolds himself with a clean handkerchief.'[24]

Dorothy Canfield Fisher, the American author of *A Montessori Mother* (1912), was enchanted:

> It is as if their little minds were suddenly opened, as our dully perceptive adult minds seldom are, to the infinite variety of surfaces in the world. They notice the materials of their own dresses, the stuffs used in upholstery furniture, curtains, dress fabrics, wood, smooth and rough, steel, glass, etc., etc., with exquisitely fairy-light strokes of their sensitive little finger-tips, which seem almost visibly to grow more discriminating.[25]

Blotting-paper and newspaper were also used in these tactile exercises. Canfield Fisher noted Montessori's belief that with proper training there is no reason why 'this valuable faculty, only retained by most adults in the event of blindness, should be lost so completely in later life'.[26] The lost paradise of touch could be regained.

The next apparatus to be explored was a cabinet with drawers holding coloured geometrical insets, which were taken out and put on the floor. The insets then had to be itemized and put back in the correct slot. The child was taught to touch the edge of the geometrical figures, and the edge of the slot, first with his or her eyes open and then blindfolded: 'The little hand which touches, feels, and knows how to follow a determined outline, is preparing itself, without knowing it, for writing.'[27] As a further preparation for writing, the children had to fit wooden geometrical figures on to cards inscribed with a matching outline – 'The game is somewhat suggestive of chess'[28] – then stencil the

outline of metal insets on to a sheet of paper. Eventually they moved on to cards on to which one or more letters of the alphabet had been glued. These letters were made from sandpaper.[29] The child touched the letters repeatedly, and thus learned the movements involved in writing them. Musical notes and numbers were taught in comparable ways.

Even those twentieth-century children who did not attend kindergartens or Montessori schools (the curriculum and materials remain unchanged today) are likely to have experienced aspects of their methods and apparatus. Constructional toys are the most obvious manifestation. The Meccano system — originally called Mechanics Made Easy — was patented in 1901. And the 1920s saw a spate of constructional toys, such as posting boxes, train sets and climbing frames, many of which were used in the kindergartens.[30] Lego was devised in the middle of the century and is an example of 'the co-operative toy with which adults and children can play happily together'.[31] Last but certainly not least, there is plasticine, a late nineteenth-century invention. All these activities are further manifestations of the modern obsession with the workman-like.

CUBIST COLLAGE and construction represents the first great artform of the era obsessed by the education of the senses. Braque was particularly concerned with the tactile qualities of his art. He put his interest in still-life down to the fact that this genre dealt with objects that are within reach of the human hand: 'Then I began to make above all still lifes, because in nature there is a tactile space, I would say almost a manual space. Moreover, I have written: "When a still life is no longer within reach of the hand, it ceases to be a still life."' He went on to say that he had always had a desire to 'touch the thing and not only to see it'.[32]

In the spring of 1911 Braque stencilled the letters BAL, and numbers beneath the letters, across a painting entitled *The Portuguese*. The art historian John Golding says that these letters 'serve to stress their quality as *objects*'. They point ahead to the invention of collage, for by applying letters to a canvas or a sheet of paper — 'elements generally considered foreign to the technique of painting or drawing' — the artist makes the spectator 'conscious of the canvas, panel or paper as a material object capable of receiving and supporting other objects'.[33] The addition of sand, sawdust and metal shavings to his paint during the course of 1912, and the development of *papier collé*, were other manifestations of this concern. As Braque observed, 'It was this very strong taste for material itself that led me to consider the possibilities of material. I wanted to

make of touch a form of material.'[34] In this way he hoped to overthrow Impressionism which, he believed, had privileged vision over touch.[35]

Experimentation with new materials, and their incorporation in mixed-media artworks, did not start with the Cubists. The Arts and Crafts Movement had already in the second half of the nineteenth century stimulated experimentation with non-fine art materials in both painting and sculpture.[36] In 1899 the fashionable Italian painter Antonio Mancini (1852–1930) exhibited a painting in Venice in which the metallic keys of a clarinet were embedded in a painted representation of it. He also attached bits of glass, foil and other substances in the deeply impastoed paint surface in order to obtain rich textural effects.[37] This was in conscious imitation of Italian 'primitives', who had often incorporated real objects, and gesso and glass imitations of objects, into their work.[38] Developments such as these eventually helped open artists' eyes to tribal art, which was often made from striking combinations of vernacular materials.

Although tribal art had been on public view in Paris for many years (the Musée d'Ethnographie du Trocadero opened to the public in 1882), active interest from artists seems to date only from after the Gauguin retrospective in 1906, which included his innovative wood carvings and ceramic sculptures.[39] In the same year the Fauve painter Maurice Vlaminck acquired a mask which came from central Africa. It is made from carved and partly painted wood, and the hair/beard consists of stringy clusters of fibre.[40] In one of the earliest studies of African sculpture, Vladimir Markov's *L'Art de Nègres* (1914), we learn that their technique is not 'pure': 'It is quite rare that one has the discipline of a single material or a single tool . . . There are fetishes that are constituted by an assemblage of numerous materials.'[41] What this explosion of materials entailed was a rejection of a lynchpin of Renaissance aesthetics. Alberti, and countless later theorists, had stressed the importance of *representing* materials and light effects with paint, rather than through the application of gold leaf, glass jewels, etc.

By and large, though, in the Victorian age new materials and mixed-media techniques were put into the service of figurative art, and they served to create a heightened sumptuousness. What is different about Cubism is that an interest in vernacular materials goes hand in hand with an interest in the vernacular objects that feature in still-life. In other words, Cubism focuses more insistently on the material world.

This down-to-earth orientation is also central to the Montessori

Method. In Canfield Fisher's *A Montessori Mother*, the principal home of still-life objects, the kitchen, is celebrated at the expense of the drawing-room – and at the expense of the museum:

> Very little children have no greater interest than in learning how to do something with their bodies. We all know how much more fascinating a place our kitchens seem to be for our little children than our drawing-rooms . . . the drawing-room is a museum full of objects . . . enclosed in the padlocked glass-case of the command, 'Now, don't touch!' while the kitchen is a veritable treasure-house of Montessori apparatus.[42]

Cubist still-life was also meant to be the antithesis of the 'padlocked glass-case' kind of art. Picasso and Braque eschewed conventional frames and varnish, and insisted that their work should not be glazed. Moreover, pictures were often displayed on the floor or on the furniture in their studios. The small, 'Lilliputian' scale of so much Cubist art is also relevant.

I have no idea whether Braque or Picasso had personal experience of kindergartens or analogous systems (Picasso seems to have had a traditional education – going to school shortly after his fifth birthday and learning by rote), but it does seem likely that some news of Montessori might have percolated through. She was one of the most famous women in the world in the years before the war, and the first Montessori school in France opened in the Champ de Mars section of Paris in October 1911, with the evocative name La Source.[43] There was extensive press coverage about the school and the Montessori Method from 1911 to 1913, and these encompass the key years for the development of collage and construction. A brief article in *Le Journal* of 21 March 1912 said that the new method of education 'overturned all our habitual expectations'. It was education through amusement: 'Studies must only be games, and all the games must be instructive.'[44] Picasso believed that the studio 'should be a laboratory' and that painting is a 'play of the spirit'.[45] That playful spirit took him far beyond oil and canvas.

Picasso's exploration of tactility was even richer and more long-standing than Braque's. In 1903, during the Blue Period, he became obsessed by blindness. Numerous explanations have been given. It has been said that he was perennially frightened of going blind due to syphilis; fearful that his eyesight would deteriorate like his father's; and wracked by castration anxieties.[46] At any rate, he made an oil painting,

The Blind Man's Meal; a bronze sculpture, *Mask of a Blind Man*, which he considered incorporating into a vase;[47] and a watercolour, *The Blind Beggar*. In a letter Picasso described *The Blind Man's Meal*: 'I've done a picture of a blind man sitting at a table. There's a piece of bread in his left hand and with his right he's groping for his jug of wine.'[48] Picasso often made rather Delphic observations about blindness, and the most frequently quoted is the following: 'There is in fact only love that matters. Whatever it may be. And they should put out the eyes of painters as they do of bullfinches to make them sing better.'[49] We can tentatively interpret this as meaning that the blind are experts in touch, and are therefore the best lovers (touch being the final stage of the *Gradus Amoris* – the Ladder of Love). Logically, if a painter wants to educate his sense of touch, he ought to blind himself. But then, of course, the blind painter would have to develop a tactile form of painting, and perhaps even make sculpture. This is precisely what would happen during the development of Cubism.[50]

Musical instruments are important tokens of the presence of touch. In 1903, when Picasso was exploring the theme of blindness, he painted *The Old Guitarist*. The destitute musician is either eyeless or has closed his eyes as he plays. In 1907 the poet W. B. Yeats wrote that a guitar player 'can move freely and express a joy that is not of the fingers and the mind only, but of the whole being'.[51] Picasso's first constructed sculptures were a solitary guitar in cardboard and then in sheet-metal, with a stove-pipe forming the sound-hole. André Salmon, writing in 1914, said that Picasso had 'constructed this huge guitar [it was in fact only 30½ inches high, less than life-size] in sheet metal in such a way that the blue-print could be sent to all the fools in the universe and they could remake it just as well as he could himself'.[52] Thus it was like the simplest of constructional toys. Fabricating it from the blueprint would have been 'child's play'.

Maria Montessori believed that for musical education it was necessary to '*create instruments* as well as music'.[53] For this purpose she devised a 'miniature piano-forte', which reproduces 'the essentials of this instrument, although in simplified form'.[54] The top had been cut away to reveal the keys and hammers, and the name of the note was inscribed on each hammer. For sure, playing with and devising constructional toys does not, strictly speaking, constitute a creative or aesthetic activity in the normal way – indeed, the Montessori Method was explicitly criticized for its failure to exercise the child's imagination.[55] But, by the same

token, a great deal of modern art does not count as art in the traditional sense.

The philosopher Richard Wollheim has argued that in Picasso's Cubism 'touch and sight are conceived of as rivals rather than as allies'.[56] In his analytical Cubist works, such as *Man with a Violin* (1912), Picasso 'asserts the edges of planes. He seizes on mouldings or the small-scale architectural aspects of furniture. He introduces impasto for no obvious visual reason, and he then introduces it elsewhere in the picture so that this fact should not escape attention. When he employs *papier collé*, he exposes its jagged edge.'[57] The exploration of textures and materials, and the direct apprehension of the edges of things, was crucial to the Montessori Method as well. When the Montessori child inserts objects into the correct slots, he or she is given a sense both of the volume and weight of an object and of the space that it occupies. The insistence that any form is simultaneously a solid and a hollow is an idea with which Cubism constantly plays.

Further analogies can be made with the Romanian sculptor Constantin Brancusi (1876–1957). Brancusi left Romania for Paris in 1903, and although he subsequently claimed that he had walked all the way, it now seems that he took the train some of the time after working to earn the fare.[58] He was very much a 'worker-artist', and in Paris made much of his earthiness and of his peasant origins. In Romania he had initially had an arts-and-crafts training, and had learned furniture making, joinery, metalwork and mechanics. He used to say that his calling as a sculptor was revealed to him when he had made a violin as an adolescent.[59] He frequently received visitors in his studio–home and charmed them with his 'simple' clothes and manners. He made his own furniture and fittings, including a stone ice-bucket and stone-clad phonograph speakers.[60] One visitor reported finding in a 'barn of a studio' an 'exceedingly simple person' wearing overalls: 'He was not in the least annoyed by the intrusion, but was like the peasant who is glad of an excuse to lay down his hoe or his ax.'[61] Yet Brancusi was also fascinated by modern technology – photography, film, aviation – and the highly polished surfaces of so many of his sculptures evoke industrial design. By the late 1920s he was also using power-tools to polish and cut his sculptures, though these were concealed from visitors.[62]

Brancusi seems to have been infatuated with children, and portrayed them throughout his career.[63] He often used to say, 'When we are no longer children, we are already dead.'[64] Critics would oblige by saying

36. **Constantin Brancusi**, *The Child in the World*, c.1917
(Wood, temporary assemblage in the sculptor's studio in Paris).

that his was 'a universe seen with childlike innocence and rendered with archaic simplicity'.[65] Although he hardly ever made sculptures based on a photographic source, in 1911 he took a series of four images of a nude baby boy learning to walk, supported by his own hands. These photographs assisted him with his *Portrait of George* (1911), and subsequently seem to have inspired one of his first 'primitive' sculptures, *The First Step* (c. 1914).[66]

Brancusi is celebrated for his radical simplification of form. In works like *The Sleeping Muse* (1909–10), *The Newborn* (1915), *Sculpture for the Blind* (1916) and *The Beginning of the World* (1920), the principal component is an egg-shaped ovoid. The corollary to simplification was adaptability: the same form, or similar forms, might be incorporated into different sculptures, and their functions and positions might change. Even the base became an integral and indistinguishable part of the sculpture, and vice-versa. The roughly carved *Adam* finished up as the base for *Eve*; the *Endless Column* was derived from a rhomboidal form that had previously been used as a base; another base was exhibited as *The Watchdog* in 1933, and was returned to its former condition after the exhibition. Brancusi also exhibited furniture as sculpture, such as the 'bench' shown in 1922.

One of the striking features of Brancusi's assemblages is the almost systematic juxtaposition of different materials and surface treatments. Bronze, steel, marble, stone and wood were all combined, with the wood usually being given the roughest surface. The high polish given to metals and marbles suggests that they ought not to be touched, but he did not rule this out entirely.[67] The Romanian writer and future biographer of Brancusi, V. G. Paleolog, describes a studio visit in 1910 when he saw two ovoid sculptures, one of which seemed to be unfinished. Brancusi quickly covered the latter with a headscarf saying, 'one does not show this sculpture, this is only for touching; it is for the blind'.[68] Paleolog subsequently speculated whether this had been *Sculpture for the Blind*.

The immediate stimulus for Brancusi's semantic flexibility was Cubism, where the neck of a bottle can also function as the neck of a guitar or woman, and where it is unclear whether something is the seat of a chair or the top of a table. But Brancusi's manipulation of contrasting geometrical forms also recalls Froebel's 'gifts', whose abstract nature was intended to stimulate the child's imagination and 'awaken the capacity to compare, infer, judge, think' and 'foster the feelings'.[69] One thinks too

of the way in which Froebel's bricks can stand for an endless variety of objects.

Froebelian ideas first seem to have been used in relation to modern sculpture by Rainer Maria Rilke in a lecture on Rodin of 1907.[70] Rilke announces that he is not going to talk about people, but about things. For Rilke, modern, 'adult' man is alienated from things. We live in an age 'which possesses no things, no houses, no external objects'.[71] By 'things' Rilke means objects such as childhood possessions, to which the child had an extraordinarily close and deep attachment.[72] These childhood things were surrogate human beings, but endlessly adaptable. They gave us the sense of loving and being loved, and of not being alone; they prepared us for human attachments in the wider world: 'Later, in the legends of the saints, you found a holy joyfulness, a blessed humility, a readiness to be all things, qualities which were already familiar to you because some small piece of wood had once shown you them all, assuming and illustrating them for you.' This piece of wood prepared you for your first contacts with the world, and when it was finally destroyed or mysteriously taken away, it 'caused you to know the whole of human experience, even to death itself'.[73] For Rilke, Rodin's sculptures are the adult counterpart to this thing, this 'forgotten object', but Brancusi's sculpture seems to fit the bill much better.

Some of Brancusi's sculpture was child-centred, and was designed with a child viewer in mind. The height of his work is determined by its content.[74] Sculptures of children and fish are placed on low supports and tables; busts at around eye-level; and birds at over head-height. In 1917 he had actually dramatized the condition of the child in a three-part wooden sculpture, *The Child in the World*. A child stands next to a column surmounted by a large cup, which is tantalizingly out of reach. The cup appears to have made what Rilke called a 'mysterious withdrawal from the scene'; perhaps, too, its inaccessibility gives the child a foretaste of death (in another of Brancusi's works, a similar cup functions as Socrates' cup of hemlock). By eschewing pedestals for his sculptures, Brancusi also brought sculpture – or a part of it, at any rate – within reach of children.

In 1913 H. G. Wells had published a book on *Floor Games* in which he urged toyshops to stock bricks, boards, planks, soldiers and trains, so that any floor could be transformed into a magical landscape, thus building up in the children 'a framework of spacious and inspiring ideas' – and, of course, a taste for Imperialism.[75] But it is twentieth-century sculptors,

with their rejection of protective pedestals, who have been able to play the most exciting floor games of the century.[76]

IT WOULD be absurd to push these comparisons too far. In the Montessori Method, for example, the road to knowledge is clearly mapped out. Despite the emphasis on auto-education, there is a right answer, and a correct order, for everything. If the system works, contrasts and discontinuities are acknowledged only in order to be transcended. The fragments are made good. There is a final synthesis. But in a Cubist collage – although we see a limited number of objects from a multiplicity of angles, and in a multiplicity of guises – there is no certainty that the disparate elements will 'settle' into a stable or comprehensive pattern. We can never be quite sure that we grasp the objects in a Cubist artwork. The point of the comparison is to suggest that modern art, and modern educational methods, emerge from a culture that was increasingly interested in an all-round education of the senses.

Sensory education was beginning to have an impact in art schools. During the nineteenth century, drawing was frequently taught in art schools using geometrical solids, which the student would arrange into different configurations before drawing. The first person to market geometrical solids, the German Peter Schmid, was partly inspired by Pestalozzi who, amongst other things, made his students draw straight lines before progressing to curves and more complex forms.[77]

Tactile eduction made dramatic inroads into the academic curriculum with the teaching of Mathias Duval, a professor of histology at the Sorbonne. Duval taught anatomy at the Ecole des Beaux-Arts in Paris from 1882. In his book, *Précis d'anatomie artistique à l'usage des artistes* (1881), he stressed the importance of examining the model from different sides, and working by feel: 'In handling the bones, and experiencing the contact between their articulated surfaces, the purely descriptive aids of the articulated mechanism will take on a surprising reality, and remain forever engraved on the brain'.[78] Matisse, who attended the Ecole des Beaux-Arts from 1895–9, and who was outstanding at anatomy, was influenced by such ideas, and they may have prompted him to try his hand at sculpture. When he made his first sculpture in the round, *Jaguar Devouring a Hare (after Antoine-Louis Barye)* (1899–1901), he worked blindfolded on the clay model, guided by a mounted skeleton of a cat provided by the Beaux-Arts anatomy department.

In 1912, we hear of a variation on this, at an art-school in Barcelona. When the teacher saw that the young Joán Miró could not draw what he saw with objectivity, he encouraged the future Surrealist to try drawing from touch instead. Miró drew objects held behind his back and felt the features of classmates with his eyes closed. This method did not lead immediately to sculpture or object-based art, but the artist recalled this experience in later years, when he declared a desire to 'kill painting' and, like the other Surrealists, had become increasingly involved in making object-based art. 'Even today,' he said, 'the effect of this experience of touch-drawing returns in my interest in sculpture: the need to mould with my hands - to pick up a ball of wet clay like a child and squeeze it. From this I get a physical satisfaction that I cannot get from drawing or painting.'[79] These works were thus a delayed after-shock of this early education of the senses.

There is no hard evidence, but it is assumed that the Froebel–Montessori tradition influenced Johannes Itten (1888–1967) to make compositional 'play' with a wide variety of materials a central component of the preliminary course at the Bauhaus.[80] The resulting works were similar in appearance to contemporaneous Dadaist collages and reliefs. Itten said that he had made 'collages of natural materials' during 1915–16.[81] He first introduced these methods in a school in Vienna in 1916, and subsequently claimed that 'tasks involving textures and the evolution of subjective forms were new'.[82] One of the purposes of these exercises was to find the materials with which the student had most affinity.[83] When doing these tasks, the students became insatiable rag-pickers. They began to 'rummage through their grandmothers' chests of drawers for the odd treasures hoarded for a lifetime, through kitchens and cellars; they ransacked the artisans' workshops, the rubbish dumps of factories and building sites'. As a result, the whole environment was rediscovered and reclaimed.[84]

By the mid-1920s it seems that everyone was at it; or at least noticing that everyone was at it. Walter Benjamin was full of admiration for the scavenger-monger activities of children, which were no doubt more pre-valent due to the economic crisis in Germany: 'Children are particularly fond of haunting any site where things are being visibly worked upon . . . In using these things they do not so much imitate the works of adults as bring together, in the artefact produced in play, materials of widely differing kinds in a new, intuitive relationship. Children thus produce their own small world of things within the greater one.'[85]

These kinds of exercises became commonplace in art-schools every-
where after the Second World War. Joseph Albers did not teach a course
on materials when he was at the Bauhaus,[86] but when he subsequently
taught at Black Mountain College, in the United States, he encouraged
his students to handle all kinds of materials.[87] One of his students was
Robert Rauschenberg, who always made a point of creating a lively
ground for his paintings, 'so that whatever I did would be in addition to
something that was already there'.[88] This interest in complex textures
was passed on to Jasper Johns.

Johns is one of the most playful and texture-conscious painter-
sculptors of the post-war period. His paintings of flat symbols – flags,
targets and numbers – have rough surfaces because they are made from
papier mâché and encaustic, a wax-based medium. Objects are
frequently attached to the surface of his paintings, lodged in their
interstices or placed in compartments let into the picture. Some of his
paintings have been cast in plaster, bronze, aluminium, resin and sculp-
metal. He has also made independent sculptures, many of which have
textures like those of his paintings, and some of which are painted. This
urge to concretize painting led the American critic Leo Steinberg, in an
important essay on Johns' early work, to stage an imaginary dialogue
between the artist and a blind man:

> It is part of the fascination of Johns' work that many of his inventions
> are interpretable as meditations on the nature of painting, pursued as
> if in dialogue with a questioner of ideal innocence and congenital
> blindness.
> *A picture, you see, is a piece of cotton duck nailed to a stretcher.*
> *Like this?* says the blindman, holding it up with its face to the wall.
> Then Johns makes a picture of that kind of picture to see whether it
> will make a picture.
> Or: *A picture is what a painter puts whatever he has into.*
> *You mean like a drawer?*
> *Not quite: remember it's flat.*
> *Like the front of a drawer?*
> The thought takes form as a picture – and let's not ask whether this
> is what the artist had thought while he made it. It's what the picture
> gives you to think that counts.
> *But if pictures are flat*, says the blindman, *why do they always speak of
> things IN pictures?*

Why, what's wrong with it?

Things ON *pictures, it should be; like things on trays or on walls.*

That's right.

Well then, when something is IN *a picture, where is it? In a fold of the canvas? Behind it, in a concealed music box?*

Johns painted just such a picture in 1955, calling it *Tango*; canvases with secret folds are the subject of *Tennyson* and of two pictures (1960 and 1961) called *Disappearance*.

What would happen if you dropped one of Cézanne's apples into a Still Life by Renoir? Would the weight of it sink right through the table? Would the table itself pulverize like disturbed dust or down from a torn pillow? Yet this is the standard anomaly of conceiving an alien solid quartered upon a pictorial field. The blindman refused to believe that it could be done.

Show me, he said; and Johns painted *Gray Painting with Ball*.

He has worked valiantly to keep him informed, this blindman who believes nothing that cannot be touched. *Green Target* was a special donation; a target in Braille, so to speak.[89]

Steinberg's use of the dialogue format is significant. It suggests that during the creation of his art Johns created what William Rubin terms a 'dialectical other'. These potentially endless and slightly absurd Socratic dialogues are a peculiarly modern manifestation. The American architect Louis Sullivan (1856–1924) was a pioneer of this approach in his *Kindergarten Chats* (1901–2/1918), which were reprinted after the Second World War. Here, Sullivan constructed an imaginary dialogue between himself and a graduate of an architectural school. He called it *Kindergarten Chats* because the ideas underlying the work are 'simple and elementary'.[90] He promoted an organic view of architecture, and the organic was a 'searching for *realities*', the 'ten-fingered grasp of things'.[91] In a similar vein, his student Frank Lloyd Wright was to claim that playing as a child with wooden building blocks inspired him to become an architect.[92] An interchange from Sullivan's first dialogue, 'A Building with a Tower', runs as follows:

'Yes, but what about the building?'

'Not very much.'

'Isn't it high art?'

'Yes, 390-feet high art – I am told.'

'Then the tower is very high art indeed?'
'You reason logically.'[93]

The point of putting his views in dialogue format is not simply for the sake of satire. It establishes that the artist is always assessing things from more than one viewpoint. He is both teacher and pupil, adult and child, knowing and unknowing. The same is true of Steinberg's conception of Jasper Johns. In modern art, you are encouraged to look at things from more than one direction.

The chatty elementarism of Johns' art was established early on. His earliest surviving work is *Construction with a Piano* (1954). It is a very small wooden relief measuring 28 × 23 × 5 cm. It is a shallow box with twelve wooden 'keys' at the top. The ivory has been stripped off the keys and the rough wood has been numbered (from left to right): 3–2–1–7–6–5–4–3–2–1–7–6. The front/top of the piano is covered with square and rectangular pieces of printed paper – a mixture of tickets and official forms in Spanish and German.[94] The edges of some have been torn and curl back. The wood on the rest of the box is untreated, and the nails with which it was assembled are exposed. Steinberg sees 'a romantic melancholy about it, even a hint of self-pity'.[95] It does appear to exude regret for the passing of the certainty, simplicity and scale of childhood. A toy has been scarred, buried and shrunk under layers of detritus. With Johns' construction, however, there is a keen sense that a piece of material culture is being reclaimed by the natural order. The paper glued to the front of the piano resembles peeling bark. This instrument is still very much alive, still evolving. Like the numbers on the keyboard, the object is caught in an endless evolutionary loop.

Johns has an equally concrete understanding of geography. His paintings of American maps and flags are not papery and flat, but are encrusted with encaustic and collage. Texture-wise, it is almost as though they were still embedded in primal ooze. A mixed-media work such as *Field Painting* (1963–4) has been scavenged as much as painted. Representation involves field-work: foraging, excavating, exploring, turning, opening.[96]

As I HAVE already noted, sculpture in the 1960s was compared – *ad nauseam* – to children's toys. The early wooden Minimalist structures of Carl André, which were inspired by Brancusi's *Endless Column*, were described as 'a child's "Build a Log Cabin" game',[97] while environmental sculpture was said to involve the viewer physically 'as if he were entering

a serious space playground for adults'.[98] In many cases, these works were vehicles for the same Utopian aspirations that Roland Barthes, in an essay on toys, found in children's building blocks. In contrast to conventional toys, which are essentially 'a microcosm of the adult world', the 'merest' set of blocks 'implies a very different learning of the world: then, the child does not in any way create meaningful objects, it matters little to him whether they have an adult name; the actions he performs are not those of a user but those of a demiurge. He creates forms which walk, which roll, he creates life, not property.'[99]

Many artists stressed their physical as much as their optical engagement with the art object. In an interview of 1970, Carl Andre said that the only 'art sense' of his work 'is almost a physical lifting of it. I can almost feel the weight of it and something running through my mind either has the right weight or it doesn't have the right weight.' He claimed that he did not even visualize his work: 'I number it sort of – something like sixty-four pieces of steel and I can have a sense of the mass of it but it's not a visual sense, it's a physical sense – almost a sense of pushing against a door and opening it.'[100]

This stress on the complete physical apprehension of objects is one of the main reasons why Andre's sculpture remains so low-slung. Indeed, the arrangements of metal plates hug the floor so closely that they are customarily called 'rugs'. If they were more vertically orientated, Andre believed they would be less accessible: 'You can enter the horizontal plane in a way that you cannot enter the vertical unless you are Simon Stylites.'[101] The critic Peter Fuller once suggested to Andre that his 'obsessional ordering and arranging of materials' was akin to the child playing with its own excrement. Andre took this immodest proposal in his stride: 'Yes, but some infants would rather smear on the wall, and others were drawn to play on the floor with it. And that's only to divide painters from sculptors. I don't think that I could be accused of being a painter, even as an infant.'[102]

Andre's association of number with mass and physicality – 'I don't even visualize – I number it sort of' – echoes a distinction made by the Canadian academic Marshall McCluhan in *Understanding Media* (1964), one of the most fashionable books of the 1960s. This same passage had particularly impressed Jasper Johns. McCluhan wrote:

In isolation, number is as mysterious as writing. Seen as an extension of our physical bodies, it becomes quite intelligible. Just as writing is

an extension and separation of our most neutral and objective sense, the sense of sight, number is an extension and separation of our most intimate and interrelating activity, our sense of touch . . . Perhaps *touch* is not just skin contact with *things*, but the very life of things in the *mind*?[103]

Before any of his readers started to think that accountants were the unacknowledged legislators of the world, McCluhan offered the example of a woman's vital statistics: 'Take 36–24–36. Numbers cannot become more sensuously tactile than when mumbled as the magic formula for the female figure while the haptic hand sweeps the air.'[104] The man obsessed with a woman's vital statistics is an adult version of Herder's 'little empirical creature' who 'weighs, touches, measures with his hands and feet'.

The 'big idea' behind *Understanding Media* is McCluhan's belief that we are living in an intensely tactile and sculptural age:

In cars, clothes, in paperback books; in beards, babies, and beehive hairdos, the American has declared for stress on touch, on partici-pation, involvement, and sculptural values. America, once the land of an abstractly visual order, is profoundly 'in touch' again with European traditions of food and life and art. What was an *avant-garde* programme for the 1920 expatriates [he is referring to the tactile education at the Bauhaus] is now the teenagers' norm.[105]

It seemed to McCluhan that the American dream really had come true: 'the American woman for the first time presents herself as a person to be touched and handled, not just to be looked at'.[106] Slowly but surely tactile awareness was climbing up the cultural pecking order. The sculptor Claes Oldenburg is a good example of the way in which Americans were getting 'in touch' with food: 'I would say that one reason [for making food sculptures] has been to give a concrete statement to my fantasy. In other words, instead of painting it, to make it touchable, to translate the eye into the fingertips.'[107]

McCluhan's notion that touch might be 'the very life of the mind' was taken very seriously in the 1960s. A Montessori revival was already under way. An English-language biography of Maria Montessori had been published in 1957, and a Montessori school had opened in Connecticut in 1958.[108] Their 'reality-oriented' approach was closely paralleled in art,

just as it had been in the earlier part of the century. But now contact with things became a central component in training adults, as well as children, to think effectively. The most popular of these training courses was developed by Edward de Bono, who coined the term 'lateral thinking'. For *The 5-Day Course in Thinking* (1967), a series of exercises was devised that would develop, respectively, Insight Thinking, Sequential Thinking, Strategic Thinking. It is a pop version of Montessori.

For training in Insight Thinking, the student was invited to assemble the following 'equipment':

Four empty beer or soft-drink bottles
Four table knives (preferably with flat-sided handles, and with rounded tips - for the sake of safety)
A drinking glass filled with water[109]

Sequential Thinking involved 'six block shaped objects of equal size', which were only allowed to touch in a certain number of places. The 'block shaped objects' recommended for use could be any of the following:

Books (of equal size and thickness; paperbacks would be best)
Cigarette packets
Matchboxes
Cereal boxes
Detergent boxes[110]

Strategic Thinking meant playing de Bono's celebrated 'L Game' – a board game for two people with two L-shaped pieces of card and two cardboard counters.

Each course required the participant to arrange the components in different configurations – the knives had to be balanced on top of various numbers of bottles; the blocks had to be arranged so that they touched only certain numbers of other blocks; the L-shape had to be placed in a new position, and could be turned round or flipped over. For all these courses, the participants had to exercise their minds in all three dimensions. Mental agility could be improved by manipulating the banal stuff of still-life.

In the wake of all this interest in three-dimensional experience, perceptual psychologists in the late 1960s conducted experiments which

prove that we can rotate three-dimensional mental images.[111] Until then, it seems, no one had given much thought to the rotation of mental images. Or perhaps, until the Swinging Sixties, the idea of thinking 'in the round' was simply too libertarian. In Will Self's novel *My Idea of Fun* (1993), the leading protagonist uses his eidetic memory and skill at mental rotation to cause chaos. First of all he spins an image of a philosopher. This would be a bit like Cosimo de' Medici revolving Giambologna's statuette of *Apollo*, were it not for the fact that he rotates him in 'all three dimensions'. Once his confidence starts to grow, he marauds through girls' schools 'as a purposive if disembodied agent' and, when he becomes really accomplished, he sexually abuses his way through the entire global village.[112]

ONE OF THE MOST elaborate post-war attempts to educate the senses is the mixed-media art of Joseph Beuys (1921–86). Beuys was much influenced by the philosophy and educational ideas of the theosophist Rudolf Steiner. Steiner placed artistic education at the centre of his movement. He put theory into practice, not only designing his own church, but also making sculpture and paintings for it. For Steiner, architecture had to be 'sculptural' – a wall had to be '*one* plastic form, a continuous relief sculpture'.[113] He also developed the concept of Eurhythmics: anyone who moves or expresses himself had to do so harmoniously ('eurhythmically'), like a 'moving sculpture'.[114]

Beuys devised his own version of Eurhythmy, which he called Social Sculpture. According to this doctrine, thinking, talking, breathing, singing were all forms of sculpture. They were all ways of moulding and shaping 'the world in which we live'. This moulding was a continuous evolutionary process in which everyone should participate, and in which everyone would be an artist.[115] Beuys was a proselytizing teacher-artist whose prime goal was nothing less than the social and aesthetic education of mankind. He believed that our schools 'must become places of education in a new sense, education as sculptural forming'; at present, the education that children get 'mostly warps them'.[116]

These ideas were not in themselves new. They ultimately go back to the idea that God is a sculptor. Educationalists and autocrats from the Renaissance onwards were attracted to the idea that they could 'mould' and 'carve' themselves, or their contemporaries. In 1997, Saddam Hussein gave a lecture at a school in Iraq in which he made an analogy between teachers and stone-carvers.[117]

Nonetheless, until the twentieth century, the idea that one might 'sculpt' the world was less compelling than the rival idea that one might 'paint' the world. This was because sculpture was restricted to the human figure and to animals, and because it was monochrome. In other words, it was relatively unworldly. During the twentieth century this situation changed. Sculpture expanded to take in any kind of subject-matter, material, colour and experience.

As a result, modern artists are more likely to think of the world in sculptural rather than pictorial terms. Beuys – who was the most influential artist of the 1970s – is a case in point. His work is made from materials such as fat and felt, and featured found objects such as batteries and pianos. He wanted our lives to be rooted in an education of the senses, and this had to be a sculptural enterprise, because painting no longer seemed so versatile or immediate.[118]

Many of Beuys' surviving works were the residue of performances – or 'Actions'. They often had, or were infused with, a strong autobiographical content. He used felt and fat, for example, because he claimed to have been wrapped in it by rescuers after his plane had been shot down during the war. He once made a work out of a bathtub that he used as a child, and another incorporated a soft toy belonging to his son.

But there is a tension in Beuys' work between words and images, between learning by rote and learning by doing. During his Actions, he often scribbled words, diagrams and symbols on to blackboards, and also did this when participating in live discussions. Fixatives were later applied to the chalk, and many of the blackboards are now displayed in museums. When he first used a blackboard for an Action, it was not on his own initiative, and he obviously used it with mixed feelings. It was part of the stage furniture for an evening of events staged by the Neo-Dadaist Fluxus group in Düsseldorf in 1963.

The previous performers had written on the blackboard, but Beuys, at the start of his *Siberian Symphony*, immediately wiped it clean – a gesture that singled him out. Having played some music by Eric Satie on a piano, he proceeded to turn the blackboard into a *tableau-objet*. He hung a dead hare on it, then fixed dabs of clay impaled by twigs on the piano's keys, and strung a wire from the hare to the piano. He wrote on the blackboard, then immediately erased the words. Finally, he pulled the hare's heart out.[119]

On subsequent occasions, after writing on blackboards, he would throw them on to the floor, where they mounted up into loose piles.

37. **Joseph Beuys**, *Directive Forces (of a New Society)*, 1974–77
(Mixed-media installation, Staatliche Museen zu Berlin, Nationalgalerie).

Some of these assemblages have been preserved and sold to museums as installations.[120] In *Directive Forces (of a New Society)* (1974–7) three blackboards stand upright, looking like large blank canvases on easels, in the midst of a Babel of used and discarded boards. This educational Golgotha implies that a vertical, Lancasterian system of education is being challenged and overthrown by a horizontal system. Whereas the former seems aloof, impersonal and didactic, the latter is down-to-earth and interactive. It is a three-dimensional floor game that revolves around movable blocks of knowledge.[121]

Beuys' use of blackboards was parodied by the American artist Jeff Koons in an advertisement for an exhibition of ceramic sculptures in the late 1980s. This showed Koons teaching a class of young children 'kindergarteners and first-graders – children really too vulnerable for such an indoctrination into my art'.[122] Indeed, they are much too young to understand the meaning of the slogans written on the blackboard: EXPLOIT THE MASSES and BANALITY AS SAVIOUR. They would, no doubt, have found his sculptures more accessible, for they are based on toys and kitsch knick-knacks. 'Everyone grew up surrounded by this material,' Koons said. 'I use it to penetrate mass consciousness – to communicate to the people.'[123]

Very recently he has made the *Celebration* series, which consists of huge, freestanding aluminium and plastic sculptures, as well as some photorealist paintings. The sculptures have titles such as *Elephant, Balloon Dog, Piglet* and *Colouring Book,* and are derived from typical children's toys and games. Their scale and sheen make them seem very aggressive, however. It is as though a childhood idyll has been power-dressed, or injected with steroids. This is a lament as much as a celebration.

Speaking in 1997, Koons saw the origins of this project in his childhood:

When I was about four and a half, five years old, I would go after school to this little building, like a little shelter. In the afternoons we'd make things out of Popsicle sticks. We'd work with Play-Doh. And this experience gave me my foundation. That's what I hold on to in the world. And whatever I made at that time I know is equivalent to what I'm doing now. And that was, for me, really, art.[124]

12. The Education of the Senses ii:
Hollows and Bumps in Space

A peculiar and important departure [in *Man with a Guitar* (1916)] is the hole in the centre of the figure; it is no longer a circle indented in the surface but a hole cut right through the sculpture from front to back. The purpose of the hole is simple: I wanted it as an element that would make the spectator conscious that this was a three-dimensional object, that would force him to move around to the other side and realize it from every angle.

<div align="right">

Jacques Lipchitz, *My Life in Sculpture*, 1972[1]

</div>

Frank, your stretchers are thicker than usual. When your canvases are shaped or cut out in the centre, this gives them a distinctly sculptural presence.

<div align="right">

Bruce Glaser talking to Frank Stella, 1964[2]

</div>

I love holes . . . They're a means of escape or access. They're sexual. Holes are really interesting because they're not there. I like the joke about the guy who dug the holes out of the ground and put them on a truck.

<div align="right">

Damien Hirst, 1993[3]

</div>

MODERN IDEAS about touch and tactility in relation to art are very different from those of earlier periods. As I have already shown, Neo-Classical writers such as Herder − while giving touch paramount importance − censored and policed those surfaces that they urged their contemporaries to touch. They believed that touch inspired disgust more readily than sight, so one had to be especially wary of those things that one might touch. Herder claimed that the Greeks avoided gruesome and expressive subjects because 'a mouth which shouts is a cave for the hand which touches and, during a smile, the cheeks are a crease'.

Hence the cavity-free surfaces and squeaky-clean contours of so many Neo-Classical sculptures. Texture was bowdlerized in the striving for shadowless silhouettes. Ultimately, Neo-Classical theories of touch seem to want to make the surface of sculpture two-dimensional, and turn it into a glossy surrogate of painting. It is no accident that nineteenth-century academic painting is often described as having a 'licked surface'. This is the counterpart to descriptions of Canova's sculptures being made by kisses and caresses, rather than by blows of the chisel.

Neo-Classical ideas about touch culminate in the art criticism of Bernard Berenson. For Berenson, writing at the end of the nineteenth century, Florentine Renaissance painting was supreme at performing the essential task of painting: 'somehow to stimulate our consciousness of tactile values, so that the picture shall have at least as much power as the object represented, to appeal to our tactile imagination'.[4] But typically, when Berenson traces the childhood origin of 'tactile values', he seems to think of art as something that lurks beyond a glassy screen: 'The child is still dimly aware of the intimate connection between touch and the third dimension. He cannot persuade himself of the unreality of Looking-Glass Land until he has touched the back of the mirror. Later, we entirely forget the connexion, although it remains true that every time our eyes recognize reality, we are, as a matter of fact, giving tactile values to retinal impressions.'[5] Painting resembles a looking-glass in the sense that textures lie behind a seamless picture plane. But Berenson was fighting a rearguard battle, for this was more the age of the distressed, rather than the seamless, surface.

During the nineteenth century, the Neo-Classical consensus broke down. In the 1790s, English critics such as Uvedale Price and Richard Payne Knight had objected to the priority accorded to smoothness in recent aesthetics.[6] For them, the Burkean idea of the beautiful sanctioned insipidity, monotony, artificiality and, at its worst, baldness. They proposed a rival category – the picturesque. By this, they meant much more than 'suitable for painting', which was the traditional meaning of this term. Their version of the picturesque encompassed anything that was wild, rugged, irregular, down-to-earth.

Sculpture was specifically excluded from the picturesque, either because the 'grave dignity' of traditional sculpture could not cope with ignoble subject-matter or because of its lack of colour.[7] But the picturesque painter was licensed – to a very limited degree – to employ a technique that was as rough as the subject matter. This opened the way

to the use of impasto and led eventually to the *tableau-objet*.

Whereas the picturesque aesthetic of circa 1800 tended to specify a vigorous handling for 'timeless' rural subjects, by the end of the century, even the most modern things could be depicted in such a way. But once modernity was the subject, the picturesque emphasis on *organic* irregularity and *natural* processes was no longer completely appropriate. Thus many modernists would also concern themselves with geometrical forms that were aggressively cantilevered and pristinely angular.

Rough execution and fragmented forms were to become ubiquitous in the nineteenth century. Creases started to appear in the most unexpected place of all – in classical art itself. The Elgin Marbles, after being bought by the British Museum in 1816, opened the eyes of the world to a completely new kind of Greek sculpture, which had uneven and expressive surfaces, and relief that seemed to 'jut out';[8] moreover, the decision to leave them unrestored and fragmented attests to a new taste for the rough-and-ready. They were immediately regarded as the acme of art, but because of their unrestored state, they were not deemed suitable models for students.[9] The British art critic R. H. Wilenski, writing in 1932, marvelled at the extent of the Elgin-inspired revolution: 'The propagandists for the Elgin Marbles would have been still more horrified if they had realized that the taste which they were creating for a rough and varied surface was opening the door to the appreciation of the bronze portraits of Jacob Epstein.'[10] Wilenski could have mentioned any number of other sculptors – from Préault and Rodin to Degas and Matisse.

The Elgin Marbles also contributed to the taste for dramatic combinations of solid and void. By being left in an unrestored state, the ensemble became a sequence of fragments punctuated by empty space. In the nineteenth century gaps started to appear between individual sculptures in sculptural ensembles, as subsidiary figures parted company with the pedestal – nowhere more so than in the Albert Memorial. Caves and creases also start to appear inside modern sculpture. We start to find a new awareness of mouths. Mouths start to gape unnaturally wide and we even find fingers being pushed awkwardly against and into them.[11] Then we find holes popping up in all sorts of non-naturalistic places. In Gauguin's anthropomorphic ceramics, where a jug is fashioned in the shape of a head, the mouth of the jug coincides with the top of the head. Writing of Rodin's *The Vanquished* in 1902, Rilke went so far as to claim that it was all mouth: 'What was expressed in the face, the pain and effort

38. The Albert Memorial, 1863–72
(Hyde Park, London).

of awakening together with the desire for this awakening, was written on the least part of the body; each part was a mouth uttering in its own manner.'[12] The most remarkable instance of this in Rodin's work is the pitted, mouthy back of *Walking Man* (1878).

In Picasso's constructions, we find the most blatant and disrupting holes of all. It is significant that Picasso's first construction was a guitar. But this guitar was made from roughly cut sheet-metal and wire, with a protruding stove-pipe forming the sound-hole. He was subsequently

inspired to make open-wire sculptures by a monument constructed for a poet in Apollinaire's *Le Poete Assassiné* (1916). This was 'a statue of nothingness, of the void' – a hole dug in the ground.[13] The poet had been brought right down to earth.

Holes are the trademark of the carvings of Henry Moore. In 1937 Moore made a formal statement about holes, and it covers most of the territory:

The first hole made through a piece of stone is a revelation.
The hole connects one side to the other, making it immediately more three-dimensional.
A hole can itself have as much shape-meaning as a solid mass.
Sculpture in air is possible, where the stone contains only the hole, which is the intended and considered form.
The mystery of the hole – the mysterious fascination of caves in hillsides and cliffs.[14]

Holes are initially revelatory in a forensic way. The boring of a hole is a kind of anatomical procedure in relation to stones. But holes are also mysterious, because they have to be explored and suggest that there is more to a stone than initially meets the eye. There is a terribly English anticlimax in Moore's reference to the 'mystery of the hole', however. We rather assume that he might be getting round to talking about adult and Freudian matters, but after teetering momentarily on the abyss (that dash!), he returns to Mother Nature and to the surer ground of speleology. Still, the issue of holes in art could not now be avoided: where Neo-Classicists were obsessed with surfaces, modernists have been obsessed with orifices.[15] Holes, by seeming to connect the back of the artefact with the front, stress its reality as an object in space. They can function like internal frames, and they imply that the object might envelop the viewer.

In nineteenth-century painting there is a comparable explosion of holes. There is a textural revolution, with painting exhibiting an astonishing range of surfaces. The Age of Impasto was kick-started by Constable, with his bold use of the palette knife.[16] His work horrified the more timid advocates of the picturesque. One critic said it was evident that his landscapes 'are *like* nature', but it was still more evident that 'they *are* paint'. They were variously described as being 'pock-marked', 'fretted' and 'scratched'. A French viewer thought that in close-up *The*

Haywain was only 'broad daubings of ill-laid colours, which offend the touch as the sight, they are so coarse and uneven'. Although he felt that Constable's pictures resolved themselves into 'picturesque' scenes once you stepped back, others were not so sure. In 1834 a critic on the *Observer* sarcastically remarked, 'a room has no room for his pictures – a four acre field should be between them and the spectator'.[17] A *cordon sanitaire* had to be created around coarse surfaces, which project forwards physically and encroach on the viewer's own space. But there was no distance from which you could safely view a Constable, or his avant-garde successors.

Courbet's even more aggressive use of the palette knife, and his complex textures, were crucial for modern painting. Cézanne's early work, with those thrashing stews of paint, strives to out-Courbet Courbet, while in his later work blobs and slivers of paint alternate with bare canvas.[18] As the painter Maurice Denis wrote in 1890, 'It is well to remember that a picture – before being a battle horse, a nude woman, or some anecdote – is essentially a plane surface covered with colours assembled in a certain order.'[19]

In 1911 Degas, now an elder statesman of the visual arts who was going blind, visited an Ingres exhibition and felt the canvases of the arch Neo-Classicist with his fingers. This must have been a kind of nostalgia for the smooth Neo-Classical surfaces of his youth: if anyone had touched one of Degas' own unvarnished pictures, with their complex impastos, or his wax sculptures, the experience would have been very different.[20] Some Impressionist pictures were in fact glazed for exhibition. This was a kind of Neo-Classicism through the back door. It was a desperate measure to re-establish the *cordon sanitaire*, and to keep digital disgust at bay. The Cubists, however, dispensed altogether with glazing and sometimes even with frames. They wanted to smash the looking-glass.

These developments were comprehensively theorized in Russia, where the concept of '*faktura*' became central to the avant-garde.[21] In an article written in 1912, the painter David Burlyuk (1882–1967) claimed that modern French painting had added two new elements to the visual language of line and colour – surface and texture. He used the word *sdvig* (shift) to imply passage across the painting and *faktura* (handling) to indicate the marks that revealed how the material of the paint had been manipulated. According to Burlyuk, in the paintings of Monet and Cézanne, and of Picasso and Braque, the brushwork had been given a

structural role in the construction of the picture surface. From this moment on the concept of *faktura* was central to the Russian avant-garde: the process by which a painting, sculpture, film or poem had been made had to be left visible. This meant that in poetry 'physical' qualities of sound and rhythm were privileged at the expense of meaning, as we see in the final 'verse' of a poem by Alexei Kruchenyk, published in 1913:

<div style="text-align:center">

dyr bul shchyl

ubeschchur

skum

vy so bu

r l ez[22]

</div>

Gaps open up between words and images, between letters and brush-strokes. And just as artists might incorporate word-fragments in their work, poets made poem-objects. In 1914 the poet Kamensky exhibited 'ferro-concrete' poems, which were mixed-media objects: *A Fall from an Aeroplane* consisted of 'a heavy weight marked with a face, hung by a wire in front of a metal sheet, above fragments of aeroplane and suggestions of blood'.[23]

The implications of *faktura* were most fully explored by the painter Vladimir Tatlin (1885–1953) – and almost inevitably his art took a three-dimensional turn. Tatlin visited Picasso (and possibly Braque) in his studio in 1913, hoping in vain to become his pupil or assistant. There he gained first-hand knowledge of Cubist collage and construction, and became aware of other Cubist-inspired sculpture by, for example, Archipenko, Boccioni and Laurens. In the same year he made a relief, *Bottle*, out of tin foil, wallpaper and other materials: '*Faktura*, which had formerly meant the handling of paint for Tatlin, was now in evidence as the handling of other materials in a way that recognized their individual qualities and resolved their oppositions.'[24] Unlike his French and Italian precursors, Tatlin would renounce imagery so that nothing could distract the viewer's attention from the qualities of the materials. Indeed, he hoped eventually completely to transcend style and self-expression. Tatlin was a thoroughbred 'worker-artist', and in his *Corner Counter-Reliefs* (1914–15) drew on his experience as a sailor to make used ropes and knots to construct a kind of rigging. In 1914 Tatlin opened his Moscow studio for the First Exhibition of Painterly Reliefs. He used a

wide variety of materials and announced that the surfaces of these materials had been worked upon with 'putty, fumes, powder and other processes'.[25] In a *Corner Relief*, made in the following year, he included a painter's palette and a set-square – old and new tools of the trade.

THE RUSSIAN avant-garde felt a close affinity with the British Vorticists. In 1915 an article appeared in a new Russian periodical, the *Archer*, entitled 'The English Futurists', which consisted of an interview with Ezra Pound, a discussion of the Vorticist magazine *Blast* and illustrations of work by Wyndham Lewis.[26] The Vorticists' counterpart to the Russian concept of *faktura* can be seen in Pound's critique of the idea of the 'caressable' in art. This theory was expounded in 1916 in a posthumous tribute to the Vorticist sculptor Henri Gaudier-Brzeska. It vividly encapsulates the paradigm shift that had taken place:

> We all of us like the caressable, but we most of us in the long run prefer the woman to the statue. That is the romance of Galatea. We prefer – if it is a contest in caressabilities – we prefer the figure in silk on the stairs to the 'Victory' aloft on her pedestal-prow. We know that the 'Victory' will be there whenever we want her, and that the young lady in silk will pass on to the Salon Carré, and thence on toward the unknown and unfindable. That is the trouble with the caressable in art. The caressable is always a substitute.[27]

For Pound, the new art, as exemplified by Gaudier-Brzeska's brusque, Cubist-inspired carvings, needed to be a robust and clearly articulated arrangement of forms. The materials had to be autonomous, standing only for themselves, rather than poor substitutes for skin or silk: the sculptor had to express the stoniness of stone, or the woodiness of wood.[28]

Paradoxically, in much British sculpture of the 1920s and 1930s, this doctrine actually led to an *increase* in caressability. For if the sculptor is expressing stoniness or woodiness, then one of the characteristics of, say, a pebble or a piece of driftwood is that it can be caressed with impunity. If, in addition to this, the sculpture evokes the naked female form, then we might conclude that the sculptor is inciting us to caress the sculpture with unprecedented abandon. The claim that the only subject-matter of a sculpture is the nature of the material from which it is made could easily be used as an alibi for erotic attachment. This is precisely what happened:

the most popular theme of the period is the naked female form. Thus the doctrine of 'truth to materials' involved equal measures of fetishism and casuistry.[29]

But the best work of the period does counter the 'caressable'. It refuses to allow the hand – much more in the imagination than in reality – to pass effortlessly over its surface. A neat Neo-Classical seamlessness no longer exists. The crevices, the angularity, the variations in surface treatment disrupt one's experience of the object, making it discontinuous. The new art objects are designed to provoke pain as well as pleasure, disgust as well as desire, emptiness as well as fulfilment. They resist complete appropriation – they suggest mountain ranges rather than pebbles. Henry Moore said that the sculpture that moved him gave out 'something of the energy and power of great mountains', and he even called one of his early works *Mountains*. In other words, the work of art should be equivalent to a mountain range – an abrupt sequence of rising and falling forms.

Caressable art tends to be understood as denoting an age of innocence – either pre-sexual or asexual. Caresses are non-penetrative, and evenly spread. For R. H. Wilenski, writing in 1932 about tribal art, the absence of caressability signifies the presence of sexuality:

> There was sexual meaning in negro sculpture but not sensual meaning. Even making the maximum allowance for the known and presumed differences between the white man's and the black man's erotic, it seemed impossible to assume that caressability was a character that the negro sculptors were mainly concerned with in their rendering of the naked human body . . . The only deduction possible was that the savage sculptors saw only sexual and not sensual meanings in the naked human body and that the expression of those meanings was not tramelled by outside prejudice or inhibited from within.[30]

Wilenski must mean that sexuality is expressed through the eye/hand having to 'enter' and 'withdraw' from the sculpture as it explores its various convex and concave components. As with Moore's notional mountains, one's engagement with it is spasmodic and unstable.

The first 'Surrealist Object' – Giacometti's *Suspended Ball* (1930–1) – is in the vanguard of the crusade against caressability. A grooved sphere, suspended from a wire, hovers over a wedge-shaped form. The sphere can be slid up and down it. When the Surrealists first saw it functioning

they experienced a 'strong but indefinable sexual emotion relating to unconscious sexual desires'. However, this emotion 'was in no sense one of satisfaction, but one of disturbance, like that imparted by the irritating awareness of failure'.[31] This 'erotic machine' has been interpreted as follows: 'the sliding action that visibly relates the sculpture's grooved sphere to its wedge-shaped partner suggests not only the act of caressing but that of cutting: recapitulating, for example, the stunning gesture from the opening of *Chien Andalou*, as a razor slices through an opened eye'.[32] There are no easy contacts here. A caress can cut, and the caresser can be cut: surfaces violate and are violated. The caves and creases that disgusted Herder have become a treacherous reality.[33]

This last sentence could easily be rephrased. We can equally say that the *shocks* and *surprises* that Herder so feared have become a reality. For an art of disruption and discontinuity is essentially an art that aims to jolt the viewer. In an essay published by Walter Benjamin in 1939, the German writer argues that coping with shocks is central to modern experience. He quotes Paul Valéry approvingly: 'The impressions and sense perceptions of man actually belong in the category of surprises; they are evidence of an insufficiency in man.' Conscious and unconscious recollection helps us to cope with these surprises: 'Recollection is . . . an elemental phenomenon which aims at giving us the time for organizing the reception of stimuli which we initially lacked.'[34] Modern man has to learn – in the words of a more recent critic – that one is 'not to "suffer" that shock, but to absorb it as an inevitable condition of existence'.[35]

This brings us back one final time to the Montessori Method. For this too is fundamentally about shock absorbency. Maria Montessori understood that children love to touch things and, in order to prove this, she cited the way children behave in church: 'Children have been seen to stand opposite a beautiful pillar or a statue and, after having admired it, to close their eyes in a state of beatitude and pass their hands many times over the forms.'[36] This is a standard Neo-Classical formulation. The children are transported into a semi-conscious reverie of caressing. There is no resistance to their hands: they pass their soft palms repeatedly over forms that one presumes are made from highly polished stone. The carvings function like ideal mothers. In a similar vein, Montessori classrooms had a reproduction of a Raphael madonna and child on the wall, and casts of classical reliefs.

But in Montessori's educational system, in which the children must

touch a variety of materials, touch is a much more complex and alarming affair. The children have to learn how and when to touch. This exposes a paradox at the heart of the method: in educating the sense of touch by repeated exposure to a variety of materials, you risk desensitizing or damaging the fingers through friction. Previous sensory educationalists, such as Edouard Seguin (1812–80), the 'Apostle of the Idiot', thought that sensitive skins sometimes needed to be toughened up by handling bricks or by digging with a spade.[37] But for Montessori, keeping the tips of the fingers as sensitive as possible was paramount. There were obvious concerns at the dangers inherent in touching the rougher materials. The children had to be taught to draw their fingers *'very, very lightly'*[38] over the sandpaper letters. The Montessori classroom, unlike the church, was not a place where children could touch with impunity. Taken to extremes, education through touch was both an assault course and an endurance test. It sought to redeem all of reality – the rough and the smooth, the hard and the soft, the solid and the void, the round and the angular. But the child was never allowed to forget that the caresser can be cut.

THE NON-CARESSABLE ARTWORK may well be an artwork that you might bump into. It is something with which you have an unpremeditated and jolting encounter. In other words, the viewer finds a solid where the void should be, or vice-versa. It is a mixture of pot-holes and mountain peaks. This type of encounter is envisaged in the most famous post-war put-down of sculpture: sculpture is what you bump into when you back up to look at a painting.[39]

If sculpture was something that you bumped into, it was only because it was increasingly occupying open space, rather than simply being placed flat against walls or in niches. It was competing directly with the viewer for floor space. In so doing, it challenged previous ideas about the ideal relationship between a viewer and an artwork. In the Renaissance, a popular conceit had it that a statue was so powerful that it turned the viewer to stone, like Medusa. But the Medusa topos envisaged a single, stationary, face-to-face confrontation. The modern mode of address is rather different. The viewer is taken by surprise in the same way, but is not then rooted to the spot. Instead, he or she is thrown off-balance, sent round, along, through, under and even over the artwork. On encountering the artwork the viewer becomes more, not less, active. If anything, the viewer experiences desiccation and liquefaction rather than

petrification. Every encounter with the artwork should have some of the characteristics of a blind date.

Roquentin's confrontation with the bowing statue in Sartre's *Nausea* is a good example of the sculpture as a mysterious, destabilizing presence: 'A vague power emanates from him, like a wind pushing me away.'[40] Roquentin has been bumped. Although he looks the statue 'full in the face' – in classic Medusa topos fashion – the statue has no face. It has 'no eyes, scarcely any nose' and the beard has been 'eaten away'. But this mutilation has in no sense weakened it. Quite the opposite. It is an energized fragment. The implication now is that any part of the statue could intimidate the viewer. Power is no longer simply vested in the face, so its defacement is irrelevant. Later on Sartre would say that Giacometti, with his inchoate stick figures, had tried 'to mineralize his fellows'.[41] Mineralization takes man back into a natural scheme of things, a place where things not only have no face, but no front, back, side, top or bottom. Winds, after all, can blow in any direction.

The lurching posture, elided anatomy and dreamy eyes of Rodin's *Balzac* – 'Look, it's melting! It already leans to one side: it's going to fall'[42] – are a forerunner of Roquentin's statue. According to Rilke, Rodin imbued the entire human body with an eye-like expressiveness: 'when he read of the weeping feet of Nicolas the Third, he found that he already knew there could be weeping feet, that there is a weeping of the whole body, of the whole person, and that every pore can bring forth tears'.[43] In Rodin's glistening work, expression had left the 'stage' of the face: 'Life showing in the face, full of reference to time and as easily read as on a dial, was, when seen in the body, less concentrated, greater, more mysterious.'[44] The human face could no longer be read like a clock. This corresponds to the 'new world of symbols' called for by Nietzsche in *The Birth of Tragedy* (1871). Once the 'Apollonian' veil of illusion has been 'torn aside' and left 'fluttering in tatters', the 'entire symbolism of the body is called into play, not the mere symbolism of the lips, face and speech'.[45] With Rodin's sculpture, there can be no 'correct' mode of address, for every part of the body is equally eloquent. The viewer is posited as a cross between a satellite and a pin-ball – someone who orbits and ricochets.

The artwork as obstacle is a major twentieth-century theme. It is the negative mirror-image of the modernist attempt to rid the world of the Victorian taste for clutter. Clutter is only admitted to modern art if it is shown to be enigmatic and alarming. This, of course, has the side-effect

of making it very powerful and alluring. Again and again modern art stages a show-trial of clutter – thereby forcing us both to wince and to wonder at it.

Duchamp's ready-mades are important pioneers. *Trap* (1917) is a text-book demonstration of the dangers of clutter: it is a coat-rack nailed to the floor, ready to trip up the passer-by. The domestic world has been undomesticated. The *Large Glass* is a kind of sash window placed in the middle of the floor. Duchamp called it a 'delay' in glass – and what gets delayed is the passer-by. Giacometti's 'disagreeable objects', deposited on the floor, are *Trap*'s most distinguished progeny. Clutter becomes really interesting clutter when it sits directly on the floor. For then it is clutter that can really take you by surprise. The American critic Philip Fisher has noted the way that modern sculptors occupy the 'downward space' in front of our feet: 'Every object within this space appears as an obstacle, something that we must move around or that we might stumble over. It is an impediment and is resisted in a primary way.'[46]

Painting, too, has become clutter. In the studios of Picasso and Braque the canvases stood on floors, chairs and other pieces of furniture, as well as being hung on the walls.[47] It must have been like a junk shop, sometimes with standing room only. Many subsequent artists have exhibited their paintings at, or just above, floor-level. The paintings of the Abstract Expressionist Mark Rothko were exhibited without frames, and the paint extended round the edge of the stretcher – a strategy that emphasized their status as material objects. In 1959, at an exhibition in London called *Place*, large abstract paintings were placed directly on the ground, forming a maze through which the viewer had to wander.[48] The critic Lawrence Alloway, writing about another exhibition of similar paintings, recommended a 'permissiveness of viewing distances' and viewing from 'various oblique angles'. When pictures were looked at in close-up, this had to be done using neck motor-action rather than eye movements.[49] Thus the artwork should be experienced actively with the whole body. All this activity meant that the art gallery, even if it hardly contained any artworks, seemed busier and bumpier than ever.

The 'downward space' that has been so assiduously occupied by modern artists is primarily that of the chair. The migration of artworks from the wall and the niche was an attack on the sedentary artlover – of the kind posited by Matisse when he said that he wanted his art to be a 'soothing, calming influence on the mind, something like a good armchair which provides relaxation from physical fatigue'.[50] Because

modern sculpture is often placed in the centre of galleries, it occupies the position that could have been reserved for seating. It literally unseats the viewer. The corollary to this is that many modern artists have made aggressively functionless furniture. Duchamp's bicycle wheel impaled in the seat of a painted wooden stool, and Joseph Beuys' *Fat Chair*, where the seat is occupied by a wedge of fat, are two of the most conspicuous examples.[51] Salvador Dalí – who in the 1930s made a sofa based on Mae West's lips, and a stool whose back consists of a pair of predatory arms – had firm ideas about chairs: 'A chair can be used to sit on, but on condition that one sits on it uncomfortably.' A chair had to express the *Zeitgeist* and cause the 'proud, ornamental, intimidating and quantified spectre of a period to spring forth instantly'.[52]

Picasso's studio became almost un-enterable. He always lived in 'chaos and clutter',[53] and in later life would simply buy another house when he ran out of space. His friend and biographer Roland Penrose evokes the 'jungle' inside the house into which Picasso moved in 1955:

> His house had always been his workshop and a place to store his belongings rather than something to be admired for its elegance and comfort . . . With haphazard finality objects took their places around the rooms. In spite of the attentions of [his wife] Jacqueline Roque, the disorder grew. Incongruous objects, crowded together, became more deeply hedged in by a forest of new arrivals.[54]

Here the wild, 'jungle' space of the workshop colonizes the space of the home.

The most elaborate meditation on clutter is Kurt Schwitters' *Merzbau*, a sculptural environment built in the artist's house in Hanover during the 1920s and 1930s. It was also known as the *Cathedral of Erotic Misery*. There was not even standing room: 'The visitor to this most holy place, the master's studio, is struck by a holy shudder, and only then dares raise his eyes when he has found a little spot for himself, but where he cannot stay because there is not enough room to stand. The interior does not give the impression of being a studio but a carpentry shop.'[55] Schwitters' first important works were made just after the end of the First World War, when he was in close contact with various branches of the European Dada movement. They were abstract collages made from pieces of wood and detritus picked up from the street, and from Schwitters' own rubbish and memorabilia. He called his art *Merz*, in

ironic homage to the German word for commerce – '*Kommerz*'. It has been said that these collages 'reveal something of a cluttered Victorian taste',[56] and that Schwitters (1887–1948) lived like 'a lower-middle-class Victorian'.[57] Yet *Merz* is devoid of sentimentality. It is supremely caustic and traumatizing.

The first indication that Schwitters might build his *Merzbau* came in 1920 when he made the sculpture, *Haus Merz*. It was a model church with a spinning top for a spire, a trouser button for the clock face, and its nave was filled with cog-wheels. Schwitters quoted with approval the comments of a friend: 'This cathedral cannot be worshipped in. The inside is so filled with wheels that no room is left for people . . . This is absolute architecture, the only meaning of which is artistic.'[58] The interior of the *Haus Merz* could in fact be seen, but only with difficulty. Various obstacles had first to be overcome. By clogging up the building, sedentary contemplation was turned into restless peering and wandering. This drama of exclusion would be echoed in the *Merzbau*, where the central feature was an abstract sculpture that Schwitters called a 'column'. It was Schwitters' own response to *statuemania*.

Over the years the appearance of the *Merzbau* changed considerably, with objects being buried inside the structure. Initially the column was an abstract sculpture in the De Stijl manner. But it was overlaid with Dadaist detritus and memorabilia, nailed and collaged together. The column was surmounted by a plaster cast of a child's head, taken from Schwitters' own son after he died in infancy. Other columns were created too, and everywhere there were themed 'grottoes', 'caves' and 'shrines' where memorabilia and curios were kept. These included a bra, a key, a nail-clipping and hair taken from friends; a hamster in a cage; a bottle of urine. Violent and seedy tableaux involving plastic figures were set up in the 'Cave of Murderers', the 'Sex-Crime Cavern' and the 'Big Love Grotto'. It was a perverse pantheon in which there were numerous tributes to 'great men' – the 'Goethe Cave', the 'Nibelungen Cave', the 'Cave of Deprecated Heroes', the 'Cave of Hero Worship', and even the 'Luther Cave'. As visitors passed through, they triggered off a variety of lights. Some of Schwitters' friends were horrified by the experience. One of them thought it was 'a kind of faecal smearing – a sick and sickening relapse into the social irresponsibility of the infant who plays with trash and filth'.[59]

In 1936 Schwitters himself described the *Merzbau* as an 'abstract (cubist) sculpture into which people can go'.[60] That could have been

39. **Kurt Schwitters**, *Merzbau*, c.1923
(Mixed-media installation, Hanover, destroyed)
The 'Merz-column' is surmounted by a cast of the head of Schwitters' child,
who died in infancy.

emended to: into which it is increasingly hard for people to go. The
Merzbau threatened to choke the entire room. It soon gained an almost
mythical status – rumours spread that it had expanded to fill the ground
floor of the house and had broken through the ceiling to the floor above,
until finally rupturing the roof; the Schwitters family and their lodgers
were thought to have been displaced, and even to have moved out.[61] It
was *horror vacui* writ large.

294

The desire to fill, or at least to puncture, the void has been a major concern of modern artists and a stimulus for the creation of a great deal of object-based art. The French philosopher Henri Bergson tried to explain the reasons for our *horror vacui* in *Creative Evolution* (1907). Bergson believed that our lives are spent in an emotional attempt to fill voids:

> If I bring a visitor into a room that I have not yet furnished, I say to him that 'there is nothing in it'. Yet I know the room is full of air; but, as we do not sit on air, the room truly contains nothing that at this moment, for the visitor and for myself, counts for anything. In a general way, human work consists in creating utility; and, as long as the work is not done, there is 'nothing' – nothing that we want. Our life is thus spent in filling voids, which our intellect conceives under the influence, by no means intellectual, of desire and of regret.[62]

Such is modern man's concern to materialize space that from the late 1930s onwards, architects have tried to fill the 'void' created by air. In order to enable architectural students to understand the spatial dynamics of buildings, solid plaster models of interior spaces have been used as teaching aids.[63]

Schwitters' *Merzbau* is in part a manifestation of a notion that had been growing increasingly popular: that the human mind is analogous to an archaeological dig. One of the main points about archaeological metaphors is that they sideline painting, and the *camera obscura* model of the mind, because paintings (Pompeii and the Egyptian tombs notwithstanding) are much more rarely found in archaeological sites. Archaeological metaphors cannot help but be largely object-based. At its most abject, we get something akin to what the poet W. B. Yeats would call the 'foul rag and bone shop of the heart'.

Two of the most famous fictional archaeologists feature in Flaubert's unfinished last novel, *Bouvard and Pécuchet* (1881). It is an affectionate satire on his contemporaries' insatiable thirst for knowledge. The eponymous heroes are Parisian copy-clerks, both aged forty-seven, who meet by chance one day in 1838 and become firm friends. The next year Bouvard inherits a fortune and decides to share it with his friend. After spending three years searching for an ideal home, they eventually retire to a house with large grounds in a small village. They then proceed to become 'experts' in almost every conceivable subject, always by reading

books. They learn how to bottle preserves, distil spirits, stack hay, plant trees, look after animals, etc.; they study medicine, chemistry, geology, palaeontology, religion, etc.; they try to learn how to have imagination, and how to write a novel. Because they insist on using books, rather than consulting local people, almost all their practical projects end in failure. Ultimately they decide to go back to being copyists. Flaubert slaved over the novel for more than ten years, researching its components down to the last nut and bolt, so it is a kind of self-portrait. He never completed the second and final part, but it would probably have consisted of the texts the clerks had copied.

Six months after trying their hands at geology, Bouvard and Pécuchet turn themselves into archaeologists. Their house becomes a museum that is perilous to pass through: 'An old wooden beam stood in the vestibule. Geological specimens cluttered up the staircase, and an enormous chain stretched along the floor for the whole length of the corridor.' They knock two spare bedrooms into one: 'Just inside one bumped into a stone trough (a Gallo-Roman sarcophagus), then a display of iron-mongery caught the eye.' It is crammed with all kinds of bric-à-brac, ranging from warming-pans, chain-mail and old books to birds' nests, a coconut, a portrait of 'Bouvard père' and a 'monstrous clog, still full of leaves'. But the 'best of all' is a polychrome statue of St Peter in a window embrasure:

> His gloved hand clutched the key to Paradise, coloured apple-green. His chasuble, decorated with fleur-de-lis, was sky-blue, and his bright yellow tiara was pointed like a pagoda. His cheeks were rouged, he had great round eyes, gaping mouth and a crooked, turned-up nose. Above hung a canopy made of an old carpet on which two cupids in a circle of roses could be made out, and at his feet, like a column, stood a butter jar, with these words in white letters on a chocolate background: 'Executed before H.R.H. the Duc d'Angoulême, at Noron, the 3rd October 1817'.[64]

What we see here, as in the rest of the novel, is an absurd manifestation of modern Europeans' desire to inventorize and hoard. It is not so different in its way from the scene of idolatry in *Salammbô*. Both are examples of *horror vacui* gone mad: fanatical dedication to filling. At the centre of it all is a statue of St Peter with a 'gaping mouth'. The 'rock' on which the church was built has become a series of caves. Peter's statue

is arbitrarily juxtaposed with a butter jar and an old carpet. Bouvard and Pécuchet's 'museum' is the spiritual grandfather of Cubist collage and the *Merzbau* – and of innumerable environments and installations.

From the mid-1890s archaeology was central to Sigmund Freud's conception of psychoanalysis, and because of this archaeological metaphors have been prevalent in all branches of subsequent psychoanalytic work. Freud (1856–1939) had an extensive collection of unrestored classical and Egyptian sculpture, which was displayed in massed ranks on his desk and around his consulting room. The Wolf Man recalled Freud telling him, 'The psychoanalyst, like the archaeologist in his excavations, must uncover layer after layer of the patient's psyche, before coming to the deepest, most valuable treasures.'[65] In 1899 he described his own self-analysis, 'It is as if Schliemann had again dug up Troy, which had hitherto been deemed a fable.'[66]

Donald Kuspit has observed that although the archaeological metaphor serves to make the core distinctions of psychoanalysis – 'between surface and depth, manifest and latent, adult and infantile, civilized and uncivilized, historic and prehistoric, fact and fantasy' – there is no clear hierarchy: 'One term subordinates the other, but they are inextricably in conflict', with neither able to exist without the other.[67] The archaeological mission of psychoanalysis was linked to its role as 'a disturber of man's narcissism'.[68] Suppressed and forbidden wishes from childhood 'break through in the dream'.[69] The ground may suddenly open up beneath our feet, and we may be called upon to be speleologists of the self.

Michel Foucault is the best-known intellectual 'archaeologist' of the post-war period. He called his early books archaeologies in so far as they exposed and disentangled the assumptions that underlay and licensed specific practices – whether they be the definition of madness or the 'Archaeology of the Medical Gaze'. In 1986 he discussed the way in which our understanding of space has changed, due in large part to the impact of phenomenology.[70] We no longer live in a 'homogeneous and empty space', but in a space that is both insistently material and fantasmic. The spaces of our primary perception, of our dreams and of our passions have their own particular qualities: 'there is a light, ethereal, transparent space, or again a dark, rough encumbered space: a space from above, of summits, or on the contrary a space from below, of mud; or again a space that can be flowing like sparkling water, or a space that is fixed, congealed, like stone or crystal'. The mind has become an ever-evolving *Merzbau*.

IN THE POST-WAR period numerous artists have tried to disrupt, usurp and fill spaces. In his introduction to a major survey show, *American Sculpture of the Sixties* (1967), Maurice Tuchman gave a vivid sense of the thrills and spills that lay in store for viewers:

> Sculpture here comes at you from all directions – from the ceiling . . . the wall . . . or it may snake around a corner. When it rests on the ground it doesn't really rest . . . but [it] still comes at you; it never reposes on a pedestal . . . New sculpture may threaten to fall . . . By violating the tradition of having an object sit on a base, all these works unsettle our common perceptions of things in relation to the ground and consequently of all things outside of us in relation to us.[71]

The dreams of the Space Age merge with the nightmares of Piranesi; the force of gravity is both acknowledged and denied.

Anthony Caro, despite being British, was included in *American Sculpture of the Sixties*. This was because of his close involvement with American sculptors, painters and critics at a turning-point in his career. As a result, he had stopped making figurative sculpture in the tradition of Henry Moore, and started making abstract sculpture out of welded and painted steel. Caro placed his sculptures directly on the floor, renouncing pedestals. Many of the steel components were scavenged, virtual found objects, and much of the welding and cutting was rudimentary. For Philip Fisher, Caro 'decisively occupied floor space' for the first time: 'The witty insouciance of Caro's work gaily toys with the danger, sharpness, resistance, and frustration of this blockaded space.'[72] The two most important of Caro's early constructed works, *Twenty-Four Hours* (1960) and *Early One Morning* (1962), dramatize the notion of sculpture-as-obstacle in a very specific way.

It has often been observed that *Twenty-Four Hours* is like a realization in relief of a Kenneth Noland 'target' painting, and that the constructed steel element that terminates *Early One Morning* resembles a painter's easel.[73] If this is so, then a key theme of these pieces is disrupted viewing, for in the former a truncated pyramid shape is placed out in front of the target, while in the latter a range of steel bars and beams cuts across what would be a front-on view of the 'canvas'. They are thus sculptures that speak of the impossibility of static, 'pictorial' vision. You cannot caress these surrogate paintings, or back up to look at them, because the space in front of them is occupied by uncouth material objects. The titles of

40. **Anthony Caro**, *Early One Morning*, 1962
(Painted metal, Tate Gallery, London).

both sculptures refer to time, which further suggests that they are abstract
visual diaries of the events that inevitably cross our field of vision. The
'dials' of these sculptures are obfuscated. What Caro's 'obstructed
paintings' also allude to is the theme of the cluttered artist's studio. Caro
initially worked in a 'one-car garage'. Sometimes, in *Merzbau* style, a
sculpture would 'get larger than the space available and poke out of the
door'. This working method forced him to 'refrain from backing away
and editing the work prematurely'.[74] Even the sculptor has to tread
warily. Stuff – the stuff of sculpture – gets in the way.

This art-as-obstacle ethos reaches its apogee in the work of Richard
Serra (born 1939). His massive slabs of rusted steel not only cut decisively
across spaces; they tilt, threatening to fall on the viewer. They are what
Rodin's *Balzac* would look like if he were converted into a length of
rolled steel; or the materialization of a shadow cast by a statue across a de
Chirico piazza. His room installations have been described as 'adversary
spaces'.[75] When Serra was commissioned to make a sculpture for the
soon-to-be-opened Pompidou Centre, the architects were unhappy. As
he later told the critic Douglas Crimp, 'Richard Rogers, the English

299

architect, said that people wouldn't be able to walk into the doorway, to which I replied, "You mean they'll have to walk around the sculpture." '[76]

Serra's most dramatic and ill-fated intervention into the urban environment came with *Tilted Arc* (1981), sited in Federal Plaza, New York. *Tilted Arc* was regarded by hostile critics as a 'rusted steel barrier', a 'Berlin Wall', an 'Iron Curtain', and a 'scar on the plaza'.[77] After a concerted campaign and a court case, it was destroyed in 1989 (ironically the same year that the Berlin Wall came down). When the sculpture was still being planned, Serra told Crimp that it would 'cross the entire space, blocking the view from the street to the court-house and vice versa'. It would be 'a very slow arc that will encompass the people who walk on the plaza in its volume'.[78] *Tilted Arc* exercised a form of social control; it functioned like a vast blindfold that sliced through sightlines.

The scenario spelt out here – of endlessly disrupted pathways – is paralleled by what the American architect Louis I. Kahn called 'the architecture of stopping'.[79] This kind of architecture consisted of monumental structures, which are akin to 'wound-up streets . . . the street come to conclusion'. Kahn also refers to them as 'the sculpture'. He added that although others might think of these structures as glorified garages, he regarded them as gateways.[80] Kahn must have meant that they are structures that can never be entered fully and which, wherever you are, always make you think you are still on the threshold, on your way in or out. You can get close to them, but not complacently close. It is the architecture not so much of stopping, as of pausing, stumbling, side-stepping.

The modern belief that we should try to come to terms with potentially hostile stimuli, rather than repress or ignore them, helps explain why modern art presents such an astonishing array of materials and textures. Once again Joseph Beuys is exemplary. In an interview in 1986 Beuys said that without collisions there is no such thing as consciousness: 'it is clear consciousness is impossible without death. It is only when I hit a sharp corner, so to speak, I wake up. In other words, death keeps me awake.'[81] This is similar to a definition of philosophy given by Wittgenstein in the *Philosophical Investigations* (1945): 'The results of philosophy are the uncovering . . . of bumps that the intellect has got running its head up against the limits of language. These bumps make us see the value of the discovery.'[82] Modern art is no less centrally concerned with the creation and uncovering of 'bumps'; and this is why so many modern artworks – whether paintings or sculptures – insist on

being disconcerting objects in space.

Bumps take us right back to Herder's disgust at faces with caves and creases. Nothing could throw into sharper relief the distance that art has travelled from the contemplative classical ideal. In *Plastik* Herder stages an interview with a blind girl. 'Do you prefer angular or rounded tables and receptacles?' he asks. She says she prefers round ones 'because they are easier and more pleasant to hold, and you can't bang yourself against a round table.' Herder's conclusion is that it is 'surely not possible to find a simpler way of saying what is the line of beauty'.[83]

Nowadays, of course, the line of beauty is very different. 'Progressive' art is routinely called cutting edge. And because art aspires to have a cutting edge, this explains why so many pieces of public art are now conceived of as temporary, site-specific 'interventions'. In 1962 for example, Christo erected *Wall of Oil Barrels–Iron Curtain* across the narrow rue Visconti in Paris, a street where Racine, Balzac and Delacroix had all lived. It was a sort of hit-and-run operation. He blocked the street off for eight hours, without getting permission from the authorities, for the evening of 27 June. The modern artist makes a Faustian pact with society. He or she says: let me place something really confrontational in your path, and I promise to have everything back to normal by morning. There is thus nothing intrinsically self-effacing or anti-heroic about temporary installations. They are simply a prescribed course of shock therapy.

Many of these installations purport to make a critique of the sites and institutions in which they are located. One of the most effective, recent examples was Hans Haacke's *Germania* (1993), which occupied the German pavilion at the Venice Biennale. The pavilion was built in the 1930s in a striped Neo-Classical style, and had been visited by Adolf Hitler and Benito Mussolini. Haacke blocked the entrance with a photograph of the Führer mounted on a large panel. Having squeezed past the panel, the viewer was greeted by another, even more unexpected obstacle – the vast, cavernous space was empty but traversable only with difficulty, because the floor had been excavated and the fragments of paving stone and cement left in random piles. The white walls of the coolly lit pavilion were bare except for a replica in relief of the inscription that surmounted the portico: GERMANIA. When the next Biennale came round, the pavilion had been given a nice new, beautifully smooth floor. But the memory of that jagged, ice-cold excavation still sets my teeth on edge.[84]

13. Loving Objects

Your triumphant bosom, is a beautiful armoire.

Charles Baudelaire, *Le Beau Navire*, 1857[1]

. . . artworks at their best spring from physical, erotic propositions.

Carl Andre, 1970[2]

This is the kind of pot I'd like to take to bed with me.

A pottery teacher, 1978[3]

Even if I may love to look at the paintings I make – and I do covet them, my real pleasure in them is that, for me, the work manifests a kind of love that I find impossible with another person, but which I can put into these paintings . . .

Julian Schnabel, 1986[4]

So FAR, I have been emphasizing the way that modern artists have been keen to activate and materialize the surface of the artwork. For the most part I have interpreted this 'becoming-concrete' in a functional, and slightly puritanical, way: impasto in Courbet, divots in Rodin, constructed elements in Picasso, angular blocks in Brancusi, fag-ends in Pollock signify a forthright and 'workman-like' attitude. But there is more to what Rilke termed this 'simple becoming-concrete' than that. The blatant physicality of the artwork can have erotic overtones. The artwork becomes animated – something you might love and hate. This way of responding to any artwork, even if it is abstract, would be in line with something that Maurice Merleau-Ponty wrote in the *Phenomenology of Perception* (1945), a book that exerted a huge influence on artists in the post-war period. For Merleau-Ponty, every perception is a 'communion' and a 'coition' of our body with things.[5]

We get an inkling of this from a troubling passage on Pollock written

by the American critic Philip Leider in 1970:

> *You could visualize the picture being made* – there were just no secrets . . .
> Another thing about Pollock was the plain familiarity with which he
> treated the picture as a *thing*. He left his handprints all over it; he put
> his cigarette butts out in it. It is as if he were saying that the kind of
> objects our works of art must be derive their strength from the
> directness of our attitudes toward them: when you feel them getting
> too arty for you (when you find yourself taking attitudes toward them
> that are not right there in the studio with you, that come from some
> place else, from some transmitted view of art not alive in the studio
> with you) give them a whack or two, re-establish the plain-ness of
> your relations with them.[6]

What Leider could easily have said is that Pollock is a modern
Pygmalion, and that his picture is his Galatea. This would square with
Pollock's longstanding desire to be a sculptor. In Pollock's hands, the
picture stops inhabiting a tantalizing, arty 'elsewhere'; it is 'alive in the
studio' with him. The art of painting is stripped bare. But this does not
mean a return to 'caressability'. Pollock is not like Degas respectfully
stroking the surface of one of Ingres' odalisques. His relationship with his
artwork is highly charged. It is more in keeping with those de-idealized
late nineteenth-century versions of the Pygmalion myth, where Galatea's
awakening causes conflict. Pollock puts his hands all over his picture; he
stubs his cigarettes out on it; he gives it a whack. We might add that he
walks all over it, too.

The sexual aggression inherent in Pollock's art was recognized almost
immediately. An early magazine article was headlined Jack the Dripper,
and the playwright Tennessee Williams said that Pollock 'could paint
ecstasy as it could not be written'.[7] While making a picture, Pollock
appeared to address the canvas with some of the sexual aggression that
had been previously imputed to sculptors. A running joke in the history
of art shows the clumsy sculptor in his studio about to strike a statue of
a woman with his chisel – and the statue, an unwilling Galatea, seems to
swoon or flinch.[8] Other modern painters have shown Pygmalion
tendencies, and they too have moved in the direction of real objects in
real space.

During the Renaissance the Pygmalion myth had been, for the most
part, a subject that had been explored *within* painting. One of the

principal purposes of pictures exploring the Pygmalion myth was to show that the artist who had colour at his disposal had the ability to infuse forms with life. Thus the animation of the statue signified the triumph of paint over marble. In the modern period, however, the Pygmalion myth has been recast. In order to make the artwork 'alive in the studio' with the artist, it has to leave its frame and be materialized in some way. It is not so much the triumph of colour, as the triumph of concretization. Thus, for example, we find the French painter Jean-Léon Gérôme, two years after painting his picture *Pygmalion and the Statue* (1890), making a polychromed marble group of the same subject.

The Impressionist painter Auguste Renoir epitomizes the spirit of the age. He claimed that he painted with his penis, thus suggesting that he dreamed of penetrating the canvas and treating it with 'plain familiarity'. In 1907, rather in keeping with this, Renoir took up sculpture. It may have seemed like a better bet, a half-way house on the road to palpation. The Italian painter Amadeo Modigliani (1884–1920) met Renoir in 1919 and the 78-year-old French artist, paralysed by rheumatism, told him to paint a woman's buttocks as he would fondle them with his hand. Modigliani was appalled and stormed out. But from 1909 to 1914 the Italian artist had devoted himself to stone-carving, and probably only gave it up because of poor health and lack of money. The sculptor Jacob Epstein implied that Modigliani's interest in sculpture was due to its being more lovable than painting: 'At night, he would place candles on top of each [sculpture] and the effect was that of a primitive temple. A legend of the quarter said Modi when under the influence of hashish embraced these sculptures.'[9]

The credo of the Pygmalion painter is laid out in Zola's *L'Oeuvre* (1886). Claude Lantier paints with enormous horse-hair brushes, but 'the most important thing was the palette-knife'.[10] It was 'solid painting, chunks of nature flung raw on the canvas, pulsating with life', and it looked as though it had been put on 'with a ladle'.[11] He regularly slashes his canvases with a knife. For years he slaves over his 'masterpiece' with its glorious centrepiece of a female nude. Frustrated, he smashes his fist through the canvas, just where her bosom is. He realizes that his gesture 'amounted to murder', and wonders how he 'could possibly have slain what he loved best in the world'. Regretting what he has done, 'he began to feel the canvas with his fingers, drawing together the torn edges as if he were trying to close a wound'. He repairs the damage, and his beloved is healed, 'with just a faint scar over the heart – enough,

however, to revive the artist's passion for her'.[12] Here the painting has taken on an awful palpability, and the 'scarring' only adds to its charms. This scene parallels the one in which the sculptor Mahoudeau is raped by his own collapsing sculpture. In terms of the painter's and sculptor's engagement with their materials, there is an increasing equivalence.

The erotic implications of the slashed canvas have been explored by numerous post-war artists. In the 1950s and 1960s the Italian artist Lucio Fontana (1899–1968) made the violation of the canvas the subject of the picture. He slashed canvases with a knife, and the sexual connotations of these vertical slits with gently curving edges have never been lost on his viewers. This was the painting turned into a chic sex-toy. Fontana said that he wanted to 'escape symbolically, but also materially, from the prison of the flat surface . . . They were objects, no longer pictures.'[13] Fontana trained as a sculptor, and made sculptural objects throughout his career, so he would have been no stranger to the dynamics of the Pygmalion myth.

The 'text-book' example of a Pygmalion painter is the British-born, New York–based artist Malcolm Morley (born 1931). During the 1960s Morley had been making what he termed 'perfect' paintings – super-real, blown-up transcriptions of postcard images. Most of these images were of ocean liners, but he also transcribed Vermeer's *Painter in his Studio*, a classic image of the gentleman artist painting a beautiful woman. In 1970 Morley rejected this way of working, on the grounds that it was pornographic: 'All two-dimensional surfaces are pornographic. You are controlled because you can't penetrate them.'[14] Paintings are, Morley suggests, no less symptomatic of modern man's alienation than the images in pornographic magazines and films. It is much healthier to get the 'real' thing – or at least a three-dimensional approximation of the 'real' thing.

Morley then tried to realize 'imperfect' works, with complex textures and collage elements. Sometimes these were painted in public, as live happenings. *New York City Postcard Fold-Out* (1972–3) was installed as a freestanding folding screen 30 feet long and roughly painted on both sides. The angled planes 'warp and curve like paper'.[15] We can see it as a muddy materialization of photography, painting and drawing. The apogee of this 'imperfect', palette-knife phase was *Disaster* (1975). Morley thrust a knife into the middle of a textured version of one of his Photo-Realist paintings, *SS Amsterdam in Front of Rotterdam* (1966). Ships are, of course, surrogate females. According to a recent critic,

Morley felt deprived of 'the full erotics of sight – real, not mediated, three-dimensional seeing and a more openly and richly physical two-dimensional painterly seeing'.[16]

IT IS IN the 'ready-made' that we see the most radical innovations of the Pygmalion painters. Instead of being satisfied with a representation of a desired object, whether it be painted or photographed, one wants the real thing – or, at least, a bit of the real thing. Of course one might object that Duchamp did not intend anyone to make love to his urinal, nor did Picasso intend anyone to kiss a *tableau-objet*. But this is not really fair. For in modern culture we find that erotic attachments can be formed with all kinds of unlikely things. Potential Galateas are everywhere – and the more ordinary and available they are, the better.

Duchamp called his ready-mades snapshots (*instantanés*).[17] By doing so, he wanted to suggest that they were produced independently of the artist. Nonetheless, he did in fact prefer ready-mades to photographs, because the sensibility of the photographer was always in evidence in a photograph.[18]

Yet although he wanted to banish emotional involvement from his art, almost all his work invites erotic attachment.[19] Accordingly, throughout his career Duchamp had a deep engagement with the Pygmalion myth. *Nude Descending a Staircase* (1912) is effectively a re-staging of Galatea's descent from the pedestal. Now, however, she is a Cubist-style Frankenstein's monster – an heir to all those troublesome Galateas of the late nineteenth and early twentieth centuries. It would take a military operation to hold her in check.

Duchamp's renunciation of painting in 1912 – and his development of the 'ready-made' – can be seen as the outcome of his concern with the Pygmalion myth. The 'ready-mades' are an attempt by a Pygmalion painter to make the object of our interest even more immediate and palpable. This comes across most clearly with *Fountain*, the up-ended porcelain urinal signed R. Mutt, which scandalized New Yorkers in 1917. Not only is the urinal a 'flesh and blood' urinal, rather than a representation; glacially smooth and seductively biomorphic, *Fountain* is also eminently statue-like. It has been compared to Renaissance madonnas, seated buddhas, and to Brancusi's polished erotic sculpture.[20]

When Duchamp defended 'Mr Mutt's fountain' in his magazine *The Blind Man*, the principal objections to it were that it was 'immoral, vulgar' and 'plagiarism, a plain piece of plumbing'.[21] It would have been

thought immoral because it is an object into which the male member is regularly inserted. Not, by and large, for sexual gratification, but the designer did go beyond the bounds of functionalism to make it a very sensuous object indeed. Duchamp's inversion made it doubly so. In a written note from 1914, he implied that the urinal was a new kind of woman: 'One only has for *female* the public urinal and one *lives* by it.'[22] Thus the urinal is a new, improved, three-dimensional version of the nude descending the staircase.

There is an element of resignation here, that one can 'only' have this substitute, this 'plain piece of plumbing'. Yet Duchamp is very matter-of-fact about it. He seems to be saying: one learns to live by urinals – to think of them as women – even more easily than people learned to live by art. Duchamp once said that he wanted 'to grasp things with the mind the way the penis is grasped by the vagina'.[23] Here he was imagining himself as a woman, as Galatea, as the urinal, penetrated by and enclosing 'things'. Cognition is posited as being akin to sexual intercourse. Art, therefore, has to approximate that encounter as much as possible. It has to become a real object that grasps and is in turn grasped; that envelops and is in turn enveloped. This was Duchamp's own response to the avant-garde art of caves and creases.

The modern artist's intense level of involvement with objects is something that emerges in the nineteenth century. The Arts and Crafts Movement had insisted that every object in our environment – whether it be a lamp-post or a bit of cutlery – should be beautiful, and pleasurable both to make and to use. But this veneration of material culture led some to assume that a relationship with objects might be more satisfying than a relationship with anything else.

An early, and rather wonderful, instance of this occurs in Søren Kierkegaard's philosophical treatise on love, *Either/Or* (1843). Kierkegaard published the book anonymously, using the pseudonym Victor the Hermit. It opens with an extraordinary explanation from Victor of how he chanced upon the manuscript that would become *Either/Or*.[24] The discovery comes about all because of a love-affair with a desk. Victor had seen it in the window of a shop that he passed every day:

With time . . . the desire awakened in me to own it. To be sure, I felt that it was a strange desire, since I had no use for this piece of furniture, and it would be a prodigality for me to purchase it. But

desire, as is known, is very sophistical . . . The writing desk was set up in my apartment, and just as in the first phase of my infatuation I had my pleasure in gazing at it from the street, so now I walked by it here at home. Gradually I learned to know its numerous features, its many drawers and compartments, and in every respect I was happy with my desk.

It's a forerunner of *Venus de Milo with Drawers*. But then something happens that changes Victor's relationship with his desk.

In the summer of 1836, my duties allowed me to make a little journey to the country for a week . . . I opened the desk to pull out the money drawer . . . But the drawer would not budge . . . The blood rushed to my head; I was furious. Just as Xerxes had the sea whipped, so I decided to take dreadful revenge. A hatchet was fetched. I gave the desk a terrible blow with it . . . a secret door that I had never noticed before sprung open . . . Here, to my great amazement, I found a mass of papers, the papers that constitute the contents of the present publication . . . Joy was victorious and had gained an unexpected augmentation. In my heart, I begged the desk's forgiveness for the rough treatment . . .

If Victor the Hermit offers one of the earliest examples of object love, then the brothers Edmond and Jules de Goncourt are perhaps the most influential of the early *objetophiles*.[25] Like their English contemporary John Ruskin, they railed against contemporary culture, but instead of looking to the Middle Ages, their ideal model was pre-revolutionary France – the age of Madame de Pompadour. The Goncourts loved the fact that rococo painters and sculptors were also artisans, doing interior decoration and making decorative art objects. The 'organicism' of the art-world was reflected in the organicism of the art: 'all harsh and rebellious matter was subordinated to the supple caress of the artisan'.[26] The brothers were confirmed bachelors and they lived together in a house on the outskirts of Paris. They filled the house with rococo *objets d'art* and drawings, trying to create what they called '*harmonie artiste*'. They had a huge influence on the development of aestheticism and Art Nouveau.

But the pleasure they took in their objects went way beyond what would have been acceptable to Ruskin and Morris. It went much further

than the chaste Christian caress. Jules de Goncourt dreamed of raping a delicate young woman who resembled one of his porcelain figures; and Edmond, in his autobiographical book *Maison d'un Artiste* (1881), describes sleeping in the bed slept in by the Princesse de Lamballe, drinking from porcelain cups moulded from the breasts of Marie Antoinette, and returning from a rococo shopping expedition exhausted 'as if from a night of sexual debauchery'.[27]

Edmond, however, was under no illusions as to why he needed to indulge in this fantasy life. It was because modern man was incapable of relating to modern woman. Society was more fragmented and less worldly than during the eighteenth century, and this had led to a 'contraction of the role of woman' in male thinking: 'For our generation, art collecting is only the index of how women no longer possess the male imagination. I must admit here that when by chance my heart has been given, I have had no interest in the objet d'art . . . This passion . . . gives immediate gratification from all the objects that tempt, charm, seduce: they have made me in particular the most passionate of collectors.'[28] The Goncourts assumed, then, that this craving for objects was an indication of failure and sterility. As Duchamp might have put it, the bachelor brothers 'only have for *female* the *objet d'art* and they *live* by it'. But it did not seem to bother them unduly. Rather they revelled in it, for it broke social and cultural taboos.

Their repudiation of women would have been influenced by the nineteenth-century conviction that marriage, particularly if it involved love, was inimical to the production of great art. In *Genius and Madness* (1863), Cesare Lombroso said that 'many great men have remained bachelors; others, although married, have had no children'. He also noted that some great women, such as Florence Nightingale and Catherine Stanley, had been celibate.[29]

A passionate engagement with the artwork can even be seen as a further manifestation of the 'collaborative' impulse felt by modern artists. The 'alienated' modern artist co-habits with his art. Claude Lantier's wife is horrified when she realizes that her husband loves only his work, 'that strange, nondescript monster on the canvas'.[30] Professor Rubek, the sculptor in Ibsen's *When We Dead Wake* (1899), is convinced that if he touches his model, or even desires her sensually, his artistic vision will be lost. Rodin assumed that ejaculation entailed the loss of creative energy (though, judging by his sexual rapacity, the only time when he can have given serious thought to the issue would have

been immediately after ejaculation, while in the depths of post-coital depression).

And once an erotic attachment is felt towards an artwork, it makes sense for that artwork to be a palpable object. The Goncourts' love-affair with artworks led them to wonder whether a painting might not be inferior 'to an exceptional candelabra'.[31] After all, what was a man to do with a flat patch of coloured canvas in the days before Fontana and Morley?

These new cults based around objects underpin the rise of object-based art in the twentieth century. The Goncourts' love of objects also runs parallel with the emergence of still-life as a major genre in late nineteenth-century art. Still-life subject-matter grounds art in the tangible and the actual – and the lovable. In Cézanne's great *Still-Life with Plaster Cupid* (c. 1894), for example, we see a piece of baroque sculpture of Cupid surrounded by onions. Love is placed at the heart of the picture. The sculpted cupid and the onions are the counterpart to the Goncourts' 'exceptional candelabra'. These objects can be engaged with wholeheartedly. Cupid makes you love, and the onions make you cry.

The art historian Meyer Schapiro has argued that Cézanne – who was, incidentally, terrified of being touched – had an almost erotic attachment to apples: 'Cézanne's apples . . . are often the objects of a caressing vision, especially in the later works. He loves their finely asymmetrical roundness and the delicacy of their rich local colour which he sometimes evokes through an exquisite rendering rarely found in his painting of nude flesh.'[32] So everyone, it seems, was conducting illicit love-affairs with inanimate objects.

A more sober celebration of still-life objects is offered by Rainer Maria Rilke in his essay on Rodin. The Austrian poet stresses the fundamental importance of *things*: 'it is not people about whom I have to speak, but things'.[33] Things are objects like small pieces of wood with which the child plays, utensils and vessels. They are objects that inspire complete confidence and affection. The first things that were made by man were modelled on 'natural things already existing', and Rilke imagines that it must have been 'a strange experience to see the made object as a recognized existence, with the same rights and the same reality as the things already there'.[34] They were, in a fundamental sense, ready-made.

A 'thing' was not beautiful, however, for 'who would have known what beauty was?' Rather, it was like Socrates' Eros, 'something between a god and a man, not in itself beautiful, but expressing pure love

310

of and pure longing for beauty'. Rilke believed that modern art was returning to a thing-like state: 'Dissociated from all big-sounding, pretentious and capricious phraseology, art suddenly appears to take its place in the sober and inconsiderable life of every day, among the crafts.'[35] In other words, art becomes something to which you can relate as intimately as a bowl, a spoon or a bed. It becomes an ever-present love-object.

The need to express a love of things is a trademark of twentieth-century artists, and it has encouraged them to migrate into object-based art. Picasso was a compulsive collector of objects – 'the king of the ragpickers', according to Jean Cocteau[36] – and he always emphasized the love he felt for the objects in his paintings. 'His *sujets* are his loves,' his dealer Daniel-Henri Kahnweiler remarked: 'He's never painted an object with which he didn't have an affectionate relationship.'[37] While opening a bottle of anise, Picasso is supposed to have said: 'One has to be careful not to break the banderole! . . . You have to take objects seriously. And lovingly; this one, very lovingly.'[38] He once asserted that his sculptures were 'vials filled with his own blood', and this offers further evidence of the seriousness and intimacy of his relationship with objects. Picasso's sculptures were engorged with his blood – first, perhaps, because they were akin to lovers; second, because they were akin to children. They were a sort of surrogate family. In accordance with these blood-ties, he surrounded himself with his sculptures and rarely sold them or let them out of his sight. He had few qualms about relinquishing his paintings – or, for that matter, his wives, lovers and children.[39]

Picasso's *Glass of Absinthe* (1914) is the first sculpture to contain a complete found object. The vessel climbs just over eight and a half inches in a lurching spiral. It has been cut open to reveal the hollow interior. At several points – both on the inside and outside – it has sprouted sudden, toadstool-like flanges suggestive of tongues and lips. This freestanding statuette has frequently been read as the figure of a drunken man or woman wearing a hat. By retaining the 'flabbiness'[40] of the wax from which it was originally modelled, it has become all orifice – all drinker and all debauchee. Kahnweiler arranged for six bronze casts to be made. Each was decorated in a different way by Picasso, and was furnished with a found object – a silver-plated, perforated absinthe spoon – and a painted bronze sugar-lump. One cast was covered in sand, while the other five were painted.

41. **Pablo Picasso**, *Glass of Absinthe*, 1914
(Painted bronze, Museum of Modern Art, New York).

Glass of Absinthe is one of Picasso's most *lovable* sculptures. The silver-plated spoon, and the anthropomorphic glass, are low–budget equivalents of the *objets d'art* with which the Goncourts had such passionate engagements (it is in a style that has been called rococo Cubism). It is a mini-monument to innumerable nights of debauchery. By virtue of its size and appearance, and by virtue of appearing in six different guises, *Glass of Absinthe* makes itself very accessible and revealing. When the critic André Salmon saw the first collages and constructions, he thought that art, for the first time, was approaching life: 'Art will at last be fused with life, now that we have at last ceased to make life fuse with art.'[41] In the *Glass of Absinthe*, that fusion is undeniably fulsome and erotic.

The modern love of objects has some of the characteristics of sexual fetishism. This too was first analysed during the object-crazed *fin de siècle*. The term was proposed by the psychiatrist Alfred Binet in his article *Le Fétichisme Dans L'Amour* (1887): 'The term fetishism suits quite well, we think, this type of sexual perversion. The adoration, in these illnesses, for inanimate objects such as night caps or high heels corresponds in every respect to the adoration of the savage or negro for fish bones or shiny pebbles, with the fundamental difference, that in the first case religious adoration is replaced by sexual appetite'.[42] The presence of the fetish was necessary for an erotic encounter with another person to take place, and often the fetish alone could stimulate an erotic experience. For the ever-ingenious Freud, the sexual fetish was a substitute for the imagined missing penis of the mother.

The Surrealists were especially enamoured of fetishism, largely because of their interest in ethnology and psychoanalysis.[43] Nonetheless, André Breton was ambivalent about fetishism because he was committed to the idea of 'the reciprocity of heterosexual love'.[44] It is obviously quite difficult to ascertain the sex of a fetish, and whether the fetish loves the fetishist in return. But what Breton did admire in the fetishist is the fact that he is convinced, and ruled, by his imagination.[45] Because of this, fetishism became a catalyst for the development of the Surrealist Object in the 1930s. The possibility of creating Surrealist Objects was first mooted by Breton in his essay, *Introduction to the Discourse on the Paucity of Reality* (1924). He argues that verbal testimony alone is less convincing than a story that can be backed up and verified by objects:

Human fetishism, which must try on the white helmet, or caress the
fur bonnet, listens with an entirely different ear to the recital of our

expeditions. It must believe thoroughly that it *really has happened*. To satisfy this desire for perpetual verification, I recently proposed to fabricate, in so far as possible, certain objects which are approached only in dreams and seem no more useful than enjoyable.[46]

Breton then describes a dream in which he came across 'a rather curious book' in the open-air market in Saint Malo. The spine of the book was formed by a wooden gnome whose white beard, 'clipped in the Assyrian manner', reached to his feet. The statuette did not prevent him turning the pages of the book, however, which were made of heavy black cloth. He was keen to buy it and, upon waking, was sorry not to find it. As a result of this dream Breton decided to put into circulation 'certain objects of this kind, which appear eminently problematical and intriguing. I would accompany each of my books with a copy, in order to make a present to certain persons.'[47]

Breton seems to have deliberately devised a completely non-sexual fetish: what could be less sexy than a bearded gnome? But there was no stopping the rest of the Surrealists. Their shopping expeditions in search of objects are worthy successors to the shopping expeditions of the Goncourts. There is rarely anything gnome-like about the Surrealist Object. Dalí (1904–89) believed there was a 'strong *desire*' for the tangible object. What was more, the 'incarnation of these desires, their manner of objectivising themselves by substitution and metaphor, [and] their symbolic realization, constitute the typical process of sexual per-version'.[48] The objects would be 'extraplastic – made without aesthetic considerations. Dalí stressed that everyone – men and women – could produce their own objects, because everyone's erotic imagination was unique.[49] Fittingly, the most famous of the Surrealist Objects – Meret Oppenheim's *Fur Tea-Cup* (1936) – was made by a woman. The homes of the Surrealists became 'cluttered' with such objects. Whereas before they had been limited to discussing their 'phobias, manias, feelings and desires', now they could 'touch them, manipulate and operate them with their own hands'.[50]

But not only were words rendered obsolete by the Surrealist Object, so too, according to Dalí, was painting: 'With the surrealist object I thus killed elementary surrealist painting, and modern painting in general. Miró had said, "I want to assassinate painting!" And he assassinated it – skilfully and slyly abetted by me, who was the one to give it its death-blow, fastening my matador sword between its shoulder-blades.'[51] Here

we have another vision of a slashed canvas.

Dalí's first Surrealist Object featured the dissolution of a drawing into a glass of milk:

> Inside a woman's shoe is placed a glass of warm milk in the centre of a soft paste coloured to look like excrement. A lump of sugar on which there is a drawing of the shoe has to be dipped in the milk, so that the dissolving of the sugar, and consequently of the image of the shoe, may be watched. Several extras (pubic hairs glued to a lump of sugar, an erotic little photograph, etc.) make up the article, which has to be accompanied by a box of spare sugar and a special spoon used for stirring leaden pellets inside the shoe.[52]

The mechanics of Dalí's still-life assemblage pretty much accord with the Goncourtian line taken by the dissident Surrealist Georges Bataille. In 1930 Bataille had written, 'I defy any lover of modern art to adore a painting as a fetishist adores a shoe.'[53]

The presence here of 'an erotic little photograph' suggests that photography (a two-dimensional artform) is compatible with the Surrealist Object – albeit in a diminutive and perhaps malleable way. Photography certainly was a complementary fetishizable art, if we judge by the Surrealist journals in which photography played a vital and distinctive part.[54] Whereas in the early Surrealist Objects, and in Duchamp's ready-mades, the human body was conspicuous by its relative absence, and had to be inferred, Surrealist photography centred on the naked female body. That said, very few photographs were included in exhibitions of Surrealist Objects, or indeed of Surrealist painting. In exhibitions of the former, the emphasis was on interaction, and on assailing the viewer's senses.

In twentieth-century art, the desire to create objects that can be touched has been mirrored by a desire to make objects that can be consumed. Dalí addressed this issue in an article entitled *On the Terrifying and Edible Beauty of Modern Style Architecture* (1933). This was illustrated by photographs of the Art Nouveau metalwork on the Paris Métro, and by details of the sculpture on Gaudí's *Casa Mila* in Barcelona. The knobbly metalwork from the Métro resembled praying mantises, which Dalí liked because of their 'sexual cannibalism': the female ate the male after mating. These were captioned 'Eat me!' and 'Me too!'

Many of Dalí's own Surrealist Objects incorporated real foodstuffs.

There is the milk and sugar in his first Surrealist object; and many other works featured loaves of bread. The *Retrospective Bust of a Woman* (1933) consisted of a porcelain bust of a woman with two maize cobs draped over the shoulders, while on the head he balanced a loaf of French bread. When it was first exhibited, Picasso's dog ate the bread.[55] Dalí was well aware of the sacramental function of bread,[56] so this is a resourceful and mischievous attempt to bring about a 'communion' of our bodies with things.

It is also a literalization of one of the founding myths of art, whereby the birds had been so convinced by Zeuxis' painting of grapes that they had pecked at it. Now, however, illusionism simply is not enough. In the early 1930s Dalí found that society women in Paris had made his terminology their own. In *The Secret Life of Salvador Dalí* he gives a flavour of a typical conversation in chic circles: 'Things were or were not "edible". Braque's recent paintings, for instance, were "merely sublime".'[57] They would have been referring to still-life paintings by Braque, but perhaps in the heyday of the edible Surrealist Object they were not quite edible enough.

Since Dalí's time there has been a great deal of 'edible' art, made from materials such as chocolate, fat, meat and bread. In 1962 the Italian Neo-Dadaist Piero Manzoni made a brave effort to increase the edibility of painting, however, by attaching bread rolls to wooden boards.[58] More recently, the American artist Janine Antoni has made 'edible' art for the purposes of social critique. In the performance piece *Gnaw* (1992), she chewed away at a 600-pound block of chocolate, and another made from lard, spitting out the pieces, until she reached the limits of physical endurance. *Lick and Lather* (1993) consisted of two series of seven identical self-portrait busts made from chocolate and soap, and displayed on pedestals in a classical style. These she proceeded to lick and to lather, thus eroding her own image. This act of cannibalism was a wry meditation on our all-consuming consumer society.

THE MOST ELABORATE artwork produced by a Pygmalion painter is undoubtedly Marcel Duchamp's final work, the hyper-real tableau *Etant Donnés* (1946–66). It is the summation of his career, and of his preoccupation with the Pygmalion myth. Its centrepiece – a naked woman lying on a bed of real twigs and leaves, with legs akimbo – is Duchamp's Galatea. She is a composite of his wife and a former lover. The torso is believed to be modelled on that of Duchamp's lover, Maria

Martins, but the left arm and hand, which holds a gas lamp, belong to his wife Teeny and are derived from a plaster cast.[59] Duchamp covered the body in stretched pigskin, because this was the closest he could get to the appearance of human skin. The landscape background is a photographic blow-up of a Swiss ravine. It has been hand-coloured and has had some collage elements attached. The most important of these is a small waterfall which, due to a motorized light projection, appears to be flowing. We see water descending all the way down to the naked woman, who seems to have been washed up on a river bank.

Etant Donnés represents a thwarted Pygmalionism. The love-object cannot be touched or inspected. It can only be peered at through two peep-holes cut into an old wooden door. But what is characteristically modern is that Duchamp makes us self-conscious about our exclusion. It is made absolutely clear that we are voyeurs. We know, *à la* Malcolm Morley, that we cannot penetrate beyond the surface and that we have been deprived of the full erotics of sight. The landscape, and the effigy incorporating elements of the women to whom Duchamp got closest, cannot be grasped.

Duchamp was unwilling for the interior of the installation to be photographed, no doubt because he wanted the voyeuristic nature of viewing brought home to everyone. We have to see it in the flesh. We have to press our faces and bodies up against a weather-beaten door that is permanently installed inside the Museum of Fine Arts in Philadelphia, the city of fraternal love. Physical contact only occurs with the artwork so that we can be reminded of our inability to make a more complete contact. There is to be only a partial communion, and certainly no coition.

Duchamp's incorporation of casts from life in *Etant Donnés* is another manifestation of the modern striving to create a loveable artwork. In order to make a cast from life, a human being or object has to come into very direct contact with the medium from which the artwork is going to be made. The evidence of that contact is a crucial part of the meaning of the work. The viewer can easily imagine the same procedures being done to themselves.

In the 1950s Duchamp made several other sculptures featuring casts from life, or casts that he intended to look as though they were taken from life. *Female Fig-Leaf* (1951) resembles a wax impression of a woman's vulva, and is usually assumed to be a direct cast. It is in fact a hand-made sculpture in galvanized plastic.[60] But Duchamp is teasing the

viewer with the idea that he might have actually cast it from life. As a wedding present, Duchamp gave Teeny *Wedge of Chastity* (1954), a wedge of galvanized plaster snugly inserted into the cleft in a chunk of pink dental plaster – like a tooth in its gum.

These casts from life get too close for comfort. They do not just speak of what Merleau-Ponty termed a 'communion' or 'coition' of a body with matter; they also speak of the suffocation and blocking of that body, either temporarily or permanently. But this ambiguous status is one of the reasons why casting from life has become so prevalent. The cast from life is one of the most extreme manifestations of the artwork-as-obstacle. Duchamp's *Female Fig-Leaf* and *Wedge of Chastity* are barriers of the most tactile and intimate sort. They suggest contact that is both erotic and deadly.

Modern castings from life have their own mythology, which derives from Pompeii and Herculaneum. The discovery of these cities in the mid-eighteenth century completely overturned ideas about the ancient world – or would have done, had the remains been properly publicized, and had Winckelmann's more refined version of the classical world not been so dominant. For far from revealing a society wedded to 'noble simplicity and calm grandeur', it revealed one that overtly enjoyed erotic frescoes and decoration, and dirty jokes. When Mark Twain wrote about Pompeii in *The Innocents Abroad* (1875), there was still one house to which women were forbidden entry. It contained frescoes that 'no pen could have the hardihood to describe', and inscriptions that were 'obscene scintillations of wit'.[61]

A poetic counterpart to the eroticism of the art was the nakedness of the inhabitants. They had in effect been stripped bare by the molten lava and preserved in a state of perfect nudity. One of the most popular exhibits was the impression of a young woman's breasts, which had been found beneath a portico of the House of Diomedes, and which was kept in the museum at Portici. In 1804 Chateaubriand wrote, no doubt with a languid sigh, that 'Death, like a sculptor, has moulded his victim.'[62] The implication is that if the woman is so beautiful, then the sculptor must have made love and death to her at the same time. This is a caress that also asphyxiates.

Not everyone, though, was equally enamoured of breasts cast from life. In 1805, Richard Payne Knight went to great lengths to prove that when we fall in love, we are not seduced by material forms alone:

I am aware, indeed, that it would be no easy task to persuade a lover that the forms, upon which he dotes with such rapture, are not really beautiful, independent of the medium of affection, passion, and appetite, through which he views them. But before he pronounces either the infidel or the sceptic guilty of blasphemy against nature, let him take a mould from the lovely features or lovely bosom of this masterpiece of creation, and cast a plum-pudding in it (an object by no means disgusting to most men's appetites) and, I think, he will no longer be in raptures with the form, whatever he may be with the substance.

Payne Knight's comments echo Erasmus's criticism of 'relics of touch', which I discussed in Part One. Whereas for Erasmus, physical contact has no intrinsic meaning unless there is faith in the spiritual reality that surrounds a sacred object, for Payne Knight, physical form is not intrinsically desirable, but is only made so by the whole network of affections that adhere to it. To make his point, he proposes a parody of a communion ceremony, whereby a 'masterpiece of creation' is cooked and consumed. Yet he writes with such lip-smacking relish (not so surprising in a man who had written *An Account of the Remains of the Worship of Priapus* [1786]) that one suspects he also quite enjoyed the increasingly prevalent association of casting from life with a predatory sexual act. He would surely have joined the Goncourt brothers in drinking from the porcelain cups moulded from the breasts of Marie Antoinette.

A fine example of a modern 'Pompeian' sculpture was exhibited by Auguste Clésinger at the Salon of 1847. *Woman Bitten by a Snake* caused a *succès de scandale*. Not only did it feature the sculptor's voluptuous former mistress writhing naked on the ground, which was scandalous enough, but it was made from an assemblage of partial moulds. To make matters worse, it had been commissioned from Clésinger by her new lover. The sculptor appears to be recording a moment of intense pleasure and pain: he was moulding a beautiful victim.[63]

A painting by Edouard Dantan, *Casting from Life* (1887), shows the erotic potential of such casting.[64] A young sculptor in a smock is working beside an old *formatore*, or plaster-cast maker. The *formatore* is bearded, and wears a beret and apron. Together, they are removing a two-part mould from the back and front of a young woman's leg. Slightly coquettish, she stands on a table, completely – and, it would seem, unnecessarily – naked. Plaster casts of famous Renaissance and antique

319

42. **Edouard Dantan**, *Casting from Life*, 1887
(Oil on canvas, Kontsmuseum, Goteborgs).

sculptures, as well as the sculptor's materials and tools, are scattered
around the studio. Strategically placed above a female bust from the
Renaissance is a life-cast of a fine young bosom. Dantan is obviously
having a bit of fun at the expense of the sculptor and the craftsman –
implying that when we have all gone, they will get down to casting the
most interesting bits. But the presence of another cast – of

320

Michelangelo's *Dying Slave* – suggests something a little more piquant. Just as Michelangelo's figures appear to struggle to free themselves from the marble block, so the model is effectively imprisoned by the life-casting process, unable – or unwilling – to break free. The message of this painting is part envious, part mocking: that sculptors have access to the parts that are beyond the reach of other artists. Dantan, after all, paints the model from a voyeuristic distance.

Freud was well aware of the mythology of casting from life, and he teased out some of its psychological implications. He believed that there was 'no better analogy for repression, by which something in the mind is at once made inaccessible and preserved, than burial of the sort to which Pompeii fell victim and from which it could emerge once more through the work of spades'.[65] Although he does not mention Pompeii in his *Essay on the Uncanny* (1919), his analysis of people's fear of being buried alive is eminently Pompeian: 'To some people the idea of being buried alive by mistake is the most uncanny thing of all, and yet psycho-analysis has taught us that this terrifying fantasy is only a transformation of another fantasy which had originally nothing terrifying about it at all, but was qualified by a certain lasciviousness – the fantasy, I mean, of intra-uterine existence.'[66]

The body-casts at Pompeii had traditionally inspired just such a mixture of fear and desire: the uncanny sense that the solidified lava was both a womb and a tomb. Shortly before this discussion of live burial, Freud noted that the *Gettatore* was an important and 'uncanny' figure of Romantic superstition. A *gettatore* is someone who casts spells – or, equally, someone who casts sculptures. Casting from life expresses the desire for direct apprehension. But in the examples I have offered it involves apprehension *in extremis*.

In 1959 Teeny Duchamp made a plaster cast of the right side of her husband's face – the cheek, chin and lips. The cheek was bloated because Duchamp placed a walnut in his mouth. The cast was attached to a piece of paper on which the rest of his profile had been wispily drawn. The resulting collage, mounted on wood, was called *With My Tongue in My Cheek* (1959). We sense two kinds of pressure operating in this image, and they move in opposite directions. There is the pressure of Duchamp's 'tongue' puffing out his cheek; and then there is the pressure of the plaster cast weighing down and smothering his pencil-drawn profile. It is rather alarming. The cast seems to squat over and engulf the drawn image like a parasitic leech.

with my tongue in my cheek marcel Duchamp 59

43. **Marcel Duchamp**, *With my Tongue in my Cheek*, 1959
(Mixed media, Collection Robert Lebel, Paris).

This is a self-portrait of the Pygmalion painter that shows two stages in his 'becoming-concrete'. The plaster image of the artist swells up from the frail-looking drawing. It is a visualization of Duchamp's credo about wanting to 'grasp things with the mind the way the penis is grasped by the vagina'. Here, however, it is a cheek that has 'grasped' a tongue, silencing it.

'GRASPING' HAS been central to a great deal of environmental and installation art of the post-war era. This is particularly the case when the art alludes to still-life objects and domestic interiors.

In 1962 the American artist Claes Oldenburg (born 1929), who had initially trained as a painter, urged, 'Love objects. Respect objects. Objectify high state of feeling.'[67] He regarded the painted muslin and plaster sculptures that filled his shop environment *The Store* (1961) as the incarnation of repressed desires. Most of them represented items of clothing and food. As in a normal store, they could be examined and bought on the spot: 'The store is born in contorted drawings of the female figure and in female underwear and legs, dreams of the proletarian Venus, stifled yearnings which transmute into objects, brilliant colours and grossly sensuous surfaces.'[68] These incarnations of the 'proletarian Venus', many of which were props from performances, expressed a desire for tangible, interactive experiences. He regarded the 'grotto form' as his particular forte.

The Austrian artist Franz West (born 1947) makes rough-and-ready objects from materials such as painted papier mâché, plaster, wood and metal. Although the spectator is supposed to handle these objects, and sometimes even move them, they are more rudimentary than Oldenburg's. In 1989 West made a series of convex and concave forms entitled *Passtück*, which the viewer was supposed to pick up and place against his or her body. West called them 'wearable neuroses'.[69] He explained that he wanted the artwork 'to be real, not like a dream or a movie, but to be able to step into it, to sit on it, lie on it'. If he were to make a ready-made, he continued, he would 'make the pissoir, but one you could really piss into'.

West saw this intimate engagement in psychoanalytic terms, as reparation: 'The missing object is the breast of your mother, like Lacan said . . . It's always the same problem, of concave and convex.' In *Eo Ipso* (1987), a washing machine was cut up (with the help of some young Viennese aristocrats) and re-welded into a series of three chairs. They

were biomorphic, and ectoplasmic in appearance: 'It was the washing machine of my mother, who had died.'

The British artist Tracy Emin (born 1963) has gone even further in the direction of the lovable artwork. This endeavour went hand in hand with a violent repudiation of painting, and of life itself. While studying painting in London, Emin decided to re-invent herself. She had just had her second abortion. She took all her paintings into the courtyard of the art-school and smashed them up with a hammer. It took a whole day and by the time she had finished her hands were bleeding.[70] 'I downed brushes,' she said. 'I downed the whole notion of these ideas of creativity. After termination, I couldn't tolerate the idea of painting any more.'[71]

Emin then did a typical 'worker-artist' thing. In 1993 she opened a ramshackle shop, in collaboration with another artist, Sarah Lucas.[72] *The Shop* was located in the East End of London, and was open from January to July. The two artists made items in the shop, which were then sold. These included ashtrays with the face of the artist Damien Hirst printed inside them, and T-shirts with the words 'Complete Arsehole' daubed on them. But perhaps the most salient items were the cut-up blankets sewn together and dubbed *Rothko Comfort Blanket*. These were classic manifestations of the modern ideal – paintings you could go to bed with, made by a childless artist.[73]

14. Beyond Photography

Sculptural form is ALL THE WAY ROUND, it is not simply a profile on a pivot . . . The great sculptor knows it ALL THE WAY THROUGH. He knows the behind side, while he works on the befront side. You can't tell him by photograph.

Ezra Pound, *Brancusi and Human Sculpture*, undated manuscript[1]

Carl Andre sees the camera as the most catastrophic invention of the Modern Age.

Robert Smithson, *Aerial Art*, 1969[2]

I couldn't say what I wanted to say with a painting or with a photograph of an object. I wanted the real thing.

Damien Hirst, 1997[3]

THE HISTORY of modern art has frequently been written in terms of avant-garde artists' engagement with photography. It has often been assumed that modern art developed as it did in response to the 'challenge' posed to traditional aesthetics by photography. Photography was reputed to have forced modern artists to eschew realism, and to develop more abstract modes. This version of events had it that, with the invention of photography, art stopped being objective and prosaic and instead became subjective and poetic.[4]

It has also been assumed that the invention of photography encouraged the development of complex surface effects in painting, for another characteristic of photography is the seamless uniformity of the picture surface. Early critics of photography frequently commented on its 'extreme perfection'.[5] The corollary to this was that any painting with a smooth surface and clearly depicted forms could be thought of in photographic terms. In 1847 Champfleury characterized the porcelain brilliancy of academic painting as '*daguerro-type fidèle*'.[6]

325

Writing in the 1930s, the French art historian Henri Focillon gave a powerful sense of the difference between photographs and the best paintings. Focillon is discussing Rembrandt, and he sees his life story as 'one of progressive liberation', in which the Dutch master passes from 'finely lacquered execution' to a style in which his hand 'piles up centuries in the passing of an instant'. The artist is a Promethean alchemist: 'Rembrandt's hand plunges to the heart of matter to force it to undergo metamorphosis: one might say that he submits it to the smelting action of a furnace, and that the flame, lapping at these rocky plains, now calcines them, now gilds them.' The artist's hand does not 'indulge in mesmerism' to produce a 'flat apparition in empty space'; rather, it creates 'a substance, a body and an organized structure'.[7]

Rembrandt's substantial, and quasi-sculptural, artistic journey is then contrasted with that of a photographer in Egypt. The photographer had got some local rabbis to pose for him in the manner of a Rembrandt painting: 'He cast about them effects of light worthy of an old master . . . Here indeed are [Rembrandt's] prophetic old men, enthroned beyond time in the misery and splendour of Israel.' Yet these 'incredibly perfect images' cause Focillon acute discomfort: 'Here is Rembrandt minus Rembrandt. Here is pure perception robbed of substance and density, or rather, here is a dazzling optical souvenir, fixed in that crystalline memory which retains everything, the darkroom. Matter, hand, man himself, are all absent. Such an absolute void in the totality of presence is a very strange thing.'[8]

Focillon's reference to the photographer's darkroom as having a 'crystalline memory' harks back to Henri Bergson's celebrated statement in *Creative Evolution* (1907) that 'form is only a snapshot view of transition'.[9] For Bergson, what is real is the continual change of form, whereas human perception has a tendency to freeze-frame existence. Bergson too contrasted the 'snapshot' view of reality with that of a portrait painter,[10] but, unlike Focillon, he does not specify what kind of portraiture he has in mind.

Yet a painting did not necessarily have to present a crystal-clear image to appear to mimic photography. There were ways in which even modernist abstract painting could end up looking like a 'dazzling optical souvenir'. The critic Clement Greenberg insisted that paintings were not windows through which the viewer could look, but flat surfaces to which paint had been applied. In the 1950s and 1960s the painters to whom Greenberg gave most support strove to apply the paint in such a

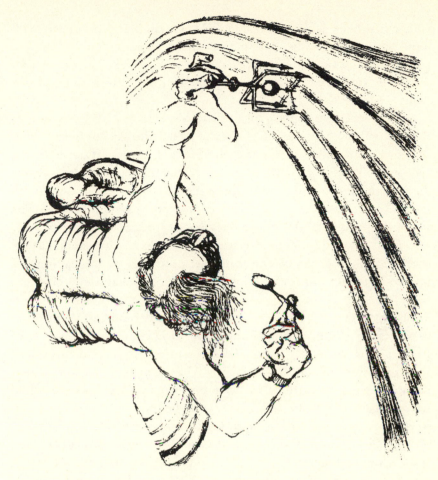

44. **Tom Wolfe**, 'When Flat was God. Using the impastometer'.
(From 'Greenberg, Rosenberg & Flat' from *The Painted Word* by Tom Wolfe, 1975.)

way that it did not undermine the flatness and unity of the picture surface. Helen Frankenthaler and Morris Louis thinned their paint so that it soaked right into the canvas. Jules Olitski sprayed paint on to canvas to create a mirage effect.

Tom Wolfe satirized the theory of 'flatness' in *The Painted Word* (1975). He wrote that although Greenberg initially accommodated Pollock's 'tactile' surfaces to his theory of flatness, he soon shifted position and advocated no surface texture at all. Wolfe illustrates the Greenbergian ideal with a sketch cartoon showing a bald-headed man with a magnifying glass kneeling across the middle of a huge painting,

which had been laid on the floor. He is examining the canvas with professorial precision using a multi-pronged 'impastometer'. The purpose of this elaborate measuring device is to check that the picture surface is completely flat and even. The man is supposed to be Morris Louis.[11]

The photographic appearance of late Modernist painting was something that was being noticed. Wolfe concludes his argument with Photo-Realism. The apologists of this movement make it out to be the apogee of Greenbergian Modernism, because there is not a brushstroke 'in an acre of it',[12] and writing about the diaphanous stain paintings of Helen Frankenthaler, the critic Harold Rosenberg was to observe, 'The soaked-in pigments, which keep the surface flat regardless of the number of veils of colour, speed the eye across an expanse as characterless as the sheen of a photograph.'[13] The technique of soaking the canvas in paint is, of course, akin to the development of a photograph in a chemical bath.

There were other ways in which painting could seem similar to photography. Traditionally, one of the key arguments in favour of painting had been that it could immediately give you an enormous amount of information about a subject. Greenberg and his acolytes took this argument to an extreme, and were adamant that every picture should have a quality of 'at-onceness', and should be taken in at a glance.[14] But since its invention these arguments had often been applied to photography as well. For Roland Barthes, the flatness of a photograph made it something whose surface could only be swept with a glance: 'I cannot penetrate, cannot reach into the Photograph. I can only sweep it with my glance, like a smooth surface. The Photograph is *flat*, platitudinous in the true sense of the word, that is what I must acknowledge.'[15] When thinking in these terms, it was easy for the distinction between painting and photography to be blurred. As the abstract painter Robert Mangold put it, 'What interests me about flat images is the fact that you receive all the information . . . at once. Somehow, in one snapshot you can get all the information that the painting has to give.'[16] Following this logic, a photograph by Irving Penn and a painting by Barnett Newman could be intimate bedfellows.

In the post-war period, the most powerful attack on late Modernist abstraction came not from figurative art *per se*, but from painting that refused to consist of a single, 'platitudinous' surface; and, above all, from the least platitudinous art of all – sculpture. Ernst Gombrich noted the

trend in a 1966 'Postscript' to *The Story of Art*, though for him the facticity of modern art was simply a reaction to photography, rather than to photography's unwitting handmaiden, late Modernist painting:

It may even be that this resistance to photographic reproduction is precisely what attracts some contemporary artists . . . Some went in for canvases of enormous size where it is the scale alone that makes an impact, and this scale, too, loses its point in an illustration. Most of all, however, many artists are fascinated by what they call 'texture', the feel of a substance, its smoothness or roughness, its transparency or density. They therefore discard ordinary paint for other media, such as mud, sawdust or sand . . . The coarseness of sacking, the polish of plastics, the grain of rusty iron, can all be exploited in novel ways. These products stand somewhere between painting and sculpture.[17]

IT SOUNDS VERY plausible that non-platitudinous art should thrive in an era of photography. But it does not quite tell the whole story. For we find similar sorts of objections being made, and similar solutions being proposed, *before* the invention of photography. This time, however, they are made in relation to drawing.

René-Louis de Girardin, in his *On the Composition of Landscapes* (1777), argued that the landscape designer ought to guard above all against the reduction of 'every terrain to the *platitude* of a piece of paper'. Girardin, who was a close friend of Rousseau, believed that formal gardens are a product of 'the laziness whereby one is quite content to work only on paper – paper which has to put up with everything so that one does not have to take the trouble to see and carefully combine on the terrain which only tolerates what is appropriate'.[18] When remodelling a landscape, instead of merely making topographical drawings, Girardin advocated the erection of wooden constructions on the site itself. These could be adjusted on the spot by the designer, and would then guide the labourers.[19] The Swiss educationalist Pestalozzi would have been thinking along similar lines when he insisted that his pupils make clay models of a landscape before looking at a map.

Constable's thickly impastoed oil sketches, which were made on the spot, were perhaps the most famous tilt against papery 'platitudes'. During Constable's formative period and on into his early maturity, drawing or painting out of doors predominated in alternation.[20] These were early examples of a dissatisfaction with the academic tradition, for

that tradition, as defined from the Renaissance onwards, had been rooted in drawing – in drawing made with a kind of aloof, idealized objectivity. Ever since, drawing on paper has been an artform in spasmodic, but continuous, decline; drawing in space, on the other hand, has been in the ascendancy.

There is little doubt, though, that the invention of photography set this revolution on a firmer course.[21] Photography, and the precursor to photography, the *camera obscura*, were inextricably linked with drawing. Many types of early camera, including the *camera obscura*, were referred to as a 'pencil of nature'. When the English pioneer of photography, William Henry Fox Talbot, published *The Pencil of Nature* in 1844–6, he referred to his light-sensitive paper as 'photogenic drawing paper'.[22] Photographs were soon being projected on to canvas or paper and thus functioned like the under-drawing. This way of making a picture was called photo-painting.[23] In Alfred H. Wall's *Manual of Artistic Colouring as Applied to Photographs* (1861), we are told that painting over photographs is no different from the Old Masters' painting over an *abozzo* (drawing).[24]

In modern art, therefore, a criticism of drawing is often also an implicit criticism of photography – and vice-versa. Rodin's remarks about the *Monument to Claude Lorrain* (1884–92) are a case in point. Rodin's intention was to 'personify, in the most tangible manner possible, the genius of the painter of light . . . I have a living Claude Lorrain, instead of a sheet of paper more or less covered with black strokes.'[25] Claude was traditionally thought to have invented a small portable mirror which was black-backed and slightly convex, used for reflecting landscapes in miniature. The device came to be known as the Claude Glass. So we may have cause to wonder just what is being denigrated here – drawing, or the proto-photography of the Claude Glass? Rodin seems to pit himself against Claude Lorrain and all those artists who were reliant both on the pencil of nature and on the pencil of art. He believes he can go one better in plaster and bronze.

None of this stopped Rodin from regularly employing both photography and drawing with great inventive brilliance. In his own work, drawing and photography were yoked together as never before in the work of a sculptor. Rodin himself sometimes drew on top of photographs of his own sculptures, while the rapid line-drawings of moving models that he undertook in the later 1890s were referred to by his contemporaries as *instantanés* (snapshots).[26] Even so, one imagines that

he must have been delighted by this early comment on *The Gates of Hell*, made by an American critic: 'It is just praise to say that they are beyond the reach of the camera.'[27] In later life he frequently attacked photography.[28]

The most profound exploration of the relationship between the pencil of nature and the pencil of art occurs in the *papiers collés* of Braque and Picasso. Here, one of the most important features is the way in which elements drawn by pencil and charcoal vie with printed matter – whether in the form of wallpaper, newspaper (which employed photography), musical scores or oilcloth printed with *trompe-l'oeil* chair-caning.

Critics have tended to emphasize the radical ephemerality of *papier collé*, largely because of the incorporation of newspaper. But as objects they are perhaps only ephemeral in comparison to an Old Master painting; in comparison to Old Master drawing, they are assertions of substance and permanence.[29] The mere fact of pasting these elements on to a sheet of paper or canvas gives them a layered, material presence that changes their identity: paper becomes a kind of *papier mâché*. Braque experimented extensively with folded and cut paper sculpture, and this too can be seen as an attempt to transcend the 'platitude' of paper. Eventually, of course, Picasso and Julio González developed sculptures made from welded wire and metal rods, which were called 'drawings in space' – some of the least platitudinous drawings that had ever been made.

Picasso regularly photographed his paintings during the course of working on them. He liked to do this because he believed that photographs enabled him to see his paintings 'differently from how they are'. He thought that photography might be able to show the metamorphoses of a painting and 'the mind's path toward the concretization of its dream'. He then added:

But what is really very strange is the observation that the painting doesn't change fundamentally, that the initial vision remains almost intact despite appearances. I often see light and shadow. When I put them in my painting, I do all I can to 'break' them by adding a colour that creates a contrary effect. But when this work is photographed, I realize that what I had added to correct my initial vision has disappeared, and that in the end the image rendered by the photograph corresponds to my primal vision, before my deliberate transformations.[30]

What Picasso is doing here is applying to photography arguments that were traditionally used in the debate over the respective values of *colore* and *disegno*. Photography exposes the inherent superficiality of colour, and the primacy of drawing. Black-and-white photography purges his paintings of colour and thereby demonstrates that their 'drawn' essentials of light and shade remain unaffected. Here photography is the hand-maiden and henchman of drawing.

Picasso was not satisfied with this state of affairs. He says that he does all he can to 'break' light and shade by adding colour – a contrary element. But conventional colour is not sufficiently contrary, so it does not cause any serious disruption. Texture and relief, however, *do* work. Picasso was particularly pleased with some photographs of paintings made with unconventional media: 'I have just received the photographs and I'm very happy with them. They are beautiful and prove me right. The Ripolin enamel paintings, or Ripolin-like paintings, are the best . . .'[31] This means that his pleasure derives from the fact that these heavily textured pictures resist photography. The Picasso scholar Anne Baldassari observes, 'the reds and blues of industrial paint were recorded only as contrasts or textures whose haptic impact reinforces the optical rendering of tonal values. The canvas thus elaborates a dialectical play in which the visual effects of chromatic variations, along with added materials such as sand and real or simulated objects, modify the structural scheme in black-and-white'.[32]

There is another way in which Picasso may have wanted to go beyond photography and drawing – by making art that was recognizable in a very primal way. It was often noted that the subject-matter of drawings and photographs was incomprehensible to people from 'primitive' cultures. The art historian Aloïs Riegl, writing in 1893, observed, 'Travellers often describe how Hottentots and Australian aborigines fail to recognize their own image in a drawing or photograph: they can comprehend things physically, but not two-dimensionally.'[33] One of these travellers' tales was used to explain the origins of Cubism. Fernande Olivier tells of a naval officer and explorer who visited Picasso's studio and explained what had happened when he had 'found himself amongst a tribe who produced sculpture'. He showed them a photograph of himself in uniform, and the tribesmen failed to recognize him. One tribesman then took a pencil and paper and proceeded to draw the naval officer, but he did a completely non-naturalistic image, placing, for example, the shiny buttons of the uniform around the face. After that,

we learn, 'a lot of curious things turned up in Cubist paintings'.[34]

The lesson of this story is not simply that the Cubists started to draw in non-naturalistic ways, but that they tried to produce things that could be comprehended physically. The most 'curious things' that turned up in Cubist paintings were objects. African art was thought to be intrinsically incompatible with drawing. It was widely assumed that one of the things that distinguished primitive sculpture from Western sculpture was that it did not derive from drawing. Carl Einstein, in *African Sculpture* (1915), wrote that drawing is 'never a sculptural element', and that if a sculpture exhibits the 'technique of painting or drawing', depth is 'seldom given immediate form'.[35] Thus if you were interested in tribal art and wanted to be a 'modern primitive', it would make sense to transcend drawing in some way.

It would also make sense to try and transcend photographic illusionism. The first written discussion of collage came in a review article by the critic Maurice Raynal published in 1912. Raynal implied that its development was primarily due to the Cubists' hostility towards photographic illusionism in painting: instead of making an exact copy of an object, the Cubists preferred to include a fragment of the object itself.[36] So the *tableau-objet* and constructed sculpture might be seen as a solution to the double 'problem' of drawing and photography.

SINCE THE SECOND World War a lively debate has been conducted over the status of drawing and photography. This was partly the legacy of the improvisational, all-enveloping quality of Pollock's work.[37] Pollock had a major influence on Happenings, and one of the major protagonists, Allan Kaprow, would claim that in Happenings there was 'no separation of audience and play . . . the elevated picture-window view of most play-houses is gone, as are the expectations of curtain openings and *tableaux vivants* and curtain closings . . .'[38] In line with this anti-pictorialism, Claes Oldenburg, who was also associated with Happenings, saw the development of his work as a gradual rejection of 'flat' visualization in favour of representations that were palpable: 'Vision at that time, for me was assumed flatter, and what was seen, taken as a plane surface, like a film, mirror, or newspaper. Thus an advertisement or part of one, ripped from a newspaper, was taken to correspond to a glance at the plane of vision.[39]

Oldenburg's first objects were papier-mâché objects made from news-paper, which suggests a certain striving beyond the merely platitudinous.

He frequently insisted that 'movement and deep space' were 'natural' to him,[40] and that he wanted to make work with an intense physical presence.[41] Some of his hostility towards two-dimensional media, and the formality and inertia they posit, was expressed in a performance entitled *Fotodeath* (1961). A studio photographer in a shiny black smock and a top hat tries to photograph a family of three. Having seated them on a bench, he shows them several samples of landscape backdrops. They dislike them, but eventually he finds one that is acceptable and hangs it behind them. When the photographer gets behind his camera, however, the family collapses in a heap; he sets them up again, but the same thing happens, repeatedly.[42] The formality, frontality and stiffness of a photograph is being mocked.

A quasi-photographic rigidity was attained in Oldenburg's *Bedroom Ensemble* (1963), a tableau inspired by a motel bedroom. It is virtually unique in his *oeuvre* as being conceived as a tableau whose individual components cannot be circumnavigated, or inspected at close quarters. They are presented on an inaccessible stage. 'Hard surfaces and sharp corners predominate,' he wrote. 'Texture becomes *photographed* texture in the surface of the formica. Nothing "real" or "human".' Every style adopted in the ensemble is 'on the side of Death'.[43] Thus the designer of the motel room is the counterpart to the studio photographer in *Fotodeath*. The deathly room is a metaphorical darkroom. Despite these apprehensions, however, Oldenburg never renounced two-dimensional media, and drawing has always been a crucial, generative component in his art. He regards drawings as malleable fragments torn from the environment, and he even referred to some drawn proposals for 'colossal monuments' from 1965 as being 'like an impressionist photograph'.[44] The informal sketch or snapshot was just about okay.

Abstract sculptors who came to the fore in the 1960s were not nearly so tolerant of 'flat' formulations. Anthony Caro asserted that his sculptures never started 'from a flat beginning', and not even from a mental image, which implied the flatness of a picture plane.[45] His sculptures are often reproduced in catalogues from at least two viewpoints. Most Minimalist sculptors stressed the importance of an active viewing, in which the sculpture has to be circumnavigated,[46] and were thus hostile to flat beginnings – and ends. Richard Serra was one of the most outspoken:

But if you reduce sculpture to the flat plane of the photograph, you're

passing on only a residue of your concerns. You're denying the temporal experience of the work . . . But it could be that people want to consume sculpture like they consume paintings – through photographs. Most photographs take their cues from advertising, where the priority is high image content for an easy Gestalt reading. I'm interested in the experience of sculpture in the place where it resides.[47]

In tandem with Serra's antagonism towards photography goes a repudiation of preliminary drawing: 'I never make drawings beforehand. Drawing is a separate activity, an ongoing concern with its own concomitant and inherent problems. It is impossible, even by analogy, to represent a spatial language. In the final analysis most depictions and illustrations are deceitful.'[48]

But it was not just that flat beginnings and ends turned art into a more easily consumable commodity; it also made it fit more neatly into a mental filing cabinet. One critic said that Serra's art is 'not in a snapshot', and that its meaning 'cannot be supposed on the basis of concomitant documents'.[49] Serra himself railed against 'XEROX history'.[50] Photography and drawing are, then, tools for the bureaucratization of art. They seek to reduce art to mere paper-work.[51]

The Minimalists' claims to have successfully resisted what Robert Morris called the 'cyclopean evil eye'[52] of photography were challenged by Allan Kaprow. Morris created 'anti-form' environments out of bits of junk and lengths of industrial felt. This detritus was scattered across gallery floors, dumped in loose piles or allowed to hang from hooks. But Kaprow, in *The Shape of the Art Environment* (1968), disputed Morris' claim to have gone beyond form: 'Morris's new work, and that of the other artists illustrating his article, was made in a rectangular studio, to be shown in a rectangular gallery, reproduced in a rectangular magazine, in rectangular photographs, all aligned according to rectangular axes, for rectangular reading movements and rectangular thought patterns.'[53] They were colluding with, rather than challenging, the visual world order.

Morris and many of his 'anti-form' contemporaries subsequently left the 'rectangular' realm of the gallery altogether, and made environmental earthworks in the great outdoors. These frequently vast projects became known as Land Art. One of the issues that was constantly being raised was that, although these pieces required prodigious amounts of effort both to make and to circumnavigate, they were so inaccessible that they

could usually be experienced only through photographs. The most celebrated piece of Land Art was Robert Smithson's *Spiral Jetty* (1970). This was a spiral promontory 1,500 feet long and approximately 15 feet wide. It was made of earth and rocks, and it projected into the red waters of Great Salt Lake, Utah. In 1969 Smithson had said that photographs 'steal away the spirit of [my] work',[54] but as his friend Richard Serra would later point out, 'What most people know of Smithson's *Spiral Jetty* . . . is an image shot from a helicopter. When you actually see the work, it has none of that purely graphic character, but then almost no one has really seen it.'[55] Serra's reference to the 'graphic' character of the aerial photograph harks back to the pencil of nature.

The point being made by Serra is similar to one made by Merleau-Ponty in *The Phenomenology of Perception* (1945): 'To return to real things themselves is to return to that world which precedes knowledge, of which knowledge always *speaks*, and in relation to which every scientific schematization is an abstract and derivative sign-language, as is geography in relation to the country-side in which we have learnt beforehand what a forest, a prairie or a river is.'[56] If this was a rather romantic view, then others were more pragmatic and sought an accommodation with 'scientific schematization'.

In *The Mechanism of Mind* (1969), Edward de Bono explored similar territory in relation to memory. He argues that memories are stored on a kind of photographic memory-surface. But instead of simply reviving the *camera obscura* model for the mind, he spatializes and materializes it. It is a mistake, de Bono argues, to expect the memory-surface of the mind to function like a photograph, faithfully recording the image 'as it is represented to them'.[57] This would be to posit the mind as wholly passive. Rather, the mind operates like a photograph that has been wrinkled in some way or has something wrong with the emulsion. It has its own prior characteristics that distort the image.

Thus far de Bono does not go much further than Leibniz, whose attempt to spatialize the *camera obscura* was discussed in Part One. But the examples which de Bono goes on to give not only suggest that the memory-surface is strikingly uneven, but also change its orientation. Whereas the *camera obscura* posits a vertical screen or wall, de Bono's memory surfaces are diagonal, curved and floor-based, and are constantly being man-handled. To understand the way the memory-surface functions, we are invited to drop marbles in sand and on to a corrugated surface as we walk over them; to place polythene over a nail-studded

board, then spray coloured water over it until pools form in the polythene.[58] We are asked to ladle hot water over a jelly, thereby 'sculpting' its surface; and even to pour water over the surface of a carpet, which is then slowly lifted from one end.[59] De Bono wants to devise a memory-surface in which the 'contours of the surface will be a sculpted record of all that has happened to the surface.'[60]

He does not, however, say that one memory-surface is superior to another. Different conceptual universes have their own rules, and it is hard – but necessary – to translate what is happening in a new universe into a form that makes sense in the old. 'If you try and represent a three-dimensional globe on a two-dimensional map there is that familiar distortion that makes Greenland and Siberia look so enormous.'[61]

Countless artists over the last thirty years have explored what we might term 'simultaneous translation', juxtaposing different types of memory-surface in the same exhibition or pieces of work. Photographs and videos have often been shown alongside objects that may well be props featured in them. The most canonical, if formulaic, example is *One and Three Chairs* (1965) by the American artist Joseph Kosuth (born 1945). Kosuth placed three items along a wall: a photograph of a chair, the chair that had been photographed, and a dictionary definition of a chair printed on a placard. The 'video corridors' of the American Bruce Nauman (born 1941) induce a comparable kind of double-take. A narrow, freestanding wooden corridor will be placed in the centre of a room. At the end of the corridor is a video monitor and, as the viewer walks along, the monitor transmits a live view of them, filmed from the back.

Alternatively, a two-dimensional image may be projected on to a three-dimensional object. In the 1970s the Italian Giuseppe Penone (born 1947) made several installations in which a photographic image of the artist's torso or face would be projected on to a plaster cast of the same area of the body. Here was a partial re-integration of a divided self, and also a re-staging of the Pygmalion myth. The British artist Mat Collishaw (born 1966) has used similar techniques to make a telling social critique. In *Snowstorm* (1994), film footage of a down-and-out asleep in an Oxford Street shop front was projected on to a child's snow-storm globe. In this type of work there is a dialectic between body and mind, real and ideal, innocence and experience.

Some artists have projected photographic images on to buildings. The doyen of site-specific projections is the Polish artist Krysztof Wodiczko

(born 1943). Much of his career has been devoted to giving photographic shock-therapy to institutional buildings. In 1984 he projected the hand of Ronald Reagan across the 'chest' of the AT&T building in New York, and the next year a swastika on to South Africa House in London. He also proposed, unsuccessfully, to project a crutch on to the statue of Abraham Lincoln in Union Square, New York. Museums have also been targeted. Hands holding a candle and a gun, and a bank of microphones, were projected on to the circular Hirshhorn Museum in Washington, DC in October 1988.

Wodiczko believes that these buildings have been 'sculptured' to operate as 'ascetic' structures, thus assisting in the process of 'inspiring and symbolically concretizing . . . our mental projections of power'. They force us to move round them, so that we are unable to focus on their 'bodies'. The slide projections are supposed to operate forensically and psychoanalytically, exposing the bad conscience of the building: 'The attack must be unexpected, frontal, and must come with the night when the building, undisturbed by its daily functions, is asleep and when its body dreams of itself, when the architecture has its nightmares.'[62]

Buildings have been furnished with a sexual as well as a political unconscious. In 1990 a tremendously derelict warehouse in East London was shown to be having a flourishing sex life: Mat Collishaw had projected an image of a crucified woman in bondage gear on to a mangy internal wall covered with wires and pipes, some of which had come adrift.

From all these kinds of artwork we receive what Donald Brook, in a 1969 article on sculpture, termed a 'picture account' and an 'object account'.[63] A picture account is the information furnished to a stationary, distant viewer, while an object account is that furnished to a mobile viewer, who may notionally or literally touch the object. But the point that needs to be made is that in the best modern art the 2-D 'memory-surface' is rarely given priority or exclusivity. This is perhaps the most important legacy of Cubist collage and the *tableau-objet*.

WHEN ROBERT MORRIS referred to the 'cyclopean evil eye' of photography, he was probably thinking of the first part of André Malraux's three-volume study of world art, *The Psychology of Art: Museum without Walls* (1949). Malraux's famous contention was that first museums, then photography have made the whole world's culture immediately available in a de-contextualized form. For Malraux, writing

when black-and-white photography was still the norm, sculpture had been a particular beneficiary: 'How many statues could be seen in reproduction, in 1850? The modern art-book has been pre-eminently successful with sculpture (which lends itself better than pictures to reproduction in black-and-white) . . . Reproduction has brought forth the whole world's sculpture.'[64] To prove his point, Malraux was to write a three-volume sequel, *Le Musée Imaginaire de la Sculpture Mondiale* (1954), which went from prehistoric sculpture to Rodin, Renoir, Gauguin, Maillol and Bourdelle.[65]

The French minister of culture was right to assert that photographers had been particularly attracted to sculpture. Louis Daguerre's first relatively permanent photograph was probably a still-life with plaster casts, and in *The Pencil of Nature* Fox Talbot asserted that 'statues, busts, and other specimens of sculpture, are generally well represented by the Photographic Art; and also very rapidly, in consequence of their whiteness'.[66] Large amounts of light were required for the chemical reactions to occur, so white sculpture was ideal. But Fox Talbot was also enchanted by the innumerable ways in which the appearance of a free-standing sculpture could change, due to variations in lighting and angles. Photographing details of paintings was evidently not so stimulating. By 1862 the *Art Journal* could state: 'Now . . . sculpture has been photographed into . . . popularity.'[67]

Sculpture is interesting and challenging to photograph precisely because of its openness – or its vulnerability – to interpretation. There may well be a definitive way of observing and visualizing a sculpture (particularly a pre-nineteenth-century sculpture), but the sculptor has less control than a painter over the way in which his work is seen. In the 1890s the great German art historian Heinrich Wölfflin had written a polemical article explaining how to photograph sculptures. He was an admirer of Hildebrand and was infuriated by the failure of photographers to appreciate that classical and Renaissance sculpture could not be photographed from any angle: 'there seems to be a widespread belief that sculptures can be photographed from any side, and it is entirely left to the appreciation of the photographer to choose the angle'. Wölfflin believed that this false notion has been inspired by modern sculpture: 'In our time it is certainly true that there are many works over which there is no certainty from which angle they should be seen: on the whole, they don't present themselves exhaustively from any side, and it is only by the sum total of all the views that the spectator gets a complete idea.'[68]

Eugène Atget's studies from the mid-1920s of the statuary in French royal parks and gardens at Versailles, Saint-Cloud and Sceaux are among the finest examples of the 'failure' to understand classical sculpture. The statues are photographed from behind, from the side and from so close up that one can read the graffiti that has been scratched into the surface of the marble. The 'weakness' of sculpture has been turned into a strength. It is easy to see why the Surrealists liked Atget's work: it is almost like probing into the statue's unconscious. But the apogee of this ethos consists of the photographs taken by Alexander Liberman of the statue of Marcus Aurelius in the Campidoglio in Rome. Liberman is best known for his photographs of the Abstract Expressionists, but in the 1950s he captured the equestrian monument from every conceivable angle. To do the job properly he even had himself suspended from a crane. Not even Princess Diana can have been photographed from so many vantage points.

The corollary to this is that many artists who have been born since the invention of photography have sought to produce artworks that – in theory – cannot be exhausted by photography. A paradox emerges which says that in order for the sculptor to make his work inexhaustibly photogenic, he must not begin the creative process with drawings or photographs. Brancusi seems to have understood this. He scarcely drew and hardly ever worked from photographs. But he took numerous photographs of his sculptures in his studio. He re-arranged, re-configured and re-lit his sculptures endlessly. It has been said that photography intensifies the 'identity crisis' inherent in many of these works.[69] But whereas sculpture had suffered in the past from having an unstable, vulnerable identity, now it makes it a perfect metaphor for modernity – an era obsessed by fragmentation and flux.

Modern artworks have also challenged our ability to get them fully in focus - either because they have to be circumnavigated, or because of disruptive surface effects, which undermine our ability to establish a 'correct' viewing distance. In the Renaissance, artists would usually adapt surface treatments of paintings or sculptures, particularly when they were displayed high up, so that the image would coalesce for a viewer in a particular position on the ground. But in modern art there is no such thing as a correct viewing position.[70]

Brancusi was the master of the unfocalizable artwork. He decided to photograph his works himself after being dissatisfied with the results of professional photographers, such as Edward Steichen. He told Man Ray

that 'perfect' photography could not represent his work.[71] He relished the fact that his own pictures fell short of professional standards – they were frequently out of focus and scratched, crudely framed and aggressively lit. He, his camera and his studio could be seen reflected in the surfaces of his highly polished metal sculptures. It may have been a phoney war, but Brancusi's crowded and ever-changing studio was in the front-line of art's battle for supremacy with photography.

I HAVE ARGUED that this striving to create a non-platitudinous artwork pre-dates the invention of photography. It was a reaction against European art in general – whether it be painting, drawing or sculpture – and against Neo-Classicism in particular. Seen in this context, the 'licked surface' of photography represents the climax of traditional aesthetics, rather than their nemesis.

A reaction against platitudinousness occurred in sculpture as well as painting. Even before the invention of photography, sculptors became interested in the idea of making sculptures that appeared to be 'fac-similes' of nature. Some early viewers of the Elgin Marbles thought they were made using life-casts from the finest human figures. When the sculptures were displayed in Lord Elgin's Park Lane gallery, two leading British boxers, with particularly fine physiques, were brought along to make comparisons. Although neither of the boxers was found to be as consistently fine in proportion as the Theseus, William Hazlitt would praise the Elgin Marbles by saying that they had 'every appearance of absolute *fac-similes* or casts taken from nature'.[72] Once photography had been invented, naturalistic sculpture and casts from life started to be thought of increasingly as three-dimensional daguerreotypes; and photography was in turn seen as a two-dimensional casting from nature.[73]

But the impulse to cast from life was intimately related to the impulse to make sculpture 'in the round'. Indeed, although life-casts were sometimes mounted on plaster blocks to make them resemble sculptures in relief, it was hard to be interested in life-casts without also becoming interested in sculpting in the round, since objects in nature – both animate and inanimate – have a less clearly defined 'main view', or none at all.

The demand for casts from life for use in art-schools and artists' studios was such that by the end of the nineteenth century you could order an astonishing array of items from the cast manufacturers. They were also catering for the general public, who liked to put life and death masks,

and casts of heads and hands, in their drawing-rooms. These casts were taken from members of their own families and from famous men, such as Beethoven. The 'science' of phrenology made these casts particularly popular, especially the heads of men of genius.

The leading manufacturer of casts in Britain was the firm of D. Brucciani. Brucciani was *formatore* – plaster-cast maker – to the British Museum. In 1864, about forty years after the family business had been established in London, Brucciani opened a 100-foot-long gallery of plaster casts in London's Covent Garden.[74] It claimed to be the 'largest collection in Europe of Antique and Modern statuary, Greek, Roman, and Medieval Ornament, &c.' The statuary featured separate casts of the eyes, ears, mouth and nose of Michelangelo's *David*. These private views of details that you would never normally get near were the equivalent of photographic close-ups. In addition to the casts of artworks, you could purchase casts 'from nature' of various body parts – hands, arms, legs, feet, torsos. A 'new and unique' feature was a collection of animals, comprising cows, greyhounds and serpents. There was also an 'assortment of leaves, cast from nature', a set of twelve geometrical solids and an assortment of flowers for ceiling centres.

Brucciani's catalogue was to become progressively less dominated by fine art. By 1948, after the firm of Brucciani had been taken over by the Victoria and Albert Museum, you could order casts of human babies, portions of human and animal bodies, life and death masks of both the famous and the anonymous, and numerous examples of flora, fauna and shells. You could order a pair of large or small ears, heads of different types of men and women, and animals with their legs in different positions, just like those in Marey's 'chronophotographs' of human and animal motion. The *pièce de résistance* was a set of twenty-four pairs of hands of people of all ages. The sequence started with the hands of a one-month-old baby and ended with those of a 60-year-old man.[75]

For the sculptor, however, casting from life was a controversial procedure, particularly if it was felt that the cast had not simply been used as a guide. The Romantic sculptor David d'Angers disapproved of the increasing use of casts from life, and regarded them as lifeless facsimiles.[76] When Delacroix saw Clésinger's *Woman Bitten by a Snake* at the Salon of 1847, it prompted him to make his first recorded observation on photography in his journal. The painter agreed with the critic Gustave Planche, whose review had almost provoked the sculptor into a duel: 'It is a daguerrotype in sculpture.'[77]

When critics wondered whether Rodin's statue of a naked man, *The Vanquished* (1877), had been cast from life, the sculptor fought back. In order to dispel the rumours, he circulated photographs of his model and of his statue, to show the considerable differences.[78] Thus he used photography to disprove the 'photographic' nature of his work. Nonetheless, it is understandable why some viewers might have suspected the use of life-casts. For when casting from life is integral to the artistic process, it encourages a democracy of detail. Although Rodin may not have cast *The Vanquished* from life, the figure is highly naturalistic, and Rodin stood on a step-ladder to check that it looked good even from above. This equal attention to all parts of the statue would have suggested the possibility of life-casting to his viewers. One thinks, too, of Kurt Schwitters' *Merzbau*. Its centrepiece was a cast of the head of Schwitters' dead child, perched on top of the 'column'. The rest of this Dadaist Pompeii took its cue from the life-cast: there are no main views, no points of greater or lesser interest.[79]

I said earlier that phrenology helped foster the nineteenth-century's fascination with life-casts. But it also provided a theoretical justification for sculpture 'in the round'. The basic principles of phrenology were laid down by the Swiss theologian and poet Johann Caspar Lavater in the late eighteenth century, and were clarified and developed by his disciples during the nineteenth. Whereas the older 'science' of physiognomy tended to focus on the face, phrenology was concerned with the shape of the cranium. Phrenologists claimed that the surface of the skull was shaped and marked according to the kind of brain activity taking place below. If the functions of the brain were localized, then it became possible to read character from the shape of the head.

Later disciples claimed that as the brain faculties developed, they not only produced their own 'bump' on the skull, but that these bumps could be developed through exercise. The frontispiece to Hippolyte Bruyères' *La Phrénologie* (Paris, 1847) showed the devil standing behind a child massaging the whole head. The back of the head is where the 'animal' faculties are supposed to be located. The frontispiece was melodramatically entitled 'Phrénologie: La Main du Diable'. By the mid-nineteenth century, forty-two different faculties were commonly accepted, and some phrenologists even claimed that there were bumps for things like political affiliations. One phrenologist inscribed on a skull, 'Each little hillock hath a tongue.'[80]

The most popular way of representing a person phrenologically was in

45. **Hippolyte Bruyères**, *'Phrénologie: La Main du Diable'*
(Engraving, frontispiece to Bruyères' *La Phrénologie*, Paris, 1847)

the profile silhouette; and in the late nineteenth century, photographs
were used to construct the phrenological profile of 'deviants'. But during
the nineteenth century the mass-production of life-casts and of ceramic
'phrenological heads' meant that it became far easier to consider people
'in the round'. Lavater's treatises were illustrated with silhouettes,
though more naturalistic images were also used, often showing several
views of the same head. In a discussion of the skulls of children, Lavater
stressed the importance of an all-round awareness. A plaster bust of John
Locke was oddly used as one of the illustrations. 'How different are

344

foreheads,' Lavater says, 'when viewed from downwards; and how expressive may those differences be!' He then extended his scrutiny to the whole body: 'I am of the opinion that man, considered under every aspect, even though but in [silhouette], from head to foot, before, behind, in profile, half profile, quarter profile, will afford opportunities of making the most new and important discoveries of all the significance of the human body.'[81]

If we now turn to Rilke's essay on Rodin, we find similar sentiments: 'To reproduce a thing meant to have made oneself familiar with every part, to have hidden nothing, overlooked nothing, nowhere to have used deceit; to know all the hundred profiles, to be familiar with it from every angle, from above and from below.'[82] Rilke's assertion that Rodin shifted the focus away from the 'dial' of the face to the whole body would have been understood by phrenologists, while his insistence that every part of a Rodin sculpture was 'a mouth uttering in its own manner' is comparable to those heads composed of hillocks, each with its own tongue.

The taste for casts from life, and for phrenology, did not just stimulate a taste for sculpture in the round. It also led to a spatialization of thought: indeed, the most important legacy of phrenology is its stress on the localization of brain functions. In *The Last Days of Pompeii* (1834), Lord Lytton makes an impromptu phrenological study of the cast of the head of a sinister Egyptian priest who was caught in the conflagration:

> the skull was of so striking a conformation, so boldly marked in its intellectual, as well as its worse physical developments, that it has excited the constant speculations of every itinerant believer in the theories of Spurzheim [a pioneering phrenologist, and the step-father of Hippolyte Bruyères] who has gazed upon that ruined palace of the mind . . . the traveller may survey that airy hall within whose cunning galleries and elaborate chambers once thought, reasoned, dreamed, and sinned, the soul of Arbaces the Egyptian.[83]

The interior of this head was once as intricate and labyrinthine as an Egyptian tomb. In a similar way, Schwitters' *Merzbau* takes its cue from the cast of his child's head. Its complex spatial structure, with its 'cunning galleries' and 'elaborate chambers', is like a materialization of the interior of Schwitters' own head. So, paradoxically, an interest in 3-D daguerreotypes went hand in hand with a conception of the mind that went way beyond the *camera obscura* model.

46. **Bruce Nauman**, *Andrew Head/Julie Head on Wax*, 1990
(Wax and wood, Leo Castelli, New York).

Since the 1950s a whole host of artists – ranging from Picasso, Johns
and George Segal to Giuseppe Penone and Rachel Whiteread – have
used casts from life in their work. In the 1960s the American artist Bruce
Nauman made casts of various parts of his body, and more recently he
has made installations that incorporate pairs of wax heads cast from life,
which come into contact with each other. Nauman has always been an
artist-anthropologist, interested in perceptual psychology and be-
haviourism. One of the most talismanic wax heads is *Andrew Head/Julie
Head on Wax* (1990). The man's head, made from dark grey wax, has
been placed on a small pedestal behind the woman's head, which is made
from pink wax. His tongue protrudes and licks the back of the woman's
skull. Both have their eyes closed. It is a contemporary counterpart to the
Devil standing behind a child, massaging his head; it also serves as an
illustration to Marshall McCluhan's ultra-phrenological contention that
touch is 'the very life of things in the mind'. Nauman wants people to
get their heads back in touch.
 One of the most impressive recent works to feature life-casts is Antony

Gormley's *Another Place* (1997), a site-specific sculpture that was installed for a few months on a beach in Cuxhaven, northern Germany.[84] Almost all Gormley's work is based on casts taken from his own body. His features are quite schematically depicted, however, for the plaster body-cast is usually covered in sheets of lead, which are beaten into shape and then welded. He thus appears to be semi-submerged in a metal 'skin'.

In Cuxhaven, Gormley dotted the shoreline with a hundred hieratic standing figures made from cast iron. They were placed between 50 and 250 yards apart along the tideline, and anything up to half a mile out to sea. Each figure faced towards the horizon, and towards a slow, stately procession of cargo ships heading to and from the port of Hamburg. Their heads were all placed at the same height. At low tide, the legs of those figures nearest the shore were partially buried, while those furthest out were completely exposed; at high tide, those furthest out were immersed up to their shoulders in water. During the day, when the beach was crowded, it took time to distinguish the sculptures from the holiday-makers milling around them. When I was there several holiday-makers posed for photographs beside them.

The daily ritual of immersion and emergence that the sculptures underwent was reflected in the process of manufacture. Each figure was made from casts taken directly from the sculptor's naked body. There were subtle differences in the appearance of the casts, depending on whether he breathed in or out. When a cast is made, the artist is covered in plastic sheeting, cloth, plaster and clay. A breathing tube keeps him alive. Gormley thinks of it as going to a 'place of darkness and of voluntary immobility. It's death in a way.'[85] But this 'place of darkness' is a darkroom where an entire body, rather than a platitudinous piece of paper, is being developed.

Aftermath: The Universe as Sculpture?

IN THIS BOOK, I have offered various explanations for a cultural shift of vast scope and importance. It is a shift away from *images* which are perceived in terms of a framing architecture (whether physical or mental), towards *objects* which assert their independence. It is a shift away from tightly focused, contemplative modes of perception, to something more mobile, contingent and confrontational.

One final question needs to be asked: is the *modus operandi* of the late-nineteenth and twentieth centuries a cultural 'blip', or will it still have relevance in the next century? And will it still be a catalyst for the best art?

I believe the answer to both questions is a resounding 'yes'. Platitudinous art of great accomplishment will continue to be produced (I am thinking in particular of those salon-scale, high-gloss photographs which are currently quite fashionable; photographic-based paintings; spray paintings; prints and drawings) but I doubt such work will ever merit more than an extended footnote in the history of art. The proper place for such art will be in studies of interior decoration, both corporate and domestic – indeed, it generally looks its best when perused in reproduction, in deluxe coffee-table catalogues.

Nowadays, an image exhibited in a museum or gallery of con-

temporary art that is not a *tableau-objet*, or that is not accompanied by an object, is almost always a mere ghost, a shadow of a shadow. This is true too of video art: videos usually seem enervated when shown in a gallery (and they often make the viewer feel enervated) unless they are conceived as part of a three-dimensional installation.

No doubt I will be proved completely wrong. No doubt a coalition of media moguls, technocrats and couch potatoes will do their utmost to ensure the triumph of platitudinousness in life as well as in art.

But I'm still not convinced they will succeed. After all, I did recently overhear a conversation in which someone admired the 'sculptural' qualities of a space-station. Could that not be the next big thing – sculpture exhibitions, and solar-system-specific installations, in outer space?

Select Bibliography and Abbreviations

The short titles given below refer to works that occur frequently throughout the Notes. Details of other works are given in the Notes the first time they are cited in each chapter. The abbreviation 'EC' is used for Exhibition Catalogue.

Alberti 1 *Leon Battista Alberti on Painting and Sculpture*, ed. and trans. Cecil Grayson, London, 1972

Alberti 2 Leon Battista Alberti, *On the Art of Building in Ten Books*, trans. Joseph Rykwert, Neil Leach and Robert Tavernor, Cambridge, Mass., 1988

Apollinaire *Apollinaire on Art: Essays and Reviews, 1902–18*, ed. LeRoy C. Bruenig, trans. Susan Suleiman, London, 1972

Aragon Louis Aragon, *Paris Peasant*, trans. Simon Watson Taylor, London, 1971

Arnheim Rudolf Arnheim, *The Dynamics of Architectural Form*, Berkeley, Ca., 1977

Ashton *Picasso on Art: A Selection of Views*, ed. Dore Ashton, London, 1972

Avery 1 Charles Avery, *Giambologna: the Complete Sculpture*, Oxford, 1987

Avery 2 Charles Avery, *Bernini: Genius of the Baroque*, London, 1997

Baedeker Karl Baedeker, *Italy: A Handbook for Travellers. First Part: Northern Italy*, London, 1906

Baldassari Anne Baldassari, *Picasso and Photography: The Dark Mirror*, EC,

Museum of Fine Arts, Houston, 1997

Baldinucci Filippo Baldinucci, *The Life of Bernini* (1682), trans. Catherine Enggass, foreword by Robert Enggass, University Park, Pennsylvania, 1966

Barasch 1 Moshe Barasch, *Theories of Art from Plato to Winckelmann*, New York, 1985

Barasch 2 Moshe Barasch, *Modern Theories of Art 1: From Winckelmann to Baudelaire*, New York, 1990

Barocchi Paola Barocchi, *Scritti d'Arte del Cinquecento*, 3 vols, Milan 1971

Battcock *Minimal Art: A Critical Anthology*, ed. Gregory Battcock, Berkeley, Ca., 1995

Baudelaire 1 Charles Baudelaire, *Art in Paris 1845–1862*, trans. Jonathan Mayne, London, 1965

Baudelaire 2 Charles Baudelaire, *The Flowers of Evil*, trans. James McGowan, Oxford, 1993

Bauer *Bernini in Perspective*, ed. George C. Bauer, Englewood Cliffs, 1976

Belting Hans Belting, *Likeness and Presence: A History of the Image before the Era of Art*, trans. Edmund Jephcott, Chicago, 1994

Bevan Edwyn Bevan, *Holy Images*, London, 1940

Blühm Andreas Blühm, *Pygmalion: Die Ikonographie eines Künstlermythos Zwischen 1500 und 1900*, Frankfurt, 1988

Blunt Anthony Blunt, *Artistic Theories in Italy 1450–1800*, Oxford, 1940

Brancusi *Brancusi*, EC, Pompidou Centre, Paris, 1995

British Sculpture *British Sculpture in the Twentieth Century*, EC, ed. Sandy Nairne and Nicholas Serota, Whitechapel Art Gallery, London, 1981

Brown Jonathan Brown, *Kings and Connoisseurs: Collecting Art in Seventeenth-Century Europe*, New Haven, 1995

Brown, *Brancusi* Elizabeth A. Brown, *Brancusi Photographs Brancusi*, London, 1995

Bush Virginia Bush, *The Colossal Sculpture of the Cinquecento*, New York, 1976

Butler Ruth Butler, *Rodin: the Shape of Genius*, New Haven, 1993

Butters Suzanne B. Butters, *The Triumph of Vulcan: Sculptors' Tools, Porphyry, and the Prince in Ducal Florence*, vol. 1, Florence, 1996

Cabanne Pierre Cabanne, *Dialogues with Marcel Duchamp*, trans. Ron Padgett, London, 1979

Canfield Fisher Dorothy Canfield Fisher, *A Montessori Mother*, New York, 1912

Canova 1 *Canova*, EC, ed. G. Pavanello and G. Romanelli, Museo Correr, Venice, 1992

Canova 2 *The Three Graces: Antonio Canova*, EC, ed. H. Honour and A. Weston-Lewis, National Gallery of Scotland, Edinburgh, 1995

Castiglione Count Baldassare Castiglione, *The Book of the Courtier*, trans. Thomas Hoby (1561), ed. Virginia Cox, London, 1994

Cellini *The Autobiography of Benvenuto Cellini*, trans. George Bull, Harmondsworth, 1958

Cennini Cennino Cennini, *The Craftsman's Handbook*, trans. D.V. Thompson, New York, 1980

Chantelou Paul Fréart de Chantelou, *Diary of Cavalier Bernini's Visit to France*, ed. Anthony Blunt, trans. Margery Corbett, Princeton, 1985

Chastel André Chastel, *The Myth of the Renaissance, 1420–1520*, Geneva, 1969

Chave Anna C. Chave, *Constantin Brancusi: Shifting the Bases of Art*, New Haven, 1993

Chipp Herschel B. Chipp, *Theories of Modern Art*, Berkeley, Ca., 1968

Cicognara Leopoldo Cicognara, *Storia della Scultura dal suo Risorgimento in Italia sino al Secolo XIX per Servire di Continuazione alle Opere di Winckelmann e di d'Agincourt*, 3 vols, Venice, 1813–18

Colour *The Colour of Sculpture, 1840–1910*, EC, ed. Andreas Blühm, Van Gogh Museum, Amsterdam, and Henry Moore Institute, Leeds, 1996

Colpitt Frances Colpitt, *Minimal Art: the Critical Perspective*, Seattle, 1993

Courbet, *Letters* *The Letters of Gustave Courbet*, ed. and trans. Petra ten-Doesschate Chu, Chicago, 1992

Cowling and Golding *Picasso: Sculptor/Painter*, EC, ed. Elizabeth Cowling and John Golding, Tate Gallery, London, 1994

Curtis Penelope Curtis, *E.A. Bourdelle and Monumental Sculpture*, Ph.D. Thesis, University of London, 1990.

Curtius Ernst Robert Curtius, *European Literature and the Latin Middle Ages*, trans. Willard R. Trask, London, 1953

Dalí Salvador Dalí, *The Secret Life of Salvador Dalí*, trans. Haakon M. Chevalier, New York, 1942

de Caso Jacques de Caso, *David d'Angers: Sculptural Communication in the Age of Romanticism*, trans. Dorothy Johnson and Jacques de Caso. Princeton, 1992

de Chirico Giorgio de Chirico, *Il Meccanismo del Pensiero: critico, polemica, autobiografia, 1911–1943*, ed. Maurizio Fagiolo, Turin, 1985

de Quincy Quatremère de Quincy, *Lettres Ecrits de Londres à Romes, et Addressés à M. Canova, sur les Marbres d'Elgin, ou les Sculptures du Temple de Minerve à Athènes*, Rome, 1818

Diderot *Diderot on Art*, trans. John Goodman, 2 vols, New Haven, 1995

Dubos Abbé Dubos, *Critical Reflections on Poetry, Painting and Music*, trans. Thomas Nugent, 2 vols, London, 1748

Elderfield John Elderfield, *Kurt Schwitters*, London, 1985

Elsen *Rodin Rediscovered*, EC, ed. Albert E. Elsen, National Gallery of Art, Washington, 1981

Fetishism *Fetishism: Visualising Power and Desire*, EC, ed. Anthony Shelton, South Bank Centre, London, 1995

Fisher Philip Fisher, *Making and Effacing Art: Modern American Art in a Culture of Museums*, New York, 1991

Flaubert Gustave Flaubert, *Salammbô*, trans. A. J. Krailsheimer, Harmondsworth, 1977

Flaxman John Flaxman, EC, ed. David Bindman, Royal Academy of Arts, London, 1979

Freedberg David Freedberg, *The Power of Images*, Chicago, 1989

Froebel Froebel's Chief Writings on Education, trans. S. S. F. Fletcher and J. Welton, London, 1912

Gamboni Dario Gamboni, *The Destruction of Art: Iconoclasm and Vandalism since the French Revolution*, London, 1997

Gamwell and Wells *Sigmund Freud and Art: His Personal Collection of Antiquities*, ed. Lynn Gamwell and Richard Wells, London, 1989

Gaudier-Brzeska Gaudier-Brzeska, A Memoir by Ezra Pound (1916), London, 1939

Gauricus Pomponius Gauricus, *De Scultura*, ed. and trans. André Chastel and Robert Klein, Geneva, 1969

Giedion Siegfried Giedion, *Space, Time and Architecture*, Cambridge, Mass., 1st edition, 1941; 4th 1962; 5th, 1967

Gilbert *Italian Art 1400–1500: Sources and Documents*, ed. Creighton E. Gilbert, Evanston, Ill., 1980

Goethe 1 Johann Wolfgang von Goethe, *Elective Affinities*, trans. R. J. Hollingdale, Harmondsworth, 1971

Goethe 2 Goethe on Art, ed. and trans. John Gage, London, 1980

Golding 1 John Golding, *Cubism: A History and an Analysis, 1907–1914*, London, 1988

Golding 2 John Golding, 'Duchamp: *The Large Glass*' in *Visions of the Modern*, London, 1994

Greenberg Clement Greenberg, *The Collected Essays and Criticism*, ed. John O'Brian, 4 vols, Chicago, 1986–93

Hagstrum Jean Hagstrum, *The Sister Arts: The Tradition of Literary Pictorialism and English Poetry from Dryden to Gray*, Chicago, 1958

Harrison and Wood *Art in Theory 1900–1990: An Anthology of Changing Ideas*, ed. Charles Harrison and Paul Wood, Oxford, 1992

Haskell Francis Haskell, *History and its Images*, New Haven, 1993

Haskell and Penny Francis Haskell and Nicholas Penny, *Taste and the Antique*, New Haven, 1981

Hawthorne Nathaniel Hawthorne, *The Marble Faun*, ed. Richard H. Brodhead, Harmondsworth, 1990

Hazlitt *Selected Essays of William Hazlitt*, ed. Geoffrey Keynes, London, 1948

Hegel G. W. F. Hegel, *Aesthetics: Lectures on Fine Arts*, trans. T. M. Knox, 2 vols, Oxford, 1975

Herder Johann Gottfried Herder, *Werke*, ed. Wolfgang Ross, vol. 2, Munich, 1987

Hildebrand Adolf Hildebrand, *The Problem of Form in Painting and Sculpture*, trans. Max Meyer and Robert Morris Ogden, New York, 1907

Hirst Michael Hirst and Jill Dunkerton, *The Young Michelangelo*, EC, National Gallery, London, 1994

Honour 1 Hugh Honour, 'Canova's Studio Practice – I: The Early Years', *Burlington Magazine*, March 1972, pp. 146–57

Honour 2 Hugh Honour, 'Canova's Studio Practice – II: 1792–1822', *Burlington Magazine*, April 1972, pp. 214–29

Honour 3 Hugh Honour, *Neoclassicism*, Harmondsworth, 1977

Honour 4 Hugh Honour, *Romanticism*, Harmondsworth, 1979

Hunisak John M. Hunisak, 'Images of Workers: from Genre Treatment and Heroic Nudity to the Monument to Labour', in *The Romantics to Rodin*, EC, ed. Peter Fusco and H. W. Janson, Los Angeles County Museum, Los Angeles, 1980

Ivy Judy Crosby Ivy, *Constable and the Critics*, Woodbridge, 1991

James *Henry Moore on Sculpture*, ed. Philip James, New York, 1992

Janson H. W. Janson, *Nineteenth-Century Sculpture*, London, 1985

Jenkyns Richard Jenkyns, *The Victorians and Ancient Greece*, Cambridge, Mass., 1980

Joyce Hetty Joyce, 'Grasping at Shadows: Ancient Paintings in Renaissance and Baroque Rome', *The Art Bulletin*, June 1992, p. 219ff.

JWCI Journal of the Warburg and Courtauld Institutes

Kemp Martin Kemp, *Behind the Picture: Art and Evidence in the Italian Renaissance*, New Haven, 1997

Kendall Richard Kendall, *Degas and the Little Dancer*, EC, Joslyn Art Museum, New Haven, 1998

Kenseth Joy Kenseth, 'Bernini's Borghese Sculptures: Another View', *Art Bulletin*, June 1981, pp. 191–210

Klein and Zerner *Italian Art 1500–1600: Sources and Documents*, ed. Robert Klein and Henri Zerner, Evanston, Ill., 1989

Knight Richard Payne Knight, *An Analytical Inquiry into the Principles of Taste*, 2nd edition, London, 1805

Kramer Rita Kramer, *Maria Montessori: A Biography*, Oxford, 1978

Krauss Rosalind E. Krauss, *The Originality of the Avant-garde and Other Modernist Myths*, Cambridge, Mass., 1985

Kristeller Paul Oskar Kristeller, 'The Modern System of the Arts', in *Renaissance Thought*, vol. 2, p. 163ff., Princeton, 1990

Kuryluk Ewa Kuryluk, *Veronica and her Cloth*, Oxford, 1981

Larrabee Stephen Larrabee, *English Bards and Grecian Marbles*, New York, 1940

Lee Rensselaer W. Lee, *Ut Pictura Poesis: The Humanistic Theory of Painting*, New York, 1967

Leonardo *Leonardo on Painting*, ed. Martin Kemp, trans. Martin Kemp and Margaret Walker, New Haven, 1989

Lessing Gotthold Ephraim Lessing, *Laocoön*, ed. and trans. Edward Allen McCormick, Baltimore, 1984

Levey Michael Levey, *Painting and Sculpture in France: 1700–1789*, New Haven, 1993

Lichtenstein Jacqueline Lichtenstein, *The Eloquence of Colour: Rhetoric and Painting in the French Classical Age*, trans. Emily McVarish, Berkeley, Ca., 1993

Luchs Alison Luchs, *Tullio Lombardo and Ideal Portrait Sculpture in Renaissance Venice, 1490–1530*, Cambridge, 1995

McClellan Andrew McClellan, *Reinventing the Louvre*, Cambridge, 1994

McHam *Looking at Renaissance Sculpture*, ed. Sarah Blake McHam, Cambridge, 1998

McLuhan Marshall McLuhan, *Understanding Media*, New York, 1964

Merleau-Ponty Maurice Merleau-Ponty, *The Phenomenology of Perception*, trans. Colin Smith, London, 1962

Miller Sanda Miller, *Constantin Brancusi: A Survey of his Work*, Oxford, 1995

Milner John Milner, *Vladimir Tatlin and the Russian Avant-Garde*, New Haven, 1983

Montagu Jennifer Montagu, *Roman Baroque Sculpture: The Industry of Art*, New Haven, 1989

Montessori 1 Maria Montessori, *Dr Montessori's Own Handbook*, London, 1914

Montessori 2 Maria Montessori, *The Montessori Method*, London, 1919

Morgan Michael J. Morgan, *Molyneux's Question: Vision, Touch and the Philosophy of Perception*, Cambridge, 1977

Norton Robert E. Norton, *Herder's Aesthetics and the European Enlightenment*, Ithaca, 1991

Oldenburg *Claes Oldenburg: An Anthology*, EC, Guggenheim Museum, New York, 1995

Onians *Sight and Insight: Essays on Art and Culture in Honour of E. H. Gombrich at 85*, ed. John Onians, London, 1994

Osborne Mary Tom Osborne, *Advice-to-a-Painter Poems: 1633–1856, An Annotated Finding List*, University of Texas, 1949

Panofsky Erwin Panofsky, *Meaning in the Visual Arts*, Harmondsworth, 1970

Passeri Giambattista Passeri, *Vite de' Pittori, Scultori, ed Achitetti che anno Lavorato in Roma Morti dal 1641 fino al 1673*, (ms. 1679), Rome, 1772

Penny Nicholas Penny, *The Materials of Sculpture*, New Haven, 1993

Poggi Christine Poggi, *In Defiance of Painting: Cubism, Futurism and the Invention of Collage*, New Haven, 1992

Pope-Hennessy 1 John Pope-Hennessy, *Italian Renaissance Sculpture*, London, 1996

Pope-Hennessy 2 John Pope-Hennessy, *Italian High Renaissance and Baroque Sculpture*, London, 1996

Praz Mario Praz, *On Neoclassicism*, trans. Angus Davidson, London, 1972

Prinz Wolfram Prinz, 'La Collezione degli Autoritratti', in *Gli Uffizi*, Florence, 1979, pp. 765–72

Read Benedict Read, *Victorian Sculpture*, New Haven, 1982

Reynolds Joshua Reynolds, *Discourses*, ed. Pat Rogers, Harmondsworth, 1992

Richardson John Richardson, *A Life of Picasso, Volume I: 1881–1906*, London, 1991; *Volume II: 1907–1917*, London, 1996

Richter *Paragone: A Comparison of the Arts by Leonardo da Vinci*, ed. I. A. Richter, Oxford, 1949

Rilke Rainer Maria Rilke, *Rodin and Other Prose Pieces*, trans. G. Craig Houston, London, 1986

Rosenblum Robert Rosenblum, *Transformations in Late Eighteenth-Century Art*, Princeton, 1969

Rousseau Jean-Jacques Rousseau, *Emile: or On Education*, ed. and trans. Allan Bloom, London, 1991

Rubin Patricia Rubin, *Giorgio Vasari: Art and History*, New Haven, 1995

Rubin, *Cubism* William Rubin, *Picasso and Braque: Pioneering Cubism*, EC, Museum of Modern Art, New York, 1989

Sanouillet *Duchamp du Signe: Ecrits*, ed. Michel Sanouillet, Paris, 1975

Sartre Jean-Paul Sartre, *Nausea*, trans. Robert Baldick, Harmondsworth, 1965

Scharf Aaron Scharf, *Art and Photography*, Harmondsworth, 1974

Sculpture Française *La Sculpture Française au XIXeme Siècle*, EC, Grand Palais, Paris, 1986

Serra Richard Serra: Interviews Etc., Hudson River Museum, Yonkers, New York, 1980

Settis *Memoria dell' Antico nell'Arte Italiana*, ed. Salvatore Settis, 3 vols, Turin, 1986

Shearman John Shearman, *Only Connect: Art and the Spectator in the Italian Renaissance*, Princeton, 1992

Siegel Jean Siegel, 'Carl Andre: artworker', *Studio International*, November 1970, pp. 175–9.

Silverman Deborah L. Silverman, *Art Nouveau in Fin de Siècle France: Politics, Psychology and Style*, Berkeley, Ca., 1989

Smithson The Writings of Robert Smithson, ed. Nancy Holt, New York, 1979

Sparrow John Sparrow, *Visible Words: a Study of Inscriptions in and as Books and Works of Art*, Cambridge, 1969

Steinberg Leo Steinberg, *Other Criteria: Confrontations with Twentieth-Century Art*, New York, 1972

Summers David Summers, *Michelangelo and the Language of Art*, Princeton, 1981

Tomkins 1 Calvin Tomkins, *The Bride and the Bachelors: The Heretical Courtship in Modern Art*, New York, 1968

Tomkins 2 Calvin Tomkins, *Duchamp: A Biography*, London, 1997

Vasari Giorgio Vasari, *Lives of the Painters, Sculptors and Architects*, trans. Gaston du C. De Vere, 2 vols, London, 1996

Vidler Anthony Vidler, *The Architectural Uncanny: Essays in the Modern Unhomely*, Cambridge, Mass., 1992

Wilenski R. H. Wilenski, *The Meaning of Modern Sculpture*, London, 1932

Winckelmann 1 J. J. Winckelmann, *The History of Ancient Art* (1766 ed.), trans. G. Henry Lodge, 4 vols, Boston, 1873

Winckelmann 2 Winckelmann: Writings on Art, ed. David Irwin, London, 1972

Wittkower 1 Rudolf and Margot Wittkower, *Born under Saturn*, New York, 1963

Wittkower 2 Rudolf and Margot Wittkower, *The Divine Michelangelo: The Florentine Academy's Homage on his Death in 1584*, London, 1964

Wittkower 3 Rudolf Wittkower, *Sculpture: Processes and Principles*, Harmondsworth, 1977

Woods-Marsden Joanna Woods-Marsden, *Renaissance Self Portraiture: the Visual Construction of Identity and the Social Status of the Artist*, New Haven, 1998

Yates Frances Yates, *The Art of Memory*, London, 1969

Zola Emile Zola, *The Masterpiece*, trans. Thomas Walton, Oxford, 1993

Notes

Introduction

1. Comte de Caylus, *Vies d'Artistes du XVIII Siècle*, ed. André Fontaine, Paris, 1910, p. 184.
2. See Blunt, p. 50ff.; Barasch 1, pp. 164–74; Leatrice Mendelsohn, *Paragoni: Benedetto Varchi's Due Lezzioni and Cinquecento Art Theory*, Ann Arbor, 1982; and as a corrective to Mendelsohn, François Quiviger, 'Benedetto Varchi and the Visual Arts', *JWCI*, Vol L, 1987, pp. 219–24.
3. Richter; Claire J. Farago, *Leonardo da Vinci's Paragone*, Leiden, 1992.
4. By Lodovico Dolce in 1557. Klein and Zerner, p. 65.
5. Vasari, vol. I, p. 742.
6. Rilke, p. 8.
7. Greenberg, vol. 4, p. 61.
8. The writer-sculptors include Donald Judd, Robert Morris, Carl Andre, Tony Smith, Sol LeWitt, Richard Serra, Robert Smithson and William Tucker. Joseph Beuys and Jeff Koons have developed their own philosophies of life and art.
9. *Dada on Art*, ed. Robert Motherwell, London 1971, p. 16. See also Greenberg, vol. 2, p. 318.
10. Previous still-life sculptures had a decorative function – as in Grinling Gibbons' limewood cravats and Canova's baskets of fruit and flowers. *Canova 1*, no. 116, pp. 212–13.

11. For more on this, see Sidney Geist, 'Sculpture and other Trouble' (1961), in Chipp, p. 582.

12. Charles Harrison, 'Sculpture's Recent Past', in *A Quiet Revolution: British Sculpture Since 1965*, ed. Terry A. Neff, Chicago 1987, p. 27.

13. Edward Lucie-Smith, *Sculpture Since 1945*, London, 1987, p. 117.

14. Damien Hirst, *I Want to Spend the Rest of my Life Everywhere, with Everyone, One to One, Always, Forever, Now*, London, 1997, p. 246.

15. Christiane Meyer-Thoss, *Designing for Free Fall*, Zurich, 1992, p. 178.

1. The Image of the Artist

1. *Filarete's Treatise on Architecture*, trans. John R. Spencer, New Haven, 1965, p. 316.

2. Read, p. 50.

3. Wittkower 1, p. 287.

4. Published in 1917 and 1920. Ibid., pp. 286–7.

5. In antiquity the visual arts and artists generated little critical interest. Phidias is not even mentioned in contemporary literature. No ancient philosopher wrote a 'separate systematic treatise' on the visual arts or 'assigned to them a prominent place in his scheme of knowledge' (Kristeller, p. 171). Only during the Hellenistic period do artists start to be esteemed for their originality and creativity (Erwin Panofsky, *Idea: A Concept in Art Theory*, New York, 1968, chapter 2). For the first time, private collections were formed (Joseph Alsop, *The Rare Art Traditions*, London, 1982, p. 190ff). Our main source of information on Greek artists comes from scattered comments in Pliny the Elder's *Natural History*, written in the first century AD.

6. Blunt, chapter 4; Wittkower 1, pp. 7–14; Kemp, passim. In Venice, however, painters had their own guild.

7. Henry Francis Cary's first English translation of 1814.

8. Dante, *La Divina Commedia*, ed. Natalino Sapegno, Florence, n.d., vol. II: Purgatorio, p. 108, note 32.

9. Kristeller, p. 163ff.

10. Chastel, p. 197.

11. Letter to Willibald Pirckheimer, October 1506, quoted in William M. Conway, *The Writings of Albrecht Dürer*, London, 1958, p. 58.

12. Blunt, p. 48.

13. The clay *modello* was subsequently used for target practice by invading French soldiers.

14. *Leonardo*, pp. 38–9.

15. Ibid., pp. 38–9.

16. See J. J. Pollitt, *The Art of Ancient Greece: Sources and Documents*, Cambridge, 1990, pp. 227–8.

17. Vasari, vol. II, pp. 668–9; see also p. 696.
18. Quoted by Anthony Hughes, *Michelangelo*, London, 1997, p. 132.
19. Chantelou, p. 277.
20. Hazlitt, pp. 623–4.
21. *Leonardo*, p. 205.
22. Barocchi, vol. 1, p. 596. The price of bronze was much greater than marble. Donatello's stone statue of St Mark is unlikely to have cost more than 100 florins; Ghiberti's bronze St Matthew cost over 1,000 florins. Advances in technology meant that by around 1800 bronze sculpture became cheaper than marble. Janson, p. 12.
23. *The Listener*, 24 January 1974. Quoted by Ernst Gombrich, 'Art History and the Social Sciences', in *Ideas and Idols*, Oxford, 1979, p. 145.
24. William E. Wallace, 'A Week in the Life of Michelangelo', in McHam, pp. 203–22.
25. Montagu, p. 23ff.
26. Ibid., pp. 21–3.
27. Vasari, vol. II, p. 664.
28. Vasari, vol. I, p. 531.
29. For aborted sculpture projects, see Kemp, p. 66ff.
30. Ernst Steinmann, *Die Portraitdarstellungen des Michelangelo*, Leipzig, 1913, illus. Ib. They are failed Pygmalions. See also Blühm, Abb. III and nos 7 and 63. *Grinling Gibbons* by Godfrey Kneller, Watteau's satirical painting *La Sculpture* and Goya's drawing *The Sculptor* are further variations on the theme.
31. The biggest danger to the painter came from lead- and mercury-based paints.
32. Castiglione, p. 87ff.
33. Ilya Sandra Perlingieri, *Sofonisba Anguissola: The First Great Woman Artist of the Renaissance*, New York, 1992, p. 120ff.; Woods-Marsden, p. 195ff.
34. Butters, p. 173.
35. Cellini, p. 340.
36. Ibid., p. 340.
37. *Gaudier-Brzeska*, p. 51.
38. Vasari, vol. II, p. 746.
39. Anne Middleton Wagner, *Jean-Baptiste Carpeaux*, New Haven, 1986, p. 15; Wagner gives an excellent account of working practices.
40. Hawthorne, p. 337. See description of a 'dreary-looking' sculptor's studio on p. 114; and of a 'delightful' painter's studio on p. 41.
41. Vasari, vol. I, p. 554.
42. Cellini, pp. 344–5.
43. Susan Beattie, *The New Sculpture*, New Haven, 1983, p. 185. See also Richard Dorment, *Alfred Gilbert*, New Haven, 1985, p. 102.

44. *Zola*, pp. 254–8. For Zola's views on sculpture, see *Emile Zola: Ecrits sur L'Art*, ed. Jean-Pierre Leduc-Adine, Paris, 1991, pp. 224–8.

45. For Hephaistos' low status, see P. Kidson, 'The Figural Arts', in *The Legacy of Greece: A New Appraisal*, pp. 401–28, ed. M. I. Finley, Oxford, 1984, p. 406. The forge of Vulcan was a popular subject with Renaissance painters.

46. See entry on Hephaistos in the *Oxford Classical Dictionary*.

47. Andrew Stewart, *Greek Sculpture: An Exploration*, New Haven, 1990, vol. I, p. 70. See also Ernst Kris and Otto Kurtz, *Legend, Myth and Magic in the Image of the Artist*, New Haven, 1979, pp. 86–7.

48. Vasari, vol. II, pp. 596–7.

49. Butters, p. 233.

50. Ibid., p. 195.

51. Avery 2, p. 164.

52. Butters, p. 247.

53. Cellini, p. 360.

54. Ibid., p. 149.

55. Ibid., p. 290.

56. Wittkower 2, p. 102. The allegory of Sculpture was, however, put in a more prominent position after Cellini complained.

57. Woods-Marsden, pp. 229–30. The tools of the trade could also be seen in paintings of St Luke, who is discussed in Chapter 3.

58. Butters, p. 373.

59. Baldinucci, p. 76.

60. Francis Haskell, *Patrons and Painters*, New Haven, 1980, p. 160.

61. Osborne, Nos 30, 69, 38R.

62. Edgar Wind, 'Shaftesbury as a Patron of Art', *JWCI*, vol. II, 1938, pp. 185–8.

63. Knight, pp. 192–3, #67.

64. Honour 1, p. 147.

65. Helen Osterman Borowitz, *The Impact of Art on French Literature*, London, 1985, pp. 117–18.

66. Levey, p. 61.

67. Ibid. For the French Academy in Rome, see Montagu, pp. 10–14.

68. Charles Wheeler was President 1956–66. Lord Leighton, a painter who also sculpted, was President 1878–96. I am grateful to Adam Waterton for this information.

69. *Alberti 1*, p. 125.

70. Gauricus, p. 100–1.

71. Wittkower 3, p. 82.

72. *Vasari on Technique*, trans. Louisa S. Maclehose, New York, 1960, p. 206.

73. Avery 1, p. 27.

74. Ibid., p. 27.
75. Bush, p. 5; Creighton Gilbert, 'A New Sight in 1500: The Colossal', in *Michelangelo: On and Off the Sistine Ceiling*, New York, 1994, pp. 227–52.
76. Bush, p. 149.
77. Kemp, p. 73. See also William Wallace, *Michelangelo at San Lorenzo: The Genius as Entrepreneur*, Cambridge, 1994.
78. Wittkower 1, p. 18.
79. Jacques Le Goff, *Time, Work and Culture in the Middle Ages* trans. A. Goldhammer, Chicago, 1980, p. 80.
80. Avery 2, p. 127.
81. Montagu, pp. 112–13.
82. Honour 1, p. 147.
83. Wittkower 3, p. 224.
84. Read, p. 66.
85. Allan Cunningham, *The Lives of the Most Eminent British Painters and Sculptors*, New York, 1844, vol. 3, p. 220. He is discussing rumours/accusations that Anne Seymour Damer received help.
86. Honour 1, p. 157.
87. Yates, pp. 155–60. Plato also admired Egyptian sculptures.
88. See Erwin Panofsky, 'The History of the Theory of Proportions as a Reflection of the History of Styles', in Panofsky, pp. 98–100.
89. Janson, p. 11, writes that, unlike painting, 'sculpture has been a replicating art ever since the Bronze Age'.
90. *Leonardo*, pp. 19–20.
91. Avery 1, p. 235. See also Haskell and Penny, p. 122.
92. Summers, p. 364ff.
93. Butters, p. 373.
94. *Vasari on Technique*, op. cit., p. 147.
95. *Conférences de L'Académie Royale*, ed. M. Henry Jouin, Paris, 1883, p. 17. See also Winckelmann 1, vol. III, p. 80.
96. Levey, p. 61.
97. From 'Kunst und Handwerk', quoted by Werner Hoffmann, 'The Death of the Gods', in *Flaxman*, p. 15.
98. Jenkyns, p. 22; M. H. Abrams, *The Mirror and the Lamp*, Oxford, 1953, p. 257.
99. Alex Potts, 'Greek Sculpture and Roman Copies I: Anton Raphael Mengs and the Eighteenth Century', in *JWCI*, vol. XLIII, 1980, pp. 150–73; Haskell and Penny, p. 106. The *Laocoön* and the *Belvedere Torso* are just about the only statues whose reputations survived intact.
100. Hawthorne, p. 115.
101. Passeri, p. 256.
102. Montagu, pp. 104–7. Theodon was dismissed from the Academy in 1690.

103. Charles Godfrey Leland, *Legends of Florence*, New York, 1896, second series, pp. 53–6. Cited by Theodore Ziolkowski, *Disenchanted Images*, Princeton, 1977, p. 68.

104. Read, pp. 66–7. See also Philip Ward-Jackson, 'Sculpture Colouring and the Industries of Art in the 19th Century', in *Colour*, pp. 73–4; Butler, pp. 75–6; and Dorment, op. cit., p. 141.

105. Philip Ward-Jackson, 'Lord Ronald Gower, Gustave Doré and the Genesis of the Shakespeare Memorial at Stratford-on-Avon', in *JWCI*, vol. L, 1987, p. 161.

106. Ibid.

107. The sculptor David d'Angers thought the profile view was 'the most expressive', de Caso, p. 173. But there is nothing expressive in a positive sense about this profile.

108. Montagu, pp. 126ff.

2. Self-Portraiture

1. Vasari, vol. I, p. 743.

2. 'The Picture of Dorian Gray', in *The Portable Oscar Wilde*, ed. Richard Aldington, Harmondsworth, 1977, p. 144.

3. See G. F. Hartlaub, 'Das Selbstbildnerische in der Kunstgeschichte', *Zeitschrift für Kunstwissenschaft*, IX (1955), pp. 97–124; André Chastel, *Art et humanisme à Florence au Temps de Laurent le Magnifique*, Paris, 1959, pp. 102–4; Robert Klein, *Form and Meaning: Essays on the Renaissance and Modern Art*, New York, 1979, pp. 250–1, note 1, for further references.

4. Part 4, Canto 3, verses 52–5. Dante Alighieri, *Il Convivio*, ed. Bruna Cordati, Turin, 1968, p. 158.

5. Barocchi, vol. I, pp. 521, 639–40.

6. See Michael Podro, *Depiction*, New Haven, 1998, p. 87ff.

7. For Mengs, see Wittkower 3, p. 224.

8. *Leonardo*, p. 120; see also p. 204. For Savanarola's comments, see Gilbert, p. 159. Marsilio Ficino applied this idea to the painter and architect – but not to the sculptor. Wittkower 1, pp. 93–4.

9. Different interpretations of Leonardo's ideas have been given by Ernst Gombrich, 'The Grotesque Heads', in *The Heritage of Apelles*, Oxford, 1976, pp. 57–75; Martin Kemp, 'Ogni dipintore Dipinge se: A Neoplatonic echo in Leonardo's art theory?', *Cultural Aspects of the Renaissance: Essays in Honour of Paul Oskar Kristeller*, ed. Cecil H. Clough, Manchester, 1976, p. 317.

10. Lorne Campbell, *Renaissance Portraits*, New Haven, 1990, p. 81.

11. My translation, *Castiglione*, p. 90ff.

12. Roger Jones and Nicholas Penny, *Raphael*, New Haven, 1983, pp. 159–62.

13. Ibid., p. 159. Dürer quote in Michael Levey, *High Renaissance*, Harmondsworth, 1975, p. 69.

14. See also Campbell, op. cit., pp. 195–6.

15. Woods-Marsden, p. 40.

16. Castiglione, p. 409ff.

17. Barasch, p. 179.

18. The depiction of hair came up constantly in the *paragone* debates; sculptors were supposed to have great difficulty depicting it. See Vasari, vol. II, pp. 660–1.

19. Osborne.

20. O. Millar, *The Queen's Pictures*, London, 1984, p. 35.

21. Barasch, p. 286ff.; Kemp, pp. 239–42.

22. Castiglione, p. 70. This conceit derives from Cicero, although he cites three sculptors and three painters. See also Elizabeth Cropper, *The Ideal of Painting: Pietro Testa's Düsseldorf Notebook*, Princeton, 1984, pp. 158–9.

23. For a wonderful description of Rubens at work, see Wolfgang Stechow, *Rubens and the Classical Tradition*, Cambridge, Mass., 1968, p. 8.

24. For Narcissus and painting, see Stephen Bann, *The True Vine: On Visual Representation and the Western Tradition*, Cambridge, 1989, pp. 105–56. Alberti made two low-relief self-portrait medals, but for him this would have counted as painting.

25. *Alberti 1*, pp. 62, 122. See also H. W. Janson, 'The Image Made by Chance in Renaissance Thought', in *Sixteen Studies*, New York, n.d. (1973?), pp. 53–74.

26. Ernst Gombrich, *The Story of Art*, 1995, p. 215.

27. Pope-Hennessy 1, p. 182ff. For sculpted self-portraits in fifteenth-century Italy, see Woods-Marsden, pp. 54–104.

28. Some not entirely convincing reasons have been offered. Xanthe Brooke, *Face to Face: Three Centuries of Artists' Self-Portraiture*, EC, Walker Art Gallery, Liverpool, 1994, p. 9, cites the difficulty of making three-dimensional likenesses, and Woods-Marsden, p. 156 cites the expense, while conceding that such considerations did not inhibit Bandinelli.

29. Pope-Hennessy 2, p. 297. The first extended study of portraiture was written by Gian Paolo Lomazzo in 1584. For sixteenth-century writings on portraiture, see Barocchi, vol. III, p. 2707ff.

30. Freedberg, p. 207.

31. Kuryluk, p. 4.

32. Sculptors tackled the theme too, but not often. The subject appears most frequently in polychrome wood carving, particularly in Spain, but as this is painted it is a borderline case.

33. Joseph Leo Korner, *The Moment of Self-Portraiture in German Renaissance Art*, Chicago, 1993, p. 95. The fact that Dürer's other self-portraits were

on wood does not invalidate my general point.

34. Johannes Wilde, *Italian Drawings in the Department of Prints and Drawings in the British Museum: Michelangelo and his Studio*, London, 1953, p. 97.

35. Vasari, vol. II, p. 737.

36. Pope-Hennessy 2, pp. 297–9.

37. John Gage, *Colour and Culture*, London, 1993, p. 48. Not that Byzantine images were especially particularized, of course.

38. Barocchi, vol. I, p. 497. Vasari is replying to Benedetto Varchi's questionnaire about the relative merits of painting and sculpture.

39. See 'The High Renaissance Portrait', in Pope-Hennessy 2, p. 297ff.

40. G. B. Armenini claimed that 'the more accomplished an artist is in *disegno*, the less he will know how to make portraits'; Woods–Marsden, p. 193.

41. For sculptors' tool marks, see Penny, pp. 81–91.

42. Pope-Hennessy 2, p. 108.

43. In a letter of 18 March 1564 to Michelangelo's nephew Lionardo, Vasari confirms that Nicodemus is a self-portrait. Many attempts have been made to find other self-portraits, i.e. *David*. See Herbert von Einem, *Michelangelo*, London, 1973, p. 29.

44. Pope-Hennessy 2, p. 108: 'The primacy of painting is maintained visually in the Deposition group . . .'

45. Belting, pp. 304–5.

46. Michelangelo's hated rival, Bandinelli, made more self-portraits, both 'hidden' and overt, than any other contemporary Italian sculptor. Of the five overt, sculpted self-portraits, all are reliefs. Kathleen Weil–Garris has suggested that Bandinelli may have been influenced by Leonardo's belief that relief was more intellectual. 'Bandinelli and Michelangelo: A Problem of Artistic Identity' in *Art the Ape of Nature: Studies in Honor of H.W. Janson*, ed. Moshe Barasch and Lucy Freeman Sadler, New York, 1981, pp. 227–8. See also Woods–Marsden, pp. 139–47.

47. Howard Hibbard, *Bernini*, Harmondsworth, 1965, pp. 175–6 and Chantelou, pp. 16–17.

48. Baldinucci, p. 15.

49. Ibid., p. 74.

50. Bauer, pp. 28–31.

51. Giambattista Passeri said that the term statue derives from the Latin '*sto stas*, which means to be firm, stable on one's feet', and that Mochi's statue is not 'permanent and immobile as it should be'. Passeri, p. 118.

52. Pope-Hennessy 2, p. 535; Montagu, pp. 30–5. Another project overseen by Bernini, the angels on the Ponte S. Angelo, included an angel with the sudarium (1668–9) by Cosimo Fancelli.

53. Gerald Ackerman, 'Gian Battista Marino's Contribution to Seicento Art Theory', in *The Art Bulletin*, December 1961, p. 333.

54. Montagu, p. 36.

55. Chantelou, p. 18.

56. For Descartes and painting, see Lichtenstein, pp. 130–5.

57. *The Philosophical Works of Descartes*, trans. Elizabeth S. Haldane and G. R. T. Ross, vol. I, Cambridge, 1931, pp. 311–12.

58. In Calderón's comedy *El Pintor de su Deshonra* (The Painter of his Dishonour), Christ is trying to paint a portrait of man, but it is continually being sabotaged by the Devil; Curtius, pp. 559–70. The inherent fragility of painting seems crucial to its religious function. Antonio Palomino, in *Calderón's Praise of Painting*, said that a painting was only a 'canvas smeared with minerals and liquids'. Elizabeth Holt, *A Documentary History of Art*, vol. II, New York, 1958, p. 228.

59. Ernst van de Wetering, 'Rembrandt's Manner: Technique in the Service of Illusion', in *Rembrandt: the Master & His Workshop – Paintings*, EC, ed. Christopher Brown, Jan Kelch and Pieter van Thiel, National Gallery, London, 1991, p. 21.

60. Antonio Francesco Gori, *Museum Florentinum*, Florence, 1731–62, 12 vols. See Prinz, pp. 765–72.

61. The decision to accept sculpted self-portraits was taken by Corrado Ricci, Director of the Uffizi 1904–8. Ibid., p. 772. Many of the early arrivals were Italian epigones of Rodin.

62. Margaret Whinney, *Sculpture in Britain 1530–1830*, London, 1988, p. 319.

63. Ibid., p. 319.

64. Martin Bailey, 'Not for Sale', in *Royal Academy Magazine*, Spring 1997, no. 54, p. 14.

65. See Prinz, p. 853.

66. James Dalloway, *Anecdotes of the Arts in England*, London, 1800, pp. 408–9. He writes far more on Damer than on any other sculptor.

67. Ibid., p. 412.

68. Allan Cunningham, *The Lives of the Most Eminent British Painters and Sculptors*, New York, 1844, vol. 3, p. 215.

69. Ibid., p. 220.

70. Canova was portrayed by more than forty artists, and some twenty copies of Thomas Lawrence's painting of him are recorded.

71. Hugh Honour informs me that the bust was probably prompted by his great rival Bertel Thorvaldsen's commission to carve a self-portrait in 1810.

72. It was donated by Giovanni degli Alessandri, President of the Florentine Academy, to whom Canova had given it.

73. One of Canova's first pictorial experiments was a pastiche of a self-portrait by Giorgione. Giuseppe Pavanello, 'The Venetian Canova', in *Canova 1*, p. 48; pp. 90–2.

74. Reynolds, pp. 235, 238.
75. Ibid., p. 232.
76. Ibid., p. 233.
77. Even Bernini was happier talking about painters. See his bizarre and bathetic comments about sculpture in Baldinucci, p. 79.
78. Reynolds, pp. 239–40.
79. David Bindman and Malcolm Baker, *Roubiliac and the Eighteenth-Century Monument*, New Haven, 1995, p. 256.
80. See Kristen Gram Holmstrom, *Monodrama, Attitudes, Tableaux Vivants*, Stockholm, 1967, p. 112.
81. *Diderot*, vol. I, p. 159.
82. A similar tolerance of Rubens, but not of Bernini, was shown by the seventeenth-century Neo-Classical critic Giovan Pietro Bellori, and by Jacob Burckhardt in the nineteenth century.
83. Alex Potts, *Flesh and the Ideal: Winckelmann and the Origins of Art History*, New Haven, 1994, p. 96: 'One of the more intriguing features of his stylistic analysis of Greek sculpture of the classic period is his "discovery" of a high style whose very formation seems to be incompatible with its existence as a palpable historical reality.'
84. Cicognara, vol. III, p. 311. This was written as a sequel to Winckelmann. He does mention some sculptors from other European countries at the end of chapters, but only fleetingly.
85. Cicognara, vol. III, p. 314. He believed that sculpture declined at the end of the century.
86. Payne Knight, pp. 242–3.
87. Alex Potts, 'Greek Sculptures and Roman Copies I: Anton Raphael Mengs and the Eighteenth Century', *JWCI*, vol. XLIII, 1980, pp. 150–73; Haskell and Penny, pp. 99–107.
88. Goethe 1, p. 170.
89. *Canova 1*, p. 346ff.; Oskar Bätschmann, *The Artist in the Modern World: The Conflict Between Market and Self-Expression*, New Haven, 1997, p. 81ff.
90. Hegel, p. 788.
91. Ibid., pp. 799, 813. Hegel was following Herder's *Plastik* (1778): 'the forms of sculpture are as uniform and eternal as simple, pure human nature; the shapes of painting, which are a tablet of time, change with history, race and times'. Herder, p. 494.
92. Hegel, p. 803.
93. Belting, p. 221.
94. Hawthorne, p. 49.
95. Ibid., p. 391.

3. Sculpture in the Round

1. *Leonardo*, p. 40.
2. Voltaire, *Philosophical Dictionary*, ed. and trans. Theodore Besterman, Harmondsworth, 1972, p. 236.
3. *Goethe 2*, p. 11.
4. John Pope-Hennessy, 'The interaction of Painting and Sculpture in Florence in the fifteenth century', *The Journal of the Royal Society of Arts*, vol. 117, 1969, pp. 406–24; Ulrich Middeldorf, 'Some Florentine Painted Madonna Reliefs', in *Collaboration in Italian Art*, ed. Wendy Steadman Heard and John T. Paoletti, New Haven, 1978, pp. 77–84.
5. Pope-Hennessy 1, p. 9.
6. The whole section is printed in Gilbert, pp. 75–87.
7. *Alberti 1*, p. 62.
8. Ibid., p. 65.
9. Ibid., p. 57. This was to become a commonplace. See, for example, *Winckelmann 2*, p. 80.
10. Charles Seymour, *Sculpture in Italy 1400–1500*, Harmondsworth, 1966, pp. 4–5, notes that 'for a short period towards 1410 the documents of the Florentine cathedral archives refer to marble figures in the full round as *picturae*, a usage perhaps encouraged by the practice of using painters to design, draw, and colour designs from statues and then, after the sculptors had carved the figures, to gild or to colour them'.
11. Michael Greenhalgh, *Donatello and his Sources*, London, 1982, p. 4.
12. *Alberti 1*, p. 73.
13. Alberti 2, p. 241.
14. Ibid., pp. 266–8.
15. Ibid., p. 243.
16. Ibid.
17. Kenneth Clark, 'Leon Battista Alberti on Painting', in *The Art of Humanism*, London, 1983, p. 91.
18. Bevan, p. 148. The Greek Church never had any systematic dogma condemning statues, so statues did not disappear entirely. The pious Emperor Justinian erected statues of himself and Empress Theodora in public squares and gardens in Constantinople. We also hear of ceremonies involving statues. (Ibid., p. 145.)
19. For interpretations of the Second Commandment, see ibid., pp. 46–50, 53, 67.
20. Runciman, op. cit., p. 81.
21. Michael Levey, *The Painter Depicted*, London, 1981, pp. 14–18; Dorothee Klein, *St Lukas als Maler der Maria*, Berlin, 1933.
22. Cennini, p. 2.
23. Rainald Grosshans, *Maerten van Heemskerck: Die Gemälde*, Berlin, 1980,

pp. 195–201.

24. Belting, pp. 478–9. See also the image of Michelangelo, chapter 1.

25. Ibid., pp. 304–5.

26. Freedberg, p. 174ff. See also Irving Lavin, 'The *Ars Moriendi* and the *Sangue di Cristo*', in Bauer, pp. 113–14.

27. Freedberg, pp. 183–4. The painters are looking at Christ, but seem to have different subject-matter on their easels. For self-portraits of painters painting religious scenes, see Woods-Marsden, p. 238ff.

28. Alberti 2, p. 330.

29. Andrew Butterfield, *The Sculptures of Andrea del Verrocchio*, New Haven, 1997, pp. 126–35, 222–3.

30. Patricia Fortini Brown, *Venice and Antiquity*, New Haven, 1996, pp. 215–16.

31. It was designed to be placed high up on the outside of the cathedral.

32. *Night* and *Day* are almost an illustration of Leonardo's point that two points of view, diametrically opposed, are sufficient to make the whole of a sculpture visible. The painter, by showing the contour twice – i.e. a front view and a back view of the same figure – could show everything that sculpture shows, but simultaneously. See David Summers, 'Figure come Fratelli: A Transformation of Symmetry in Renaissance Painting', in *Art Quarterly*, vol. I, 1977, pp. 59–88; L. Fusco, 'The Use of Sculptural Models by Painters in Fifteenth Century Italy', *Art Bulletin*, June 1982, pp. 175–94.

33. For the 'Medusa topos', see Shearman, pp. 48–50.

34. Wittkower 2, pp. 128–9.

35. Translation in Blunt, p. 73.

36. For Vasari and *disegno*, see Rubin, pp. 241–6.

37. This is particularly so with the second edition, in which the entries on sculpture were substantially beefed up. Ibid., pp. 210–11. However, the longest life, on Bandinelli, was a hatchet-job.

38. Said in answer to Benedetto Varchi's opinion poll on the visual arts. Barocchi, vol. 1, p. 497.

39. Ibid., pp. 546–7; see also Antoine Coypel, in *Conférences de L'Académie Royale*, ed. M. Henry Jouin, Paris, 1883, p. 216.

40. Barocchi, vol. I, p. 545.

41. Elisabeth Blair MacDougall, *Fountains, Statues and Flowers: Studies in Italian Gardens of the Sixteenth and Seventeenth Centuries*, Washington, 1994, p. 23ff.

42. Ibid., p.118.

43. This was the unwitting implication of the full title of an exhibition at the Hayward Gallery, London, in 1991:

Richard Long: Walking in Circles
Sponsored by Becks Beer

44. Claudia Lazzaro, *The Italian Renaissance Garden*, New Haven, 1990, p. 131.

45. 'Prior to 1816, when it was cast, the figure was set more deeply in its niche than it is now,' Pope-Hennessy 2, p. 433.

46. Haskell and Penny, p. 13.

47. Cellini, p. 384; see also Pope-Hennessy 2, pp. 133–4; Wittkower 3, p. 147.

48. Butters, p. 152.

49. Vincenzo Borghini, quoted in Barocchi, vol. I, p. 642.

50. Vasari, vol. 1, p. 644. Vasari may have learned about it from Paolo Pino's *Dialogo di Pittura* (1548). If so, he changed his source, for Pino refers to 'an armed St George, standing and leaning on the shaft of a spear'. He is reflected in two mirrors. Barocchi, vol. I, p. 552. The painting is lost.

51. Bronze casters also made weapons, so the link was even closer.

52. Vasari, vol. I, p. 641.

53. *Giambologna, Sculptor to the Medici, 1529–1608*, EC, ed. Charles Avery and Anthony Radcliffe, Victoria and Albert Museum, London, 1978, no. 210.

54. Avery 1, p. 114; see also Pope-Hennessy 2, p. 153.

55. Avery 1, p. 114.

56. Ibid., p. 112.

57. Yates, pp. 281–4. Bruno's work remained unpublished until 1891.

58. Ibid., p. 249.

59. Ibid., p. 284.

60. Avery 1, p. 139.

61. Kenseth, p. 191ff.

62. Avery 2, p. 63.

63. St Teresa herself had compared her own visions to paintings. *The Life of St Teresa*, trans. J. M. Cohen, Harmondsworth, 1957, p. 199. See also Richard Crashaw's poem, which was inspired by Bernini's sculpture, *The Poems English, Latin and Greek of Richard Crashaw*, ed. L. C. Martin, Oxford, 1957, p. 324ff.

64. Bauer, pp. 47–8.

65. Irving Lavin, 'The *Ars Moriendi* and the *Sangue di Christo*', in ibid., pp. 111–26. Bernini might have used a sculpture for this purpose. He later made a half-length sculpted figure of Christ, with a seven-foot-high pedestal, which was left to the Queen of Sweden in his will. Baldinucci, p. 66; Avery 2, pp. 173–7.

66. Brown.

67. Before the seventeenth century, the mind might be regarded as a repository of visual images. Aristotle said that it was 'impossible even to think without a mental picture'. Yates, p. 47. Plato had reservations about whether the 'scribe' and the 'painter', whom he imagined working away

in the soul, would give a true representation of reality. Plato, 'Philebus', 38e–39a, in *The Dialogues of Plato*, ed. B. Jowett, London, 1871, pp. 595–6.

68. Charles H. Hinnart notes that Marvell is rejecting the Tudor and Jacobean tradition of 'verbal tapestry paintings'. 'Marvell's Gallery of Art', *Renaissance Quarterly*, vol. 24, 1971, p. 29. Tapestries were the most expensive luxuries of the time. In King Charles' collection a nine-panel tapestry of Raphael's *Acts of the Apostles* was valued at £7,000; the most expensive painting, Raphael's *Holy Family*, was valued at £2,000; Brown, pp. 228–9. Tapestries, however, were often designed by painters.

69. Quoted by Jean Seznec, *Essais sur Diderot et L'Antiquité*, Oxford, 1957, p. 78.

70. Hazlitt, pp. 668–9.

71. Hazlitt: 'I say nothing of the statues [in the Louvre]; for I know little of sculpture, and never liked any till I saw the Elgin Marbles.' Ibid., p. 629.

72. Guy Walton, *Louis XIV's Versailles*, Harmondsworth, 1986, p. 82ff. Kenneth Woodbridge, *Princely Gardens: the Origins and Development of the French Formal Style*, London, 1986, p. 214.

73. Haskell and Penny, p. 39; Montagu, pp. 169–72.

74. Roy Strong, *Splendour at Court: Renaissance Spectacle and Illusion*, London, 1973, p. 73. I am grateful to Françoise Carter for this reference. In 1703 the Academy of Architecture formulated precise viewing distances for buildings based on size, and similar rules were probably also applied to gardens, and to painting and sculpture. See Michael Baxandall, *Patterns of Intention: On the Historical Explanation of Pictures*, New Haven, 1985, p. 99; McClellan, pp. 74–7.

75. Avery 2, pp. 247–8. The architect Charles Mansart made the drawings from which sculptors worked when he was in charge of the campaign to erect equestrian monuments of Louis XIV in various French cities. See Michael Martin, *Les Monuments Equestres de Louis XIV*, Paris, 1986, p. 74 ff. Martin implies that the viewer was expected to wander freely round the sculptures. I disagree: they were surely meant to be seen at their best from a series of fixed viewpoints, as were the buildings that frame them.

76. John Dixon Hunt, *The Figure in the Landscape: Poetry, Painting and Gardening during the Eighteenth Century*, Baltimore, 1989, p. 64.

77. He was later ridiculed by Pope in *The Dunciad*.

78. Erwin Panofsky, *Galileo as a Critic of the Arts*, The Hague, 1954. See also Martin Kemp, *The Science of Art: Optical Themes in Western Art from Brunelleschi to Seurat*, New Haven, 1990, pp. 93–9. Kemp's book suggests the 'unscientific' nature of sculpture. Of the 553 illustrations, only seven refer to sculpture. The magnificent seven are reliefs by Donatello and Ghiberti.

79. Colin Murray Turbayne, *The Myth of Metaphor*, Columbia, South Carolina, 1970, p. 203.

80. Svetlana Alpers, *The Art of Describing*, London, 1989, pp. 37–8.

81. Turbayne, op. cit., p. 204.

82. For *tabula rasa*, see John W. Yolton, *A Locke Dictionary*, Oxford, 1993, pp. 288–9.

83. *The Philosophical Writings of Descartes*, trans. John Cottingham, Robert Stoothoff and Dugald Murdoch, Cambridge, 1985, vol. I, p. 165, #112.

84. John Locke, *An Essay Concerning Human Understanding*, 5th edition, London, 1706, book II, chapter I, #2.

85. G. W. Leibniz, *New Essays on Human Understanding*, trans. Peter Remnant and Jonathan Bennett, Cambridge, 1981, #53.

86. Ibid., #52.

87. Ibid., #144–5.

88. See chapter 10, 'Beyond Relief', and Part Two generally.

89. M. H. Abrams, *The Mirror and the Lamp*, Oxford, 1953, p. 57ff.

90. See 'Toward the Tabula Rasa', chapter IV of Rosenblum, who makes no mention of the philosophical origins of the idea of the *tabula rasa*.

91. Said in response to Varchi's opinion poll. See Summers, p. 269ff.

92. Quoted by Praz, p. 59. The French sculptor Etienne-Maurice Falconet was one of many in the eighteenth and nineteenth centuries who thought plaster casts superior to originals, particularly for the purpose of study.

93. Winckelmann 1, vol. II, p. 41. See also the Dutch antiquarian François Hemsterhuis, *Lettre sur la Sculpture* (1765), ed. Emmanuelle Baillon, Paris, 1991, p. 39: 'beauty in all the arts ought to give us the greatest number of ideas in the smallest space of time'.

94. The Laocoön was displayed in a poorly lit niche in a courtyard in the Vatican. David Irwin, *Neoclassicism*, London, 1997, p. 24.

95. Haskell and Penny, p. 114.

96. Paola Barocchi, *Michelangelo's Bacchus*, Florence, 1982, p. 8. It was, however, illustrated from three sides in Anton Francesco Gori's *Museum Florentinum*, Florence, 1734, vol. III, plates LI, LII and LIII. The antique statues *Amor et Psyche* (XLIII and XLIIII), *Hermaphrodite* (XL and XLI), *Faun* (LVIII and LVIII) and the *Explorator* (XCV and XCVI) are shown from two angles. It was perhaps more acceptable to view *Bacchus* from several angles when it had been transformed into discrete pictures, than in real life.

97. Cicognara, vol. 2, pp. 386, 285.

98. Honour 3, p. 113.

99. Irwin, op. cit., p. 45.

100. Rosenblum, p. 167. For Ghiberti's reputation, see Richard Krautheimer, *Lorenzo Ghiberti*, Princeton, 1982, p. 22ff.

101. Joseph Farrington in 1806; Rosenblum, p. 167.
102. John Flaxman, *Lectures on Sculpture*, 2nd edition, 1838, p. 188.
103. Bruce Tattersall, 'Flaxman and Wedgwood', in *Flaxman*, p. 48.
104. Letter to Louise Colet, 18 September 1846. Gustave Flaubert, *Selected Letters*, trans. Geoffrey Wall, Harmondsworth, 1997, p. 86.
105. *Flaxman*, p. 86. In 1810 he was appointed the first ever Professor of Sculpture at the Royal Academy, most probably due to his engravings.
106. Sarah Symmons, 'Flaxman and the Continent', in *Flaxman*, p. 154.
107. Heinrich von Kleist, 'On the Marionette Theatre', in *Essays on Dolls*, London, 1994, p. 6.
108. Kenseth, p. 191.
109. Avery 2, p. 55.
110. Quatremère de Quincy, writing in 1834, thought it was a sort of 'Bernini antico'. *Canova 1*, p. 236.
111. Cicognara, vol. III, p. 251. For Canova and Ghiberti, see p. 319.
112. *Canova 1*, p. 236.
113. Hegel, p. 532.
114. Ibid., p. 532.
115. Ibid., p. 532.
116. It is the first of the three 'Romantic' arts (before music and poetry).
117. Baudelaire 1, p. 111.

4. Sight versus Touch

1. Richard Rorty, *Philosophy and the Mirror of Nature*, Princeton, 1980, pp. 38–9. This chapter shows that it is not a 'fruitless' inquiry to make – at least for the post-classical period.
2. *Leonardo*, p. 20.
3. Ibid., p. 18.
4. Ibid., p. 15.
5. For a bibliography on touch, see Martin Jay, *Downcast Eyes: The Denigration of Vision in Twentieth-Century French Thought*, Berkeley, 1993. For scientific ideas about touch, see Diane Ackerman, *A Natural History of the Senses*, London, 1990, pp. 65–123.
6. Barocchi, vol. 1, p. 533.
7. *Dio Chrysostom*, trans. J. W. Cohoon, London, 1939, vol. 2, 'The Twelfth, or Olympic, Discourse: on man's first conception of God', p. 65 (#61): 'For precisely as infant children when torn away from their father or mother are filled with terrible longing and desire, and stretch out their hands to their absent parents often in their dreams, so also do men to the gods.'
8. John Larson, 'The Cleaning of Michelangelo's Taddei Tondo', *Burlington Magazine*, CXXXIII, Dec. 1991, p. 845.

9. Margaret Aston, *England's Iconoclasts Vol. 1: Laws Against Images*, Oxford, 1988, p. 152. I am grateful to Andrew Graham-Dixon for drawing my attention to this book.

10. Belting, pp. 416–17; Henk van Os, *The Art of Devotion*, EC, Rijksmuseum, Amsterdam, 1994, pp. 98–103.

11. Christiane Klapisch-Zuber, 'Holy Dolls: Play and Piety in Florence in the Quattrocento', in McHam, pp. 120–1.

12. Elizabeth Gilmour Holt, *A Documentary History of Art*, Vol. I, Princeton, 1981, p. 164. Richard Krautheimer, in *Lorenzo Ghiberti*, Princeton, 1982, pp. 282–3, says that Ghiberti was only interested in tactile qualities at the beginning and end of his career.

13. Anthony Ratcliffe, *European Bronze Statuettes*, London, 1966, p. 23.

14. Pope-Hennessy 1, p. 287.

15. Texts by Martial and Statius had survived in which they had praised a statuette belonging to Novius Vindex, and before that to Alexander, Hannibal and Sulla. Jennifer Montagu, *Bronzes*, London, 1963, pp. 5–6.

16. Penny, pp. 246–7, observes that Roman statuettes invited and warranted 'rotation' far less than Renaissance bronzes because they were 'for the most part sculptures of divinities before which prayers were made or to which tribute was brought.'

17. Anthony Synnott, 'Puzzling over the Senses: From Plato to Marx', in *The Varieties of Sensory Experience: A Sourcebook in the Anthropology of the Senses*, ed. David Howes, Toronto, 1991, pp. 61–76; Karl Nordenfalk, 'The Five Senses in Late Medieval and Renaissance Art', in *JWCI*, vol. XLVIII, 1985, pp. 1–22.

18. The association of touch with carnal love was a prime reason for condemning it – see Ficino's remarks quoted by Leatrice Mendelsohn, *Paragoni: Benedetto Varchi's Due Lezzioni and Cinquecento Art Theory*, Ann Arbor, 1982, p. 61.

19. John Pope-Hennessy, *The Portrait in the Renaissance*, Princeton, 1966, pp. 145–6, 318, note 46. In Rembrandt's painting, Aristotle's hand rests on Homer's bald patch, making it a less entangled form of touch.

20. See Carlos M. N. Eire, *War Against the Idols: The Reformation of Worship from Erasmus to Calvin*, Cambridge, 1986, p. 40.

21. Ibid.

22. Belting, p. 299.

23. Barocchi, vol. I, p. 637.

24. Ibid., p. 615.

25. Ibid., p. 639.

26. Erwin Panofsky, *Galileo as a Critic of the Arts*, The Hague, 1954, p. 32.

27. For the theme of men touching busts, see 'Aristotle', in Julius S. Held, *Rembrandt Studies*, Princeton, 1991, p. 17ff. Held does not, however, refer

to the theme of blind men, or to the *paragone* debates.

28. Peter Hecht, 'The Paragone Debate', *Semiolus*, vol. 14, no. 2, 1984, pp. 125–36. The picture is in the Galleria Sabauda, Turin.

29. D. Fitz Darby, 'Ribera and the Blind Man', *Art Bulletin*, September 1957, pp. 195–217. The standard account of Gonnelli is Filippo Baldinucci, *Notizie dei Professori del Disegno*, Florence, 1728, vol. VI, pp. 253–8.

30. Cesare Ripa, *Iconologia*, Rome, 1603, p. 446 (entry on sculpture).

31. Rudolf Preimesberger, 'Themes from Art Theory in the Early Works of Bernini', in *Gianlorenzo Bernini: New Aspects of His Art and Thought*, ed. Irving Lavin, University Park, 1985, pp. 1–18.

32. Chantelou, p. 23.

33. Avery 2, pp. 267–8; and Montagu, p. 106.

34. Chantelou, p. 185.

35. Ibid., p. 186. Chantelou reiterates that 'whenever there is anything new to be seen', French people touch it.

36. De Piles refers to Gonnelli in *Dialogue sur le Coloris*, Paris, 1673, pp. 19–23.

37. Roger de Piles, *Cours de Peinture*, Paris, 1708, p. 330.

38. De Piles, *Cours de Peinture*, op. cit., p. 332 (not quoted by Lichtenstein).

39. Ibid., pp. 333–4. For a reprise of these ideas, see Charles-Nicolas Cochin, *Voyage d'Italie*, Paris, 1758, vol. II, p. 88.

40. Roger de Piles, *Conversation sur la connaissance de la peinture et sur le jugement qu'on doit faire des tableaux*, Paris, 1677, p. 300; Lichtenstein, p. 162.

41. Morgan; William R. Paulson, *Enlightenment, Romanticism, and the Blind in France*, Princeton, 1987.

42. Herder, p. 475.

43. The theories of Newton were used by Frances Hutcheson to vindicate touch; see David Solkin, *Painting for Money*, New Haven, 1993, p. 233.

44. 'Letter on the Deaf and Dumb', quoted in Norton, p. 217. Locke's follower, George Berkeley, paved the way for this sort of conclusion in *An Essay Toward a New Theory of Vision* (1709).

45. Morgan, p. 35 (almost the whole letter is quoted).

46. Ibid., pp. 47–8.

47. Ibid., p. 57.

48. See Paulson, op. cit., p. 52.

49. Rousseau, p. 133.

50. Ibid., p. 143.

51. Ibid., p. 144.

52. Ibid., p. 144.

53. The only actual example of a blind person's experience of art in the *Letter on the blind* concerns drawing – albeit on skin! See Morgan, p. 48.

54. Norton, pp. 203–32; Michael Podro, 'Herder's Plastik', in Onians, pp. 341–54.

55. Herder, p. 469.

56. Ibid., p. 478.

57. Ibid., p. 483.

58. *The Glory of Venice: Art in the Eighteenth Century*, EC, ed. Jane Martineau and Andrew Robinson, Royal Academy, London, 1994, pp. 446–7. I am grateful to Bruce Boucher for drawing my attention to Corradini.

59. *Winckelmann 2*, p. 71. For the Greeks' love of swimming, see p. 62.

60. Ibid., pp. 72, 93, 119, 80.

61. Herder, p. 528.

62. For baroque fountains, see Bruce Boucher, *Italian Baroque Sculpture*, London, 1998, p. 39ff.: C. d'Onofrio, *Le Fontane di Roma*, Rome, 1967.

63. Jurgen Baltrusaitis, *Aberrations: An Essay on the Legend of Forms*, trans. Richard Miller, Cambridge, Mass., 1989, p. 87.

64. J. A. Pinto, *The Trevi Fountain*, New Haven, 1986, p. 221.

65. Winckelmann 1, vol II, p. 126.

66. Ibid., p. 192.

67. Ibid., p. 209.

68. Herder, p. 528.

69. For statuettes in clay and porcelain, see Levey, p. 119.

70. François-René de Chateaubriand, *Oeuvres romanesques et voyages*, Paris, 1969, vol. II, pp. 1783, 1474. Quoted by Vidler, pp. 47, 49. From the mid-eighteenth century the French were haunted by the fear of live burial. Robert Favré, *La Mort au Siècle des Lumières*, Lyons, 1978, pp. 365–6.

71. Diderot, vol. I, p. 161.

72. Jean-Antoine Houdon is the exception to prove the rule. The eyes in Houdon's busts were deeply undercut, except in the 'deliberately classic works'. So Houdon is not strictly a Neo-Classical sculptor. H. H. Arnason, *The Sculptures of Houdon*, London, 1975, p. 20.

73. Hugh Honour informs me that Canova always indicated pupils in portraits, sometimes indicated them in mythological statues such as the Hercules, and often resolved the problem by lowering the upper lid.

74. Edmund Burke, *Philosophical Enquiry into the Origin of our Ideas of the Sublime and Beautiful*, London, 1759, part II, #14.

75. Hugh Honour, 'Canova's Three Graces', in *Canova 2*, p. 45. See also Ugo Foscolo's remarks, quoted by Carol Ockham, in *Ingres's Eroticized Bodies*, New Haven, 1995, p. 50.

76. Johann Wolfgang von Goethe, *Roman Elegies and Venetian Epigrams*, trans. L. R. Lind, University of Kansas, 1974, p. 45 (no. 5).

77. See epigraph and note 1.

78. Letter to Korner, 1 November 1790. Quoted in Friedrich Schiller, *On the Aesthetic Education of Man*, ed. and trans. Elizabeth M. Wilkinson and L. A.

Willoughby, Oxford, 1967, p. xxxvi.

79. Arnason, op. cit., p. 23.
80. Canova used a variety of textures in *Cupid and Psyche*, which his contemporaries regarded as his most Bernini-esque, but 'seldom repeated' such virtuoso effects. Penny, p. 91.
81. Baudelaire 1, p. 205.
82. Burke, op. cit., part II, #14 and 20.
83. Norton, p. 203.
84. Herder, p. 490.
85. Ibid., p. 523.
86. Quoted by Lessing in chapter 25 of *Laocoön*, and partially refuted: 'there are some such objects. A mole on the face, a harelip, a flat nose with prominent nostrils, a complete lack of eyebrows are cases of ugliness repugnant to neither our sense of smell nor taste nor touch.' Lessing, p. 131. For the ethos that prevented physicians from touching patients, see Roy Porter, 'The Rise of Physical Examination', in *Medicine and the Five Senses*, ed. W. F. Bynum and Roy Porter, Cambridge, 1993, pp. 184–5.
87. Jean-Paul Sartre, *Being and Nothingness* (1943), trans. Hazel E. Barnes, London, 1958, p. 579.
88. See Herder, p. 526, and chapter 12 of this book.
89. Byron, *Don Juan*, canto II, verse 118.
90. See Haskell, p. 236.
91. Ibid., pp. 237–8; McClellan, p. 155ff.
92. Ibid., p. 156.
93. Ibid., p. 182.
94. Ibid., p. 184. In 1833 Victor Hugo was to coin the term 'restorative vandalism'; Gamboni, pp. 39, 217.
95. For Leopoldo Cicognara's complaints, see Haskell, p. 247.
96. McClellan, pp. 166–7.
97. Baudelaire 1, p. 111. My translation: Mayne has bowdlerized Baudelaire.
98. Paulson, op. cit., p. 113.
99. George Eliot, *Romola*, ed. A. Sanders, Harmondsworth, 1980, Ch. 5.
100. Ibid., p. 101.
101. Ibid., chapter 59, p. 571. Hugh Witemeyer, *George Eliot and the Visual Arts*, New Haven, 1979, p. 15, says that the painter and feminist Barbara Leigh Smith Bodichon was probably the model for Romola.
102. Eliot, op. cit., chapter 67, pp. 637–9.
103. In her subsequent novels, classical sculpture is treated more sympathetically, but it is much more peripheral than painting. Witemeyer, op. cit., p. 38, says that 'to paint a picture' was Eliot's 'favourite figure of speech for the realization of vision in literature', though she did like grand 'statuesque' female forms (ibid., p. 89).

5. Sculpture and Language

1. Barocchi, vol. 1, pp. 645–6.
2. Quoted by Thomas Puttfarken, *Roger de Piles' Theory of Art*, New Haven, 1985, p. 58.
3. Quoted by Peter Gay, *The Bourgeois Experience: Victoria to Freud – Volume I: Education of the Senses*, New York, 1984, p. 399.
4. The association of painting with poetry is also a feature of Eastern culture. See Joseph Alsop, *The Rare Art Traditions*, London, 1982, p. 220ff.
5. The two standard works are Lee and Hagstrum.
6. Hagstrum, chapter I.
7. J. J. Pollitt, *The Art of Ancient Greece: Sources and Documents*, Cambridge, 1990, p. 225.
8. Hagstrum, p. 13.
9. Ibid., p. 3.
10. Kristeller, p. 183.
11. Lessing, pp. 74, 207.
12. Stephen Larrabee, 'Critical Terms from the Art of Sculpture', in *Notes and Queries*, 3 April 1937, p. 239.
13. For medieval views on words and images, see Barasch, pp. 63–6.
14. Bevan, p. 126.
15. John Gage, *Colour and Culture*, London, 1993, p. 48.
16. See Filippo Villani's remarks in Michael Baxandall, *Giotto and the Orators*, Oxford, 1971, p. 71.
17. Cennini, pp. 1–2.
18. Horace, *The Art of Poetry*, ed. and trans. Edward Henry Blakeney, New York, 1970, p. 41: 'Suppose a painter wished to couple a horse's neck with a man's head, and to lay feathers of every hue on limbs gathered here and there, so that a woman, lovely above, foully ended in an ugly fish below; would you restrain your laughter, my friends, if admitted to a private view?'
19. Paolo Pini, *Dialoghi di Pittura*, (1548), ed. E. Camesasca, Milan, 1954, p. 44.
20. David Cast, *The Calumny of Apelles*, New Haven, 1981, p. 125.
21. Blunt, p. 53, note 2.
22. Barocchi, vol. 2, p. 1153, notes the 'meagre critical fortunes of sculpture'. See also Herder, *Plastica*, ed. Giorgio Maragliano, Palermo, 1994, p. 12.
23. Alberti's *De Statua* (c. 1443–52) was probably unfinished and, when published, was little read. Ghiberti's *Commentaries* (c. 1445–55) survive in one manuscript, first published in 1912. Gauricus' *De Statua* (1504) was scarcely read. Cellini's *Autobiography* was first published in 1728, but was only widely known outside Italy in the nineteenth century. For some publishing histories, see Kemp, p. 79ff.
24. Vasari, vol. I, pp. 14–22.

25. Comte de Caylus, 'Reflexions sur la Sculpture', *Vies d'Artistes du XVIII Siècle*, ed. André Fontaine, Paris, 1910, p. 183.

26. Brown, p. 247.

27. Jacques Derrida, *Of Grammatology*, trans. G. Spivak, Baltimore, 1977, pp. 144–5; and 'The Supplement of Copula: Philosophy *before* Linguistics', in *Textual Strategies*, ed. Josue V. Harari, Ithaca, 1979, pp. 82–120.

28. Blunt, p. 103ff.

29. Summers, pp. 17–20, 129–34; Blunt, p. 112ff.

30. Klein and Zerner, p. 131.

31. Blunt, p. 116.

32. Klein and Zerner, pp. 127–8.

33. Part II, chapter III. *Don Quixote*, trans. J. M. Cohen, Harmondsworth, 1950, pp. 489–90. See also Emilie L. Bergmann, *Art Inscribed: Essays on Ekphrasis in Spanish Golden Age Poetry*, Cambridge, Mass., 1979, pp. 126–30.

34. Dubos, p. 173. For Dubos, see D. J. Gordon, 'Ripa's Fate', in *The Renaissance Imagination*, Berkeley, 1975, pp. 51–76.

35. Andrew Martindale and Edi Baccheschi, *The Complete Paintings of Giotto*, London, 1969, p. 106.

36. Bernard Berenson, *The Italian Painters of the Renaissance* (1894–1907), Oxford, 1952, p. 46.

37. John White has written, 'By this time Giovanni is working so completely on the painter's ground that he is fully committed to a competition which he cannot win.' 'Paragone', in *Studies in Renaissance Art*, London, 1983, p. 16.

38. See James A. W. Heffernan, *Museum of Words: The Poetics of Ekphrasis from Homer to Ashbery*, Chicago, 1993, pp. 37–45.

39. Byron L. Sherwin, *The Golem Legend: Origins and Implications*, New York, 1985, pp. 17–19.

40. Neil MacGregor, 'Foreword', Humphrey Vine, *Claude: The Poetic Landscape*, EC, National Gallery, London, 1994, p. 9: 'Alone among the great painters of Europe, Claude frequently wrote on to his paintings the subjects they represented. There the inscriptions stand, like irremovable labels.'

41. When reproduced, the inscriptions are often ignored by the photographer or book designer. Michelangelo's New Sacristy at San Lorenzo and the Julius Tomb lack inscriptions, but they were left unfinished. For inscriptions, see Sparrow; Philippe Aries, *The Hour of our Death*, Harmondsworth, 1981, p. 202ff.

42. Pope-Hennessy 1, p. 182, See also Irving Lavin, 'On the Sources and Meaning of the Renaissance Portrait Bust', in McHam, pp. 60–78.

43. Baxandall, op. cit., p. 90.

44. Sparrow, p. 26.

45. Erwin Panofsky, 'Albrecht Dürer and Classical Antiquity', in Panofsky, pp. 277–339. For the statue of Mercury, see Oskar Bätschmann and Pascal Griener, *Hans Holbein*, London, 1997, pp. 16–17.

46. Ibid., p. 30. They discuss the inscriptions.

47. Sparrow, pp. 25–6.

48. Haskell and Penny, p. 45: 'The amount of writing describing the beauties, discriminating the styles and assessing the artistic value of classical sculpture is negligible compared to the number of books devoted to topography, epigraphy and iconography for which taste was irrelevant.'

49. Ibid.

50. Chastel, p. 164.

51. Sparrow, p. 101–2.

52. No replicas were ever made of it. Haskell and Penny, pp. 291–2.

53. Shearman, p. 47. The modern term *pasquinade* derives from this statue.

54. Chantelou, p. 25.

55. Pamphlets of poems were on sale in the nineteenth century, according to Charles Godfrey Leland, *Legends of Florence*, 1st series, London, 1896, p. 64.

56. L. G. Giraldi, *Dialoghi*, 1545; cited by James Hutton, *The Greek Anthology in Italy to the Year 1800*, Ithaca, 1935, p. 60.

57. Shearman, p. 46.

58. This was in *I Ragionamenti*. See Jennifer M. Fletcher, 'The Venetian Self-Image' (book review), *The Art Newspaper*, May 1997, p. 33.

59. Pope-Hennessy 2, pp. 146–53, 489–90; Avery 1, p. 109ff.; Mary Weitzel Gibbons, *Giambologna: Narrator of the Catholic Reformation*, Berkeley, 1995, pp. 4, 87ff.

60. Gibbons sees the increasing use of relief in his late work as a response to the Council of Trent's insistence on clarity. Ibid., p. 19.

61. Margaret Aston, *England's Iconoclasts, Vol. 1: Laws against Images*, Oxford, 1988, p. 405.

62. Quoted in Thomas Puttfarken, *Roger de Piles' Theory of Art*, New Haven, 1985, p. 58. Dubos also thought that in sculpture 'invention' and the 'poetic part' were less in evidence. Dubos, pp. 397–8.

63. *The Essential Erasmus*, ed. John P. Dolan, New York, 1964, p. 134.

64. Richter, pp. 13–14.

65. Hagstrum, p. 145.

66. Ibid., p. 145.

67. *Selections from the Writings of Joseph Addison*, ed. Barrett Wendell and Chester Noyes Greenough, Boston, 1905, p. 78.

68. Sparrow, pp. 101–2.

69. David Bindman and Malcolm Baker, *Roubiliac and the Eighteenth-Century Monument*, New Haven, 1995, p. 321.

70. Chantelou, p. 30. That did not prevent the Cardinal from commissioning a bust, albeit more subdued, from the inflammatory Bernini.

71. Sparrow, p. 132.

72. de Caso, p. 104. Diderot says that the sculptor 'only has one word to say', and so 'this word must be energetic'. Quoted by Anne Betty Weinshenker, *Falconet: His Writings and His Friend Diderot*, Geneva, 1966, p. 113.

73. de Caso, p. 104. David also added facsimile signatures of the subject to his portrait medallions to increase their expressivity. Ibid., p. 173. His followers only put a bronze crown on his tomb.

74. Lessing, p. 5.

75. Ibid., p. 7.

76. Ibid., p. 8.

77. Ibid., p. 9.

78. Ibid., p. 11.

79. The Dutch antiquarian François Hemsterhuis thought that simplicity of subject was essential for sculpture. Thus there is scarcely any perfect sculptural group, and the art only reaches perfection in single figures. Even the *Laocoön* 'belongs more to painting than to sculpture', and in general 'our modern sculptors are too much painters'. *Lettre sur la Sculpture* (1765), ed. Emmanuelle Baillon, Paris, 1991, pp. 54–6.

80. See Haskell and Penny, pp. 221–4.

81. Lessing, pp. 151–2.

82. Martin Butlin, *William Blake*, EC, Tate Gallery, London, 1978, no. 315.

83. Grevel Lindop, 'When his Humanity awake', in *Times Literary Supplement*, 26 September 1997, p. 19. See also William Blake, *Milton, A Poem*, ed. Robert N. Essick and Joseph Viscomi, London, 1993, pp. 237–9.

84. Nancy M. Goslee, 'From Marble to Living Form: Sculpture as Art and Analogue from the Renaissance to Blake', *Journal of English and German Philology*, vol. 77, 1978, p. 189: 'the writing that encircles the figures forces us, instead, to turn the page again and again, denying the figures their space as we assert the control of word over image, or flat pictorial surface over sculptural form.'

85. The apogee of the 'Ozymandian' monument is the Vietnam War Memorial in Washington. It is like a half-buried obelisk placed on its side, and its polished surfaces are covered in the names of the dead.

86. Mario Praz, *The Romantic Agony*, trans. Angus Davidson, Oxford, 1970, p. 25.

87. Hegel believed that you needed to be armed with scholarship to appreciate sculpture. Hegel, p. 797. See also Diderot, vol. 1, p. 158.

88. McClellan, p. 156.

89. Ibid., p. 192.

90. Hawthorne, p. 125.

91. Theodore Ziolkowski, *Disenchanted Images: A Literary Iconology*, Princeton, 1977, p. 149. Mirrors are, however, better informed and more talkative than paintings.

92. J. L. Carr, 'Pygmalion and the Philosophers', *JWCI*, vol. XXIII, 1960, p. 253.

93. The Pygmalion myth influenced the statue in Etienne de Condillac's *Traité des sensations* (1754). Ibid., p. 254; Morgan, p. 62ff.

94. *Barasch 2*, p. 104.

95. *Les Carnets de David d'Angers*, ed. André Bruel, Paris, 1958, vol. 2, p. 4.

96. Carr, in Ibid., p. 242.

97. Canto VI, XLIII, ll 5–8 (1823). *Lord Byron: Don Juan*, ed. T. G. Steffan, E. Steffan and W. W. Pratt, New Haven, 1982, p. 274.

98. Richard Jenkyns, *Dignity and Decadence: Victorian Art and the Classical Inheritance*, London, 1991, p. 134.

99. Lines 311–12.100. Hegel, p. 816.

100 Hegel, p. 816.

101. Ibid., p. 826.

102. Ibid., p. 766.

103. George Combe, *Phrenology Applied to Painting and Sculpture*, London, 1855, p. 30. See also Charles Colbert, 'Each Little Hillock hath a Tongue: Phrenology and the Art of Hiram Powers', *Art Bulletin*, vol. LXVIII, June 1986, p. 288.

104. *Flaxman*, p. 118.

105. Leopold von Sacher-Masoch, 'Venus in Furs', in Gilles Deleuze, *Masochism*, New York, 1989, p. 271. 'She has come to life for my benefit like Pygmalion's statue', p. 156.

106. The cuckolded Vulcan had troubled relations with the opposite sex, and traps Aphrodite and Mars in a net.

107. Michael Holroyd, *Bernard Shaw*, London, 1997, p. 437. *Venus in Furs* was translated into English in 1902, so Shaw could have known about it.

108. Chapter 22. Quoted in Jenkins, p. 142.

109. Andro Linklater, *Compton Mackenzie: A Life*, London, 1987, p. 111.

110. Information from a lecture by Peter Read, 'Et moi aussi je suis Sculpteur: Movement, Immobility and Time in the Fictional Sculptures of Apollinaire', at the National Gallery of Modern Art, Edinburgh, 21 September 1996.

111. Apollinaire, *Oeuvres en prose complètes*, ed. Pierre Caizergues and Michel Décaudin, Paris, 1991, vol. II, pp. 572–5.

112. Ruskin contrasted the vacancy of the face in a Greek terracotta figure of

a dancing girl with the thoughtfulness of the face in a Fra Angelico madonna. See Jeanne Clegg and Paul Tucker, *Ruskin and Tuscany*, EC, Ruskin Gallery, Sheffield, 1992, p. 65.

113. Albert Boime, *Hollow Icons: the Politics of Sculpture in Nineteenth-Century France*, Kent State, Ohio, 1987, p. 3.

114. Anne Middleton Wagner, *Jean-Baptiste Carpeaux*, New Haven, 1986, p. 1.

6. Sculpture and Colour

1. *Filarete's Treatise on Architecture*, trans. John R. Spencer, New Haven, 1965, p. 309.
2. Quoted in *Marxism and Art*, ed. Maynard Solomon, London, 1979, p. 65.
3. Quoted by Andreas Blühm, 'In Living Colour', in *Colour*, p. 35.
4. Chaucer, 'The Franklin's Tale', in *The Complete Works of Geoffrey Chaucer*, ed. F. N. Robinson, Oxford, 1957, p. 135, ll. 723–7.
5. For colour and language, see Lichtenstein.
6. Erwin Panofsky, 'Erasmus and the Visual Arts', in *JWCI*, vol. XXXII, 1969, pp. 224–5.
7. Barasch 1, p. 359.
8. Honour 3, p. 114.
9. See the introduction to Friedrich von Schiller, *On the Aesthetic Education of Man*, ed. and trans. Elizabeth M. Wilkinson and L. A. Willoughby, Oxford, 1967.
10. C. A. du Fresnoy, *The Art of Painting*, with a Preface by Mr Dryden, 2nd edition, London, 1716, pp. li, lii.
11. Blake attacked those who advocated colour over line in 'To Venetian Artists': 'That God is Colouring Newton does shew; And that the devil is a Black outline, all of us know.' He used vivid colour in its 'proper place'.
12. Penny, p. 35ff.
13. Yates, p. 155. Montagu, p. 21. Orfeo Boselli, *Osservazioni della Scoltura Antica*, ed. P. D. Weil, Florence, 1978, f. 9.
14. Wittkower remarks: 'it is a serene, philosophical and almost puritanical architecture that [Alberti's] descriptions conjure up before us'. *Architectural Principles in the Age of Humanism*, London, 1973, p. 10.
15. J. Chipps Smith, *German Sculpture of the Later Renaissance c. 1520–1580: Art in an Age of Uncertainty*, Princeton, 1994, p. 37.
16. Francis Yates, *The French Academies of the Sixteenth Century*, New York, 1988, p. 111ff.
17. Ibid., p. 146.
18. Ibid., p. 145.
19. *Master Gregorius: The Marvels of Rome*, trans. J. Osborne, Toronto, 1987, p. 26.
20. Quoted by Timothy Clifford, 'Canova in Context', in *Canova 2*, p. 17.

21. Chantelou, p. 16.

22. A Russian woman called Marie Bashkirtsev; Praz, p. 220.

23. Jenkins, pp. 146–54.

24. Praz, p. 59.

25. Walter Pater, *The Renaissance*, ed. Kenneth Clark, London, 1961, p. 209.

26. Part Four: Epigrams and Interludes, no. 91. *Basic Writings of Nietzsche*, trans. Walter Kaufmann, New York, 1968, p. 272.

27. Luchs, p. 17.

28. Vasari, vol. I, pp. 559–60.

29. John Rupert Martin, *Baroque*, Harmondsworth, 1977, p. 271.

30. Barasch 1, p. 367.

31. *Goethe 2*, p. 17.

32. Joachim du Bellay, *Les Antiquités de Rome*, ed. Françoise Joukovsky, Paris, 1994, p. 27.

33. Jonathan Richardson, *Two Discourses* (1719), London, 1972, part II, p. 21.

34. Ibid., p. 33. The Ugolino bas-relief is now attributed to Pierino da Vinci. See *Michelangelo nell'Ottocento: il Centenario del 1875*, EC, ed. Stefano Corsi, Casa Buonarotti, Florence, 1994, p. 59, no. 47.

35. The Abbé Dubos is similarly reluctant to discuss sculpture, in case he grows 'tiresome' to his readers. Dubos, p. 340.

36. Richardson, op. cit., part II, p. 35.

37. Jenkins, p. 147.

38. Mark Norman and Richard Cook, ' "Just a tiny bit of rouge upon the lips and cheeks": Canova, Colour and the Classical Ideal', in *Canova: Ideal Heads*, EC, Ashmolean Museum, Oxford, 1997, pp. 47–58.

39. Hugh Honour, 'Canova's Three Graces', in *Canova 2*, p. 43.

40. Andreas Blühm, 'In Living Colour', in *Colour*, p. 16.

41. See Richard Jenkyns, *Dignity and Decadence: Victorian Art and the Classical Inheritance*, London, 1991, pp. 108–10.

42. See Olga Raggio, 'The Myth of Prometheus', in *JWCI*, vol. XXI, January 1958, p. 44ff.; Oskar Walzel, 'Das Prometheus Symbol von Shaftesbury zu Goethe', in *Neue Jahrbücher für das klassiche Altertum, Geschichte und deutsche literatur*, vol. 25, 1910, pp. 40–71, 133–65.

43. Rudolf Preimesberger, 'Themes from Art History in the Early Works', in *Gianlorenzo Bernini: New Aspects of His Art and Thought*, ed. Irving Lavin, University Park, 1985, pp. 1–4.

44. See Sharon Fermor, *Piero di Cosimo*, London, 1993, p. 92.

45. Raggio, in op. cit., illustration 7c & d, 8c.

46. See Ernst Kris and Otto Kurtz, *Legend, Myth and Magic in the Image of the Artist*, New Haven, 1979, p. 38ff.

47. Barocchi, vol. I, p. 594. See also p. 562.

48. Julius von Schlosser, 'Der Weltenmaler Zeus', in *Praludien*, Berlin, 1927,

pp. 296–303. E. R. Curtius, 'God as Maker', in *Curtius*, p. 545, says that 'occasionally also painting' was mentioned.

49. Book 1, chapter XLIX.

50. *Alberti 1,* p. 62.

51. Felix da Costa, *The Antiquity of the Art of Painting*, trans. George Kubler, New Haven, 1967, p. 380.

52. See Oskar Bätschmann, 'Pygmalion als Betrachter: Die Rezeption von Plastik und Malerei in der Zweiten Hälfte des 18. Jahrhunderts', in *Der Betrachter ist im Bild, Kunstwissenschaft und Rezeptionsästhetik*, ed. Wolfgang Kemp, Cologne, 1985, pp. 183–224. Compare Herder in *Italienische Reise*, ed. A. Meier, Munich, 1989, p. 191ff. See also Iain Gordon Brown, 'Canova, Thorvaldsen & The Ancients', in *Canova 2*, pp. 76–8, for the diary of Lord Minto. Rodin viewed casts of antiques by lamplight, as recounted by Paul Gsell. But Gsell's surprise at the practice shows that it had long since gone out of fashion. It had been killed off by the introduction of gas and then electric light in galleries. Auguste Rodin, *Art: Conversations with Paul Gsell*, trans. Jacques de Caso and Patricia B. Sanders, Berkeley, Ca., 1984, pp. 22–3.

53. Act III, scene III, 170–2. *Shelley's Prometheus Bound*, ed. Lawrence John Zillman, Seattle, 1959.

54. 'Commentary on Falconet', in *Goethe 2*, p. 17 (note).

55. *Poems of Matthew Arnold*, ed. Kenneth and Miriam Allott, London, 1979, pp. 318–19.

56. Lenoir's Museum of French Monuments had stained-glass windows, as did the Sir John Soane Museum, which opened in 1837.

57. See Blühm; J. L. Carr, 'Pygmalion and the Philosophes', in *JWCI*, vol. XXIII, 1960, pp. 239–55.

58. *Confessio Amantis*, book IV, pp. 11, 372ff., in *The English Works of John Gower*, ed. G. C. Macaulay, London, 1900, vol. I, pp. 311–13.

59. Blühm, p. 36.

60. Blühm cites three eighteenth-century reliefs. Ibid., nos 50, 80, 96.

61. Levey, pp. 133–5.

62. *Diderot*, vol. I, p. 167.

63. Blühm, in *Colour*, p. 26.

64. John Gage's translation, *Colour and Culture*, London, 1993, p. 11.

65. Blühm, in *Colour*, p. 26.

66. Quoted in Bauer, p. 54.

67. Blühm, in *Colour*, pp. 46–7.

7. The Classical Ideal

1. Vasari, vol. I, p. 135.

2. Giambattista Vico, 'De Nostri Temporis Studiorum Ratione', #12, in

Opere Filosofiche, Florence, 1971, p. 844.

3. Poem quoted in Gilbert, p. 174.

4. Patricia Fortini Brown, *Venice and Antiquity*, New Haven, 1996, p. 117.

5. See catalogue entry in Christopher Lloyd, *The Queen's Pictures*, National Gallery, London, 1991, no. 4; Peter Humfrey, *Lorenzo Lotto*, New Haven, 1997, pp. 106–7. For the decoration of collectors' studies with sculpture, see Dora Thornton, *The Scholar in his Study: Ownership and Experience in Renaissance Italy*, New Haven, 1997, pp. 99–103.

6. See Charles Perrault, *Paralèlle des Anciens et des Modernes en ce qui Regarde les Arts et les Sciences*, Paris, 1688, vol. 1, p. 177ff. Perrault argued that the painters of his day surpassed those of the High Renaissance (Raphael, Titian and Veronese), as well as the art of the painters of antiquity. Only in sculpture in the round – the most simple and limited of the arts – could the ancients be admitted to have excelled. They were feeble at the more 'intellectual' art of bas-relief because they did not understand perspective.

7. See Joyce, p. 219ff.

8. Pomponius Gauricus includes Apelles' paintings as examples of sculpture in Gauricus, pp. 42–3. But I have not come across any examples of modern sculptors being compared to Apelles.

9. For this theme, see Julius S. Held, 'Aristotle', in *Rembrandt Studies*, Princeton, 1991, p. 39ff.

10. Stuart Currie, 'Bronzino's Early Male Portraits', in *The Sculpted Object 1400–1700*, ed. Stuart Currie and Peta Motture, Aldershot, 1997, p. 121.

11. Luchs, pp. 9, 27; Barocchi, vol. 3, pp. 2878–82.

12. Vasari, vol. I, p. 619.

13. Ibid., vol. II, p. 735, for Michelangelo's 'innumerable' anatomical studies. The heavy emphasis on anatomy is a feature of the second, 1568 edition of the *Lives*. See Rubin, pp. 212–3.

14. Vasari, vol. I, p. 186.

15. *Alberti 1*, p. 36.

16. See Hans Baron, 'The Quarrel of the Ancients and the Moderns as a Problem in Renaissance Scholarship', in *Journal of the History of Ideas*, vol. XX, 1959, pp. 3–22; for a bibliography, see Michael Greenhalgh, in *The Classical Tradition in Art*, London, 1978, p. 256.

17. Modern scholars such as Wölfflin, Berenson and Panofsky have all said that Renaissance painting is superior to Renaissance sculpture because of the lack of antique models. See P. P. Bober, *Renaissance Artists and Antique Sculpture: A Handbook of Sources*, London, 1986, p. 32; Joyce, p. 219. Neither author gives references. For similar views, see Winckelmann 1, vol. II, pp. 133–4.

18. Gauricus, pp. 62–7. *The Aeneid*, book III, line 658; *The Odyssey*, book IX, lines 190–2. Translation of Homer: *The Odyssey*, trans. A. T. Murray,

London, 1953, vol. I, p. 317.

19. Joyce, p. 219, observes: 'The total loss of ancient paintings, however - or at least of all the masterpieces so warmly praised by the ancient sources – confronted both theorists and artists with a *tabula rasa* on to which each could project his own image, based on varying interpretations of the ancient authorities.'

20. Lee, p. 6, note 20, pp. 69–70.

21. Quoted in Peter Humfrey, *The Altarpiece in Renaissance Venice*, New Haven, 1993, p. 274.

22. Klein and Zerner, p. 23, Sabba di Castiglione, *Ricordi*, Milan 1559, p. 114. Typically, the only stylistic description of an artwork is of Leonardo's *Last Supper*: ibid, p. 116.

23. John T. Paoletti, 'Familiar Objects: Sculptural Types in the Collections of the Early Medici', in McHam, p. 98.

24. Haskell and Penny, p. 16.

25. Cellini, p. 298.

26. Haskell and Penny, p. 16.

27. Avery 1, passim and chapter 20.

28. Thomas Peacham, *The Compleat Gentleman*, London, 1634, pp. 107–8.

29. Antonio Francesco Gori, *Museum Florentinum*, Florence, 1734, vol. III, plates LI, LII and LIII (Michelangelo's *Bacchus*) and plate LIIII (Sansovino's *Bacchus*). For the history of the Tribuna, see Haskell and Penny, p. 53ff. Charles-Nicolas Cochin, in his *Voyage d'Italie*, Paris, 1758, vol. 2, p. 40ff., is unaware that one of the statues of Bacchus in the Uffizi is by Sansovino. The other modern sculptures he mentions are a female bust by Bernini, Michelangelo's *Brutus*, a female figure 'commencée par Michel-Ange', a small figure of *Bacchus* and a copy of *Laocoön* by Bandinelli, plus a figure by a pupil of Bernini.

30. For Sixtus IV, see Roberto Weiss, *The Renaissance Discovery of Classical Antiquity*, Oxford, 1988, p. 100. But see also Bush, p. 77.

31. Andrea Emiliani, *Leggi, bandi e provvedimenti per la tutela dei beni artistici e culturali negli antichi stati italiani 1571–1860*, Bologna, 1978, p. 32. The full list is as follows: Michelangelo, Raphael, Andrea del Sarto, Mecherino, Rosso, Leonardo, Franciabigio, Perino del Vaga, Pontormo, Titian, Salviati, Bronzino, Daniello da Volterra, Fra Bartolommeo, Sebastiano del Piombo, Fra Filippo Lippi, Antonio Correggio, Parmigiano and Perugino.

32. Vasari, vol. I, p. 805. (Vasari calls him Lorenzotto.) See also Haskell and Penny, p. 103; Michelangelo Cagiano De Azevedo, *Il Gusto nel Restauro Delle Opere D'Arte Antiche*, Rome, 1948, p. 13. Seymour Howard, *Antiquity Restored*, Vienna, 1990, p. 70, says that wholesale restoration only became commonplace after about 1540.

33. Quoted in Thomas M. Greene, *The Light in Troy*, New Haven, 1982, p. 169.

34. Cagiano De Azevedo, op. cit., pp. 36, 38.

35. Haskell and Penny, pp. 154–7, 205–7.

36. Nicole Dacos, 'Italian Art and the Art of Antiquity', in *History of Italian Art: Vol. I*, preface by Peter Burke, Cambridge, 1994, pp. 157–8.

37. Quoted by John Pope-Hennessy, *Cellini*, London, 1985, p. 227ff. Most of my translation is taken from Cellini, p. 335.

38. Montagu, pp. 161–2; for du Quesnoy as a perfect restorer, see Passeri, p. 92.

39. Jennifer Montagu, *Bronzes*, London, 1963, p. 5.

40. The attribution of Renaissance sculpture is particularly difficult. See E. R. D. Maclagen, in *Catalogue of a Collection of Italian Sculpture and other Plastic Art of the Renaissance*, London, 1912, pp. 18–19.

41. See Hugh Honour, 'Bronze Statuettes by Giacomo and Giovanni Zoffoli', *Connoisseur*, November 1961, p. 198. Andrew Butterfield says that if Verrocchio's *Il Pugilatore* was based on classical statuettes of a nude warrior in a similar pose, then it would be 'the only Renaissance statuette based directly on a small bronze from antiquity'. *The Sculptures of Andrea del Verrocchio*, New Haven, 1997, p. 126.

42. Anthony Hughes, 'Authority and Authenticity: Walter Benjamin and Michelangelo', in *Sculpture and its Reproductions*, ed. Anthony Hughes and Erich Ranfft, London, 1997, pp. 38–9.

43. Charles Seymour, *Sculpture in Italy 1400–1500*, Harmondsworth, 1966, p. 118. In around 1300 the sculptor Master Bertuccio signed a set of bronze doors made for the west façade of San Marco in Venice. Six large female heads adorn the main crossbar. They were cast from moulds made from classical originals. See Fortini Brown, op. cit., p. 28.

44. *Filarete's Treatise on Architecture*, trans. John R. Spencer, New Haven, 1965, p. 309.

45. Luchs, p. 109.

46. Caroline Elam, 'Lorenzo de Medici's Sculpture Garden', in *Mitteilungen des Kunsthistorischen Institutes in Florenz*, vol. XXXVI, 1992, pp. 41–83.

47. J. M. Fletcher, 'Isabella d'Este: Patron and Collector', in *Splendours of the Gonzagas*, EC, Victoria and Albert Museum, London, 1981, p. 53.

48. For a summary of the whole episode, and the sculpture's subsequent removal to, and disappearance in, England, see Hirst, pp. 20–8.

49. See A. Radcliffe, 'Antico and the Mantuan Bronze', in *Splendours of the Gonzaga*, op. cit., pp. 46–9. Isabella's court sculptor was the relatively undistinguished Gian Cristoforo Romano.

50. See Otto Kurz, *Fakes*, New York, 1967; *Fake?: The Art of Deception*, EC, ed. Mark Jones, British Museum, London, 1990.

51. Hirst, p. 23.

52. Vasari, vol. II, p. 845.

53. Gauricus, p. 12.

54. Isabella d'Este returned some statuettes when a panel of experts, including Jacopo Sansovino, decided they were modern fakes. See Fletcher, op. cit., p. 54.

55. Haskell and Penny, p. 13.

56. Herbert von Einem, *Michelangelo*, London, 1973, p. 250.

57. Orietta Rossi Pinelli, '*Chiurgia della memoria: scultura antica e restauri storici*', in Settis, vol. III, p. 199.

58. Reproduced in Howard, op. cit., p. 16.

59. Orfeo Boselli, *Osservazioni della Scoltura Antica*, ed. Phoebe Dent Weil, Florence, 1978, f. 171v. See also Montagu, pp. 151–72.

60. Passeri, pp. 199–200.

61. Quoted by Elizabeth Cropper, *The Ideal of Painting: Pietro Testa's Düsseldorf Notebook*, Princeton, 1984, p. 159.

62. Ibid., p. 159, note 70.

63. In Descartes' unfinished dialogue, *The Search after Truth*, an architectural metaphor is used and one of the speakers says, 'I do not wish to be placed amongst the number of these insignificant artisans, who apply themselves only to the restoration of old works, because they feel themselves incapable of achieving new.' *The Philosophical Works of Descartes*, trans. Elizabeth S. Haldane and G. R. T. Ross, Cambridge, 1911, p. 313.

64. C. A. du Fresnoy, *The Art of Painting*, with a Preface by Mr Dryden, 2nd edition, London, 1716, p. 96.

65. For Diderot, see Jean Seznoc, *Diderot et L'Antiquité*, Oxford, 1958, p. 43ff.

66. A. Dresdner, *Die Kunstkritic*, Munich, 1915, vol. 1, pp. 214–6.

67. Winckelmann 1, vol. II, p. 135.

68. Hugh Honour, 'English Patrons and Italian Sculptors in the First Part of the Eighteenth Century', in *Connoisseur*, May 1958, p. 225.

69. Winckelmann 1, vol. II, p. 198.

70. Ibid., vol. III, p. 218.

71. Quoted in Bauer, p. 56.

72. Harold Bloom, *The Anxiety of Influence: A Theory of Poetry*, New York, 1973. For the 'anxiety of influence' applied to painting, see Norman Bryson, *Tradition and Desire: from David to Delacroix*, Cambridge, 1984.

73. Honour, in *Connoisseur*, op. cit., p. 225. Honour has also observed, 'While most outstanding settecento painters are represented in English country house collections, very few important sculptors of the same period appear there except as the carvers of copies of antique statues.' 'After the Antique: Some Italian Bronzes of the Eighteenth Century', *Apollo*, 1963, p. 194.

74. Ibid., p. 194. Carl Goldstein, *Teaching Art: Academies and Schools from Vasari*

to Albers, Cambridge, 1996, p. 145: 'Painters [at the French Academy in Rome] made drawings after the sculptures with the aim of assimilating antique form. Sculptors were expected to submit themselves entirely to the antique.'

75. Haskell and Penny, p. 38.

76. For a comparison of prices for new work and restorations, see Hugh Honour, *Canova's Theseus and the Minotaur*, London, 1969, p. 11. Copying was often, however, more labour intensive than original work. See Honour 1, p. 153.

77. Howard, op. cit., p. 157.

78. Herder, p. 495.

79. See note 2.

80. Quoted by Agostino Lombardo, 'An English Paradox', in *Canova 1*, p. 11.

81. Cecil Gould, *Trophy of Conquest: the Musée Napoléon and the Creation of the Louvre*, London, 1965.

82. 'Bouchardon's *Amour*, Coustou's copy of du Quesnoy's *St Suzanna*, Giambologna's *Mercury*, and two antiques are on record as having been installed in the gallery after November 1797.' McClellan, pp. 255–6, note 58.

83. Charles de Tolnay, *Michelangelo*, Princeton, 1970, vol. IV, p. 97; Kenneth Woodbridge, *Princely Gardens: the Origins and Development of the French Formal Style*, London, 1986, p. 144. Most of the garden sculpture at Richelieu, which was complete by 1639, was antique or *all'antica*. The quantity of sculpture was unprecedented in France.

84. McClellan, p. 156.

85. Reynolds, p. 329.

86. *Flaxman*, p. 131. For Michelangelo's reputation in the seventeenth and eighteenth centuries, see Samuel H. Monk, *The Sublime*, Michigan, 1960, pp. 167–91.

87. Cicognara was at that very moment writing the first history of Italian sculpture, in which he singles out quattrocento sculpture for praise.

88. Gould, op. cit., p. 84.

89. Quoted in Janson, p. 14.

90. Jean-René Gaborit, *The Louvre: European Sculpture*, London, 1994, pp. 7–12; Haskell, p. 274.

91. Honour 4, p. 342, note 2.

92. Marcel Proust, *On Reading Ruskin*, ed. and trans. Jean Autret, William Burford and Phillip J. Wolfe, New Haven, 1987, p. 16. For the Leonardo cult, see A. Richard Turner, *Inventing Leonardo: The Anatomy of a Legend*, New York, 1993, p. 100ff.

93. Hawthorne, p. 124.

94. *Futurist Manifestoes*, ed. Umbro Apollonio, London, 1973, p. 51.

95. Ibid., p. 176.
96. Ibid., p. 51.
97. Ibid., p. 51.
98. Ibid., p. 176.

8. Worker–Artists i: Courbet to Picasso

1. Rilke, p. 58.
2. Quoted by Poggi, p. 179.
3. See Lynne Cooke, *In Tandem: the Painter-Sculptor in the Twentieth Century*, EC, Whitechapel Art Gallery, London, 1986.
4. *German Expressionist Sculpture*, EC, ed. Stephanie Barron, Los Angeles County Museum of Art, 1983, p. 47.
5. Quoted by Margaret A. Rose, *Marx's Lost Aesthetic: Karl Marx and the Visual Arts*, Cambridge, 1984, p. 81.
6. Marie-Thérèse de Forges, *Autoportraits de Courbet*, EC, Louvre, Paris, 1973.
7. *Gustave Courbet (1817–77)*, EC, Royal Academy, London, 1978, no. 9. This self-portrait has received little attention from scholars. Michael Fried briefly discusses it in *Courbet's Realism*, Chicago and London, 1990, p. 53ff.
8. Ibid., p. 59.
9. Honour 4, pp. 133–4. The carving of mountains was a characteristic Romantic ambition. See Charles W. Millard, 'Auguste Préault Sculptor', in *Auguste Préault 1809–1879: Romanticism in Bronze*, EC, Van Gogh Museum, Amsterdam, 1997, p. 19; Simon Schama, *Landscape and Memory*, London, 1995, pp. 385–446.
10. I am largely going by the Uffizi self-portrait collection, where sculptors have to paint a self-portrait before they can gain entry: in other words, sculptors dream of being painters.
11. Charles Léger, *Courbet*, Paris, 1929, p. 104. Courbet says in a letter to Francis Wey of December 1853 that he had started 'a life-size statue representing a Fisher of Bullheads' but could not continue with it 'because my atelier does not allow me to have anyone pose in the nude in winter, something I had not thought about'. Courbet, *Letters*, p. 119. However, his main period of sculptural activity seems to have started in the 1860s.
12. Léger, op. cit., p. 190ff.
13. Gamboni, pp. 39–42.
14. Klaus Herding, *Courbet: To Venture Independence*, New Haven, 1991, p. 6.
15. Honour 4, p. 157.
16. Haskell, p. 243.
17. Honour 4, p. 163.
18. Ibid., p. 182.

19. John Ruskin, *The Stones of Venice*, London, 1851–3, vol. II, chapter VI, #XIV.
20. Ibid., vol. II, chapter VI, #VIII.
21. Ibid., vol. II, chapter VI, #XXII.
22. Ibid., vol. II, chapter VI, #LXXVIII.
23. William Morris, *Three Works*, London, 1986, pp. 362–3.
24. *Gustave Courbet (1817–77)*, op. cit., p. 86.
25. James Henry Rubin, *Realism and Social Vision in Courbet and Proudhon*, Princeton, 1980, p. 10. See also M. Z. Shroder, *Icarus: The Image of the Artist in French Romanticism*, Cambridge, Mass., 1961, pp. 88–9; Neil McWilliam, *Dreams of Happiness: Social Art and the French Left 1830–1850*, Princeton, 1993.
26. Baudelaire 1, p. 111.
27. Quoted in T. J. Clark, *Image of the People: Gustave Courbet and the 1848 Revolution*, London, 1982, p. 146.
28. Courbet, *Letters*, p. 214.
29. Ibid., p. 204. Open letter to the young artists of Paris, 25 December 1861.
30. Ibid., p. 205. Letter to his father, 10 March 1862.
31. Ibid., p. 254. Letter to Max Buchon, early January 1865.
32. *Michelangelo nell'Ottocento: Il Centenario del 1875*, ed. S. Corsi, Casa Buonarroti, Florence 1994, p. 16. For Rodin's visit to Florence in 1876, see *Michelangelo nell'Ottocento: Rodin e Michelangelo*, EC, Casa Buonarroti, Florence, 1996; Butler, pp. 91–8.
33. The *Doni Tondo* in the Uffizi is the only painting in Florence.
34. It was first read as a self-portrait by a critic in 1855. For a discussion of the picture and a refutation of the idea that it is a self-portrait, see Lee Johnson, *The Paintings of Eugène Delacroix*, Oxford, 1986, vol. 3, pp. 126–8.
35. In the anniversary year of 1875 a piazza overlooking Florence was renamed Pizzale Michelangelo and bronze casts of *David* and the New Sacristy *Times of the Day* were placed there.
36. Cooke, op. cit., p. 12.
37. See 'Color and Worldview', in Herding, op. cit., pp. 111–34.
38. Ibid., p. 162.
39. Charles Léger, *Courbet Selon les Caricatures et les Images*, Paris, 1920, p. 51.
40. Herding, op. cit., p. 166.
41. John Berger, *The Success and Failure of Picasso*, London, 1992, p. 52.
42. Ivy, pp. 46, 41, 46.
43. *The Complete Letters of Vincent van Gogh*, London, 1958, 'Letters to Theo', no. 370.
44. This is emphatically borne out by a grotesque tableau from the 1970s in Los Angeles' *Palace of Living Arts*. Umberto Eco has described how Vincent is shown sitting in a bedroom adorned with his own paintings:

'But the striking thing is the face of the great lunatic: in wax, naturally, but meant to render faithfully the rapid, tormented brushstrokes of the artist, and thus the face seems devoured by some disgusting eczema, the beard is palpably moth-eaten, and the skin is flaking, with scurvy, herpes zoster, mycosis,' *Travels in Hyper-Reality*, trans. W. Weaver, London, 1987, p. 20.

45. Ernst van de Wetering, 'Rembrandt's Manner: Technique in the Service of Illusion', in *Rembrandt: the Master & His Workshop — Paintings*, EC, ed. Christopher Brown, Jan Kelch and Pieter van Thiel, National Gallery, London, 1991, p. 21. He refers primarily to Vasari and Karel van Mander. Richard Payne Knight, writing in 1810, believed that Rembrandt's technique, 'like all other extraordinary means of extraordinary men', is 'liable to great abuse, and is therefore to be employed with much caution and reserve'; he further doubted if Titian's technique of layering paint and using glazes 'contributed most to the benefit or the injury of the art'. Unsigned review, 'The Works of James Barry', in *Edinburgh Review*, vol. XVI, 1810, pp. 317–18.

46. Quoted in Steinberg, p. 59.

47. See Elizabeth Johns, *Thomas Eakins: The Heroism of Modern Life*, Princeton, 1983, p. 82ff.

48. Ibid., p. 111.

49. Ibid., p. 104.

50. Ibid., p. 113.

51. Hunisak, p. 52. See also Philippe Durey, 'Le Réalisme', *Sculpture Française*, pp. 354–77.

52. Emile Verhaeren, quoted in *Impressionism to Symbolism: the Belgian Avant-garde 1880–1900*, EC, ed. MaryAnne Stevens and Robert Hoozee, Royal Academy of Arts, London, 1994, p. 188.

53. Hunisak, p. 59.

54. John M. Hunisak, *The Sculptor Jules Dalou*, New York, 1977, p. 221.

55. Hunisak, pp. 57–8.

56. Hunisak, *The Sculptor Jules Dalou*, op. cit., pp. 238–9.

57. Ibid., p. 229.

58. Hélène Pinet, 'L'atelier du sculpteur vu par les photographes', in *Sculpture Française*, p. 15.

59. *Chez le Fondeur* (1886) is reproduced in Linda Nochlin, *Realism*, Harmondsworth, 1971, p. 135.

60. Albert E. Elsen, *Rodin*, London, 1974, p. 9.

61. Flaxman had a worldwide reputation, but he was far more famous for his engravings than for his sculptures.

62. Auguste Rodin, *Art: Conversations with Paul Gsell*, trans. Jacques de Caso and Patricia B. Sanders, Berkeley, Ca., 1984, pp. 105–6.

63. Ibid., p. 4.

64. Hunisak, p. 59.

65. Butler, p. 262.

66. Ibid., pp. 262–3. See also Albert E. Elsen, 'Rodin's "Perfect Collaborator", Henri Lebosse', in *Rodin Rediscovered*, EC, ed. Albert E. Elsen, National Gallery of Art, Washington, 1981, p. 249ff.

67. Butler, p. 141ff; for the decorative arts revival, see Silverman.

68. Quoted in Albert E. Elsen, *Rodin's Thinker and the Dilemmas of Modern Public Sculpture*, New Haven, 1985, p. 110.

69. Ibid., pp. 128–9.

70. Rilke, pp. 42–3.

71. Albert E. Elsen, *Rodin*, New York, 1963, p. 133ff.

72. For the role of *praticiens* and repetition within Rodin's work, see Krauss, pp. 151–94.

73. Rubin, *Cubism*, pp. 19–20. Much of the following is based on Rubin, though he does not put the 'worker-artist' phenomenon in context.

74. Ibid., p. 20.

75. Ibid., p. 19.

76. Quoted by Poggi, p. 29.

77. Quoted in Harrison and Wood, p. 183. The issue of Courbet's influence on Cubism is a vexed one. For the views of Gleizes and Metzinger, see ibid., p. 188.

78. Poggi, pp. 1–2.

79. For a detailed chronology, see Rubin, *Cubism*.

80. Robert Wohl, *A Passion for Wings: Aviation and the Western Imagination 1908–1918*, New Haven, 1994, p. 272.

81. Rubin, *Cubism*, p. 33.

82. Wohl, op. cit., pp. 14–15.

83. The journalist was François Peyrey. Ibid., pp. 25–7.

84. Ibid., p. 23.

85. Richardson, vol. 2, p. 254.

86. Ibid., p. 254.

87. Rubin, *Cubism*, p. 20.

88. Rubin, *Cubism*, p. 15.

89. Ibid., p. 30.

90. Quoted by Robert L. Herbert, 'Renoir the Radical', *New York Review of Books*, 20 November 1997, p. 10.

91. Yve-Alain Bois describes this as a time when art historians in Paris were 'vitally concerned only with the Middle Ages': 'Kahnweiler's Lesson', in *Painting as Model*, Cambridge, Mass., 1990, p. 67. This intensified after the Germans bombed medieval monuments, during the First World War. See 'Sculpture's Neo-Medieval Lineage', in Romy Golan, *Modernity and Nostalgia: Art and Politics in France Between the Wars*, New Haven, 1995, pp. 28–36.

92. See Rubin, *Cubism*, p. 36ff.
93. *Still-Life with Chair-Caning* is one of a number of oval works made in 1912. Three others incorporated the words '*Notre Avenir est dans L'Air*'. These have been interpreted as homage to the Wright brothers. But the low-slung oval format may have been inspired by the lozenge-shaped Zeppelin airships. For 'Zeppelin fever', see Peter Fritzsche, *A Nation of Fliers*, Cambridge, Mass., 1992, pp. 9–58.
94. For the impact of Gauguin on Picasso, see *Richardson*, vol. 1, pp. 455–61.
95. Paul Gauguin, *Noa Noa*, trans. O. F. Theis, San Francisco, 1994, pp. 37–49.
96. Ibid., p. 76.
97. John Golding, 'Introduction', Cowling and Golding, p. 18.
98. Richardson, vol. 1, p. 444.
99. For Durrio, see ibid., p. 456ff.
100. Golding, op. cit., p. 20.
101. Quoted by P. D. Anthony, *John Ruskin's Labour*, Cambridge, 1983, p. 154.

9. Worker-Artists ii: Duchamp to Now

1. *Julian Schnabel Paintings 1975–1986*, EC, Whitechapel Art Gallery, London, 1986, p. 97. Schnabel is referring primarily to his paintings in which broken crockery and other found objects are fixed to the surface.
2. Smithson, p. 197.
3. Richard Wollheim pointed out, in his 1965 essay that gave rise to the term Minimal Art, that Duchamp's ready-mades force us to reconsider 'what is the meaning of the word "work" in the phrase "work of art"'. Richard Wollheim, 'Minimal Art', in Battcock, p. 395.
4. Thorstein Veblen, *The Instinct of Workmanship, and the State of the Industrial Arts*, New York, 1914, pp. 306–7. Quoted in Fisher, p. 161.
5. Lewis Mumford, *Technics and Civilization* (1934), London, 1946, p. 410.
6. Ruskin believed in manual work because he thought it kept society stable – even though that society was deeply flawed: 'it is only the peace which comes necessarily from manual work which in all time has kept the honest country people patient in their task of maintaining the rascals who live in towns'. P. D. Anthony, *John Ruskin's Labour*, Cambridge, 1983, pp. 152–3.
7. Linda Nochlin, *Realism*, Harmondsworth, 1971, p. 127.
8. Thierry de Duve regards Duchamp's visit to Munich in 1912, and his exposure there to German '*Kunstgewerbe*' – arts and crafts – and functionalism as a crucial catalyst in the development of the ready-made. *Pictorial Nominalism: On Marcel Duchamp's Passage from Painting to the Ready-Made*, trans. Dana Polan, Minneapolis, 1991, chapter 5.

9. Notable examples of pastoral idylls in Duchamp's art include *Young Man and Girl in Spring* (1911) and *Etant Donnés* (1946–66).

10. See, for example, Andrew Marvell's poem 'The Garden', in which ripe fruit seems to press itself on the poet. *The Complete Poems*, ed. Elizabeth Story Donno, Harmondsworth, 1972, p. 101, lines 34–40.

11. Cabanne, pp. 24–5.

12. Rousseau, p. 195.

13. Ibid., p. 201.

14. Quoted in Tomkins 1, p. 24.

15. Tomkins 2, p. 98. John Golding says that Duchamp 'viewed the machine and its effects with distrust': Golding 2, p. 275.

16. The original terms are '*machine agricole*' and '*instrument aratoire*'. Sanouillet, p. 66.

17. Golding 2, p. 305.

18. See Albert Boime, 'Ford Madox Brown, Thomas Carlyle and Karl Marx: Meaning and Mystification of Work in the Nineteenth Century', *Arts Magazine*, September 1981, pp. 116–25.

19. Ibid., p. 121.

20. Colleen McDannell and Bernhard Lang, *Heaven: A History*, New Haven, 1990, p. 233ff.

21. Ibid., p. 281.

22. Ibid., p. 282.

23. Edward Burne-Jones revered Michelangelo, thought sculpture superior to painting, and designed gesso reliefs. John Christian, 'Burne-Jones and Sculpture', in *Pre-Raphaelite Sculpture: Nature and Imagination in British Sculpture 1848–1914*, ed. Benedict Read and Joanna Barnes, London, 1991, p. 77ff. For frames, see Lynn Roberts, 'Victorian Frames: Pre-Raphaelites, Victorian High Renaissance and Arts and Crafts', in *In Perfect Harmony: Picture + Frame 1850–1920*, EC, ed. Eva Mendgen, Van Gogh Museum, Amsterdam, 1995, p. 57ff.

24. Cabanne, p. 94. He may have been thinking of Holman Hunt's *Light of the World*, in which Christ holds a lantern. Holman Hunt designed his own studio props, including the lantern. Judith Bronkhurst, 'Holman Hunt's Picture Frames, Sculpture and Applied Art', *Re-framing the Pre-Raphaelites*, ed. Ellen Harding, Aldershot, 1996, pp. 237–8. The naked woman in Duchamp's *Etant Donnés* does, of course, hold a lamp.

25. Golding 2, p. 265.

26. Steinberg, p. 60. He sees the worker-cult as typically American, but does not note its European origins.

27. Tomkins 2, pp. 399–40.

28. The painter Eugène Carrière said of Rodin that 'he has not been able to collaborate on the absent cathedral'. Rilke, p. 68.

29. Tomkins 2, pp. 396–7.

30. Sanouillet, p. 49.

31. Rubin, *Cubism*, p. 30.

32. In conversation with Christian Zervos in 1935. Ashton, p. 9.

33. For the considerable effort that Brassaï went to, because he still liked to work with heavy photographic plates, see *Picasso and Co*, London, 1967, p. 19.

34. Werner Spies, *Pablo Picasso on the Path to Sculpture*, Munich, 1995, p. 5.

35. Quoted in Cowling and Golding, p. 57; Ashton, p. 60.

36. The teacher's 'respect for personal defects' was a central feature of the 1863 reforms of art education in France. See Albert Boime, 'The Teaching of Fine Arts and the Avant-Garde in France during the Second Half of the Nineteenth Century', *Arts Magazine*, December 1985, p. 47.

37. Douglas W. Druick and Peter Zegers, 'Scientific Realism: 1873–1881', in *Degas*, EC, ed. Jean Sutherland Boggs, Metropolitan Museum of Art, New York, 1988, p. 199. See also Kendall.

38. Daniel Kahnweiler, *Juan Gris: His Life and Work*, trans. Douglas Cooper, London, 1947, p. 88. For Picasso, mastery seems to have come more easily with painting, if we are to judge by this remark from 1935: 'I put all the things I like in my pictures. The things – so much the worse for them; they just have to put up with it.' Ashton, p. 34. Sculptors have reacted against the 'slickness' of clay, but they obviously have a wide range of more intractable materials to turn to. Anthony Caro has said, 'I had been trapped by the ease of clay . . . [steel] gave me just the resistance at the time I needed.' Diane Waldman, *Anthony Caro*, Oxford, 1982, p. 30.

39. Wilenski, p. 99.

40. Ibid., p. 99.

41. Letter to Carola Giedion-Welcker, Maloja, 1935. Carola Giedion-Welcker, *Contemporary Sculpture: An Evolution in Volume and Space*, New York, 1955, p. 242.

42. 'The Passion for Sculpture: a Conversation with Alain Kirili' (1989), in Louise Bourgeois, *Destruction of the Father, Reconstruction of the Father: Writings and Interviews 1923–1997*, ed. Marie-Laure Bernadac and Hans-Ulrich Obrist, London, 1998, p. 184.

43. See Jonathan Katz, 'The Art of the Code: Jasper Johns and Robert Rauschenberg', *Significant Others: Creativity and Intimate Partnership*, ed. Whitney Chadwick and Isabelle de Courtivron, London, 1993, p. 189ff.

44. Max Kozloff, *Jasper Johns*, New York, 1967, p. 36. Tim Hilton provided an interesting gloss on the Picasso-Braque analogy in 'Review of Andrew Forge's Rauschenberg', *Studio International*, November 1970, p. 208.

45. Katz, op. cit., p. 204.

46. Tomkins 1, pp. 193–4.

47. Ibid., p. 204. For related comments, see Calvin Tomkins, *Off the Wall: Robert Rauschenberg and the Art World of our Time*, New York, 1980, p. 88; *Claes Oldenburg*, EC, Museum of Modern Art, New York, 1971, p. 189.

48. Tomkins, op. cit., p. 182.

49. Fred Orton, *Jasper Johns: the Sculptures*, EC, Henry Moore Institute, Leeds, 1996, p. 62.

50. Ibid., p. 63.

51. Ibid., p. 63.

52. Rosalind Krauss believes that in the mid-1980s Johns' art switched from being tactile to optical: 'Whole in Two', *Artforum*, September 1996, p. 82. I would argue that this split occurs around the time of *Voice 2*.

53. Maurice Berger, *Labyrinths: Robert Morris, Minimalism, and the 1960s*, New York, 1989, pp. 83–4.

54. Ibid., pp. 81–2.

55. For after-thoughts by the curators, Michael Compton and David Sylvester, see the insert 'Robert Morris', *Tate Magazine*, Spring 1997.

56. The nail artist *par excellence* is the German sculptor Gunther Uëcker.

57. Siegel, p. 178. See also 'On a Journey to Philadelphia and Consecutive Matters October 28 1962', in *Carl Andre, Hollis Frampton 12 Dialogues 1962–1963*, ed. Benjamin H. D. Buchloh, Halifax, Nova Scotia, 1981, p. 25; and Phyllis Tuchman, 'Background of a Minimalist: Carl Andre', *Artforum*, March 1978, p. 30.

58. Siegel, p. 178.

59. Ibid., p. 179.

60. Ibid., p. 175.

61. William Rubin, *Anthony Caro*, London, 1975, p. 106.

62. Waldman, op. cit., p. 34.

63. Bruce McLean. Quoted by Nena Dimitrijevic in *Bruce McLean*, EC, Whitechapel Art Gallery, London, 1981.

64. David Smith, ed. Garnett McCoy, New York, 1973, p. 146.

65. Quoted as the frontispiece of *Jackson Pollock: A Catalogue Raisonné of Paintings, Drawings, and Other Works*, vol. 4: *Other Works*, ed. Francis Valentine O'Connor and Eugene Victor Thaw, New Haven, 1978.

66. Gutzon Borglum had been educated in Paris and was very impressed by Rodin's work. At Mount Rushmore he was 'carving' the heads of four Presidents out of a granite rock-face, with the help of dynamite (never before used by a sculptor), power-tools and dozens of assistants. President Calvin Coolidge dedicated the monument in 1927 – 'I don't know anything about art, but I know that great governments do this kind of thing' – and the first head (Washington) was unveiled in 1930, the last (Roosevelt) in 1939, after 400,000 tons of granite had been removed. For a wonderfully entertaining account of Borglum, see Robert J. Dean,

Living Granite: The Story of Borglum and the Mount Rushmore Memorial, New York, 1949.

67. *Jackson Pollock: A Catalogue Raisonné of Paintings, Drawings, and Other Works*, op. cit., p. 120.

68. Ibid., p. 120.

69. Ibid., p. 130.

70. Quoted by Ellen G. Landau, *Jackson Pollock*, London, 1989, p. 168.

71. Ibid., p. 168.

72. Pollock had in fact painted a picture of *Cotton-Pickers* in the mid-1930s. They are a series of fluttering shadows bent over the ground.

73. Allan Kaprow, 'The Legacy of Jackson Pollock', in *Essays on the Blurring of Art and Life*, ed. Jeff Kelley, Berkeley, Ca., 1993, pp. 7–8.

74. The art critic John Russell quoted in Robert Hughes, *Frank Auerbach*, London, 1989, p. 82.

75. Ibid., p. 13.

76. Victor Bockris, *Warhol*, London, 1989, pp. 188–9.

77. Douglas Davis, *The Museum Transformed: Design and Culture in the Post-Pompidou Age*, New York, 1990, p. 173.

78. Robert Harbison, *The Built, the Unbuilt, and the Unbuildable: in Pursuit of Architectural Meaning*, London, 1991, pp. 123, 124.

79. A useful list is given in *The Art Newspaper*, June 1994, p. 24, after an interview with Nicholas Serota about the new Tate Gallery of Modern Art in the former Bankside Power Station.

80. Quoted by James Hall, 'Sinking the Green', *Guardian*, London, 4 April 1994.

81. 'Richard Wilson: Site-Specific Sculptor', *CV*, September 1989, pp. 13–14.

10. Beyond Relief

1. Rilke, p. 8.

2. Ashton, p. 114.

3. Maurice Tuchman, 'Introduction', *American Sculpture of the Sixties*, EC, Los Angeles County Museum of Art, 1967, p. 11.

4. Roger Fry, *Vision and Design*, Oxford, 1981, p. 71.

5. Bernard Berenson, *Aesthetics and History*, London, 1950, p. 45.

6. Wilenski, pp. 139–40.

7. Tribal art is more important historically for being highly abstracted and for being made out of numerous 'poor' materials than for being in the round.

8. Wittkower 3, p. 233.

9. Hildebrand, p. 33. A more recent translation, together with commentaries, can be found in *Empathy, Form, and Space: Problems in German Aesthetics 1873–1893*, ed. and trans. Harry Francis Mallgrave and

Eleftherios Ikonomou, Santa Monica, 1994, pp. 227–79.

10. Hildebrand, p. 80. Duchamp's *Large Glass*, in which the components are sandwiched between panes of glass, takes this notion to a parodistic extreme.

11. Ibid., p. 88.

12. Edwin Becker, 'White, Blue and Gold: In Search of New Harmony', in *In Perfect Harmony: Picture + Frame 1850–1920*, EC, ed. Eva Mendgen, Van Gogh Museum, Amsterdam, 1995, p. 205.

13. Hildebrand, p. 95.

14. Ibid., p. 95.

15. Rosalind E. Krauss, *Passages in Modern Sculpture*, Cambridge, Mass., 1977, p. 14.

16. Silverman, p. 252.

17. Hildebrand wrote a paper about Rodin in 1918, but it remained unpublished at the time.

18. Hildebrand, p. 116.

19. Ibid., p. 117.

20. Ibid., p. 113.

21. Ibid., p. 113.

22. de Quincy, p. 49. For English interiors, see Louis Simond, quoted by Peter Thornton, *Authentic Decor: The Domestic Interior 1620–1920*, London, 1984, p. 147. I am grateful to Christopher Wilk for suggesting this book.

23. Curtis, p. 28.

24. Ibid., p. 51.

25. For Hildebrand's influence on Wölfflin, see *Kenseth*, pp. 192–3.

26. Hildebrand, p. 113.

27. Curtis, pp. 56–7.

28. For Begas and Hildebrand, see Janson, pp. 236–7.

29. Read, p. 97.

30. Hugh Kenner, *The Pound Era*, London, 1991, p. 258.

31. Curtis, p. 32.

32. According to de Caso, p. 248, note 1, the term was first coined by Auguste Barbier as the title of a long poem in which he apologized to the reader for using such a 'barbarous title': 'Poésie. La Statuomanie' in *Mercure de France*, 16 November 1851.

33. Curtis, p. 34.

34. Ibid., p. 38.

35. Sartre, p. 14.

36. Ibid., p. 15.

37. Ibid., p. 46.

38. Ibid., pp. 46–7.

39. Peter Gay, *The Bourgeois Experience: Victoria to Freud – Vol. I: Education of*

the Senses, New York, 1984, p. 382.

40. Flaubert, p. 236.
41. Ibid., p. 239.
42. Ibid., p. 241.
43. Ibid., p. 241.
44. Jean Seznec refers to the 'worker' Flaubert. Quoted by Eugenio Donato, 'The Museum's Furnace: Notes towards a Contextual Reading of Bouvard and Pécuchet', in *Textual Strategies: Perspectives in Post-Structuralist Criticism*, ed. Josue V. Harari, Ithaca, 1979, p. 215, note 3.
45. Ibid., p. 215.
46. Edmund Husserl, 'Ding und Raum' (1907), quoted in *Empathy, Form and Space: Problems in German Aesthetics 1873–1893*, op. cit., p. 84, note 222.
47. Butler, p. 106ff.
48. Ibid., p. 107.
49. Ibid., p. 106. The critic Henry Jouin.
50. Baudelaire 1, pp. 203–4.
51. Ibid., p. 204.
52. Richard D. E. Burton, *Baudelaire in 1859*, Cambridge, 1988, p. 171.
53. Baudelaire 1, p. 205.
54. Baudelaire 2, p. 43.
55. Kirk Varnedoe discusses the centrality of the 'surprise' and the 'life-enhancing jolt' to the ideas of modernity in *Jasper Johns*, EC, Museum of Modern Art, New York, 1996, pp. 17, 34, note 10.
56. Baudelaire 1, p. 112.
57. Some scholars believe it was painted by Titian.
58. See G. Vapereau, *Dictionnaire Universel des Contemporaines*, 1893; *L'Art*, vol. XXIV, 1881, pp. 334–5. He exhibited at the Paris Salon 1859–88, after which he returned to Holland.
59. Wieland Schmied, 'De Chirico, Metaphysical Painting and the International Avant-Garde: Twelve Theses', in *Italian Art in the 20th Century*, EC, ed. Emily Braun, Royal Academy of Arts, London, 1989, p. 72.
60. Hildebrand, pp. 117–18. The Viennese architect and planner Camillo Sitte rejected public monuments in *City Planning According to Artistic Principles* (1889). The centre of plazas should be kept free, with monuments pushed to the encircling walls to give a sense of an 'enclosed tableau'. See Cornelis van de Ven, *Space in Architecture*, Assen, 1977, pp. 102–9.
61. Paolo Balducci, 'De Chirico and Savinio: The Theory and Iconography of Metaphysical Painting', in *Italian Art in the 20th Century*, op. cit., p. 64.
62. de Chirico, p. 13.
63. Ibid., p. 21.

64. Ibid., p. 32.

65. Baedeker, p. 505. It has now sadly been moved to a corner of the square, to the left of the church steps.

66. Charles Godfrey Leland, *Legends of Florence*, 1st series, London, 1896, p. 143.

67. In the Bargello, Michelangelo's *Bacchus* and the unfinished *Apollo* were installed on revolving plinths. See Baedeker, p. 500.

68. Zarathustra says contradictory things about statues. Friedrich Nietzsche, *Thus Spoke Zarathustra*, trans. R. J. Hollindale, Harmondsworth, 1969, pp. 154, 304. See also Lesley Chamberlain, *Nietzsche in Turin*, London, 1997; David Farrell Krell and Donald L. Bates, *The Good European: Nietzsche's Work Sites in Word and Image*, Chicago, 1997, pp. 203–27.

69. *Turin and Its Neighbourhoods*, 'Pro Torino' Association, Turin, 1911, p. 84.

70. For the 'surprises' offered by Paris, see de Chirico, p. 270. For a fine example of a 'real-life' de Chirico, see Michele H. Bogart, *Public Sculpture and the Civic Idea in New York City, 1890–1930*, Chicago, 1989, pp. 236–7.

71. André Breton, *Nadja*, trans. Richard Howard, New York, 1960, p. 15.

72. Ibid., p. 24.

73. *Guides Bleus: Paris et ses Environs*, Paris, 1920, p. 311; see also Sergiusz Michalski, *Public Monuments: Art in Political Bondage, 1870–1977*, London, 1998, p. 35–7.

74. Plate 8 shows more statuary on the 'extremely handsome, extremely useless Porte Saint-Dénis'.

75. For more on this, see chapter 12.

76. Breton, op. cit., p. 129; plates 39, 41.

77. Aragon, pp. 131–2.

78. Ibid., p. 147.

79. Ibid., p. 150.

80. Ibid., p. 152.

81. Ibid., p. 150.

82. Ibid., p. 163.

83. Ibid., p. 166.

84. Ibid., p. 167.

85. Ibid., p. 167.

86. Ibid., p. 220, note 14.

87. Ibid., p. 168.

88. The statue is on a low pedestal at knee-height. I am grateful to Philip Ward-Jackson for drawing my attention to it.

89. 'Pygmalion and the Sphinx', in *Nouvelles Hebrides et autre textes 1922–1930*, ed. Marie-Claire Dumas, Paris, 1978, p. 465. Desnos seesaws wildly between admiration and contempt for modern statuary. He also

proposes monuments to bottles and trains, and even to X-rays.

90. Aragon, pp. 169–70.
91. Ibid., p. 172.
92. Article on Rude of March 1913. *Apollinaire*, p. 277.
93. Jean Cocteau, *La Mort et les Statues*, with photographs by Pierre Jahan, Paris, 1977.
94. Peter Adam, *The Arts of the Third Reich*, London, 1992, pp. 201–2.
95. Cocteau, op. cit., p. 11.
96. Ibid., p. 12.
97. Ibid., p. 18.
98. Ibid., p. 26.
99. Ibid., p. 40.
100. Ibid., p. 46.
101. Edgar Wind, *Art and Anarchy*, London, 1985, p. 42.
102. Adam, op. cit., p. 203; see also Michalski, op. cit., p. 93ff.
103. Hugh Honour tells me that a statue of Puccini has been erected in Lucca and of Mazzini in Florence.
104. Richard Calvocoressi, 'Public Sculpture in the 1950s', in *British Sculpture*, p. 135.
105. For the 'problems' encountered by public sculpture after the war, see Andrew Causey, *Sculpture Since 1945*, Oxford, 1998, p. 15ff.
106. Calvocoressi, op. cit., p. 137.
107. Richard Cork, 'An Art of the Open Air: Moore's Major Public Sculpture', in *Henry Moore*, EC, ed. Susan Compton, Royal Academy of Arts, London, 1988, pp. 14–26.
108. Calvocoressi, op. cit., p. 135.
109. 'Sculpture in the Open Air' (1951), in James, p. 114.
110. Colpitt, p. 96.
111. Peter Read, 'From Sketchbook to Sculpture in the Work of Picasso, 1924–32' in Cowling and Golding, p. 201.
112. Miller, p. 209.
113. Penelope Curtis, 'Open to the Elements', in *Art Quarterly*, Summer 1995, pp. 39–43.
114. 'Sculpture in the Open Air' (1951), in James, p. 100.
115. Giedion, 4th edition, 1962, p. xxxviii.
116. Ibid., p. xli.
117. Quoted by Stan Allen, 'Minimalism and Architecture', in *Sculpture: Contemporary Form and Theory*, Art and Design, London, no. 55, 1997, p. 23.
118. Paul Frankl, *Principles of Architectural History: The Four Phases of Architectural style, 1420–1900*, trans. James F. O'Gorman, Cambridge, Mass., 1968, p. 144.

119. Ibid., p. 145.
120. Ibid., p. 149.
121. Arnheim, p. 120.
122. Dennis Sharp, *Modern Architecture and Expressionism*, London, 1966, p. 54.
123. Nikolai Tarabukin, 'From the Easel to the Machine', in *Modern Art and Modernism: A Critical Anthology*, ed. Francis Frascina and Charles Harrison, London, 1982, p. 137. I am grateful to David Batchelor for drawing my attention to this essay.
124. Giedion, 5th edition, 1967, p. 686.
125. Ibid., p. 684.
126. Ibid., p. 672.
127. Ibid., p. 862.
128. Giedion, 5th edition, 1967, pp. 849, 851.
129. Merleau-Ponty, p. 203.
130. Giedion, 4th edition, 1962, pp. 729–30.
131. Tony Smith, 'Interview with Samuel Wagstaff Jr (1966)', in Battcock, p. 386.
132. Robert Goldwater, *What is Modern Sculpture?*, Museum of Modern Art, New York, 1969, p. 132. See also Michael Benedikt, 'Sculpture as Architecture' (1966–7), in Battcock, pp. 61–91.
133. Goldwater, op. cit., p. 139.
134. Robert Hughes, *American Visions: the Epic History of Art in America*, New York, 1997, p. 407.
135. Friedrich Teja Bach, 'Brancusi: The Reality of Sculpture', in *Brancusi*, p. 30.
136. Ibid., p. 32.
137. Quoted by Richard Cork, 'Towards a New Alliance', in Eugène Rosenberg, *Architect's Choice: Art in Architecture in Great Britain since 1945*, London, 1992, p. 16.
138. 'What is a Museum? A Dialogue between Allan Kaprow and Robert Smithson' (1967), in *Smithson*, pp. 60–1.
139. André Malraux, in his *Antimémoires* (1967), told the story of an Indian prince who spent years building the most beautiful tomb in the world for his beloved wife. But when her coffin was moved in, it so disturbed the harmony of the funeral chamber that he ordered it to be taken out again. See Arnheim, p. 217.
140. *Empathy, Form, and Space: Problems in German Aesthetics 1873–1893*, op. cit. p. 293. There are even earlier precedents. For Michelangelo, 'other things being equal, in matters of architecture the sculptor was to be preferred to the painter, for architecture was in relief so that it came within the normal scope of a sculptor's work.' Chantelou, p. 58. Hegel has a section on 'Architectural Works Wavering Between Architecture and

Sculpture', which features phallic columns, obelisks and Egyptian temples. Hegel, p. 640ff. But not much seems to be made of these issues until the development of abstract art.

141. André Salmon, *La Jeune Sculpture Française*, Paris, 1919, p. 91.
142. Quoted in Colpitt, pp. 79–80.
143. Robert Venturi, Denise Scott Brown, Steven Izenour, *Learning from Las Vegas*, Cambridge, Mass., 1972, p. 64.
144. Reproduced in Arnheim, p. 219.
145. Venturi, Brown and Izenour, op. cit., pp. 87, 100 (drawing).
146. Ibid., p. 104.
147. Ibid., p. 50.
148. Ibid., p. 39.
149. Ibid., p. 42.

11. The Education of the Senses i: Child's Play

1. *Gauguin by Himself*, ed. Belinda Thomson, Boston, 1993, p. 257.
2. *Energy Plan for Western Man: Joseph Beuys in America*, ed. Carin Kuoni, New York, 1990, p. 7.
3. This was a touring exhibition that began at the Institute of Contemporary Arts, London. It featured manikins of children.
4. Kramer, p. 95.
5. Ibid., p. 121.
6. Jonathan Fineberg, *The Innocent Eye: Children's Art and the Modern Artist*, Princeton, 1997.
7. S. J. Curtis and M. E. A. Boultwood, *A Short History of Education*, 5th edition, Slough, 1977, p. 347.
8. *Froebel*, p. 50.
9. Ibid., p. 72.
10. Laura Coyle, 'Strands Interlacing: Colour Theory, Education and Play in the Work of Vincent Van Gogh', in *Van Gogh Museum Journal*, 1996, p. 131. I am grateful to Rachel Esner for drawing my attention to this article.
11. *Froebel*, p. 180.
12. Ibid., p. 183.
13. Ibid., p. 205.
14. Ibid., p. 206.
15. Ibid., p. 205.
16. Jules David Prown, 'Thomas Eakins' Baby at Play', *Studies in the History of Art*, no. 18, 1985, pp. 121–7.
17. Ibid., pp. 126–7.
18. Coyle, in *Van Gogh Museum Journal*, op. cit., pp. 118–31.
19. Kramer, p. 49.
20. Quoted by Antonia Fraser, *A History of Toys*, London, 1966, p. 213.

21. Montessori 1, p. 4.
22. Ibid., p. 13.
23. Ibid., p. 43.
24. Ibid., pp. 43–4.
25. Canfield Fisher, p. 60.
26. Ibid., p. 58.
27. Montessori 1, p. 59.
28. Ibid., p. 62.
29. Ibid., p. 102.
30. Fraser, op. cit., p. 214.
31. Ibid., p. 234.
32. Dora Vallier, 'Braque, la peinture et nous', *Cahiers d'Art*, October 1954, p. 16. Quoted by Poggi, p. 98.
33. Golding 1, p. 93.
34. Ibid., p. 98.
35. Ibid., p. 97.
36. For mixed-media and polychrome sculpture, see *Colour*; for Degas, Kendall.
37. William Seitz, *The Art of Assemblage*, EC, Museum of Modern Art, New York, 1961, p. 26. For Mancini, see Fortunato Bellonzi, *Antonio Mancini*, Milan, 1978.
38. The Futurist painter Gino Severini recalled a discussion with Apollinaire in 1912 about 'certain Italian primitives who had put elements of true reality in their pictures': Poggi, p. 171. Apollinaire cited Carlo Crivelli's *Trittico del Duomo di Camerino* (1482) in the Brera, Milan. The madonna wears a real brooch, while St Peter carries real keys and a staff sculpted in relief, and he also wears a large brooch. Ibid., p. 172.
39. See Merete Bodelsen, *Gauguin's Ceramics*, London, 1964; Christopher Gray, *Sculpture and Ceramics of Paul Gauguin*, Baltimore, 1963.
40. Vlaminck sold it to his friend André Derain, and it has subsequently become 'the principal tribal icon of twentieth-century primitivism'. William Rubin, 'Introduction', *'Primitivism' in Twentieth Century Art*, EC, ed. Museum of Modern Art, New York, 1984, vol. 1, p. 13.
41. Quoted by Poggi, p. 52.
42. Canfield Fisher, pp. 52–3.
43. Kramer, p. 246.
44. These are the main articles included in the Archive of the Association Montessori Internationale in Amsterdam:

Le Matin 15(?) October 1911, front page, 20 column inches, photograph of Maria Montessori and cartoon of boy and girl feeling letters: *'Auto-education'*.

L'Éclair, December 1911 (no day given), 24 column inches, two drawings of children playing.

L'Éclair, 16 January 1912, 17 column inches: '*Dans la maison des enfants*'.

Siècle 16 February 1912, 37 column inches, with three engravings *(le déjeuner, les enfants au travail, après le travail: le repos)*.

Le Journal, 21 March 1912, 5 column inches, with engraving of three girls sweeping with brooms: '*Une méthode d'éducation*'.

Télégramme (Toulouse), 29 June 1912, 33 column inches.

Le Rappel, 11 July 1912, 7 column inches: '*L'Éducation des Sens*'.

Le Siècle, 20 July 1912, 25 column inches: '*Propos de Vacances*'.

La Démocratie, 14 and 15 August 1912, each article 42 column inches: '*Souvenir d'Italie: Une école harmonieuse*'.

La Semaine Littéraire, 26 October 1912, 1⅓ pages, with photograph of Maria Montessori: '*Les Cases dei Bambini*'.

La Grande Revue, 10 November 1912, 4 column inches, book review of Maria Montessori: '*La méthode de la pédagogie scientifique à l'éducation des tout petits*', trans. Mme H. Gaillard, preface by M. P. Boret.'

Le Soir, 23 August 1912, 36 column inches, front page.

UBL (Geneva), 20 December 1912, 10 column inches: '*Quelques suggestions pour le Noël des petits*'.

La Démocratie, 17 April 1913, 21 column inches: '*L'éducation enfantine*'.

L'Action, 26 June 1913, 12 column inches: '*Les travaux des tout petits*'.

Télégramme (Toulouse), 2 July 1913, 33 column inches: '*L'enfant et des méthodes nouvelles d'éducation*'.

Le Siècle, 24 July 1913, 32 column inches, with two engravings (*Après le travail: le repos; Les enfants au travail*): '*Les Cases dei Bambini*'.

L'Action, 24 July 1913, 32 column inches, reprint of above.

Le Journal des Débats, 3 September 1913, 18 column inches, review of *Jardin d'Enfants*, by Pierre de Quirielle.

Revue Hebdomadaire, 20 September 1913, pp. 394–412, three engravings (painting and modelling; exercises; reading by touch): '*Une expérience personelle*'.

45. Poggi, p. 88.
46. Richardson, vol. 1, p. 277.
47. Ron Johnson, *The Early Sculpture of Picasso 1901–14*, New York, 1976, p. 17.
48. Richardson, vol. 1, p. 504, note 24.
49. Ibid., p. 279. This remark was made to Roland Penrose.
50. Penrose argued that in the *Vollard Suite*, many of which feature a sculptor in his studio, the blind minotaur (no. 94, 1934) is an analogy for Picasso in his sculptor's role. *The Sculpture of Picasso*, London, 1967, p. 15.
51. 'The Guitar Player', quoted by Frank Kermode, *The Romantic Image*,

London, 1957, p. 50.

52. Quoted in Cowling and Golding, p. 258.

53. Montessori 2, p. 208.

54. Montessori 1, p. 115.

55. William Boyd, *From Locke to Montessori*, London, 1914, p. 240.

56. Richard Wollheim, *Painting as an Art*, London, 1987, p. 292.

57. Ibid., p. 293.

58. Miller, p. 49.

59. Chave, p. 175.

60. Ibid., p. 173.

61. Ibid., pp. 173–4.

62. Ibid., p. 211.

63. Miller, p. 51.

64. Chave, p. 175.

65. Ibid., p. 175.

66. Brown, *Brancusi*, p. 9.

67. After quoting Brancusi's claim to have 'eliminated holes which cause shadows', Sidney Geist writes, 'But his forms are such as could be known by the touch, with the eyes shut, or in the dark. It is worth noting that Brancusi made no low reliefs, that type of sculpture that disappears when the lights go out.' *Brancusi: A Study of the Sculpture*, New York, 1968, p. 157.

68. Miller, pp. 125–6.

69. *Froebel*, p. 180.

70. This is the first reference – or rather, allusion – I have found.

71. Rilke, p. 67.

72. Ibid., p. 46.

73. Ibid., pp. 46–7. Alex Potts, 'Dolls and Things: The Reification and Disintegration of Sculpture in Rodin and Rilke', in Onians, pp. 355–78. Potts does not mention Froebel, and focuses mainly on naturalistic dolls, which was a conventional comparison to make when writing about sculpture. And see Kendall, p. 45ff.

74. Chave, p. 231.

75. H. G. Wells, *Floor Games*, London, 1913, pp. 9–10: 'The British Empire will gain new strength from nursery floors.'

76. See Jack Burnham, 'Sculpture's Vanishing Base', Chapter One, *Beyond Modern Sculpture: The Effects of Science and Technology on the Sculpture of this Century*, London, 1968.

77. Martin Kemp, *The Science of Art*, New Haven, 1990, p. 239–40.

78. Hilary Spurling, *The Unknown Matisse: A Life as Henri Matisse, Vol. 1*, London, 1998, pp. 212–3.

79. *Joán Miró: Selected Writings and Interviews*, ed. Margit Rowell, Boston,

1986, p. 208.

80. Marcel Franciscono, *Walter Gropius and the Creation of the Bauhaus in Weimar: the Ideals and Artistic Theories of its Founding Years*, Urbana, 1971, p. 173ff.

81. Johannes Itten, *Design and Form: The Basic Course at the Bauhaus*, (1963), London, 1975, p. 7.

82. Ibid., p. 7.

83. Ibid., p. 8.

84. Ibid., p. 34.

85. Walter Benjamin, 'One Way Street (1925–6)', in *One Way Street and Other Writings*, trans. Edmund Jephcott and Kingsley Shorter, London, 1979, pp. 52–3.

86. Franciscono, op. cit., p. 181.

87. Calvin Tomkins, *Off the Wall: Robert Rauschenberg and the Art World of our Time*, New York, 1980, p. 30.

88. Ibid., p. 86.

89. Steinberg, pp. 48–50.

90. Louis H. Sullivan, *Kindergarten Chats and Other Writings*, New York, 1947, p. 15. It was reprinted in 1955 and 1960.

91. Quoted from Giedion, 5th edition, 1967, p. 415.

92. Grant Carpenter Mason, *Frank Lloyd Wright to 1910: The First Golden Age*, New York, 1988, p. 6–10.

93. Sullivan, op. cit., p. 17.

94. Max Kozloff, *Jasper Johns*, New York, 1967, p. 15: the tickets and forms were 'collected from a cache of papers happened upon in Yorkville'.

95. Steinberg, p. 52. See also Roland Barthes, 'Toys' (1954–6), in *Mythologies*, trans. Annette Lavers, London, 1973, p. 54.

96. See also Leo Steinberg's description of Rauschenberg's work surface as an analogy for the mind itself – 'dump, reservoir, switching centre'. Steinberg, p. 88.

97. Colpitt, p. 78.

98. Ibid., p. 82.

99. Barthes, op. cit., pp. 53, 54. The association of object–based art with toys cut across styles. See Oldenburg, p. 36.

100. Siegel, p. 178.

101. Peter Fuller, 'Carl Andre on his Sculpture: Part II', *Art Monthly*, no. 17, 1978, p. 9.

102. Ibid., pp. 10–11.

103. McCluhan, p. 107. Quoted by Max Kozloff, *Jasper Johns*, New York, n.d. (1972?), p. 19.

104. McCluhan, p. 109. For number and corporality, see also Burnham, op. cit., p. 133.

105. McCluhan, p. 120.

106. Ibid., p. 121.

107. From 'Claes Oldenburg, Roy Lichtenstein, Andy Warhol: A Discussion' (1964), in Chipp, p. 586.

108. The Montessori Method failed to make serious inroads into the American educational system. Followers of John Dewey believed that her methods placed too much emphasis on cognitive learning in a reality-oriented environment, and too little on spontaneous expression and fantasy play. Her didactic materials were thought to play too dominant a role. But the method was successfully reintroduced in the late 1950s. In 1957 E. M. Standing published *Maria Montessori: Her Life and Work*. In 1958 a school was founded in Connecticut, stimulating the birth of a new Montessori movement.

109. Edward de Bono, *The 5-Day Course in Thinking*, London, 1967, p. 13.

110. Ibid., pp. 66–7.

111. R. N. Shepard and J. Metzler, 'Mental Rotation of Three-Dimensional Objects', *Science*, 1971, pp. 701–3; L. A. Cooper and R. N. Shepard, 'Chronometric Studies of the Rotation of Mental Images', in *Visual Information Processing*, ed. W. G. Chase, New York, 1973, pp. 75–115; Michael Tye, *The Imagery Debate*, Cambridge, Mass., 1991.

112. Will Self, *My Idea of Fun*, London, 1992, pp. 15, 50, 71, 95.

113. Dennis Sharp, *Modern Architecture and Expressionism*, London, 1966, p. 151.

114. Rudolf Steiner, *An Introduction to Eurythmy* (1919–24), Spring Valley, 1984, p. 44.

115. Caroline Tisdall, *Joseph Beuys*, EC, Guggeaheim Museum, New York, 1979, p. 7.

116. Heiner Stachelhaus, *Joseph Beuys*, trans. David Britt, New York, 1991, p. 85.

117. Gamboni, p. 114; For a Renaissance example, see Giovanni della Casa, *Galateo* (1558), trans. R. S. Pine-Coffin, Harmondsworth, 1958, p. 86.

118. Beuys' work is not terribly colourful, of course; but it is not generally monochrome either.

119. *Joseph Beuys*, EC, Centre Georges Pompidou, Paris, 1994, pp. 269–70.

120. Ibid., pp. 182–7.

121. Eric Michaud believes the 'flood' of words that flowed from Beuys overwhelmed the 'plastic language'. 'The End of Art According to Beuys', *October*, Summer 1988, p. 37.

122. *The Jeff Koons Handbook*, London, 1992, p. 92.

123. Ibid., p. 98.

124. David Rimanelli, 'Jeff Koons: A Studio Visit', *Artforum*, Summer 1997, p. 116.

12. The Education of the Senses ii: Hollows and Bumps in Space

1. Jacques Lipchitz, *My Life in Sculpture*, New York, 1972, pp. 37–8.
2. Bruce Glaser, 'Questions to Stella and Judd', in Battcock, p. 162.
3. Interview with Adrian Dannatt, 'Life's Like This, Then It Stops', in *Flash Art International*, March/April 1993, p. 62.
4. Bernard Berenson, *The Italian Painters of the Renaissance* (1894–1907), Oxford, 1952, p. 40.
5. Ibid., p. 40.
6. See Christopher Hussey, *The Picturesque: Studies in a Point of View*, London, 1927; Walter John Hipple, *The Beautiful, the Sublime and the Picturesque in Eighteenth-Century British Aesthetic Theory*, Southern Illinois, 1957; John Dixon-Hunt, *Gardens and the Picturesque*, Cambridge, Mass., 1992.
7. Payne Knight, p. 72; Uvedale Price, *Essays on the Pictureque*, London, 1810, vol. 2, p. xiii–xvi.
8. de Quincy, p. 51.
9. Ian Jenkins, *Archaeologists and Aesthetes in the Sculpture Galleries of the British Museum, 1800–1939*, London, 1992, p. 34.
10. Wilenski, pp. 26–7.
11. i.e. Préault's *Silence* (1842–3) and Carpeaux's *Ugolino* (1857–61).
12. Rilke, p. 16.
13. See Werner Spies, *Pablo Picasso on the Path to Sculpture*, Munich, 1995, pp. 10–11.
14. Henry Moore, 'The Sculptor Speaks', in James, p. 69.
15. Although Brancusi spoke like a paid-up Neo-Classicist when he claimed that he had 'eliminated holes which cause shadows'. He drove holes through some of his forms, and in his photographs he exploited the dramatic shadows cast by his undulating and zigzagging assemblages. Sidney Geist, *Brancusi: A Study of the Sculpture*, New York, 1968, p. 157.
16. Constable's late paintings, especially *The Leaping Horse* (1825), could almost be homages to the flickering, fragmentary presence of the Elgin Marbles.
17. Ivy, pp. 46, 46, 48, 49.
18. For Cézanne, see Richard Shiff, 'Cézanne's Physicality: the politics of Touch', in *The Language of Art History*, ed. Salim Kemal and Ivan Gaskell, Cambridge, 1991, pp. 129–80.
19. Herschel B. Chipp, *Theories of Modern Art*, Berkeley, Ca., 1968, p. 94.
20. Ann Dumas, *Degas as a Collector*, EC, National Gallery, London, 1996, p. 20. Dumas claims that 'although he was too blind to see the paintings, he could, according to Daniel Halévy, still recognize the contours and surfaces of those he knew by touch'. I think this is a misreading of what Halévy writes in *Degas Parle*, Paris, 1960, pp. 138–9. Degas says, *'Les*

tableaux que je connais, je peux en retrouver quelque chose; ceux que je ne connais pas ne sont rien pour moi.' Halévy then comments: *'Et il se tenait devant les toiles, les palpant, promenant ses mains sur elles.'* What Degas is saying is that he can just recognize visually the forms of the canvases he already knew; all the others are meaningless blurs. He could still see *something* (Halévy describes Degas' first sighting of an aeroplane in the same year). When Degas touches the canvases he is not trying to 'feel' the shapes – raised contours, etc. What he is feeling for is their smoothness. After all, Ingres wrote, 'Touch should not be apparent . . . Instead of the object represented, it makes one see the painter's technique; in the place of thought, it proclaims the hand' (Henri Delaborde, *Ingres, sa Vie, ses Travaux, sa Doctrine*, Paris, 1870, p. 150).

21. See Milner, p. 44ff.

22. Ibid., p. 63.

23. Ibid., p. 90.

24. Ibid., pp. 82–3.

25. Ibid., p. 91.

26. Ibid., p. 99.

27. *Gaudier-Brzeska*, p. 113. This echoes the point made by Galileo in his letter to the painter Cigoli, discussed in chapter 4.

28. Ibid., p. 114.

29. For a survey of the period, see *Carving Mountains: Modern Stone Sculpture in England 1907–37*, EC, Kettle's Yard, Cambridge, 1998.

30. Wilenski, p. 144.

31. Maurice Nadeau, quoted by Krauss, p. 57.

32. Ibid., p. 57–8.

33. See the rather conservative passage on the caress in Jean-Paul Sartre, *Being and Nothingness* (1943), trans. Hazel E. Barnes, London, 1958, p. 389ff. He refers to what he calls the 'anti-caress' only in a footnote on p. 392.

34. Walter Benjamin, 'On Some Motifs in Baudelaire' (1939) in *Illuminations*, trans. Harry Zohn, London, 1970, pp. 163–4. He also cites Freud.

35. Manfredo Tafuri, *Architecture and Utopia: Design and Capitalist Development*, trans. Barbara Luigia La Penta, Cambridge, Mass., 1976, p. 86.

36. Montessori 1, p. 65.

37. William Boyd, *From Locke to Montessori*, London, 1914, p. 111.

38. Montessori 2, p. 186. Canfield Fisher, p. 100: the child 'needs at first a little guidance in learning how to draw his finger-tips *lightly* from left to right over the sandpaper strips . . .'

39. Credited to a bewildering variety of people (Barnett Newman and even Baudelaire!), but the most likely source is the waspish Ad Reinhardt.

40. For more winds emanating from artworks, see André Breton, *What is Surrealism?*, trans. David Gascoyne, New York, 1978, p. 160.

41. Jean-Paul Sartre, 'The Search for the Absolute', in *Alberto Giacometti*, EC, Pierre Matisse Gallery, New York, 1948, p. 3.

42. Remarks overheard in the Salon of 1898. *Butler*, p. 317.

43. Rilke, p. 11.

44. Ibid., p. 10. See also Edgar Wind's remarks on the 'devaluation of the human face' in modern art. *Art and Anarchy*, London, 1985, p. 42.

45. *Basic Writings of Nietzsche*, ed and trans. Walter Kaufmann, New York, 1968, #1, p. 37, #2, p. 40.

46. Fisher, p. 44.

47. Golding 1, p. 93.

48. David Mellor, *Sixties Art Scene in London*, London, 1993, pp. 61–73.

49. Ibid., p. 80. Alloway was writing in 1962 about *Situation*, an exhibition of British abstract art held at the ICA in 1960.

50. Henri Matisse, 'Notes of a Painter' (1908), in *Matisse on Art*, ed. Jack D. Flam, Oxford, 1973, p. 34.

51. Beuys made some furniture from 1949 to 1954. See Caroline Tisdall, *Joseph Beuys*, EC, Guggenheim Museum, New York, 1979, p. 19.

52. Robert Descharnes, *The World of Salvador Dalí*, Lausanne, 1962, p. 93. Liz Brooks says that the raised arms of the chair recall the central figure in Picasso's *Guernica*, which was then touring Britain. *Edward James and Surrealism: Architectural and Decorative Schemes of the 1930s*, M. A. Report, Courtauld Institute of Art, 1988, p. 47. See also Willem de Kooning's refusal to sit 'in style'. Chipp, p. 560.

53. Elizabeth Cowling, 'Objects into Sculpture', in Cowling and Golding, p. 229.

54. Roland Penrose, *Picasso: His Life and Work*, Harmondsworth, 1971, pp. 412–13.

55. Alfred Dudelsack, Kurt Schwitters' studio in 1920. Elderfield, p. 144.

56. By John Elderfield. Ibid., p. 91.

57. The Dadaist Richard Huelsenbeck, Ibid., p. 170.

58. Ibid., p. 114.

59. Alexander Dorner, a supporter of Constructivism. Ibid., p. 162.

60. Ibid., p. 165.

61. Ibid., p. 156.

62. Henri Bergson, *Creative Evolution*, trans. Arthur Mitchell, London, 1964, p. 314.

63. Anthony Vidler, 'A Dark Space', in *Rachel Whiteread: House*, ed. James Lingwood, London, 1995, p. 67.

64. Gustave Flaubert, *Bouvard and Pécuchet*, trans. A. J. Krailsheimer, Harmondsworth, 1976, pp. 103–4. A similar scenario is found in the house of Mr Oldbuck, the antiquary in Walter Scott's *The Antiquary* (1816), ed. David Hewitt, Edinburgh, 1995, p. 22.

65. Quoted by Peter Gay, 'Introduction', Gamwell and Wells, p. 16.
66. Lyn Gamwell, 'Freud's Antiquities Collection', in ibid., p. 28.
67. Donald Kuspit, 'A Mighty Metaphor: The Analogy of Archaeology and Psychoanalysis', in ibid., p. 135.
68. Ibid., p. 136.
69. Ibid., p. 141. William James used a sculptural/geological metaphor for the mind in *The Principle of Psychology* (1890), Cambridge, Mass., 1981, vol. I, p. 277; Walter Benjamin frequently used archaeological metaphors, as in 'A Berlin Chronicle' (1932), *One-Way Street and Other Writings*, trans. Edmund Jephcott and Kingsley Shorter, London, 1979, p. 314.
70. Michel Foucault, 'Of Other Spaces', *Diacritics*, 16–1, Spring 1986, reprinted in an edited version in *Politics-Poetics Documenta X The Book*, EC, ed. Catherine David and Jean-François Chevrier, Kassel, 1997, p. 264.
71. Maurice Tuchman, 'Introduction', *American Sculpture of the Sixties*, EC, Los Angeles County Museum of Art, 1967, pp. 10–11. See also Colpitt, pp. 86–7.
72. Fisher, p. 44. For Caro's work as an 'obstacle course', see William Rubin, *Anthony Caro*, London, 1975, pp. 98–9.
73. For example, Rosalind Krauss, 'How Paradigmatic is Anthony Caro?', *Art in America*, September/October 1975, p. 82.
74. Diane Waldman, *Anthony Caro*, Oxford, 1982, p. 34.
75. By Carter Ratcliff, about Serra, Bruce Nauman and Michael Asher at the 1972 Kassel Documenta. 'Adversary Spaces', *Artforum*, October 1972.
76. Interview with Douglas Crimp, in Serra, p. 173.
77. *The Destruction of Tilted Arc: Documents*, ed. Clara Weyergraf-Serra and Martha Buskirk, Cambridge, Mass., 1991, pp. 5, 7.
78. Serra, p. 168.
79. Louis I. Kahn, 'Spaces Order and Architecture' (1957), in *Writings, Lectures, Interviews*, ed. Alessandra Latour, New York, 1991, p. 78.
80. Louis I. Kahn, 'New Frontiers in Architecture' (1959), in ibid., p. 87.
81. Interview with Achille Bonito Oliva, 'Death Keeps me Awake', in *Energy Plan for Western Man: Joseph Beuys in America*, ed. Caron Kuoni, New York, 1990, p. 179.
82. Ludwig Wittgenstein, *Philosophical Investigations*, Oxford, 1953, no. 119.
83. Herder, p. 526.
84. They recalled Beuys' blackboards and the broken ice in Caspar David Friedrich's *Arctic Shipwreck*.

13. Loving Objects

1. Baudelaire 2, pp. 106–7. I have added the opening 'your'.
2. Siegel, p. 178.
3. This incident occurred during the judging of a school pottery

competition. The pot was one of my own. The judge picked it up and fondled it. It was a squat, rotund jar with a deep brown, *tenmoku* glaze. I do not recall whether it was awarded a prize.

4. *Julian Schnabel: Paintings 1975–1986*, EC, Whitechapel Art Gallery, London, 1986, p. 91.

5. Merleau-Ponty, p. 320.

6. Philip Leider, 'Literalism and Abstraction: Frank Stella's Retrospective at the Modern', *Artforum*, April 1970, p. 44.

7. Ellen G. Landau, *Jackson Pollock*, London, 1989, p. 17.

8. See the woodcut of Michelangelo in chapter 1.

9. Carol Mann, *Modigliani*, London, 1980, p. 65.

10. Zola, p. 285.

11. Ibid., p. 86.

12. Ibid., p. 284.

13. Tommaso Trini, 'The Last Interview Given by Lucio Fontana' (1968), in *Lucio Fontana*, EC, Whitechapel Art Gallery, London, 1988, p. 34.

14. Kim Levin, 'Malcolm Morley: Post-Style Illusionism' (1973), in *Super Realism: A Critical Anthology*, ed. Gregory Battcock, New York, 1975, p. 171. Levin mentions Duchamp's *Etant Donnés* in the next paragraph.

15. Ibid., p. 182.

16. Klaus Kertess, 'On the High Sea and Seeing of Painting', in *Malcolm Morley*, EC, Centre Georges Pompidou, Paris, 1993, p. 235.

17. Sanouillet, p. 49.

18. Jean Clair, *Duchamp et la Photographie*, Paris, 1977, p. 68. As a result, he rarely made direct use of photographs in his work.

19. Craig Adcock, 'Duchamp's Eroticism: A Mathematical Analysis', in *Marcel Duchamp: Artist of the Century*, ed. Rudolf Kuenzli and Francis M. Naumann, Cambridge, Mass., 1989, pp. 149–67.

20. Tomkins 2, p. 186.

21. Quoted in its entirety in Harrison and Wood, p. 248.

22. Box of Notes (1914). Sanouillet, p. 37.

23. Tomkins 2, p. 85.

24. Søren Kierkegaard, *Either/Or*, ed. and trans. Howard V. Hong and Edna H. Hong, Princeton, 1987, vol. 1, pp. 5–6.

25. See Silverman, p. 17ff.

26. Ibid., p. 21.

27. Ibid., p. 35.

28. Ibid., p. 36. The hero of J.-K. Huysmans' decadent novel, *A Rebours* (1884), thinks that 'two locomotives recently put into service on the Northern Railway' are more beautiful than any woman. J.-K. Huysmans, *Against Nature*, trans. Robert Baldick, Harmondsworth, 1959, p. 37.

29. Cesare Lombroso, *The Man of Genius*, New York, 1984, pp. 13–14.

Previous ages believed this too – Lombroso quotes Francis Bacon – but it became a *cri de coeur* for the Romantics. See Jacques Lethève, *Daily Life of French Artists in the Nineteenth Century*, trans. Hilary E. Paddon, London, 1972, pp. 185–6.

30. Zola, p. 124.
31. Ibid., p. 209.
32. Meyer Schapiro, 'The Apples of Cézanne: An Essay on the Meaning of Still-Life', in *Modern Art: 19th & 20th Centuries*, New York, 1979, pp. 27–8.
33. Rilke, p. 46.
34. Ibid., p. 47.
35. Ibid., p. 48.
36. Elizabeth Cowling, 'Objects into Sculpture', in Cowling and Golding, p. 229.
37. Ashton, p. 35.
38. Camilo José Cela, 1960. Ibid., p. 79.
39. Picasso once said that Braque *was* his wife, when told that only Braque's wife was allowed to see him in hospital.
40. William Tucker, *The Language of Sculpture*, London, 1974, p. 68.
41. André Salmon, *La Jeune Sculpture Française*, Paris, 1919, p. 104.
42. Anthony Shelton, 'The Chameleon Body: Power, Mutilation and Sexuality', in *Fetishism*, p. 29.
43. See Dawn Ades, 'Surrealism: Fetishism's Job', in ibid., p. 67ff.
44. Ibid., p. 72.
45. Ibid., p. 73.
46. *What is Surrealism?*, ed. Franklin Rosemont, London, 1978, p. 26.
47. Ibid.
48. Ades, op. cit., in *Fetishism*, p. 72.
49. Ibid., p. 76.
50. Dalí, p. 313.
51. Ibid., p. 314.
52. Ades, op. cit., in *Fetishism*, p. 76.
53. Ibid., p. 68.
54. Ades, op. cit., in *Fetishism*, p. 83.
55. Dawn Ades, *Dalí*, London, 1982, p. 158ff.
56. Dalí, pp. 306–11.
57. Ibid., p. 311.
58. Manzoni also made egg sculptures, some of which he ate.
59. Dalí, p. 462.
60. Tomkins 2, p. 377.
61. Robert Etienne, *Pompeii: The Day a City Died*, trans. Caroline Palmer, London, 1992, p. 168.

62. Quoted by Vidler, p. 49. Viscount de Chateaubriand, *Travels in America and Italy*, London, 1828, vol. 2, pp. 249–54. For Charles Dickens' wonderful description, see Etienne, op. cit., p. 164.

63. See also Antoinette Le Normand-Romain, 'Le moulage sur nature: objet de plaisir ou document de travail?', *De Plâtre et D'or: Geoffroy-Dechaume, Sculpteur Romantique de Viollet-le-Duc*, EC, Musée d'Art et d'Histoire Louis Senlecq, L'Isle-Adam, 1998, p. 127–139. Later in the century Rodin was accused of having cast *The Vanquished* from life – another statue of a beautiful victim.

64. Penny, p. 199.

65. Sigmund Freud, 'Delusions and Dreams in Jensen's Gradiva' (1907), in *The Pelican Freud Library, Volume 14: Art and Literature*, Harmondsworth, 1985, p. 65.

66. Sigmund Freud, 'Essay on the Uncanny', ibid., pp. 366–7. See also Vidler, pp. 45–55.

67. Oldenburg, p. 143.

68. Ibid., p. 23.

69. *Possible Worlds: Sculpture from Europe*, EC, ed. Iwona Blazwick, James Lingwood and Andrea Schlieker, Institute of Contemporary Art and Serpentine Gallery, London, 1990, p. 83.

70. Matthew Collings, 'A Tart for her Art', *Independent*, 25 March 1997, p. 4.

71. Richard Gott, 'Sexual Intent', *Guardian*, Weekend Supplement 5, April 1997, p. 27.

72. Sarah Lucas is a junk sculptor who makes assemblages with raw materials ranging from fried eggs to mattresses and lavatories. 'My work is about one person doing what they can. I like the handmade aspect . . . I'm not keen to refine it: I enjoy the crappy bits round the back.' Quoted by Sarah Kent, *Shark Infested Waters: The Saatchi Collection of British Art in the 90s*, London 1994, p. 58.

73. Emin is painting again, but it is a minor string to her bow.

14. Beyond Photography?

1. *Ezra Pound and the Visual Arts*, ed. Harriet Zinnes, New York, 1980, p. 307. For a similar view, see Jacques Lipchitz, *My Life in Sculpture*, New York, 1972, p. 38.

2. *Smithson*, p. 92.

3. Damien Hirst, *I Want to Spend the Rest of My Life Everywhere, with Everyone, One to One, Always, Forever, Now*, London, 1997, p. 299.

4. See Pollock's comments on photography in Harrison and Wood, p. 576.

5. Paul Huet in *On Painting after Nature* (1864). Quoted by Scharf, p. 147. See also comments by Eugène Durieu and André Derain on pp. 141, 252.

6. Ibid., p. 345, note 35.

7. Henri Focillon, *The Life of Forms in Art*, trans. Charles Hogan and George Kubler, New York, 1989, pp. 180–2.

8. Richard Payne Knight contrasted the richness of Rembrandt's effects with the 'feeble, flat and insipid' efforts of other colourists. He was responding to James Barry's criticism of the 'obtrusive, licentious, slovenly conduct of his pencil, or his trowel, which he is said to have used'. Unsigned Review, 'The Works of James Barry', in *Edinburgh Review*, vol. XVI, 1810, p. 317.

9. Henri Bergson, *Creative Evolution*, trans. Arthur Mitchell, London, 1964, p. 319.

10. Ibid., p. 360.

11. Tom Wolfe, *The Painted Word*, New York, 1975.

12. Ibid., p. 117.

13. Harold Rosenberg, 'Art and Words', in *The De-definition of Art* (1972), Chicago, 1983, p. 64.

14. Greenberg, vol. 4, pp. 80–1. He refers later to painting *and* sculpture, but he is basically dealing with painting.

15. Roland Barthes, *Camera Lucida: Reflections on Photography*, trans. Richard Howard, London, 1984, p. 106.

16. Colpitt, p. 94.

17. Ernst Gombrich, *The Story of Art*, London, 1995, pp. 605–6. See also Fisher, p. 26; Meyer Schapiro, 'Recent Abstract Art' (1957), in *Modern Art: 19th and 20th Centuries*, New York, 1979, pp. 217–18. See Richard Shiff, 'Cézanne's Physicality: the Politics of Touch', in *The Language of Art History*, ed. Selim Kemal and Ivan Gaskell, Cambridge, 1991, pp. 147–8.

18. René-Louis de Girardin, *De la Composition des Paysages* (1777), Paris, 1992, p. 19, referred to by Yve-Alain Bois, 'Promenade pittoresque autour de Clara-Clara', in *Richard Serra*, EC, Centre Georges Pompidou, Paris, 1983, pp. 13–14. For Girardin, see Dora Wiebenson, *The Picturesque Garden in France*, Princeton, 1978, p. 70ff. Rousseau was buried on an island in Girardin's estate at Ermenonville.

19. de Girardin, op. cit., pp. 30–1.

20. Ian Fleming-Williams, 'Introduction', *Constable, a Master Draughtsman*, EC, Dulwich Picture Gallery, London, 1994, p. 10.

21. Robert Smithson believed photography persuaded artists to work out of doors: 'we now have to introduce a kind of physicality; the actual place rather than the tendency to decoration which is a studio thing'. *Smithson*, p. 168.

22. Quoted by Beaumont Newhall, 'The Pencil of Nature', in *The Art of Photography: 1839–1989*, EC, ed. Mike Weaver, Royal Academy of Arts, London, 1989, p. 13.

23. Scharf, p. 57.

24. Ibid., p. 156.

25. Quoted by Silverman, p. 252.

26. Kirk Varnedoe, 'Rodin and Photography', in *Rodin Rediscovered*, EC, ed. Albert E. Elsen, National Gallery of Art, Washington, 1981, p. 205.

27. Truman Bartlett in Albert E. Elsen, *'The Gates of Hell' by Auguste Rodin*, Stanford, 1985, p. 127. Rodin also said that his *Balzac* was an attempt to make a kind of sculpture that was not 'photographic'. Butler, p. 320.

28. Varnedoe, op. cit., p. 203ff; Albert Elsen, *In Rodin's Studio*, Oxford, 1980.

29. Notions of what constituted 'permanence' and 'longevity' as regards media became a subject of heated debate in the late nineteenth century. There were concerns about the durability of oil paint when it was seen how Manet's paintings had visibly darkened. Claims were made for the greater durability of pastel, gouache and distemper. Douglas W. Druick and Peter Zegers, 'Scientific Realism: 1873–1881', in *Degas*, EC, ed. Jean Sutherland Boggs, Metropolitan Museum of Art, New York, 1988, p. 202.

30. Baldassari, p. 16.

31. Ibid., p. 17.

32. Ibid., p. 17. On occasion, Picasso acted as though he believed that photography could stand in for object-based art. He made several elaborate mixed-media installations in his studio that survive only as photographs, and in 1946 he proposed to Brassaï that he should come and photograph 'paper objects that will exist thanks only to photography'. The second project, however, was never carried out.

33. Aloïs Riegl, *Problems of Style: Foundations for a History of Ornament*, trans. Evelyn Kain, Princeton, 1992, p. 14, note 1.

34. Quoted by Poggi, p. 50. Gertrude Stein also tells us that 'Picasso at this period often used to say that Spaniards cannot recognize people from their photographs.' Ibid., p. 51.

35. *German Expressionist Sculpture*, EC, ed. Stephanie Barron, Los Angeles County Museum of Art, 1983, p. 35. Primitivizing sculptors restated these notions. For George Kolbe, see ibid., p. 133; for Henry Moore, see James, p. 70.

36. Golding 1, p. 105.

37. Pollock made sculptures from rejected drawings glued over a chicken–wire frame – more drawings in space.

38. Allan Kaprow, 'Happenings in the New York Scene', (1961), in *Essays on the Blurring of Art and Life*, ed. Jeff Kelley, Berkeley, Ca., 1993, pp. 17–18.

39. Quoted by Germano Celant, 'Claes Oldenburg and the Feeling of Things', in Oldenburg, p. 24.

40. From his Notebooks, 1960. *Claes Oldenburg*, EC, Museum of Modern Art, New York, 1970, p. 189.

41. Celant, op. cit., in Oldenburg, p. 22.

42. Ibid., pp. 62–3.

43. Ibid., p. 204. This was written in 1976.

44. Gene Baro, *Claes Oldenburg: Drawings and Prints*, Secaucus, New Jersey, 1988, p. 19.

45. William Rubin, *Anthony Caro*, London, 1975, p. 72.

46. Colpitt, pp. 93–9. Carl Andre insisted that he did not 'visualize' or 'draw' works. Siegel, p. 178.

47. Interview with Douglas Crimp, in *Serra*, p. 170. See also Bois, op. cit., pp. 11–27.

48. Ibid., p. 11.

49. Article from 1969 reprinted in Robert Pincus-Witten, *Postminimalism*, New York, 1977, p. 31.

50. Richard Serra, 'Extended Notes from Sight Point Road', in *Recent Sculpture in Europe 1977–85*, Galerie m, Bochum, 1985, p. 13.

51. See also Jean-François Lyotard's comparison of dream-language to a piece of paper which has been crumpled, so that whatever has been written on it is now embedded in the squashed lump. *Discours/Figure*, Paris, 1971, pp. 239–70. Cited by Yve-Alain Bois and Rosalind E. Krauss, *Formless: A User's Guide*, New York, 1997, p. 103.

52. Robert Morris, 'The Present Tense of Space' (1978), in *Continuous Project Altered Daily: The Writings of Robert Morris*, Cambridge, Mass., 1993, pp. 199–201.

53. Kaprow, op. cit., p. 92.

54. 'Discussions with Heizer, Oppenheim, Smithson' (1969), in *Smithson*, p. 177.

55. Interview with Douglas Crimp, in *Serra*, p. 170.

56. Merleau-Ponty, p. ix.

57. Edward de Bono, *The Mechanism of Mind*, Harmondsworth, 1969, p. 52.

58. Ibid., p. 61.

59. Ibid., p. 153.

60. Ibid., p. 97.

61. Ibid., pp. 59–60.

62. Krzystof Wodiczko, 'Public Projection' (1983), in Harrison and Wood, pp. 1094–7.

63. Donald Brook, 'Perception and the Appraisal of Sculpture', *Journal of Aesthetics and Art Criticism*, Spring 1969, pp. 323–30.

64. André Malraux, *The Psychology of Art: Museum without Walls*, trans. Stuart Gilbert, London, 1949, pp. 17, 50.

65. André Malraux, *Le Musée Imaginaire de la Sculpture Mondiale*, 3 vols, Paris, 1954.

66. W. H. Fox Talbot, *The Pencil of Nature*, London, 1844–6, plate V.

67. Quoted by Geraldine A. Johnson, *'The Very Impress of the Object'*:

Photographing Sculpture from Fox Talbot to the Present Day, EC, Henry Moore Institute, Leeds, 1995, p. 2.

68. The text is reprinted in French translation in *Pygmalion Photographe: La Sculpture Devant la Caméra 1844–1936*, EC, Cabinet des Estampes, Musée d'Art et d'Histoire, Geneva, 1985, p. 127.

69. Friedrich Teja Bach, 'Brancusi and Photography', in *Brancusi*, p. 315.

70. See also Jean-Paul Sartre's comments on Giacometti's sculpture: 'we no longer know what position to take, or how to synthesize what we see'. Many of the photographs that accompanied Sartre's essay, taken by Patricia Matisse, seem deliberately unfocused. Jean-Paul Sartre, 'The Search for the Absolute', in *Alberto Giacometti*, EC, Pierre Matisse Gallery, New York, 1948, p. 14.

71. Quoted by Hubertus von Amelunxen, 'Skiagraphia: L'Exposition du Sculpture', in *Sculpter-Photographier Photographie-Sculpture*, EC, ed. Michel Frizot and Dominique Paini, Musée du Louvre, Paris, 1993, p. 35.

72. Hazlitt was influenced by Benjamin Robert Haydon, who had compared a cast of a live hand with hands represented in the metopes. Jacob Rothenberg, *Descensus ad Terram: The Acquisition and Reception of the Elgin Marbles*, New York, 1977, pp. 251–2, 345–6.

73. *Sculpter-Photographier Photographie-Sculpture*, op. cit., p. 9.

74. D. Brucciani, *Catalogue of Casts for Sale*, London, 1864. See Haskell and Penny, p. 117ff.

75. D. Brucciani, *Catalogue of Casts for Schools*, London 1948.

76. Antoinette Le Normand-Romain, 'Moulage', in *Sculpture Française*, p. 71.

77. Entry for 7 May 1847. Scharf, p. 342, note 34.

78. Butler, p. 110.

79. Adolf von Hildebrand thought the impulse to have naturalistic figures at the base of monuments came from a desire, encouraged both by positivism and by photography, to simulate the confused sensory experiences of the first few hours of a person's life. Hildebrand, p. 44.

80. Charles Colbert, 'Each Little Hillock hath a Tongue: Phrenology and the Art of Hiram Powers', *Art Bulletin*, June 1986, p. 298. There is a poem of W. S. Gilbert about a policeman sizing up a dubious-looking character. John D. Davies, *Phrenology: Fad and Science: A 19th-Century American Crusade*, New Haven, 1955, p. 98. But it was also seen as an egalitarian science, which held everyone up to scrutiny. Roger Cooper, *The Cultural Meaning of Popular Science: Phrenology and the Organisation of Consent in Nineteenth-Century Britain*, Cambridge, 1984, pp. 117, 136. George Combe applied these methods to the visual arts: *Phrenology Applied to Painting and Sculpture*, London, 1855.

81. Johann Caspar Lavater, *Essays on Physiognomy*, trans. Thomas Holcroft, London, 1810, p. 251.

82. Rilke, p. 52.
83. Lord Lytton, *The Last Days of Pompeii*, London, 1933, pp. 495–6.
84. It is featured in *Follow Me: Britische Kunst an der Unterelbe*, EC, ed. Martina Goldner, Stade, 1997.
85. James Hall, 'Frame Game', *Guardian*, 7 November 1994.

Index